Women's Camera Work

New Americanists

A Series Edited by Donald E. Pease

Women's

Self/Body/Other in American Visual Culture

Camera

JUDITH FRYER DAVIDOV

Work

DUKE UNIVERSITY PRESS Durham and London 1998

© 1998 Duke University Press
All rights reserved
Printed in the United States of America
on acid-free paper ∞
Designed by Mary Mendell
Typeset in Galliard
Library of Congress Cataloging-in-Publication Data
appear on the last printed page of this book.

For these women photographers:
Deborah Jane Fryer
Ravina Eve Gelfand (1922–1996)
Penny Jacobs
Barbara Klingelhöfer
Lynn Rachel Stein

Contents

Acknowledgments ix

Prologue 3

I Histories: Versions and Subversions 13

II The Geometry of Bodies: Gender and Genre in

 Pictorialist Photography 45

III "Always the Navajo Took the Picture" 103

IV Containment and Excess:

 Representing African Americans 157

V "The Only Gentile among the Jews": Dorothea Lange's

 Documentary Photography 215

VI The Body's Geography: Female Versions of Landscape 295

 Epilogue 377

 Notes 387

 Index 479

Acknowledgments

It was lovely. Not to be stared at, not seen, but being pulled into view by the interested, uncritical eyes of the other. Having her hair examined as a part of her self, not as material or a style. Having her lips, nose, chin caressed as they might be if she were a moss rose a gardener paused to admire. —Toni Morrison, Beloved

Next to starting a new book, this must be the place every writer likes most to arrive at, the piece that is made last but comes first, that traces the long and lonely path of hard thinking, and in this case hard looking, but remembers that along the way there were fellow spirits who eased and enriched the journey.

Portents of this work were already looming by the time I reached the end of *Felicitous Space* and began to understand the kind of sense the body makes. What I imagined for my next project—a ranging widely across genres of visual images and discourse to explore the body's expression—is very different from the book that has emerged. Perhaps because in the early stages of this project I was myself so often photographed, or perhaps because the end of that period of my life coincided with the inheritance of a large box of photographs, left unsorted by my mother, what Toni Morrison calls "rememory" became for me bound up with the deep cultural and personal meaning—the stories—photographs can yield. The result owes more than I can express here to colleagues, friends, and familiars.

My greatest debt is to Laura Wexler, for her encouragement at every stage, for her meticulous and compassionate reading, her penetrating insights. It is a heartfelt pleasure to thank her in print for the important contribution she has made to this work.

Alan Trachtenberg's *Reading American Photographs* is the place where cultural historians who write about photography must begin. In addition to the importance of this and other work, Alan has been for many of us an

enabling, always generous presence. My opening chapter, which engages him in a dialogue about the problems of writing history, even as it works to go beyond his sense of a master narrative, builds upon his work and has profited from his incisive criticism.

My research-sharing group in Amherst has been an important source of support: Frank Couvares has insistently asked hard questions that have pushed me to think clearly about history; Rowland Abiodun, Bob Paynter, and Jackie Urla have helped me to think through problems of representation. Several colleagues contributed time and energy to this project. Miles Orvell's careful and attentive reading of the entire manuscript came at a crucial time; my revisions benefited from his wise suggestions. James Boylan offered insightful comments on the Dorothea Lange chapter; Mick Gidley gave me a perceptive reading of an early version of the landscape chapter; Sandra Matthews helped me to state problems of the histories chapter more clearly; Joseph T. Skerrett made constructive suggestions for the African American chapter; Jackie Urla read the American Indian chapter and shared resources that broadened my understanding of visual anthropology.

Parts of chapters 2 and 5 were published, in different form, in *Prospects: An Annual of American Cultural Studies* and *The Yale Journal of Criticism*. Various pieces were presented at several American Studies Association meetings; the French American Studies Association meeting in Strasbourg; the European American Studies Association meeting in Seville; the Women and Social Change series at Smith College; the American Studies faculty seminar, Institute for Advanced Study in the Humanities, University of Massachusetts at Amherst; and the Five Colleges faculty seminar on "Visual Images and Cultural Politics." The book has benefited from responses to that work by Joyce Berkman, James Boylan, Deborah Carlin, Jules Chametzky, Annette Kolodny, Sandra Phillips, Paula Rabinowitz, Martha Sandweiss, Maren Stange, and Sally Stein; from conversations with Beverly Brannan, Noll Brinckmann, Martin Christadler, Therese Thau Heyman, Sarah M. Lowe, Barbara Head Millstein, Percy North, William Oedel, Mary Panzer, Rondal Partridge, Toby Quitslund, and Mark Roskill; and from feedback from graduate students in my seminar on Photography and American Culture, especially Cynthia Packard, Roxanna Pisiak, and Matthew Schmidt.

Several colleagues helped me to obtain leaves of absence by writing letters of support: Jules Chametzky, Elaine Scarry, John Stilgoe, Alan Trach-

tenberg, Laura Wexler. Murray Schwartz, as dean of the faculty in fine arts and humanites, matched my American Council of Learned Societies award to extend the semester's leave into a year-long period of writing. Foundations supporting this project include the American Council of Learned Societies, the National Endowment for the Humanities, and the Center for Advanced Study in the Visual Arts at the National Gallery. The time spent at CASVA was especially valuable both because it enabled me to do most of the necessary hands-on research in Washington, D.C., and because of a supportive community, under the direction of Hank Millon and Therese O'Malley, brought together in working conditions undreamed of by most scholars. In its funding of a related, collaborative project, the Getty Grant program was instrumental in creating the conditions for thinking about representation that fundamentally reshaped this book.

A number of curators and librarians went out of their way to help me at the National Gallery, the National Museum of American History, the National Museum of American Art, the Anthropological Archives of the National Museum of Natural History, the National Archives, the Prints and Photographs, Manuscripts, and Film Divisions of the Library of Congress—all in Washington, D.C.; the Bancroft Library, University of California, Berkeley; Beinecke Library, Yale University; the Clarence White Archives, Princeton University; the University of Delaware; the Brooklyn Museum; the Oakland Museum of California, where Therese Thau Heyman was very generous with her time in the early stages of work on Dorothea Lange; and at the University of Massachusetts, Amherst, the hardworking staff of the interlibrary loan office.

I am grateful to archivists and registrars at historical societies and museums who helped me to locate and gave me permission to use images from their collections, all named elsewhere in this book. I would especially like to thank Carol Johnson, Prints and Photographs Division, Library of Congress, for her patient good will with my long list of questions; Amy Kelly, Amon Carter Museum, Fort Worth, Texas, who returned to work after delivering her baby to nail down Gilpin negatives for me; Jerry Richardson, who loaned me a rare Gilpin photograph in which he is the pictured babe; Elizabeth Partridge of the Imogen Cunningham Trust for her generous support of this project; Leslie Overstreet, Dibner Library, Smithsonian Institution; and Richard Engeman, Special Collections, University of Washington Library, Seattle, for their efficient locating of obscure images. I am grateful to the Regional Oral History Office, Bancroft Library, University

of California, Berkeley, for permission to quote from Suzanne Riess's *The Making of a Documentary Photographer* (her long interview with Dorothea Lange) and *Paul Schuster Taylor: California Social Scientist,* and from interviews with Ansel Adams and Imogen Cunningham, and thank Suzanne Riess and for her helpful suggestions in handling this material.

Lee Suzlner made many of the slides that I used in presentations of this material; she and Louise Bloomberg were helpful over the long period of time that I used the art history department's collection at the University of Massachusetts, Amherst. Carrie Suhr was an invaluable research assistant in Washington, D.C., particularly in confronting the Farm Security filing system at the Library of Congress. Deirdre Murphy was tireless in tracking down images and fastidious in checking references. Jacqueline Ellis assisted in the arduous task of acquiring prints and permissions. Dede Heath helped to compile the index. Jennifer Ackerman Bruinooge, Deborah Fryer, and Christopher Hanlon took time out of their busy lives to proofread the final copy, for which I am enormously grateful.

I was fortunate to work with a wonderful staff at Duke University Press, especially Reynolds Smith, who believed in this project for a long time before it saw print, and talented designer Mary Mendell.

Finally, thanks and hugs to those who sustained me during the long period of laboring under the sign of *Festina Lente*—words given to me by my classicist daughter, Deborah, that turned out to be Gertrude Käsebier's advice to Laura Gilpin: "Make haste slowly." These special people are my gardening buddy Priscilla; my walking partners Willa, Rosie, Tigger, and Arlyn; and my daughters Lynn and Deborah, photographer and filmmaker, for their ekphrastic imaginations.

Women's Camera Work

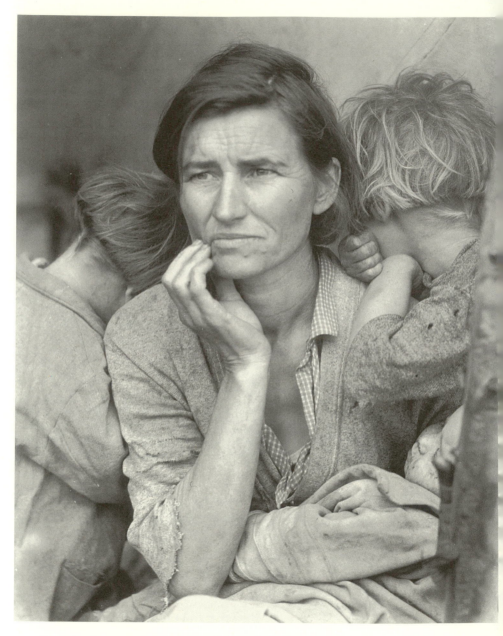

P.1 Dorothea Lange, *Migrant Mother,* 1936. U.S. Farm Security
Administration Collection, Prints and Photographs Division,
Library of Congress, no. USF34 2T01-9058.

Prologue

All stories are discontinuous and are based on a tacit agreement about what is not said, about what connects the discontinuities. . . . The discontinuities of the story and the tacit agreement underlying them fuse teller, listener and protagonists into an amalgam. An amalgam which I would call the story's reflecting subject. . . . If this sounds unnecessarily complicated, it is worth remembering for a moment the childhood experience of being told a story. . . . You were listening. You were in the story. You were in the words of the story-teller. You were no longer your single self; you were, thanks to the story, everyone it concerned. —John Berger, Another Way of Telling[1]

Reading photographs—visual records of time past—is a way of constructing versions of history. Interpretation includes assigning categories of meaning ("art," "document") to images, ordering them into sequences of other pictures and words, and from these pieces creating a narrative— which might be based upon chronology, a linear mode of perception, or differently grounded in circularity, indirection, and play, as memory and imagination, ideology and cultural context direct. Narrative patterns are potentially as multiple and as changeable as readers of images.[2]

Photographs invite an especially broad range of responses because of their widespread accessibility and use, from art museum to billboard, from police report to family snapshot album. A good example of the way in which responses to images alter over time and of the varied cultural work that photographs do is Dorothea Lange's well-known "Migrant Mother" (fig. P.1). When Lange took this picture in 1936 in a Nipomo, California, migrant workers' camp, she was on assignment for the Resettlement Administration (later the Farm Security Administration), hired to "document" the living conditions of homeless families pouring into California in a futile search for work. Roy Stryker, head of the RA's Historical Section, would later call this one, of the set of photographs Lange made that day,

3

"the ultimate, . . . *the* picture of Farm Security."³ But it was two other pictures in the series that generated immediate and dramatic results. Within days after the photos were made, the *San Francisco News* carried these two images in a story that reported the heroic role of the photographer—"Ragged, ill, emaciated by hunger, 2,500 men, women and children are rescued after weeks of suffering by the chance visit of a Government photographer to a pea-pickers' camp in San Luis Obispo County"—and the news that the federal government was rushing 20,000 pounds of food to feed the hungry migrants.⁴ In September 1936, *Survey Graphic* (the journal that had published so many of Lewis Hine's child labor photographs), reprinted the soon-to-be-famous image along with other Lange photos and a report by sociologist Paul Taylor on the work of the RA. In the same year, *U.S. Camera* invited Lange to include *Migrant Mother* in its show of outstanding photographs. Recognizing the importance of this new context, she demanded both control over the printmaking and that the print be signed.⁵ Its first gallery showing, at the Museum of Modern Art in the new photography department's first exhibit, firmly stamped *Migrant Mother* as art. In 1962 art critic George Elliott, in attempting to account for the response to this work, would call it an "anti-Madonna and Child" and attribute its power to "the viewer's . . . understanding [of] the profounder, the humanly universal, results of . . . poverty"; by 1966, in his introductory essay for the catalog of the Lange Retrospective at the Museum of Modern Art, he would acknowledge its wide acceptance "as a work of art with its own message rather than its maker's; . . . a great, perfect, anonymous image [that] is a trick of grace."⁶

This photograph would go on to have a life beyond both the FSA files in the Library of Congress and the MoMA holdings. *Popular Photography* reproduced the image in 1960 along with Lange's account—a story about an exchange between an anonymous photographer in a hurry and an anonymous suffering woman that presents the making of the image as a two-way transaction. Headed home on a rainy day from a long assignment, passing a sign saying "Pea-Pickers Camp," something made her turn around and backtrack twenty miles. "I drove into that wet and soggy camp and parked my car like a homing pigeon," she recalled:

> I saw and approached the hungry and desperate mother, as if drawn by magnet. I do not remember how I explained my presence or my camera to her, but I do remember she asked me no questions. I made five

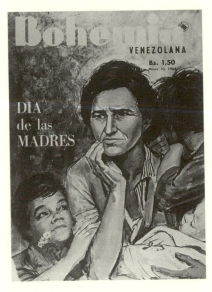
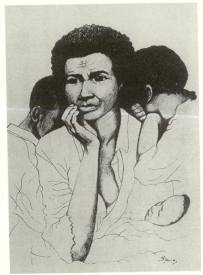

P.2 "Dia de las Madres," *Bohemia Venezolana* (May 10, 1964),
Oakland Museum.
P.3 Malik, "Poverty Is a Crime," *Black Panthers' Newsletter* 9, no. 8
(Dec. 7, 1972), back cover. Special Collections, Alderman Library,
University of Virginia. ©1972 by Huey P. Newton.

exposures, working closer and closer from the same direction. I did
not ask her name or her history. She told me her age, that she was 32.
She said that they had been living on frozen vegetables from the sur-
rounding fields, and birds that the children killed. She had just sold
the tires from her car to buy food. There she sat in that lean-to tent
with her children huddled around her, and seemed to know that my
pictures might help her, and so she helped me. There was a sort of
equality about it.[7]

In later years, Lange would complain that the Library of Congress never
reproduced *Migrant Mother* the same way twice, despite the guide print
she supplied. Indeed, as the image became a kind of icon, assimilated into
vernacular culture, it never was reproduced the same way twice. Margery
Mann, in a 1970 *Popular Photography* story on Lange, recalled passing "the
display window of an artist who would paint your portrait from your pho-
tograph, and amidst his samples, the glorified girls and the 30-year-old,
slyly-smiling Bette Davis and the muscle men, sat 'Migrant Mother,' big as

life, and blue and yellow and lilac." Closer to its original purpose, a Spanish Civil War artist would make a closely copied lithograph of the mother alone, entitled "The Spanish Mother, Terror of 1938." In 1964 the Latin American magazine *Bohemia* reproduced an artist's rendering of the photograph on its cover, turning the head of one child to show its face (fig. P.2). And in 1973 the Black Panthers' *Newsletter* ran in full page an artist's version of the photograph that gave black features to the faces and the hair, adding the caption, "Poverty is a crime, and our people are the victims" (fig. P.3). None of these credited Lange as the author of the image.[8]

Migrant Mother, then, is not only a visual representation of "our" history but a picture with a sixty-year history of use and appropriation. An all-inclusive icon—mother and child—it is also a locus for different stories, for alternative histories that have to do with class and race. In fact, the power of this image to convey both sameness and difference, not only in 1936 but in 1964 and 1973, suggests that its meanings have been and are constructed by powerful responses to it. Yet this is also Dorothea Lange's image—the work of a photographer who would claim her own physical and historical "outsidedness" as a source of special affinity for her suffering subjects. Her own "otherness," which made it possible for her to understand others' stories, was also the source for her claim to agency: to be a Photographer, a History Maker, a Storyteller. The question that interests me here is this strategy of claiming agency for oneself by representing otherness, particularly when it is practiced by women photographers emerging from a tradition (into which they at first tried to place themselves) of the history of art that had consistently represented *them* as other.

Lange, as well as Gertrude Käsebier, Imogen Cunningham, and Laura Gilpin, have been variously referred to in the way Willa Cather described Sarah Orne Jewett: as having a "gift of sympathy."[9] The very mention of this term, however, calls for an immediate warning: the problem of speaking for those one can only approach—what Theodor Adorno called "the condition of all truth"—presupposes the resolution of an entire set of power relationships and decisions about a posture, a stance, a style of being present in the world of those who are considered voiceless.[10] Any "power of sympathy" is challenged by the sense of absolute separateness of one's own reality from that of other persons. This split, Elaine Scarry argues, has to do with conceiving of the body from *outside*—"as parts, shapes, and mechanisms"—rather than in terms of capacities and needs or as a source of aliveness. Self, body, other—these are the themes of this book whose focus is

this question: to what extent is it possible to traverse this separating space, to be able to perceive another from within "the felt-experience of sentience"?[11]

To tie this problem to *women's* camera work is to tread between polarizing traps. Some women, because of the material circumstances of their own lives, are particularly responsive to "felt experience"; others are quite capable of abusing positions of power. Diane Arbus's trying on of alien experience—a kind of "panopticon of the spirit"; Margaret Bourke-White's descriptions of war, the work of killing and maiming, as pageantry and pattern; Cindy Sherman's performance art, a dis-guise of the self, re-presented as an illusion, a culturally constructed contrivance[12]—all constitute a powerful argument against a "gift of sympathy" when the woman looks. I make no attempt to address a universal category called Woman or to sentimentalize women's work as deriving from a kind of female utopian community. Instead, this book is a study of work—some well known and heavily freighted, some heretofore unrecognized—by certain women photographers connected by time (from Gertrude Käsebier's work at the turn of the century to the late work of Imogen Cunningham and Laura Gilpin) and place (for the most part, the western United States), by interaction, example, and friendship. The narrative frame is neither chronological nor neat: the works of Käsebier, Cunningham, Lange, and Gilpin are of primary importance, but I also include work of a number of lesser-known (and some virtually unknown) photographers; I focus on the early and middle part of the twentieth century, but Gilpin's and Cunningham's long careers lasted nearly to our own time and invite comparisons with contemporary works. Yet this wide focus is in its own way quite narrow: I have chosen to sacrifice broader inclusion (a wider net) for a thick reading of some images that have generated my own strong response.

Women's Camera Work is an attempt to understand the work photographs do in constructing histories. As I have suggested with the example of *Migrant Mother*, such constructions have to do not only with the art of making but with institutional practices, social contexts, the politics of circulation, and a wide variety of personal and public responses. Through the lens of contemporary cultural studies discourse, this narrative endeavors to critique influential male-centered historiography, to retrieve and rehearse the value of gender as an analytical category in photographic production, to exhibit the work itself and tell the absorbing story of the women who made it, to evaluate their distinct contributions in relation to constructions

of American-ness and otherness, to discover the aesthetic and deconstructive power of close reading of certain images, and to learn to see what these women saw.

Self, body, other—including interconnecting constructions of gender, race, and class—these are the warp threads of a fabric whose woof threads are problems within particular photographic genres: images made by women Pictorialists who both worked within and departed from the conventions of the fine arts as defined by Alfred Stieglitz in his journal *Camera Work* and his gallery 291; "documents" of American Indians, African Americans, the poor; and representations of landscape as spacious and mythical as primeval monuments *and* as precise and intimate as the human body.

Chapter 1 explores the way in which makers, distributors, and readers of images construct histories, including the relationship between visual imaging and national culture, the representation of difference, and the creating of sub-versions. As a way of recovering photographic history and thinking about the cultural work that images do, and in opposition to the hierarchical *line* of male photographers descending from Stieglitz (or on the West Coast, Edward Weston), I propose here the more amorphous structure of a *network* of women. This network is not only my subject but a construct that gives shape to my narrative and functions as a discursive analogue.

Chapter 2 explores women's photographic networks in the period of the "coming-of-age" of photography—from 1890 to the First World War, coinciding approximately with both Stieglitz's *Camera Work* and the Clarence H. White School of Photography. Women like Gertrude Käsebier, Imogen Cunningham, Laura Gilpin, Dorothea Lange—the major figures of this study—mentored and supported one another in important ways. Many of them shared a common rootedness in a significantly more open form of Pictorialism taught by Stieglitz's one-time collaborator and later rival, Clarence H. White, with whom Käsebier was associated and Gilpin and Lange studied. Entering the field coincidentally with the development of new methods of producing cheap paper, photoengraving, and printing, these women joined photographic societies, published in photographic journals, exhibited at galleries, and contributed to the popular press. Many of them who, like Käsebier, were well educated and trained in painting turned to photography as a more effective means of developing an expressive language in their visual images. Although women worked in all photographic genres, their subjects were often (unlike their male counterparts who often favored allegorical representations of female nudes) friends and

family members; rarely did women hire models. To examine their work—a trove of visual documentation of everyday life that makes a strong case for female agency in the making of (photographic) histories—is to understand the way in which personal and social experiences in this period led women to make visual choices contingent on contexts and relationships.

Picturing difference (as in the "otherness" of women's bodies) is, however, by no means peculiar to men. Pictorialist photography as practiced by both men and women was bound up from the beginning with representing exotic difference.[13] The intertwined issues of class and gender—insofar as the distinction between middle-class women who took up the camera and the women who modeled nude for male photographers is concerned— were not ones that women thought or wrote about, even though they did rise through the ranks, from receptionist or photofinisher to photographer. Specifically targeted by marketing strategies to take up the camera, their concern was to use their camera work as a legitimate way of claiming time and space of their own. Middle-class white women usually began by photographing the familiar. But they were also drawn to picturing what was strange—and here is where the issue of gender intersects with those of race and of class in complex ways. Chapters 3, 4, and 5 focus on this intersection and deal, respectively, with representations of American Indians, African Americans, Asian Americans, and the migrant poor.

Gertrude Käsebier, who would prove so strong a presence for the women photographers of this study, "documented" (the word used for Käsebier's work by her friend Frances Benjamin Johnston) a great range of Americans who came to her Fifth Avenue studio in New York, including a group of American Indians traveling with Buffalo Bill's Wild West Show. Käsebier claimed an affinity for these "red" men, women, and children because of her own western origins, and her mode of representation was an early model for her younger Colorado colleague, Laura Gilpin. Preserving the empathic relationship between sitter and subject she had learned from her mentor, Gilpin, however, would discard her soft-focus lens and ultimately move away from an artful picturing of American Indians. Her mature work, particularly *The Enduring Navaho,* is distinctly her own, and strikingly at variance with most visual records of a "vanishing race." This difference, I argue here, has a great deal to do with gender, not only in terms of public support or its lack, but also in terms of the life experience of the photographer.

Many women whose camera work might not otherwise have been pub-

lished and exhibited were supported by Käsebier and especially by John-
ston, who celebrated these unknown photographers' achievements in a se-
ries of articles for the *Ladies' Home Journal* and at the Paris Exposition in
1900—where Johnston's own Hampton Institute series won a Grand Prix.
These pictures of a white, middle-class "Progressive" institution's reformist
attempts to remake the Other in its own image are complicated, I suggest,
by Johnston's gendered response to her subject matter. This is the subject
of Chapter 4 and includes, in addition to Johnston's work, that of Doris
Ulmann, another Clarence White student, and Consuelo Kanaga. Ulmann
is best known for her pictures of Appalachian rural culture, in which she
seems to have achieved a rapport with the "folk" in Kentucky and Tennes-
see, who often re-created tableaux from the past for her camera. My inter-
est, however, is in her relatively unknown photographs of Gullah Negroes
for Julia Peterkin's *Roll, Jordan, Roll,* a less successful but more interesting
project because of strategies of resistance demonstrated by her subjects.
Consuelo Kanaga, a friend of Cunningham and of Lange, worked both in
art photography and photojournalism and had ties to the West and East
Coasts. From her early days in Paris when she discovered African sculpture
to her work with the leftist Photo League in New York, she was attracted to
black subjects, photographing them, she claimed, as a mode of self-explora-
tion.

As I have suggested in my discussion of Lange's *Migrant Mother,* FSA
images have been and continue to be read in disparate, even contradictory
ways. Susan Sontag, for example, has argued that the artistic preconcep-
tions of FSA photographers, who took dozens of frontal pictures of their
sharecropper subjects until they got just the right look—"the precise ex-
pression on the subject's face that supported their own notions about pov-
erty, light, dignity, texture, exploitation, and geometry"—override and
thus negate the reality, and the validity, of their subject. Although there are
reasons to see the FSA images as a body of camera work (photographers
operated under Stryker's direction: he kept the "good" negatives and
punched holes in others, wrote the "shooting scripts" and distributed the
pictures), there are significant grounds for differences among them as well.
Andrea Fisher locates these differences in gender: the FSA photographs by
men, she contends, exhibit a kind of unity, a frontality that connotes direct
and immediate presence, whereas those by women—through complex
poses and evocative, directional lighting—arrest, unsettle, and provoke
disparate responses.[14] I find Fisher's distinctions between women and men

suggestive but finally troubling. I am more interested in exploring questions of visibility and invisibility (Lange's self-descriptive terms), of distance and proximity; in questions of power—inherent in the gaze of those who see and implement policy—and powerlessness, as those who are represented bear its consequences. Chapter 5 focuses on the way in which Lange's work for the FSA and the War Relocation Authority (WRA) confounds these categories of self and other.

It is no coincidence that bodies and land were both objects of the colonial gaze and subjects of high art in the latter part of the nineteenth century. It is no accident that as Pictorial photographers, eager for acceptance of their work on aesthetic grounds, turned to that other great subject of Western art, the landscape, "documentary" photographers in the United States went west to record visually new land claims. Like the railroad, which allowed Whitman and his fellow travelers to see "distances joined like magic," the camera was an active agent in the process of turning nature into culture.[15] Landscape was a subject to which women photographers came late not only for practical reasons—heavy equipment, arduous travel conditions—but also because in the tradition of the genre they—their bodies—*are* the subject. Anne Brigman, working at the turn of the century, tackled this problem, Symbolist fashion, by turning her camera on her self in her "visualization of the human form as part of tree and rock rhythms."[16] Cunningham's California pictures of peopled places and her sensual photographs of plants in her garden in various stages of growth offer an obvious comparison with the precisionist photographic landscapes of her male contemporaries, particularly Edward Weston. A sentient physical world, Cunningham's primary interest, was also Gilpin's subject for most of her long career. Gilpin's sense of place—her photographic record of the Southwest—differs markedly from that of both male travelers who recorded their impressions of vast tracts of unpeopled spaces and Anglo-European women who journeyed west with their husbands carrying seeds, root cuttings, and scraps of fabric from home to re-create in the wilderness the familiar gardens of their eastern places. In the most empty vista Gilpin sensed a history, a presence, or what she called the *spirit* of place—by which she meant the indigenous history and peculiar geography of each locale. Her conception of place as feminine and maternal, which is to some extent shared by Brigman and Cunningham, is tied to a sense of the land as not merely a "scape"—something viewed—but as an inhabited *place*. Such a redefinition of "landscape" opens up the genre to a consideration of Lange's

work in terms of the human histories embodied in particular places and in terms of the meaning of *dis*placement.

The meditations in this book depend very much upon attempting to establish the broadest possible context—personal, social, artistic—for reading certain images. At the same time, the reading itself is highly interactive and depends upon selecting and ordering. Lange's *Migrant Mother* can be placed beside that other famous suffering woman of the Depression, Walker Evans's "Annie Mae Gudger," or, more broadly, alongside a selection of other documents in the FSA files, such as those made by Carl Fleischhauer and Beverly Brannan in *Documenting America* or by Andrea Fisher in *Let Us Now Praise Famous Women*. This reading thus shifts the argument from content—documentation of a specific historical period—to form—composition, technique, angle of vision. Lange, who argued that grouping photographs is a way of telling stories, created her own new context for this well-known image by placing it, in her retrospective exhibit, in a series of photographs spanning her career which she called *The Last Ditch*. Edward Steichen used *Migrant Mother* in his 1955 Museum of Modern Art exhibit *The Family of Man* as part of a mythic global village—in a section of nursing mothers and children that came to be called "Tits and Tots."[17] Or with the sort of imaginative history making practiced by a historian such as Simon Schama, one could use Lange's representation in an attempt to reconstruct the subject's, Mrs. Florence Thompson's, own story.[18] Such a narrative, pieced together through the lens of one's own viewing eye/I would be no less ingenious than one created by placing Lange's iconic image alongside Käsebier's *The Manger* and Gilpin's *Navaho Madonna*, Cunningham's *Pregnant Woman* and Kanaga's *Black Madonna*. To do so not only situates the image diachronically, but also discovers unlikely likenesses across the lines of race and class in adding the elements of *tableau vivant* (Käsebier), in foregrounding the body (Cunningham, Gilpin) as a source of aliveness, in trying on the identity of the other (Kanaga). The imaginative narrative I have constructed thus derives from my own hard looking and also my own intuition, shaped and fixed in time and place by a particular configuration of historical conditions. Pattern—that is, the form and substance that give shape and meaning to my story—is, as in music, an invention spun on the ground of these visual images.

I | Histories: Versions and Subversions

Stereotypes are a crude set of mental representations of the world. They are palimpsests on which the initial bipolar representations are still vaguely legible. They perpetuate a needed sense of difference between the "self" and the "object," which becomes the "Other."
—*Sander Gilman*, Difference and Pathology[1]

The simplest cultural accounts are intentional creations. . . . [I]nterpreters constantly construct themselves through the others they study.—*James Clifford, introduction to* Writing Culture[2]

THE SPECTACLE OF HISTORY

It is the entrance to a flea market. . . . Sloppy crowds. Vulpine, larking. Why enter? What do you expect to see? I'm seeing. I'm checking on what's in the world. What's left. What's discarded. What's no longer cherished. What had to be sacrificed. What someone thought might interest someone else. But . . . it's already been sifted through. But there may be something valuable, there . . . something I would want. . . . Something that speaks to me. To my longings.—*Susan Sontag*, The Volcano Lover[3]

History pictures. History *pictures*. Rulers and priests, scholars, madonnas, and courtesans. Symbols of power and eminence—reproduced, re-presented by the artful assemblage of wigs and costumes, masks and makeup, false noses and breasts. Performances. A spectacle. A series of life-size *tableaux vivants* photographed and hung in gold and silver frames: Cindy Sherman's *History Portraits*.

And, through the looking glass, our history, Carl de Keyzer wryly suggests with his photograph of the exhibit. A woman is looking at a photograph. Young, blond, dressed in jeans and turtleneck, her head in profile, her body arrested in the forward stride of her right leg as she turns away

1.1 Cindy Sherman, Untitled, color photograph, 1989. Courtesy of the artist and Metro Pictures, MP no. 209.

from us, hands clasped in front of her crotch, she mimics the posture of the object of her gaze: a framed portrait of a woman with an enigmatic smile, her body turned slightly away, hands folded in her lap, her gaze averted (fig. 1.1). To be a spectator at this *History Portraits* exhibit must have seemed like being in a funhouse of distorted mirrors. Within the multiply framed gold borders of Sherman's "Mona Lisa," de Keyzer catches the ghostly reflected presences of a "man" in another portrait and of the young woman standing before this one. Because of the camera's position to the left, "Mona Lisa" here is off center, hanging on an angled wall, so that the viewer is the other gazer, completing a triangle in which each looks at the other who does not return her gaze.[4]

Living in Rome at the time (a sort of postmodern Henry James New-woman, come to make over Europe in her own image), Cindy Sherman went shopping in Old World flea markets for the props—silk garters, lace

curtains patterned with angels, tiaras, tapestries, lengths of satin fabric, collars, books, dolls, and an assortment of false body parts—that (like Edith Wharton's Undine Spragg in *The Custom of the Country*) she would play with in front of her mirror, making up (herself) and making up (stories). These are gawky simulations of the teasingly familiar: the Virgin with One Bare Breast, a balloonlike protrusion stuck on to the middle of her chest or a falsie attached loosely to her dress (fig. 1.2); Renaissance profiles with tremendously elongated noses. Which is which, however, is not always so easy to tell: it becomes difficult to distinguish virgin from courtesan, or even male from female (some of the subjects seem to be in drag) when what commands attention are the exaggerated and prominent body parts. Indeed, the wit and brilliance of the details—the tinny cast to the pearls, the hair covering of fishnet or tartan scarf, the voluptuous pregnant torso clipped on at the shoulders, the drop of blood running along the seamed nose or of milk at the end of the fake breast, the red locket that matches the nipples of attached breasts like some Cyclopian eye, the richly patterned and textured tapestry that figures in more than one portrait—have the cumulative effect of flattening the individual portraits. The overwhelming impression is of a collection of parts, of props, of pomp and artifice.

1.2 and 1.3 Cindy Sherman, Untitled, color photographs, 1989.
Courtesy of the artist and Metro Pictures, MP no. 216 and MP no. 205

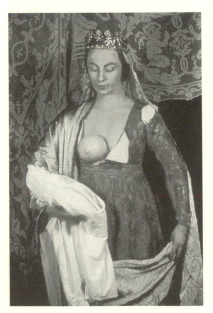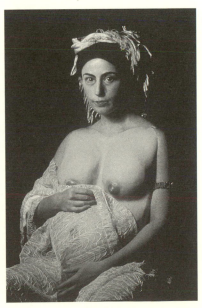

The thirty-five portraits in the exhibit, identified only by number (they come from a much larger collection), follow a chronological sequence from the Renaissance to the nineteenth century. There are also visual and icono-graphic sequences: a carnival of prominent body parts features grotesque breasts or noses; the placement of hands calls attention to symbols of power and knowledge (objets d'art, crosses, jewels, eyeglasses, books) or to genitalia, bellies, and death heads; details of costume or setting (wigs, head coverings, jewelry, draperies) form patterns, as do poses (the Renaissance profile, the downcast introspection of the Virgin, the almost frontal gaze of the Mona Lisa) and themes (female alternating with male, holy with secu-lar or profane). These patterns do not add up to a reassuring narrative, however; to the contrary, the bits and pieces are combined and recombined in a most disorderly parody.

In assembling the segments of her history, Sherman draws upon tradi-tions from both high and popular culture. Piecing together forms of the ideal has been a technique practiced by artists from Phidias, who used the face of one model, the mouth of another, the nose of a third to create a beauty that transcended its models, to Albrecht Dürer, who in his six-teenth-century *Treatise on Measurement* advocated a similar construction of an ideal nude, to Charles Dana Gibson, who at the beginning of this cen-tury printed "bits and pieces of the pretty girls he saw . . . like snapshots in his memory," later to be combined at will in the creation of his famous Gibson Girl.[5]

Sherman also draws on theatrical traditions—the trying on and display of clothes, which Peter Stallybrass has identified as the source of the forma-tion and dissolution of identity in the Renaissance theater[6]—particularly *tableaux vivants,* which were often grandiose presentations with large casts, exotic themes, and elaborate scenery and costumes especially popular with nineteenth-century theater audiences in Paris and London. Contemporary with the Gibson Girl, *tableaux vivants* were staged in New York at society balls, such as the one depicted in Wharton's *The House of Mirth,* and in turn-of-the-century (as well as earlier) photographs. These living pictures de-pended for their effect on verisimilitude—that is, how accurately the live representation of a painting duplicated the appearance of an original—and upon the audience's ability to recognize the works represented. Sherman (like Wharton) re-presents historical portraits with which we are immedi-ately familiar—by Leonardo, Raphael, Caravaggio, La Tour, Fouquet—and some with which we are teasingly familiar (fig. 1.3). We seem to recognize

these pictures by pose and gesture, backdrop and costume. But upon close inspection, the very details we identify—the band on the arm of Raphael's mistress turns out to be a garter found at the flea market—become the clues to sacrilege. The pictures invoke History—its authority and power—only to question it: History as a fertile field for parody by the scavenger, the wit, the reprobate performer.

In Sherman's spectacular and subversive history, the "real thing" is masked, or is only a mask; the real subject is in flux, or is the masked photographer, her self. If Wharton offers her readers a kind of safety net in creating distance between her fictional viewers, who are disturbed by Lily Bart's presentation of her self in her representation of Joshua Reynolds's *Mrs. Lloyd,* and us, a more savvy audience aligned with the author, in *History Portraits* Sherman does no such thing. Her representations unsettle—even as they amuse—us at a deeper level by disrupting the categories upon which we depend to order our world: the connectedness of history, the collaboration between author and viewer, the distinctions between fiction and reality, between high and popular art. Neither can we take solace in the distance between these likenesses of the rich and famous, of the religious and the secular, from quattrocento Florence to nineteenth-century Paris and our own times. *History Portraits* only *seems* to depict a world more remote from viewers than that of Sherman's earlier film stills. Because the subject of the pictures this time is not the private fantasies of women watching soaps, but the public foundations of power that Sherman's educated and affluent audience (vaguely) recognizes and understands, the fit between subject and audience is closer. As Arthur Danto suggests in his introduction to the published volume, *History Pictures,* in "draining the old masters and their subjects at once of a certain power by showing the artifice, the convention, the transparent fakeness of the worlds they believed were solid and unshakable and real," Sherman's images also undermine the foundations upon which her audience's world rests.[7]

That power is what masterpieces of art are all about can be ascertained by a walk through any museum of high culture; what such institutions preserve and exhibit are representations of privilege, influence, and authority—religious, political, financial, sexual. Sherman is doing something more in *History Portraits,* however, than exposing as fraudulent the power of those pillars and foundations of an ordered world in which we once believed. She is also playing with our memories, making us question what we remember and, therefore, the very truth of our perceptions. History is not

what we thought we knew. The space she penetrates is "the space between what we perceive and the images of recollection," Danto writes, and these pictures are about the "warping processes of memory," about "the distance between memory and truth, . . . the play between remembering and disremembering." Like the earlier film stills, which referred to movie narratives that were familiar but not precisely identifiable, these historical portraits are part of our common "cultural literacy"; but in this case, not even art historians can identify with certainty more than a few of the sources for these portraits. Sherman herself seems not to have seen the originals. She apparently did not go to the Palazzo Barberini in Rome where *La Fornarina* (the portrait of Raphael's mistress) hangs, for example, but chose to work from books of French and Italian portraits[8]—working, that is, from reproductions of works of art to re-produce works of art as photographs, which we in turn see in a book of reproductions of her photographs.

That these are *photographs* is the punchline. Photographs purport to tell the truth; but these photographs, as some wickedly perverse version of truth, expose the lie that Art is. Like the earlier film stills, *History Portraits* draws us into a similarly plausible but not exactly identifiable world of representation that is only partly clear, only partly anchored in experience, half shadowy and fantastical rather than lit by the true and steady illumination of (Art) History. Using the technology of the camera, Sherman's project makes visible Donna Haraway's contention that "late twentieth-century machines have made thoroughly ambiguous the difference between natural and artificial, mind and body, self-developing and externally designed." By our time, "a mythic time," she writes, "we are all chimeras." Like Haraway, Sherman points to the "tradition of reproduction of the self from the reflections of the other" and posits "an argument for *pleasure* in the confusion of boundaries."[9]

Positioning her altered self at the center of her reconstructed versions of iconographical subjects, the photographer thus invites us to view institutions of patriarchal power—History, Truth, Art—as social and historical constructions open to revision. Understanding this, we are at liberty to imagine other stories—sub-versions—that might be recovered. This is *not* to suggest that *History Portraits,* in its disruption of the seamless whole of History, stages some sort of unified view from the shore by the colonized of the colonizer. In this production, Sherman herself plays every part and directs the wit of her constructions toward a sophisticated, museum-going

audience, who may or may not share in her view of a "disassembled and reassembled, postmodern collective and personal self." Technology, in her version, shows us the impurity of intermixtures; history, in her version, is "multisubjective, power-laden, and incongruent,"[10] a carnivalesque world of ruptures and fissures.

HISTORY/HISTORIES

The idea is not to find outside the work of art some rock onto which interpretation can be securely chained but rather to situate the work in relation to other representational practices operative in the culture at a given moment in both its history and our own.
—Stephen Greenblatt, "Resonance and Wonder"[11]

Readers who like closure might look here for a kind of affinity between Cindy Sherman's *tableaux vivants* and those of a century earlier—between Sherman's masquerades and some of Imogen Cunningham's projects. But for this viewer and writer, *History Portraits* not only opens the way to questions about history and history making, power and influence, mimesis and alterity; the project, in showing master narratives to be social and historical constructions, allows other, less tidy and differently configured versions to surface.

"Untidiness"—as in Cunningham's *The Unmade Bed* (see fig. E.6)—often has to do with blurring the boundaries between one's life and one's work in a way that master narratives eschew,[12] between what we know for certain and what we imagine, as in the variety of responses to *Migrant Mother*, and even between past and present as an ordering narrative principle—for example, Lange's grouping of images, personal and social, to tell particular stories.[13] As we shall see, impurity is the very ground for patrolling the peripheries of photographic mastery, a basis for inclusion in or exclusion from inner circles, for patronage and support in terms of exhibition and publication.

Most of us are uncomfortable with disjunction. As Danto suggests, viewers of *History Portraits,* like listeners to rap music, "fuse into integral wholes what we may unavailingly know are alien parts [because we] . . . cannot help but perceive them, for deep aesthetic reasons, as unities."[14] Such "unity," or coherence, is the goal of most history making, not only on aesthetic grounds, but for intellectual, political, and psychological reasons. Photographic histories are no exception: their writers have tended to find

coherence in a male line of descent, beginning with Joseph-Nicéphore Niepce or Louis Daguerre, and in the United States with Mathew Brady.[15] In the case of Alan Trachtenberg's *Reading American Photographs: Images as History, Mathew Brady to Walker Evans,* the "unity" that matters is "the making of America." I deal with his book at some length here not to single it out as an especially pertinacious myth-making text in American Studies, but rather because it is the best representative example of its kind in reading, as its subtitle suggests, the way in which visual images are used to reveal and construct history.

Trachtenberg frames his penetrating analysis of photographs as cultural documents with two photographic collections—Mathew Brady's *Gallery of Illustrious Americans* and Walker Evans's *American Photographs*—in order to establish a linear history of the first hundred years of photography marked by these two masters of the medium. Brady's *Gallery,* published in 1850, portrays "representative" Americans in specific categories of eminence: senators, generals, an artist, a historian, a minister, a poet. Like earlier engraved portraits of leading citizens—and, one might add, like one contemporary collection of essays, Ralph Waldo Emerson's *Representative Men*—Brady's history of representative men presents the underlying theme of individual heroes' triumph over adversity. The *Gallery* as a work thus claims a civic function for American photographs: "Image and word together constitute a . . . political text reflecting a patrician concern about values and symbols at the basis of nationhood."[16]

In his own search for "the basis of nationhood" Trachtenberg takes great pains to use an egalitarian range of images as the basis for his narrative. His materials for constructing a history of America are not only well-known images by Stieglitz, O'Sullivan, and Evans, but also daguerreotypes of African slaves commissioned by Harvard's Louis Agassiz for a "scientific" study of race, medical photographs of wounds inflicted in the Civil War, and reform photographer Lewis Hine's pictures of social welfare concerns. Not surprisingly, the possibility of representing a truly democratic culture is located in the person and project of Walt Whitman, whose photographic image fronts the first edition of *Leaves of Grass* and concludes Trachtenberg's chapter on "Illustrious Americans" (fig. 1.4). This 1855 daguerreotype displays the creator of the "great poem" of the United States—a project that Evans would take as inspiration for his *American Photographs*—"the stalwart and wellshaped heir," the "goodshaped and wellhung man" who presents his self with "egalitarian 'ecstasy.'"[17]

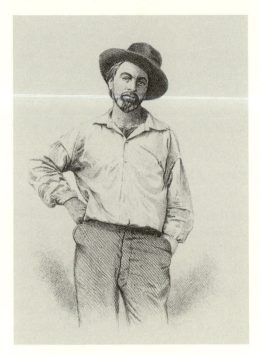

1.4 Frontispiece of the first
edition of Walt Whitman's
Leaves of Grass, 1855. Engraving
by Samuel Hollyer after a lost
daguerreotype by Gabriel Har-
rison, 1854. Yale Collection of
American Literature, Beinecke
Rare Book and Manuscript
Library, Yale University, New
Haven, Conn.

Trachtenberg's search for an American culture is an insistent one, read
through a chronological series of images in his own attempt to make
"simple, separate" say "en masse"; but it does not lead to an examination of
the assumption that history can be read as a series of connected events
shaped by individual representative men—here, Brady, O'Sullivan, Stieg-
litz, Hine, and Evans. To the contrary, he assumes the connectedness of
history—and, therefore, of the men who make it. We read, for example,
that

> Hine's reform photography shares . . . in a contradictory current of
> practices that reaches back to [Charles Willson] Peale's vision of the
> marriage of science and representational art in the grand enterprise of
> human self-definition through *natural* history and knowledge; to
> Agassiz's less enlightened wish to corroborate a social denial of univer-
> sal species-being among humans through exact representation of nat-
> ural fact; to the Civil War medical photographs which identify persons
> with wounds inflicted in the name of the state; to the use, in the West-
> ern survey, of the photograph to lend artistic validation to a scientific

enterprise on behalf of aggressive exploitation—we can add Edward S. Curtis's project, contemporary with Hine's child-labor pictures, to join art to the science of the camera and the social science of anthropology to explain and justify the "vanishing" of North American Indians. . . . [The implications of his counterstatement for American photographs] remain[ed] for Walker Evans in the 1930s to develop . . . an antinomian rejection of political liberalism [that] allowed him to conceive a project of American photographs as deliberate counterstatement.[18]

Trachtenberg thus links Evans through Hine, not only to the origins of American photographic history, but also to cultural history, to Emerson and Whitman—"in his eager receptivity to the natural facts of contemporary life"—and to Henry James, in *The American Scene*, "in the acute skepticism with which he gathers impressions and assembles them into an order."

As viewer, reader, order maker, Trachtenberg works not just to make sense "of the discontinuous but tightly knit flow of images," but, like Evans, to understand the "story of how photographs can be seen and experienced as American, *perceived* . . . as one's own story." As a sequence, the camera work he chooses provides a "way of seeing and realizing America, making the nation real as one's experience."[19] The "certain photographers" of Trachtenberg's narrative not only "discovered in their medium resources for representing America as fact and idea," but actually participated in "the making of America." Reading American photographs is also a way of reading the past, he concludes:

the past as culture, as ways of thinking and feeling, as experience. . . . [F]rom Brady to Evans the passage toward a self-conscious art of the camera has followed the contours of major social transformation and ideological adjustment. The history told here . . . [is] a series of analyses of key moments defined by major photographic . . . projects. What has been continuous between the separate parts is the persistence of certain ways by which Americans have attempted to grasp the meaning of their social lives, to make imaginative sense of their history as they lived and reflected upon it. A key term in this story . . . has been the word "America" itself, the myths it has embodied and engendered, the meanings which have seemed intrinsic to it. America names a discourse in which the photographers discussed here have participated. . . . [This] is a history of participation by photographers in the making

of America, the illumination of its cultural patterns, the articulation of its social and political contradictions. The dialectical view of history gives us an American photography more richly American, more significant . . . as a past which interprets our present—past images as present history.[20]

In order to "make" an America, Trachtenberg has linked certain events — the work of representative individuals—that have meaning for him, enabling him to read the past as a kind of unified whole. Other readers, of course, may have different ways of linking and reading—ways that might well lead to perceptions of fragmentation and disorder. That is the subject of this book.

My narrative has to do with the way in which personal, subjective experience matters as much as—and indeed influences—public and political activities. The title suggests agency for women photographers as history makers, but its play on the title of Stieglitz's journal is not meant to imply a substitution of women's work for men's work. A willingness "to entertain the notion that history as a unified story was a fiction about a universal subject whose universality was achieved through implicit processes of differentiation, marginalization, and exclusion," as Joan Wallach Scott argues, does not mean locating *difference* in "some essential quality inherent in the female sex."[21] To subsume women into a general "human" identity is to lose the specificity of female diversity and women's experiences, to be "back, in other words, to the days when 'Man's' story was supposed to be everyone's story, when women were 'hidden from history,' when the feminine served as the negative counterpoint, the 'Other,' for the construction of a positive masculine identity." The point is not women's sameness *or* difference from men or from one another, but rather to see "differences as the condition of individual and collective identities, differences as the constant challenge of the fixing of those identities, history as the repeated illustration of the play of differences, differences as the very meaning of equality itself."[22]

This is an important point—one to which I return in discussing feminist film theory: the insistence on particularity is a warning against any reductive reading of evidence from the past that would deny historical variability. Insofar as disempowered image makers whose (subversive) works seldom made it past the gatekeepers are concerned, there are bound to be multiple stories, in a variety of forms, that need not add up to one story. Those who are discomfited by such open-ended history making will hear this emphasis

on the fictional properties of hegemonic culture as cacophony, but it is precisely the noisy voices of reader/hearer collaborators outside the "significant" story that I wish to recover.

One morning when I got up, I thought that my bed depicted my life, that it was disorderly enough, so I threw a few handfuls of hair pins in it and photographed it. —Imogen Cunningham[23]

Noise is the formidable subversion of frozen words, of the Tables of the Law, of meaningless repetition, Jacques Attali suggests in his work on the political economy of music: the noise of marginals—clusters of women, slaves, expatriates—"indicates the limits of a territory and the way to make oneself heard within it. . . . And since noise is the source of power, power has always listened to it with fascination." The centerpiece of his analysis is Brueghel's *Carnival's Quarrel with Lent,* in which noise is a weapon against attributes of power; "*noise is violence:* it disturbs." To take pleasure in the production of differences is, as in jazz, "to freak freely," to be a monster, a marginal; it is to undertake an activity "laden with risk, disquieting, an unstable challenging, an anarchic and ominous festival, like a Carnival with an unpredictable outcome."[24]

Noise is like dirt. Its opposite, harmony, is like rituals of purity—attempts to create unity in experience. In fact, purity is the enemy of change, of ambiguity and compromise. "In chasing dirt," anthropologist Mary Douglas argues, "we are not governed by anxiety to escape disease, but are positively re-ordering our environment, making it conform to an idea. . . . Ideas about separating, purifying, demarcating, and punishing transgressions have as their main function to impose system on an inherently untidy experience." Dirt, formless, transgresses and threatens boundaries; its threat is *power.*[25]

Cultures are most concerned with purity when they are in fact most permeable or open to change, Douglas has shown. To situate the immediately popular activity of photography in this country in its mid–nineteenth-century context is to connect it, then, to a time of increasing visibility (or audibility) for women in political, social, and literary spheres. Noise was also Whitman's project in this period: to inject his vulgar self into what Douglas calls "the protected habit grooves" of "iron-hard categories of thought"

characteristic of a culture "richly organized by ideas of contagion and purification."[26] In fact, in the daguerreotype that serves as the frontispiece for the 1855 edition of *Leaves of Grass,* Whitman's pose forces us to think about the multiple play of differences and to ask about the connection between cultural representation and self-definition. Among the images of "Illustrious Americans" reproduced in Trachtenberg's *Reading American Photographs,* Whitman's seems to be linked to those of women, slaves, and prisoners—to the marginals the poet included as the celebratory subjects of his poems. With one exception (Horace Greeley), the daguerreotypes of white men selected as representative are head-and-shoulders shots; these figures of public eminence present themselves to viewers whose gaze they do not meet. Women, slaves, and prisoners, on the other hand, are *presented* in three-quarter view. White women, copiously clothed and associated with narrative props (they mourn, for example), also avert their gazes, whereas the black women slaves photographed by J. T. Zealy are partially naked, their clothing dropped to the waist by force or direction, and decontextualized. Both male and female slaves confront our gaze in a discomfiting way: these are objects of study, not precious artifacts. Whitman, on the other hand, in three-quarter view, touching his own body, *presents himself* in his image not less than in his poems.[27] Trachtenberg argues that the slouching figure of the workingman-poet, standing in a posture of insouciance and open sexuality, deferential to no one and accessible to all, represents a dissent from ideas about public decorum and cultural propriety.[28] But Whitman's noisy barbaric yawp also becomes a touchstone for American individualism—the belief in the individual as the basic social and political unit of law and social life. Based upon the notion of the power of human reason to order knowledge, which presupposes a society composed of rational, accountable, autonomous human beings,[29] individualism is a Romantic conception of the self available to those who have already achieved a certain level of political and economic power, a conception that ignores the material existence of the disfranchised, the poor, the enslaved. Emerson's "Self-Reliance" leads, ultimately, to a canon of "representative men": "lenses through which we read our own minds." What remains unrepresented are those very gatherings of women, slaves, expatriates whose noise threatens subversion and disruption.[30]

What is excluded from symbol systems characterized by compulsive rituals of purification, Julia Kristeva concludes from Douglas's anthropological data, is the feminine, particularly "the dangerous power of the maternal."

Women, contends filmmaker Trinh Minh-ha, "in writing themselves . . . *have attempted to render noisy and audible* all that had been silenced." *"Your body must be heard,"* Hélène Cixous insists; women "must invent the impregnable language that will wreck partitions, classes and rhetorics, regulations and codes." And film theorist Mary Ann Doane argues that "the male body comes fully equipped with a binary opposition—penis/no penis, presence/absence . . . while *the female body is constituted as 'noise,'* an undifferentiated presence which always threatens to disrupt representation . . . [and thus] results in her different relation to language and representation."[31]

Whether in its nineteenth-century version or its twentieth-century reincarnation voiced by these theorists, the doctrine of separate spheres, as I have suggested, obscures the variable, often contradictory postures of women. Contemporaries of Brady's "Illustrious Americans" and Emerson's *Representative Men,* women argued, as Margaret Fuller did, for the rights of woman, based upon the case for the rights of man (i.e., for *equality*) *and,* as Catharine Beecher and Harriet Beecher Stowe did, for the moral superiority of women (i.e., for *difference*) and for their important and beneficial roles as mothers in shaping (male) citizens. But if the alternative to the binary construction of sexual difference is not sameness, neither is it the androgyny propounded by Whitman. The poet's own gender ambiguity reminds us that lesbian, gay, and bisexual women and men are left out of such definitions. To take an example from photography of our own time, how, given only the categories of "male" and "female"—or androgynous— gaze, can we begin to understand something so complicated as Helmut Newton's erotic, high chic photographs of female models posed for the voyeuristic perusal of *Vogue*'s female readers? Or indeed, how are we meant to understand Cindy Sherman's masquerades?

It is precisely this complex relationship between an assumed heterogeneity and the representation of alterity that has been and is at stake in understanding the cultural work that images do. A gendered argument about purity and difference was, significantly, the basis for the exclusiveness of Group f.64, which flourished in the San Francisco Bay area from 1932 to 1935. Michel Oren notes that in contrast to the (male) photographers clustered around Edward Weston—who identified "feminine" with "radical" —and Ansel Adams, known for their "photographic Purism," the women, especially Imogen Cunningham, were considered "slipshod" in technique, "unconcerned about the kind of quality we were looking for," creating "images . . . [that] weren't all that sharp." Dorothea Lange was also criticized by

f.64 stalwarts for her "impurity." Although he praised her perception and intention, Adams was "frankly critical of her technique in reference to the standards of purist photography." Several young male photographers who worked with Lange when she was well established would later remark on her technical "messiness." (Consuelo Kanaga, on the other hand, who was a master printer, was criticized for the "impurity" of her subject matter.) Rondal Partridge (Cunningham's son), who assisted Lange in the darkroom and on field trips, said that she didn't really investigate the developing process and that in the field she didn't make any test shots: she "used a Weston meter rather casually, set the camera, shot the picture, and went away." She could read negatives marvelously, but didn't print them well. Homer Page, who also worked with her, found her technically inept and clumsy. He contrasted her uncertainty with Adams's superb technical skill: "She could use an old film pack or pull the wrong lever. Yet when it was all over, she had the picture she wanted. She had to go to great pains to make a good print. It took her an endless amount of time. But look at the results." Lange herself, however, told Partridge, "The print is not the object; the object is the emotion the print gives you. You look past the print to the inner meaning." Others saw Lange's approach as her strength. Willard Van Dyke recalled that she didn't really care about great technique: "She was excited about the subject she was shooting, not the how of doing it." "What she was always after," Arthur Rothstein observed, was "the idea, the feeling, all the rest, including technique, was secondary."[32]

Why this formulaic, obsessive repetition by photographers that feminine = radical/messy/emotional? What threat did Cunningham, Lange, Kanaga—and also Käsebier and Gilpin—pose that evoked such strong negative response? Quality is *not* the issue. Rather, to put it in Douglas's terms, some disruptive power outside the main narrative relegated women's camera work to the margins of hegemonic culture.

INDIVIDUALISM/INFLUENCE

I was self motivated, but I did see something of Gertrude Käsebier—and that's all I'm going to tell you about what started me off. —Imogen Cunningham[33]

The chronological analysis of certain bodies of work by five male photographers that Trachtenberg presents as his linear version of American cultural history—a veritable American (photo) Renaissance—begins and ends in

New York. Even the photographers' views of the western landscape, commissioned in connection with a U.S. government survey project, are eastern views of the western spaces as "other." Shifting the focus to the West Coast, Michel Oren offers a more concentrated and more inclusive, if somewhat messier, schema for Group f.64: Edward Weston is at the center, linked prominently to Alfred Stieglitz, Paul Strand, and Ansel Adams, with Imogen Cunningham and the women photographers around her forming a somewhat denser cluster off to the side.

Oren both places Group f.64 in its specific physical environment and situates it in a broader context. As Willard Van Dyke recalled, "The look and smell and feel of the East Bay [Northern California] area" affected f.64 work. In the days before pollution there was "a marvelous California light—the skies were so blue and the air was so crisp and clean and there was a kind of hard brilliance that we accentuated by using very sharp lenses and very small apertures."[34] Group f.64 also defined itself as avant-garde— that is, in terms of European associations such as the Milanese Futurists and Russian Constructivists, typically "geographically marginal or provincial groups of visual artists . . . intent on forcing recognition from a centre or mainstream." Consciously modeled after the Fauves and the Blue Four (whose work was exhibited in Oakland), Group f.64 polemically asserted itself in the face of New York[35] (fig. 1.5).

Oren argues that in defining itself against the eastern photographic establishment, this predominantly male group was characterized by the anxi-

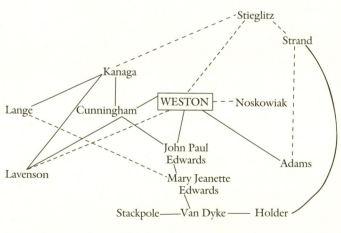

1.5 From Michel Oren, "On the 'Impurity' of Group f.64 Photography," *History of Photography* 15, no. 2 (summer 1991): 122, reprinted by permission, Taylor and Francis, Publishers.

ety of influence: it was set up as a gesture of independence from the Stieglitz circle in New York even while it craved recognition from that circle. He notes Weston's agonizing over "verbal whack[s]" from Stieglitz in response to his work and Van Dyke's resentment about the way "the Eastern photographic establishment provincially scorned any work that was not anointed by the high priest of 291 Fifth Avenue." He also points out that the gallery in Oakland was called "683" after "something called '291' back in New York" and that Adams, whose theory of "correspondences" derived from Stieglitz's doctrine of "equivalents," had an adulatory attitude toward Stieglitz and Strand.[36] This anxiety of influence continued into the second generation; Van Dyke migrated to the East and into documentary film in order to find his own voice: "I needed him [Weston] a lot and at the same time I needed to make a very strong statement that my work was *not* Weston," he wrote. "What I did was to walk away from it and go and do something else."[37]

The *line* of male influence—from Stieglitz and Strand to Adams and Weston, and from Weston to his disciples—was powerful. One of its most pernicious aspects was in the "lively ambivalences" Weston exhibited toward women. Often treating women and their work with contempt, as well as expressing fear and distrust of the feminine and maternal—a subtext of the "purity" of Group f.64—Weston also saw women as a source for "fecundat[ing]" his work. His disciples followed: "When I observed Edward and the stimulus that he got from a new love, I wanted to try some of that too," Van Dyke recalled. "It was as if that was part of the artistic life. That's what you did—you had a lot of girls."[38]

Women in Group f.64 (with the exception of Weston's lover, Sonya Noskowiak) were influenced not so much by Weston as they were helped and encouraged by Imogen Cunningham. Dorothea Lange, Mary Jeanette Edwards (who worked in Lange's darkroom), Alma Lavenson, and Consuelo Kanaga (who was castigated by Adams for her portraits of black women and children[39]) constituted a subgroup that was characterized not by anxiety of influence, but by reciprocity. In fact, Group f.64 would ultimately split along the lines of a somewhat, but not entirely, gender-based social concern, with Cunningham and Lange on one side, Weston and Adams on the other. Pressured to politicize their work as the Depression deepened in 1934, Adams would write that "Dorothea at that time was not in sympathy with the Group f.64 principles." He would complain to Weston when Van Dyke showed Lange's work in his gallery and then wrote

about that work in *Camera Craft:* "I come to think of him more as a sociologist than a photographer. His photography seems to be turning into a means to a social end, rather than something in itself. . . . I still believe there is a real, social significance in a rock—a more important significance therein than in a line of unemployed." Weston responded, "There is so much talk of the artist getting down to the realities of life. But who is to say which are the realities?"[40]

Exactly. If we shift the focus to the subgroup of women with Cunningham at its center, the diagram would not be confined to Group f.64, and would not run in neat linear fashion back to Stieglitz (or Brady); rather, it would have the more amorphous configuration of a net, including a myriad of anonymous photographers who worked at home, learned from each other at camera clubs, and (mostly) slipped through the cracks of History (fig. 1.6).

My diagram of a *network* of women photographers gives structure to this book. I use the term *network* rather than *influence* because I do not mean simply to substitute a group of Illustrious American Women for the canon of Representative Men. This is not a chronological history of the work of women photographers; it does not construct a corrected version of "an American culture"; and it is by no means all-inclusive. The photographic images by women are not gathered together here for the purpose of making a case that all women look, imagine, and construct what they see in the same way, using a visual language unique to their sex. To the contrary, I

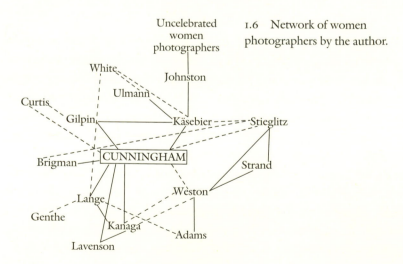

1.6 Network of women photographers by the author.

intend to show that women photographers are multilingual[41] in terms of the imaginative and technical range of their camera work. This is not to say that women's historical experiences do not include abuse and oppression, that women have not been subjected to the voyeuristic and fetishistic gazes of men, or that in the Western tradition of visual images they have not been represented as "other." It is not to say that men are not phallocentric and that patriarchal Western history has not excluded and misrepresented women. Instead, my argument suggests that we forego a simple binarism as we peel back the layers of silence that have shrouded women's work, acknowledging as we do so the wide and interesting variety of visual images women photographers compose, exhibit, and publish; the conformity as well as the originality of their techniques and subjects; the ways in which they both borrow and distance themselves from each other and from their male colleagues; and the ways in which they associate and distance themselves from dominant models of respectability and from what they perceive as national culture.

GAZING

Vision is not only a passive, feminine receptacle where the real gets photographed, but it is also a phalloid organ able to unfold and erect itself out of its cavity and point towards the visible. The gaze is the erection of the eye. —Jean Clair, "La Pointe à l'oeil"[42]

"Is photography a feminine art?" I asked. "No, indeed; photography is a matter of individuality, not of sex."—Interview with Imogen Cunningham[43]

The landscape is one of those scenes framed by trees with a small figure positioned in front of a body of water in the foreground and transcendent mountains in the background. Close-up, the viewer is invited to encircle visually the rounded nude form, which, like some smooth stone or boulder, crouches alongside the water. In the first sequence of images, the naked body kneels and touches a blasted tree, moves or stands, with muscular back to us, directing our gaze through or over the landscape, frustrating our desire. Then, beginning with the sixth image, Imogen Cunningham's nude husband, subject of her extraordinary Mt. Rainier series, turns, revealing what has been hidden: his speaking jewel (fig. 1.7).

That these pictures were and are more unsettling than countless similar scenes in which woman's body is the subject of the male photographer's (and viewer's) gaze goes without saying. A roughly contemporary imagi-

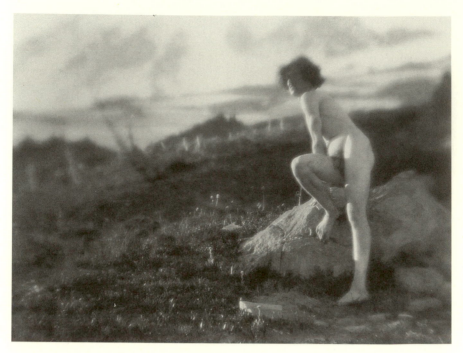

1.7 Imogen Cunningham, *On Mt. Rainier 7*, 1915.
©1970, 1996 by the Imogen Cunningham Trust.

nary series, subject and maker of the images in their "normal" relation-
ship—in a story by Sadakichi Hartmann published in *Camera Work*, nicely
makes the point that vision belongs to men. (It also implies that technology
belongs to men, despite the fact that to be no longer burdened with awk-
ward equipment and to be able to carry a camera easily in the out-of-doors
would be of crucial importance to women photographers.) The protago-
nist of "The Broken Plates" has moved out of his daguerreotype studio and
into a new technology, a new set of visual opportunities, and an attendant
set of liabilities. On a glorious autumn day with his sweetheart at the ocean,
concentrating on his mission of capturing her beauty on photographic
plates—his vision of her body as "a passing shimmer, a flash of whiteness"
in his composition blinds him to her actual presence—he drops the plates
on the rocks and loses both woman and image. This modern photographer,
freed from lengthy exposures, can pose and repose his model without the
headrest that had held daguerreotype subjects in stiff immobility. He makes
images on glass plate negatives instead of metal: "Given this technology,
his immediate concerns are about 'composition,' about the 'lines and values

of the scene'; and his larger concern is to establish, in the same manner that more traditional artists do, a reputation through his work." Its meaning, Carol Shloss suggests in assigning it a pivotal place in the history of photography, has to do with "the consequences of disassociated vision," marking "a new perception of the role of the artist-photographer's shaping imagination, an end to the idea of vision as a passive activity, and a sense of the power inherent in observation itself." By focusing on the activity of the artist, the sketch "demonstrates the fallacy of thinking the search for the picturesque to be an innocuous activity, devoid of its own manipulative strategies," Shloss writes. "Hartmann would have us understand that both modes of interaction—whether observation be in the service of science or of art—have a political status. Because a relation of knowledge is, for him, a relation of force, he considers photography to be enmeshed in, and emblematic of, a series of complicated social structures."[44]

It was precisely these social structures—widely embodied, from the "soft porn" of *September Morn* to Weston's later images of naked women on California beaches—that Cunningham challenged with her playful Mount Rainier series. Like Stieglitz's photographs of Georgia O'Keeffe, the Cunningham series was a collaboration between two artists. Cunningham's later comments suggest the quality of play, contrivance, and performance in these images: "This was made in 1915 when I was first married. You could never chase a naked husband around Mount Rainier today"; "We called this 'The Faun' then, but I'd never call it that now. He was absolutely sitting on a sheet of ice."[45]

Some of us—some of us women—"get" Cunningham's joke; others merely read (or understand) it. As Mary Ann Doane points out, "getting" and "reading" are not the same. A joke cannot be explained to someone who has not understood it the first time: "The term 'getting' suggests that the effect of the joke must be instantaneous, that comprehension and the induced affect (i.e., laughter, pleasure) must be simultaneous. The one who 'gets' the joke automatically, unthinkingly, colludes in the maintenance of the systems of sexual oppression which support its meaning."[46] In other words, for a woman to "get" such a joke would be like "getting it in the neck."

Making a distinction between the critical act and the act of reception— between "reading" and "getting" the joke—is informed by feminist film theory, which has argued until recently that cinematic pleasure in looking is predominantly masculine. Based on Freud's concepts of scopophilia and

33

fetish, this body of work contends that the portrayal of women's bodies is designed to gratify male viewers, that the masculine gaze is literal voyeurism, that fetishism of the female body (or its parts) is a means of circumventing fear of castration—in other words, that the female "film body" is projected as an object of male desire.[47] The Freudian basis for this scholarship, important as much of it has been, has defined its limits: the assumption of a unified female subject (and male agent); the essentializing and ahistorical notions of human response; the privileging of male pleasure. The other theoretical pole, which casts sexual pleasure in terms of power, has its problems as well, however: for example, Foucault's notion that "the pleasures of the body are subject to historically changing social constructions, . . . especially the idea that pleasures of the body do not exist in immutable opposition to a controlling and repressive power but instead are produced within configurations of power that put pleasures to particular use."[48]

Writing of the modern *scientia sexualis*—that is, our desire to *know* everything about sex—that has replaced the *ars erotica* of ancient and non-western cultures, Foucault sees us as "living in the realm of Prince Mangogul: under the spell of an immense curiosity about sex, bent on questioning it, with an insatiable desire to hear it speak and be spoken about, quick to invent all sorts of magical rings that might force it to abandon its discretion."[49] He refers to Diderot's 1748 fable *Les bijoux indiscrets* (The Indiscreet Jewels), in which the genie Cucufa, seeking to gratify the sultan Mangogul's desire to have the women of his court speak frankly of their sexual adventures, pulls from his pocket a silver ring. "Turn the setting of the stone," he advises, and "all the women on whom you turn it will recount their affairs"—not through speech but "through that part which is the most frank in them, and the most knowledgeable about the things you wish to know, . . . through their jewels."[50] For Foucault, the silver ring of the fable serves as emblem for a number of optical inventions and surveillance techniques that emerged in the nineteenth century: cameras, magic lanterns, zoetropes, kinetographs, kinetoscopes, and the early precursors of the silver halide of celluloid emulsion that registers the "truth" of body movements on film.[51] Linking *scientia sexualis* to class, and power to pleasure, Foucault argues that the new bourgeois, capitalist, industrial society of the nineteenth century, with its development of juridical and medical control of perversions for the sake of a general protection of society and the species, put into operation an entire machinery for producing true discourses con-

cerning sex. In the resulting "sensualization of power and gain of pleasure," he writes, "an impetus was given to power through its very exercise," but the ones who had to reply to that power "were fixed by a gaze, isolated and animated by the attention they received." On the one hand, there is "the pleasure that comes of exercising a power that questions, monitors, watches, spies, searches out, palpates, brings to light; and on the other hand, the pleasure that kindles at having to evade this power, flee from it, fool it, or travesty it. The power that lets itself be invaded by the pleasure it is pursuing; and opposite it, power asserting itself in the pleasure of showing off, scandalizing, or resisting."[52]

Foucault helps us to understand the complexity and discontinuities in the cultural construction of sexualities in diverse eras—but his ideas are not so radical as they seem. "In neither the ancient and Eastern construction of an erotic art nor the Western construction of knowledge-pleasure have women been the true subjects of sexual art or sexual knowledge," Linda Williams points out; "even though Foucault can argue that 'sex' as an entity is radically discontinuous from one culture to the next, the fact remains that the pleasure of women is alien and other to both systems."[53]

This, of course, is what Cunningham was up to as early as 1915 in her Mount Rainier photographs: foregrounding women's pleasure. Anticipating by some sixty-five years women filmmakers' and theorists' reversal of the roles of spectator and performer, she put "women at the keyhole" so that in the "masculine" position, a woman appropriates the male gaze for her own pleasure.[54] Laura Mulvey suggests that trans-sex identification easily becomes second nature for women, but that "this Nature does not sit easily and shifts restlessly in its borrowed transvestite clothes."[55] Doane, too, is intrigued with the notion of female spectatorship but points out that to reverse the subject/object dichotomy is to remain locked within the same logical system. To Mulvey's opposition between passivity and activity she adds an opposition between proximity and distance in relation to the image, and suggests that when the female pretends she is other, a woman "transvestite" becomes a man in order to attain the necessary distance between self and image.

For Doane, *masquerade* is a way out of the problem of the construction of sexual identity in terms of binary opposition: the antithesis of spectatorship/subjectivity—foregrounding the feminine, flaunting one's femininity—is to produce oneself "as an excess of femininity" (as Madonna, for example, does) in order to acknowledge that femininity itself is constructed

as a mask. This refers to psychoanalyst Joan Riviere's notion that the masquerade of femininity is a kind of reaction formation against the woman's trans-sex identification—an attempt to compensate for this theft of masculinity. "Womanliness," according to Riviere, "could be assumed and worn as a mask, both to hide the possession of masculinity and to avert the reprisals expected if she was found to possess it." Whereas Riviere treats masquerade—including that of "normal femininity"—as pathological, however, Doane sees it as a destabilization of the image, or a "defamiliarization of female iconography."[56]

Riviere's question—where, then, is the line between womanliness and the "masquerade"?—is directly opposed to Edward Weston's, "Which are the realities?" If "reality" was clear to Weston, Riviere's denial of any difference between womanliness and masquerade—"whether radical or superficial, they are the same thing"[57]—suggests what Cindy Sherman enacts in her film stills: that femininity itself is a representation, a cultural construction.

My problem with feminist film criticism, grounded as it is in psychoanalysis, is that whether based on the binary opposition between passivity and activity (Mulvey) or on the opposition between proximity and distance (Doane),[58] the analysis of the "male" or "female" gaze, of the male or female spectator is ahistorical; the "female"—subject or object—is thus positioned outside of history. This problem bothers some film theorists as well. Teresa de Lauretis, for example, argues that feminist theory should be based

> not in [notions of] femininity as a privileged nearness to nature, the body, or the unconscious, an essence which inheres in women but to which males too now lay a claim; not in a female tradition simply understood as private, marginal and yet intact, outside of history but fully there to be discovered or recovered; not, finally, in the chinks and cracks of masculinity, the fissures of male identity or the repressed phallic discourse; but rather in that political, theoretical, self-analyzing practice by which the relations of the subject in social reality can be rearticulated from the historical experience of women.[59]

In other words, we need new structures, not repositionings, for thinking about the gaze, as well as for understanding assumptions that underlie relationships of power and surveillance—structures that support mutual regard and the sharing and accessibility of information, work, and exhibit spaces. Before we can build such structures, however, we need to break

down the ways of naming photographic practices that confer and limit status.

REPRESENTING/RE-PRESENTING

On the one hand, truth is produced, induced, and extended according to the regime in power. On the other, truth lies in between all regimes of truth. . . . To question the image of a historicist account of documentary as a continuous unfolding does not necessarily mean championing discontinuity; and to resist meaning does not necessarily lead to its mere denial. . . . what is put forth as truth is often nothing more than a meaning. And what persists between the meaning of something and its truth is the interval, a break without which meaning would be fixed and truth congealed. —Trinh Minh-ha, When the Moon Waxes Red[60]

The problem with deconstructing the master discourse in order to cast a wider net—make a *rassemblage* that would reject the holistic in favor of a jagged fabric with the fissures and disjunctions of its pieces in plain view— in other words, to put histories in place of the overarching myth of a national culture, is this: isn't the disassociation of oneself from History (à la Whitman), paradoxically, the very quintessence of American ideology?[61] If the answer is yes, then any focus on cultural expression outside the mainstream would seem to be doomed to circle back not only to the question of difference—another exclusive and narrow version of history that oppresses some others—but also to hegemony itself. But the answer might be no: no to *self*-reliance *and* no to the "Americanness" of liberal discourse. My own "take" on this question is based on my strong response to the visual images of a cluster of women photographers who were not a group in any formal sense, and who did not consider their primary identity to be their gender, but whose lives intersected and whose work extends from the 1890s—when camera, print, paper, and media technology made it feasible for women to enter the photography field—nearly to, in their old age, our own times. More different than alike, they pictured a wide range of subjects and practiced a variety of photographic strategies. The threads that link them into a kind of network are their connection to the White/Käsebier version of Pictorialism, their mutual regard and support, and the way in which each of them uses her own experience to experiment with mimesis and alterity.

As I confront the problem of constructing cultural meaning from glossy bits of black and white paper seen on museum walls, posters, and postcards

or in books, critical journals, and popular magazines—the materials of my narrative—I am reminded of Roland Barthes's story of the Argonauts, a story Cindy Sherman might take to heart. Ordered by the Gods to complete their long journey in one ship, the *Argo,* against the certainty of the boat's disintegration, the Argonauts slowly replace each piece of the ship over the course of the voyage "so that they ended with an entirely new ship, without having to alter either its name or its form." The *Argo* "affords the allegory of an eminently structural object, created . . . by two modest actions . . . *substitution* (one part replaces another, as in a paradigm) and *nomination* (the name is in no way linked to the stability of the parts): by dint of combinations made within one and the same name, nothing is left of the origin: Argo is an object with no other cause than its name, with no other identity than its form."[62] Both Barthes and Rosalind Krauss, who recounts it, use this story to reject the historicist model of the way the work of art comes to mean—as an organism developing out of a past tradition, embedded in the history of a given medium—and to argue that the work should instead be understood as a *structure.*

As I have suggested, *Women's Camera Work* is not about substituting one part (photographer) for another, as in a paradigm, while keeping the old name (historical structure). In my narrative, moreover, the particular personal, social, and material histories are integral to the works. Although it is true that "objects of art not merely interest and absorb, they move us," as Stanley Cavell writes, and that "we treat them in special ways, invest them with . . . value," this does not mean that we need to accept the assumption upon which this understanding of *art* rests—namely, that "it is possible to draw boundaries around the aesthetic organism: starting with *this* work within its frame, and the formal decisions it manifests, moving to *this* medium, with the conditions that both unify it and separate it from other media; and continuing to this author and the unity or coherence of his oeuvre." As Krauss points out, "The categories of such a discussion—work of art, medium, author, oeuvre—are never, themselves, seriously opened to question." Like the life of the *Argo,* such autonomous concepts tend "to dissolve against the background of actual, material history."[63]

Krauss uses poststructuralism here to ask certain questions about "all those transhistorical categories out of which most of the work of modernist production is thought," which in turn leads to a consideration of authorship and oeuvre (as in her own "Photography's Discursive Spaces").[64] To sharpen her focus for my own ends, it is not works of *art* that interest me

here, but the cultural meanings that photographs—images made with machines, infinitely reproducible *works*—express. Categories such as "art" and "document" are finally not very helpful. "Art" hangs on museum walls and is published in exhibit catalogs, scholarly books, and journals, but E. J. Bellocq's photographs of Storyville prostitutes exhibited at the Museum of Modern Art in New York, to take one example, are declared "not art" by MoMA photography czar John Szarkowski in the exhibit catalog. "Documentary" photographs by Riis, Hine, Evans, Lange, and others are published or exhibited as "art" and function as works of commerce (advertisements), journalism (published in newspapers, televised), and reportage (used as evidence in police reports and in government documents such as the survey photos—which are also associated with a landscape tradition in painting). To say only that photographs are works whose meaning is defined by their contexts is too simple, however, because some photographs interest, absorb, and move very different audiences—in the way Cavell suggests that certain works of art do—across time and in a variety of contexts. This is not merely a question of aesthetics—the notion that those things we invest with value are "art" (a category which is a peculiarly Western notion)—but a question of the way in which certain images elicit powerful *responses*. Certain responses, like Cavell's or like Szarkowski's, have in effect patrolled the boundaries of art history, but other responses, and the way in which they change over time, also matter.[65] Works not chosen as "art," those that are noncanonical, silenced, made invisible—some with great popular appeal in their own time, which interested, absorbed, and impassioned people—have the power, when made visible, to move us now.[66]

Why do photographs, which we usually take to be pieces of truth—we look at them and accept them as accurate representations of things that really happened; they are used in courts of law as incontrovertible evidence[67]—have the power to influence us in a way that "truth" itself often does not? Is it because of the very tension that Sherman's *History Portraits* demonstrates—that is, the "truth" that representations are not necessarily real, nor even about the real? Or is it that representations *are* the real? Barthes argues that the photograph is a message without a code: there is no signifier, no supplementary message in addition to its content—what we call the style of a painting, for example—and no "treatment" of the image that refers to a certain "culture" of the society receiving the message. In other words, a photograph is "indexical": it refers to something in the real world.[68] But what if the "real" is only a representation? Or what if, as David

39

Freedberg maintains, there is no cognitive difference between the two? His argument—"representation is miraculous because it deceives us into thinking it is realistic, but it is only miraculous because it is something other than what it represents"—is based on what he believes to be "the great deceptiveness of the central theories of representation . . . [which] has made us measure response (and success of making) in terms of the absolute distinction between representation and reality." Everything about the object, however, "demands that we see both it and what it represents as a piece of reality: it is on this basis that we respond. To respond to a picture . . . 'as if' it were real is little different from responding to reality as real."[69]

To respond, of course, is often to act; thus, to conflate "representation" and "reality" can be pernicious. As Freedberg shows, works of art have been mutilated as a consequence of this fusion: the body in the images of Michelangelo's *Pietà*, Rembrandt's *The Night Watch*, Velasquez's *The Rokeby Venus* loses its status as representation for a person with acid or with a knife who treats the image as living, believing that he or she can diminish the power of the represented by destroying it. And not only *images* are destroyed in attempts to diminish power: western landscapes are represented as unpopulated spaces open to cultivation and "civilization"; North American Indians are represented as a "vanishing race"; in our own times, conservative lawmakers and feminist theorists from the right and the left argue that there is a direct connection between responses to pornographic visual images and violence against women.[70]

Response implies two-way communication: a question and an answer, a call and a reply. But to deny the way in which cultural context conditions the response (or the question, for that matter), as in Freedberg's formulation of a theory of response to the figured image across cultures and across time, is to insist upon seeing oneself—one's culture, one's response—in the "other": that is, to engage in a one-way kind of looking that is blind to cultural differences.[71]

A good example of the way such blindness goes to the very heart of the problem of observing and inscribing the "other"—and of the way responses to visual images are culturally conditioned—can be seen in James Clifford and George Marcus's collection of self-reflexive essays called *Writing Culture*, whose cover photograph has become the site of contested meanings. The image was chosen because to Clifford it represents "the ethnographer [who] hovers at the edge of the frame—faceless, almost extraterrestrial, a hand that writes." bell hooks, however, sees "a white male sitting at a dis-

tance from darker skinned people, located behind him." The man is writing. A piece of cloth attached to his glasses, "presumably to block out the sun, . . . also blocks out a particular field of vision. This 'blindspot,' artificially created, is a powerful visual metaphor for the ethnographic enterprise as it has been in the past and as it is being rewritten"; it calls attention to "the white male as writer/authority . . . actively producing, and the passive brown/black man who is . . . merely looking on." As for the woman in the shadows, her "brown female gaze . . . is veiled by the graphics of the cover: a black line drawn across her face." To hooks, "an onlooker, conscious of the politics of race and imperialism," the most striking thing about the photograph is its whiteness and maleness. "The most visible body and face, the one that does not have to be searched for, is the white male image," she writes. "I see visual metaphors of colonialism, of domination, of racism."[72]

The best intentioned of us—including, as this book demonstrates, those outside the circles of power—fall into the trap of one-way looking. Consider anthropologist Edmund Carpenter's anguished description of a visit by a group of field-workers, equipped with Polaroid cameras, to the village of Sio, Polynesia, and of the "contamination" caused by their responsive recording of objects of ritual and daily use. When villagers were shown pictures of themselves, he recounts, "At first there was no understanding. The photographs were black & white, flat, static, odorless, far removed from any reality they knew. They had to be taught to 'read' them." Gradually, recognition and then fear came into their faces. They ducked their heads and turned their bodies away, retreated to private places, "sitting apart, without moving, . . . their eyes rarely leaving their portraits." The field-workers then put cameras into the hands of these villagers, who in a short time were making movies and still photographs of themselves, and endlessly playing with tape recorders. Returning to Sio a few months later, Carpenter no longer recognized the place: houses had been rebuilt; people were dressed in European clothing; "they carried themselves differently, they acted differently." What right does anyone have to do this to another human being, he asks, assuming that only the field-workers have agency and that the people of Sio are only acted upon. Moreover, how can we answer this question, painful in microcosm, "when seen in terms of . . . reaching hundreds of thousands of people daily, the whole process [of documenting otherness] unexamined, undertaken blindly?"[73]

The photograph on the cover of *Writing Culture* and the pictures taken in Polynesia by "self-reflexive" anthropologists are models of white repre-

senting black, "civilized" representing "primitive." hooks reverses this pattern in her own work by taking on white culture, specifically by applying the "freshness" of black street culture to aesthetic concepts in order to add "something new to our way of seeing—enhancing the visual experience of the look, the gaze."[74] Her ruminations on race, gender, and cultural politics are surely *fresh:* she resists Frederick Douglass's devaluation of black women; disparages postmodernist scholars such as Andrew Ross for constructing "black culture as though black women have had no role in black cultural production"; criticizes ethnographers such as Clifford and white feminists such as Teresa de Lauretis and Elizabeth Spelman for using the buzz-words "difference" and "other" with a passionate focus on race neatly divorced from a recognition of racism; and describes her own academic presentations in "a popular, performative, black story-telling mode," willing to risk "being seen by the dominating white other as unprepared, as just entertainment" in order to claim her right to subjectivity, to determine "how we will be."[75] But hooks's construction of herself as noisy outsider shares with feminist film theorists a strategy of reversing the positions of self and other without altering these oppositional structures—an angle of vision deliberately exclusive, surely essentialist.

Resisting these binary structures, Trinh Minh-ha represents her own culture from inside. In her filmic images and in her writing, she maintains that when we listen to the language of others and read with the eyes of others, "The more ears I am able to hear with, the farther I see the plurality of meaning and the less I lend myself to the illusion of a single message."[76] *Woman, Native, Other* opens with a story that reaches back to the remote village of her grandmother and forward to her own innovative play with surfaces, suggesting the casting of a net, a loose and open-ended structure. Proceeding in the old way, the story is allowed to emerge indirectly, to mature when it will: "There is no catching, no pushing, no directing, no breaking through, no need for a linear progression which gives the comforting illusion that one knows where one goes. Time and space are not something entirely exterior to oneself, something that one has, keeps, saves, wastes, or loses." Trinh's narrative has no beginning or ending:

> It appears headless and bottomless for it is built on differences. Its (in)finitude subverts every notion of completeness and its frame remains a non-totalizable one. The differences it brings about are differences not only in structure . . . but also in timbre and in silence. We—

you and me, she and he, we and they—we differ in the content of the words, in the construction and weaving of sentences but most of all, I feel, in the choice and mixing of utterances, the ethos, the tones, the paces, the cuts, the pauses. The story circulates like a gift; an empty gift which anybody can lay claim to by filling it to taste, yet can never truly possess. A gift built on multiplicity.[77]

In insisting upon cultural and gender difference that has *not* been lost and upon resistance to Western colonialist, capitalistic, patriarchal hegemony—thus reversing Freedberg's proposition or structuring the terms of the argument differently—Trinh argues that no distinction can be made between representation and reality in terms of response: "The *real,* nothing else than a *code of representation,* does not (cannot) coincide with the lived or the performed."[78] Real and represented on one side; lived and performed on the other.

This is the tension at the nexus of this book. Men, in all their variety, to be sure, but always men in power, have gazed through camera lenses at women—white women and women of color, privileged women (those whose portraits were paid for), working women (models, paid to pose), poor women (involuntary subjects)—and have fixed them, whether as artistic representations or documents of reality, as "other." Men have portrayed other men as "representative," in Emerson's sense—that is, as the namers, the language makers of visual culture and of "American" culture. To insist, however, that there are different stories in unrecognized forms does not mean that there are pure, uncontaminated specimens of the "other" outside this closed, "representative" circle. Even so compelling a notion as "we"—"you and me, she and he, we and they"—or so seductive a process as Trinh's "proceed[ing] in the old way" must come to terms with the argument in Kwame Anthony Appiah's recent study of African culture: "we are all already contaminated by each other" in a complex, interdependent human world ill-served, finally, by the dead-end effort of engaging in the "manufacture of Otherness."[79] In the late twentieth century, moreover, we must come to terms with theories of the hybridization of human and technological. We are all, Donna Haraway contends, cyborgs: "The cyborg is our ontology; it gives us our politics. The cyborg is a condensed image of both imagination and material reality, the two joined centers structuring any possibility of historical transformation. In the traditions of 'Western' science and politics—the tradition of racist, male-dominant capitalism; the

tradition of progress; the tradition of the appropriation of nature as a re-
source for the productions of culture; the tradition of reproduction of the
self from the reflections of the other—the relation between organism and
machine has been a border war."[80] Appiah's and Haraway's compelling ar-
guments about the *manufacture* of otherness, pure and simple, as a dead-
ended effort collide with any attempt at such representation. How, indeed,
do we untwist the strands of hybridization, acknowledge that there are
other strands, and attempt to recover sub-versions without falling into the
dialectical pattern of binary thinking? We can only begin by acknowledging
the complexity and multiplicity that underlie all social constructions.

II | The Geometry of Bodies: Gender and Genre in Pictorialist Photography

For Descartes . . . to see was to perceive . . . but, without stripping perception of its sensitive body it was a matter of rendering it transparent for the exercise of the mind: light, anterior to every gaze, was the element of ideality—the unassignable place of origin where things were adequate to their essence—and the form by which things reached it through the geometry of bodies. . . . [By the eighteenth century] the residence of truth in the dark centre of things is linked . . . to this sovereign power of the empirical gaze that turns their darkness into light. All light has passed over into the thin flame of the eye, which now flickers around solid objects and, in so doing, establishes their place and form.—Michel Foucault, The Birth of the Clinic[1]

UNDRESSING

Then his arm moves and we see he has an eye in his hand. . . . The nude passes before him: its nudity is not the skin, the limbs, the face, even though the skin, the limbs and the face are part of it; it is more; it is—on them—this gentle touch, like a burst of light. . . . [it is] the touch of the eyes on the body.—Bernard Noël, The Nude[2]

A naked woman stands before an artist seated in front of his easel, the elegance of his beret and frock coat, his little Vandyke beard more anachronistic for 1914 than her slender, unclothed figure[3] (fig. 2.1). Light molds the back of the woman's body, outlining her outstretched right arm and her bent right leg, accenting her discarded dress draped over the seat of the chair that supports her weight. Light that idealizes and a gaze that possesses—which can, as Foucault suggests, be as penetrating as a surgeon's knife or as the artist's paintbrush—is aligned with the lower rod of the artwork against which the woman stands and that seems to pierce her body. The shadows, the dark places of her body, echo the partial covering of the

2.1 Richard Polack, *The Artist and His Model,* platinum print, 1914, Royal Photographic Society, Bath, England.

representation of nature that hangs on the wall behind her—a tapestry or a topographical map, the words of whose partially obscured label, *"obsid,"* suggest the dark places of the world. All of the conventions of the artist's studio are writ large here: the model's doffed slippers and corset, to which the toe of the artist's polished boot points, add an artistic disorder to the rigid patterning of the black and white tiles and point to class distinctions between model and artist (she is for hire); and the woman is linked both with nature (to be conquered and represented) and pet. This is not a painting, however, but a photograph—a representation of a representation— that documents without irony certain institutions and practices dominating "art" photography at the turn of the century. Certainly, by the year following the Armory Show, Richard Polack's *The Artist and His Model* is dated. The convention upon which this photograph draws, however, and the ideology to which it subscribes are both as old as the earliest representations of (male) artists and their female models and as current as this antimodern portrayal, created on the eve of World War I, of the insulated world of art and its (masculine) power to represent, to dominate, and to control. At the turn of the century in the United States, this tradition in-

cluded a wide range of representations of naked females, from Eadweard Muybridge's 1880s studies of bodies in motion to Pictorialist photographers' "art" nudes, Bellocq's pictures of Storyville prostitutes, and anatomical documentary studies for ethnographic, military, and medical purposes.

One of the earliest examples of the nude woman in the artist's studio is a drawing from Albrecht Dürer's *Treatise on Measurement* (1525) (fig. 2.2), in which the model's body, exactly replicating the curves of the landscape seen through the open window, is turned so as to be available to the gaze of both the (male) spectator and the (male) artist who, with the help of his rectangular grid, transfers his notion of her monumental curvilinear figure to a composition of reduced, divided, and angular forms. Not only is the reclining woman larger than the frame that fails to contain her, but she is also in the smaller of the two spaces: the grid does not divide the drawing evenly; it is slanted so that the spectator is included in the artist's half of the picture. Neatly framed by the window in his half are domesticated emblems of (female) nature—the pitcher and the potted tree.[4]

Particular ways of seeing and framing are tied to cultural conventions and beliefs—in Dürer's case, to Renaissance ideology and to the "discovery" of new lands, charted, mapped, and represented as female terrain to be explored.[5] So, too, in the American Renaissance at the end of the nineteenth century[6] was that other famous composite, the Gibson Girl (fig. 2.3), bound up with an ideology of cultural imperialism. Larger than life, she not only represented the bodily health and stature of the New Woman, as Martha Banta suggests, but became a sign of the times or a "type," standing for the nation's "vaunted independence of spirit and proud self-confidence."[7]

The problem of representation in drawings like Gibson's—the translation of what the artist sees (parts of a woman's body) into signs (the marks

2.2 Albrecht Dürer, draftsman drawing a nude, woodcut, c. 1525, from *Unterweysung der Messung* (Nuremburg, 1538). Photograph, Edgar Sabogal.

2.3 Charles Dana Gibson, "The American Girl to All the World," *The Gibson Book,* vol. 1 (New York: Scribner's, 1900). Photograph, Richard Fish.

on his paper) to be read as an imagined concept—is complicated in photography by the fact that the photograph not only records what the photographer sees, but what the camera sees. Laura Wexler has suggested that there are multiple ways in which the camera sees more than and differently from the photographer; it is this very difference that the artist-photographer must fathom, play with, and compose. Or, as Joel Snyder and Neil Walsh Allen put it, "It is the light reflected by the objects and refracted by the lens which is the agent in the process, not 'the physical objects themselves.' These 'physical objects' do not have a single 'image'—'their image'— but rather, the camera can manipulate the reflected light to create an infinite number of images." In other words, the way an image is represented in the camera's field (no less than on the artist's canvas) is neither natural nor necessary.[8]

The problems of photographing "what we see" are substantial, as several recent critics have shown,[9] especially when we turn to things that move or might move. When Muybridge succeeded in "freezing" the rapid motion of race horses at the finish line, his results were met with dismay by artists, photographers, and the general public as being "untrue" or "unnatural"—a reaction not to the veracity of the results but to the perception that Muy-

bridge had represented a phenomenon located in a realm outside common visual experience.[10] His attempt to document the measurement of the human body comes down to us from the Renaissance, but the assumptions that underlie his representation of the body as a mechanism are those of modern science. Like Dürer, Muybridge strips the body to reveal its musculature and movement; he isolates it against a bare background or grid in order to measure it. His male figures progress from various forms of walking, running, jumping to the more complex tasks of throwing, catching, kicking, boxing, and wrestling, and finally to the performance of trades—carpentry, hod carrying, and so on. Women similarly progress through various kinds of activities except that their work is more passive: they pick up and put things down; they stand, sit, or kneel amidst bedclothes, curtains, robes, and furniture. Props, gestures, and expressions tend to mark woman as more embedded than her male counterparts within a socially prescribed system, Linda Williams suggests: male activities are purposeful, never erotic—perhaps because the women Muybridge used were professional models, whereas the male "performers" were everyday people whose movements were linked to their activities in real life. Not only are the women fictionalized in this narrative sequence, she concludes, but they are also *more nude* than the men.[11]

I would argue that both men and women in these sequences play roles, dramatize their activities, and tell stories; moreover, the extension and musculature of male bodies engaged in these exercises can indeed be erotic, although Williams *is* right to see that the women's postures and activities are more explicitly linked to concepts we identify as erotic. The photographs of Muybridge's contemporary Thomas Eakins display similar gender differences. Made as anatomical studies for paintings, the photographs show the artist's own naked body and those of male friends—often with genitals proudly displayed—posed in series to demonstrate the musculature of the body and the engagement in such purposeful and communal activities as swimming and wrestling. Female nudes, mostly professional models but including the artist's wife, are more likely to pose with props and more likely to be solitary. Often they shroud their eyes and genitals with cloths and hands—an erotic veiling, as Barthes would say, that stages "an appearance-as-disappearance."[12] To this female viewer, the naked bodies of men predominant in these images have strong erotic content. At the same time, there is a frontality and openness about the representation of male nakedness that distinguishes it from the masquerade that female nu-

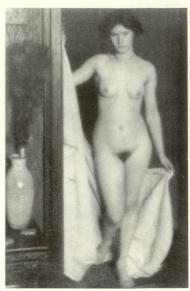

2.4 (near right) Clarence H. White and Alfred Stieglitz, [Miss Thompson], gelatin silver print, c. 1907. ©The Metropolitan Museum of Art, New York, Alfred Stieglitz Collection, 1933, no. 33.43.389.

2.5 (middle right) Thomas Eakins, *William Rush's Model*, c. 1908. Honolulu Academy of Arts, gift of Friends of the Academy, 1947.

2.6 (far right) Hiram Powers, *The Greek Slave*, marble (1847), 1869. The Brooklyn Museum, gift of Charles F. Bound.

dity seems to be in these pictures. As John Berger suggests of painting, "To be naked is to be oneself. . . . To be nude is to be seen naked by others and yet not recognized for oneself. A naked body has to be seen as an object in order to become a nude. . . . To be naked is to be without disguise. To be on display is to have the surface of one's own skin, the hairs of one's own body, turned into a disguise."[13]

Berger implies here that some kind of *self* is freed (by purposeful activity and, in his view, by love) or covered in this dichotomy: naked/nude. The covering, or disguise, takes the form of specifically encoded representations, signaled by expressions, gestures, and props. An example of nudity as disguise is the series on which Clarence White and Alfred Stieglitz collaborated in 1907–1908 (fig. 2.4). The photographs present women's bodies in terms of the classical abstractions that figured in *tableaux vivants*, painting, statuary, and paper money. Explicit iconographical references (here, vase and peacock feather) denote both mythological themes and erotic intent. Eakins plays with this idea of disguise in his several versions of William Rush, particularly in those paintings and studies in which he dwells on the artist's model who is freed by the sculptor, Pygmalion-like, to step down from her pedestal (fig. 2.5). These series of photographs and paintings likely refer to Hiram Powers's *The Greek Slave* (fig. 2.6), whose chaste and perfect form became the nineteenth century's model for beauty in woman, but

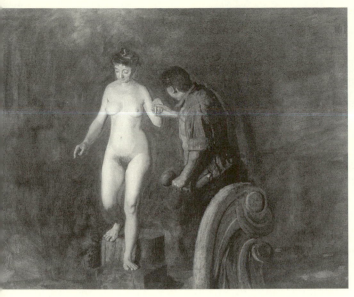

whose nude, manacled body also signifies the need to be set free.

The fact that certain creative (real) women identified with *The Greek Slave*, seeing her as a model of oppression,[14] points to the way in which the very language of high art was (and is) an exercise of power, especially in constructions based on the human body. Drawing on well-known, often-reproduced and exhibited paintings, Rozsika Parker and Griselda Pollack suggest that women artists, denied access to the nude model, were not only excluded from the tools of their trade, but both as artists and as models were also subject to a form of domination that denied them the power to give meanings of their own to themselves and their culture.[15] Photography, however, in its democratic appeal—with ever-increasing numbers of men and women of various classes, education, and experience, often outside the conduits of power of the art world, taking up the camera—complicates such neat dichotomies.

Photographic meaning, then, is constructed and reconstructed in a variety of ways. Obviously, Muybridge's documents for scientific study differ in intention and reception from a work like Polack's, yet there is a certain sense in which the subject of both is sexual power. This power is the more insidious when art is joined to science because of the commonly held belief that the camera does not lie. Such a coupling intensifies the way in which sexual power becomes intertwined with racial and class power, as in the

Zealy daguerreotypes of naked, enslaved African Americans, in medical documentation of the wounded body parts of Civil War soldiers, in representations of American Indian bodies in the Pictorialist art of Joseph Keiley and Gertrude Käsebier, or in the "art-science" of Edward S. Curtis. Indeed, the purpose of this chapter is to explore the way in which Pictorialism in particular is inscribed from the beginning by racially, sexually, and class-encoded systems of power.

Given its stated aesthetic aims, and given most of what has been written about the genre, it might seem understandable to describe Pictorialist photography in terms of the power structures of the art world, but odd to link it to other hegemonic belief systems. Pictorialism, which in its most literal sense refers to the making of photographic *pictures,* was a response to the impact of science and technology in general and in particular to the widespread popularity of photography, especially after 1888, when the handheld camera made possible the easy and infinite reproduction and circulation of millions of photographic images. Pictorialist photographers, one might say, wished to preserve in their carefully crafted pictures the very thing Walter Benjamin would declare dead after the invention of photography: the *aura,* the unique and irreproducible quality that made a pictorial work "art." For subject matter, Pictorialist photographers turned, logically enough, to the great themes of high art, which were often those of contemporary Symbolist painters as well: landscapes and nudes, female figures and visual idylls. They achieved special painterly effects by using soft-focus lenses and, in the darkroom, tools, brushes, and fingers to shape or alter forms in the soft gums and oils with which they coated photographic plates. Printed on a variety of art papers, from the heavily textured to the smooth Japanese tissues, no print was exactly like its negative; each individual picture was meant to be a collector's item.[16]

I am interested here in the way in which the female nude was the "legitimizing" subject for Pictorialist photographers and those who began as Pictorialists. It would be an oversimplification to say that only women posed for only men photographers: Anne Brigman and F. Holland Day photographed their own naked bodies and those of their friends; Käsebier made at least two photographs of nude women—in one of which Jane White (Clarence's wife) posed as *The Bat*[17]; Cunningham photographed her husband's naked body. Nevertheless, in photography as in painting, the predominantly male artist (as culture) transformed the female nude (woman's body as nature) into a work of art.[18] The *work* that the nude fe-

male model does, on the other hand, is not the subject of most camera work: models were paid to pose, and although they sometimes developed strategies for asserting their own agency under direction, picturing their bodies was the photographer's work—most often, the work of men of a certain class.

Because of the preponderance of the naked female body as subject in the corpus of male Pictorialist photographers, let the kinds of images made by Muybridge and Polack stand for the moment as markers for the conventions of representing women in the camera work of this period from the late 1880s to the First World War. Included in this contextual frame of reference are, on the one hand Muybridge's images of the western landscape and its native peoples, contemporaneous with the U.S. government survey project, and, on the other, as precursors of motion pictures, his studies of the geometry of human bodies. This period also includes the publication of Alfred Stieglitz's *Camera Notes* (1897–1903), *Camera Work,* and his Little Galleries of the Photo-Secession (1905–1917).[19]

The centrality of Stieglitz, *Camera Work,* and 291 (as the gallery came to be called) to photography at the turn of the century can hardly be overestimated. It is not too much to say that this most ardent and influential spokesman for photography as art defined what art was and was not; he even propagated the notion that there was no photographic art in America of any importance before the self-conscious pictorialism he himself represented. Certainly, the prominence of the so-called Stieglitz school has overshadowed other camera work in the period, including that of photographers who were taken up and then disdained by the master, White and Käsebier among them, and who were to have so marked an influence on the work of the next generation. Trachtenberg reminds us that the premises of the fine-art movement in photography conceived of the history of the medium as a history of styles, "of changing looks and aesthetic intentions, isolated from social practices, cultural patterns, and institutional forms." In imposing a hierarchy of value, an ideology based on elitist notions of class, "artists" thus insulated themselves from the work of "documentary" photographers such as Lewis Hine, who expanded the range of photographic subject matter and technique.[20] Such distinctions turn out to be artificial when photographic history is expanded to include less well-known makers of images, particularly when we consider the origins of the women's work with which this study is primarily concerned. *Art* and *document* turn out to be terms that have to do more with institutions of power—of exhibition

and distribution—than with the content or form of a given picture. Allan Sekula calls this a "traffic in photographs," which is tied to institutions as parts of a cultural circulation deeply connected to specific issues of class, race, business relations, sponsorship, publication, and exhibition.[21] The argument that the making, showing, and reading of photographic images is a political act—that visual images can be understood only in their social contexts—leads to a reconsideration of the reasons for continuous circulation of certain photographs and of what may be a false dichotomy between photographic practices and intentions.

Pictorialism, for example, was a much broader art form at the turn of the century than we tend to think. For one thing, it was a training ground for documentary photographers (Lange, Bourke-White), modernist experimenters in form (Cunningham, Weston), portrayers of indigenous peoples (Gilpin, Curtis, Ulmann) and of the western landscape (Gilpin, Adams), and successful commercial artists (Paul Outerbridge, Ralph Steiner)— most of whom were associated with the Clarence H. White School of Photography in New York or with White's associate Käsebier. In this period, White did not become a single figure of influence, nor was his own work strikingly experimental. Rather, his importance can be found in the openness fostered by his school. As Lange recalled toward the end of her life, "[White] would and did accept everything. . . . The man was a good teacher, a great teacher, and I can still occasionally think, 'I wish he were around. I'd like to show him this.'"[22] Including institutions that trained

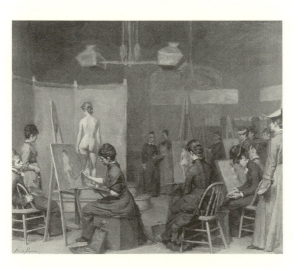

2.7 Alice Barber Stephens, *The Women's Life Class*, c. 1879, oil on cardboard (grisaille). The Museum of American Art of the Pennsylvania Academy of FineArts, Philadelphia, gift of the artist.

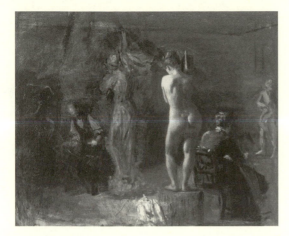

2.8 Thomas Eakins, *William Rush Carving His Allegorical Figure of the Schuylkill River,* study, 1876. Yale University Art Gallery, New Haven, Conn. Collection of Mary C. and James W. Fosburgh, B.A. 1933, M.A. 1935.

women—as most of White's students were—in the history of photography shifts the emphasis from women as subjects to women as makers—opening up "camera work" in exactly the way that was anathema to Stieglitz. Such a shift makes possible a reframing of this period in photographic history: with institutions that trained women in the making of art identified, representations of women by men can be replaced as markers for this period by Alice Barber Stephens's painting *The Women's Life Class* of 1879 (fig. 2.7) and the White School, founded in 1914 "as an institution for teaching the science and art of photography and for the training of its students for the vocation of photographer."[23]

Barber Stephens was a student of Thomas Eakins; in fact, his wife, Susan MacDowell Eakins, is the artist in the foreground of her painting, which may have been done in his class and which clearly refers to his *William Rush Carving the Allegorical Figure of the Schuylkill River* of 1876 (fig. 2.8). The difference between Barber Stephens's work and Eakins's is striking: in *The Women's Life Class,* the women encircle and protect the naked female model, whereas in *William Rush,* the chaperone faces away from the foregrounded, isolated, and vulnerable model. Eakins was not unaware of the vulnerability of female models; it was perhaps at their own wish that nude women in paintings from the 1860s and in photographs from the early 1880s are masked or chaperoned.[24] Similar in composition to Barber Stephens's work, Frances Benjamin Johnston's photograph of a life drawing class at the Washington, D.C., Art Students' League (fig. 2.9) emphasizes the juxtaposition in forms also found in the painting—rounded fe-

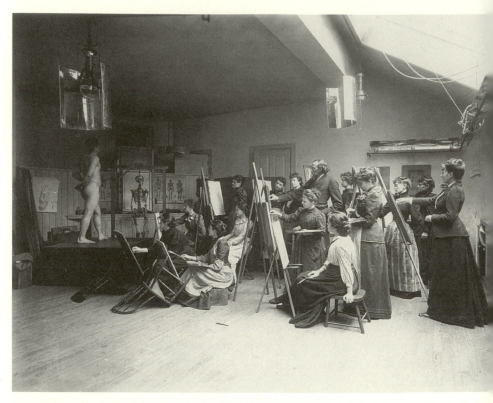

2.9 Frances Benjamin Johnston, *Art Students' League,* c. 1900.
Frances Benjamin Johnston Collection, Prints and Photographs
Division, Library of Congress, no. J698-90061.

male bodies against sharp diagonals of the easel stands—in order to point
to the more radical and contested nature of the subject matter. In John-
ston's photograph, the male model and instructor tower over the women
students working at their easels; the model affects a striding pose while the
women, if not seated, stand in a state of arrested motion. What those fully
and decorously clothed women are doing, however, is looking at and rep-
resenting the body of a naked man. Although we cannot see what is on the
women's easels, it is but a small step from a photograph that captures the
frank gaze of women painters to the kinds of images constructed by
women photographers during this period. Our focus has shifted from the
woman with masked eyes who is Eakins's subject to the open eyes of the
woman artist in Barber Stephens's and Johnston's images.

Whether or not access to nude models was a limitation for women artists

in general at this time, women photographers—makers of art photography, photojournalists, commercial portraitists, record keepers of family histories—flourished.[25] Some did publish in *Camera Work* and other photographic journals, exhibit at Stieglitz's gallery 291, and become associated with photographic societies such as the Linked Ring and Photo-Secession; a great many more were well known in the popular press. They were encouraged in these activities by Johnston and Käsebier, by other working members of camera clubs, and, for those lucky enough to get their start there, by the White School of Photography.

The shift from woman as subject to women as makers puts into sharp contrast the way in which women were pictured in an artistic tradition embraced by male photographers and the ways in which women camera workers served as mentors for one another—helping one another, through camera clubs and less formal means of communication, to overcome the hurdles of mastering technology and to show and publish their work. Such mentorship is most notable in Käsebier's efforts and in the exhibit organized by Johnston for the Paris Exposition of 1900 and her series of articles for the *Ladies' Home Journal* the following year. Like Johnston's own work, the camera work of women is wide ranging and various. The photographers Johnston championed did, however, share one thing: they tended to include their own life stories, overtly or covertly, in their picturing. Because their stories reveal the difference that being female makes at the end of the century, one of the questions this chapter addresses is whether these women, given their own "otherness" in the world of art, developed distinctly gendered strategies for representing other bodies, strategies tied to modes of perception based upon their own experiences—including an internalization of their own continuous typecasting and representation as "subject."[26] This investigation of the links between "expressive language" and "difference," then, aims to broaden our understanding of Pictorialism—and the social practices, cultural patterns, and institutional forms in which it is embedded—by foregrounding the fact that from its inception, one of its main purposes was to picture difference.

DRESSING

His eye . . . lighted on a recent photograph of Miss Bart. . . . The photograph was well enough—but to catch her as she had looked [in the tableaux vivants] last night! . . . Could photography capture that light?—Edith Wharton, The House of Mirth[27]

Cindy Sherman, in her reconstructed "Mona Lisa" (see fig. 1.1), is one of a long line of women who dress up for purposes of "masking, camouflage, inversions, and play,"[28] many of whom posed at the turn of the century for the New York photographer Gertrude Käsebier. Käsebier was a master of *tableaux vivants.* Her own "Mona Lisa" (fig. 2.10), printed in the *Bulletin of Photography* in 1910, was exhibited and reproduced under various titles from the time it first appeared as *Cornelia* in Charles Caffin's *Photography as a Fine Art* in 1896. Käsebier's portraits are most often characterized, however, by a term that would never be applied to Sherman's work: *sympathy.* Said to be peculiar to women, this attribute is regularly used to explain what is so revealing and affecting in Käsebier's images. Caffin used the term repeatedly in his chapter entitled "Mrs. Käsebier and the Artistic-Commercial Portrait," and it serves as the basis of Giles Edgerton's (Mary Fanton Roberts's) assessment in *The Craftsman,* 1907.

Sympathy connotes an ability to penetrate to and represent with empathy "the real," as in Käsebier's description of her purpose: "I have longed unceasingly to make pictures of people, not maps of faces, but pictures of real men and women as they know themselves, to make likenesses that are biographies."[29] For Caffin, however, the photographer's skill lay in her understanding of the real as formed by *appearances.* Käsebier did not labor under the misconception that a good photographic portrait "should be clear and distinct, full of definition, the features clearly rendered," he wrote. Rather, she understood that:

> If people would study each other across the space of an ordinary sitting-room, they would discover how little definition they, respectively, present. They become patches of color against the colors of walls and furniture; they are animated, individual personalities, and yet the outlines of their figures are not rigidly carved, but merge with the surroundings, and are softened by atmosphere. . . . The figures are not lighted from all the points of the compass in a stark glare, like the people on the stage. The real scene is a maze of shadows as well as light, moving with the movements of the figures, giving a hundred different suggestions. . . . The photographic artist . . . will reproduce the accidental effects that . . . form so much of the charm in real life.[30]

This emphasis on the way things appear more real in proportion to the way in which they suggest themselves to our imaginations is at the core of Henry James's "The Real Thing," in which a professional model, posing for

2.10 Gertrude Käsebier, *Cornelia*, 1896. Prints and Photographs Division, Library of Congress, no. K2-3.

an illustrator of popular romances, is able to portray a lady more effectively than a *real* lady. The model "realizes intuitively that a living is to be made by an exaggeration, a coarsening, of what she is actually. At the same moment, she can draw back toward subtle sublimations of the self in order to approximate the type," as Martha Banta suggests: "Such an altered self is not less real for all that. It is *more real* when taken as the occasion for . . . disclos[ing] . . . the processes of *making* reality."[31] What we—readers and viewers, writers and image makers—take to be *real*, then, is that which gives a multitude of suggestions to the imagination. This cross-fertilization works both ways, as Banta points out: popular images in this period filtered down and filtered up. American girls self-consciously mirrored the ways in which they were portrayed in visual images from high art—painting and sculpture—to various forms of popular culture—posters, advertisements, mass media photographs, drawings, and movies.[32] *Imaging American Women* presents a "real" midwestern young woman—Banta's mother, in photographs made in a small Indiana town in the early part of this century—and her friends acting out the whole gamut of popular cul-

tural images, from goddess to innocent American Girl to New Woman. In their imitations before the camera, they play with, reconstruct, and reflect back the pervasive ways in which they, as young women, were represented.

It is in this vein of self-conscious mirroring, then, that Cornelia Montgomery poses for Käsebier as the Mona Lisa. In this portrait, one of the photographer's many *tableaux vivants* based on Renaissance, Impressionist, and Symbolist portraits, the interaction between photographer and model is more complex than simply making a photograph that imitates art (a common judgment made of Käsebier's work).[33] A successful collaboration between model and artist in such constructions has to do not only with making art, but with making—or remaking—identity. For the women who modeled for Käsebier in such productions, the pleasure must have derived from imagining that identity is fluid. As in other forms of mimesis, from masked balls to minstrelsy, the experience of trying on or constructing other selves is tied to the possibility of authoring alternative scripts to the one in which one finds oneself. In this light, we can understand Madame Merle's famous lesson to Isabel Archer (in James's *Portrait of a Lady*) not only as pointing out the impossibility of the purity of one's "naked" self, apart from one's "envelope of circumstances," but also as affirming role-playing as a way of achieving a certain freedom. Wharton makes the same point in *The House of Mirth*, when Lily Bart, re-presenting her self as a work of art in the *tableaux vivants*, attains a special "radiance"; and with Undine Spragg, who, playing dress-up before the mirror in *The Custom of the Country*, finds the possibility of transcending—at least for the moment, of re-presenting—her class and station.[34]

These fictional performers owe a debt to Emma Hart, a lower-class woman who played at being a lady and who was undoubtedly the most famous performer of *tableaux vivants*. Goethe, among others, traveled to Naples at the end of the eighteenth century to watch "Lady Hamilton" represent herself as figures from classical and modern masterpieces, figures which he would then re-present in his 1809 novel *Elective Affinities*, as would Susan Sontag nearly two centuries later in *The Volcano Lover*. By the nineteenth century, "attitudes" like those created by Emma Hart in her master's art gallery had become grandiose public presentations with large casts, exotic subject matter, elaborate scenery and costumes that catered to audiences' sheer love of spectacle. One of the most popular producers of *tableaux vivants* on the New York stage was Madame Warton's [sic.] "Troupe of Living Females," which presented works by Reynolds, Angelica

Kauffmann, Corressio, Canova, Titian, Rubens, David, Hiram Powers, and others. In the latter half of the nineteenth century, such performances drew respectable audiences, who, given permission to stare at semi-nude women (often the only covering would be paint sprayed on the body) under the guise of viewing "great art," crowded such entertainment places as Ham-merstein's Roof Garden, but they also outraged certain segments of the population (such as the Women's Christian Temperance Union) by their indecent displays.[35]

By the 1890s, having survived attacks by the self-appointed safeguard of public morality Anthony Comstock, *tableaux vivants* had a last great surge of popularity in New York. They were staged not only in theaters, but also in hotels, in private homes like the one in Wharton's novel, in boarding houses like that in Jack Finney's recent *Time and Again,* and in churches as benefits for charitable and artistic organizations. By 1897, instructions for do-it-yourself dressing as various figures from history or legend could be found in a booklet issued by the Butterick Pattern Company.[36] Performers, professional or amateur, were most often women;[37] stagers of living pictures included not only theatrical managers, but also American artists. The *Illustrated American* of October 1895, reporting on the way in which "Living Pictures took the country by storm," noted that William Merritt Chase "has the names of over three hundred models in his address-book. Small foot-notes tell him just for what each one is valuable. One girl he hires because she has a beautiful arm, another who has the exact shade of hair which he loves . . . while the third, fourth, and fifth he will take for symmetry of form, handsome carriage, or because her skin matches some fabric."[38]

The artist who stages the *tableaux vivants* in Wharton's novel is probably meant to represent Chase, for his name is prominent in surviving programs for such entertainments: one for a benefit for the New York Decorative Arts Society in 1893, which staged representations of paintings by Velasquez, Doré, David, Alma Tadema, Gerôme, and Gainsborough; another for the benefit of St. Katharine's Home in Jersey City, which included representations by Van Dyke, Frans Hals, and others. A program for an entertainment in the Church at the Corner of Pierrepont and Clinton Streets in 1890 was a collaboration of various artists, with a mixed selection of masterpieces by Velasquez and Van Dyke and of popular works, such as scenes from "The Courtship of Miles Standish" and "The Angel of the Scriptorium" arranged by Will H. Low (who also created designs for U.S. paper currency and illustrations for Stephen Crane's poetry). The article

about Chase in the *Illustrated American* also describes artists' models, such as Minnie Clark—"known to the world as the typical American girl, or the Gibson girl," whose "well-shaped head" was used for Daniel Chester French's "statue of the Republic that still stands overlooking the ruins of the White City" (from the World's Columbian Exposition in Chicago of 1893)—and Lillie Daly, "immortalized by Augustus Saint-Gaudens" as his *Diana* atop the Madison Square Garden tower. At one point, Daly was to complain that

> Today, when the curtain rises on a group of apparently nude women posed to represent some classic masterpiece, an audience will go wild with excitement, clap until their fingers tingle, and have the curtain run up and down until the stage carpenters are in a dripping perspiration; but once the curtain has fallen for the last time, the Living Pictures have hardly time to step from their agonizing positions before they are criticised, harshly judged and condemned by the very persons who applauded just before.[39]

Julia Margaret Cameron, posing young village women as characters in Arthurian legend and her servants as madonnas in her rudimentary studio on the Isle of Wight in the 1860s and 1870s, was probably the first photog-

2.11 Gertrude Käsebier, *The Silhouette* (The Gerson Sisters), 1906. Prints and Photographs Division, Library of Congress, no. USZ62-67899.

2.12 Gertrude Käsebier, *Serbonne* (A Day in France), gum bichromate print, 1901. ©1997 by the Museum of Modern Art, gift of Hermine M. Turner.

rapher to arrange family members and friends as living pictures. Käsebier's madonna studies—such as *The Manger* (purchased by the actress Ellen Terry, who posed for both painter John Singer Sargent and for Käsebier), her prize-winning image of a young woman in Greek costume, her Renaissance portrait *Flora, Serbonne,* modeled on Manet's *Le déjeuner sur l'herbe,* and studies of the Gerson sisters in the manner of Sargent (fig. 2.11)—are all in this tradition, as are many of Johnston's society portraits, Day's crucifixion scenes, Cunningham's pictures of friends in pre-Raphaelite poses, and a group of California photographers' representations of themselves as the holy family.

As students of painting at the Pratt Institute, Käsebier and her friends had enjoyed performing *tableaux* of the sort later staged as *The Rehearsal* (c. 1912), in which a pair of them donned seventeenth-century court dress to perform for one of Mrs. Stuyvesant Fish's *soirées.*[40] Pratt students also went on excursions, such as the picnic scene pictured in *Serbonne* (or *A Day in France*) (fig. 2.12), in which artists Edward Steichen, Frances Delehanty (who had earlier posed for *The Manger*), and Charlotte Smith (whose sister Clara would later marry Steichen) posed with Käsebier's daughter Hermine for a playful composition on paintings by Manet and Titian. The se-

ries in which the Gerson sisters try on dresses for the Assembly Ball of 1906 in New York's old Astor House (called the "Crinoline Ball" for the mid-nineteenth-century costumes traditionally worn) is a record of another artistic circle: Virginia and Minnie's sister ("Toady") married William Merritt Chase; Chase, Alice Barber Stephens, and Stieglitz were among the jury members for the Pennsylvania Academy of Fine Arts and Photographic Society of Philadelphia Salon in 1898, which selected Käsebier prints for an exhibit to which Barber also contributed photographs.[41]

In these playful stagings, Pictorialist photographers often drew on their training as painters. When she turned to photography following her Pratt years, Käsebier, for one, would see the French countryside in terms of Barbizon paintings she knew: "One color, or half-tone melts into another in the most seductive fashion, whether it be the costumes of the peasants, the stain upon the buildings, or the gray-green of the landscape," she wrote in an article for the *Monthly Illustrator* in 1895. "It is no wonder that Corot and the followers of his method were captivated by this district." Posing a mower and his wife, she found that "the scene made another *Angelus* in its way, as Millet must have seen hundreds of times before he painted his immortal picture."[42] Arthur Wesley Dow, who taught at Pratt during Käsebier's last year there before he moved on to the White School of Photography, championed her photography in *Camera Notes* in the same year his *Composition* was published (1899). Käsebier would continue to make allusions to painting in her work: using canvas-textured backgrounds, placing white-gowned children against dark backgrounds in the manner of Titian, designing Whistlerian compositions of mother and child, creating ambiguous constructions of shadowy forms (for example, *The Manger* and *The War Widow*),[43] or posing Dow as a Holbein.[44]

Käsebier's special interest in studies of mothers and children had to do with her interest in progressive child-raising methods. At Pratt she would have been exposed to Friedrich Froebel's theories, which made mothers responsible for the physical, moral, and intellectual development of their children. The geometrical shapes in Käsebier's *The Hand That Rocks the Cradle,* particularly the child's cradle, are a visual reference to Froebel blocks (which were also of interest to architect Frank Lloyd Wright). Believing that a child's education should begin at birth, Froebel recommended the use of finger play games to spur an infant's intellectual development. His idea that a child understands through imitation was

popularized in books of songs and finger play. *The Hand That Rocks the Cradle* also pictures a mother engaging in such play, which her young daughter imitates.[45]

It is likely that Käsebier was specifically interested in the element of play afforded by the staging of *tableaux*. Charles Horton Cooley's 1902 *Human Nature and the Social Order*, for example, described the ways in which children use private play as a means of progressing toward a sense of self-identification by a process he called "fantastic socialization," which stressed the difference between the self as an *object* given its identity by others and the self drawn from the *sentiment* one has about oneself. Using masks and costumes for make believe, Cooley argued, enabled children and young adults to experiment with a variety of self-created identities, to discover and enact private desires, and to come to terms with their more public "social selves." Banta uses family photographs from this period to illustrate the way in which young women acted out a variety of "types," from chaste innocents to Felliniesque free spirits—including variations on "Poor Butterfly" that reflected not only the popular appeal of the contemporary David Belasco play and Puccini opera, but also "one consequence of America's recent imperialistic moves into the Pacific by which males . . . annexed new territories of female innocence to betray."[46]

Most photographers were inclined, however, to represent the maternal figure in idealized form. As industrialization and urbanization increasingly threatened family values, the mother was visually represented as a paragon of womanhood, particularly when intimately engaged with her children in leisurely domestic activities. Her recurrent image in Pictorial photography —as a composition of shapes, tones, mood, line, light, and evocative half lights that, as Caffin wrote, set all objects "in due relation to one another within an *enveloppe* [*sic*] of atmosphere"—only enhanced a symbolic value that stood in direct contradiction to the existence of hordes of immigrants (represented in the work of Jacob Riis and Lewis Hine) who posed a threat to middle-class gentility.[47]

Käsebier's *Blessèd Art Thou Among Women* (fig. 2.13), which appeared in the first issue of *Camera Work*, falls within this tradition. Like *The Manger*, it is a study in shades of white, of rounded forms set against or framed by rectilinear shapes, and is meant, with its enigmatic religious references, to suggest the purity of woman; the text, "blessèd art thou among women," refers to the passage from Luke in which the Virgin Mary is told by the

angel that she will conceive. In collaboration with women friends who pose for her, however, Käsebier also constructs pictures of an (illusory) unity of mother and child in the prelinguistic realm—that is, a time before, or at the moment when, the female child must enter the symbolic world of subject and object in which she, as the recipient of male desire, is assigned the place of object.[48]

Mothers and children were a favorite subject for Pictorialist photographers in general, but conventions of representation differed in ways that have to do with a complex intertwining of gender and class, as well as of subject, photographer, and audience. Käsebier was an artist *and* a commercial photographer; she had her own studio, published and exhibited along with the best of the men, but also made commercial portraits. In this she was like a good many other women of the period, some her friends or some younger women whom she mentored in one way or another, taking them on as assistants in her studio and encouraging their work at the White School or in correspondence. But many middle-class women took up the now more accessible technology of the camera as amateurs—often working out of their homes, developing and printing in their kitchens and bathrooms.[49] Women *and* amateurs almost always photographed not hired models but their family and friends.[50] In photographing the familiar, obviously, distance is bridged; the photographer stands in a noninvasive relationship to her subject. Consistently, in these photographs by women Pictorialists, figures touch one another. Käsebier's portraits of Clarence and Jane White and their sons show the closeness of this family, differentiating White from his photographic colleagues—depicted, for example, in Frank Eugene's picture of the alienation between Stieglitz and his first wife Emmeline sitting at two ends of a garden bench and in Steichen's cool portrait of Stieglitz and his daughter.[51] White's own double nude of a mother and baby from 1912 (fig. 2.14) can be compared with Alice Boughton's *Children* (1902) or *Nature* (1901) (fig. 2.15) and with Käsebier's *The Picture Book* (1899) or *Happy Days* (1902) (fig. 2.16): in the latter images, the subject is not only composition and line, light and texture, but the intimacy of human communication. Käsebier pictures children at play quite differently than White: his *Ring Toss* (1899) (fig. 2.17), like paintings by Chase (*Ring*

2.13 Gertrude Käsebier, *Blessèd Art Thou among Women,* platinum print on Japanese tissue, c. 1900. ©1997 by the Museum of Modern Art, gift of Hermine M. Turner.

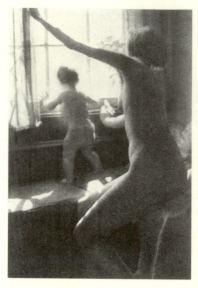 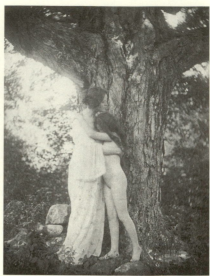

2.14 Clarence H. White, *Nude with Baby,* 1912. Prints and
Photographs Division, Library of Congress, no. usz62 63794.
2.15 Alice Boughton, *Nature,* 1901. Courtesy of the Miller-
Plummer Collection, Philadelphia.

Toss [1896]) or Sargent (*The Daughters of Edward Darley Boit* [1882]), is a
study of isolation in which despite their joint activity, the girls are distanced
from each other, from their game by the exaggerated space of the fore-
ground, and from the viewer by the dreamlike quality of a light-saturated
interior.

Such gender differences are confirmed by the stories told in photographs
from the albums of Irma Purman Banta—she and her friends touch, en-
circle one another's waist, grasp hands, embrace—and in the more public
photographs of the same period by Alice Austen of Staten Island, who pic-
tured herself and her women friends (in some cases masked and costumed)
in the close physical proximity of friendship and play (fig. 2.18). Written
documents survive in which women describe the narratives they picture
when they take up the camera: these stories are about friends and families,
and in their pictures, women figures touch, suggesting a human connect-
edness, a concern for community and continuity significantly at odds with
narratives about the isolation of the photographer in the modern world.[52]
Thus, the solitary male artist—who becomes a distinctly gendered type in
this period—works with his head and hands. His isolation is assumed; his

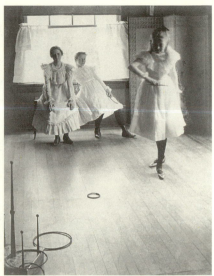

2.16 Gertrude Käsebier, *Happy Days,* 1903. Prints and
Photographs Division, Library of Congress, no. USZ62 52445.
2.17 Clarence H. White, *Ring Toss,* 1899. Prints and Photo-
graphs Division, Library of Congress, no. USZ62 41661.

human connections are rarely discussed. In sharp contrast, contemporary
accounts of Käsebier as artist often referred to her physical and human,
even grandmotherly, qualities. Finding in 1907 that one could hardly pick
up a leading photographic magazine without coming across a reproduc-
tion of or a reference to Käsebier's work, Joseph Keiley attributed this
popularity to "her personality . . . as much as her artistic genius," which was
"necessarily uneven." Going on to describe her body as "of medium size
and rather inclined to fullness of figure," he called her appearance eccen-
tric—"utterly careless of dress or appearances . . . hair flying every way"—
and her temperament "nervous," with the "energy of perpetual youth," de-
spite the fact "that her hair is gray-streaked, and she is a grandmother."[53]

Emotional qualities were often stressed in describing the work of
women photographers; indeed, it was their special sensitivity to others that
was said to make them either more or less (depending upon the bias of the
writer) suited for photography and to distinguish their work from that of
men. Käsebier was proud of the fact that "I am now a mother and a grand-
mother, and I do not recall that I have ever ignored the claims of the . . .
ceaseless call for sympathy, and the greatest demand on time and patience"

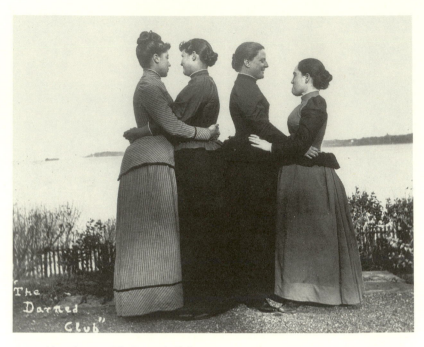

2.18 Alice Austen, *The Darned Club*, 1891.
The Staten Island Historical Society.

in order to illuminate the "temperament, soul, humanity" of the "real men and women" who were her subjects.[54] By transferring these qualities to a man, however, it was possible to show just how absurd it was to judge aesthetics according to emotional expression. In his "Emotional Art (After Reading 'The Craftsman,' April 1907)," which referred to the piece written by Giles Edgerton (Mary Fanton Roberts), Charles Caffin lampooned Käsebier by transforming her into a male photographer named Theodosius Binney. "To be an artist is to suffer through nature, and to think suffering a little price for great emotional opportunity," Edgerton had written, citing Käsebier's statement that "my development came slowly through much suffering, much disappointment and much renunciation. I have learned to know the world because of what the world has exacted of me." In Caffin's parody, Mr. Binny "burst out in a kind of prolonged sob: 'But it is out of the suffering of the body that the artist reaches up to the emotionalism of his soul. It is only, when the whole fabric of his flesh collapses into a palpitating confusion of pain, that his spirit is disengaged and rises to sublimity. That is we why we artists glory in our missions, cherish our weaknesses, and are in love with pain.'"[55]

Caffin's piece, published in 1907, was especially vitriolic on the subject of Käsebier's portrait of her friend Stanford White, the architect whose murder by Harry K. Thaw was much sensationalized in the press in that year when the trial resulted in a hung jury. Käsebier's earlier portrait for White of his young mistress (and Thaw's wife) Evelyn Nesbit is probably her most famous *tableau vivant*. Nesbit, a well-known model for a number of painters in New York and Philadelphia, was said to be the original of the Gibson Girl and of sculptor Augustus Saint-Gaudens's *Diana* (although White's friend Saint-Gaudens called her a woman with "the face of an angel and the heart of a snake").[56] Käsebier called her 1902 portrait *Miss N.* (fig. 2.19)—perhaps to suggest her subject's notoriety, like Sargent's *Madame X* (Madame Gatreau), or as an explicit reference to Nesbit's role-playing (photographer Rudolf Eickemeyer, for example, had posed her variously as nymph, goddess, pinup girl, and vamp).[57]

Käsebier portrayed Evelyn Nesbit in 1902 as the type of the *art nouveau* woman made famous by Alphonse Mucha and, in this country, by Gibson's

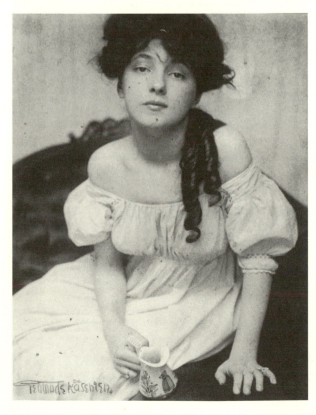

2.19 Gertrude Käsebier, *Miss N.* [Evelyn Nesbit], platinum print, 1902. George Eastman House, Rochester, New York.

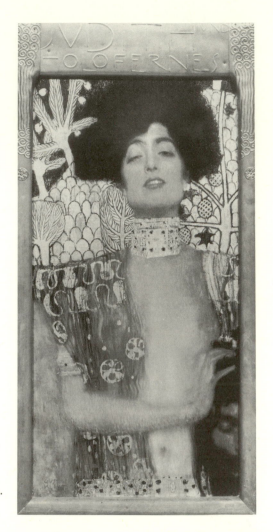

2.20 Gustav Klimt, *Judith* I,
1901. Osterreichische Galerie
Belvedere, Vienna, Austria.
Photograph, Fotostudio Otto.

drawings. Chiding Stanford White, who commissioned the work, for tak-
ing so young a "protegee," she managed in her portrait to combine the
qualities of a *femme fatale* with youthful innocence. Yet Käsebier's *Miss N.*
bears a striking resemblance to Gustav Klimt's *Judith* I (fig. 2.20). Often
confused with Salome, Klimt's *Judith* I of 1901 represents the moment of
ecstasy for the biblical heroine who, with flushed face, half-closed eyes, and
parted lips, displays the head of her enemy, severed in his lust—an image
that stunned and enthralled Viennese critics with its "blatant decadence
and terrifying invocation of the irrational."[58] Although Käsebier's *Miss N.* is
certainly erotic—the result had to please Stanford White—Käsebier, per-
haps because of a strong homoerotic arousal of her own, seems to allow

Nesbit to discover, acknowledge, and display her own sensuality in a way significantly different from both Klimt's work and from other images of the model. Eschewing both the rather trite combination of coyness and vulnerability of Eickemeyer's images and the gilded decadence of Klimt's painting, Käsebier covers what Klimt bares and flattens to expose more of the woman's rounded body, thus bringing the model, without ornament or props, forward into the viewer's space. We see here the result of a collaboration between the two women—a relationship neither exploitative nor detached, but a case of the photographer's encouraging her model to participate in the creation of her own representation as "Miss N." Beautifully sensuous in gesture, dress, and hair, Evelyn Nesbit, like Wharton's Lily Bart and like dancer Loïe Fuller, is capable of transforming herself into a work of art. She presents herself in terms of composition—of line and pose and effect; she knows that she "cost a good deal to make,"[59] and, one might say, authors her own image.

Käsebier brilliantly captures the tension between the unique and the infinitely reproducible, the woman and the model, the work of art and the photograph. Taking the model of woman that has come down to us from Dürer, she removes the artist and completely fills the space with the woman, whose direct but inwardly focused gaze suggests a withdrawal that contradicts the forward-leaning body. All of the details in the photograph are completely subservient to her form—the curving sofa upon which she sits an echo of the folds of her dress, the curl of her abundant hair, the roundedness of her body. And note that the pitcher that appears in the artist's half of the Dürer drawing is here placed in the woman's hand.

NETWORKING

I earnestly advise women of artistic tastes to train for the unworked field of modern photography. It seems to be especially adapted to them, and the few who have entered it are meeting with gratifying and profitable success. If one already draws and paints, so much the better equipment.—Gertrude Käsebier[60]

The mythic moment of modernism is often taken, by cultural historians, to be Henry Adams's epiphanic experience at the Paris Exposition of 1900, which he recounts in his *Education*. Standing in front of the Dynamo engine display and mourning the passing of the age of the Virgin, he felt that cultural representations of women were the seminal fact for compre-

hending a paradigmatic change in historical meaning from thirteen centuries of "unity" to the new force of "multiplicity." Yet unmentioned by cultural historians—and perhaps deliberately overlooked or ignored by Adams—is the collection of works at the exposition by American women photographers.[61]

This rather prominent exhibit would have been difficult to miss or later to dismiss as historically insignificant, unless one were predisposed to do so. As one of the four American delegates to the International Photographic Congress, Frances Benjamin Johnston departed for Paris with 142 photographs by twenty-eight women, an event announced in the newspapers of the nation's capital; from Paris, her exhibit went on to Moscow and St. Petersburg. In the following year, the *Ladies' Home Journal,* the magazine with the largest circulation in the country in 1901, published a series of articles by Johnston called "The Foremost Women Photographers of America," each issue devoted to the works of a single photographer or team who had exhibited in Paris. Professionals and amateurs, they were represented with portraits, genre scenes, costumed figure studies, landscapes, flowers, documentary studies—in other words, the whole spectrum of photographic practice in 1900. Their work encompassed both a meticulous attention to detail on a wide range of documentary subjects—from immigrant street life on the Lower East Side to historical events such as the World's Columbian Exposition—and a conscious attempt to create painterly effects by softening details and simplifying composition. Zaida Ben-Yusuf was a rising young professional in New York whose images were a "radical departure" from conventional photography (fig. 2.21). Amelia Van Buren from Detroit and Eva Watson-Schütze from New Jersey were students of Eakins who shared a studio in Atlantic City, where they specialized in portraits and figure studies; Watson-Schütze and Mathilde Weil from Philadelphia were members of the Philadelphia Pictorialist group. A Käsebier student, Alice Austin opened a Boston studio in 1899, which she would run for twenty years. Mary Bartlett from Chicago, who studied in Vienna, was known for her fine platinum- and gold-toned silver prints and for her pioneering use of platinum paper, which she prepared for printing. Catherine Weed Barnes (Ward), who built her own attic studio, would use her position as associate editor of *American Amateur Photographer* and then editor of the British *Practical Photographer* to promote photography as an artistically and intellectually satisfying occupation for women. Frances and Mary Allen from Deerfield, Massachusetts, and Sarah Jane Eddy from

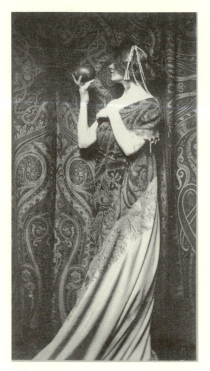 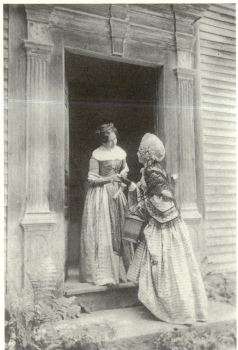

2.21 Zaida Ben-Yusuf, *The Odor of Pomegranates,* 1899. Prints and
Photographs Division, Library of Congress, no. USZ62 66959.

2.22 Frances and Mary Allen, Untitled [Two Women in Doorway], c. 1900.
Prints and Photographs Division, Library of Congress, no. USZ62 67233.

Providence produced photographic versions of "local color" (fig. 2.22).
Painter Rose Clark and Elizabeth Flint Wade, an editor for *Harper's Weekly,*
operated as a team. When she turned from studying art to amateur photog-
raphy, Emma Justine Farnsworth from Albany won awards in the United
States, Canada, England, Europe, and India.[62]

Amateur—in the sense of "for art alone"—was the term Stieglitz used to
distinguish his photographic practice from that of commercial photogra-
phers. The latter were *professionals*—those who had set up studios and were
in the photography business. Although Käsebier and Johnston called
themselves professional photographers because they had their own studios
and considered themselves artists, women like Farnsworth might well have
preferred to think of themselves as amateurs. The education, training, pay-
ment for work, and public role associated with the term *professional* meant
confidence, ability, and accomplishment in a chosen field that "contra-

dicted a 'lady's' position . . . [because] paid labor for women was denigrated in her class, advanced education was often unavailable and unacceptable, and the so-called masculine traits of commitment, drive, and assertiveness were deemed totally inappropriate."[63] Flint Wade, however, in sharing her success story with other women in *The Photo-American* series, "Amateur Photography through Women's Eyes," was careful to show that camera work was not unladylike: "What was begun as a diversion has now become a vocation, and my camera is a source of income as well as a source of pleasure and recreation," she wrote. "I believe there is no other vocation open to women in which so much pleasure and profit is combined with so little drudgery."[64]

In 1900, according to the national census, 13 percent of the 3,580 photographers in the United States were women. Many had trained as painters; in fact, both amateur and professional women photographers were more likely than their male counterparts to have studied art. They were mostly from privileged social backgrounds and usually members of local camera clubs, which gave them access to technical instruction and equipment. They exhibited as amateurs, won prizes, and had their work reproduced in photographic and household journals. They were considered and believed themselves to be engaged in a profession particularly suitable for women. Käsebier, Johnston, and others spoke and wrote to this point, stressing woman's inborn artistic feeling, natural cleanliness and patience, attention to detail, light and delicate touch, and eye for light and shade.[65]

Käsebier, Austin, Weil, Ben-Yusuf, Watson-Schütze, Van Buren, Clark and Wade began to work professionally after 1896, and all but Ben-Yusuf attended prominent art schools at home and abroad. Käsebier studied at the Pratt Institute in Brooklyn and then in France and Germany, Van Buren and Watson-Schütze at the Pennsylvania Academy of Fine Arts. They and other women turned to photography for good reason, however. Beginning their work in a hierarchical and isolated field, apprenticing themselves to male masters in painting, with the move to photography they discovered a means of expression that was less competitive and, in its connection to camera clubs, more communal. Certainly, they were less handicapped than women painters by exclusion from the system of male patronage. Their considerable success in photography had a good deal to do with the fact that their entry into the field coincided with the development of new modes of the production of cheap paper and new methods of photoengraving and printing, all of which had its effect on the popular

press—which, as it did for women writers, became a vehicle for the publication of their work.[66]

Pictorial photographers who entered the field as professionals—especially women like Johnston and Käsebier who were already prominent in commercial portraiture—tended to approach their work as painters and wanted their work judged as art. Johnston believed it her "ambition to make photographic portraits much as a painter would give a sitting"; Ben-Yusuf described her studio as "one ordinarily used by a painter"; Watson-Schütze wrote to Johnston, "I [am] . . . very emphatic about not . . . hav[ing] my work represented as 'women's work.' . . . I would not want anything said of me unless it were simply that I was a serious student of painting and am now a most serious worker in Photography."[67]

Johnston opened her portrait studio in Washington, D.C., in 1895 and quickly became, according to *Life* magazine, "the closest thing to an official court photographer the United States has ever had" with her portraits of families of the Harrison, Cleveland, McKinley, Roosevelt, and Taft administrations.[68] Beginning in 1899, she provided articles and illustrations for the Associated Press and for *Demorest's Family Magazine, Harper's Weekly, Cosmopolitan, Frank Leslie's Once A Week,* the *Illustrated American,* as well as the *Ladies' Home Journal.* Her documentary subjects ranged from Yellowstone Park to the World's Columbian Exposition (her photographs illustrated the U.S. government report on the fair), from women workers (fig. 2.23) to African American and American Indian students at the Hampton and Tuskeegee Institutes, from historical events such as the signing of the Spanish American peace protocol and the return of Admiral Dewey to early architecture of the southern states and landscapes.

Although Johnston carried out her expressed intention to make photographs that were like art—by posing well-known subjects in the manner of paintings and in the conscious framing and pattern-making of the Hampton photos—she also described herself as a reporter, a careful noter of detail, a documentor of all aspects of American life.[69] She saw Käsebier (fig. 2.24) as a kindred spirit, the great documentor of America, by which she meant her friend's ability to portray with artistic insight all works and conditions of people: "the unwearying succession of the tall and the short, the stout and the lean, who fill the hours of the professional photographer, [which] requires not only genius but a rare combination of other qualities—intuition, tact, sympathy and infinite patience." It was for these very qualities that Stieglitz, in 1898, called Käsebier "beyond dispute the leading

2.23 Frances Benjamin
Johnston, *Woman Worker, Lynn,
Massachusetts,* c. 1895. Prints and
Photographs Division, Library
of Congress, no. USZ62 26133.

2.24 Gertrude Käsebier
(attr.), *Gertrude Käsebier,
Self-Portrait,* platinum print,
c. 1912. George Eastman
House, Rochester, New
York.

portrait photographer in the country."[70] And it was for these qualities that her name and pictures would have been familiar not only to readers of *Camera Work*, the first issue of which was devoted to her work, but also to the thousands of readers of *The World's Work, McClure's, Everybody's*, the *Ladies' Home Journal*, and *The Craftsman*, which published her portraits of politicians, educators, and artists, among them Mark Twain, Jacob Riis, Booker T. Washington, and the painters of the "Ashcan School." Johnston's descriptive terms were, as I have suggested, familiar ways of describing women's work in this period. Such language was used both to claim a certain moral superiority for women—which gave them a claim to empathic pictorial representation, the very means of their success in portraiture—and to devalue their work as "soft" or "sentimental." Of course, the term *sentimental* has been used in exactly the same way to describe (and devalue) women's written narratives. As Nina Baym has shown, (male) critics, "modestly alienated from their culture," have taught us to consider the "melodrama of beset manhood" as more significant than female experience.[71]

I have focused so far on women whose work was published and exhibited in their own times and is therefore now recoverable to us in recent publications and exhibits or in libraries and archives. To approach this women's work, which has remained outside the purview of histories of photography, as a collection of *images* to be studied formally, or even to gather biographical and contextual information about their makers, does not, however, tell the whole story. Unnoticed by the U.S. census takers among the five hundred or so published women photographers in 1900 were an uncountable number of women who took up the camera to picture what they saw—families, friends, their environments. Found (like the earlier discovery of women's unpublished manuscripts, diaries, letters, and journals) in family albums, frames, envelopes and boxes, some recovered from attics and cupboards, some exhibited and published, collections of photographs offer a rich source for reformulating social history.[72] Hypothesizing that women, trained as painters but denied access to the patriarchal system of patronage that dominated the art world, subsequently turned to photography as a more accessible means of creative expression does not explain the widespread fascination the camera held for middle-class women who were not trained as artists and who were supposed to have no particular affinity for technology. To get at the meaning camera work held for women at the turn of the century—its widespread use truly amounting to

the popular culture Stieglitz most abhorred—it is therefore necessary to turn our attention from the image and its better-known makers to market-place strategies designed to appeal to women; to women workers in the field of photography who were not image makers but darkroom assistants, receptionists, and machine operators; and finally to the meaning of the act itself of picking up the camera.

A great many women were lured into photography by promotional strategies developed most aggressively by George Eastman in advertising his new handheld camera, which was equipped with roll film, simple to operate, and inexpensive. Eastman's introduction of factory processing of the finished product and his slogan—"You press the button and we do the rest"—were aimed at a vast purchasing public. Because of a major market-ing shift in which every man and woman was now a potential consumer, Eastman widened his campaign from photographic trade journals to popu-lar magazines such as *Scribner's, Century, Harpers, Popular Science, Outing, Scientific American,* and *Frank Leslie's Illustrated Weekly.* Dealers specializing in photographic equipment had been the principal channels of distribution for roll holders, films, and cameras; now, with the stocking of these items in department and drug stores, "the Kodak camera was as near as the corner

2.25 Unidentified artist, "Take Kodak with You" (Kodak ad), c. 1910. George Eastman House, Rochester, New York.

2.26 Unidentified photographer, [Women Working at Kodak], gelatin
silver print, c. 1889. George Eastman House, Rochester, New York.

store."[73] By 1888, Eastman began specifically to target middle-class women
who had money and time to devote to leisure pursuits. Women were not
only considered potential customers in the popular press, but used as ad-
vertising images to sell cameras. Soon, the Kodak girl—wholesome, active,
and curious, dressed in a striped dress that many readers adopted as a fash-
ion fad—could be seen everywhere (fig. 2.25). As *The Photographic Times*
reported in 1891, "It matters little whether the subject be religious or ro-
mantic or the spot sacred or very ordinary, the Kodak girl will be found
around, adjusting her lens to a proper focus and 'taking in' the sights."[74]

Women also came up through the ranks. Photographs from 1889 show
them at work—in dress and body language strikingly different from that of
the Kodak girl—assembling the new Kodak cameras and working as
photofinishers[75] (fig. 2.26). In "Photography as an Industrial Occupation
for Women" (1873), Jabez Hughes spoke specifically to the issue of class,
comparing women workers in photography to "three grades that are met
with in every-day life." The "maid-of-all-work" class worked behind the
scenes, preparing the paper and producing the print from negatives. "This
class of labor is the most laborious and dirty, and . . . the least remunera-
tive," he noted. "Their recommendation is, not that they do their work
better, but that they can be got cheaper than men." Most women worked in
what he called "the shopwoman class." They pasted photographs onto

cardboard and painted out "the numerous white spots and other marks that constantly occur in producing the 'print,'" as well as "attend-[ing] in the 'reception room,' and also render[ing] assistance to the lady patrons . . . prior to undergoing the dread ordeal of the camera." In the "governess class" were women of "higher intelligence and superior manners [who] . . . keep the accounts, . . . conduct the correspondence, . . . take the orders and see them properly executed." Photography, he concluded, will gain very much as a profession "by the importation into it of this higher class of female labor," so long as they "do not make the mistake of considering themselves above their business."[76]

Women employed in the lowest ranks of photography—those who worked long hours for low pay at the production end and those who worked in darkrooms with smelly, staining chemicals—were for the most part invisible, as Hughes suggests, but many who pressed the button chose not to let others "do the rest." Käsebier seems to have gone out of her way to make the process of photography visible, calling notice to herself as a photographic worker by appearing in her drawing room "enveloped in a voluminous, badly stained developing apron, . . . [her] face sometimes streaked with dust and developer."[77] Because the attributes that supposedly suited them to the work of coloring and retouching were the very qualities said to make photography an ideal profession for women image makers, class distinctions in the upper two grades of photographic workers must have been more difficult to maintain than Hughes wished, particularly in the face of massive advertising campaigns that promoted the democratic nature of photography. "The lady in attendance" must be "refined, enthusiastic and sympathetic," Miss E. F. Hannavan said in her address to the Photographers' Association of California in 1907. "Retouching is an art," Clara Weisman wrote in 1905. "A good retoucher is a student of character as well as an artist," she continued, one who has "experience in drawing, an appreciation of form or beauty, a knowledge of physiognomy and of the anatomy of the head, an understanding of the placement and action of those muscles of the face that produce the changes of expression; all are important helps."[78]

If retouchers were skillful at their work because of the patience with which, as women, they were naturally endowed, and if portraitists were successful in proportion to their tact and innate sympathy, it was not so large a step for women to move from assisting to making. Alice Austin and Alice Boughton began as darkroom assistants to Käsebier. As both Lange,

who worked as a young woman in Arnold Genthe's New York studio and as a "counter girl" in a San Francisco photo shop, and Cunningham, who worked as a retoucher in Curtis's studio, were to demonstrate, the "important helps" Weisman listed could be *acquired*. A good retoucher, who combined experience in drawing with scientific knowledge, was well equipped to enter the field as a photographer, thus emulating Flint Wade, who in 1898 encouraged women photographers to consider, in addition to the making of "artistic" images, the legal, medical, and scientific uses of photography.[79] By 1924, ranks had indeed been muddied. Pointing to the way in which women are more easily "integrated" with families as evidence for their ability to be superior portraitists, Clarence White argued at the same time for the lucrativeness of commercial photography as a field for women, especially with the growing popularity of house and garden magazines, *and* for careers in photo-finishing labs, medical offices, museums, and libraries.[80]

Describing the young woman her mother was in 1916 as she posed in a tailored suit with lace at the neck, about to depart for a holiday, her golf clubs leaning against her luggage, Martha Banta notes that Irma Purman Banta might have been modeling for a fashion magazine illustration or for one of the familiar Eastman Kodak ads for the Girl with the Brownie. But there is something about the way the woman in this photograph holds the camera in her gloved hands that moves the picture beyond conventionality. "It was not in my mother's nature to express her very strong, very private character in overtly pictorial terms or aggressively dramatic attitudes," Banta writes:

> although it is only one of the scores of occasions she faced a camera
> . . . she at last, at the age of twenty-four, picks up her own camera and
> aims it directly at the man with the camera. She is about to push the
> button, to activate the trigger of the image-making weapon she holds.
> Reciprocal energy is released through this double image of perception
> and thought, action and counteraction. It is a small statement she
> makes here, and a quiet one, but her steady gaze says clearly enough,
> "Look, I can do it, too!"[81]

Banta moves the reader from an aesthetic or historical consideration of the image—a picture of a woman holding a camera—to contemplation of the significance of the act of picking up a camera for middle-class women at the turn of the century. For this young woman, the camera represents not

work but a kind of pleasure linked to self-assertion. "Look, I can do it, too!" has all kinds of ramifications: I can look at you; I, too, can master and use a machine; I can create a space for myself in which I focus on making my own meaning of what I see. It is, of course, difficult to reconstruct the meaning of this act—picking up the camera—from the distance of nearly a century. We cannot interview a sampling of women, as Janice Radway has done in *Reading the Romance,* in order to understand the meaning for middle-class women of reading, of picking up a particular kind of book— widely available, inexpensive, with a narrative that fulfills needs about which Radway speculates from the combined perspectives of ethnography and psychoanalysis. In turning our attention to manuscripts and letters in photo archives, or to articles and interviews in the popular press by and about women photographers, we can, however, shift our focus away from statements by and about well-known image makers and their artistic inten- tions, away from descriptions of their lives and work, and thus begin to focus on the concerns of amateurs. Letters to Johnston in which women write to ask questions such as, "What sort of lens shall I buy? How should I equip my darkroom? What developer do you recommend?" offer clues as to why these writers are interested in using a camera in the first place.[82]

Some of the better-known women photographers in the early part of the century were resolutely single—Johnston, Austen, Boughton, the Allen sis- ters. Some had unfulfilling marriages: Käsebier pictured marriage as two cows yoked together and made family images that focus on women to the exclusion of men; Clover (Marion Hooper) Adams's suicide suggests an unhappy marriage; Ulmann's and Cunningham's marriages ended in di- vorce. These women (with the exception of Adams) pursued their camera work as a career.[83] For some who saw themselves as "other"—Gilpin as les- bian, Cunningham as "ugly as a mud fence," Lange as crippled—the ability to picture others must have been a means to power. But most of the women who picked up the camera at the turn of the century were middle- class wives and mothers: we know this because their pictured subjects are their families. These would be women whose full-time occupation was re- sponsibility for the care and nurturance of others.

As Radway speculates about the purpose of reading the romance, for a family-centered woman, picking up the camera also served as a means of temporary escape—from a situation that left her no time for herself or for a fantasy world. Mrs. Charles McCutchen of Plainfield, New Jersey, began

with a camera lent her by her brother-in-law. When he gave it up for billiards and whist, she wrote, "I, no longer fettered by masculine interference, had some tolerable luck." Some fourteen years later, she advised beginners not to "waste all your time on 'press the button' photography, and let some one else 'do the rest,' but get a good camera and easy, safe plates and as you have time and opportunity, study it out for yourself." Recounting both her great satisfaction in experimenting with plate and developer and the frustrations of being interrupted at her printing, she justified her pleasure by describing it as "worth while" *work* that allows a mother to see and to preserve "a thousand interesting moments of childhood" as "little every-day pictures." "I call my photography my fancy work, and have never regretted that it took that form rather than crocheted mats and embroidered pillows," she wrote. "They would have been worn out and faded long ago, whereas I have now in my series of negatives a sort of family history running through the years (a seventeen-year-old daughter now, whose first negative dates back to four) from which I can print at any time."[84]

Camera work, in other words, was an acceptable escape because it was *useful* work. Moreover, its cost was minimal in terms of the family's resources and a woman's time away from her responsibilities. For ten dollars, according to Margaret Bisland, one could be completely outfitted with camera, lens, films, and tripod, the latter folding into a case no larger than that of an umbrella, and the "camera, with its plate holder, achromatic lens and book of data and formulas, slips into a box the weight of which is inconsiderable." Its recommendations to the beginner are numberless, Bisland wrote in *Outing* magazine in 1890:

> Photography makes a strong appeal to woman for the reason that she may study and practice it in her own home, in the very corner of her room; yet it does not interfere with daily duties and pleasures by demanding of its disciples long, tedious courses of study and hours of unremitting practice to gain mere facility in the use of the camera's parts. Photography appeals directly to a woman's intelligence, demands constant exercise of her powers of judgment, giving her in return rapid and beautiful reward. . . . More than all, it is an art within the reach of women of modest means; no expenses are entailed beyond the purchase of a good outfit, always to be had for a moderate sum, . . . [with which] pictures can be taken of which one can feel reasonably proud.[85]

To retreat behind the camera lens, especially under cover of the dark cloth, and to the darkroom was literally to make space for oneself. As Mabel Osgood Wright wrote to Johnston, her darkroom was a place where "I can absolutely control the space." Osgood was one of a number of amateurs from all over the country who communicated with Johnston following the publication of the "Foremost Women Photographers" series. Johnston probably contacted women suggested by Stieglitz and by the editor of *Photographic Times* in order to create the exhibit of women's work she would take to Paris. Early in 1900 she wrote to participants; and although her letters do not survive, we can deduce from the responses she received and preserved that she asked them to describe how and why they took up the camera. Some positioned themselves within or in opposition to artistic instruction and conventions of the times: Alice Austin wrote of her studies at Pratt, mentioned Arthur Wesley Dow, and noted the influence of Käsebier, in whose studio she worked; Zaida Ben-Yusuf, however, called her own work "daring and original." Amelia Van Buren also described painting as the road to photography, but her comparison of her work to Sargent's is unusual: in their correspondence with Johnston, most women presented themselves as timid, self-deprecating. Some described opening studios after their husbands died. Most wrote that they preferred either flower or figure studies. Calling herself a realist and what she produced not pictures but records, Mary T. Schäffer described her preference for botanical studies rather than mountains, which are too massive; but a Miss Elton mentioned her devotion to "physical culture," which suggests that she might have seen the camera as a way of being out of doors, away from home. Alta Belle Sniff made a point of having studied chemistry. From London, Catherine Weed Ward wrote that, occupied with illustrating her husband's books on Dickens and Shakespeare, she had little time for own work; her letter includes talk of exchanging cuttings and seeds. And Eva Watson (Schütze) wrote that she did not want her work represented as "women's work."[86]

For Eliza W. Withington, the camera was literally her means of finding voice. In "How a Woman Makes Landscape Photographs" (1876), she described traveling "as I could, by stage, private conveyance, or fruit wagons" with her photographic equipment: "With this kit I travelled some hundreds of miles last summer, seeking health and negatives of our mountain scenery, mines, quartz mills, etc. For four months before starting I had

scarcely spoken above a whisper; after eight weeks, I returned home, speaking as well as ever. See what we can do if we try!"[87]

Whereas Charlotte Adams attributed to instruction in drawing the ability to compose on the spot with her camera and argued for compulsory education in art as a means of "self-development," Catherine Weed Barnes (Ward) argued for scientific training as well. Joining the staff of the *American Amateur Photographer* in 1890, with her series called "Women's Work" she became perhaps the first woman photography columnist and was soon associate editor of the journal. Having trained herself "simply as a worker," she wrote,

> my absorbing interest . . . [combines] the exactness of scientific truth with the keen pleasure of artistic effort. I have found that eye and mind have gained . . . new power of observation . . . [and] a broader delight and appreciation of the world. . . . While previous work in art schools and painters' studios has not been wasted, it has yielded place to the mysteries of the dark room and the subject is viewed through the sharp eye of a long or short focus lens, . . . for side by side with a love of art was a latent love of science.

Barnes went on to say that although she preferred interiors to landscapes or cityscapes, particularly because "training gained in various reading and dramatic clubs has . . . aided me in posing a sitter as well as preparing to take an interior," and although interiors were especially suitable for "ladies who possess the requisite taste and patience," gender distinctions had more to do with exhibition practice than with images themselves. "Good work is good work whether it be by man or woman," she insisted, and it should be admitted to exhibitions on equal terms, "allow[ing] the question of sex to be laid aside."[88]

On the other hand, citing a woman who protested women's exhibits, who like Barnes, wanted her work hung side by side with men's, and who had written that "There is no sex in art," Mary Carnell, president of the Women's Federation, argued that "there *is* sex in business, and that the really and permanently successful business women are comparatively few and far between." The reason for this, she said, was "a lack of solidarity" among women. Freed from the frying pan, the needle, and the blackboard, "we are women of a different day; we have much to learn, and we must learn it together; . . . we must get together, compare notes, and talk things over,

adding to the general store of knowledge each her bit of personal experience or discovery, whether in the darkroom, the office, or under the light."[89]

Nancy Chodorow has pointed to the importance of social networks for women in preindustrial societies, networks that provided a means of supporting and reconstituting one another. Often based in local churches or operating as informal neighborhood societies, they offered individual women "the opportunity to abandon temporarily their stance as the family's self-sufficient emotional provider" and instead to receive "the attention, sympathy, and encouragement of other women."[90] At the turn of the century, in addition to a wide variety of how-to articles in the popular press, lectures by photographers, and the willingness of professionals such as Johnston and Käsebier to mentor junior colleagues, aspiring women photographers had two institutionalized forms of communal assistance: the camera club and the photography school.

Helen L. Davie's description of the sunny, capacious, and convenient spaces of the Los Angeles Camera Club, published in *Camera Craft* in 1900, includes a drawing that shows work rooms, assembly and reading rooms, a portrait gallery, and bicycle racks, the nearly three hundred "club members being enthusiastic devotees of the wheel as well as the camera."[91] Clearly, its spaces encouraging the pleasures of both self-absorbed work and communal activity, such a place in itself must have been an attraction for middle-class women. Although it was possible to make pictures in isolation—one's studio occupying "but a corner of a family drawing room or one's own private apartment, while for a dark room an empty unused closet often answers"—Margaret Bisland also pointed to the importance of camera clubs, "three or four in each of our large cities, with a prosperous one in every small town," not only for the lantern slide equipment, desks, easy chairs, perfect quiet and reading materials, as well as operating rooms, lockers, enlargers, printing rooms, and laboratories they provided, but for the support and assistance they offered.[92]

There were almost as many women as men members of camera clubs in most major cities, which ranged from the large and lavishly appointed spaces Bisland describes to the single room rented for meetings, but the exact nature of middle-class women's participation in these clubs was somewhat problematic. Jane Gover sees them as an outgrowth of the unstructured, voluntary, mutually supportive associations that had their roots in the earlier quilting bees (a social activity in which women as a group put

together pieces sewn by individual women for domestic use) and associations (originally formed for literary and intellectual activities, but which in the later nineteenth century shifted toward social reform). Beginning with the New York State Photographic Association in 1851, by the mid-1850s camera clubs had formed throughout the country with the purpose of providing "fraternity . . . 'a chemical apparatus, and an embryo library.'" In the 1860s "exchange clubs" allowed amateurs in the United States to communicate with one another by mail. In addition to swapping views, club members sent photographs of themselves at home or in the studio, thus providing intimate glimpses of one another's lives. Camera clubs expanded steadily into the 1880s, flourishing in several major cities, publishing their own journals, and because their members shared experiences and experiments, they were often credited for advances in the field. Photographers in small towns and rural areas in the 1880s often joined postal clubs, which featured the creation of albums by an organizer who mounted submitted prints and sent them around to members for viewing and criticism. *Cosmopolitan* magazine reported in 1893 that well-known amateurs Sarah Jane Eddy of Providence, Emilie Clarkson of Potsdam, New York, and Cornelia Needles of Philadelphia participated in this form of club organization.[93]

By far the grandest of these associations was Stieglitz's Camera Club of New York. "I had a mad idea that the club could become the world center of photography and eventually create a museum," he said.[94] His plan was to a large extent realized with the influence the club and its journal *Camera Notes* came to exert on the world of photography. Women (most prominently Käsebier, but also Johnston, Ben-Yusuf, Clarkson, Farnsworth, and others) participated as exhibitors and lecturers, were listed as fellows and associate members, but not as officers.[95]

Camera clubs in general accepted women as members, but their attitudes toward women varied. Mary Kennedy McCabe suggests that even as the number of women Pictorialists expanded, even up to and following the suffrage movement, "female pictorialists found little of the support and encouragement available to their male counterparts through local camera clubs," despite numerous articles expounding and pleading the possibilities for women in photography. That they were often given separate, smaller spaces in which to work and meet, and that their prints were often exhibited in special "ladies'" sections suggests women's subordinate membership in most clubs. In fact, according to Pictorialist Ira Martin, a woman photographer "usually works out her salvation by herself," therefore learn-

ing "what she likes" rather than timidly offering "her first pictures for criticism to the 'fathers' of the club, who are usually set in their ways and have no sympathy for anything that is not the accepted type."[96]

The "fathers" were, of course, men like Stieglitz and Steichen, who according to Laura Gilpin, were "not the least bit interested in women photographers."[97] Certainly, Johnston and Käsebier were extraordinarily generous to aspiring women photographers, encouraging them through exhibition, publication, instruction, and example. During the winter of 1909–1910, Käsebier taught free classes in composition to women photographers in connection with the Women's Federation of the Photographers' Association of America, which she had been instrumental in forming. Stieglitz did encourage *some* women: he devoted the first issue of *Camera Work* to Käsebier, exhibited and published the work of women less well known, corresponded at length with Anne Brigman, and had a warm friendship with Consuelo Kanaga. He even wrote to Johnston, although somewhat sanctimoniously, as she worked on her exhibit of women's photography for the Paris Exposition: "The women of this country are certainly doing great photographic work and deserve much commendation for their efforts." But he shared Sadakichi Hartmann's sense of "the line which divides artistic and professional photography, as it does art and potboiling." "Only men like Messrs. Stieglitz, Day, and Keiley," Hartmann concluded in his review of Käsebier and Ben-Yusuf's work, "are artistic photographers." This would be the basis of the later split between Stieglitz and White—whom Stieglitz criticized for allowing himself "to be deified by his stupid pupils, mostly women"—because White, in establishing his school of photography (fig. 2.27) would bridge those things that Stieglitz wished to keep separate.[98]

If Stieglitz assumed a "patriarchal stance with his artists, controlling the patronage of their works," White, Bonnie Yochelson suggests, became a kind of "good father" to his students. "[A]n artistic 'bolshevik' and immense ego who sought leadership of a revolutionary vanguard, first in photography with the Photo-Secession, then in painting with Steichen's guidance, and later still in [straight] photography with Strand," Stieglitz "would never deign to teach photographic art, which for him was irreducible and spiritual." White, on the other hand, was "an artistic 'democrat,'" an endless source of support and encouragement, whose approach was "self-effacing, flexible, permissive, and practical."[99]

Originally an Ohio bookkeeper and self-taught amateur who took up

2.27 Ruth M. Anderson, *Spring Session, Canaan, Connecticut,* platinum print with pencil manipulation, c. 1916–17. The Art Museum, Princeton University, collection assembled by Professor Clarence H. White Jr. and given in memory of Mr. Lewis F. White, Dr. Maynard P. White Sr., and Professor Clarence H. White Jr., the sons of Clarence H. White Sr. and Jane Felix White.

photography as a substitute for painting, White, who had first caught Stieglitz's eye when he exhibited in the Philadelphia Salon of 1898, moved to New York in 1906. The following year he was hired by Arthur Wesley Dow, chair of the art department of Columbia University's Teacher's College, as that institution's first photography instructor. In his book *Composition* (1899, condensed in the April 1913 version of *PhotoEra*), Dow had not only outlined a theory of aesthetics based on "harmony of line, tone, and expressive unity," easily transferable to photography but also formidably argued for merging "fine arts" and utilitarian objects — a philosophy of art that would bring White into increasing conflict with Stieglitz and would become a founding principle of the White School. Dow's notion of harmonious "space filling" gave a name to something that White, who paid great attention to light and background spaces as integral parts of his composition, already understood; it was also the basis of White's theory of photography, which emphasized good design, encompassed photographic work

of all sorts, and was a subject that could be taught.[100] Käsebier, Alvin Langdon Coburn, and Max Weber all learned from Dow at the Pratt Institute to make a picture the way a photographer composes with a camera. Students would be asked, Weber later recalled, "to copy . . . [an unbounded] drawing freely and enclose it in a rectangle, to make a horizontal picture or a vertical, as they chose, and to make whatever changes necessary to fit the drawing to the frame, which they had selected." Both Dow and Weber, who lectured on art history and design, would join the faculty of the White School along with Paul Anderson, who taught the technical and scientific aspects of photography, and Karl Struss, who would become a cinematographer.[101]

There were several reasons why the White School, which opened in Maine in 1910 and in New York in 1914, enrolled a large number of women —among them Bourke-White, Gilpin, Lange, Clara Sipprell. At Columbia's Teacher's College, White's constituency had been largely female. He formed a close association with Käsebier, who although not on the faculty, lectured occasionally and with White co-founded the journal *Platinum Print: A Journal of Personal Expression* in 1913 (later published under the name *Photo=Graphic Art*) and in 1915 the Pictorialists Association of America. There was also a perception of the school as "a haven for ardent female pictorialists from the unsympathetic male-dominated camera clubs throughout the country" and a sense of White himself as a sympathetic figure.[102] Like so many women photographers, White concentrated in his early work on genre subjects, using members of his own family as models. That he was often compared in his day to "local colorist" writers such as Mary E. Wilkins Freeman suggests that he must have conveyed a sense of the everyday, familiar world that would have appealed to the largely female reading public of magazines in which regional writers published their stories. Peter Bunnell points out that popular illustrations in such magazines as *Brush and Pencil, Everybody's, Godey's,* the *Metropolitan Magazine,* the *Monthly Illustrator, Munsey's,* and *Scribner's* provided sources for White's compositions of incidental life and that White himself was commissioned in 1901 to illustrate a new edition of Irving Bacheller's *Eben Holden* and in 1903 to illustrate Clara Morris's "Beneath the Wrinkle" for *McClure's* magazine.[103]

As an outsider who became a professional photographer out of economic necessity, and as one who adhered to Pictorialism in the face of new standards of the "straight aesthetic" promoted by Stieglitz and Strand,

White has been considered hopelessly old-fashioned in standard histories of photography. But as Yochelson persuasively argues, White's modest midwestern origins included a populist socialism, fostered by his friendship with Eugene Debs; moreover, with teaching experience in technical, not liberal arts schools, he was especially open to the idea of raising the artistic awareness of the "common man." White was active in the American Institute of Graphic Arts and the Art Alliance, which aimed at uniting art and industry, and like Dow, who gave him his first full-time teaching job, he addressed amateurs and professionals—potential artists, art teachers, patrons. *Platinum Print/Photo = Graphic Art,* like *Camera Work,* published essays on modern art, especially by Weber; but unlike Stieglitz's journal, White's included articles on photographic technique. Moreover, White's New York group established close ties with the Los Angeles Pictorialists— the precursor of the Group f.64—which resulted in Cunningham's exhibiting with the East Coast Pictorialists in Buffalo in 1914, the publication of works by Weston in *Platinum Print* in that year, and in 1917, the joining of the California and New York groups to form the Pictorialist Photographers of America.

White School of Photography students such as Paul Outerbridge, Anton Bruehl, and Ralph Steiner would develop a cubist-derived art deco style associated with modernism and commercial art; some would go on to careers in motion pictures or, like Lange and Bourke-White, in documentary photography and photojournalism. In fact, the "straight" view of modern photography "posits a standard lineage of masters analogous to the outdated, formalist version of modern painting which proceeds from Manet to abstract expressionism," Yochelson contends, "a view totally ill-equipped to explain the so-called chaos of current art photography." The contrast between White's practical aims and the high-art goals of Stieglitz and Strand suggests a Romantic/Symbolist component in "straight" photography. Documentary photographers, on the other hand, would follow White in rejecting the isolation of the artist from society (by submitting their work to the requirements of the FSA and to national magazines) and the isolation of the photograph as a unique work of art (by accepting the premise that their works would be reproduced and printed with text)— White, not Stieglitz, blazing the trail.[104]

I want a real raw Indian for a change. . . . The kind I used to see
when I was a child.—Gertrude Käsebier[105]

Women who studied at the White School spoke of that experience as nurturing and encouraging: Lange remembered White's "uncanny gift of touching people's lives,"[106] and Gilpin's friendship with White and also with Käsebier continued long after her years of study at the school. Returning to her native Southwest, Gilpin would draw on Käsebier's American Indian portraits, and her western landscapes would in turn remind the older photographer of her own frontier childhood, strengthening the link that had formed between the two women in New York. Cunningham would also trace her photographic origins back to Käsebier and would produce, as her initial attempts with the camera, Symbolist *tableaux* with a strong resemblance to Pictorialist scenes staged by White.

Although the West figures into this equation (three of the four women who are the focus of this study came from the West; Lange, born in Hoboken, New Jersey, would move west; Käsebier, raised in the Colorado Territory, would move east), I am less interested here in the opening up of eastern Pictorialism to the representation of wider national concerns than in the early interconnection of Pictorialism with what is usually taken to be the province of documentary photography: representing alterity. Like the topographical map with its partially obscured word—*obsid*—that forms the background of the first illustration for this chapter (fig. 2.1), the dark places of the world are inscribed within the very conventions of Pictorialism.

Two distinct modes of representation are associated with this practice. One is Stieglitz's cool perception of otherness as "shapes in relation." The often-recounted story about his famous photograph, "How *The Steerage* Happened," is framed by his sense of his own alienation and by his artistic aspirations. Trapped in the first-class section of an ocean liner, he felt himself to be separated from what he perceived as a scene of greater intensity and color beneath him. His photographic genius, however, enabled him to transform the very isolation of his private vision into meaningful experience that would ensure a public response (fig. 2.28). Looking down, he saw, and recorded, a series of shapes: "a round straw hat, the funnel leaning left, the stairway leaning right, the white drawbridge with its railings made of circular chains—white suspenders crossing on the back of a man in the steerage below, round shapes of iron machinery, a mast cutting into the sky,

2.28 Alfred Stieglitz, *The Steerage*, 1907, *Camera Work* 36 (1911). ©The Metropolitan Museum of Art, New York, Alfred Stieglitz Collection, 1933, no. 33.43.420-469.

making a triangular shape." This accidental arrangement of shapes becomes *equivalent* to his own perceptions: "I saw shapes related to each other," he would recall. "I saw a picture of shapes and underlying that the feeling I had about life." That feeling, emanating from "people, the common people," released Stieglitz personally from the oppression of his estrangement and at the same time generated the kind of "vision" Rembrandt must have had ("Would he have felt as I was feeling?" Stieglitz wondered). It was an epiphanic moment that "opened up a new era of photography, of seeing": here was "a picture based on related shapes and on the deepest human feeling, a step in my own evolution."[107]

Far from being an isolated moment, however, "trying on" the shape of "the common people" as a means of experiencing his own exotic alter ego, coupled with the distancing of aesthetic response to the picturesque shapes presented to his imagination, pervades Stieglitz's descriptions of his New York City photographs. "Nothing charms me so much as walking among the lower classes, studying them carefully and making mental notes," he said on another occasion. "They are interesting from every point of view. I dislike the superficial and artificial, and I find less of it among the lower classes. That is the reason they are sympathetic to me as subjects." Every-

thing was for Stieglitz a symbolic event, Trachtenberg suggests of these early New York pictures, an expression of personal crisis—"a way of discovering himself, his camera, and his subject in the act of looking upon an alien but restorative reality":

> Wherever I looked there was a picture that moved me—the derelicts, the secondhand clothing shops, the rag pickers, the tattered and the torn. All found a warm spot in my heart. I felt that the people nearby, in spite of their poverty, were better off than I was. Why? *Not because of a sentimental notion.* There was a reality about them lacking in the artificial world in which I found myself and that went against my grain. Yet it was my business experience that drove me into New York's streets and so into *finding myself in relationship to America.* . . . Above all there was the burning idea of photography, of pushing its possibilities even further.[108]

Although he does not invoke Emerson's theory of correspondence here, Stieglitz yokes oppositional terms in these two passages—the "real" world of others as against his own, artificial world; the expression of this "real" world as shapes in relationship; autobiographical act as national self-expression—in order to effect a technological transcendence of artifice. That is to say, the autobiographical/national act of recording otherness, with the cool eye of the camera, as a geometry of bodies is based upon the gazer's assumed power—his class, race, and gender superiority, his intelligent discrimination, his artistry. The result is an American masterpiece. Opposite to this mode of representing is not, as Stieglitz suggests, "sentimental notion," but the language of sentiment—or what we might call the "romantic racialism" of women's culture.[109]

Käsebier was also interested in "primitive qualities," but her net was wider: she found such traits not only in American Indians, but also in the sculptor Rodin and in her grandmother, both of whom she considered "simple people." For her, the point was not separation, but recovering and expressing a deep connection to her own past. "My people were all simple frontier people," she said. "My grandmother was of the splendid, strong, pioneer type of woman. She was an artist with her loom. She made her own designs, and weaved [*sic*] the most beautiful fancies into her fabrics. She knew life from living, and was great through her knowledge. She was a model to me in many ways, and the beginning of what I have accomplished in art came to me through her." Käsebier's camera work was also a means of

self-expression: "It is not just that I am anxious to make these photographs for the sake of people . . . [but] I am thirsty to do it for my own sake, to express what there is in me. I want to re-live life in this way. I want to see what life is doing to other people."[110] A claim to sympathetic interaction is different in both intention and result from an acknowledged cultural difference rendered as abstract pattern. But in looking for "real, raw Indians" to photograph, stripping the other down to his essence and slipping into his skin in her mind's eye—that is, "trying on" otherness as a way of reliving her own past—Käsebier's attempt to bridge difference, however empathic in intent, was perhaps *more* invasive than representing the other as "shapes in relation." "Beautiful fancies" could impinge upon her subjects' self-perception or sense of privacy.

Anathema to her own conception was the "glittering toggery" in which Buffalo Bill costumed his show Indians or the full and often outmoded regalia in which Edward Curtis was wont to dress representatives of various tribes in order to preserve the iconography of a vanishing race. Stripping Chief Iron Tail of "distracting accessories," she would represent him, in a photograph published in *Everybody's*, neither as noble savage—"typical of the wild Indians" (referring, perhaps, to his role in the Battle of Little Bighorn in 1876), "still part of the wild life, unregenerate, tall and straight like pine trees"—nor as the vanished chieftain whose profile would be used on the Buffalo nickel coined from 1913–1938, but as a man defeated, exposed, and vulnerable (fig. 2.29). An observer of the photographic session recalled:

> Quite at random she selected Iron Tail, and proceeded to divest him of his finery. Feathers and trinkets were removed, and amid a dead silence she placed him before the camera and secured the most remarkable portrait of the whole collection. He never said a word, but obeyed instructions like an automaton. In the wonderful face . . . it is perhaps not fanciful to read something of the misery which he was really undergoing. For the truth was that every feather represented some act of bravery either on his part or that of his ancestors. . . . When the portrait was handed to him some days later, he tore it in two and flung it from him. Luckily, however, an explanation and a second sitting in full regalia entirely restored his peace of mind.[111]

Käsebier's famous *The Red Man* (fig. 2.30) was published in *Camera Work* in 1903. This photograph, in which her subject is unidentified by

2.29 Gertrude Käsebier, *Iron Tail*, 1898. Division of Photographic History, National Museum of American History, Smithsonian Institution, no. 85-7212.

name, is the result of an altogether different sort of interaction. It was, she said, "the last of a hundred" attempts: "I never could get what I wanted. Finally, one of them, petulant, raised his blanket about his shoulders and stood before the camera. I snapped and had it."[112] These two stories share a reported "petulance" on the part of Käsebier's subjects that may in part have been due to the belief of native peoples that photographers who took their likenesses were stealing their spirits. Inasmuch as these men and women were paid to perform and made their way willingly to Käsebier's studio, however, it is more likely that what they resented, especially given the fact that so many of them turn their faces away from the camera, was the undressing—being stripped of their chosen mode of presentation. Thus, as the Red Man *covered himself* with his cloak, it was his "petulance"—

his resistant spirit—that Käsebier caught.

Or did she? We have only her side of the story; we know only that she got "it"—a perfect image that corresponded to something in her imagination, a work of art that was the reward of great patience. We do know that Käsebier photographed most of her subjects a number of times: in portraits, she was after a "true" representation of character; in the *tableaux vivants,* the creation of a fictional likeness. We find both modes of representation in her images of American Indians, in one case in multiple portraits of a young Indian woman whose double identity must have fascinated Käsebier. Not part of Buffalo Bill's Wild West Show, Zitkala-Ša (Red Bird), also known as Gertrude E. Simmons (Bonnin), was a Sioux woman who became assimilated into East Coast cultural circles, including an intimacy with the Käsebier family. She was the friend and correspondent of young Frederick Käsebier, about her own age; of F. Holland Day, who encouraged her to write and publish her memoirs; and of Joseph Keiley, who photographed her in Indian dress as *An American* and in Chinese dress as

2.30 Gertrude Käsebier, *The Red Man,* c. 1900. Prints and Photographs Division, Library of Congress, no. USZ62 67897.

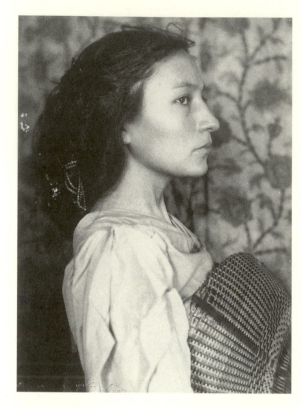

2.31 Gertrude Käsebier, *Zitkala-Ša,* 1898. Division of Photographic History, National Museum of American History, Smithsonian Institution, no. 89-13432.

Asia. In 1898, Käsebier made some nine portraits of Zitkala-Ša both in traditional Sioux dress (the same as in the Keiley picture) and in the pale flowing gown of a middle-class white woman of the time.[113]

Daughter of a full-blooded Sioux mother and a white father, raised as a Sioux until her eighth year, Zitkala-Ša claimed kinship to Sitting Bull; later, as teacher, writer, lecturer, and political activist, she devoted her life to American Indian rights. At the time of her portrait sittings with Käsebier she had earned a diploma from a Quaker missionary school in Wabash, Indiana, returning to the reservation "neither a wild Indian or a tame one";[114] completed two years at Earlham College in Richmond, Indiana, where she won prizes in oratory; and was about to begin two years of teaching at the Carlisle (Pennsylvania) Indian School. She went on to study violin at the Boston Conservatory of Music and would become known for her concert performances and recitations of Longfellow's "Hiawatha," which she gave to raise money for the Carlisle Indian Band's projected visit to the Paris Exposition of 1900. In the seven "white" portraits, Käsebier

portrayed the young woman as "neither wild nor tame": herself a decorative object against patterned wallpaper, she is unnaturally stiff in an Empire dress that lifts her breasts uncomfortably and inhibits all movement, except for her hands, which steady a book or violin on her lap, and for her slightly pivoted head, half in shadow. We are meant to understand from her profile, set between artificial flowers and the Sioux basket she clutches to her chest, the conflict of the young woman's double heritage (fig. 2.31).

Zitkala-Ša was one of several American Indians with whom Käsebier encouraged a familiar relationship: some who posed repeatedly for the photographer became personal favorites and were encouraged between 1898 and 1912 to visit her studio and home, their presence causing some stir in the press and among her neighbors.[115] Frequent interaction between certain of her Indian subjects, especially Sammy Lone Bear, with whom she had an extended correspondence, and members of her family made for an intimacy totally unlike the more distant and fleeting relationships between most other photographers and their American Indian subjects. Käsebier published some of her images in *Everybody's, Camera Notes, Camera Work,* and *Photographic Times.* Unlike her contemporaries Frank S. Rinehart in Omaha, Karl Moon in Grand Canyon, Arizona, Curtis in Seattle, and other photographers with studios in frontier towns who specialized in stereographs or *cartes-de-visite,* however, she was not particularly concerned with the commercial distribution of her pictures. Nor was she interested, like so many "anthropological" photographers, in documenting the lives of various American Indian tribes.[116] She seems to have made these images for her own pleasure. As her later letters to Laura Gilpin make clear, the picturing had to do with nostalgia for the West of her childhood, a playing with "as if": this displaced other as mirror image of her lost self. These conflicting attempts to bridge and to impose distance in her representations of alterity (uncovering the "real, raw Indian," capturing the perfect type) converge in a kind of "romantic racialism" also present, as we shall see, in Gilpin's early images of Pueblos and Navajos.

III | "Always the Navajo Took the Picture"

Viewed from a certain distance, the great, simple outlines which define the storyteller stand out in him, or rather, they become visible in him, just as in a rock a human head or an animal's body may appear to an observer at the proper distance and angle of vision. . . . [P]eople imagine the storyteller as someone who has come from afar. But they enjoy no less listening to the man who has stayed at home, . . . and who knows the local tales and traditions. If one wants to picture these two groups through their archaic representatives, one is embodied in the resident tiller of the soil and the other in the trading seaman. . . . If peasants and seamen were past masters of storytelling, the arti-san class was its university. In it was combined the lore of faraway places . . . with the lore of the past, as it best reveals itself to the natives of a place.—Walter Benjamin, "The Storyteller"[1]

"THE DISCOVERY SELF MAKES OF THE OTHER"

Comradeship in a common interest is very rare.
—Gertrude Käsebier to Laura Gilpin[2]

I'm definitely a westerner and I just have to be in the mountain country.
It's where I belong.—Laura Gilpin[3]

For a book called *My Best Photograph and Why*, Laura Gilpin chose, in 1937, to submit a print she had made in 1932 (fig. 3.1) when she accompanied her friend Elizabeth Forster, field nurse to the Navajo at Red Rock, Arizona, on one of her daily visits to a young girl whose hands had been badly burned. In the dim light of the hogan—a blanket hung in the doorway, the only available light within from the smoke hole in the center of the roof— Gilpin found "the lovely mother seated at her loom. . . . The beautiful over-head light accented the Oriental quality of this woman as she sat patiently while Betsy attended to the child's hands and I attempted to capture the

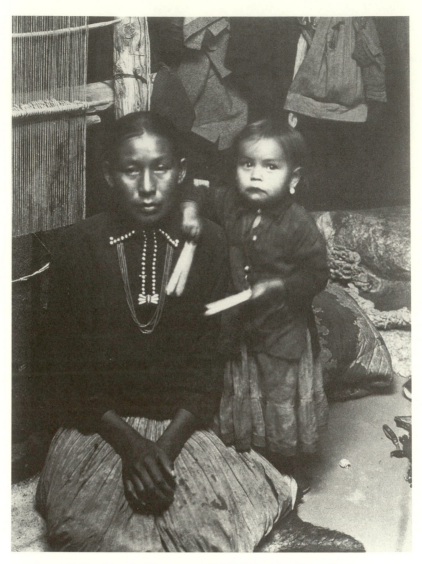

3.1 Laura Gilpin, *Navaho Woman and Child in Hogan,*
gelatin silver print, 1932. ©1979 by the Amon Carter Museum,
Fort Worth, Texas, Laura Gilpin Collection, no. 4219.1.

picture I saw." The pictorial quality of this vision is suggested, even before
Gilpin's last words, by her earlier use of the terms "light" and "Oriental."
Subject aside, this image is like any number of Käsebier's pictures of moth-
ers and children in darkened interiors, such as *The War Widow* or her
Whistlerian *Mother and Child.*[4] Although this image does not, except by

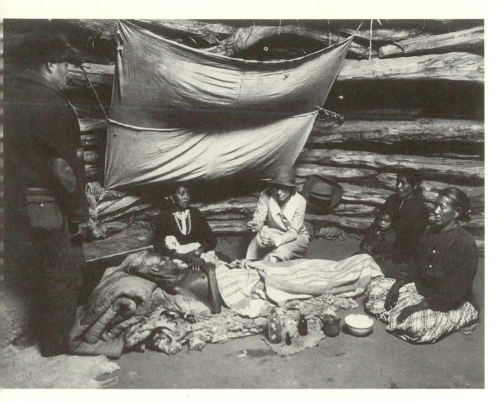

3.2 Laura Gilpin, *Hardbelly's Hogan,* gelatin silver print, 1932.
©1981 by the Amon Carter Museum, Fort Worth,
Laura Gilpin Collection, no. 79.95/100.

implication, document the occasion of its making—the slightly out-of-
focus child's hands, holding feathers, are not readable as injured—Gilpin
made another image at the same time that more specifically refers to
Forster's work, as well as to the material conditions of Navajo life inside the
hogan, from bottles, bowls, clothing, and bedding to the lamb brought
inside and held in one woman's arms (fig. 3.2). Forster is at the center of
this image: she kneels to treat an old man named Hardbelly, who lies on his
pallet surrounded by his family. Together, the group forms a half-circle
against the circular wall of the hogan, the further reaches of which include
the photographer—the nurse's trusted friend—and the viewer. But in
Gilpin's chosen image—the highly charged portrait of the Navajo woman
and child—the focus is on the melancholy Navajo woman, and on the way
light accents the facial planes of mother and child. Gilpin must have liked
the way in which these faces—as well as the shapes of loom, bedding on the

floor, tools, and clothing hanging from pegs—emerge from the gloom to make beautiful patterns, and the way in which these abstract patterns that shape and give structure to the composition are in tension with the viewer's emotional response to the woman's haunting face. In her own words, however—"I consider this one of my best photographs because I believe it portrays truly the individual character and the patient resignation of a member of this vanishing race"[5]—her pleasure in the success of this composition (and the viewer's visual pleasure) belies a not yet acknowledged struggle be-tween an inherited mode of representing Indianness and a way to record a personal encounter with a particular woman.

Navaho Woman and Child in Hogan suggests the tension Gilpin would confront between her western inheritance and her eastern training—between the traditions of William Henry Jackson and Edward Sheriff Curtis, on the one hand, and those of Gertrude Käsebier and the White School, on the other. The same kind of tension is evident in the young Willa Cather, who composed her elegantly structured first novel, *Alexander's Bridge,* in the manner of Henry James and Edith Wharton while at the same time leaving traces of an imaginative return to the western landscape of her childhood, the reclaiming of which, in her "novel of the soil," would enable her to find her own voice. In a parallel way, in order to find her own means of expression Gilpin would need to negotiate both the current conventions of representing the "vanishing race"—which dominated painting and photography, anthropology and history writing, popular literature and travel lore of the period—and the conventions of Pictorialism in which she had been trained. Her early work consistently reveals this conflict: the interior of *Grace Church, Colorado Springs* (1928) refers both to her *Chartres Cathedral,* which she photographed in 1922 while traveling in Europe with sculptor Brenda Putnam, and, in its sheltering space, to her own landscape pictured in *Corley Road Tunnel* (1925). Her *The Little Medicine Man* (1932) pays tribute both to Käsebier's *Red Man* (1902) and to Curtis's shrouded Zuñi. Gilpin's portrait of a medicine man, wrapped in a tribal blanket, is more straightforward in its crisp rendering of the blanket's texture and in the directness of the man's gaze, which suggests her own presence hovering around the margins of the photograph, although all three portraits of American Indians represent alterity in terms of exoticism and mystery.

Gilpin's struggle, again like Cather's, was also personal, having to do with the divergent ways in which her parents settled into the West. Her father "could not find his seam of gold"; her mother "could not re-create

the world of gay parties and sophisticated conversation she had left behind in the Midwest." Both hoped that their daughter would redeem the disappointments of their lives by finding the steady income that continually eluded the father and acquiring the sense of accomplishment and self-fulfillment that had eluded the mother. Like Thea Kronborg's mother in Cather's autobiographical *The Song of the Lark*, Gilpin portrayed her mother, fifty years after her death, as "a remarkable woman[,] . . . all for my doing what I wanted to do. In 1916 for a girl to go off on her own was not the usual thing, but whatever I wanted to do she was for; she was right behind me. She was wonderful—the more that I think of her the stronger I feel that."[6]

It was Gilpin's mother who introduced her to Käsebier, taking Laura and her brother, ages fourteen and five, to New York in 1905 to sit for their portraits; and it was at Käsebier's urging, in 1916, that the younger woman enrolled in the White School of Photography in New York. In 1918, Gilpin left New York in the middle of her second year of study, ill with influenza and, as a complication, a heart lesion. She lay in bed for six months, believing "the end of time" had come,[7] literally in limbo. She had left behind the supportive community at the White School, the world of art and music into which she had so ardently plunged, and a close circle of women friends, most important of whom were her mentor Käsebier and her friend Brenda Putnam. She returned home to Colorado, where she would soon assume the responsibilities of a son, and to a very different sort of artistic tradition. William Henry Jackson, who had, as part of the Hayden Surveys of the 1870s, been among the first to photograph the Colorado Rockies, had visited his Gilpin kin to make a series of photos illustrating Colorado ranch life with Frank Gilpin posing as the archetypal cowboy.[8] And Edward Sheriff Curtis's photograph of seven Navajo horsemen crossing the Canyon de Chelly hung in the family living room. Out of this illness, however, came the beginning of Gilpin's relationship with Elizabeth Forster, hired as her nurse, that would profoundly affect the lives of both women for the next fifty years.

Living and working among the Navajo, Forster would make possible an intimate connection that Gilpin, as her companion, would also develop with several Navajo families—ties that would define and shape her mature work. First, however, she would have to overcome the tendency, everywhere around her, to see the other as spectacle—a project analogous to learning to develop a sense of place not as land*scape* but as inhabited land.

The Curtis print that hung in her living room was, in other words, only a fine example of a common mode of representation. Pictures of American Indians were on display at a number of expositions throughout the country: the 1876 Centennial Exposition in Philadelphia exhibited objects and photographs from private and government surveys of the American West; the 1893 World's Columbian Exposition in Chicago attempted to represent "all mankind . . . either in persons or pictures"; and the 1898 Trans-Mississippi and International Exposition in Omaha, Nebraska, displayed, amid all the advantages in art and industry of "manifest destiny," a group of North American Indians who felt the impact of that destiny. Spectacles such as the Wild West Show that William F. Cody took on the road, and whose participants Käsebier photographed in her studio at the turn of the century, were another version of these expositions.[9]

Gilpin dated her discovery of her own interest in photographing native peoples to her trip to St. Louis (her mother's birthplace) in 1904 as companion to her mother's blind friend at the Louisiana Purchase Exposition. With the Brownie camera she had received the year before for her twelfth birthday, she went day after day to look at and capture on film a band of scantily clad Igorots from the Philippines who were attempting to carry on traditional rituals and practices in a reconstructed village. Gilpin would also have seen portraits of various North American Indians by the Gerhard sisters (Emma and Mamie), who along with Jessie Tarbox Beals (one of the first women press photographers) visited the anthropological exhibit to photograph the Igorots.[10] If Gilpin discovered her subject at the St. Louis Fair, Martha Sandweiss suggests, she discovered "art" at the Panama-Pacific Exposition in San Francisco and at the Panama-California Exposition in San Diego in 1915, the year before she went east to study at the White School. In San Francisco, she would have seen Roland Reed's Indian photographs (one of which, of a Hopi pottery maker, won a gold medal) and pictures from the Wanamaker expedition of 1913. Reed's photographs of Pueblo and Navajo Indians were on display in San Diego, as was Jesse Nusbaum's recreated Pueblo village, where potters Julián and María Martínez, who would later become Gilpin's friends, were part of the exhibit. Nusbaum, the park supervisor, and his wife Aileen introduced Gilpin to the Anasazi ruins when she traveled with her friends Putnam and Forster to Mesa Verde in 1924, the year before Cather's Tom Outland in her novel *The Professor's House* discovered the ancient cliff dwellings.[11]

It is tempting to read gender into the kind of trip Gilpin made to the

Four Corners area, a very small-scale and independent sort of camping trip with two close women friends. In contrast, official expeditions undertaken by all-male teams of photographers, artists, scientists, and entrepreneurs were elaborate and often well-supported projects, especially in financial, promotional, and exhibitional terms.[12] It is important to remember, however, that before the invention of the lightweight Kodak in 1888, the sheer weight and bulk of camera equipment would have made travel impractical for most women (fig. 3.3). Moreover, the prominence of more famous expeditions obscures the fact that by the end of the century a significant number of men and women—including women anthropologists overshadowed in historiographies by their male counterparts—were traveling west singly or in small groups to study and photograph what were generally believed to be the last survivors of a vanishing race. Simultaneously, amateur pleasure seekers of both sexes traveled west, bringing back souvenirs of their journeys in the form of photos of exotic landscapes and peoples.[13] Women travelers' responses to the Indians they saw along the way were as varied as men's. Mrs. E. H. Kemp, who gathered in a "photographer's row" to watch a snake dance, described "the intense dramatic action, peculiar

3.3 Portable outfit used for outdoor photography in the 1850s. From Eugene Ostroff, ed., *Pioneers of Photography: Their Achievements in Science and Technology* (Springfield, Virginia: Society for Imaging Science and Technology, 1986). Photograph, Edgar Sabogal.

dirge-like chanting, the fascinating weirdness of the scene, all [of which] make it a picture never to be forgotten." Mildred Ring was more sensitive to her subjects, however, and more willing to grant them agency. "When next you attempt to photograph an Indian, friend tourist or fellow kodak enthusiast, and he turns his back or otherwise spoils your film," she wrote, "bear with him tolerantly knowing this to be his belief. The picture produced is a materialization of his spiritual self which is bound to cause his death." The younger Indians, she continued,

> having accepted the ways of the white man, have been educated away from the inhibitions placed by superstition. In truth, many of them own kodaks themselves. However, their consent to be kodaked is oftentimes as difficult to obtain as that of the older Indians. This antagonistic feeling was explained to me by a Carlysle woman in this way: "A tourist passing through hops out of his machine with his kodak and says, 'Hey, you, line up! I want to get your picture!' Then he chooses a setting and attempts to back us up against it. I wonder how kindly the white people in Los Angeles or San Francisco would take to the idea of our appearing on their streets with a kodak and demanding that they line up for their pictures. It seems that they overlook the fact entirely that we, too, are human beings."[14]

Gilpin's journey to Mesa Verde in 1924 was symbolic as well as physical: she was following Timothy O'Sullivan's trail, making a pilgrimage to the famous ruins and canyons as others—from her contemporary Paul Strand to Mark Klett in our times—would do. It was Gilpin's second trip with Putnam; the two artists' journey to Europe in 1922 to historical monuments and museums had been a kind of preparation for the way in which she would now confront the primordial past of her own land. She was an independent woman in her early thirties traveling with her two closest women friends, bringing together parts of her life that had been separate. Her travels took her not so distant geographically—from Colorado Springs to Mesa Verde, south past Shiprock to Gallup and Zuñi, and from there to San Ildefonso and Taos—as far back in time. This was her subject: in the present, the time of her travel, Gilpin, like so many of her contemporaries—photographers, painters, writers—recorded what she believed to be the last vestiges of a disappearing culture. One particular quality, however—a way of framing—distinguishes (for those familiar with her mature work) many of these early images as Gilpins.

As a tourist among others, she would get up at dawn to picture unpeopled Indian ruins as they *had* been, and Indian people caught in an unchanging past. Like Curtis's image of the Indian "as he moved about before he ever saw a pale face" or painter Frederick Monsen's wish to show what the "earliest Americans were like before they were disturbed by the influences of the white man," she would photograph a young Zuñi woman from the knees up, as Putnam noted in her journal, because "this girl did not have the usual white moccasin-legging that most of the women wear." She did not go so far as the painters she met in Taos, Victor Higgins and Bert Greer Phillips, who introduced her to an experienced model and offered to lend her props—feathered head dress, beaded moccasins, deerskin quiver and bow; she preferred to photograph the man wrapped in a white sheet against an adobe wall.[15] But on a return trip to Mesa Verde in the following year, she photographed a summer pageant that Aileen Nusbaum staged by firelight and moonlight, in which Navajos played the parts of the original Anasazi inhabitants, whose Pueblo descendants lived far away. Although, as Sandweiss notes, these photographs would later be a source of embarrassment to her, Gilpin justified her part in this performance (her photographs were made during scenes staged especially for her) in the same way Curtis explained his presentation of staged rituals: "the life, the customs, the very types which the play represents are passing away with a speed that frightens one. Quite aside from my photographer's interest in its scenes, I am eager to add one more bit of accurate pictorial information about these Indians to the pitifully small amount we possess."[16]

Gilpin pictured Mesa Verde, however, particularly those images taken from inside rock walls, in a way distinctly unlike that of other well-known photographers—O'Sullivan's views for the U.S. government survey project, Curtis's outsider interest in the myth of primitive cultures, Strand's conception of the formal beauty of the cliffs. Gilpin and her friends were following another track: the literal and imaginative journey of Willa Cather, a re-finding in the fissures and hollows of Mesa Verde and Walnut Canyon (Arizona), in the visible remains of ancient cultures in Ácoma, Laguna, Taos, of the felicitous combination of vast and enclosed spaces and the archaic connection between matter and spirit, or form and desire, that Cather's autobiographical heroine Thea Kronborg had found in the southwestern desert.[17] Cather was a kind of touchstone for both Gilpin and Forster: Forster would carry *Death Comes for the Archbishop* with her to the Navajo reservation at Red Rock, Arizona, in 1931; a decade later, in *The*

Pueblos: A Camera Chronicle, Gilpin would retell Cather's story of Father Ramirez, who built a garden at the top of Ácoma Mesa, for which both soil and water were carried by Indians from the valley below. For one who has also traveled Cather's trail, *The Pueblos* is a kind of visual re-membering. One who follows the photographer's trail must start here at the beginning, with her erotic body knowledge—female constructions of vistas framed from within rooms, ceilings, doorways, cliffs: a "cave . . . comparatively shallow and . . . tucked away in a slight bend in the canyon so that it cannot be seen until one is directly opposite it."[18] Some of these views are unsettling. As Karen Hust suggests of *Round Tower* (fig. 3.4), viewer and photographer stand within a surrounding space and are themselves available to others' gazes: the two windows, like eyes in the wall, emphasize the way in which the "beholding eye is one point in a larger web of relationships and cannot be considered transcendent or objective; representation here does not banish the object but rather inaugurates intersubjectivity." No masculine symbol in Gilpin's vision, the tower is stopped in its upward progress by the curve of the cliff from which it is built: it takes on the roundness of a vessel, whose purpose is to shelter. Situating the photographer's viewing

3.4 Laura Gilpin, *Cliff Palace, Round Tower* (*Mesa Verde, Colorado*), glass plate negative, 1925. ©1981 by the Amon Carter Museum, Fort Worth, Laura Gilpin Collection, no. 1003.

eye within a space associated with the female body, Gilpin undercuts the supposed objectivity of the photographer and locates subjectivity within feminine consciousness. She makes her angle of vision more explicit in the later *Shiprock, New Mexico* so that the rock itself exists only as the subject of the woman's gaze: here the huge monument is smaller than the woman who observes it; its importance as a symbol is not more significant than the woman's material life, suggesting "that whatever is ahistorically masculine- or feminine-positive in aestheticized Nature is only as real as this woman's act of calling it forth and giving it value."[19]

Gilpin's early work, then, is contradictory and disturbing: a work such as *The Pueblos* offers, in both pictures and text, a way of envisioning place as embodied and inhabited that leads directly to the "intersubjective" work of her late life, *The Enduring Navaho,* coexisting with a kind of nineteenth-century romantic racialism—and what Sandweiss calls a "crude form of cultural relativism" in the text—that one would not expect to find in Gilpin's work as late as 1941.[20] Fine contemplative portraits of an old woman at Ácoma (fig. 3.5) or a grandmother and child at San Ildefonso that might have been made by Dorothea Lange, had the FSA been interested in the American Indian population; the depiction of material culture—baskets, pottery, clothing, jewelry, blankets, the drying of food—that finds its equal only in John Collier Jr.'s studies of the Lopez family in Northern New Mexico[21] are part of the same story as scenes staged in Nusbaum's pageant. Perhaps unsure of her audience, the more intimate images seem to be almost secret revelations when juxtaposed with a text that is part travelogue, part popular history of the sort one might find in an anthropology museum display, introduced by an expert archaeologist who has literally dug up the evidence Gilpin re-presents.

The photographs in this early work deserve to be read on their own, not *from* the text. Gilpin's language in the introduction to *The Pueblos,* however, does provide a theoretical base from which to evaluate the later work: "For many of us, American History begins with Columbus and the European discovery of the so-called New World. It is only in recent years that we have begun to realize the thrilling and amazing history that the archaeologists are unfolding for us—a history 'old as Egypt'" (7). Even disregarding the overblown "thrilling and amazing," Gilpin's sense of "discovery," which extends to both land and people, reveals a great deal about her interaction with Pueblo culture. A problem for the "discoverer" is that in describing what one espies s/he is limited to the language and images of one's known

3.5 Laura Gilpin, *Old Woman of Ácoma,* safety negative, 1939. ©1979 by the Amon Carter Museum, Fort Worth, Laura Gilpin Collection, no. 2961.1.

culture. Thus Gilpin, writing of "this great southwest, [where] the vast landscape plays an all-important part in the lives of its people. Their architecture somewhat resembles the giant erosions of nature's carving. It is a land of contrasts, of gentleness and warmth, and fierce and raging storms; of timbered mountains and verdant valleys, and wide arid desert; of gayety and song, and cruel strife" (123–24), clearly drew upon literary and artistic sources. In Romantic landscape paintings and poems, even fictional Westerns[22] she found language to describe what she saw: the relationship between the material culture of the Pueblos and the land that was its source and inspiration. *Discovery,* moreover, presupposes a distinction between the known—and knowing—self and the unknown other. Whereas Navajos in her later work are named and distinguished from one another, *The Pueblos* pictures *types* that are described in period clichés:

> In many ways the Indians are a simple and childlike people, while in other ways they are exceedingly difficult to understand. . . . One trait which is universally found is an extraordinary dignity of bearing, even

among entirely strange surroundings. Their chief desire is to be let alone and allowed to live their lives as they may choose. They are a friendly, happy people, with an excellent sense of humor unsuspected by strangers. (86)

Children in my neighborhood swimming pool play a game called "Marco Polo" in which one, with eyes closed, calls out "Marco" and the others, signifying their whereabouts, respond "Polo." When the one who is "it" comes upon one of the others, they change places—suggesting that in this game of discovery, where only the discoverer cannot see, positions are infinitely interchangeable. But just as the Venetian explorer's fourteenth-century journeys that helped to transform the world of maritime commerce were not so innocent, *discovery,* in the world of cultural imperialism does not imply interchangeable positions. Associated in photographic history with the visual recording of newly conquered western lands in the years following the Civil War, *discovery* hardly referred to transposable situations. Rather, both the practical work and the goals of this venture—to study geological structures and resources, to map and document lands that had been possessed—were those of a colonial power, its enterprise patriarchal but also supported, however obliquely, by the white women who would prosper from its success. *Discovery,* here, is related to *conquest:* the camera is the recording instrument that produced views of land unpeopled, of a natural wilderness prime for the taking and taming by the white race. The head of the U.S. survey project in the 1870s is a case in point. Recognizing his "most sanguinary Caucasian prejudice," Clarence King wrote in *Mountaineering in the Sierra Nevada:*

> I guardedly avoid all discussion of the 'Indian question.' When interrogated, I dodge, or protest ignorance; when pressed, I have been known to turn the subject; or, if driven to the wall, I usually confess my opinion that the Quakers will have to work a great reformation in the Indian before he is really fit to be exterminated.[23]

King, in fact, had much to guard against on the issue of race and good reasons for turning the subject: he had an African American wife, and the secret of this marriage, which produced five children, was kept from all but his closest friends.[24] "Fond of Negroes since his childhood days," he had a "compulsive" passion for the "archaic"—dark-skinned—woman. "He has a peculiar weakness for color," his friend Samuel Franklin Emmons re-

marked, "especially when it is on a fair cheek," and Henry Adams noted, "If he had a choice among women it was in favor of Indians and negroes."[25] King was both "voluptuary of the primitive and exotic" and "bitter misogynist." If a "buck" in the act of spearing a salmon reminded him of a statue cast in bronze, he was "almost afraid to describe the squalor and grotesque hideousness" of the man's wife "engaged in maternal duties." "Savage," as Trachtenberg observes, means for King "something in nature impossible to resist and impossible to accept—a term which inflicts the consequences of a white man's dilemma upon native dwellers."[26] In the case of the chief surveyor, then, *discovery*, as a projection of a personal and cultural dilemma, is literally a search for what is hidden.

The language King used to represent alterity—contradictory expressions of attraction to and repugnance for "savage" women's bodies, an appreciation of native men's bodies for their noble attributes—has long echoes, especially in the post-1992 rethinking of Columbus's "venture" some five hundred years ago. Tracing this history in *The Conquest of America*, Tzvetan Todorov takes as his subject "the discovery *self* makes of the *other*,"[27] which turns out to be a one-way kind of looking. He links the familiar terms— *discovery* and *conquest*—to the way in which war and military culture serve as vehicles for defining self and other. What is missing from this narrative, as in the game of discovery, is the kind of two-way looking that is at the center of the problem of representation. My interest here is in this missing story: one that would introduce and shift the focus to the term *encounter*. Such a story would not be the usual quest narrative, but rather a tale about "the irruption of the other," which, as Wlad Godzich points out, "is not a threat to be reduced or an object that I give myself to know in my capacity as knowing subject, but that which constitutes me as an ethical being: in my originary *encounter* I discover my . . . response-ability, that is, my capacity to communicate with others and with myself in noncoercive ways."[28]

These terms—*discovery, conquest, encounter*—are linked in literary discourse, but, as noted, they speak to a similar concern with identity and alterity in other fields. Anthropologist Clifford Geertz, for example, warning that "objectivity" is self-congratulation and tolerance a sham, urges us to see ourselves "amongst others, as a local example of the forms human life has locally taken, a case among cases, a world among worlds."[29] Historians and theorists draw on the work of Jürgen Habermas, among others, to investigate the possibilities for "reciprocal communication"; or, like John Berger, they propose a way of thinking about images that is not unilinear—

from photographer to subject—but radial, with the subject in the center in the fullest possible context of social experience and social memory.[30]

This placing of the subject in the center of the story is the work of narratives collected in Lucy Lippard's *Partial Recall,* in Victor Masayesva's *Hopi Photographers,* in filmmaker Sol Worth's *Through Navajo Eyes.* In each of these narratives—like Making Medicine's drawings of Indian prisoners lined up before the cameraman at Fort Marion in St. Augustine, Florida, 1875–78—those who are usually represented "look back" and tell their own stories. Laura Gilpin's work does not constitute such a narrative; it is the story of a middle-class white woman raised in the West and educated in the East, who struggled for most of her life with poverty, and whose world was circumscribed by women. Had she lived long enough, given the relationships she developed with the Navajo, it is indeed possible that she would have experimented with teaching her indigenous friends to use cameras. But her story begins in a different place: the discovery associated with the survey projects, to which she was linked through Jackson, was past, but the conquest—the documentation of conquered, about to be extinct peoples— was very much present. When she began to work, camera equipment had become easily portable (although she preferred view camera and tripod) and travel comfortable; in her lifetime it was possible to photograph from the window of an airplane. In other words, her story begins when women travelers, recording their own versions of history, are no rarity.

In her early work, Gilpin came up against conflicting notions of the photograph as an index to a specific reality—a concept that, as propounded by Roland Barthes among others, would continue to exercise a particular hold[31]—and the awareness that photographs could be used to tell particular stories. Only beginning to explore the question, "Whose reality?" her own agency as against a received authority was a weighty source of struggle. Situating Gilpin in the broader context of her time and place—her dual heritage from Käsebier and Curtis, her life in both the New York art world and the Colorado Gilpin family, as well as her lesbian entry into a traditionally male preserve—leads to the interesting and complex questions, "What difference does the addition of gender make to the representation of alterity?" and "How did this woman, struggling with her own identity, *see* otherness?" Inasmuch as my focus is on *Gilpin's* work, any answers to these questions can be only partial. To begin with, that each photograph records a specific moment that has ceased to exist. Pieces of memory arranged in sequences, these visual ciphers are narratives, encoded with personal and

cultural meanings, to be deciphered. We can also think about agency—of photographer and subject or of those who authorize, exhibit, publish, and interpret images. In other words, we can question the preconceptions of commissioners of other, larger projects of representation (those who had the authority to command the documentation of other races and who paid the costs of the undertaking) and of viewers, at the time of the project's first presentation and thereafter, whose responses to what they see arise from particular cultural contexts. These are important issues for the cultural historian, who presupposes that photographs, like all documents, have cultural and iconographic meanings that can be decoded; for the contemporary cultural anthropologist, who raises ethical and practical questions about representing otherness; and for the feminist theorist, who insists that who is looking, who is viewing, who is being represented matters and that, in this case, the intersection of race and gender matter very much.

OF SEPIA KINGS AND OTHER PINHOLE ILLUSIONISTS

While she was being massaged she told me only that the children's governess had brought her an ethnological atlas and that some of the pictures in it of American Indians dressed up as animals had given her a great shock. "Only think, if they came to life." (She shuddered). I instructed her not to be frightened of the pictures of the Red Indians but to laugh heartily at them. And this did in fact happen after she had woken up: she looked at the book . . . and laughed out loud at the grotesque figures.—Sigmund Freud, from "Frau Emmy von N."[32]

Not even Indians can relate themselves to this type of creature who, to anthropologists, is the "real" Indian.—Vine Deloria Jr., Custer Died for Your Sins[33]

In a vegetarian restaurant in Northampton, Massachusetts, some thirty carefully matted and framed prints from Edward Sheriff Curtis's *The North American Indian* hang on the walls at the eye level of good liberal diners. Meant as fine art, in this context the exhibit has another meaning as well. The message is complicated, and as a viewer I participate in the construction of its meaning. That is, as a customer—a consumer—I respond positively to Curtis's eye for composition, and also to the haunting beauty of these faces. Familiar with Curtis's historical context and photographic practices, however, I respond negatively to the way in which these human beings are displayed as elegant compositions. What, finally, should I make of

portraits such as that of an old Cheyenne man (fig. 3.6) and of their power to move me? How do I deal with the confusing responses of aesthetic appreciation, rapport, and moral outrage? The problem seems more painful than constructing meaning from the experience of viewing Lewis Hine's photographs of immigrants arriving at Ellis Island—perhaps because of my own shared history with some of these immigrants—and as complex as the experience of viewing and responding to the faces of poor tenant farmers photographed by Dorothea Lange. The problem is that viewing seems to place me alongside the photographer, and feels like a false, an unequal encounter.

I start with this fact: in their early and late twentieth-century versions of presentation and display, Curtis's photographs are themselves objects that represent particular social and political realities. Confronting a similar problem, Trachtenberg has suggested that the J. T. Zealy daguerreotypes of South Carolina slaves, made for Harvard scientist Louis Agassiz, exist within a system of representation as firmly as their subjects are trapped within a system of chattel slavery. To think about Curtis's photographs in this way is to recognize that inasmuch as the viewer of these images might respond to the downward glance of the man whose wrinkled face is lit as beautifully as a Rembrandt or an Eakins portrait, the subject of this photograph was fully aware of being portrayed, of being in the presence of spectators. As Trachtenberg suggests of the slave portraits, this acutely strained double awareness signals back to us "our own presence as spectators, 'the pressure of our own gaze upon the portrait subject,'" and our troubling realization of our own entrapment in this same system of representation.[34]

Edward S. Curtis's photographic project, *The North American Indians*—twenty volumes of text and 1,500 bound photographs accompanied by twenty portfolios of 722 unbound photographs, published between 1907 and 1930—has come in for a good deal of negative criticism in recent times. My own interest in this project is not in finding it more outrageous than other projects that sought to document the "last" representatives of this "vanishing race" in the late nineteenth and early twentieth centuries, but because I see a direct line from Curtis to Gilpin, who grew up under his famous image of Navajo horsemen in the Canyon de Chelly (fig. 3.7). Borrowing Walter Benjamin's conceit, we might liken Curtis, who traveled from the Mississippi River west and visited more than eighty tribes in the making of his comprehensive document, to the trading seaman, and Gilpin, who repeatedly revisited parts of a small geographic area within her

3.6 Edward S. Curtis, *Black Belly—Cheyenne,* from *The North American Indian* (Cambridge, Mass.: The [Harvard] University Press, and Norwood, Conn.: Plimpton Press, 1907–1930), portfolio vol. 19, plate 671. Special Collections, University of Washington Libraries, no. 17583.

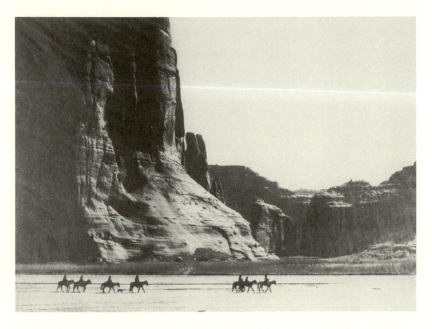

3.7 Edward S. Curtis, *Cañon de Chelly—Navaho*, from *The North American Indian* (Cambridge, Mass.: The [Harvard] University Press, and Norwood, Conn.: Plimpton Press, 1907–1930), portfolio vol. 1, plate 28. Special Collections, National Museum of American History, Smithsonian Institution, no. 88-17671.

own native Southwest in order to deepen her relationship with Navajo people and places, to the resident tiller of the soil. Gilpin's insider position in *The Enduring Navaho,* the last of four books of pictures of a particular people and place, stands in contrast to Curtis's authorized version of conquest.

Curtis made some forty thousand photographs of indigenous people, more than 2,200 of which—along with written descriptions of homelands, accounts of religious beliefs, tribal organizations, ceremonies, arts, and hunting practices, as well as versions of myths, songs, and stories—were published in *The North American Indian.* As Mick Gidley has observed, this monumental work is also a monument to the zeal and stamina of the project's creator and producer: a comprehensive written and photographic record of those indigenous Americans west of the Mississippi and Missouri Rivers who still retained "to a considerable degree their primitive customs and traditions."[35]

Curtis's pictures, as we now know, are not so different from the vast quantities of images made by missionaries, doctors, tourists, journalists, anthropologists, and geologists in the early twentieth century—which, if less ambitious in scope, were similar in intent—and used in reports or published, like Curtis's photographs, in books or as lantern slides and postcards. Anthropologist Edmund Carpenter argues that Curtis's photographs are not even the best of these pictures—that in the unknown portraits he made before 1914 when he was a mining engineer and before his film *Nanook of the North,* Robert Flaherty is to Curtis what Cartier-Bresson is to a passport photographer.[36] (I envy Carpenter his dispassionate judgment; it makes less painful and difficult the problem of seeing the story of conquest so exquisitely documented.) Curtis's project is, however, unique in the kind of sponsorship it received during the period of its publication and exhibition (it was funded largely by J. Pierpont Morgan as what the *New York Herald* called "the most gigantic undertaking in the making of books since the King James edition of the Bible"[37]) and in its current visibility. Curtis unsuccessfully attempted to gain public support for his project through postcards, lantern-slide lectures, and a film, but the multivolume set was not in fact intended for public consumption. The twenty volumes of text with bound and unbound plates, printed on imported handmade paper, in luxurious bindings of irregularly grained Morocco leather, were issued in an edition limited to five hundred sets, priced at $3,000–$4,500, and sold by subscription to museums and private collectors.[38] They were placed in the rare book rooms of the institutions that housed them and more or less forgotten until a 1971 showing that launched a revival of interest in Curtis's work.

Curtis's pictures are now the subject of museum and gallery exhibits and are published in books as single-volume excerpts of the original project, as prints suitable for framing, and on calendars and postcards. The responses to these pictures, among Euroamericans and native peoples, have been both positive and negative. Curtis's own term for his work, "art-science," is undoubtedly the right one, whether one takes the term to mean disciplines combined to present and record as pictures/anthropological objects the people whom the sponsors, presenters, and viewers of this project had helped to annihilate, or sees the photographs as *documents*—relics of a lost reality whose appeal is at the same time a romanticization of native peoples. The most popular images—those reproduced on postcards and calendars or framed, like the one that hangs on the office wall of one of my colleagues

who teaches Victorian literature—are the closeup portraits that, shot from below, ennoble their subjects: they are ethnographic compositions in the pictorial mode, printed in rich sepia tones to enhance the artistic quality of the images. Vine Deloria suggests that it is exactly this romanticization that engages those whose alienation from the values of modern society was spawned by the discontent of the 1960s: whether they are part of the ecological movement or members of minority groups whose awakening pride in their heritage has been triggered by movements toward power in ghettos, barrios, and reservations, these new viewers see Curtis's images as symbols of authentic human values.[39]

The Curtis revival also includes detractors such as Rayna Green, who dismisses the "Curtis boys dripping dentalia and fur—the sepia kings, shot through spit and petroleum jelly, Lords of the Plains, Potentates of the Potlatch, the Last-Ofs"[40]—and Christopher Lyman, who launches a full-scale attack in his 1982 book *The Vanishing Race and Other Illusions.* Linking Curtis to the Pictorialist tradition in photography and to "scientific" attitudes toward racial superiority in the early twentieth century, Lyman argues that the photographer costumed his subjects, staged ritual performances, manipulated negatives, and cropped prints in order to convey a particular "truth" and elicit a certain emotional response among viewers.

The self-conscious attempt to define camera work as fine art was not limited to the East Coast at the end of the nineteenth century. In Seattle, Curtis was making Pictorialist photographs such as *Evening on the Sound* (fig. 3.8) and *The Clam Digger,* which drew first prize in the "genre class" at the 20th Annual Convention of the Photographers' Association of America in 1898. These two photographs offer different framings of the same scene: a dreamy landscape with backlighted figures, the canoe suggesting "Indianness," are silhouetted against the evening stillness. Clearly *not* ethnographic documents, they would reappear thirteen years later in volume 9 of *The North American Indian.* Portraits that Curtis made later that year link race and gender to represent dark-skinned women in the fanciful and exotic way typical of the period. Models for *The Egyptian* and *A Desert Queen* (fig. 3.9) are the wife of a Seattle judge, a frequent sitter for Curtis, and an African American woman. Using studio props, Curtis posed the former in profile (a vague reference to Renaissance portraits meant to suggest nobility, but also a reminder of contemporary anthropometric photographs); the latter is draped with a piece of fabric in such a way as to suggest sexual allure. Both are wearing the same "Egyptian" necklace and tiara.

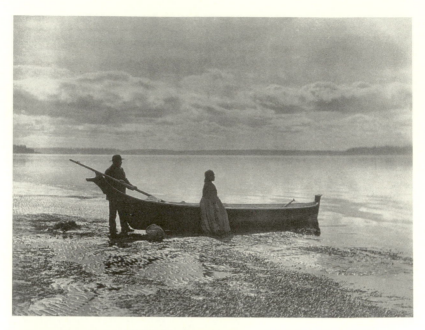

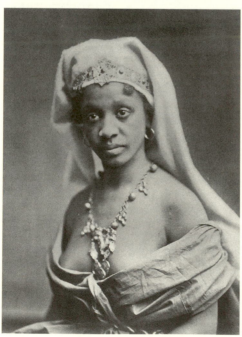

3.8 Edward S. Curtis, *Evening on the Sound,* 1898, from *The North American Indian* (Cambridge, Mass.: The [Harvard] University Press, and Norwood, Conn.: Plimpton Press, 1907–1930), portfolio vol. 9, plate 312. Special Collections, University of Washington Libraries, no. NA321.

3.9 Edward S. Curtis, *A Desert Queen,* 1898, *Camera Craft* 2, no. 2 (Dec. 1900):128. Special Collections, University of Washington Libraries, no. UW147.

These early images contain clues to the work that would become *The North American Indian*. First, the picture-making techniques Curtis developed early on—the soft-focus lens, use of suggestive props and indirect lighting, manipulation of negatives and cropping of prints—are among the criteria by which his images continue to be judged. Pictorialist photographer Arnold Genthe, for example, wrote in 1901 of Curtis's *The Three Chiefs* that it "just misses being great. If the head of the foremost horse could have been turned so as to break the straight line formed by the three horses the composition would have been perfect. But even as it is, the photograph is a very beautiful rendition of a picturesque phase of Indian life."[41] Second, representing the ethnic other as exotic was common practice for ethnographers and Pictorial photographers of Curtis's time (and is not so uncommon in our own). John K. Hillers's *Wu-Nav-Ai Gathering Seeds* and Case and Draper's *Good Morning* and *Kaw Claa, a Thilget Maiden*, circa 1900, appealed to popular stereotypes of "Indianness" and titillated Victorian audiences who viewed them, mounted on cards, through parlor stereoscopes. Anthropologist Margaret Blackman suggests that entertainment value governed the selection of subject matter: "The bare-breasted 'Wu-nav-ai gathering seeds' certainly was not viewed by Victorian gentlemen for its documentation of Great Basin seed gathering."[42] And third, these complicated attitudes toward race—artistic, quasi-scientific, sexual—were informed by the political doctrine of "manifest destiny." *The Vanishing Race* (fig. 3.10), which opens *The North American Indian* series, is a study in lights and darks, a contrast Curtis said he used to express the spirit of the entire project. "The thought which this picture is meant to convey," he wrote in the caption, "is that the Indians as a race already shorn of their tribal strength and stripped of their primitive dress, are passing into the darkness of an unknown future."[43]

President Theodore Roosevelt, with whom Curtis gained an audience in 1905 in an attempt to elicit support for his project, stated the case more clearly: "I suppose I should be ashamed to say that I take the Western view of the Indian. I don't go so far as to think that the only good Indians are dead Indians, but I believe nine out of every ten are, and I shouldn't inquire too closely into the case of the tenth. The most vicious cowboy has more moral principle than the average Indian."[44] At the time of this interview, "manifest destiny" had been accomplished, the frontier had been officially declared closed, and projects like the Carlisle Indian School, whose purpose was to assimilate Indians through education, were well underway.

3.10 Edward S. Curtis, *The Vanishing Race—Navaho,* from *The North American Indian* (Cambridge, Mass.: The [Harvard] University Press, and Norwood, Conn.: Plimpton Press, 1907–1930), portfolio vol. 1, plate 1. Special Collections, National Museum of American History, Smithsonian Institution, no. 91-11796.

Conquest had been accomplished, and Curtis's documentation was its photographic record.

This project, which would occupy Curtis for the next thirty years of his life, was conceived when he joined a group of ethnographers on the Harriman Expedition to Alaska in 1899. Anthropology in the United States was not yet a professional discipline at that time: it came of age in this country only with the disappearance of the "barbaric savages" whose presence had been seen as a menace and with the rise of a nostalgia cloaked in the trappings of science; it emerged in an intellectual environment where value-laden terms such as "barbarian" and "savage" would be replaced with scientific classifications according to race that proposed or presupposed hierarchical rankings of humans.[45] Curtis's work is part of this context, which included the circular logic of early twentieth-century ethnology, based both on the premise that Indians "improve" through acculturation and that their "culture" remains sacrosanct.[46] His work also reflects early twentieth-century political morality, as exemplified by Theodore Roosevelt's in-

troduction to *The North American Indian:* "The Indian as he has hitherto been is on the point of passing away. His life has been lived under conditions through which our own race past [*sic*] so many ages ago that not a vestige of their memory remains. It would be a veritable calamity if a vivid and truthful record of these conditions were not kept."[47]

Whereas Roosevelt assumed a static and single culture, Curtis attempted to record the "ethnographic present" of "Indianness" in all of its tribal variety. His range of images includes housing and material culture, work, crafts, rituals, and above all portraits; yet his single subject is the imaginative portrayal of the typical member of a disappearing racial type: "the Indian." Front and profile views of a Wisham girl are one example of Curtis's anthropometric interest in race. His *Typical Apache* (which he also called "Life Primeval") demonstrates the way in which Curtis often altered images: here he cropped from an earlier print his man-made studio tent in the background, thus thrusting his subject forward, Lyman argues, to make him more threatening—to achieve a particular effect.

In his mission to present "the vanishing race" in its pure form, before altered by contact with whites, Curtis felt compelled to present indigenous peoples as he imagined them to have been. It was for this purpose that he employed Pictorialist techniques, carried costumes with him, staged recreated rituals, and removed evidence of the taint of white civilization from

11 Edward S. Curtis, *Mother and Child,* n.d. National Anthropological Archives, ʾational Museum of Natural History, Smithsonian Institution, no. 81-9635.

12 Edward S. Curtis, *Spectators,* n.d. National Anthropological Archives, ʾational Museum of Natural History, Smithsonian Institution, no. 81-8713.

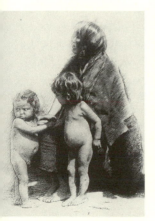

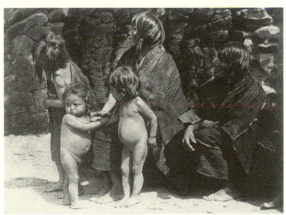

pictures. Lyman, comparing published and unpublished prints and examining negatives for evidence of scratchy marks of the retouching stylus, has come up with a number of ways in which Curtis worked to create his own version of "Indianness." One kind of retouching removed evidence of white culture such as hats, suspenders, machine-made seams from fabrics, product labels, for instance, *In a Piegan Lodge,* where a clock has been removed. Another sort of manipulation was to make changes for dramatic or narrative effect. *Night-Scout—Nez Perce* was made in daylight, but its illusion of dark sky was created by scraping emulsion away from the area of the sky in the negative or by painting on a print and rephotographing the print. When the title of *Firing Pottery* was changed to *Preparing Wedding Feast,* a pot was added with a retouching stylus. In some cases, the contextualizing background was removed, as in *Mother and Child* (fig. 3.11) and *Spectators* (fig. 3.12), highly retouched presentations of the same negatives; or as in *Chief Joseph—Nez Perce,* an earlier studio portrait reframed for *The North American Indian.* In cases such as *Haschebaad—Navaho* and *Haschelti—Navaho,* dancers in a Yebechai ceremony insisted that Curtis make their costumes in order to avoid exposing ritual objects to public view; in *Yebechai Prayer—Navaho,* the dancers performed the dance backwards to secularize it.[48] Members of different tribes were often posed in the same costumes, obviously studio props, as in *Little Dog (Shunkala)* and *Sitting Owl—Hitdatsa.* And sometimes the same person was posed in "Indian" and "civilian" clothing, as in the case of *Upshaw—Apsaroke* (fig. 3.13), a Crow who worked for Curtis as interpreter, and *A. B. Upshaw—Interpreter* (fig. 3.14), the same man, photographed by one of Curtis's lab technicians.

Volume 10 exhibits a preoccupation with reframing and editing, staging and costuming, in order to re-create the imaginatively authentic, which goes beyond the artful in Pictorial photography. Curtis started using a motion picture camera to record special events and ceremonies as early as 1906. He took his images on the road, accompanied by music recorded in the field, to promote *The North American Indian.* The success of his illustrated lectures on "The Vanishing Race"[49] might have given him the idea of making a full-length feature film. In 1913 and 1914, he worked with the Kwakiutl on the film he had been planning since 1910, *In the Land of the Head-Hunters.* Curtis undertook this project with the assistance of George Hunt, a man born among the Kwakiutl who, long before he became Curtis's interpreter and assistant, had reached high status among the Kwakiutl tribes. Hunt organized the enormously complex work of making

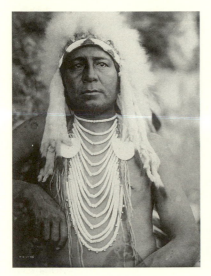

3.13 Edward S. Curtis, *Upshaw—Apsaroke,* from *The North American Indian* (Cambridge, Mass.: The [Harvard] University Press, and Norwood, Conn.: Plimpton Press, 1907–1930), portfolio vol. 4, plate 139. Special Collections, National Museum of American History, Smithsonian Institution, no. 81-8708.

3.14 Frank A. Rinehart (attr.), *A. B. Upshaw—Interpreter,* 1898. National Anthropological Archives, National Museum of Natural History, Smithsonian Institution, no. 81-9647.

masks, canoes, imitation houses, costumes, and wigs; hired those who worked on props and those who played the roles, many of whom were his children and grandchildren; and directed the filming.[50] Under Hunt's guidance, the Kwakiutl became Curtis's collaborators in erecting house fronts and carving totem poles, reproducing dances and rituals, staging chases by canoe in rough waters (fig. 3.15) and the burning of a village, even shaving off their mustaches for fifty cents apiece. Because the film is not a documentary but a romance—Curtis believed that the best way to capture the powerful character of the people and their lives was to present a dramatic story of love and war—it elicits different responses from those to the still photographs in *The North American Indian.*[51] Expecting and accepting films as theatrical events, audiences acknowledge such simulations of "real" life as part of the truthfulness of the stories films tell. Photographs, on the other hand, are supposed to record the unvarnished truth of a given situation; still photographs are usually taken to be documents of reality. The still photographs presented as anthropological documents in volume 10 of *The North American Indian* were, however, taken by Curtis with his motion picture camera for the film *In the Land of the Headhunters.*

Bill Holm and George Irving Quimby, who discovered and reconstructed *In the Land of the Headhunters* (changing its name to *In the Land of the War Canoes*), point out (along with other Curtis defenders) that in such textual passages in *The North American Indian* as "no single trait noble redeems the Kwakiutl character" or "[the Mohave] are dull and slow—brothers to the ox," Curtis was simply voicing the beliefs of his times.[52] From the sentiments expressed by Theodore Roosevelt in his introduction, to studies such as Jacob Riis's *How the Other Half Lives,* the context in which *The North American Indian* was created includes both ethnocentrism—a social Darwinistic judgment of one people's qualities by another in terms of the latter's own ideals and standards—and racism, a specific social doctrine invented by Europeans in the modern period of their world-wide expansion that understands human diversity in terms of inherent racial differences. Racism, Robert Berkhofer points out, rests upon the assumptions that moral qualities in a human group have correlations in physical characteristics and that all humankind is therefore divisible into superior and inferior races.[53] The nineteenth-century doctrine of "race-science," the study of comparative anatomy, which included body measurement and anthropo-

3.15 Edward S. Curtis, *Thunderbird dancer "flying" in the bow of the Canoe,*
1913–14. Special Collections, University of Washington Libraries, no. NA441.

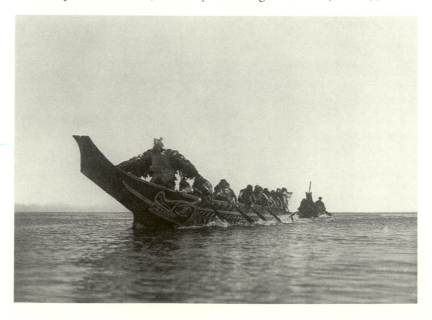

metric photography, physical and cultural anthropology—all contemporary with Curtis's project—are based on these assumptions. This is the context of what Lyman has identified as illusion making in Curtis's photographs, a practice common among both photographers and anthropologists of his day, whose assumptions were shared by a wider public.

To take an example from another master of "art-science," Eadweard Muybridge, best known for his precinematic studies of the human figure in motion, indulged in similar illusion making. His *Modoc Brave on the Warpath*, for example, is actually a man from a Warm Springs tribe who was working as a U.S. Army guide and posed against a gnarled rock for the photographer. Returning to San Francisco, Muybridge would sell these theatrical images as documents of the Modoc War.

Franz Boas, a pioneer of anthropology, set up "villages" for various tribes—in some cases dismantling existing villages and in others using props—at the World's Columbian Exposition in Chicago in 1893 in order to recapture a presumed pristine, pre-Columbian condition. In his book *The Social Organization and Secret Societies of the Kwakiutl Indians* (1897), Boas used an image made at the exposition by his assistant John Graybill of a group of posed Kwakiutl dancers, retouching the photograph to block out the original context—literally to block out the changes of time.[54] Boas's methods were perfectly in keeping with the aims of the exposition. He was an assistant to Frederick Ward Putnam, head of the Department of Ethnology and Archaeology for the exposition, who explained to its Committee of Liberal Arts that he envisioned an "essential and appropriate display" of "native peoples of America, in their own houses, dressed in their native costumes, and surrounded by their own utensils, implements, weapons and . . . handiwork." He attributed the very existence of the exposition

to the fact that the voyage of Columbus 400 years ago led to the discovery of America by our race, its subsequent peopling by the Europeans and the consequent development of great nations on the continent. This development . . . has been of a most remarkable character upon this continent; and all nations of the world will show what they have done in the great struggle during four centuries. The result will be such a wonderful exhibition of the works of man that even those of us who know in part what it is . . . will be surprised and astounded when we see it . . . as a grand whole. But what will all this amount to without the means of comparison in the great object lesson? What,

then, is more appropriate, more essential, than to show in their natural conditions of life the different types of peoples who were here when Columbus was crossing the Atlantic Ocean and leading the way for the great wave of humanity that was soon spread over the continent and forced those unsuspecting peoples to give way before a mighty power, to resign their inherited rights, and take their chances for existence under the laws governing a strange people? We know the results, and we know well that 400 years has brought the last generation upon the stage of action, when it will be possible to bring together the remnants of native tribes . . . in anything approaching purity of stock, or with a precise knowledge of the ways of their ancestors. These peoples, as great nations, have about vanished into history, and now is the last opportunity for the world to see them and to realize what their condition, their life, their customs, their arts were four centuries ago. The great object lesson then will not be completed without their being present. Without them, the Exposition will have no base.[55]

As one more example of *conquest* in the documentation of North American Indians, it is useful to look at the "straight" photography of Dr. Edward H. Latham, U.S. agency physician on the Colville Reservation, Washington state, home to several languages and cultures—from indigenous peoples such as the San Poils to resettled tribes such as the Columbias. Unlike Curtis and so many other travelers to photographic sites, Latham lived on the reservation, learned the Chinook jargon (the lingua franca of the Indian Pacific Northwest), and recorded the changing life at Nespelem, especially that of the Nez Perce people and their leader Chief Joseph. After 1890, when he arrived, Indians were forced onto reservations, where they became wards of the state in their dependence on the government for supplies, equipment, and food (sometimes withheld to coerce them into a particular course of action). Although not granted citizenship until 1924, by the turn of the century they were encouraged to wear "citizen's" dress, cut off their braids, live in houses, and send their children to boarding school—where they were beaten for speaking their own language. They were imprisoned for using medicine men or pursuing their "barbarous rites and customs."[56]

Edward and Mary Latham, both physicians from Cincinnati, moved to Spokane for the drier climate, where she prospered professionally—

gaining fame as an expert on the ailments of women and children, being elected chairman of the Medical Department of the Washington branch of the Queen Isabella Association and in that role representing the State of Washington at the World's Columbian Exposition, founding a public library, writing for women's magazines, and becoming the most prominent woman physician in the Northwest—but he did not. He practiced his hobby, photography, drank heavily, and when they divorced, moved to Colville, one hundred miles from Spokane by wagon road, where he was hired "to lift this people out of superstitious regard for the grotesque need of 'the medicine man.'" His dry-plate photographs of his subjects, all of whom have names, date from 1890 to 1910, during which time he was the first permanent white doctor and one of the first whites to live and work there.[57]

One might expect Latham's images to reveal an intimate relationship between photographer and subject; but we find instead that they are *more* alienating than Curtis's. Mick Gidley points to a flatness in these pictures that has partly to do with Latham's lack of craftsmanship: scenes with too much detail, undistinguished surface planes, even an "aerial" effect that causes the viewer's eye to roam, and portraits of "wooden" subjects who seem to be waiting for instructions from the photographer. Clearly, Latham was deficient in the skills of selection and composition (at which Curtis excelled), but he also lacked the ability to interact with his subjects in a way that ultimately involves the viewer in the construction of meaning. In other words, the fact that all parts of a picture are on the same plane has less to do with the photographer's decision to confer equal importance upon all objects in front of his lens than with a failure of communication. If Latham held his camera at eye level—his subjects are neither disparaged by being looked down upon nor ennobled by being looked up at—it is not because he eschewed art in favor of honest documentation. As Gidley points out, an image such as *Mother and Child* (fig. 3.16) provides both ethnographic information—a baby's cradleboard is strung up in a tree to keep the baby cool—and photographic information—the mother and child are in harmony with their natural environment. It is a very *white* idea, however, to place a blanket on the ground to stand on, making a special place for the photograph, a studio in nature.[58]

For Gidley, the problem with Latham's images is a matter partly of art but also of disposition; he argues that Latham photographed the same subjects again and again over a period of twenty years in more or less the same

way. The photographic vision of the man for whom Chief Joseph was never anything more than an "old scoundrel" or an "old rascal" is "that of someone quite deeply alienated by the world around him"—the landscape, the strange ceremonies, the people, not so much the vision of an amateur photographer as that of "a folk or *primitive* artist, a kind of Edward Hicks of the camera who rendered not a series of peaceable kingdoms but a set of alien ones."[59] The argument cannot be made, then, that in themselves craft or its lack, a neutral eye or a collaborative performance, the brevity of the photographic sessions arranged by Curtis or the continuous proximity in which Latham lived with his subjects prevent or make possible the kind of *encounter* that Gilpin's mature photographs record. After all, the interaction between the photographer and the Indians trained to perform as themselves (for spectators of Buffalo Bill's Wild West Show) that took place in the studio of Gilpin's mentor, Gertrude Käsebier, produced some surprisingly intimate portraits.

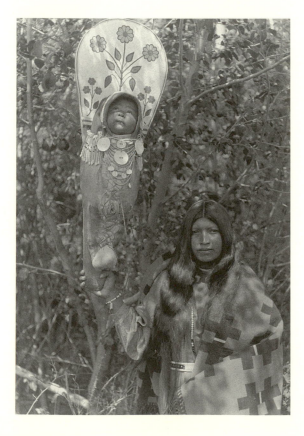

3.16 Dr. Edward H. Latham, *Mother and Child,* c. 1900. Special Collections, University of Washington Libraries, neg. no. 4947.

Struggles over what will count as rational accounts of the world are struggles over how to see. The terms of vision: the science question in colonialism; the science question in exterminism; the science question in feminism. . . . [W]hat counts as an object is precisely what world history turns out to be about. —Donna Haraway, Simians, Cyborgs, and Women[60]

There is no pretense here of a scientific or an ethnologic approach, but all factual statements have been checked . . . finally, with the Navaho People themselves. (vii) —Laura Gilpin, The Enduring Navaho

During her New York years, Gilpin had studied composition and technique at the White School, but her real heritage from that period was learning to communicate the resonance and tone of her own partial knowledge: the empathy for which Käsebier's portraits were consistently praised, and sensuous perception, especially with relation to domestic spaces and the creation of symbolic landscapes. When Gilpin began to send Käsebier photographs from their common place of origin, the elder photographer responded with thanks for photographs "doubly precious to me because of the years of my childhood which were spent among such surroundings" and for Christmas wreaths and pine cones that evoked memories of "the vast altitudes and spaces." A great admirer of Gilpin's work, Käsebier must have had the same importance Sarah Orne Jewett had for Willa Cather early in the younger writer's career. She warned Gilpin, as Jewett had cautioned Cather, to devote herself to her own gifts: "There will come a time when you must call a halt, nature demands her toll, and the sooner you realize it the better. It is a great privilege to have work to do that we love to do but we must not waste our forces. Make haste slowly." The correspondence between the two women, and the exchange of gifts and prints, would continue until the elder woman's death. "There are so few who make a life work of it and nothing else counts in the long run," Käsebier wrote. "I feel that you are on your way to succeed with your work and wish you the fullest accomplishment."[61] It was Gilpin's work of the 1920s that Käsebier was responding to, and her praise may have had a great deal to do with the younger photographer's early approach to her own landscape and its native people. But as she found that what she had learned imposed a way of seeing upon a place imbued with a presence of its own, as she worked toward capturing her sense of human presence in the vast spaces of her

environs, Gilpin began to move in her own direction. Käsebier, however, continued to praise the photographs for their "bigness" of conception and of the accompanying text for its dignity, simplicity, and charm. Of some winter scenes she wrote, "How they did refresh me. They are just like your dear self in simplicity and truth. Truly photography is a wonderful medium to those who can understand."[62]

Käsebier, as well as Gilpin's friends Anne Simon, Brenda Putnam, Betsy Forster, and later on Imogen Cunningham, constituted a network of women from which Gilpin drew sustenance all her life. This support was all the more important because it existed in isolation from the outside world. That is to say, situated and nurtured as she was, it makes a kind of gendered sense that on her increasingly distant independent forays Gilpin saw and brought back visions of an embodied landscape. Women in her life were to her what the Harriman Expedition, J. P. Morgan, brother Ashael, and colleague Adolph Muhr were to Curtis. *His* masterwork begins with an image of a people forced to *vacate* their land so that the great work of civilization can prosper: *The Vanishing Race* represents retreat before conquerors now free to open the land to settlement and its resources to exploitation. Gilpin begins *The Enduring Navaho* with an image of human marks made upon the land (fig. 3.17), pictorial representations of the creation myth, which signifies the Navajo relation to all of Nature. This is a story about female fecundity: it relates "how a ray of light from the Sun passed through drops of water from a waterfall impregnating Changing Woman." Her twins were the hero gods, Monster Slayer and Child-of-the-Water, who made a safe place for the Diné, the people of the earth, to live, and blessed the water

3.17 Laura Gilpin, *Twin War Gods* [Rock Painting], safety negative, 1959. ©1979 by the Amon Carter Museum, Fort Worth, Laura Gilpin Collection, no. 4210.1.

3.18 Laura Gilpin, *Changing Woman* [Petroglyph], safety negative, 1959. ©1979 by the Amon Carter Museum, Fort Worth, Laura Gilpin Collection, no. 4210.2.

that would bring rich crops to the dry and barren land. Changing Woman (fig. 3.18) "in one hand . . . holds an ear of corn; in the other, a corn tassel containing pollen; around her neck is the rainbow necklace, made from the sacred stones from the four sacred mountains—white shell, turquoise, coral, and jet" (9). In *The Enduring Navaho*, as in each of her books—*The Pueblos, Temples of Yucatan, The Rio Grande*—the interconnection of people and place, of human and spiritual spaces, is the ground upon which her composition is based and out of which it grows, an organic understanding of her work that Gilpin, also a musician, would have encouraged.

I have described the way in which Curtis's project, whatever his difficulties, was circumscribed by financial patronage of the House of Morgan and by presidential promotion; it was designed as a valuable artifact and destined for elite audiences. Not only was it tied, that is, to the vested interests and to the financial and political power of militant expansionism in the

United States, but this public and powerful support must have fueled Curtis's own sense of the importance of his work.[63] Gilpin's struggle to complete her project is another story. She began to photograph the Navajo in the 1930s while traveling with her friend Betsy Forster. Although she and Forster were in contact with John Collier Sr., the local Indian commissioner whose son would do a photo-documentary project for the FSA during the Depression, her documentation of this particular people's way of life was not of interest to federal or local government officials. Not until 1950 did this work assume a concrete shape for her: it would be a record, in pictures and text, of some forty years of change and continuity—*The Enduring Navaho*—that would take her more than eighteen years to complete. During this period, Gilpin worked with no institutional support— she was repeatedly turned down by the Guggenheim Foundation—and no prospects of publication.[64] She lived modestly, working to support herself and Betsy Forster, who was severely ill with polioencephalitis and needed constant care, by taking on small commercial jobs—portraits, Christmas cards, a photo essay on Georgia O'Keeffe for *House Beautiful*—earning in 1960 about $900 and in 1962 reporting a $350 net loss in income. Only the continuing support of the Navajo people and her own deep sense of the importance of her work kept her going. As the project neared completion, she was on crutches because of an arthritic hip joint that she blamed on years of carrying around a heavy large-format camera and tripod; she was able to work no more than a few hours in a darkroom, yet made one more trip to the reservation to get better aerial views of the Navajo's four sacred mountains. In 1968, when *The Enduring Navaho* was published, she was seventy-seven years old. The book was for Betsy—acknowledging, in the letter to her with which it begins, its coproduction during their fifty-year companionship—and for the Navajo people, many of whom she thanks by name and whose praise—"We think it is 'The Book' of all Navajo books that have ever been published" (v, ix)—was the response she valued most.[65]

Standing in contrast to Gilpin's earlier, romanticized photographs of the Pueblo and to most other photographs of the Navajo, *The Enduring Navaho* includes photographs from the entire forty-year encounter. It demonstrates change and continuity both among the Navajo and in her own work from the time she began to photograph the Navajo as Forster's friend in the 1930s to the late 1960s. Forster had demonstrated her willingness to learn Navajo ways and, although believing in the efficacy of her own nursing methods, was open to the teachings of the Navajo medicine men and to the

healing power that faith in traditional practices had in the Navajo community.[66] Gilpin learned much from Forster; her early photographs suggest empathy, but they are not yet the straightforward photographs of the later years. The 1930s Navajo pictures, which depend upon no props and whose subjects are neither photographed without consent nor paid to pose, are—like FSA photographs from the same period—above all beautiful pictures: with their play of light and shadow, some with titles such as *Navaho Madonna,* they are a particular photographer's composition.[67] Later photographs are strikingly different. Gilpin would describe not only the distance she had come in learning Navajo ways—her own process of adaptation—but also the way in which she had learned by this time to see differently. In the 1930s, in order to overcome their natural shyness or antipathy to photographs, she interested her Navajo subjects in her large view camera and gave them copies of pictures she made of them. By the 1960s, she had learned of the Navajo that "their [own] powers of observation are photographic" (20), and she took it as a sign that real encounters took place when, as a gesture of courtesy and respect, she offered them either money or a copy of the photograph and "always . . . the Navajo took the picture."[68] As she worked on *The Enduring Navaho,* Gilpin would carry along a mock-up of the book with high-quality photographs; she would sit quietly, letting them decide whether and how to be photographed.

The term *encounter* is one Gilpin used in her descriptions of people with whom she interacted. In her forty-year relationship with the Navajo, she was aware of the time "it takes . . . to make friends. There are some regions where other photographers have spoiled it for me by paying very high model fees, etc. Mine come through friendship," she wrote. "By far the hardest thing on this whole job has been the building up of human relations to the point where I have such permission given. No one knows how long it takes to build this all up. Many of the pictures have taken two, three, and even more trips and visits to finally win through. On several I have made two and three trips of 500 miles to get one picture! Not very practical but all a necessary part of the picture as far as this book goes, and it all has to be right, no 'set ups' and as complete in the Navaho story as possible."[69] Recalling my earlier definition of *encounter*—an exchange between self and other in which the voice of the other is heard, not a threat to be reduced or an object that I give myself to know in my capacity as knowing subject, but that which constitutes me as an ethical being—we can see how appropriate this term is for Gilpin's project from the journal she kept during the years

she was working on *The Enduring Navaho*. Introspective entries and reflections on her own values—such as "A related atom is the building stone of nature. A lone human being is the destroyer of values; a related human being is the builder of individual and social peace"—demonstrate her profound sense of identification with her subjects.[70]

I have described the way in which Curtis's photographs immediately seem artful, their subjects mysterious and remote. That Curtis's images strike one first as "art" has to do with his use of Pictorialist techniques—the soft focus, for example, which creates a kind of mist between subject and viewer that translates into distance in time and space—and with the camera's focal length, usually either uncomfortably near or too far away, that defines a subject, identified only by type, as something to be studied up close or as something remote. Curtis tended to portray the Indian body as related shapes in a composition or—shrouded or bared, costumed and decorated, with a fetishizing focus on the adornments of squash blossom hairdo, feathers, nose rings, earrings, necklaces—as exotic. The unpictured presence of the photographer—and the closure of the narrative—intervenes and prevents me from participating in his story. Gilpin, in contrast, acknowledges her own outsidedness: she presents us with something that is clearly *not* a scientific document; her voice signals that she is no expert, that she is willing to wait a very long time to hear, more distinctly, the voice of the other, which comes slowly through a native interpreter. At the same time, her own inherence is felt in every photograph—not as an interfering mediator, not as stage director and choreographer, but as an identifying presence.

This *embodied* nature of vision is what Donna Haraway calls "situated knowledge": not the "leap out of the marked body and into a conquering gaze from nowhere[,] . . . the gaze that mythically inscribes all the marked bodies, that makes the unmarked category claim the power to see and not be seen, to represent while escaping representation[,] . . . signif[ying] the unmarked positions of Man and White," but a doctrine of "embodied objectivity." Whereas vision has been tied to the power structures of militarism, capitalism, colonialism, and male supremacy, which distance "the knowing subject . . . in the interests of unfettered power," Haraway argues, *embodied vision*—a kind of feminist writing of the body—is a way of reclaiming this sensory perception in order to "construct a usable, but not an innocent, doctrine of objectivity." All Western cultural narratives about objectivity, she insists, are allegories of mind and body, of distance and re-

sponsibility. The "feminist objectivity" she calls for comes from "limited location and situated knowledge, not . . . transcendence and [the] splitting of subject and object." This way of knowing, described here in terms of feminist science, is what I have called, in humanistic terms, "encounter." Recognizing that there is no unmediated photograph or passive camera obscura in scientific accounts of bodies and machines but only highly specific visual possibilities, each with a wonderfully detailed, active, and partial way of organizing worlds, Haraway argues that "all these pictures of the world should not be allegories of infinite mobility and interchangeability, but of elaborate specificity and difference and the loving care people might take to learn how to see faithfully from another's point of view, even when the other is our own machine."⁷¹

Gilpin's projection of self in her work may be ascribed, as Sandweiss sensibly argues, to the photographer's sense of history and tradition, her own attachment to the land, her understanding of the direct connection between hardship and the creation of art, and her own need to adapt to a world of rapidly changing values. I believe, however, that there is another dimension to Gilpin's narrative: another story moves in counterpoint with the story of the Navajo, and that is the story of her love for Betsy Forster.⁷² Gilpin learned to love the people Forster loved. The book in which they figure as subject begins with the return of an elderly woman to the place where she and Forster began. "I can see us now," she recalls of their first vacation trip to Arizona in her letter to Betsy with which *The Enduring Navaho* opens, "sitting in the old Buick [with an empty gasoline tank] wondering what we should do. . . . We were in the middle of a vast semidesert; visibility in every direction was fifty miles or more, but we saw nothing, not a distant hogan, nor a horse, nor a flock of sheep—just empty land." The story of the two women begins, then, exactly as Gilpin would begin her story of the Navajo. She must learn to read and understand the land in which she found herself. "Leaving you, . . . I set forth on foot. . . . I remember meeting a Navaho man and a little boy in a wagon. . . . I tried to talk to them, but they spoke no English. . . . [T]he man shook his head; then, reaching for something under a canvas in the wagon bed, he handed me three cool, delicious peaches." She follows this sensuous image—this gift— with another that takes her back to Betsy and establishes the connection between her friend and the Navajo. Finally reaching the trading post and then returning with the trader's wife and the gasoline, she finds Forster "completely surrounded by *Navaho Indians,* like a swarm of bees about a

honeysuckle." Later, when Forster had accepted a position as field nurse to the Navajo, in her visits Gilpin would witness "the response of the Navaho People to your attitude toward them." When there were no more funds for her work during the Depression and Forster had to leave, her best friends among the Navajo arrived to watch the packing, "stood, bowed their heads, and wept in unison." The letter ends with the later eighteen-year journey the two women made together, hunting for old friends after a more than thirty-year lapse. "As a tribute to our long and happy friendship," Gilpin writes: "this is your book" (v).

The book is a kind of fugue: there is a synchronous movement between the subject and countersubject that made me turn repeatedly, while reading *The Enduring Navaho,* to the dust jacket to study the photograph of Laura Gilpin (fig. 3.19). I see a somewhat heavy and smiling woman with short white hair, drop cloth draped over one shoulder of a loose, light-colored blouse, one hand on her hip, the other on her view camera mounted on a tripod: the photographer at work. She is as close to me here as most of Gilpin's subjects (the frame stops about at her waist) and named—*Laura Gilpin*—in the same way as *May Adson* and *Irene Yazzie* (fig. 3.20) are named. Like the working hands of the photographer, hands in her photographs do work: they tool silver and shape pots; they card, spin, weave, and operate sewing machines (fig. 3.21); they hold a paintbrush or a cigarette, are poised above typewriter keys, hold syringe to medicine bottle, or gently touch a child's forehead. Faces, often caught in conversation or at work, express friendship, worry, concentration, introspection. There is a sense of weight to the bodies: bodies are in close contact with other bodies; fingertips touch; a woman puts her hand to her throat (fig. 3.22); the sagging breasts of an old woman are heavy against her shirt; a man squats on

3.19 Earnest Johansen, *Laura Gilpin,* n.d., safety negative. ©1979 by the Amon Carter Museum, Fort Worth, Laura Gilpin Collection, no. III.

.20 Laura Gilpin, *Irene Yazzie, Pine Springs*, safety negative, 1952. ©1981 by
he Amon Carter Museum, Fort Worth, Laura Gilpin Collection, no. 4235.1.
.21 Laura Gilpin, *Daisy Tauglechee, Hand Study*, safety negative, 1955. ©1979 by
he Amon Carter Museum, Fort Worth, Laura Gilpin Collection, no. 4291.2.

the ground, the weight of his body felt in his lower legs, the roughness of
the earth through his stockinged feet. A key dangles from a traditional
skirt: the Navajo wear handmade and machine-made clothes, beads and
eyeglasses; their hair, covered or not as they prefer, is often white and strag-
gly like Gilpin's (fig.3.23).

Gilpin recalls that when she and Forster returned to Red Rock after
thirty-three years, no one recognized them. She produced her portfolio
and pointed to a picture made in 1932 in Hardbelly's hogan with Forster
at work. The Navajo shook their heads. "My grandmother ["Mrs.
Hardbelly"] says this is not the nurse, she had dark hair," a young boy told
them. "Tell your grandmother she did too," was Gilpin's reply. Recognition
broke through, she writes: "the old woman stood up, put her head on
Betsy's shoulder and her arms around her, and wept." Typical of Gilpin's
working methods, the resulting photograph of five generations of daugh-
ters in their summer hogan (fig. 3.24) was not made spontaneously, but
two days later, in deference to the women's wish that "we . . . come back
. . . when their clothes would be freshly washed and they would all be ready
for more pictures." Gilpin tells us what she saw: "The Old Lady [Long Salt]

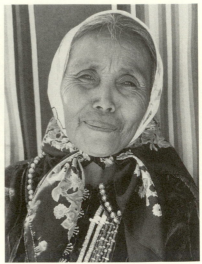

3.22　Laura Gilpin, *Mrs. Hardbelly and Sister,* gelatin silver
print, 1953. ©1979 by the Amon Carter Museum, Fort Worth,
Laura Gilpin Collection, no. P1979.128.54.
3.23　Laura Gilpin, *Mrs. Hardbelly,* gelatin silver print, 1953.
©1981 by the Amon Carter Museum, Fort Worth, Laura Gilpin
Collection, no. 4223.2.

(94, we figured, and still vigorous) sits at the extreme left . . . ; making
kneeldown bread near the fire is the Old Lady's daughter; beyond the Old
Lady, looking at my book of pictures, are her granddaughter and great-
granddaughter. The little girl in the center is the great-great-granddaugh-
ter" (31–32, 69–72).

　This is a story about history and continuity. It affirms that "the old ways
. . . [cannot] really be lost. Another generation will want to know all those
things that their grandparents can tell them"; it affirms that, in her con-
cluding words, "their tradition will endure." And it explains why Gilpin
circles back in her book to "the return of the Dinéh to the land that was
their home" (250): her path leads from myth and ritual in the creation
story, the coming of Changing Woman to the land of the four sacred
mountains in the first of the four sections of her book; to "The Way of the
People," a description of habitation, farming methods, and crafts; to "The
Coming Way," an overview of systems of health, education, and tribal gov-
ernment in the modern world; and back to the Navajo heritage in "The
Enduring Way." Contemporary Navajo now have their own Anglo-style
classrooms and courtrooms, practice medicine in old and new ways, and

are part of traditional Navajo families. The Diné endure, in other words, because they are both "immeasurably adaptable" and tenaciously traditional. Noting the way in which "they bring to their everyday living dignity, vitality, realism, and acceptance of things as they are," Gilpin finds that "they have character, they have the ordinary run of human weaknesses, they have humor and a sense of fun, they have their own code of honor. They are tenacious. They are practical . . . they are poetical. They are capable of long hours of work, and they are capable equally of inactivity. There are many good Navajo People and some bad, dependable and some undependable, strong and some weak" (20). Rejecting generalities, however, she insists that only in stories of particular people can the Navajo be understood: stories that continue across generations: of Old Lady Long Salt and her daughters, granddaughters, and great-granddaughters (figs. 3.25 and 3.26) carding and spinning and weaving; of the old Ute Woman who is cared for by the family of Willie Lee; of Old Hardbelly—his heart condition, his sev-

.24 Laura Gilpin, *Long Salt Summer Hogan,* safety negative, 1953. ©1979 by the Amon Carter Museum, Fort Worth, Laura Gilpin Collection, no. 4250.1.

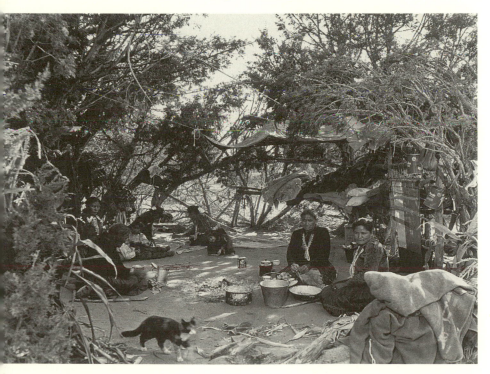

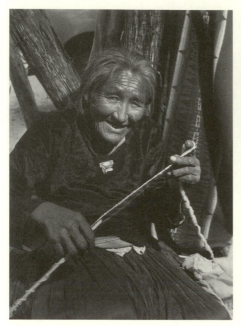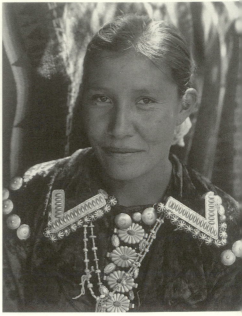

3.25 Laura Gilpin, *Old Lady Long Salt Spinning*, safety negative, 1954. ©1979 by
the Amon Carter Museum, Fort Worth, Laura Gilpin Collection, no. 4289.1.
3.26 Laura Gilpin, *Florence at Long Salt Hogan*, silver print, 1953. ©1979 by the
Amon Carter Museum, Fort Worth, Laura Gilpin Collection. Courtesy of the
Albuquerque Museum. Photograph, Damian Andrus.

eral wives, his granddaughter; or of a woman encountered in the 1930s
carrying her small son and two lambs, and twenty-five years later found
again with her husband, whom Gilpin photographed with a small boy, the
son of the boy held by his mother in the earlier picture. Through all of these
people runs a special quality, an "integrated personality," that has to do with
the way in which "simply and quietly they abide by their tradition" (23). "I
have moved the 'Tradition' section to the last," she wrote to friends while
working on the book. "Tradition is still going on and is the essence of the
Navaho, and of course with this section last, it completes the circle."[73]

"FROM A WITCH'S DISTANCE"

*Perhaps it is my love for landscape and geography that makes me want to fly. From the
air one can see so clearly the great structures of the earth's surface, the different kinds of*

mountains, the sweep of contours, the age-old erosions. In the air one becomes detached and the mind goes deep into the past, thinking of Time in depth. —Laura Gilpin, The Enduring Navaho [10]

The completed circle includes Gilpin as the teller of the tale. "While I was reading the Creation Story, my thoughts traveled to the four sacred mountains bordering the Navaho world. It was then, I think, that it occurred to me to illustrate this beautiful story with photographs of these mountains from the air," she recounts in *The Enduring Navaho.* High above the ground, Gilpin retraced in time and space the route of Navajo history (fig. 3.27)—encircling the area bounded by the four sacred mountains; then flying directly over the route of the exile march following the scorched-earth attack of Kit Carson, the Long Walk of 1864; visualizing "the straggling line of slowly moving, destitute people," some 8,500 Navajo with nothing left; and then retracing their 1868 return journey to their mesas and canyons, deserts and mountains to begin life anew. "It seemed incredible that in the course of a few hours, I could have seen so closely and so clearly practically the entire 25,000 square miles of Navaho domain, and looked down on areas where so much history had taken place," she writes. "It gave me new insight and understanding of the Navaho and their land" (10–19).

Gilpin's connection of technology to *in*sight poses a final problem that makes impossible a neat conclusion. Aerial photography as a means of documenting North American Indians' land dates from the Lindberghs' flight over Maya country in 1930 for the purpose of what we might call *over*sight, or surveillance—a technologically updated version of the survey project. But in the late twentieth century, such "oversight" is a means to art, and here I turn briefly to the work of a contemporary woman photographer whose much more extensive aerial project sheds a kind of retrospective light on Gilpin's.

"There are moments when I seem to have reached beyond everyday experiences and found a balance of emotional, intellectual, spiritual, and physical energies," Marilyn Bridges writes of the experience of flying, which, she says, lifts her into her most creative state.[74] Bridges's work on the one hand confronts modernism at its most phallocentric—Picasso's statement, for example, that "through art we express our conviction of what nature is not."[75] That is, Bridges challenges both Art and the "lack" imposed upon a submissive female nature through the power of twentieth-

3.27 Laura Gilpin, *Doko'oosłííd, Sacred Mountain of the West,* safety negative, n.d. ©1979 by the Amon Carter Museum, Fort Worth, Laura Gilpin Collection, no. 4214.1.

century technology—an airplane—which enables her to read and record signs hitherto illegible to the human eye. On the other hand, in its aim to recover the archaic by means of the methods and materials of modern technology, her project represents the realization of photography's extreme possibilities: to see and to record the secrets of the past that can never be seen, and were never meant to be seen, by the human eye. No *encounter* can take place when others are not present; this project represents a *discovery* of sacred artifacts, the audience for which is us. Bridges's sumptuous photographs adorn the pristine white walls of galleries and museums. They appear in gorgeous coffee-table books such as the 1983 *Markings,* described by the photographer as somewhere between science and art, map and picture—reminding us somewhat uncomfortably of Edward Curtis's "art-science."

Lucy Lippard, whose own work explores the political dimensions of cultural pluralism, suggests that Bridges sees herself as a kind of shaman, approaching Indian American sacred sites "from a witch's distance," great in terms of daily experience, small in terms of safety—a comparison that offers metaphors for the distance between the two cultures she spans and the way in which she focuses on values that our own society is in danger of forgetting.[76] Bridges characterizes her own photography as a way of questioning modern attitudes that have manipulated the land and its history, venerating indigenous peoples' pasts while destroying their futures and refusing to respect their present. Her intention is to give body and life to the extraordinary lines and images that she sees as a way of recovering the sort of "primitive" knowledge that comprehends intuitively the rhythm of the forces of nature. Her work, then, is not about conquest, not about recording the last vestiges of what has been destroyed, but about recovery, preservation.

That shamans could fly, or dreamed of flying, might explain the existence of lines, topographical deities, effigy mounds, and giant figures drawn or embedded in the natural landscape. Flying over these patterned fields, mythological monsters, healing sites, and sacred serpent mounds, what kind of shaman is this photographer who records these sacred marks and signs with her modern machinery? Hovering above them, Bridges captures with her camera a five-hundred-year-old intaglio such as *Fort Mojave Twins,* the top figure seventy-five feet high and the lower one, which has been ritually decapitated, slightly less; or a snaking "dance pattern" created by dancers who stood side by side and moved in a regular sequence, three-

quarters of a mile long and six feet wide—which are so large, and so incomprehensible from the ground, that they must have been intended for the hovering spirits alone.[77]

These beautiful photographs raise disturbing questions that once again invoke the ghosts of the "old masters" of landscape photography—the views of O'Sullivan, Watkins, and others—that project "a two-dimensional illusion of three-dimensional space in which something worth seeing can be seen."[78] Is Bridges's mapping of heretofore unseen sites merely a different means to the same end—the advanced technology of the airplane replacing wagon trains and mountain climbing, thus allowing her to overcome the two-dimensionality of the photograph by flying *around* the object or site? The goal of the earlier survey project—centrally funded, planned, supervised, and defended with U.S. troops—was to collect and provide *information* about a newly possessed but as yet unknown area, to produce a body of visual documents for topographical analysis and, by naming what was seen, to lay claim to the view. Bridges's photographs, however, neither document "a boundless place of isolation," a landscape "unmarked, unmeasured," nor do the work of surveying—taking measurements, making marks.[79] Rather, they record the marks of a very old landscape rich in history and myth, marks that are signs of human habitation, ritual, work, and play. Her insistence that we—as well as the threatened sacred sites—are at risk if we lose sight of these marks of the past points to a fundamental difference between the earlier survey project and her photographs of ancient landmarks. For Bridges, the peril lies in modern projects of possession and destruction, which rename and map as a precursor to the plunder and erasure of sacred sites. To re-member these marks is to be reminded of something we need to know to be able to reorder our world. Bridges's purpose is not, then, to document what is strange and exotic so much as it is to engender an imaginative retelling, or reshowing, of the familiar. We do know that what has not been seen before *can* be familiar—in dreams, in premonitions, in the buried history and myth of the archaic. It is not so much of a leap, then, to understand Bridges's intention to show —to recreate—in her picturing what indigenous cultures knew in nonvisual ways.[80]

Ancient peoples would have known the landscape's language in a way *other than visual*, Lippard suggests, reminding us of what anyone who walks a great deal knows: "there are ways of perceiving topography that are kinetic rather than directly visual. One can sense, through movement and

the relationship of body to land, a pattern that is transmitted to the brain as an image without ever being seen as a whole with the eye." Ancient peoples understood the fundamental concept of mapping, she points out; these marks and monuments are analogous fusions of the real and abstract—as in the Hopi symbol of migration represented by a spiral to the right of the mountain lion in a Blythe, California, intaglio. Working by removing pebbles to expose the light undersoil, the Pima-Papago people made an image of their protector, Iitoi, in the shape of their own bodies, and then they danced, circling across his knees and around his figure. The body of an eighty-foot-high anthropomorphic figure in Winterhaven, California, said to represent a mythological monster in Mojave lore, is crossed by a trail and marked by a cross representing the four cardinal directions. Such shapes, known rather than seen, would have been as recognizable as a Christian church in the form of a cross to represent Christ's body or a prehistoric temple shaped like the Great Goddess's body. Macrocosmic forms engraved in the land have also been found in the textiles and pottery of indigenous cultures, and perhaps marked the bodies of the makers at ceremonial times.[81]

Bridges believes that her photographs give body and life to the extraordinary lines and images that she sees. On the other hand, the very thing that offers the greatest sense of freedom—freedom from the "right side up"—can be seen as a metaphor for the power of modern humankind to see nature from every angle, from satellite surveillance to remote sensing that penetrates below the surface of the earth.[82] "When I photograph," Bridges writes, "my focus is seldom confined solely to concrete subject matter, but rather to the concrete as well as illusive matter, which is light itself. . . . Often the light dictates to me the angle at which to bank the aircraft and capture both the positive and negative structure of my image. I tilt the camera at a slight downward angle as the plane bows before the subject matter. This position enables me to cheat reality and bend the light."[83] Her words—the plane's bowing before the subject matter—are corroborated by her pictures, which insist upon keeping the scale of her subjects comprehensible as physical objects: her photograph of an Ohio serpent mound, an embankment of rocks, earth, and clay more than 1,300 feet long, 20 feet wide, and 4 feet high, built by the Adenas between 100 and 300 B.C.; of a 165-foot-long, two-hundred-year old rattlesnake in Arizona, studded with stone rattles and quartz eyes; of a molded earth bear and geometric mounds from about A.D. 650 in the Midwest, all about 3 feet high, 70 feet wide, and 100

3.28 Marilyn Bridges, *Ha-ak, Blythe Site no. 1, California,* 1981.
© Marilyn Bridges.

feet long; of the 170-foot figure in Blythe, California, the monster Ha-ak
(fig. 3.28), whose abdomen is slightly distended to the right to denote sym-
bolic pregnancy (and womanhood) but who also has male genitals. Light
sharpens the details of an excavated ninth-century Anasazi complex, which
covers nearly three acres and contains six to eight hundred rooms, and an
unexcavated Anasazi complex begun in the tenth century. In cinematic
fashion, Bridges's camera eye traces a journey through Monument Valley
and zooms in on a tiny Navajo hogan nearly dwarfed by giant hands point-
ing to the sky (fig. 3.29).

There is, however, something finally discomfiting about these beautiful
pictures—about the arrogance of a white woman's seeing herself as a sha-
man with the extraordinary power to read these ancient signs, and about
the relationship of technology to a contemporary revival of "primitiviz-

3.29 Marilyn Bridges,
*Navajo Hogan, Monument
Valley, Arizona/Utah,* 1983.
© Marilyn Bridges.

ing art" among contemporary Euroamerican artists of both sexes. Ameri-
can Indian artists do not make art that imitates ancient earthworks; nor
do they photograph geoglyphs. French Cree/Flathead/Shoshone painter
Jaune Quick To See Smith, saddened by the massive absorption of indig-
enous imagery into white "primitivizing" art, says that "White artists can
be objective about it, where Indians are subjective and not exactly sure how
to draw on their backgrounds because they are so much closer"[84] — and also
less likely to have access to airplanes.

 Photographers drawn to native artifacts insist that they are sensitive to
the issue of colonial imperialism in that they *avoid* interpretation, avoid
imposing "Western" identity on those who are "unlike ourselves." Linda
Connor writes of her photographs of petroglyphs, "I am comfortable with
not knowing. Often just the . . . placement, the energy . . . and the relation-
ship [the drawings] hold with their environment are enough for me. The
reward is delight, not information."[85] Despite the often upscale Anglo audi-
ence for the work of Bridges and other contemporary photographers
drawn to "primitive" sites and its distribution in art galleries and publica-
tions, Bridges wants us to see her images as documents, as exercises in
matching rather than making, as records of human history: marks scraped

and molded by human hands engaged in work and ritual. She instructs us to read her work not only as an aesthetic revisioning of precious relics of ancient cultures, but also to take note of the "message" her pictures send us. "My goal," she says, is "to make photos that will please those who look at them. However, I have the impression that in breaking harmony with nature, modern man is destroying his own environment. Primitive man comprehended, intuitively, the rhythm of the forces of nature, and how to accommodate himself to them. In order to survive, we must recover that knowledge."[86]

The assumptions that underlie this statement of purpose are troubling: that "primitive man" is both "our" ancestor and the opposite of modern, civilized man; that this "primitive man" categorically possessed intuitive knowledge; that this knowledge can be ours—recovered with the help of the photographer-shaman to reveal to "us" what it is we need to understand. It might be the case, however, that what fascinates "us"—Bridges's Anglo, educated, affluent audience—about these images is the opposite of intuition. What draws me deep into these mysterious photographic spaces is their sense of otherworldliness: the terrain of dreams and subterranean places hauntingly familiar and yet distinctly not the world known and inhabited. Finally, then, it is not technology itself that is troubling—although the world of surveillance is ominous enough—so much as the deeply, inevitably predatory nature of photographic consciousness: the use of the tools of the dominant culture to mark the artifacts of other cultures as *other.*

A body of work like Bridges's aerial records—or pictures—of sacred sites is itself a collection of artifacts tied to the context of making and showing, of viewing and interpreting. As my reading of these photographic projects involving indigenous peoples makes clear, the deciphering of images is also a political act—one to which I bring my own set of questions, sharpened in a particular way by thinking about Bridges's project. Finally, then, any wish to conclude my inquiry with the link between women's work and the *encounter* suggested by Gilpin's photographs runs up against the facts of historical process and the complicated intersection of gender and race, of the privileged and the disempowered. The prodigious achievement of Gilpin's mature years is, in the end, bounded by acts of discovery and conquest and well-intentioned rediscovery.

Mapping practices may draw boundaries, but real boundaries materialize in social interaction, as Donna Haraway reminds us: "accounts of a 'real'

world do not . . . depend on a logic of 'discovery,' but on a power-charged social relation of 'conversation.' The world neither speaks itself nor disappears in favor of a master decoder." Trickster is here: the figure embodied in American Southwest Indian accounts, who teaches us to "give up mastery but keep searching for fidelity, knowing all the while we will be hoodwinked." This is the kind of "feminist objectivity" Haraway argues for—one that makes room for surprises and ironies at the heart of all knowledge production—and one, I think, that Gilpin came to understand: "we are not in charge of the world."[87]

IV | Containment and Excess: Representing African Americans

It has become clear that every version of an "other," wherever found, is also the construction of a "self," and the making of ethnographic texts . . . has always involved a process of self-fashioning. —James Clifford and George E. Marcus, Writing Culture[1]

"CLASS IN AMERICAN HISTORY": FRANCES BENJAMIN JOHNSTON'S HAMPTON ALBUM

Modern sensibility moves between two seemingly contradictory but actually related impulses: surrender to the exotic, the strange, the other; and the domestication of the exotic, chiefly through science. —Susan Sontag, "The Anthropologist as Hero"[2]

Photography never lies: or rather, it can lie as to the meaning of the thing, being by nature tendentious, *never as to its existence.* —Roland Barthes, Camera Lucida[3]

In the winter of 1899–1900, Frances Benjamin Johnston, an upper middle-class white woman and professional Washington, D.C., photographer, arrived in Hampton, Virginia, on assignment. Hired by the trustees of the Hampton Normal and Agricultural Institute, she would take a series of promotional pictures, which, as part of "The American Negro Exhibit" at the Paris Exposition of 1900, would win a Grand Prix.

One photograph in particular, in which six African American male apprentice carpenters work on the "Stairway of [the] Treasurer's Residence" (fig. 4.1), has been so often reproduced that it has come to represent Johnston as well as the essence of the Hampton Institute. This image addresses the post–Civil War issue of "competency." It works both as an "index" to the real task of Reconstruction—to educate newly emancipated black slaves in order to equip them for employment and integration into

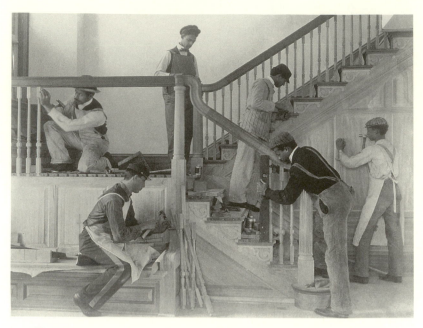

4.1　Frances Benjamin Johnston, *Stairway of Treasurer's Residence,* 1899.
Frances Benjamin Johnston Collection, Prints and Photographs Division,
Library of Congress, no. USZ62 38595.

white society—and as a representation of black youth being trained at a
model educational institution in the literal work of reconstruction. Pic-
tured as master craftsmen, and contrary to the message conveyed in the
visual arts of the time, they are extraordinarily meticulous: not a speck of
sawdust litters the surface of their workspace; not a drop of glue spatters
their clothing, from bow ties to neatly shined shoes.[4] But like the caps that
cover their "woolly" heads, these six young men are subsumed in the de-
sign they help to make. Spacing among them is as measured as the balusters
that they set in place; the angles of their bodies follow the strong horizon-
tal, vertical, and diagonal lines of the posts and railing of the staircase. This
composition becomes the subject and announces the motif of *The Hamp-
ton Album,* which is characterized most of all by its sharply focused, se-
verely classical designs.

　　This group of images is strikingly different from the work of her contem-
poraries—all Pictorialists—that Johnston assembled for the Paris Exposi-
tion as examples of women's photography and also from the way in which
her colleagues approached the issue of race. Käsebier's *Black and White* (fig.
4.2), for example, portrays a black laundress in a way that links the image

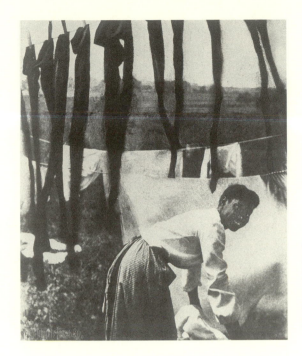

4.2 Gertrude Käsebier, *Black and White,* gum bichromate print, 1903. ©1997 by the Museum of Modern Art, gift of Hermine M. Turner.

both to nineteenth-century French paintings of laundresses and to the theme of sensuality in artistic representations of black women. The pronounced compositional structure of Käsebier's picture—the contrasts of black stockings and white sheets, black skin and white blouse, and the opposing verticals of the long black stockings and the horizontal clotheslines—is in sharp tension with the overtly sexual subject: shapely legs of the black stockings hanging on the line, toes pointing to the rounded back of the smiling black woman. In Johnston's image, any sexual tension, any disorderliness, has been subdued to the design. Stillness predominates. Although the purpose of the Hampton Institute—as a number of "before" and "after" shots make clear—was to transform the primitive, squalid, and disorderly into the improved, well kept, and civilized,[5] the absolute containment of these photographs is in itself tantalizing, perhaps because it belies what we viewers today know: that these images of inviolate tranquility at Hampton are not in fact the "after," but scenes of utopian perfection, moments of arrest.

In his introduction to the collection exhibited and published by the Museum of Modern Art in New York as *The Hampton Album* in 1966, Lincoln

Kirstein observes that this group of photographs "comprise a body of work almost inexhaustibly revealing"—but what it is that they reveal must be learned by reading around the edges, beyond the frame of each photograph and of *The Hampton Album* itself. In words that might have come from the pen of Henry James, Kirstein describes the way in which, browsing in an old Washington bookstore, he found "a plump, anonymous, leatherbound album, old and scuffed, . . . obviously . . . put together with love and care." The original album may have been bound up for presentation purposes, to interest patrons in the work of the institute, or as a record of the Paris Exhibition. It was carefully printed, from large glass plates, one image to a page, each with a thin protective sheet upon which is written a brief explanatory title. As a Museum of Modern Art exhibit catalog, the album reproduces forty-four of the original 159 plates, edited by Kirstein and Department of Photography Director John Szarkowski, who notes "the historical reality so poignantly described in Frances Johnston's pictures." In fact, Kirstein argues both that "social and historical factors outweigh purely aesthetic values" in these plates and that (because of their aesthetic value) they can be compared to paintings from the "Golden Age" of American art, especially works by the "noble and greatly gifted artists" William Sidney Mount and Thomas Eakins that depict a similarly strong sense of place and nostalgic loneliness.[6] The making of the pictures in early December 1899, when "the weather was seasonably cool and fine," he writes, and the "all but shadowless landscape, with its etched, leafless trees, gave the photographer a silvery-half light, a fine-grained taffeta shimmer that she was quick to grasp and able to render with unique subtlety and finesse," produced results that "remind one of Seurat's vibrant landscapes" (5, 4, 10, 9). In other words, whatever "historical reality" the original pictures might have depicted, this album—its pieces selected, arranged, and mediated by Kirstein and Szarkowski for exhibition in 1966—has its own reality as a work of art.

When Johnston arrived at Hampton, Virginia, in 1899, the Hampton Normal and Agricultural Institute was at the peak of its success, having grown from its original home in a leftover Civil War barracks in 1868, with two white teachers and fifteen pupils, to nearly a thousand students, a hundred teachers, and a group of impressive buildings, including the Italian Romanesque chapel in which the student body congregated for the album's frontispiece (fig. 4.3). Considering the fact that this photograph was taken indoors in December, requiring an extended exposure, Kirstein

4.3 Frances Benjamin Johnston, *400 Students in Memorial Chapel,* 1899.
Frances Benjamin Johnston Collection, Prints and Photographs Division,
Library of Congress, no. USZ62 94863.

"marvels to find how few forms are blurred—in this, or indeed in any of the
prints":

> The sea of faces, each of which in the unreduced original possesses its
> own cameo characterization, reads as if transfixed in suspended,
> breathless animation. In the front row there is the heartening neigh-
> borliness of Negro and Indian lip and cheekbone; several arrestingly
> blonde heads accent some farther ranks. How beautifully has she cap-
> tured the architectural detail, the pristine crispness of new, well-laid
> brick (fired in their own kiln); how well she maintains the balance
> between exterior and interior light, the outdoors streaming through
> the pierced tracery of the central supraporte; the tactile plasticity of
> mouldings; the pearly reflection of the electroliers. Every student is
> caught in unstrained ease: dignity, not stiffness. (9)

Every student is indeed "caught," not in "unrestrained ease," but "trans-
fixed," as Kirstein elsewhere notes, "frozen," suspended "like flies in am-

ber"—"almost, but not quite entirely—believable." It is precisely this qual-
ity of haunting stillness that makes these images seem like pieces from an
old photograph album and gives them their "translucent air of history" (11,
10). The effect of the extreme stillness suggests more than Kirstein's nostal-
gic version of "history": it is indicative of the kind of photographic equip-
ment Johnston was using, but beyond that, the exaggerated quietness and
cooperativeness is so striking as to make one wonder what went on behind
the carefully staged scenes.[7]

Calling viewers' attention to the prim pinafores and starched blouses,
Kirstein observes that "no hair ribbon is out of place, no boot unshined." In
an important contextual reading of these pictures, Laura Wexler points out
the work that went into this appearance: Hampton graduate Booker T.
Washington recalled in his autobiography the students' frantic struggle "to
get all the shoes shined, all the buttons buttoned, all the many pieces and
parts of the Victorian costume presentably assembled—sometimes even to
get the shoes to wear and the buttons to button in the first place, while
'struggling with a poverty that prevented their having the necessities of
life.'" It is precisely this knowledge that seeps through the cracks of
Washington's address to a white audience and, as Wexler notes, so often
"heaves his sentences awry"—and *our* knowledge that seeps between the
spaces and around the edges of these "almost inexhaustibly revealing" im-
ages. Johnston's camera shows "nothing of such exertion except its out-
come. She portrays the scene that she enters as already fundamentally
composed. Her task . . . was to arrange the students in orderly rows and
graceful groups. Their task . . . was to present themselves in the first place in
such a way that she would be able to arrange them" (10).[8]

Struck by the balletlike image of the black carpenters at work on the stair-
case, I, too, was in an old bookstore when I discovered *The Hampton Al-
bum*. Mine was not the plump, old leatherbound album so lovingly de-
scribed by Kirstein, but the slim, chaste, paperbound museum publication,
which, if less sensuous in its making, offered the photographs themselves
for my own private and continuously troubled reflections. The museum
has, of course, made these images available, but the mediation of its spon-
sorship weights the very artfulness of these beautiful pictures against the
situation they represent—in 1900 and in 1966—and with which they are at
odds. This artifact contains within its making a series of multilayered sto-
ries told, like Washington's, for the benefit of the viewer—of the promo-

tional purpose, the Paris Exposition, the Museum of Modern Art exhibit, and for the viewer who, a century after their making, meditates upon these images in the light of the failure of what they seem to have promised. This is not to suggest that the photographs *lie,* but rather that they pose questions of moral ambiguity that cut deeper than the question of whether or not the subjects were arranged for the benefit of the photographer.[9] Like ethnographic writings that are "fictions," as James Clifford and George Marcus suggest, both in the sense of "something made or fashioned" and in the sense of "making up, of inventing," this visual document, in its continuous reshaping for presentation, is all the more a kind of cultural fiction that "may involve silencing incongruent voices," "translating the reality of others," and "excluding 'irrelevant' personal or historical circumstances" through the use of "expressive tropes, figures, allegories that select and impose meaning."[10]

One of these cultural fictions is the narrative of "progress," which works by the selection of similar detail in pairs of before-and-after sequences: the placement of objects of use or value, for example, or the location of trees relative to the house or of fences enclosing the yard where the well is located. In *The Hampton Album,* five of the six photographs so paired build the role of observer into activities that would normally be private. The first two picture family meals: *The Old Folks at Home* (fig. 4.4), showing a family in their simple cabin, is made into a kind of primitive Vermeer, the light from the window burnishing the pots and cans and vessels lined up with loving exactness atop the cupboard and carefully covered mantle-piece; *A Hampton Graduate at Home* (fig. 4.5) is staged in a carpeted and dimly lit room that includes a framed print of the Rocky Mountains, a shawl-cov-

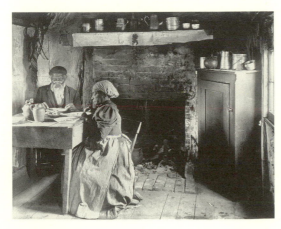

4.4 Frances Benjamin Johnston, *The Old Folks at Home,* 1899. Frances Benjamin Johnston Collection, Prints and Photographs Division, Library of Congress, no. USZ62 61017.

4.5 Frances Benjamin Johnston, *A Hampton Graduate at Home,* 1899. Frances Benjamin Johnston Collection, Prints and Photographs Division, Library of Congress, no. USZ62 38150.

ered piano topped by decorative objects, and a linen-covered table set with silver and matching dinner service, at which a prosperous black family is formally seated—except for the youngest, who has vacated his place to stand facing the camera. In *The Old-Time Cabin* the activities of wood splitting, conversation, and in the distance, transporting goods in a loaded wagon take place in front of a rustic cabin with door askew, roof shingles loose, and yard unswept. *A Hampton Graduate's Home,* with two young women in starched white pinafores displaying their bicycles on the lawn in front of their spacious two-story house, resembles photographs taken by itinerant photographers (such as the Howes brothers of New England) of both black and white families at the turn of the century. The third set pictures the activity of drawing water, first from an old well and then from an improved well on the property of the Hampton graduate: in the first image, a mother and three children wait in a garbage-strewn yard, bounded by an uneven and partly broken fence, for their cooking utensils to be filled from the old well with its makeshift ropes and poles; in the second, a neatly dressed young man demonstrates to two girls in crisp pinafores, protectively enclosed by the regular and close-fitting slats of a new fence, how to pump water from a modern well. "One man's life is another man's spectacle," Barbara Kirshenblatt-Gimblett writes of objects of ethnographic study. "Such exhibitions 'stage the back region,' thereby creating a new front region."[11] That is, staging areas of life that would normally take place in nonpublic spaces—eating, drawing water—transforms the simplest events of everyday life into activities to be performed for an audience. Reading around the edges of these pairs of pictures, *we* viewers not only get

the didactic message of before ("primitive") and after ("civilized"), but also understand the difference between *them* (on display) and *us* (with our own private "back regions").

Other, more subtle images make the same point: activities at the Hampton Institute are pictured as temporal steps in the civilizing and Christianizing process—linked in founder General Samuel Chapman Armstrong's descriptions of his work and intended to teach former slaves self-sufficiency. At the Whittier School—named for the abolitionist Quaker poet who was one of the institute sponsors and whose works were the subject of study in a literature class for midlevel students—primary classes learn the virtues of patriotism, cleanliness, and order; they salute the flag, identify plants, wash and iron their clothes, and learn about Thanksgiving in New England.[12] Students of the middle class sit in rapt attention for a slide lecture on the geography of the cathedral towns (fig. 4.6), sketch agricultural and seashore scenes, and study arithmetic, botany, and mechanical drawing. Older students participate in musical and athletic groups, learn about history by viewing a cannon at Fort Monroe, and study the physics of the cheese press as well as the practical work of butter making. Two of the images are specifically about spatial delineation. In *Arithmetic—Measuring and Pacing* (fig. 4.7), a group of young women in front of a classical building, defined by the proportional relationship of its components, mark with yardsticks distances that correspond to body paces—to the appropriately measured movements of proper young women in tight-fitting corsets, long skirts, and restrictive shoes. In *Trade School—Mechanical Drawing*, a group of young men in military dress work with compasses and T-squares, the angles of their uniformed standing bodies squared with desktops and

4.6 Frances Benjamin Johnston, *Geography Lesson*, 1899. Frances Benjamin Johnston Collection, Prints and Photographs Division, Library of Congress, no. USZ62 59188.

4.7 Frances Benjamin Johnston, *Arithmetic— Measuring and Pacing,* 1899. Frances Benjamin Johnston Collection, Prints and Photo-graphs Division, Library of Congress, no. USZ62 94864.

stands, with the square room's beams and window frames, and with the angular model house in the background, apparently the goal toward which they work in their diagrams. All of these images are about measurement and pacing: bodies are positioned singly or grouped, standing or seated, according to well-understood regulations. From the proportions of cathedrals to the measurements of swine and cattle, from the mixing of fertilizer to the rituals of serving dinner, regular patterns are at the core of the learning process at Hampton. But the last picture of a student at work (fig. 4.8) makes clear that Hampton was intended to "teach Negroes to become better workers, not political activists," as Armstrong assured his southern white constituents:[13] a black maid in a black dress, white apron, cap, and cuffs is part of a beautiful design in an elegantly proportioned room with heavy dark furniture and moldings set off by the white cloth on the dining table—a perfectly trained servant under the watchful eye of the country's founding father.

Armstrong argued that, in their present state, the former slaves represented a danger to southern society. Hampton Institute was designed to correct the "improvidence, low ideas of honor and morality" in the black race. He saw "the black man's chief problem" as his "passivity" and proposed a system of "tender violence" to "rouse him." The black man needed above all to acquire "habits of labor," he wrote. "Improvidence and laziness must be overcome by some propelling force; hence the manual labor feature of this school." His goal was "to make of them not accomplished scholars, but to build up character and manhood."[14] Students' lives were programmed from "rising bell" at 5:15 A.M. to "light's out" at 9:30 P.M., a Hampton trustee pointed out. They attended chapel twice daily and per-

formed manual labor that was intended to teach them Christian virtues. Male students, required to wear uniforms, were organized into a cadet corps that marched to classes and meals; each student and his room were inspected daily. Women students were differently regimented: closely supervised by teachers and dormitory matrons, they "were taught to cook and sew, to set a proper table, to acquire all the graces that would make a good housewife—or housekeeper." The school's intensive program to indoctrinate its students in the proper way of life was reinforced by the example of their educated, middle-class northern teachers. That is, in appearance and conduct—in body language—Hampton students were expected to absorb and assimilate a "proper" way of life, that of their preceptors, who "stressed to their pupils the need to acquire middle-class styles of behavior, perhaps more intently than they emphasized middle-class goals and aspirations." This meant, Robert Engs notes, keeping "the little world of Hampton Institute free from contamination." Students were rarely permitted to leave campus and then only on a day that did not coincide with village market day "when the forces of corruption were about."[15]

The "lesson" of Hampton—the "purity" of the institution—and the absolute denial of subjectivity to its students in these pictures is made most explicitly clear in a photograph of an Indian in full tribal regalia posed on a platform for display to a class of African American and American Indian students (fig. 4.9). These attentive young people are grouped along one side of the room, women in Victorian dress—high collars, leg-of-mutton sleeves, long, full skirts—men in military costume. Behind the students

4.8 Frances Benjamin Johnston, *Serving the Dinner*, 1899. Frances Benjamin Johnston Collection, Prints and Photographs Division, Library of Congress.

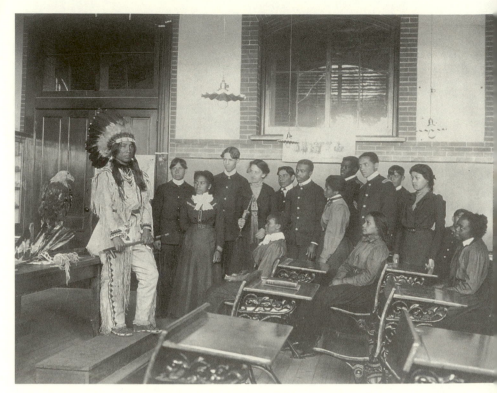

4.9 Frances Benjamin Johnston, *Class in American History,* 1899.
Frances Benjamin Johnston Collection, Prints and Photographs
Division, Library of Congress, no. USZ62 38149.

hangs a reproduction of a painting, identified by Kirstein as Frederick
Remington's U.S. "cavalry, on their rough-riding way to exterminate rebel-
lious Piute or Ojibwa" (11).[16] Behind the live, captured Indian is a glass case
in which other artifacts of "natural history" are displayed; next to him is a
stuffed American eagle. The lesson of this class in American history—which
the students demonstrate by their dress and decorum in the confined space
of the classroom—is the taming and uplifting of the primitive races. This is
presented straightforwardly, as a lesson not only in "their" history but in
"ours." And yet, across the separating space of a row of gleaming desktops
which pins the students against the background wall, as stiffly posed in
their foreign costumes as their alter image in his tribal costume, it is impos-
sible for us late–twentieth-century viewers not to read with irony these
icons of "history": the *tableau vivant* in which the live Indian poses, the
painting on the wall, the American eagle, the class at the Hampton Normal

and Agricultural Institute in training to "go out and teach and lead their people," the photograph itself in the context of the Paris exhibit and as it has come down to us in the slim volume called *The Hampton Album*.[17]

In Johnston's *Class in American History,* what seems obvious—that which has been silenced or excluded, that which is imposed or made up—is encoded within a series of layered meanings. Kirstein describes the picture in this way: posed on a model stand, "glorious as a thunderbird, isolated and strange as if he were stuffed and cased behind glass in the old Smithsonian Institution, that 'attic of America,'" the live Indian presents himself as a spectacle to his classmates and in particular to "an Indian boy, uniformed in the official Battalion blue-and-gold version of a U.S. Trooper's dress, [who] regards his blood-brother with awe." But it is not the photographer who has composed this *tableau,* Kirstein insists; she intended no conscious parody in the still life she created of the Indian on display, the "ferociously disinfected" stuffed and mounted American eagle, and the equally harmless patient students who survey the scene:

> Her subjects, within her eyes, continue their essential lives, independent of her or our observation, locked in the suspension of time, like flies in amber, but nevertheless alive in the translucent air of history. They stand as metaphor or parable in their sturdy dreaminess, their selfless absorption in self-improvement. It is a measure of Miss Johnston's vision that she enables us to spy upon so many anonymous, long-vanished individuals, who still so vividly speak to us in public of their proper private longings for a shared social paradise. Despite her camera's candor, her entire incapacity to trim or trick, we must know it was not, nor by no means yet is, any earthly heaven. But she did capture, to an almost magical degree, the better part of an historic aspiration in its innocent and necessary striving. (11)

However audacious Kirstein's assumption that through public pose he can read private desire, the "history" of this lesson (or the lesson of this history) is, in fact, none of the things he says it is: essential (i.e., unified), private, translucent, innocent. Drawing our attention to distinctions among the young men and women who are the subjects of this photograph, Wexler points out that although the students in the classroom who look at the costumed Indian with such rapt and serious attention do not explicitly take on the role of objects—they self-consciously perform for the photographer—the Indian on display looks neither at them nor at us. In

the self-enclosed subjectivity of his averted vision he outwits the camera, taking upon himself the role of object, exaggerating and deepening it so as to transcend it, making clear that if his body is captured, his spirit is free. Inasmuch as *we* stand for the original viewers—at the Paris Exposition or as Hampton Institute patrons—and thus represent both private vision and American policy, in eluding our gaze he manages to escape the official grasp as well,[18] reserving for himself some other story than the "made up" version presented here.

On the page facing *Class in American History* in the MoMA album are separate portraits of a native American young woman and young man that make clear the extent to which the pictures are not only about class and race in American history, but also encoded with notions about gender. One is identified as "Adele Quinney. Stockbridge tribe. A girl whose every physical measurement is artistically correct," the other as "John Wizi. Sioux, Son of Chief Wizi of Crow Creek, S.D." (figs. 4.10 and 4.11). As Wexler shows, they are constructed as both the same and not the same as one another. They sit successively in the same chair, against the same backdrop, and are photographed according to the same conventions of portraiture. But the caption relates the young man to his tribe, to geographical/political location, to his heritage, and by means of his father's chiefdom to the patriarchal authority of his own nation and of the larger, conquering white nation. In other words, he is an historical subject: it is possible to speculate about his history and the effect of the school upon it. Adele Quinney, on the other hand, is named as a member of a tribe, but its location, and her familial, social, or political position within that tribe, are unspecified. Identified only by data common to anthropometric photographs of the time— the correctness of her physical measurements—she is portrayed as an ahistorical racial *type,* and thus by virtue of her gender as more distinctly other than John Wizi. Looking closely at the group picture, we see that Adele Quinney appears in *Class in American History* as the last standing student on the right, and the least comfortable—her hands tense upon the desk top, her posture stiff, her gaze troubled. The outline of the girl's sleeve and the angle of her face mirror that of the costumed Indian; together, we now see, the two figures who face us in the individual portraits make a parenthesis in the group picture. The costumed Indian is John Wizi in another guise, the model Indian in more than one sense. He is kin to a long line of costumed Indians: those who traveled to Washington in hopes of preserving claims to their land and, in both native and modern garb, submitted to the cam-

4.10 Frances Benjamin Johnston, *Adele Quinney, Stockbridge Tribe,*
1899. Frances Benjamin Johnston Collection, Prints and Photographs
Division, Library of Congress, no. USZ62 86982.
4.11 Frances Benjamin Johnston, *John Wizi, Sioux,* 1899. Frances
Benjamin Johnston Collection, Prints and Photographs Division,
Library of Congress, no. USZ62 94865.

eras of John Hillers, De Lancey Gill, James McClees, and other capital
photographers; or Edward Curtis's interpreter, A. B. Upshaw, photo-
graphed in his everyday dress and as a traditional Apsaroke; or Carlisle
Indian School students—Pueblo, Apache, Navajo, Plains Indians in their
before and after incarnations, such as Tom Torlino, a Navajo, who sat at
Carlisle for the camera of J. N. Choate in 1882 and 1884.[19]

Armstrong apparently understood all that civilizing the Indians implied.
"It meant changing them culturally into Europeans, eradicating their tradi-
tional ways of life," according to Hampton professor of education William
H. Robinson, "and replacing that mode of existence with an alien one
based on binding constraints in a controlled social order. Specifically, it
meant throwing off buckskins and blanket and drawing on trousers, shirt,
and tie." In a culture that stressed the cult of the individual, it also meant
abrogating tribal relations and modes of life in order to earn a livelihood
through time-measured labor. "Instruction in American history is, as may
be imagined, somewhat difficult," Armstrong's annual report to the com-

missioner of Indian Affairs concluded in 1882, "and is further complicated for the teacher by her realization that 'there is some doubt as to how the graphic descriptions of the aborigines, with scalping knife and tomahawk, will strike their descendants and how they will relish the comments of the historian, sometimes by no means flattering.'"[20]

In *Class in American History,* Wizi stands prouder and taller—and lighter —than his classmates, all dressed in dark clothes and most of whom have dark skin. But his costumed presence, however commanding, is at the apex of a visual triangle that includes the Remington print and the American eagle, suggesting that his savageness has been tamed, and of a larger triangle that includes the print and the (official) viewer. If this photograph is constructed to imply that the Indian can be displayed because he is now locked into a particular history from which, as the closed door behind him suggests, there is no escape—as there is no escape from "civilization" for the students who regard his otherness—the dignity of the pair of portraits in figures 4.10 and 4.11 is meant to suggest the benefits as well as the totality of the transformation effected by Hampton.

Viewers are, of course, at liberty to construct other meanings. With a hundred years' distance, readers of this document are privy to the information that both the white woman photographer and the authorities who commissioned her came from a socioeconomic class well off financially and liberal in political philosophy, and also to knowledge about the two groups of displaced persons: one recently enslaved, the other brutally conquered. Although Kirstein points to the ambiguity of American Indians in military dress regarding their blood brother in full tribal regalia as a totem of their past, I find more troubling the far larger number of African American students who, as citizens in training, gaze upon the otherness of the Indian, whose history is now ennobled in contradistinction to their own, which must be forgotten.[21] The absurdity of imagining a black man or woman posing either as a former slave or as an African chieftain for a class in American history leads us to conclude that the geography classes ranged no further from these shores than Europe, that the literature classes did not include Phyllis Wheatley or Frederick Douglass, and that the subject of this history class is cultural imperialism.[22]

Together, including the Indian on display—and without ironic comment on the part of either Johnston or institute personnel—these students are placed between a paradigmatic Western image, a framed reproduction of a Remington painting, and the all-powerful American eagle.[23] "Infinitely

4.12 Mills Thompson, advertising poster for Frances Benjamin Johnston, c. 1896. Frances Benjamin Johnston Collection, Prints and Photographs Division, Library of Congress, no. J713-8769.

revealing," as Kirstein says of the collection in general, these particular photographs (figs. 4.9, 4.10, and 4.11) raise complicated questions about interracial matters, from the way in which history gets constructed, taught, and recorded to the way in which particular versions construct and empower.[24]

All of the icons in *Class in American History,* Wexler argues, have to do with patriarchal authority. She points to the way in which Johnston, who moved in prominent political and social circles, portrayed herself in rebellion against Victorian social conventions by "dressing up"—in one picture wearing a man's cap, smoking and drinking, skirts raised to show off petticoats and shapely legs; in another presenting an equally sporting mockery of Victorian decorum. In a third self-portrait, used as a promotional poster, she presents herself in the guise of the Gibson Girl or New Woman (fig. 4.12). We know that Johnston did some investigative reporting in 1892 on the Pennsylvania coal fields for *DeMorest's Family Magazine*—Kirstein calls her "a photo-taking Ida Tarbell" (53)—and that she photographed the Lynn, Massachusetts, shoe factory and illustrated Jacob Riis's story on "President Roosevelt's Children" for the *Ladies' Home Journal.* On the other hand, she accepted assignments to photograph "White House Orchids" and the United States Mint for the *Journal,* Admiral George Dewey on the flagship U.S.S. Olympia on his triumphal return voyage around the world after the battle of Manila, as well as exteriors and interiors of million-

4.13　Frances Benjamin Johnston, interior of Johnston's studio, c. 1895.
Frances Benjamin Johnston Collection, Prints and Photographs Division,
Library of Congress, no. J698-8734.

aires' palaces built by McKim, Mead & White and decorated by Elsie de
Wolfe. A photograph of her own studio (fig. 4.13) shows what Kirstein calls
"a typical Bohemian residence of the Nineties, recalling the interiors of
William Merritt Chase, complete with tiger rugs, paisley throws, Indian
basketry, a plaster Venus de Milo, Parisian posters and oriental bric-a-brac"
(53–54). Given Johnston's wide range of activity, her degree of comfort in
the socio-economic class in which she moved, and her phenomenally suc-
cessful career, it is difficult—even if one believes that a photographer's sub-
ject is always to some degree a self-portrait—to argue (as Wexler does) that
Johnston's personal challenge to traditional gender roles translates into
empathy for racial and class oppression. Clearly, her own individual desire
for independence of mind and body contrasts sharply with the subjects of
her Hampton photos so severely contained in their rigid patterning.[25]
Given the nature of her assignment, the absolute control the school exer-
cised over its students, and the students' own fragile transitional position,
the intertwining threads of race, class, and gender, insofar as agency (of
photographer, school officials, students) is concerned, are hard to disen-
tangle. What is clear, in looking at other images Johnston made, is the con-
nection between political and physical submission. When the students are
white, as in a slightly earlier group of photographs of a Washington, D.C.

school, in images with as strong a design, children are pictured in *movement*—in gymnastics classes, performing stretching exercises at their desks, riding on public transportation, or attending exhibits away from school.[26]

At Hampton, Johnston seemed to have chosen to focus on the co-educational aspects of the institute—the mixture of girls and boys washing and ironing in the kindergarten class, of young men and women studying geography and physics (although only women study dressmaking, only men study shoemaking, mechanical drawing, carpentry, and brick-laying)—thus approving the way in which both racial and gender "uplifting" were, for the most part, on the agenda. "The question of co-education of the sexes is, to my mind, settled by most favorable experience with the present plan," Hampton Trustee Francis Greenwood Peabody wrote, in language that recalls John Humphrey Noyes's description of the intermingling of the sexes at Oneida Community:

> Our school is a little world; the life is genuine; the circle of influence is complete. . . . If the condition of woman is the true gauge of civilization, how should we be working, except indirectly, for a real elevation of society by training young men alone? . . . In every respect the opportunities of the sexes should be equal, and two years of experience have shown that young men and women of color may be educated together to the greatest mutual advantage, and without detriment to a high moral standard. . . . Co-education, involving the normal intimacy of young people . . . [is] not only desirable, but a humanizing and elevating influence, second only to manual work. . . . "There is little mischief done when there is no time for it. Activity is a purifier."[27]

Johnston was certainly an advocate for women: she was a kind of hero to amateur women photographers who, as I have described, wrote to her from all parts of the country in response to activity on their behalf for the Paris Exposition and to her *Ladies' Home Journal* series. She also made it a point to photograph Susan B. Anthony, Ida Tarbell, and other leading feminists of her time. But as a professional photographer for hire, she also made pictures of "women of class and station"[28]—portraits that bear a strong resemblance to the work of John Singer Sargent—from Mrs. John Philip Sousa and daughters to the ladies of the Cleveland administration, from Ellen Terry among her potted plants to Alice Roosevelt Longworth posing in a tropical garden. Some of these women present themselves to the camera in celebration of traditional roles, and some, in their strength

and bearing, as "new women." Pictures in which her subjects are women of color, however, tell another story. Sitting still in their seats before blackboards and framed pictures reminiscent of Hampton, the group of black women at Snow Hill Institute (fig. 4.14) display a range of attitudes that are far from passive. The pattern Johnston composes with their hats, especially the diagonal slant of the one in the center, and with their dark and light clothes, is in tension with the restlessness of their bodies, emphasized by the fact that they are squeezed into children's school desks, and with their uneasy awareness of the photographer's intrusion: three of the women in the foreground, one of whom sits with statuelike stiffness, avert their eyes, and the fourth glares with outright hostility.

The Snow Hill photograph (which Johnston did not publish) is contemporary with portraits in black publications of African American women as "New Negroes" and with the elegantly dressed and formally posed woman in the dinner table portrait of the Hampton graduate. Surely the point is the way in which *class* in American history informs issues of both race and gender. There is a world of difference between the refusal of the black cook at Hampton—"Uncle Tom"—to sit for his photograph and the way in which Hampton Institute students displayed their "put on" whiteness (or middle classness) for the photographer. Helen Ludlow, a Hampton teacher, described the "coal-black genius" who presided over the kitchen:

> He has a quick, bright eye and a decidedly Roman profile, and as he stands at the kneading trough, with his paper cap on his little grizzled head, and the charcoal shadows of his handsome little face startlingly intensified by some comically high lights of flour, he makes a picturesque figure which I should have liked to add to the illustrations of this article, but no persuasion could induce him to have his picture taken. He seemed to have some strange superstitious dread of the operation, and after chasing him into the depths of a dark cellar, whence he was brought with suspicions of tear tracks on his powdered cheeks, our artist was obliged to give up his persecutions. "You knows, missis, I'd jess do anyfin fur de General [Armstrong], but I can't have no pictur' took. Loisa, she's wanted my pictur' afore now, but I done tell her no. I doesn't 'prove ob picturs. I don't want to look at no picturs. Uncle Tom will die jess as he is, an' be forgot. Don't want no pictur' took."[29]

4.14 Frances Benjamin Johnston, *Snow Hill Institute,* cyanotype, 1902.
Frances Benjamin Johnston Collection, Prints and Photographs Division,
Library of Congress, no. J694-536.

Whether Tom feared that the camera would penetrate the "Uncle Tom-
ness" he put on for his white employers or simply refused to have his pos-
turing captured ("Uncle Tom will die jess as he is, and be forgot"), his re-
fusal contrasts sharply with the enforced mimesis at Hampton Institute
that carried over into what Henry Louis Gates calls the creation of the New
Negro (both male and female) between 1895 and 1925 as "a mythic figure in
search of a culturally willed myth." The New Negro, he writes,

> was a paradoxical metaphor that combined a concern with history and
> cultural antecedents with a deep concern for an articulated racial heri-
> tage that would establish once and for all the highly public faces of a
> once-subjugated but now proud race. This figure, which combines
> implicitly an eighteenth century vision of intellectual utopia with
> nineteenth century ideas concerning optimistic progress, climaxed by
> the end of the nineteenth century in the dream of a self-made, coher-
> ent, and powerful identity signified by the upper case "Negro" and
> the belated introduction of the adjective "New." The paradox of the

self-willed beginning of the New Negro is that the "success" of this image depended fundamentally upon self-negation, upon turning away from the labyrinthine memory and societal patterns of the enslaved "old" negro, offering in his place the register of a "New Negro," a self-sufficient, powerfully creative, black self.[30]

The word "self-made" is striking here, given the enormously coercive mechanisms at work in places like Hampton; but these terms—"self-willed beginning," "success"—so familiar in white Euroamerican mythology, and the instrumentality they represent had a particular meaning for struggling former slaves. If his doppelgänger was represented by "Uncle Tom," the New Negro was perfectly represented in the person of Booker T. Washington, who, after his graduation from Hampton, wrote of the great eagerness with which students entered into their "civilizing" process. "One day, while at work in the coal-mine, I happened to overhear two miners talking about a great school for coloured people somewhere in Virginia," he recalled in 1900:

> As they went on describing the school, it seemed to me that it must be the greatest place on earth, and not even Heaven presented more attractions for me at that time than did the Hampton Normal and Agricultural Institute in Virginia. . . . I resolved at once to go to that school, although I had no idea where it was, or how many miles away, or how I was going to reach it; I remembered only that I was on fire constantly with one ambition, and that was to go to Hampton. This thought was with me day and night.[31]

In 1900, Washington's portrait would be featured as the frontispiece for the volume he compiled with Fannie Barrier Williams and N. B. Wood, *A New Negro for a New Century.* "The progressive life of the Afro-American people has been written in the light of achievements that will be surprising to people who are ignorant of the enlarging life of these remarkable peo-ple," the introduction states. *A New Negro* features portraits of black men and women abolitionists, soldiers, artists, and members of the "progressive" class (fig. 4.15) who, among other things, formed such self-help institutions as "Colored Women's Clubs." The word "progressive" is deliberately and repeatedly used to suggest upward mobility and to counteract the restrictive dialogue within which the black man or woman's "capacity" was, at its worst, determined by cranial measurements, Mrs. Booker T. Washington

4.15 Unidentified photographer,
Mrs. Booker T. Washington, from
A New Negro, 1900, compiled by
Booker T. Washington, Fannie
Barrier Williams, and N. B. Wood.
Photograph, Edgar Sabogal.

pointed out in an essay on "The Club Movement among Negro Women,"
citing Frances Allen Watkins Harper's lines, "There is light beyond the
darkness, / Joy beyond the present pain; / There is hope in God's great
justice / And the Negro's rising brain."[32]

Despite the unprecedented emphasis in *A New Negro* on black histories
written by black historians, Gates finds the "New Negro's" relation to the
"Old Negro" problematic because the past "is buried beneath all of the
faintly smiling bourgeois countenances." He especially objects to the no-
tion that the black woman was at the center of the New Negro's philoso-
phy of self-respect, as Fannie Barrier Williams argued in a 1902 essay. "To
feel that you are something better than a slave, or a descendant of an ex-
slave," she wrote in "Club Movement among Colored Women," urging the
displacement of racial heritage with an ideal based on sexual bonding, "to
feel that you are a unit in the womanhood of a great nation and a great
civilization, is the beginning of self-respect and the respect of your race." In
an essay in *Voice of the Negro* entitled "Rough Sketches: A Study of the Fea-
tures of the New Negro Woman," Professor John Henry Adams Jr., agree-
ing with Williams's assessment of the central role of the African American
woman in the movement, reproduced seven sketches of ideal "New Ne-
gro" women so that other women might pattern themselves after these
prototypes.[33] In dress, posture, bearing, these women pose as Victorian la-
dies—as grown-up versions of the young women pictured in *The Hampton
Album,* or as versions of white women whose images appeared in the popu-
lar press of the dominant culture. But note the tension between the image

of a seductive woman in décolletage, hands on hips in provocative posture, and its restrained caption (fig. 4.16): "An admirer of Fine Art, a performer on the violin and the piano, a sweet singer, a writer mostly given to essays, a lover of good books, and a home making girl, is Gussie."[34]

The resistance to stereotype signaled by this sketch suggests the complexity of the question of "putting on" the garb and attributes of the other. Michael Taussig, who has written at length on the subject of mimesis, insists that "alterity is every inch a relationship, not a thing in itself," and that when those who are subjugated in a colonial relationship choose to "put on" the attributes of their colonizers, the reasons, and the results, are not always what "we" expect. When the Cuna put on Western gear, for example, they are covering their inner, Cuna, "secret": "Not only is the healer copying the look of the West (imitation); he is also putting it on (contact). *In putting it on* he is establishing physical contact with the West, the touch, the feel, like putting on a skin. . . . [T]he mimetic faculty bears exactly on

4.16 Unidentified photographer, "Gussie," from John Henry Adams Jr., "Rough Sketches: A Study of the Features of the New Negro Woman," *Voice of the Negro* (August 1904). Photograph, Edgar Sabogal.

this crucial matter of *bringing out* the spiritual power of images that material things stand in for." The interpreting self is thus grafted into the object of study: "the self enters into the alter against which the self is defined and sustained."[35]

In the case of Johnston's photographs, it is difficult to know how much willfulness and what sort of motives to attribute to the Hampton students who posed in their new clothes, or, on the other hand, to determine to what degree the photographer went beyond her assignment in presenting her subjects with an empathy shaped (or distorted) by liberal politics or through the lens of her own rebellion against the strictures of Victorian society. As for viewing these images, however—for surely they were made with an audience in mind—one can imagine entering the American Pavilion at the Paris Exposition in 1900, "conceived in the style of a majestic Pantheon . . . surmounted by a cupola of 20 metres topped by an American eagle which seems about to launch itself to conquer the world."[36] In all likelihood, this would be a white Euroamerican gazing upon these images of mimesis and alterity—at Johnston's photographs included in "The American Negro Exhibit." In that case, the images would have seemed to express a kind of "truth," or at least a commonly held belief "in the innocence of the United States." As Rebecca West wrote of the European view of America in that year: "We ['progressives'] fondly believed that the black man's sufferings were over now that the North had won the Civil War, and that the Red Indian was still better off if he were in tutelage to the white man." But the kind of stasis these images present would have been totally out of keeping with what Henry Adams perceived at the Exposition as a time of "abysmal fracture" between a world of unity, in which things were fixed and certain, and one of multiplicity and chaos. Both Adams and West noted the dichotomy between the arts at the Exposition, "which looked backwards rather than forwards," and new inventions such as X-ray photography, wireless telegraphy, frozen air, and automobiles.[37]

As one of the few African Americans attending the exposition, on the other hand, one could review the American Negro Exhibit as a "social study"—a "treatise on Negro progress and present conditions." In the twelve-foot-square exhibit, shelves contained books and pamphlets from Hampton and Tuskegee Institutes, as well as Howard, Fisk, and Atlanta Universities; from Hampton, cabinets displayed "150 of the finest photographs to be seen anywhere in the exposition." It was the general opinion that "nowhere had the photographer's lens been so eloquent and impres-

sive in the story of a great work silently narrated." According to Thomas Calloway, an associate of Booker T. Washington at Tuskegee Institute, until this exhibit,

> there was little serious effort to compile information upon the personal characteristics of one race as compared with another, yet few questions are so constantly before the mind. . . . [T]he question of race, the capabilities of this or that race, its industrial genius, its organic ability, its intellectual capacity, integrity, etc., all form the subjects of discussion in every degree of society from the legislatures that enact laws separating races or restricting them, to the workingmen who make rules to exclude a race from membership in their trade unions for reasons of organic policy. . . . Whatever other message the exhibit may convey the one which seems to me most important is that we should avail ourselves of every opportunity to put before the public . . . evidences of our progress.[38]

The reality that awaited most of these students, however, would make of what Hampton represented, and what Johnston photographed, if not a deliberate falsehood, then "a myth on the eve of its explosion," one in which the school officials, the students, and the international audience at Paris were all complicit, Wexler suggests: "the individualized, small-scale, low-capital, unmechanized operations that Hampton taught—the kind of work that would fit easily into a pastoral setting—was in actuality outmoded almost as soon as it was learned." In the years after the pictures were made, black farmers all over the South would lose their land in a rapid downward spiral, while those who migrated north would find a market for their skills not as independent small businessmen, but as an increasingly degraded industrial workforce. "A generation after the Civil War, it was evidently much more attractive," she writes, "to believe that contemporary black life was like life at Hampton than to attend to evidence of catastrophic social disintegration such as the rising incidence of lynching and other racial violence during and after the Reconstruction era."[39] Wexler is, of course, right about the relation—or lack of relation—between the reconstructed image of the African American and the failure of Reconstruction. Yet Hampton Institute was a great success in some ways, and Johnston's photographs must have helped to make it so. It was financially secure; in terms of reputation, its work was heralded by both northerners and southerners; and in terms of results, its graduates, sought by school

systems throughout the South, were teaching nearly ten thousand black children by 1880. Moreover, the public image that Armstrong carefully created, and that we see in these promotional photographs, contrasted sharply with some of the results of a Hampton education. In other words, we should be wary of a *counter*-essentializing history that also denies subjectivity to these black students—who went out from Hampton to a variety of careers and political postures, some of which were hardly consonant with the insti-tute's public philosophy and its training for manual labor.[40]

By 1920, the affirmation of the "New Negro" was fundamentally at odds with the image espoused by Booker T. Washington at the end of the nineteenth century. The "New Negro" was one who realized that "labor is the common denominator of the working class of the world. Exploitation . . . [is] the common denominator of oppression everywhere," W. A. Domingo argued. The "New Negro" has "grievances against those who profit from the present system which operates against the interests of all workers"; he "speaks the language of the oppressed" and defies the "language of the oppressor." Although so militant an attitude would have been unacceptable to white Americans and problematic for most black Americans in 1920, its under-current was strong in the 1960s when the Museum of Modern Art published its cool *Hampton Album*. MoMA's artistic presentation was, in fact, exactly the sort of vehicle through which, as Gates argues, white Americans could at last embrace the Negro: "ahistorical" and "'just like' every other American, a Negro more deserving than the Old Negro because he had been reconstructed as an entity somehow 'new.'"[41] If the "reconstruction" to which Gates points is a denial of history, the *Hampton Album* documents the historical moment of that reconstruction. Made, assembled, and used for exhibition originally, in 1900, and in 1966, the display of these pictures assumed an audience for whom the images would have the status of trophies of imperial conquest. At the same time, this collection records the very process of colonization: the other transformed into the same, the other's mimicry of the civilized.[42] This polarization of self and other, which the neat sets of persistent oppositions in Johnston's photographs make clear—white/black, civilized/savage, seen/unseen—is, then, what makes them so disturbing in their perfect tranquillity. Historical documents, by the authority of the Museum of Modern Art transmuted into art, their visual framing exactly represents what is contained: the potential of dark and unruly transgression beyond hegemonic social constructs.

PICTURING AMERICAN TYPES:
DORIS ULMANN AMONG THE GULLAHS

The Negroes hold fast to the old ways and beliefs acquired by their forefathers through years of experience. . . . Undisturbed by the machine age, they live close to the earth which feeds them, free from the fear of starving in the midst of plenty. . . . [T]hey find happiness in the present instead of looking for it always in tomorrow. —Julia Peterkin, Roll, Jordan, Roll[43]

In the early 1930s, a wealthy New York woman would arrive in the Appalachian mountain villages of Kentucky and Tennessee in a tightly packed Lincoln driven by a German chauffeur, with an attached baggage car containing her camera equipment—an 8-by-10 and a 6H-by-8H view camera, about ten boxes of glass plates, a large box of liquids and trays for developing, and a bolt of cloth for darkening her hotel room—along with many containers of clothing and food (she had an ulcer and could not tolerate the mostly fried local food). Her entourage included a man in a Chevrolet, a rugged mountain man and a collector of Appalachian folk ballads, who took her into remote places to photograph, carried her equipment (she was a small woman with a bum knee) and sometimes her person over the rough places. The photographer, Doris Ulmann, wore long dresses that were "particularly attractive to the female-persons she encountered in the South," her companion John Jacob Niles recalled. "She wore filmy summer dresses because she said she suffered from the heat of our southern states. The local women, particularly the ones who lived far from the towns and high roads, loved her lacy summer things and would touch the cloth, admire the way it was sewn and put together." Declining her offer of a similar dress, "what pleased them most was a proposal to let the original dress be worn sometime"—although no one ever took her up on the idea.[44]

Ulmann's sense of herself as a pictorial recorder of "folk" cultures predates the work of New Deal photographers: she died the year before Walker Evans, Dorothea Lange, Arthur Rothstein, and others began to document the nation's poverty for the Farm Security Administration. But as a young woman her liberal disposition would have been encouraged by Lewis Hine, with whom she studied (before he turned to photography) at the Ethical Culture Society in New York. Her pictorial sensibilities were shaped by Clarence White at the Teacher's College of Columbia University (where she also studied law and psychology) and then at the Clarence H. White School of Photography. This combination of temperament and

training resulted in images of rural craftspeople in traditional societies that Ian Jeffrey has aptly characterized as "pastoral documentary." That is, Ulmann worked in the tradition of Hine's portraits of immigrants and child laborers—finding "jewels in a swine's snout"—but like the Pictorialists (and later documentarians) she eschewed Hine's modernist celebration of men and machines in the thirties.[45] Unlike the FSA photographers, Ulmann was not concerned with effecting social change—her work looked to the past rather than to the future—but rather with recording "a lasting memory of certain aspects of American life."[46] Less interested in poverty than in what Hamlin Garland called "passing types" of rural communities—"sturdy primitive types," "American types"—Ulmann loved most, as Niles put it, to photograph

> the old mountaineers with white whiskers, the patriarchal types, and their ancient wives, though she also made many photos of young men and women and their endless children. It was, however, in the faces of the old men and women that she saw what attracted her the most— the care and trouble of their lives, but also the ultimate serenity. . . . They actually seemed to have been waiting for her. Inside their dark cabins they would be working at the spinning wheel, the younger women sitting at the loom or carding wool for the older ones. The children might be pulling weeds in the tobacco beds or later in the season, when the crop had been cut, gathering flines to be tied later in small bundles and sold with the rest of the crop. All these things fascinated her. These were the people she wanted to record for posterity. She feared they were disappearing.[47]

What could the encounters have been like between these Arcadians who "put on their grannies' linsey-woolsey dresses," produced "spinning wheels and portions of looms and some wool-cards" from attics and lean-tos, and "that white angel with the black eyes," as a "Negro" laundress who did up a fresh white dress for her every day referred to her,[48] or as Ulmann's subjects imagined themselves, wearing one of her filmy dresses? Because the unlikely transactions produced stunning results. The empathy Ulmann clearly felt for and communicated to her subjects distinguishes her intention of preserving these descendants of seventeenth and eighteenth-century settlers of English and Scots-Irish descent as authentic American primitives. Her subjects—individuals—apparently welcomed her in the way the villagers in Sarah Orne Jewett's Dunnet's Landing looked forward to visitors.

One woman whose portrait she made (*A Venerable Dunkard of the Shenandoah Valley*) lived in a "little house [that] seemed vacated for the day as I came along," Ulmann recalled:

> Walking to the kitchen door I heard the water kettle simmering, which was evidence of her presence somewhere in the place. Walking up the path I saw her approach in a sunbonnet and with a pail on her arm. She greeted me: "I have been expecting you," and said she would go in and change her dress. When she came out she had on her lovely Dunkard dress and cap.[49]

Ulmann was not part of the network I have loosely defined as descending from Käsebier and associated with Cunningham. Unlike the other women of this study, Ulmann did not have to earn her living: she never accepted money for her portrait studies of literary, artistic, and political celebrities (nor did she pay the backcountry folk who posed for her), and her only photographic assignments were of her own devising. By 1926, the index of *Pictorial Photography in America* described "Doris Ulmann [as one who] collects quaint and unspoiled types in remote places, before they are jazzed out of existence."[50] As with Lange and Gilpin, studying at the White School would have put Ulmann in touch with Käsebier, though the older photographer's work is not mentioned as an influence upon her own.[51] Like Cunningham's and like Gilpin's, her earliest photographs were Pictorialist depictions of young women dressed in long, filmy dresses in wooded settings. Like them, she abandoned this tradition for portraiture, but she did not relinquish it entirely. Although a noticeable urban influence was discernible in Appalachian communities by the 1930s—in the availability of mass-produced consumer goods such as candles and soap, for example—with the help of her subjects Ulmann constructed *tableaux* that recreated traditional activities. Folk singer Jean Ritchie recalls that when Ulmann visited her family in eastern Kentucky in 1933, Ulmann had a clear idea of what she wanted to photograph. She would ask about specific details and then arrange people and props in a place and manner that could be photographed to her liking. An entry in Niles's diary describes an incident in Pine Mountain, Kentucky, in which Ulmann had Wilma Creech wear a dress brought out of storage for a picture with a spinning wheel. In another photograph, a woman holds a dulcimer that is not in fact a traditional instrument, but a larger, embellished one belonging to Niles and used by him in performance.[52]

Ulmann went to South Carolina in 1929, the first of three trips she was to make to the area, to work with Pulitzer Prize winning novelist Julia Peterkin (for *Scarlet Sister Mary*) on a project based on the lives of Gullah Negroes who worked on Peterkin's farm, the Lang Syne Plantation near Fort Motte.[53] Their collaborative book, *Roll, Jordan, Roll,* published in 1933, predates a spate of books of pictures and text by Depression-era photographers and writers, beginning with Margaret Bourke-White and Erskine Caldwell's *You Have Seen Their Faces* in 1937. Unlike Bourke-White's images of the black poor in physical postures of extreme dependency—lying, sprawling, crouching, kneeling, huddling; often deformed or grotesquely distorted—a perspective that reinforces relationships between the powerful reader/viewer and the powerless victim, Ulmann's series about black workers in the employ of a wealthy white woman deals obliquely with the issue of power. But in her focus on the "Old Negro" she in fact situates her subjects back some sixty years, in positions of extreme dependency upon white masters. These are not just "simple folk," as Nicholas Natanson writes, describing the pastoral quality of the world Ulmann evokes: "nary a machine present, nary a machine needed."[54] Pictures (and text) mean to portray faithful, contented, and cared-for darkies who manage to preserve a picturesque way of life that is both traditional and exotic. Early in the book, a black woman is pictured ironing her white mistress's clothes (fig. 4.17); the text assures us that black workers continue to "do everything necessary for the comfort of their owners," receiving land and protection "in return for faithful work and loyalty" (9, 11, 13). On the other hand, there are several later images of a less happy chain gang, whose members, Peterkin tells us, failed to pay their poll or property tax. Ulmann makes no attempt to comment on these scenes, either by lingering upon details or by juxtaposing them in a way that would make clear the anachronism and incongruity of punishment that they represent. Both sorts of photographs of black workers living a plantation life in the 1930s under the control of their usually beneficent mistress, Julia Peterkin (reinforced by the general tone of the text) resonate against other images that represent a more private kind of existence. Wishing to document Gullah life, Ulmann set up her camera in the streets and fields, church and market, in an attempt to create in her pictures what anthropologists call "salvage ethnography": black folk baling and hoeing, fishing, eating, and praying, carrying on their traditional lives in what seems to be a state of grace.

Lang Syne Plantation was a working farm in 1929, with a main building

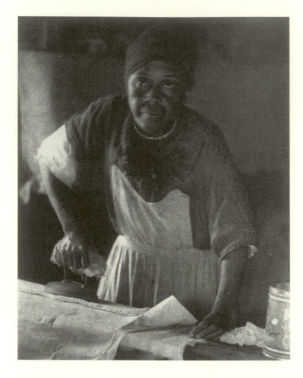

4.17 Doris Ulmann, [Woman Ironing], c. 1934. Doris Ulmann Collection. © Special Collections, University of Oregon Library, no. CNI319.

of modest dimensions and the still-standing original slave quarters in which many of the workers lived. In fact, they may have been descendants of slaves photographed by J. T. Zealy in 1850 for zoologist Louis Agassiz ("father of American natural science"), who went to the plantations surrounding Charleston and Columbia, South Carolina, to examine "Ebo, Foulah, Gullah, Guinea, Coromantee, Mandrigo, and Congo Negroes," finding enough evidence to "satisfy him [that] they have differences from other races."[55] Ulmann's purpose was pictorial rather than scientific, but for those who know the haunting daguerreotypes of Renty, Delia, Jem, and Jack, the pall of such earlier anthropometric projects colors the way we now view Ulmann's collection of "quaint and unspoiled types." At Lang Syne Plantation she made individual portraits and documented group activities, from religious traditions—foot-washing rituals, prayers and hymn singing in churches, baptism by immersion in the river (fig. 4.18)—to labor on the farm and street scenes in Charleston. She found her work "exceedingly difficult" because the lifestyle and distinct dialect of the Gullah people were so remote from her own. Her "hunt for Negro types" went slowly, she wrote to a New York friend: "The place is rich in material, but these

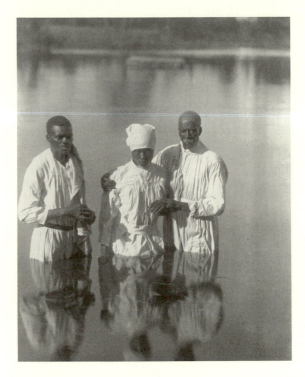

4.18 Doris Ulmann,
South Carolina, 1929–
30. Doris Ulmann
Collection. © Special
Collections, University
of Oregon Library, no.
CN1333.

negroes are so strange that it is almost impossible to photograph them. So this is rather a strenuous affair and then I do not feel satisfied!"[56]

The difficulty Ulmann encountered had to do in part with a very real language barrier. Peterkin reproduced, in her version of their dialect, a number of stories told by local characters, noting that Gullahs use their limited English vocabulary with economy—one gender serving for three, singular and plural disregarded along with tenses—"while Gullah tongues wrap around words in a way that makes them unintelligible except to trained ears" (23). Moreover, as Lorenzo Dow Turner was to note in his pioneering study of 1949, *Africanisms in the Gullah Dialect,* "The Gullahs say that they have fared so badly at the hands of strangers that they are suspicious of anyone they do not know very well." Black himself, it took Turner a long time to get the Sea Islanders to speak naturally to him; he discovered that the vocabulary and syntax they used with strangers differed markedly from that used with friends and relatives. Lawrence Levine suggests that this defensiveness was hardly surprising considering the denigrating attitudes of folklorists who had come among them. He cites John Bennett's 1908 study of the Gullah dialect as "a grotesque patois, . . . the

quite logical wreck of once tolerable English, obsolete in pronunciation, dialectical in usage, yet the natural result of a savage and primitive people's endeavor to acquire for themselves the highly organized language of a very highly civilized race." In Ambrose Gonzales's 1922 version: "Slovenly and careless of speech, these Gullahs seized upon the peasant English used by the early settlers and by the white servants of the wealthier Colonists, wrapped their clumsy tongues about it as well as they could, and, enriched with certain expressive African words, it issued through their flat noses and thick lips." Moreover, Ulmann certainly would have found "strenuous" the way in which Gullahs had learned to use their guile and wit as tools for confronting the dominant culture.[57]

She must have been dissatisfied as well with the final result of her work. Her long exposures, unsuited to action shots, resulted in blurred images, especially in group scenes—a problem intensified by the poor quality of the reproductions in the first edition of *Roll, Jordan, Roll*.[58] In fact, there were two books. The trade edition—the one available in libraries today—contained seventy-two images so poorly printed that in some cases visual content was unintelligible. A 350-copy limited edition with ninety hand-pulled, copper-plate gravure reproductions was released the next year, but very few copies of the better edition were in distribution before Ulmann's death in 1934. Reviewers who saw only the earlier edition noted the "deliberate overexposure . . . [that] makes in some cases for bad reproductions," pictures "so soft and vague as to be mere black blobs"; because the photographs "tell stories in their own right . . . it is a pity they don't come out more in the reproductions."[59] In his book *Doris Ulmann: American Portraits*, David Featherstone reproduces mostly images from the limited edition—for some reason not printed in the trade edition—that give a very different sense of Ulmann's project. Clearly, her purpose was not merely to illustrate Peterkin's condescending and paternalistic text, with its references to the "naturally cheerful" Negro disposition, "the ancient wisdom of their race," "their nimble feet . . . born with the patterns of dance steps," and so on (10, 12, 179). The portraits Ulmann made have another—unintended—story to tell.

Ulmann was essentially a portraitist. Group shots of the Gullahs, especially the nearly one-fifth that have to do with religious rituals, although a necessary and interesting documentation for this project, are much less interesting than her strong, disquieting, and unusually sensitive closeups of Gullah individuals. We cannot know to what extent workers on Peterkin's

farm voluntarily posed for their employer's friend. Portraits in this series reveal a tense interaction between photographer and subject: she was allowed to come close enough to frame an individual in three-quarters' view, to highlight sculptural planes and textures of face and skin and clothing against wooden window frame and burlap cotton sacking, but was prevented, by the stiffness of inward-turning postures, the averted yet marvelously expressive eyes with which her subjects protect themselves, from violating personal space. Given what she found to be their "strangeness"—or estrangedness—Ulmann focused, as she had done in her Appalachian portraits, on hands, costume, identifying props, and background as a way of revealing inner character: hands guiding a loaded wagon or weighing asparagus, leaning on a plow handle or a cane, holding a corncob pipe, a chicken leg, or a stringer of fish. In one of her softest and most beautiful portraits, an elderly woman, framed by a large and leafy vine whose branch she holds, stands against a brick wall, the crispness of stripes, of scalloped trim on her dress, of dots on her apron, of safety pin on her shoulder and brooch at her neck a setting for her luminous and meditative face (fig. 4.19). In another, the stripes, checks, and flowered patterns of a woman's clothes are muted in contrast to the wryly ironic expression on her face. In a particularly compelling image, the sharpness of form—round against angular, black against white—is played off against the intimate protectiveness of a couple (fig. 4.20). He stands, she sits, enclosed and supported by the

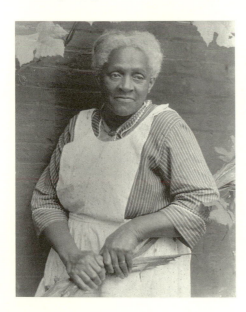

4.19 Doris Ulmann, South Carolina, 1929–30. Doris Ulmann Collection. © Special Collections, University of Oregon Library, no. CN5283.

rough wooden post and seat of a porch front. From his rounded head to her rounded hat, the viewer's eye is drawn by his downcast eyes to her downcast eyes and along the length of her body to follow the angle of her black arm against her white dress to the point where she holds, balanced on her knee, the black hat of the man behind her. His hat, and her arm and hand holding his hat, form a barrier that protects their bodies from our prying eyes. She holds his hat because with his one good arm he grasps the post behind her, encircling her. Similarly, in an image of a mother and two children (fig. 4.21), the woman makes an acute angle with her body and the long handle of a tool with which she has been working, creating a barrier behind which her children shelter, the older girl grasping the pole in imitation of her mother's gesture, the little boy nearly hidden between them. There is a marvelous dissonance between the visual pleasure of contrasting forms—light and dark, rounded and sharp, softened and crisply rendered (such as the mother's sharply angled corn rows, the daughter's similar but more softly sculpted hair)—and the sternness of the woman's averted and protective gaze, from which we traverse the triangle of pole and body, only to return to the forbiddenness of too close an approach.

What I see in these portraits is that whereas Ulmann's Appalachian sub-

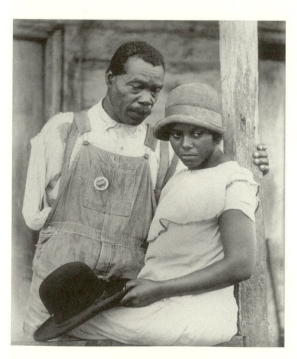

4.20 Doris Ulmann, South Carolina, 1929–30. Doris Ulmann Collection. © Special Collections, University of Oregon Library, no. CN5301.

4.21 and 4.22 Doris Ulmann, South Carolina, 1929–30. Doris Ulmann
Collection. © Special Collections, University of Oregon Library,
no. CN5839 and CN5908.

jects enter into the process of making the photograph—they pose, as-
semble props, dress up—the Gullah Negroes refuse to do so by turning
away, averting their gaze (fig. 4.22), and—with their bodies, hands, canes,
hats—establish protective barriers. Appalachian subjects who dreamed of
dressing up in the photographer's clothes could imagine trading places
with their more privileged visitor, or they could *act out* being a type. But,
by maintaining their distance, these proud and strong black subjects re-
fused to enter into the *play* of being pictured: for them the act of being
photographed was neither recreation nor drama. What they offered—or
withheld—was their perceived "strangeness"; and the way in which
Ulmann received and recorded this strangeness makes for a tension in these
portraits that is both compelling and disturbing.

"TO CATCH THE SPIRIT": CONSUELO
KANAGA'S NEGRO STUDIES

*When you make a photograph, it is very much a picture of your own self. That is the
important thing. Most people try to be striking to catch the eye. I think the thing is not to
catch the eye but the spirit.—Consuelo Kanaga*[60]

Of late she has become involved in social-significances, which I frankly believe to be detrimental to the fulfillment of her art. It is not the function of art to present Dialectics. The philosophic properties of subject material are better suggested in subtle aesthetic intention rather than in outright and obvious propagandic treatment. —Ansel Adams, "Consuella *[sic]* Kanaga" *(1933)*[61]

On November 15, 1932, the one and only exhibit of the Group f.64 photographers opened at the M. H. de Young Memorial Museum in San Francisco's Golden Gate Park. Included in the show were ten prints by Ansel Adams; nine each by the other six group members (Imogen Cunningham, John Paul Edwards, Sonya Noskowiak, Henry Swift, Willard Van Dyke, Edward Weston); and four each by invited photographers Preston Holder, Consuelo Kanaga, Alma Lavenson, and Brett Weston. "Seen together, the images established a varied but singular point of view," noted Therese Heyman in recreating the exhibit at the Oakland Museum in 1992: "For the most part, objects were seen closely, framed by the sky or similarly neutral backgrounds. Nothing was moving, and there was great attention to the finely detailed surface textures of the subjects. There was little in the photographs to suggest either the modern industrial world or the troubles of the times."[62] If not the troubles, there were certainly *signs* of the modern industrial world—Lavenson's gas tanks, Holder's rollers, stacks, and bridges —and, as Naomi Rosenblum points out, of the world of modern art. Preoccupied with "the life force within the form," Group f.64 photographers brought their lenses close to bones, eroded rocks, and driftwood; to wheels, funnels, fence posts, and house fronts; to vegetation in various stages of growth; to human faces—separating everyday objects from their surroundings, framing them whole or slicing through portions, so that these materials of their intense focus become strange and exotic. These are all techniques of modernism "proved" by the camera: a sheer pleasure in substance, texture, and pure form—what Edward Weston called "an *impersonal revealment* of the objective world . . . in the discipline of camera technique."[63] But the lack of a common point of view—even the "impurity" of the group vision—is pointed up by a few prints that seem to rebuke both Cunningham's notion of f.64 as a "western" (by which she meant California) phenomenon and Weston's notion of "impersonal revealment." These are the four entries submitted by Consuelo Kanaga, images of African Americans clearly linked to the enthusiasm for things *nègre* in Paris, especially to the interest in African sculpture in the work of Picasso and Matisse, which Stieglitz exhibited at his gallery 291. Modernist in their attention to

4.23 Consuelo Kanaga, *Annie Mae Merriweather* III, gelatin silver print, c. 1935. The Brooklyn Museum, gift of Wallace B. Putnam from the estate of Consuelo Kanaga, no. 82.65.14.
4.24 Consuelo Kanaga, *Eluard Luchell McDaniel,* gelatin silver-toned print, 1931. The Brooklyn Museum, gift of Wallace B. Putnam from the estate of Consuelo Kanaga, no. 82.65.12.

shape, pattern, and texture, these portraits reveal a deep engagement between photographer and subject that disrupts the viewer's contemplation of pure aesthetics.[64]

The 1992 exhibit at the Oakland Museum presented Kanaga's four images as *Annie Mae Merriweather* (1935), *Eluard Luchell McDaniel* (1931), *The Girl with the Flower* (Frances) (*Frances with a Flower*) (1928), and Untitled *(Hands)* (n.d.), (figs. 4.23, 4.24, 4.25, and 4.26), perhaps to offer a wider representation of her work or possibly to create a closer connection between Kanaga's images and the rest of the exhibit. Kanaga photographed Annie Mae Merriweather three years *after* the original exhibit, however. And the image of the clasped black and white hands (perhaps Kanaga's own hand, judging from a 1933 portrait made of her by Lavenson [fig. 4.27] or her own *Self-Portrait with Bottles* [n.d.]), used in 1992 as a potential indicator of "troubles of the times," is less about race relations in 1932 than it is an exercise in photographic form and technique, an abstract study in tone and contrast, shape and texture.

According to Barbara Millstein, who with Sarah Lowe put together the first thorough study of Kanaga's work, for the original 1932 exhibit Kanaga chose two photographs of the woman known only as Frances and two of Eluard Luchell McDaniel.[65] Why *these* four images? Choosing a repetition

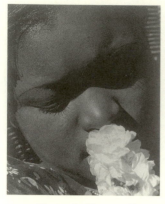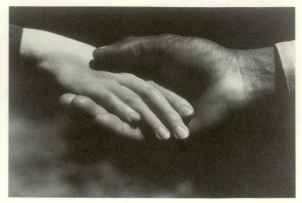

4.25 Consuelo Kanaga, *Frances with a Flower*, gelatin silver-toned print, early 1930s. The Brooklyn Museum, gift of Wallace B. Putnam from the estate of Consuelo Kanaga, no. 82.65.10.
4.26 Consuelo Kanaga, *Hands*, gelatin silver print, 1930. The Brooklyn Museum, gift of Wallace B. Putnam from the estate of Consuelo Kanaga, no. 82.65.2248.

of subject matter was not in itself unusual: Cunningham chose to exhibit multiple images of leaf patterns and succulents, Van Dyke repeated house fronts, Brett Weston presented two photographs of driftwood, John Paul Edwards offered two wheels and two chained anchors. And Kanaga's cropping, her sharply focused definition of human features at so close a range that flesh and bone become pattern, and her play with light, as in the sharply accented white flower against dark face, were perfectly in keeping with the aesthetic intentions of the other exhibitors, as was her emphasis on "the fundamental reality of things." But there is also a sense in which these four images, two and two, were a kind of spectacle in the midst of a visual manifesto of "pure photography" that possesses "no qualities of technic, composition or idea, derivative of any other art-form."[66] Kanaga made patterns from pores and rough places of the skin, sproutings of hair on an upper lip and oil at the hairline, thickened cuticles and deep finger lines. To foreclose the distance between self and other—to represent her subject as both exotic and known—was to inject into this insular exhibit an "essence" foreign and impure, disturbing to some (Adams, for example), misunderstood by others. In his review "Venus and Vulcan," William Mortensen seemed to allude to Kanaga's portraits, although he did not single out her work in describing the exhibit as so many five-finger exercises with the camera:

Rationalizing their prejudices into a definition of the aim of photography, they found it to consist in an objective rendering of fact free from any "conceptions reminiscent of other mediums." Manipulation or retouching of negatives or prints they shunned as the plague. They stressed the need of simplicity and sincerity, and the vital importance of solid technical knowledge. Their work is uniformly hard and brittle, shows technical competence, and consistently avoids any subjective interest. . . . [By] "staticism" in portraiture . . . they mean photographing a head or figure in objective terms as if it were a piece of sculpture . . . ; but . . . the Realists are betrayed by their unselective and literal rendering of details. . . . A wisp of hair out of place, a skin imperfection, an assertive pattern in the dress—and the desired static, sculptured quality breaks down into a mere conglomerate of detail.[67]

Kanaga's four images are anything but static; they are, as Millstein suggests, "confrontational and powerful." The effect of deliberately chosen imperfections and assertive patterns is not to break down the quality of sculpture so much as to accentuate and contend with it. In her *Frances with a Flower,* Frances's forehead, nose, and cheeks are highlighted by flash and dodged (underexposed) in developing to create a sharper contrast with eyes set deep in shadow. Similarly, Kanaga's use of light in the closely cropped portrait of Eluard Luchell McDaniel makes a vertical pattern of the strong upright fingers supporting his chin, his glittering eyes, splayed nose, and full lips, and gives the portrait what Millstein calls "sculptural tactility."[68]

If Kanaga was no purist in technique, unabashedly cropping, burning (overexposing), and dodging her negatives for greater effect, the eclectic

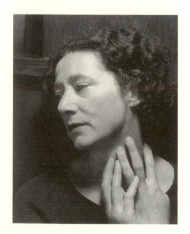

4.27 Alma Lavenson, *Consuelo Kanaga,* gelatin silver print, 1933. Courtesy of Alma Lavenson Associates and Susan Ehrens.

scope of her work must have made her inclusion in the exhibit somewhat problematic.[69] She was a friend of Cunningham, a prominent member of Group f.64, and of Lavenson, an invited exhibitor—but she was also a friend of Dorothea Lange, whose work was not included. By 1916, Kanaga was working for the *San Francisco Chronicle* covering all aspects of city life from the longshoremen's strike to society events. As a Hearst reporter in the early 1920s, she was publishing documentary photographs a decade before Lange would begin to do so. At the same time, familiar with Charles Caffin's *Photography as a Fine Art,* which appeared in 1900, and possessed of a complete set of *Camera Work,* she experimented with nuances of light and dark in her softly focused *Chinatown* and paid homage to Stieglitz in some of her New York city scenes, although other, later views of the city suggest Eugène Atget and Berenice Abbott.[70] She experimented with landscape photography while living in France and constructed a visual travel narrative from her journey to North Africa in the late 1920s. She made portraits of friends and celebrities and of black laborers in the South, exquisite still lifes and abstract designs, straight photographs of everyday objects in her home place. A master printer in both art photography and photojournalism, she also did commercial work for advertising.[71] Given the broad range of her work, she may have been included in this exhibit by purist photographers not only because of her friendship with Cunningham. Edward Weston—even though he distanced his own work from "Negro carving"—felt beholden to her or sensed that it might be detrimental to his own career to exclude her: in 1927 she had taken a group of his photographs to New York to arrange for an exhibit, and particularly to show them to Stieglitz. (The master's reaction would plague Weston for a decade, repeatedly cropping up in his *Daybooks:* "'Stieglitz seemed disappointed,' Kanaga wrote. 'He thought your technique was very fine but felt the prints lacked life, fire, were more or less dead things not part of today.'[!]")[72]

"Edward was so pure; he was a true artist," Kanaga later told Margaretta Mitchell. "I was much more interested in living. I had friends and I visited and lived and walked in the hills and stayed all night on Mount Tamalpais and did things that appealed to me." Working to support herself five days a week, she used the other two "looking for something beautiful. I would work in the direction of making a photograph that I could love."[73] Invited to exhibit her work "in that f.64 show," although "I wasn't a belonger," Kanaga could have chosen from any number of portraits, still lifes, or city scenes she had made by 1932. (The Oakland exhibit catalog includes her

San Francisco Kitchen [1930] as an example of a different sort of work.) Clearly, she selected four images that represented what she believed to be her best achievements to date. They have the most "life" and "fire," are more innovative in technique, and represent the direction she would take in her strongest camera work.

Kanaga was first drawn to racial others as photographic subjects when she traveled to Paris in the late 1920s. "Here there are no color distinctions whatsoever," she wrote (naïvely) to Alfred Bender in 1927:

> The most beautiful white women are freely seen with Negroes. I believe it is wonderful. I am sick of seeing colored men and women abused by stupid white people. How terrible to be a Negro, to have no place, as the American Negro. . . . In Paris one day I saw the first Negro. . . . He was tall and beautiful and proud and there was none of the insolence, the aggressiveness of our Negroes in America. He was like a child who knows it is welcome and loved and I must admit to see his fine tranquil face was a great joy to me.[74]

In that year she met Mahonri Young, "one of the best American sculptors in Paris" who had "interesting observations on photography," and Jean Charlot, whom she compared to Diego Rivera. She also came across a book of photographs of American types by Emile Otto Hoppé, a German photographer who had moved to London in 1907. "[He] has rather a nerve to make a book of a country he has so little understanding of, his work so lacks in feeling," she wrote to Bender, vowing to do her own book of photos of the West when she returned.[75] The Hoppé book was probably *Romantic America,* published in 1927, which included among its views of cities and landscapes picturesque "types." These examples of what a traveler might expect to find in the United States—a black fruit vendor, a cowboy, American Indians, an Hispanic guitarist, an elderly black man actually called "Uncle Remus"—isolated within their frames, cut off visually from place and from other people, as Mick Gidley shows, are constructed "as different, archetypal, even exotic"; thus, in composition and content they "constitute or affirm the ('bourgeois') viewer as an adherent of cultural norms from which such subjects deviate."[76]

The idea of the "type" was not, of course, new in 1927; it had been of interest to both artists and scientists from the inception of photography and was applied to both upper and lower strata of society, as Mathew Brady's gallery of "Illustrious Americans" and the Zealy daguerreotypes of

African slaves make clear.[77] But Hoppé's collection was contemporary with two other projects that, in time, would influence Kanaga. Winold Reiss's *Harlem Types* in a special issue of *Survey Graphic* in 1925 and Doris Ulmann's images of Gullah Negroes for *Roll, Jordan, Roll* came at an important time in her life: she had discovered books on African masks and was about to travel to North Africa, where she would settle in Kairouan, Tunisia, for the first four months of 1928. There she would make a series of images for three small albums, prototypes for projects she hoped to publish on San Francisco and the Sierra, and for later portfolios of African Americans and of New York City. Her intention was not to photograph Africans as anthropological subjects but to document *her own experience* in another culture.

Back in New York, she would write to Bender about her deepening interest in portraiture: "Strange but the more I see in portrait work the nearer I feel toward expressing myself. Now I can see how hours passed absorbing the quality of painting and sculpture abroad has given me a longing for more clear and penetrating work. I would sacrifice resemblance any day to get the inner feeling of a person."[78] The camera becomes a mimetic machine for Kanaga: a tool for discovering "myself" and the "inner feeling" of another, which are increasingly bound together, a sort of "second nature"— what Taussig calls "other ways of being identical, other ways of being alter."

The startling closeups of Frances and of Eluard McDaniel that Kanaga would make when she returned to San Francisco in the early 1930s reflect her interest in the sculptural quality of African features, her increasing identification with African American culture, and her own radicalization; but their great power derives from the way they violate conventional photographic distance between viewer and subject. It is as if Kanaga were literally trying to create the sense of *being* other by bringing herself up against the very texture and feel of black skin, in the process forcing the viewer to confront this other not as a type, not as one of a group, not from an appropriate distance, but as a sentient—and potent—being. Since this closeness is achieved with the mechanical device of the camera, however, its effect enhanced in the privacy of the photographer's darkroom, there is something of Hawthorne's Dr. Aylmer, or even Dr. Rappaccini, in her fascination with dark-skinned bodies—particularly in that, in rendering what is animate and singular as exquisitely abstract form, she transforms life into art. This is the way she saw Frances, who worked for one of her friends: "I thought she was lovely, so we got a flower and we made this photograph, and it had to be sharp to do a flower against a face like that and have it all clean and alive.

It had to be stopped down."[79] What Kanaga does in this image, in fact, is to create a tension between alive and not-alive. Frances is supine, her eyes closed: she could be lying in a coffin with the flower on her face—a flower that seems no more alive than the white flowers on her black dress. But her eyelashes shadow her cheek; there is oil at her hairline: she must be smelling the flower, closing her eyes in ecstasy—or perhaps against the intrusion of the camera eye. Frances is a study in black and white, a black mask with a white flower; or Frances, in her flowered dress, *is* a flower: we can almost smell her odor, sharper than that of the white blossom. We are privy to a moment intimate and sensuous; but after all, we see her face printed on a flat piece of paper, exhibited on a museum wall: we are having an artistic experience.

Kanaga's relationship with Eluard McDaniel, to whom she was attracted for his "sensuous, sculptural face," was more interactive and more power laden. In 1931, she and Junius Cravens, an art critic, had found the nineteen-year-old, Mississippi-born man on the beach. He had been working his way around the country on levee camps, as a bootblack, waterboy, newsboy, bellhop, and automobile mechanic. Kanaga took him home, where he would work for a number of years for her family as houseboy and chauffeur: he did everything from sweeping the porch to helping in the darkroom in exchange for room and board. At her insistence, he attended secondary school and college, where he learned to write well enough to publish several short stories. She introduced him to union and leftist activities, bringing him into the International Longshoreman's Association, where he would become a union organizer, and she would keep in touch with him when he left California to defend the Loyalists during the civil war in Spain.[80] Her pictures of McDaniel are filled with tension: he, too, is supine, and in one case, his eyes are closed (fig. 4.28). Hands to his face (as in so many of Kanaga's portraits—her own, that of two young women in Harlem with whom she lived for a time, her portrait known as *Girl with Double-Heart Ring*, her portrait of sculptor Wharton Esherick holding his own life mask) and seemingly asleep in a field, he is reminiscent of a Barberini faun, or of William Sidney Mount's indolent black in *Farmers Nooning*. Kanaga looks down at him with power *and* intimacy; as in the portrait of Frances, his closed eyes suggest both vulnerability and a way of turning off the camera. In another image his eyes are open, his gaze so direct as to suggest a disturbing familiarity; but at the same time, he seems to hold in his hands his own African mask.

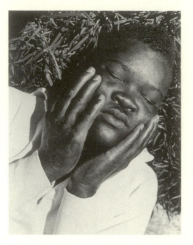

4.28 Consuelo Kanaga, *Eluard Luchell McDaniel,* gelatin silver-toned print, 1931. The Brooklyn Museum, gift of Wallace B. Putnam from the estate of Consuelo Kanaga, no. 82.65.389.

On the day after the Group f.64 exhibit opened in San Francisco, the first of two experiences occurred that Kanaga would remember as marking her radicalization. McDaniel, driving the car in which Kanaga and her sister Neva were riding, was stopped by two plainclothesmen suspicious of a "negro" in a car with two white women. They intended, they said, to establish "unwritten Jim Crow laws in San Francisco regardless of California law," and when the Kanaga sisters accused the police inspectors of "browbeating" them, the story made the front page of the *San Francisco Chronicle.*[81] The second experience had to do with Kanaga's increasing involvement in radical activities on the West Coast. Along with Dorothea Lange and Maynard Dixon, Willard Van Dyke, Lester Balog (a founding member of the Film and Photo League in New York), and others, she joined the Photo Commontors. Their only exhibition lasted one day in May 1934 before it was closed down by the American Legion, just a few days before the San Francisco Longshoreman's Association began a strike that by July would involve 150,000 workers and 30,000 soldiers, police, and vigilantes. Balog's smuggling Kanaga into a *Western Worker* newspaper office "when it was busted up" would result in the same kind of epiphanic experience Lange recounted about the making of *White Angel Breadline* a year earlier. In the midst of the riot, Kanaga managed to take two pictures: one of the circular motion of policemen's swinging clubs, the other of three policemen laid out on the ground after being felled by a longshoreman with a piece of fence. "But for this experience I might still be doing quiet portraiture," she recalled. "I was rudely awakened to the social scene. It now seemed to me the richest field for photography is history in the making, the

rhythm and tragedy of the human struggle. Here are masterpieces to be made quite different from the posed photograph."[82]

By 1935, Kanaga was back in New York, involved in radical activities of the Photo League, photographing for *New Masses, Daily Worker* and *Sunday Worker, Labor Defender,* and other radical papers, and taking a course at the Workers School on "Fundamentals of Marxism." She joined Aaron Siskind and Max Yavno on a project called "The Most Crowded Block in the World"—142nd Street and 143rd Street between Lenox and Seventh Avenues—for Siskind's *Harlem Document.*[83] Siskind recalled that "Connie loved black people," and by 1936 she was beginning to assemble a portfolio of "Negro studies" that would reflect "what experience and appreciation I have for these beautiful people." Looking for a place to live in Harlem, close to her subjects, she wrote to Bender that year, "Why wasn't I born black, I would have loved it so?" She moved in with two young black women for a few months while keeping her studio in the Village.[84] In the portrait she made of the two women (fig. 4.29), in which she portrays both their deep feeling for one another—dressed identically, they lean into an intimate embrace—and her own attraction to them, she created a deliberate or an extraordinarily coincidental copy of one of Winold Reiss's *Harlem Types,* his *Two Public School Teachers* (fig. 4.30). African American philosopher Alain Locke, editor of the series *The New Negro: An Interpretation* for *Survey Graphic* in 1925, chose Reiss—a German-born graphic artist known

4.29 Consuelo Kanaga, *Two Women, Harlem,* gelatin silver-toned print, mid-to late-1930s. The Brooklyn Museum, gift of Wallace B. Putnam from the estate of Consuelo Kanaga, no. 82.65.424.

4.30 Winold Reiss, *Two Public School Teachers, Survey,* March 1925. Collection of Fisk University, Nashville, Tennessee.

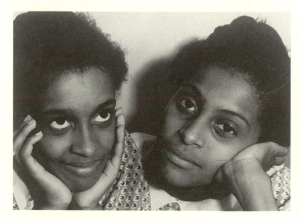

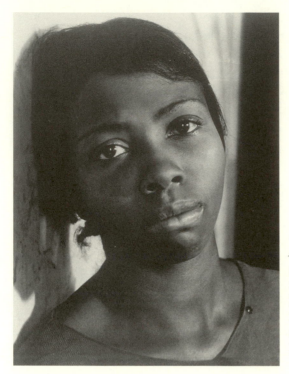

4.31 Consuelo Kanaga,
Annie Mae Merriweather,
gelatin silver-toned print,
1935. The Brooklyn
Museum, gift of Wallace
B. Putnam from the
estate of Consuelo
Kanaga, no. 82.65.379.

for his drawings of American Indians and Mexicans considered especially
good at depicting "folk character"—to illustrate this portfolio of African
American writing on the theme "Harlem: Mecca of the New Negro" be-
cause he believed that Reiss's drawings revealed "some of the rich and
promising resources of Negro types."[85]

Kanaga's re-creation of a "type," although it had the sanction of the black
community, is a complicated piece of work that needs unraveling. It is help-
ful to recall that John Berger (who, had they known one another, would
likely have been one of Kanaga's kindred spirits) has argued that the tradi-
tional function of the portrait was to confirm a subject in his or her *posi-
tion.*[86] Like Berger (in *Another Way of Telling*), in keeping with her own
deepening Marxist sensibilities, Kanaga must have seen her image making
as "confirming" or giving value to those who have been elided—also the
purpose of James Agee and Walker Evans's more famous "celebration" of
previously unrecognized Alabama sharecroppers. It was at this time that
she made her portraits of Annie Mae Merriweather for *New Masses,* one of
which, like Evans's *Annie Mae Gudger,* took on a life of its own. A portrait

of a young widow "stripped of her clothes, beaten and left for dead by these plantation owners because her husband had started a sharecroppers' union," Kanaga's *Annie Mae Merriweather* (fig. 4.31) expresses precisely the tension of thirties' documentary work. "When you look at her face," Kanaga said of Merriweather, "you can see all the sorrow and trouble in the world. And yet it's so beautiful." Edward Steichen, who exhibited one of the prints at the Museum of Modern Art, agreed, as did Carl Jung, who referred to the image as a "black madonna."[87]

Sorrow and trouble, even more than pictorialist versus modernist conventions of portraiture, are what separate Kanaga's studies of African Americans from Ulmann's photographs of the Gullahs, which she probably knew.[88] "One thing I had to say in my photography," she said toward the end of her life, "was that Negroes are beautiful and that poverty is a tender and terrible subject to be approached on one's knees."[89] Rarely does the subject of a Kanaga portrait smile: folksinger Kenneth Spencer, pictured in an ecstatic moment in 1933, a joyful young mother with her child taken in Florida in 1950 are exceptions to the way in which her black subjects face her camera with a solemnity reminiscent of Arthur Rothstein's evicted sharecroppers or Lange's ex-slaves.[90]

Kanaga and Lange, both of whom created great emotional impact in their images through what must have been an empathic bonding with their subjects, admired and respected one another's work. Both women combined art, politics, and photojournalism; both specialized in portraiture. Lange arrived at what would come to be called documentary photography via training in Pictorialism at the White School and apprenticeship to Arnold Genthe. Kanaga, who also admired Genthe, was a reporter first, but she experimented around the edges with her creative work and joined the California Camera Club, where she met Lange and discovered Stieglitz's *Camera Work,* which, she said, "changed my life." The prints were, she felt, "the most beautiful things that had ever been done in photography, and I wanted to start from there."[91] It was Stieglitz's own work that especially moved Kanaga: from close observation of his technical skill, she learned to control both the aesthetics and the meaning of her own work through cropping, scale, tone, and paper selection.[92] This was not a direction Lange pursued, and there were important differences in what we might call their photographic vision as well. Most obviously, once she finished her newspaper work, Kanaga was a free agent, unlike Lange, who in her work for the FSA had to produce quantities of images on a schedule

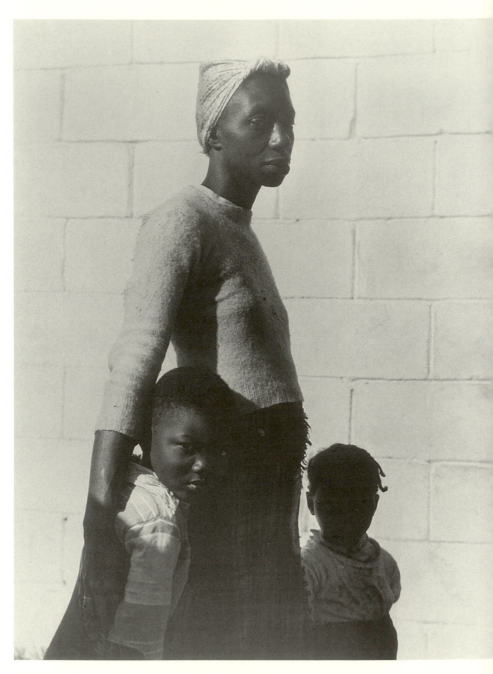

4.32 Consuelo Kanaga, *She Is a Tree of Life to Them,* gelatin silver-toned print, 1950.
The Brooklyn Museum, collection of Charles and Lucille Plotz, no. 82.65.2250.

that was not her own and to follow, her resistance notwithstanding, the "shooting scripts" Stryker sent to all of his photographers. Beyond the fact that Kanaga had no prescribed agenda, she was also less interested in context—which she rarely includes—than in visceral engagement, in bringing her subject's face into the face of the viewer. In order to accomplish this, she did not stop with the negative as composed in her ground glass, but worked endlessly with one print—like Stieglitz—until she created an aesthetic composition that satisfied her. Max Yavno remembers that she "could easily spend a week with one 4 x 5 negative" and that she taught him "to distinguish between various shades of white in different grades of illustration board."[93] The several images of Frances, for example, vary so markedly from one another, not only in facial expression, but in skin texture, in highlighted and shaded areas, in cropping, that they seem to represent different women. This is also the case in the multiple images of Annie Mae Merriweather. The one that captivated Jung is probably the one in which her polished cameo face is half set in shadow; another, more harshly lit and much more viscerally immediate, exposes her roughened skin and cracked, swollen lips; and in a third, the sides and top of her head have been radically cropped, the dark skin tones burned and the whites of the eyes and sheen along the lower lip dodged to concentrate the impact of so close a contact with this very black face.

Like Lange's *Migrant Mother*, which Stryker said was *the* image of the FSA, there is one image of Kanaga's that has become an icon: Steichen featured it in his *Family of Man* exhibit at the Museum of Modern Art in 1955 and, when asked in a television interview to choose his favorite photograph from the exhibit, said, "This is it."[94] *She Is a Tree of Life to Them* (fig. 4.32; Steichen's title) is from the second of two journeys Kanaga made to the South to work on her "portfolio of Negro studies." Her 1948 trip resulted in a number of strong images, especially of young women, among them her "Girl with Double-Heart Ring," "Child with Apple Blossom," and a series of portraits of one young woman in a white blouse, taken in full or partial profile (fig. 4.33). Most of the work on these images was done in the darkroom, darkening the girl's skin and highlighting her white blouse, hair ribbon, sheen on her skin to create a silhouette effect.[95] In two of her closely cropped faces—which the viewer confronts at rather odd angles, one from slightly above, the other from slightly below—Kanaga has managed to create images that seem to take on a tactility that defies their material essence as photographs. It is as if she has actually shaped these heads with her

4.33 Consuelo Kanaga, *Young Girl in Profile,* gelatin silver-toned print, 1948. The Brooklyn Museum, gift of Wallace B. Putnam from the estate of Consuelo Kanaga, no. 82.65.11.

hands, using a sculptor's tools to chisel, to make smooth or roughen, and in the case of the "Girl with Double-Heart Ring," to etch the lines of her fingers, polish the whites of her eyes, and burnish the metallic strands of her hair. For this viewer, these images are almost physically disturbing, not least of all because this penetration of another's personal spatial envelope causes me to imagine as my own the subject's discomfort. The images are also disturbing because they seem to propose a merging with an other while at the same time maintaining, for the photographer who remains behind her camera and works at even greater remove in her darkroom, the distance of art. It is as if Kanaga, in wishing to come as close as possible to African American *people,* is at the same time probing her fascination with the essence of blackness: in trying to recreate art that is African, she tries on the other's face, only to find that in coming so close, she has created a black mask.

She Is a Tree of Life to Them was made in Florida in 1950 when Kanaga and her husband, the painter Wallace Putnam, were guests of Milton and Sally Avery at an artists' colony in Maitland, Florida. There, Kanaga went to

black baseball games, to a revivalist church near Maitland, and to the "mucklands"—the fields of a reclaimed swampy area where migrant workers were picking crops (imaged in Zora Neale Hurston's *Their Eyes Were Watching God*) and where she made a series of photographs of Norma Bruce and her children, the subjects of this famous picture.[96] *Mother and Son* or *The Question* (fig. 4.34) from this series, in which the woman in profile against a stark white background inclines her head toward her son's uplifted face, demonstrates Kanaga's continuing preoccupation with the sculptural quality of black faces. But the viewer is at some distance from the woman's head in this case, enough to appreciate the sculpted head as art; and the effect of the woman's lowered eyes is to make the image abstracted rather than confrontational. Here, we might say, is pure "essence"—a word Roland Barthes used to describe the effect of the exhibit for which Steichen chose another image of Norma Bruce, and which traveled to Paris under the title "The Great Family of Man." Referring to the many images of mothers and children in the exhibit, Barthes asks,

in the whole mass of the human problem, what does the 'essence' of

4.34 Consuelo Kanaga, *Mother and Son* or *The Question* (Florida), 1950. The Brooklyn Museum, gift of Wallace B. Putnam from the estate of Consuelo Kanaga, no. 82.65.13.

this process matter to us, compared to its modes which, as for them, are perfectly historical? Whether or not the child is born with ease or difficulty, whether or not his birth causes suffering to his mother, whether or not he is threatened by a high mortality rate, whether or not such and such a type of future is open to him: this is what your Exhibitions should be telling people, instead of an eternal lyricism of birth.[97]

Kanaga claimed that in her conception of *She Is a Tree of Life to Them* she was influenced by the African American sculptor Sargent Johnson, but her image of a very tall and thin black woman against a white wall, children pressed against her to make a triangle of her lower body, is also reminiscent of Giacometti and Modigliani. That this image is reproduced alongside a portrait of the same woman's face in the Millstein-Lowe catalog brings to mind the two images Lange made of Nettie Featherston: the tall, thin, weatherbeaten *Woman of the High Plains;* this same woman's face, backlit, her hand shielding her eyes from the sun, exactly like Kanaga's Norma Bruce. Whereas we read Lange's images in the context of Nettie Featherston's own words (which Lange reproduces) and know the more famous image from its repeated inclusion among documents of the Depression, Kanaga's comments about her work tell us only about the subjective act of picture making. *She Is a Tree of Life to Them,* the last image in the series, was made after Norma Bruce's husband had seen and liked earlier photographs of his wife and children: "He said he didn't know she was so good looking." Kanaga recalled that as she was leaving, "I saw this potential for a beautiful photograph. And I asked her to draw the little boy closer and the little girl closer. I had her move . . . so she had this cement wall in back of her." The result was "the most—liked photograph I've ever taken."[98]

Kanaga's hesitation here conveys what is problematic about a work that goes on to have a life of its own, as this one has. If we are familiar with this image because of its inclusion in *The Family of Man* exhibit, then together with other images from that collection, we think about it as occupying a position somewhere between the conventions of high modernism and those of mass culture.[99] Since these are the two streams—art and journalism—from which Kana-ga's work flows, seeing her work in this way would not in itself have displeased her; but she would hardly have allied herself with the politics of the exhibit.

Steichen selected *She Is a Tree of Life to Them* for a *New York Times Maga-*

zine article as one of seven from MoMA's collection of five thousand prints that he considered "great from among many great works" and "proof that photography is an art just as painting and sculpture and poetry are." He saw it as a "picture [that] . . . speaks for itself! This woman has been drawing her children to her, protecting them, for thousands of years against hurt and discrimination."[100] But, we might ask, hurt by whom? In the context of the *Family of Man* exhibit, sponsored by the U.S. Information Agency and corporations such as Coca-Cola, it would have been one of many images that Steichen put together to create a metaphor of the universal family—which Allan Sekula describes as part of a discourse "explicitly that of American multinational capital and government . . . cloaked in the familiar and musty garb of patriarchy." A valuable marketing and public relations tool, the exhibit was shown in cities all over the world and especially in political "hot spots" of the Third World. In Johannesburg, for example, "at the entrance of the hall the large globe of the world encircled by bottles of Coca-Cola created a most attractive eye catching display and identified our product with *Family of Man* sponsorship"; "in the political landscape of apartheid, characterized by a brutal racial hierarchy of caloric intake and forced separation of black African families, sugar and familiar sentiment were meant to commingle in the imagination," Sekula writes. "*The Family of Man* is a virtual guidebook to the collapse of the political into the familial that so characterizes the dominant ideological discourse of the contemporary United States."[101]

To an audience of American viewers at the original Museum of Modern Art showing, the exhibit would have had a somewhat different meaning. We might even call it a "MoMA meaning"—a particular kind of universalization that the museum would take as its theme again in its 1984 exhibit, *The Tribal and the Modern,* which gathered "primitive" objects in order to demonstrate that "the tribal is modern and the modern more richly, more diversely human." As James Clifford notes, the "tribalism" selected to resemble modernism was "itself a construction designed to accomplish the task of resemblance"—especially problematic in underlining a "disquieting quality of modernism, its taste for appropriating or redeeming otherness, for constituting non-Western arts in its own image, for discovering universal, ahistorical 'human' capacities."[102]

The Museum of Modern Art and its exhibits are not, of course, the only context for these images Kanaga made, and then remade, in her darkroom.

And if Clifford is right about works gathered for this latter day "enthusiasm for things *nègre*," that they leave out the "essential link with coded perceptions of black bodies—their vitalism, rhythm, magic, erotic power" in the modernist concern only "with artistic invention," a category separable from the "negative primitivism of the irrational, the savage, the base, the flight from civilization"[103]—then Kanaga's "Negro Studies" represent something else altogether. What they are most fundamentally *about* is the vitalism, rhythm, magic, erotic power of black bodies. Moreover, in the context of her own photographs at the Brooklyn Museum exhibit of 1992 (where, the museum's director points out, the department of photography's first chief instructor was Clarence White), they stand out against her landscapes and still lifes and portraits of white friends and artists as the work that mattered most. *Why* this fascination with blackness is a question that leads to the very heart of the problem of representing otherness.[104]

Kanaga's discovery of "things *nègre*" in Paris was contemporary not only with high modernism, but in this country with "the jazz age"—a decade characterized by a white appropriation of African American music, epitomized by the film *The Jazz Singer* (1927) in which a Jewish musician, trained to be a cantor, claims freedom and power by performing in blackface. "Putting on" blackface allowed the performer "to transgress boundaries, to violate cultural taboos," Michael Rogin argues, "to speak from his own, authentically felt interior." The interracial other is "not the exotic other but the split self, the white in black face." In this film, according to Rogin, blackface *stands for* something else: like the earlier *Birth of a Nation*, in which whites played the roles of blacks in order to tell a story about the conflict between old and new ways that stood for the Americanization of immigrants present in the audience, the hidden subject of *The Jazz Singer* is the union of Jew and Gentile.[105] The subtext of blackface also intrigues Eric Lott, who argues that minstrelsy was "a mediator of northern class, racial, and ethnic conflict—all largely grounded in a problem of masculinity"; thus, to "put on the cultural forms of 'blackness' was to engage in a complex affair of manly mimicry." Both Rogin and Lott confine their analyses to the white man who appropriates the "primitive" energies of the black male body—in order, as Lott puts it, "for a time to become black, to inherit the cool, virility, humility, abandon, or *gaîté de coeur* that were the prime components of white ideologies of black manhood." Rogin's and Lott's discussions are helpful in understanding the production of *blackness* (a cultural construction) as a way of indulging in "certain dangerous moments of

pleasurable disorder" and "a titillating ambiguity" that has to do both with crossing cultural boundaries—class, racial, sexual, religious—and with opening up what Peter Stallybrass and Allon White call "the white Imaginary."[106]

In Kanaga's case, I see this "trying on" of blackness not so much in the taking of pictures but rather in her continuous playing with her negatives of African Americans in her darkroom, coming closer than would have been possible in the light, cropping and manipulating tonal values until she got to what she felt was the essence of a black face. Overlaying the issue of gender onto Rogin's and Lott's analyses of the interplay of race, class, and ethnicity that such mimesis involves leads me to speculate about what the hidden subject might be for Kanaga that is *not* "manly mimicry." At the very least, we can say that Kanaga, who lived a kind of doubleness all her life, was imagining here an alterity that allowed for the experience of private passions. A restless, energetic, sensual, bohemian woman who throughout her life formed deep, often stormy attachments to both men and women, Kanaga enjoyed playing at the margins.[107] In her picture making, she practiced two kinds of work simultaneously: photojournalism, which taught her to compose quickly, seizing from any given scene the vision of greatest emotional impact, and artistic printmaking, discovered in Stieglitz's *Camera Work,* which became, throughout her life, a process of constant and meticulous experimentation. Professionally, she was associated with antithetical photographic groups on the West and East Coasts—exhibiting in the ("pure art") Group f.64 exhibit in San Francisco in 1932 and affiliating with the (leftist) Photo League in New York in the late 1930s and 1940s—where the same images would have had different meanings. Operating always at the margins of disparate contexts must have given her both a sense of displacement *and* a certain freedom to explore alterity, through mimesis, as a means of discovering her own identity—or identities.

Playing at the margins, then, allowed her to focus on the carnivalesque—not, I hasten to add, as Diane Arbus or Cindy Sherman did or do, because Kanaga's connection to her photographic subjects was always (at least on her side) deeply empathic. I use the term *carnival* here in the sense of the spectacle as (deliberate) exposure, or in Kanaga's case, the (photographic) exposure as spectacle. The kind of exposures Kanaga made (overtly) had to do with racial difference. But the term *exposure* often signifies gender difference, carrying various sexual connotations: men deliberately expose themselves; women are "exposed" when they step outside of boundaries, are

caught out and found blameworthy. These overlapping ways of thinking about exposure in light of racial *and* gender difference lead me to speculate about whether the sort of exposure Kanaga practiced might have been a way of gaining control. Encountering this racial other with her camera as a way of embracing her mirror image might be seen as a way of containing both "purity and danger," both radical negation, silence, withdrawal, invisibility (her own) *and* the bold affirmations of feminine performance, imposture, and masquerade (her camera work).[108] Her foregrounding of black faces and bodies, symbolically and literally at the margins of the social system where they are grotesque simply in being other, was for Kanaga an affirmation: to her they were beautiful. But her exaggerated mode of presentation—her focus on *excess*—is also an expression of the "carnivalesque" precisely as resistance to and destabilization of the distinctions and boundaries that mark and maintain high culture and organized society. Her vision and her politics in this expression were not merely oppositional and reactive; rather, her work contains what Mary Russo calls "a redeployment or counterproduction of culture, knowledge, and pleasure." That is, her exposures are not simply an inversion: her work exposes the issues of containment and excess. As Russo suggests of women's masquerades generally, in these images Kanaga finds "models of transformation and counterproduction situated within the social system and symbolically at its margins." Or to put it another way, recalling Bakhtin's opposition of the grotesque body to the classical body—the latter monumental, static, closed, and sleek, corresponding to the aspirations of bourgeois individualism (as in many f.64 productions, e.g., Edward Weston's nudes)—Kanaga exposes the "grotesque" body as a way of being connected to, and separate from, the rest of the world.[109]

V | The Only Gentile among the Jews: Dorothea Lange's Documentary Photography

A photographer's files are in a sense his autobiography. More resides there than he is aware of. Documentation does not necessarily depend upon conscious themes. It can grow almost of itself, depending upon the photographer's instinct and interests. As fragmentary and incomplete as the archaeologist's potsherds, it can be not less telling. —Dorothea Lange, *Museum of Modern Art retrospective exhibit, New York, 1966*

SELF, BODY, OTHER

Photography can only operate with the directness of a physical graft; photography turns on the activity of direct impression as surely as the footprint that is left on sand. —*Rosalind Krauss, "Tracing Nadar"*[1]

"To produce out of the body of my photographs a group which will represent my photographic belief, to document and caption them decently, in order to explain my photographic existence is a formidable order," Dorothea Lange wrote to Beaumont and Nancy Newhall in 1958 as she chose pairs of photographs for their *Masters of Photography* exhibit. "I find that it has become instinctive, habitual, *necessary*, to *group* photographs. I used to think in terms of single photographs, the Bulls-eye technique. No more. A photographic statement is more what I now reach for. Therefore these pairs, like a sentence of 2 words. Here we can express the relationships, equivalents, progressions, contradictions, positives and negatives, etc. etc. Our medium is peculiarly geared to this. (I am just beginning to understand it.)"[2]

The Newhalls published this letter as introduction to *Dorothea Lange Looks at the American Country Woman* (1967), a photoessay that is a set of variations upon this theme: images in pairs—each woman, her homeplace—along with fragments of her own words, as Lange re-members

them. The "relationship" Lange intends, and demonstrates by a joining of woman and place, of image and text, includes that of the photographer-storyteller and her subjects, whose narratives are paired with her own. Thus, the "long memory" of an ex-slave is evoked by the photographer's recollective vision, as is the submerged story of a young girl, a cotton picker who "migrates with her family from crop to crop and lives under conditions of deprivation," whose persistent Anglo-Saxon line "reaches back from the western cotton fields of California and Arizona through the little settlements in the Ozarks, through the Appalachians . . . and across the Atlantic Ocean to Elizabethan England": individual life stories are presented in counterpoint with a mythic telling, an unfolding of visual and verbal patterns. Farm wives, migrant workers, daughters of Zion, women of the High Plains, the South, and the Far West are gathered as a community of unsung heroes by Dorothea Lange, a woman among them. The images in *The American Country Woman* are "photographs [that] seem to have a life-span," as Lange referred to her best work: those few that "survive, and go on functioning as images in their own right and on their own."[3] These photographs are indeed so compelling that, along with our wish to enter into the now-distant past they represent, we almost believe in them as something more than images, nearly forget to ask: whose story?

Lange believed that she was the medium, the lens, through which her subjects—anonymous, voiceless, unrepresented Americans—could tell their stories. It is their words, culled from her voluminous notes, that form the bulk of her captions for the thousands of images in the FSA files, their stories she meant to tell with her own explanations. But images that take on lives of their own, as documents or as works of art (depending on their contexts), are just that—images—separate from those other lives they represent: they are pictures. They make manifest what Lange called "my photographic belief"; they explain "my photographic existence."

At the end of her life Lange was working on two openly autobiographical projects: one was a photographic exploration of family life at their seashore retreat, Steep Ravine; the other was the retrospective exhibit at the Museum of Modern Art in New York, which opened just after her death in 1966. At a time when, struggling against painful and inoperable cancer, she wished to focus her attention on her own homeplace, to spend her little remaining time on the images of family later collected in *To a Cabin,* she reluctantly gave herself up to the MoMA exhibit, working closely with,

5.1 Dorothea Lange, *First Born, Berkeley*, 1952. ©The Dorothea Lange Collection, the Oakland Museum of California, City of Oakland, gift of Paul S. Taylor.
5.2 Dorothea Lange, *Oak Tree, Berkeley*, 1957. ©The Dorothea Lange Collection, the Oakland Museum of California, City of Oakland, gift of Paul S. Taylor.

and sometimes against photography curator John Szarkowski,[4] choosing images, grouping and captioning them, striving to create patterns of connection and meaning in her life and work. All that remains of the organic whole she meant for us to see is a much reduced and altered catalog from the exhibit of 1966, a collection of iconic images, eighty-eight of the original 209 photographs, given equal weight by their identical size and reordered so as to create quite unintended patterns and connections. But from the original list of works and photographs of the installation we can recover Lange's version. No pedantic exercise, this takes us to the heart of the story Lange wanted to tell.

That story might be called Lange's "Family of Man"[5] or "Self as Other." Inviting us to see this story as her story, she begins with a pair of photographs from home—one of her son John holding his firstborn child, the other of the oak tree outside her Berkeley, California, house (figs. 5.1 and 5.2)—and with these words:

> Time has edited these photographs, made over a span of twenty-five years. They are a product of the files. Some were made at random, by instinct, waiting on streetcorners or during expeditions to the supermarket. Some were made on the fringes of assignments. Some were

made between bouts of illness, to test whether the eye remained true and the hand steady.

A photographer's files are in a sense his autobiography. More resides there than he is aware of. Documentation does not necessarily depend upon conscious themes. It can grow almost of itself, depending upon the photographer's instinct and interests. As fragmentary and incomplete as the archeologist's potsherds, it can be not less telling.[6]

Particular stories merge into the larger one, as in the opening sequence of faces of an Egyptian, a Venezuelan, Lange's mother, and a Hopi Indian —all one group; the particulars of place, date, circumstance have meaning only as they reverberate in our memories. We are meant to embark on a life's journey with Dorothea Lange, to see what she saw, once, behind the lens of her camera, and then again as she worked with images to create patterns of resonance. Eyes mirror the camera's power to represent the "I" in *images* that now meet our gaze; bodies express sentience (figs. 5.3 and 5.4)—feet, legs, hands, backs, bodies at work, bodies under tension; groups of people come together; juxtapositions make ironic contrasts: a

5.3 Dorothea Lange, *A Sign of the Times—Depression (Mended Stockings— Stenographer)*, c. 1934. ©The Dorothea Lange Collection, the Oakland Museum of California, City of Oakland, gift of Paul S. Taylor.
5.4 Dorothea Lange, *Foot of Priest,* 1958. ©The Dorothea Lange Collection, the Oakland Museum of California, City of Oakland, gift of Paul S. Taylor.

black man supporting with his head and arms the weight of a bucketful of water/a white man in a rocker; a billboard reading "It takes 8 tons of freight to k.o. one Jap"/a group of Japanese children pledging allegiance to the U.S. flag.

Large thematic groupings—"Introduction," "New California," "Old South," "Home," a series of individual pictures, travel in Asia, Ireland, Egypt, more individual pictures—frame the central group called "Last Ditch." Here are gathered together Lange's first "social" photograph, *White Angel Breadline; Ditched, Stalled, Stranded; Woman of the High Plains;* the *Six Tenant Farmers* from Texas; *Bad Trouble over the Weekend;* the *Public Defender* series; two of later California—two wounded people, focus on their legs; a terrified horse from her *Death of a Valley* series; and in the center of what Lange must have felt to be the core of her life's work, *Damaged Child* (fig. 5.5). This image, in this series, is what the exhibit leads to; it remains in the memory to anchor the rest, including photographs of Lange's healthy grandchildren, of children in the South, in California, in Ireland, Asia, and Egypt—children who have enough food, love, care, and whole, healthy bodies.

A girl, about seven years old; behind her, a tarpaper shack, home, perhaps, in Shacktown, Elm Grove, Oklahoma. Dark and flimsy, the bends and creases of the shelter's uneven surface create a richly textured background for the very pale girl who stands or leans, aligned by the crooked part in her short hair, against the cross of its rough seams. She wears a loose shift made from a sack, knotted over one shoulder, over her open and vulnerable body, denied even the comfort of her own hands—like the hands of the "Woman of the High Plains" that touch the place of her pain, or like the protecting hands of Mia Dixon in *Bad Trouble Over the Weekend*. This child is thin, malnourished, bruised—there are signs of contusions on her left eye and cheekbone, of scars on her nose and right cheek—and damaged; her eyes, slightly squinting and not quite focused, look inward and nowhere.

To look into the eyes of this child and confront, with the clear and unflinching eye of the camera, her unmeeting gaze is to be reminded of other images of other children. This photograph echoes both backwards and forwards—to Lewis Hine's "human junk," Walker Evans's Alabama sharecroppers, Diane Arbus's grotesques, Sally Mann's vulnerable exposed children. A strange collection, dissimilar to one another, but each, in terms of "social work," aesthetic intent, autobiographical content, tangential to Lange's

5.5 Dorothea Lange, *Damaged Child, Shacktown, Elm Grove, Oklahoma,* 1936. U.S. Farm Security Administration Collection, Prints and Photographs Division, Library of Congress, no. USF34 9690E.

child. A photograph with a "life-span": one of many taken for the Farm Security Administration, filed now at the Library of Congress under "South, Children";[7] chosen to hang, framed, on a white wall of the Museum of Modern Art as a piece of a pattern that includes a member of Lange's family and these words by Lange:

> I am trying here to say something
> about the despised, the defeated,
> the alienated.
> About death and disaster.
> About the wounded, the crippled,

The helpless, the rootless,
The dislocated.
About duress and trouble.
About finality.
About the last ditch.

This damaged child, Dorothea Lange, or so it must have seemed when she chose the images for the sequence she called "Last Ditch." "With me," she said—looking back on a life circumscribed by debilitating illness, the last twenty years' activity narrowed by stomach ulcers, malaria, and finally cancer of the esophagus that left her literally starving—"it was always expenditure to the last ditch. I know the last ditch. I've lived on the last ditch."[8] But also not Dorothea Lange: in 1936, when this photograph was made, she was newly married to Paul Taylor; they were at work together in the field, he to determine the economic and social causes of poverty and dislocation, she to provide visual documents, the damaged child in the photograph uncontrovertible proof of human erosion—which Lange, having herself surmounted it, could now look at, frame, picture, make others see.

The power of this photograph lies precisely in the contradictory meanings of the layers of response to it, and of the memory—personal and national—that it evokes for each viewer and for the photographer. It is painful to look hard at this visual document, this child. But it is also pleasurable to look at this image, not only because it is a beautiful picture, but because it is not me, or not my child: empathy is possible *because* of distance, in time and circumstance. And also: coming upon this image with knowledge of the body of Lange's work (from this exhibit, from other readings and viewings) one knows something about heroism in the face of adversity, about the camera's power to arrest, picture, and transform. Finally, it is difficult to look at this photograph and not to remember the stories recounted endlessly about the woman who made the picture, legends that have grown up around her through her own retelling: her childhood polio, which left her with a damaged leg and a permanent limp; abandonment by her father when she was twelve; her mother working, leaving young Dorothea to wander about the streets alone for hours, wearing her "cloak of invisibility"; her bravado which ends up as a success story—embarking on a round-the-world tour, losing her money in San Francisco, and setting up there as the studio photographer "to whom you went if you could afford

it"; [9] her marriage to an artist twenty years her senior, in which she repeated the mistakes of her mother and grandmother; the "shock of re-cognition" that changed her life, drawing her into the street to take part in what was going on "down there"; her marriage to Paul Taylor, their work and life. We are encouraged to read these legends of Lange's life into the body of her work in a way that, with the possible exception of Diane Arbus, runs counter to the way in which we look at photographs of other makers — Walker Evans, say, or Lewis Hine (about whose lives we know very little) — a way that runs counter to the many discourses on the meaning of "documentary" and is explicitly gendered.

Damaged Child exists visually in the context of other images of despair, poverty, hunger, exhaustion, betrayal, loneliness, fear, and physical pain; *and,* in this exhibit, in the context of interconnectedness, personal and communal — to Lange's family history, and, linked by her very alienation — by posture, gesture, iconographic suggestion — to the broader human community. To viewers who lived through the Great Depression on whatever level, the *Damaged Child* must also have resonated in a particular way. Meant to be understood in terms of her damaged body, as one denied the embrace of the outstretched human arm, the shape and weight of healthy legs and feet, the healing touch of the hand, she represents the wounded body of the nation during the Depression, stands for the crippled body of the President, who, like Lange, had suffered polio as a child and who, like Lange, had surmounted his infirmity by carefully covering up its trace. [10]

Although he does not discuss Roosevelt, Michael Rogin suggests that the doctrine of "the king's two bodies" offers us a language in which confusions between person, power, office, and state become accessible. According to this seventeenth-century doctrine, "The king has in him two Bodies, . . . *viz,* a Body natural, and a Body politic. His Body natural . . . is a Body mortal, subject to all infirmities that come by Nature or Accident. But his Body politic is a body that cannot be seen or handled . . . and this Body is utterly void of Infancy, and old Age, and other natural Defects and Imbecilities." [11] Thus, Rogin argues, finding their mortal bodies problematic, certain chief executives have sought transcendent authority and immortal identity in the White House, absorbing the body politic into themselves. Conversely, to center one's inquiry on the body in pain is to focus, as Elaine Scarry does, on the extent to which the world is destroyed (uncreated, unmade) by causing pain to others whose silence renders them invisible to us.

That is, where power is equated with the disembodied voice, and power-lessness with embodied silence, a purely rational power has the potential to unmake the world. "To have a body is to be describable, creatable, alter-able, and woundable. To have no body, to have only a voice, is to be none of these things," Scarry writes. "Consequently, to be intensely embodied is the equivalent of being unrepresented and . . . is almost always the condi-tion of those without power."[12]

This damaged child suggests against the cross of the seams of the tarpaper shack, the archetypal wounded body—and the head of state, mir-ror opposites: she silent, vulnerable, made visible by Lange's picture; he a vocal disembodied presence who presides, powerfully and unseen, over the damaged body of the nation, recognized by millions of Americans who listen to his "fireside chats" on their radios.

Lange tells us that she was able to make images like this one because of "some kind of memory that the blood carries."[13] If she believed in her spe-cial ability to make visible and to represent the body of the damaged nation, it was not only because of her authorization by the federal govern-ment to do so; her assignment for the Farm Security Administration con-firmed her own sense of mission and power. She had known since she was about six or seven and had heard her grandmother say, "That girl has line in her head," meaning "that sense I had very early of what was fine and what was mongrel, what was pure and what was corrupted in *things,* and in workmanship, and in cool, clean, cleanly thought about something. I had that. I was aware of that."[14] But she also knew that:

> I was physically disabled, and no one who hasn't lived the life of a
> semi-cripple knows how much that means. I think it perhaps was the
> most important thing that happened to me, and formed me, guided
> me, instructed me, helped me, and humiliated me. All of those things
> at once. I've never gotten over it and I am aware of the force and
> power of it. I have a grandson who had a birth injury. I nearly broke
> down at that time, because I knew. . . . Cripples know that about each
> other, perfectly well. When I'm with someone that has a disability, we
> know. Especially . . . if you grow up with this thing. . . . We all have
> those things that form us. They are of what we are built; they are our
> architecture.[15]

As a photographer, Lange found that she could walk into situations as an outsider and find that "to be a crippled person, or a disabled person, gives

an immense advantage. . . . It puts you on a different level than if you go into a situation whole and secure."[16] On the other hand, "I knew how to keep an expression of face that would draw no attention, so no one would look at me. I have used that my whole life in photographing. I can turn it on and off. If I don't want anybody to see me I can make the kind of a face so eyes go off me. . . . I learned that as a child in the Bowery. So none of these drunks' eyes would light on me. I was never obviously there."[17] She used both of these methods according to Paul Taylor: "She would talk with the people she photographed. . . . She not only saw, but she heard, and she recorded both"; "she covered herself with 'a cloak of invisibility.' It made her feel that she could go up and do things which otherwise seemed to be intruding on their privacy. It gave her a feeling of confidence in working with the camera. That is what she said, to herself."[18]

Who among us learns how to keep an expression of face that will draw no attention? Women walking alone in potentially dangerous sections of town; a black person in a white neighborhood, a white person in a black neighborhood; children who do not want to be found out; pickpockets, spies, and detectives—the vulnerable, those who would gain some forbidden thing, such as knowledge, those who would reserve to themselves the right to look. "It was like saying magic to herself. 'They can't see me,'" interviewer Suzanne Riess suggested to Taylor. "That's right," he confirmed. "Just playing that they couldn't see her. Well, actually she was naturally very skillful, not playing games, not maneuvering, but just naturally skillful in her relations with people."[19]

Lange's story of her childhood is the story of the outsider learning to use this magic, this skill, to effect her own transformation: a child whose "mother would kind of like to have Dorothea conceal her withered leg . . . so that people wouldn't see it, . . . [giving her] the impression . . . that her mother was ashamed of her";[20] a child abandoned by her father; a bright child in school in a strange neighborhood near her mother's place of work, "in the ghetto of New York City where I was the only Gentile among 3,000 Jews, the only one," and where

> I fell from my perch because I couldn't keep up with them. They were too smart for me. And they were aggressively smart. And they were hungry after knowledge and achievement and making, you know, fighting their way up. Like their parents, this the children had. To an outsider, it was a savage group because of this overwhelming ambi-

tion. . . . They [other children] were all right to me. But I was an outsider. And I didn't live there besides.[21]

Walking alone from the school to the library in all seasons of the year, sitting in the library at windows that looked out on and into tenements, she "saw a very great deal":

> I could look into all these lives. All of a tradition and a race alien to myself, completely alien, but I watched. And every year, never a September comes that I don't stop and remember what I used to see in those tenements when they had the Jewish holidays, the religious holidays. In those days all the women wore *sheytls,* you know, the black wigs, and the men wore beards and little black hats, *yarmulkes.* . . . I'm aware that I just *looked* at everything. I can remember the smell of the cooking too, the way they lived. Oh, I had good looks at that, but never set foot myself. Something like a photographic observer. I can see it.[22]

She, of course, was unseen. Drawing her "cloak of invisibility" over her limp, her difference, her young female body vulnerable to the leers of drunken men in the Bowery, learning to make the eyes go off her, she could "look into all those lives." With her cloak of invisibility, she could, like the young man in "The Twelve Dancing Princesses," follow unseen and learn the princesses' secrets, dance all night with whole and strong limbs, and inherit the kingdom. Like "Cinderella," magic clothes could transform her into somebody else: the poor and damaged child of ashes is invisible to the ballgoers; they see only the beautiful princess, the prince's chosen dancing partner.[23]

Deformity, difference, keen and generous insight, as these tales teach us, can be the tools of transformation. Like a mythical hero, young Dorothea Lange sets off on a journey. She gets as far as San Francisco, where she has "an experience that affected me throughout my life": seeing Isadora Duncan dance. Attending every performance that she could possibly find a way to, she recalled later,

> I had never been taken into the upper reaches of human existence before then. . . . It was something unparalleled and unforgettable . . . the greatest thing that ever happened. I still live with that, not as a theatrical performance, but as an extension of human possibility. . . . She was a person who . . . gave a new form of something. It wasn't based on

5.6 Arnold Genthe, *Isadora Duncan in* La Marseillaise, c. 1914. ©Museum of the City of New York, gift of an anonymous donor, no.46.100.246.
5.7 Dorothea Lange, Untitled [Joan Lange Nutzhorn], c. 1915. ©The Dorothea Lange Collection, the Oakland Museum of California, City of Oakland, gift of Paul S. Taylor.

other dancers' work. You were on unfamiliar ground. There wasn't any business of it being "like something else," at least not for me. I was unprepared.

In a way, Lange *was* prepared for Isadora Duncan. In New York she had worked as an assistant to Arnold Genthe and was undoubtedly familiar with his photographs of the dancer; in fact, her own early photograph of her mother bears a strong resemblance to Genthe's images of Duncan (figs. 5.6 and 5.7). But it was seeing Duncan in motion that suggested to her *an extension of human possibility:* a woman who was "rather sloppy-looking, rather fat, with very heavy upper legs, yet with a peculiar grace, not grace as I had preconceived it, but different," who could "electrify thousands of people at once [with] . . . a minimum of physical motion."[24]

If she looked around her at the audience, Lange very likely found herself again surrounded by Jews, who in San Francisco as well as New York were to be envied. Now merchant princes at the other end of the socioeconomic scale, they were still, to her, exotic others: "This group of rich people lived a very warm inter-family life. They were large families who knew each other, and had a very strong community sense and that warm, responsive love for many things—children and education and buildings and pictures,

music, philanthropy—was their private personal life and their public life together." As Willa Cather was drawn to a Jewish family on the Nebraska prairie and in her later life was a friend of Yehudi Menuhin, Lange remembered Jewish families who "gave string quartets in their living rooms or in their drawing rooms, and they educated talent: Yehudi Menuhin is one they did, Isaac Stern is another. They did these things. They gave money freely."[25]

Now Lange could observe them *professionally*. By this time she had worked with Genthe in New York and studied with Clarence White, whose New York group of pictorialist photographers established contact with the Los Angeles Camera Pictorialists, the precursor of Group f.64. The undogmatic, heterogeneous approach of the White School—which, as noted, allowed for experimentation in subject, focus, composition, and method of printing—resulted in a range of work among the Pictorialist Photographers of America, from near abstract compositions that retained the pictorialist preference for soft focus to commercial photography, from the portraiture of Käsebier and Genthe to the "fine art illustration" of Genthe's *Old Chinatown* (1913) and to the crisp still lifes of Outerbridge and Steiner for *Vanity Fair* and *Vogue*.[26] Lange's time in New York, spent being "something like a photographic observer," "neglecting what I should be doing . . . [and] looking at pictures," now became, in the telling, an apprenticeship: "I looked and looked and looked at pictures" like those of Leopold Stokowski's hands—"I couldn't see the man; I could just see the hands. . . . Years later I read about his hands and I knew who he was! It could be no one but those hands that I saw on that winter afternoon." For someone who would always "*remember what has happened in my life through moments that I remember visually*,"[27] it was not such a great distance from Stokowski's hands to Duncan's legs, from New York to San Francisco, where she soon became part of the artistic community that included, among others, Imogen Cunningham. When she set up her own portrait studio, she would recall, "I had the cream of the trade." Her customers were "all the rich Jews of San Francisco, . . . [who] have been . . . the bulwark of art, culture, everything." In Lange's photographs from this period, there are studies of legs and hands; Jewish bodies touch, embrace, display their "warm, responsive love" to her observing camera eye (fig. 5.8). "It's odd, isn't it," she would later say, "that I who was one in 3,000 Jews . . . should have as my customers . . . nine out of ten people of that group, of whom I'm very, very fond."[28]

5.8 Dorothea Lange, *Katten Portrait, San Francisco,* 1934.
©The Dorothea Lange Collection, the Oakland Museum of
California, City of Oakland, gift of Paul S. Taylor.
5.9 Dorothea Lange, *Bad Trouble over the Weekend,* 1964.
©The Dorothea Lange Collection, the Oakland Museum of
California, City of Oakland, gift of Paul S. Taylor.

An odd story, yes, and one that goes to the core of her work as photo-
graphic *observer,* an outsider who reaches for her camera to record a gesture
of love, anger, trouble—the outstretched hand of her son John offering
flowers, the raised leg and tensed body of her stepson Ross in a fury of rock
throwing, her daughter-in-law Mia's clasped hands over a face distraught
with the misery of a failed marriage (fig. 5.9). Lange's story begins to seem
an odd reversal of the story of Diane Arbus, a Jewish photographer whose
trying on of alien experience can be called a transformation of another sort.
And Lange's story becomes odder still when we think about the fact that
while this experience of being "the only Gentile among the Jews" undoubt-
edly informed her lifelong project of documenting the other, once she left
her portrait studio to go down into the street that day in 1933, Lange said
no more about Jews—not a word about the Holocaust, despite the fact
that she photographed the internment of Japanese Americans during
World War II—until, in her old age, she recalled this story.

I came here [with] . . . a camera, an assurance that wherever I wanted to go I could
probably earn my living . . . and I was pretty sure that I was working in a direction. I
don't know just what that direction was; I don't know to this day quite. I had launched
myself, educated myself. . . I knew something about what a resonant, good photographic
print is. I have print sense . . . like perfect pitch. . . There is something about a fine print
. . . its range of tone, in its print quality, its print color, its print vibration, impregnated
with a life of its own. You can compare it with a full, fine chord of music. It has richness,
it has depth. It can be very, very quiet and very mild, but nevertheless it speaks. . . . It
may be in only three or four tones, but those tones ring. —Dorothea Lange: The Making
of a Documentary Photographer

Another story: One day in 1933, Dorothea Lange looked from the window
of her San Francisco studio down onto Montgomery Street. On that day
she made the crucial decision of her life, transforming herself from "a per-
son of the twenties—financially successful, artistically concerned . . . [into]
a person of the thirties—a social welfare crusader, uninterested in 'success'
or 'art.'" Where she had used her talent to please, William Stott suggests,
"she now used it to upset and admonish; where she had serviced well-to-do
individuals, she worked on behalf of the mass of people who were poor."[29]
As Lange later told it,

> I remember well standing at that one window and just watching the
> flow of life. Up from the waterfront it came to that particular corner,
> that junction of many different things. There was the financial district
> to the left, Chinatown straight ahead, and the Barbary Coast and the
> Italian town. The unemployed would drift up there, would stop, and I
> could just see they did not know where next. . . . The studio room was
> one flight up and I looked down as long as I could and then one day I
> said to myself, "I'd better make this happen," and that started me. I
> made a print and put it on the wall to see what reaction I would get,
> and I remember well the customary, common reaction was, "Yes, but
> what are you going to do with it?" I hadn't the slightest idea. . . .
> Things are very often apt to be regarded as a vehicle for making a name
> for yourself. But the way it happened with me, I was compelled to
> photograph as a direct response to what was around me.[30]

The photograph Lange took on that day is the first in her *Last Ditch*
sequence, the *White Angel Breadline* (fig. 5.10). Her story of how she made

5.10 Dorothea Lange, *White Angel Breadline, San Francisco*, 1933.
©The Dorothea Lange Collection, the Oakland Museum of California,
City of Oakland, gift of Paul S. Taylor.

this photograph teases the memory with echoes of Stieglitz's story of look-
ing down from his first-class deck onto the immigrants in the steerage be-
low and finding in the "picture based on related shapes and on the deepest
human feeling, a step in my own evolution." It is even not too much to say
that Lange, like Stieglitz, "longed to escape from my surrounding and join
these people."[31] For Stieglitz, however, the emphasis was upon the power of
the image as *aesthetic* experience—what Allan Sekula calls a "fetishized
product . . . of the Imagination" as expressed in the equation "common
people = my alienation," which becomes "shapes = my alienation," and
finally "shapes = feelings."[32] Lange focused not on the resulting print, about
whose meaning she was unsure, but on the *imprint* of the experience. This
conceptual change was not aesthetic (although *White Angel Breadline* is in
fact constructed as a succession of round shapes of hats, echoed by the tin
cup in the clasped hands of the man in the foreground), not reductive and
mystical, but directly political. In other words, Lange's interpretation of
this experience is that she did not leave her world briefly, to return with a
token of her successful quest—albeit on this occasion that is what she did,
putting the captured image on her studio wall for customers' reactions. As
she saw it, in going out into the street—the literal junction of different
things—she ceased to be one kind of photographer and became another,
leaving the narrow world of her studio for "what was around me" in the
world out there, interrupting the indirect flow of activity with her own
direct action. In Lange's story, this moment marks her transformation into
a "documentary" photographer, a term she used somewhat reluctantly to
describe not only the scope of her own work from this moment, but what
would become a new genre. The event of making this photograph had no
precedent, she would claim:

> artists don't influence artists unless they're promoters. Artists are con-
> trolled by the life that beats in them, like the ocean beats in on the
> shore. They're almost pursued; there's something constantly acting
> upon them from the outside world that shapes their existence. But it
> isn't other artists' work, or other artists; it's what belongs to the artist
> as a solitary. . . . Well, that window . . . really got me going in the
> direction of the kind of photography for which at the time there was
> no name. They call it "documentary" now, and though it isn't a good
> name, it sticks to it. I don't like it, but I haven't been able to come up
> with a substitute. . . . But that was the very beginning of documentary
> photography. People often tell me I was the first one and of course

that's nonsense. When you're in a thing you find there were many people there a hundred years ago! But the impulse that I had didn't stem from anyone else.[33]

No mention here of Genthe's *Old Chinatown* project; none of Hine's immigrants arriving at Ellis Island or his captioned photographs of workers in *Survey Graphic;* nor of Jacob Riis, who wandered around the Lower East Side, as Lange had once done, taking photographs that he would combine with text in *How the Other Half Lives.* "I later saw the connections," she said, but "I'm not aware photographically of having been influenced by anyone."[34] Those few figures who have made collections, such as Hine and Riis, "didn't do documentary photographs. They made photographs that they kept together. They were series and sequences. The documentary thing is a little different because it's filed and cross-filed in its pure state, and it's buttressed by written material and by all manner of things which keep it unified and solid. *I thought I had made a discovery.*"[35]

This definition of "documentary"—a "pure" (single) photograph that is part of or can be made into a series or sequence of other photographs (filed and cross-filed), that is "solid" because it is buttressed by written material and other things—fits the FSA-OWI (Office of War Information) collection. By no means, however, does it clearly distinguish Lange's work from that of other documentary photographers; nor is it even an especially apt description of her own method of working. An examination of the microfilm of the FSA-OWI collection or the more limited microfiche of Lange's FSA photographs reveals that all FSA photographers on assignment shot series of photographs, and that Lange made a particular kind of series: she approached her subject from a distance, contextually—the land and buildings of a farm, for example—and worked closer and closer to individual people, her primary interest. Although Lange seems to address the *archival* function of the documentary photograph (a quality that made it possible for her, and others, to make photographic sequences from individual photographs), her real subject is the "pure" photograph—the portrait, which is the final product of her series. Lange's "discovery" is not the documentary photograph's function; rather, what distinguishes a Lange photograph— the reason anyone who has studied her work can say, "this is a Lange"—has to do with the quality of response her images generate in viewers. And I think she believed that good "documentary" work enjoined a viewer's response in a way directly proportionate to her own strong connection to her subject:

in my case the thing is that the business of uniting the conception of the documentary photograph with the photograph that also carries within it another thing, *a quality that the artist responds to,* is the only way to make a documentary photograph. You see how difficult this is? A documentary photograph is not a factual photograph per se. It is a photograph which carries the full meaning and significance of the episode or the circumstance or the situation that can only be revealed— because you can't really recapture it—*by this other quality.* Now there is no real warfare at all between the artist and the documentary photographer. He has to be both. But he isn't showing—as the artist does who works in abstraction, or who works rather more divorced from conditions—just "how he feels," but it is more that the documentary photographer has to say "what is it really?" You see that there is a difference. That is a very, very hard job.[36]

Lange seems to argue here that in bringing together her own empathic feeling with another's circumstances—"what is it really?"—a uniting of self with another becomes possible, that the ability to speak for, or to show, can transform another's experience into "everyone's experience." The best documentary work, then, would represent a personal and universal *encounter*—a mutual exchange in which each of us learns to see, and teaches others to see, into the other's heart and circumstances.[37]

These "circles of human involvement," as Robert Coles calls Lange's interaction with her subjects, had to do with her own circumstances. She had young sons of her own, and with the marriage to Taylor, stepchildren—"all left behind, as their mother took pictures of other mothers, struggling to make do with other children." She was "an artist who kept on the move so steadily, leaving behind a family—children who must have missed her so very much for just the reasons others posed for her, or let her hover nearby; this was an engaging woman, tenacious of spirit and immensely responsive to others. . . . The evidence is at hand: her visions. Children being held. Children near at hand."[38] But this transfer of romantic angst to one's subject (Lange to the poor, Coles to Lange)[39] suggests a *one-way* kind of looking that Lange had learned as a portrait photographer: she, wearing her cloak of invisibility, her subject facing the camera eye. This is a way of seeing that, even as it comes closer, imposes distance—psychological, moral, aesthetic—because the price for the *discovery* (Lange's word) is the ignoring, or even the effacement of something else. To the extent that in projecting oneself (or one's purpose) onto the other one fails to see what *is* other, to the

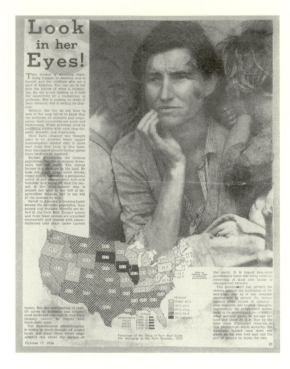

Look in her Eyes!

This woman is watching something happen to America and is herself and her children who are a part of America. You can see in her eyes the horror of what is happening, for she is not looking at it with the objectivity of a statistician, or professor. She is making no study of farm tenancy, but is feeling the landless.

Millions like her do not have to look at the map below to know that the problems of absentee and corporation land ownership are acute and frightening. These problems grow by terrifying strides with each crop disaster, drought and depression.

Once Farm tenancy was thought while to an America where rugged homesteaders needed only to move west from free farm to free farm. Now the rugged tenant-farmer moves from landlord to landlord.

Besides intensifying the farming population, the the tenancy devastates the soil itself. The tenant farmer is a source in the land. He does not plant trees, more shrubs, repair fences or follow a permanent policy of soil improvement and crop rotation. And worse off than the tenant is the farm-laborer who is stopped dead only to the will of impoverished tenants, but to the will of the masses as well.

Revolt in America is brewing faster among the agrarian population than among city workers. Sheriffs are defied in the Corn Belt. Tenant unions are organized successfully and clashes with communi-culations take place under harvest moons. But the multiplication of sheriffs adds no more to problems and solution cannot hold farm tenancy cannot be longer with two-thirds odds.

The Resettlement Administration is trying to move tenants off eroded lands and onto farms where crops actually rise above the surface of

(column at right) the earth. It is hoped long-term government loans will bring eventual ownership of their new homes to transplanted farmers.

The government can protect the farmer against the institution of the mortgage, just as it can reliably mechanize to protect the farmer against these causes of tenancy—crop disasters, soil erosion, droughts, depression. An enlightened nation looks to its government, no matter what portland yields, to salvage the land and those on it so that by the time these blighted children, in this photograph reach maturity, the American farmer once more will stand on his own feet and call the plot of ground he works his own.

October 17, 1936.

Percentage of the Value of Farm Real Estate Not Belonging to the Farm Operator, 1930

23

5.11 Dorothea Lange, Untitled, from *Midweek Pictorial* (Oct. 17, 1936), FSA Scrapbook, U.S. Farm Security Administration Collection, Prints and Photographs Division, Library of Congress.

extent that individual others are portrayed and displayed, for political purposes, as types or tropes (*Migrant Mother, Damaged Child*), and insofar as individual others are lost to themselves in their transformation into images exhibited and published as a *photographer's* work—then, as Warren Susman has suggested of moving images, what we become privy to are the "disguised or unconscious assumptions and perceptions, clues to issues and concerns" fundamental to the makers of images. Moreover, to the extent that the power of these images lies in *our* responses to them, we viewers of FSA-OWI still photographs would be on much safer ground to approach the people pictured in these documents as different from ourselves, Lawrence Levine advises, "as people whose lives and thoughts we have to strive to understand in however flawed a manner."[40]

Recall, for example, that in the case of Lange's most famous photograph, the *Migrant Mother* (fig. 5.11), Lange felt no need to "ask her name or her history," no need to spend more than a few minutes in the camp because with the six photographs she took (including the image Roy Stryker would call "*the* picture of Farm Security"), "I knew I had recorded the essence of my assignment."[41] As Stott suggests of Lange's best portraits of people, it

was a case of "simplify[ing], . . . abstract[ing], and expand[ing] their characters, universaliz[ing] their essence."[42] It was something that could stand for everything, both poignant ("local") and typical (universal).

What is "local," of course, is a particular woman's situation in the Nipomo pea-pickers' camp. From Lange's description we know that the subject of this picture is a thirty-two-year-old mother of several children "living on frozen vegetables from the surrounding fields, and birds that the children killed," trapped there because "she had just sold the tires from her car to buy food." In a more general sense, we know the conditions for which this photograph stands and the situation that its publication was intended to ameliorate: 1930s migrants traveling to California in search of work, hungry and homeless, living in squalor and poverty. We also "know" the deep structure of this image; that is, we recognize this woman iconographically, and it is this aspect of the photograph that is the source of its power and gives it, even in altered form, its long life. Iconographically, it is a type with which "everyone" can identify—an "everyone" who changes over time and experience: readers of the *San Francisco News, Survey Graphic,* and *U.S. Camera* in 1936, when the photograph was presented as a visual representation of the Depression; readers of *Popular Photography* and *American Photography;* viewers of museum exhibits, such as the Lange retrospective in 1966, who are concerned with a particular photogra-pher's work; readers of the *Los Angeles* and *New York Times* in the 1970s (who were introduced to the "real" Mrs. Florence Thompson, a Cherokee, through re-photographic projects[43]); recent appropriators of the image for political purposes, either in the form of partisan posters or academic discourse. Document or art, history or propaganda, the pictured woman is "real" insofar as what is represented in the photograph is "everyone's experience." "Migrant Mother" has "lived a life of its own through these years; it goes on and on," Lange would say many years later. "Whenever I see this photograph reproduced, I give it a salute as to an old friend. . . . The woman in this picture has become a symbol to many people; until now it is her picture, not mine." Lange meant that the nameless woman's *picture*—this combination of "what is it really" and "that other quality"—no longer "belonged" to the photographer. The picture is not art, she would insist—"I did not create it, but I was behind that big, old Graflex, using it as an instrument for recording something of importance"—but something produced out of a deep involvement in her undertaking, an "inner compulsion . . . [that is] the vital ingredient in our work."[44]

That successive generations of viewers do respond to the power of an *artistic* type—the madonna—and that this same image was used by newspapers in order to document a particular situation—that it has been taken as "real," as *the* image of the FSA—is not so much a contradiction as a complex tangle of threads. John Tagg helps us to understand that Realism, as a social practice of representation, works by the use of a "type," a recognizable image with only a strictly delimited range of variations: "It works by the controlled and limited recall of a reservoir of similar 'texts,' by a constant repetition, a constant cross-echoing."[45] Clearly, Lange understood this in knowing when she had the "right" image, even though Paul Taylor would insist that "she surely, on the migrant mother, wasn't saying, as she made the photograph, 'Now I am doing a Madonna.' *I* say it is a Madonna, but I assure you that wasn't what she was saying when she went and did it. She was down there, going back to that Nipomo pea-pickers camp where the year before she had worked her first day in the field on a new assignment. She had the impulse to return and see again what sort of conditions she might find there." She was unconcerned with "art," according to Taylor:

> she let that judgment come out of the photographs themselves. If the final product was art, that was fine. . . . When she photographed that one woman and her children, she was emotionally finished when she got through. But as for art, she took the photographs over to the San Francisco *News*—either she didn't take the one print which is now recognized as the Madonna, or the editor picked two of the others. She wasn't concerned, I am sure, with getting printed in the newspaper, the photograph which was true art, and passing by others that might not have been quite that, but showed the situation. I think she drew no line at all. She made six negatives of the migrant mother and her children, in what order I do not know; she never said. Her standards of photography were her own.[46]

Taylor, in other words, identifies this series as a document—of real people in a specific situation to which Lange responded deeply. But the "realism" of documentary is complicated: photographs are often cropped (e.g., Lange's picture of former tenant farmers on relief in a 1937 series from Imperial Valley, California, cropped to present one figure as a "New Pioneer" for a *Life* magazine story, or her picture of a plantation owner from Clarksdale, Mississippi, photographed in 1936 with his black field hands, cropped to stand alone in Archibald MacLeish's *Land of the Free*), re-

touched (as *Migrant Mother* was); embedded in descriptive texts (e.g., a news story, caption that quotes Mrs. Thompson's words about the family's lack of food, Lange's own story about *her* making of this photograph); or used with other photographs in order to tell a particular story. On the other hand, *Migrant Mother* is so often reproduced and exhibited as an icon that even alone it reverberates with a wide range of other images not present. This is what Tagg calls the *metaphoric* tendency of Realism, in which a part can stand for the whole, and easily identified similarities substituted for one another. Typicality, as perceived by a particular group of viewers, is grounded in the specific character of the historical moment, demonstrated in the appropriation of this image over time. In order to understand an historic type, then, "we must *historicize the spectator*," as Tagg suggests, specifying "*to whom* and under what conditions . . . photographic images . . . *appear* 'realistic.'"[47]

Made for middle-class spectators in a specific period of our history and associated with the aims of the corporate liberal state (although Lange's problems with the bureaucracy complicate that association); historicized as the best work of a photographer known for her documentary photographs of the thirties (although Lange spent only five of her sixty-eight years in the employ of the FSA); appropriated and rephotographed in the sixties in a mode of rediscovery of documentary photography,[48] this photograph reverberates with particular historical meanings for different audiences. Viewers familiar with Lange's disavowal of Riis's and Hine's work are more likely to perceive the "echoes" of other FSA photographs—other Lange work, such as the image of the eighteen-year-old Oklahoma mother and her child, drought refugees in Blythe, California, from 1936, that appeared on the cover of John Steinbeck's *Their Blood Is Strong* (fig. 5.12); or Walker Evans's 1936 portrait of "Ivy Woods, Alabama sharecropper"; or Ben Shahn's black mother and child from his 1935 "Cotton Pickers" series—than the influence of Riis's *Italian Madonna* (c. 1890) or Hine's *A Tenement Madonna* (1911) (fig. 5.13), even though both *Tenement Madonna* and *Migrant Mother* were published in *Survey* and *Survey Graphic*.[49] The Hine photo, subtitled "A Study in Composition," was meant as "a study made by the instructor [at the Ethical Culture School in New York] to represent maternity among the poor, following the conception used by Raphael in his 'Madonna of the Chair.'" Working to teach the art of *social* seeing, and following John Dewey's argument in *School and Society* that students must gain an appreciation of art not as something esoteric, but in relation to

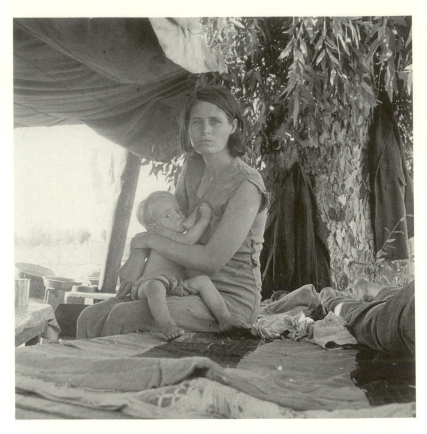

5.12　Dorothea Lange, *Oklahoma Drought Refugees,* 1936. U.S. Farm
Security Administration Collection, Prints and Photographs Division,
Library of Congress, no. USF34 9665E.

common experience, Hine strove to bring out in this photograph "in every
way possible the beautiful and picturesque in the commonplace."[50]

Lange's and Taylor's aims were more specifically political. Whereas *Mid-
week Pictorial* used the "Migrant Mother" as a representative victim of the
inequities of farm tenancy, the September 1936 issue of *Survey Graphic*
heroicized her. The full-page photograph—captioned "A blighted pea crop
in California in 1935 left the pickers without work. This family sold their
tent to get food"—is set against another full-page image of a "gaunt Mexi-
can in Imperial Valley" (fig. 5.14), who in his own words has "worked hard
all my life and all I have now is my old body." *Her* body is a visual and literal
sign of nurturance and sustenance. With no irony intended (Lange and

Taylor apparently did not know that Florence Thompson was a Cherokee), Taylor contrasts her strength—"As on the old frontier, women often supply the courage when the hearts of men flag"—to the despondency of the Mexican worker, pointing out to middle-class readers the threat to social order that this totally exhausted and despairing man poses: "The life of the migrants is hard. Employment is intermittent, jobs are precarious, and annual income is low. . . . Protestant, Catholic, and Jewish [clergy] urged the growers to raise the [per hour] rate, declaring that 'underpaid workers offered a fertile field for agitators and radicalism.'" A third image (fig. 5.15) shows a young farmer, "resettled on the Bosque Farms in New Mexico," who has benefitted from the Resettlement Administration's work to eradicate unsanitary living conditions—filth, squalor, crowding that breeds social sullenness—by building camps (examples of which we see) that pipe in pure water, provide sanitary toilets in place of open pit toilets, and provide hot and cold showers.[51] Thus, Lange's photograph does a certain kind of

5.13 Lewis Hine, *A Tenement Madonna,* 1911. Lewis W. Hine Papers, Rare Books and Manuscripts Division, the New York Public Library, Astor, Lenox, and Tilden Foundation.
5.14 Dorothea Lange, *Mexican Migrant Worker* (California Field Hand), 1936. U.S. Farm Security Administration Collection, Prints and Photographs Division, Library of Congress, no. USF34 1618C.

5.15 Dorothea Lange, *Young Farmer in New Mexico*, 1936. U.S. Farm Security Administration Col-lection, Prints and Photographs Division, Library of Congress, no. USF34 1642E.

cultural work; like Hine's images of immigrants and child laborers, it is meant here not as "camera work" but as "social work"—a transaction not only between photographer and subject, but one that demands participatory work by the viewer as well.[52]

The difference between the kinds of cultural work that Lange's and Hine's photographs do is partly at the level of response. Undoubtedly Lange shared Hine's sense of "sociality"—the ability to imagine another's situation provisionally as one's own in order to respond to it; but her imaginative ability in the making of this photograph, and others like it, would be underscored by her own gendered experience. Tagg's suggestion that the strength of Lange's representations contrasts sharply with Hine's portrayal of people caught, without potential to recover, in causes beyond their effective reach as unorganized immigrants, homeworkers, and children[53] is only partly right. A thorough examination of Lange's work, in the files of the Library of Congress and the Oakland Museum, discloses a fair number of what Stott calls the "unanimously grim." "Those whom we are merely to pity sit beneath us, in the dust. But those," he writes, "whom we are to respect as well as pity . . . stand above our eye level, high in the frame with a low horizon behind them so that they seem both heroic in size and part of the sky." Lange shot in direct sun with the sun *behind* her subject, widening the aperture and lengthening the exposure so that the sun seems

to thrust the figure toward us. As a result, her figures "looming on the sky, uncertainly related to the earth, . . . *fall* forward on us, forc[ing] us to embrace them, hold them up, acknowledge their existence and humanity."[54]

"Social work" for Lange would have meant the literal activity of her social scientist husband and collaborator Paul Taylor. Lange and Taylor worked closely together in the field—Taylor often talking with subjects to distract them as Lange photographed—and in photo-text productions. Their introduction to *An American Exodus* refers to "cooperation in every aspect from the form of the whole to the least detail of arrangement or phrase," a pattern established in their earliest collaborative reports. As Taylor would recall, "We travelled together, we were on the ground together, we saw it together, we talked to them together, and then we made the reports together, I doing the text, she the photographs, and she usually reporting what they said to her."[55] The traditions from which they come are very different, however. A midwestern Progressive, educated at the University of Wisconsin, who worked early in his career on Mexican American laborers in rural California and then on self-help cooperatives among the unemployed, Taylor, professor at the University of California at Berkeley, conceptualized the plight of migrant workers in the West as part of a national problem. He believed that what happened in the West reached to the South, with its dependency on cotton and its failure to develop a diversified agriculture or to take steps toward the restoration of depleted soil, as well as to the Great Plains, where the development of machine technology left human beings subject to uncontrolled forces. In his reports to state and federal agencies, his speeches to the Commonwealth Club of California, and his articles in *Survey Graphic*—addressed both to middle-class audiences fearful of communism and to property owners worried about radical agitation, the decline of schools, and the spread of disease—he directly depicted the migrants' situation:

> we found filth, squalor, an entire absence of sanitation, and a crowding of human beings into totally inadequate tents or crude structures built of boards, weeds, and anything that was found at hand. . . . During the warm weather, when the temperature rises considerably above 100 degrees . . . there is bred a social sullenness that is to be deplored, but which can be understood by those who have viewed the scenes that violate all the recognized standards of living.[56]

He also appealed to the history and tradition of the West:

> Riffraff? Probably no more than in every great migration. The weak are matched by the strong, the hardy, and the adventurous who seek in the West a new hold on life. Indigents? They are poor and in distress and many have had to take relief before they could obtain employment. When they arrive in our fertile valleys, without work or with insufficient work, they are the most ragged, half-starved, forgotten element in our population, needy, the butt of the jibes of those who look down on "pea-pickers," and "fruit tramps," but with a surprising morale in the midst of misery, and a will to work. These people are not hand-picked failures. They are the human materials cruelly dislocated by the processes of social erosion. They have been scattered like the dust of their farms, literally blown out. And they trek into California, these American whites, at the end of a long immigrant line of Chinese, Japanese, Koreans, Negroes, Hindustanis, Mexicans, Filipinos, to serve the crops and farmers of our state.[57]

In pointing out that American whites waited at the end of a long line of immigrant others and in naming the specters of disease and disruption, Taylor's strategy was deliberate. Against "a powerful, concentrated, economic interest" whose concern was, "If we set up those camps, would the campers organize their laborers?"[58] his agenda for dealing with the situation of hordes of migrants pouring into California (30,500 in the period between June 15 and October 15, 1935 alone) was to introduce stability by giving migrants small garden plots of ground where they could raise a portion of their substance, live in a decent house, and keep the children in one school as long as possible; by selecting some families for low-rental housing in cooperatives for dairy, poultry, and vegetable production; and by establishing landless farm families as operators on farms.[59]

His agenda and Lange's were the same, Taylor believed. "Anyone studying Dorothea's photography would see how she fitted it to the program that we were trying to support," he said of their early spiral-bound collaborative reports and of the book they published together, *An American Exodus.* "She thought of the immediate, specific purpose, and served that purpose. You can see it in her photographs. . . . [T]he message was: These people are worth helping! They are down and out, but they are not the dregs of society. They've just hit bottom, that's all."[60] A study of Lange's work, however, including photographs made before and after her work for

the FSA, makes clear that she also had her own agenda, complementary to Taylor's, certainly, but not identical.

Lange and Taylor agreed that Beaumont Newhall's definition of "documentary" applied more to the social scientist than the photographer member of the team: "Before going out on an assignment, he [the documentary photographer] carefully studies the situation which he *is to visualize*," Newhall had written in 1938. "He reads history and related subjects; he examines existing pictorial material for its negative and positive value—to determine what must be *re*-visualized in terms of his approach to the assignment, and what has not been visualized." Taylor was sure that this approach "wouldn't fit Dorothea's work very well. It could fit some kinds of work. But she went right out and faced it, you see." Taylor "was interested in the history of a situation, . . . [and] did some of those things Beaumont talked about. Some were helpful to Dorothea. I could bring to her attention aspects of things that might not have occurred to her. But as for that being her method of work, no. No. I am sure that she took many photographs when I said, 'Dorothea, you see this?' and it was interpreted through *me*. Many times she'd do that. Also there were times when she would say, 'Now you let *me* do this.' . . . And then I would remain silent and let her do it."[61] What she would do was guided not by plan but by instinct. "If I had reading to do I would do it in the area. I couldn't retain it otherwise," she recalled of her FSA assignments. "But the . . . reading that was most fruitful and the best was the reading that I did after I had been there. . . . It's a somewhat questionable thing to read ahead of time in a situation like that, because then you're not going under your own power. It is often very interesting to find out later how right your instincts were if you followed all the influences that were brought to bear on you while you were working in a region." Although she acknowledged Taylor's help—"I learned a good deal from Paul about being a social observer"—she insisted that photographing, completely without plan, that to which one instinctively responds, is "a very good way to work[,] . . . to open yourself as wide as you can, which in itself is a difficult thing to do, just to be yourself *like a piece of unexposed, sensitized material*. To know ahead of time what you're looking for means you're then only photographing your own preconceptions, which is very limiting, and often false." To be guided by instinct, in fact, might lead one *not* to the image that communicates information most clearly, but rather "to the place where you say, 'It doesn't make any difference' whether many people see what you meant when you chose this little

thing, this obscure photograph which has in it some turn that the big, brilliant, much more obvious and much more attractive thing, much more vigorous, with wider appeal, doesn't. You focus on that other. And it leads you to odd places."[62]

Lange did have finely honed instincts, but she did not exactly go into the field like a piece of unexposed film. Her photographer's sensibility was shaped by layers of experience, much of which preceded her union with Taylor and her work for the FSA: a good many years of successful portrait practice,[63] an earlier marriage to artist Maynard Dixon, and, in her young womanhood, the training with Genthe and White,[64] all of which widen the range of reverberations produced by images like the *Migrant Mother* series. An early photograph of an American Indian mother and child made in the Southwest (fig. 5.16) while Lange was living there with Dixon and their own children, for example, foreshadows *Migrant Mother.* In this portrait from about 1930, the mother cradles her child with an encircling arm; together they are encircled by the bare roof ribs of the wagon in which they sit, framed by a kind of halo as they turn to look back at the camera. Maternal images were, as I have described, a common subject for Pictorialist photographers—especially women—from Cameron to Käsebier, and among White's students, for Ulmann, Gilpin, and Lange in early work. As noted, Käsebier must have been a strong influence upon these younger women because what begins to seem striking in their portraits of mothers and children is not the difference between soft-focus Pictorialism, which Käsebier never abandoned, and sharp-focus documentary, which the

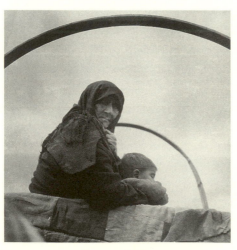

5.16 Dorothea Lange, *Southwest,* c. 1930. ©The Dorothea Lange Collection, the Oakland Museum of California, City of Oakland, gift of Paul S. Taylor.

5.17 (left) Laura Gilpin, *The Babe,* platinum print, 1927. Courtesy of Jerry Richardson. 5.18 Doris Ulmann, *Mrs. Hyden Hensley and Child, Brasstown, North Carolina,* c. 1933. Doris Ulmann Collection. ©Special Collections, University of Oregon Library, no. CN4979.

younger women took up, but rather the difference that social class makes in the messages these representations convey.

In both Gilpin's *The Babe* (1927; fig. 5.17)[65] and Ulmann's Appalachian portrait *Mrs. Hyden Hensley and Child* (c. 1933; fig. 5.18), Brasstown, North Carolina, for example, mothers are posed in profile, holding babies who face the camera. But Mrs. Hensley's child is passive, asleep, whereas the child in the Gilpin photograph is not only awake but alert and looking beyond his mother, nascently independent. In Gilpin's *Maya Women, Yucatán* (1932) all of the women framed by the doorway face away from the camera; the nursing mother's pose is similar to that of the woman in *The Babe,* except that her child is passive. In Gilpin's *Navaho Madonna* (1932) the woman confronts us directly and openly, but her child is passive. Gilpin's *The Babe* resembles Käsebier's many portraits of mothers and children of her own class: in *Mother and Child (Adoration)* (1897), *Blessèd Art Thou Among Women* and *Mother and Child (Decorative Panel)* (1899) (fig. 5.19), *Emmeline Stieglitz and Katherine (Kitty) Stieglitz* (1900), *The Picture Book, Mother and Child (Mrs. Ward and Baby),* the triptych of *Gertrude O'Malley and Charles O'Malley* (1903), all of the children look indepen-

dently out upon the world.⁶⁶ These portraits are conventional in theme—Käsebier's contemporaries, painters such as Mary Cassatt and Eugène Carrière, as well as photographers such as Zaida Ben-Yusef, Eva Watson-Schütze, and Clarence White worked in this genre—but unconventional in treatment: Käsebier's children are unique in their independence. Those Käsebier children who will grow into strong and assertive people like her daughter, pictured in *Gertrude Käsebier O'Malley Playing Billiards* (c. 1909), were affluent white children—their privilege setting them apart from American Indian children like Willie Spotted Horse and Mary Lone Bear. This difference suggests that we cannot think about the category "gender" without thinking about the category "class," which in the case of these mothers and children is inscribed in their very bodies.

Lange's early photographs of mothers and children are marked both by class and ethnicity: her subjects came from those wealthy San Francisco Jewish families who so fascinated her, particularly, as we can see, in their sensuousness. Her portrait *Mrs. Kahn and Child, San Francisco* (fig. 5.20) is set in a darkened bedroom in which the mother, silken legs extended, leans over her baby on a chaise longue in a pose of erotic abandon. In *Clausen Portrait* (1932), a loosely robed mother (in the tradition of Käsebier's *Blessèd*

5.19 Gertrude Käsebier, *Mother and Child,* platinum print, 1899. ©The Metropolitan Museum of Art, Alfred Stieglitz Collection, 1933, no. 33.43.141.
5.20 Dorothea Lange, *Mrs. Kahn and Child, San Francisco,* 1928. ©The Dorothea Lange Collection, the Oakland Museum of California, City of Oakland, gift of Paul S. Taylor.

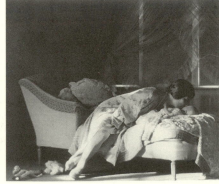

Art Thou Among Women) caresses her naked young daughter with just-budding breasts. This pleasure in the other's body is not often, nor so easily depicted—and for good reason—in Lange's portraits of poor mothers and children. White, black, Mexican, southern, Appalachian, and migrant California mothers hold their children to nurse them, to feed them the only possible food, or because there is no one to care for them while they work in the fields or squat in camp. These are mostly worried mothers—their faces drawn, their bodies sagging—and passive babies. "People just can't make it back there [Texas] with drought, hailstorms, windstorms, duststorms, insects," one of these mothers says to Lange. "People exist here [near Wasco, California] and they can't do that there. You can make it here if you sleep late and eat little. But it's pretty tough—there's so many people They chase them [the migrants] out of one camp because it isn't sanitary; there's no running water. So people live out here in the brush like a den of dogs or pigs. We just barely exist. What's it going to terminate to? . . . What's to be done? That's above my knowledge."[67]

As we (a "we" by no means uniform because our gender, class, ethnicity, and age, as well as our different memories and experiences, color our viewing) read the image of this woman through her words, read both against a body of text, of other images in a given publication or exhibit, or of grey cards in the files of the Library of Congress upon which so many similar words and photographs are mounted, our layers of responses are powerful and conflicting. The problem is not only that these representations are simultaneously "documents"—factual communications by people pictured with a directness that seems to guarantee the authenticity of the transaction between photographer and subject; "portraits" of individual women and their children; "types" of migrant farm women—Mexicans, Asians, American Indians, African Americans, poor whites—who in their similar poses come to resemble one another; *and* iconographic types. There is also the way in which these images reach us at a level of primary sensuousness that confuses and arouses us, whether we think we are responding to represented otherness or to aesthetic form whose references we understand from some other context. There is something in Lange's images that, as Martha Rossler suggests, pushes "against the gigantic ideological weight . . . which presses on us the understanding that in the search for transcendental form, the world is merely the stepping-off point into aesthetic eternity."[68] It has to do, I think, with the body beneath the cloak of invisibility.

[The woman] turned, smiled, and lifted her arm in the air in an unexpected gesture, easy and flowing. It was an unforgettable moment. . . . It was as if the upward gesture wished to show . . . the direction of flight, . . . so unexpected and beautiful that it remained in . . . [the girl's] memory like the imprint of a lightning bolt; it invited her into the depths of space and time and awakened . . . a vague and immense longing. At the moment when she suddenly needed to say something important . . . and had no words for it, that gesture came to life and said on her behalf what she herself was unable to say.
—Milan Kundera, Immortality[69]

Another story: Dorothea Lange in Taos, New Mexico, with Maynard Dixon, her artist husband, and their two children: camping, living simply, escaping the Great Depression. "A man in a Ford used to drive by almost every morning," she recalled:

> I saw this very sober, serious man driving with a purpose down the road and I wondered who he was. I thought he was an artist, but he went by always at the same time, and at the same time of night he would come back. "Who is that man?" It was Paul Strand. And it was the first time I had observed a person in my own trade who took his work that way. He had private purposes that he was pursuing, and he was so methodical and so intent on it that he looked neither to the right nor the left. He went down that road and he came back at night I didn't until then really know about photographers who went off for themselves.[70]

A woman lifts her hand as if to wave. But she is not waving. She raises her hand to her head as if in pain, to hold it, to express it. A gesture. In Dorothea Lange's photograph, a migrant mother of six children raises her hand to her worried face, her body's direct, physical expression of her pain echoes the similar gestures made by the "woman of the high plains" (fig. 5.26), the "migrant cotton picker" with his hand across his face (fig. 5.21), the man in *White Angel Breadline*, the men in *Crowd, San Francisco*, raising their arms in protest, and the policeman in *Strike, San Francisco*, folding his hands over his sturdy torso. Such gestures can also be seen in the hands of Maynard and Dan Dixon in 1930, the hand of young John Dixon offering Mother's Day flowers, Mia Dixon's hands shielding her sorrowing face, Paul Taylor's hands on his sixty-second birthday, the expressive hand of an Indonesian dancer (fig. 5.22), and Lange's own body language when she

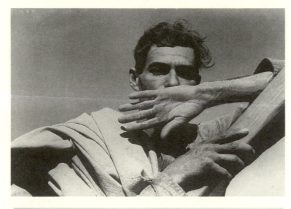

5.21 Dorothea Lange,
Migrant Cotton Picker,
Elroy, Arizona, 1940.
©The Dorothea
Lange Collection,
the Oakland Museum
of California, City
of Oakland, gift of
Paul S. Taylor.
5.22 Dorothea Lange,
Hand, Indonesian
Dancer, Java, 1958.
©The Dorothea
Lange Collection,
the Oakland Museum
of California, City
of Oakland, gift of
Paul S. Taylor.

posed for a portrait taken by Rondal Partridge in 1936 (fig. 5.23).[71] Gesture as the body's quotation.

Lange remembered photographing "almost nothing" in that period when she saw the purposeful man go by in his car.[72] "That thing that Paul Strand was able to do, I wasn't able to do," she said. "Women rarely can, unless they're not living a woman's life."[73]

Thirty years later she would have a great body of highly acclaimed work to her credit, a partner in a companionate marriage, an extended family for whom she cared deeply, and such bad ulcers that digesting food, the traveling fundamental to so much of her photography, prolonged working were all difficult for her. Since 1945 "I have been, I would say handicapped," she

5.23 Rondal Partridge, *Dorothea Lange,* 1936. ©1974, 1997 by Rondal Partridge.

admitted. "I have serious limitations healthwise, and there's no way out of it." Now, toward the end of her life,

> How much I would really like to devote myself to really living the kind of life that I know it takes. I only know enough about it to know what it takes. This is either impossible for me, or I am not sufficiently ruthless to do it. . . . I would disappoint my family very much if I devoted myself to photography. . . . And as far as my husband is concerned, he would understand it, but he wouldn't know how to adjust to it. . . . [I]t isn't the amount of time it takes . . . but what it takes to pursue my purposes is uninterrupted time, or time that you interrupt when you want to interrupt it. It means living an utterly different way of life, inexplicable to some people. . . . And I'm not focusing this entirely on myself, I'm speaking of the difference between the role of the woman as artist and the man. There is a sharp difference, a gulf. The woman's position is immeasurably more complicated. There are not very many first-class woman producers, not many. That is, producers of outside things. They produce in other ways. Where they can do both, it's a conflict.[74]

Given the emotional and psychological investment required of a viewer involved in experiencing the volume and *weight* of Lange's photographs in the files in Washington, D.C., and in Oakland, California, it might well be the case that the very nature of her work—the physical strain of arduous travel, the emotional stress of her subject matter—contributed to Lange's poor health. But the continuous conflict to which she refers—the stress that accrued over the years of balancing responsibilities to children from two families with responsibilities to her husband, to their shared work, to her demanding employer while she worked for the FSA, with little time left for her creative self—was too much for her to bear. "A few years ago I realized that the entire span of my life I have fought dreadful fatigue," she said. "I've been weary all my life, and I've always had to make a great effort to do the things that I really wanted to do, combating not having quite enough to do it with. . . . I've been tired all my life, every day of my life. . . . I think maybe I expended all I had always in one direction or another. . . . You do, really, what you must do. You can't deny what you must do, no matter what it costs."[75]

In his own oral history, begun after Lange's death, Taylor seemed surprised by Lange's complaint of tiredness; he related fatigue to her childhood polio, and spoke of her "immense courage," her vividness. But drawn out by Suzanne Riess, who had earlier interviewed Lange, he admitted that the team on the road was not a team at home because one member of the team "has to do the cooking, . . . is harnessed to the house, . . . [is] not a liberated woman." He recalled Dorothea telling him more than once that

> she felt pulled apart all her life. . . . Here she was living so vital a role at home, so important, so essential a part of the family, at the center of it. Then, here she was at the same time trying to do something which required her to be out of the home, too. Not that she couldn't photograph in the home, but in the home she couldn't do the outside photographing. So you see, there was always a question, what do you do with the children? . . . You are trying to maintain a home, and you are trying to do something else, and it pulls you. I suppose she meant that the man just takes things for granted, and figures that the woman has the first responsibility of being the center of the home, while he has the first responsibility of bringing in the support by doing his job outside. I suspect that is the difference that she felt—for her there was a first responsibility in the home as well as a first responsibility to her photography. And that pulled her apart. . . . But being pulled apart

didn't seem to impede her high accomplishment in either the home or in her work outside of it.[76]

These are narratives of sexual difference told by two people, a woman and a man, who lived and worked closely together. Different versions of history, a mapping of differences. For him, the tiredness she carried within her body was an invisible scar; for her, it was a wound that inscribed the body of her experience. Their joint text, *An American Exodus: A Record of Human Erosion,* documents not only these differences, but also the way in which the invisible scar was a metaphor for the Great Depression itself, the absent presence that, as Caroline Bird suggests, has driven American culture for a half-century: "a wound to the American body politic, the traces of which remain hidden as the historical *non-dit,* the ideological unspoken text (of history) that inscribes the body (of experience)."[77]

A man who would become a "first-class producer," *he* "went down the road and he came back at night"; *she* stood by the roadside—invisible, lame, but watching, imprinting the experience on her visual memory like a snapshot. "I remember what has happened in my life through moments that I remember visually," Lange would say of looking down from the window of her studio into the street in that later moment taken to mark the beginning of her life as a thirties woman, a *documenter,* an "observer of history [who] becomes a participant in it."[78] Thirties women, Paula Rabinowitz argues in her study of their writing, "speak of History—with a capital 'H'—intervening into their lives and remaking them." Josephine Herbst, for example, felt that "yesterday's road" led from the "vagabond twenties" to Moscow through "the crossroads where my own history intersected the history of our time."[79] Lange's photographs of the highway in New Mexico leading west to the Pacific would likewise serve as a metaphor for her own transporting.[80]

Although Lange had begun her photodocumentary work before she met Taylor, their union literally facilitated her movement in this direction: their joint projects for the Resettlement Administration secured her employment with that agency (later the FSA); at the same time, Taylor's expertise freed her from the heavy-handededness of Stryker's directives and gave her license to follow her own instincts; their collaboration resulted in the publication of government reports and ultimately the book of photographs and text published in 1939. *An American Exodus* was one of a dozen such books in print by 1942 illustrated with FSA photos, including James Agee and Walker Evans's *Let Us Now Praise Famous Men,* Archibald MacLeish's

In This Proud Land, Richard Wright and Edwin Rosskam's *Twelve Million Black Voices,* Herman Nixon's *Forty Acres and Steel Mules,* Arthur Raper and Ira Reid's *Sharecroppers All.*

For the most part, Taylor was responsible for the text of *An American Exodus* and Lange for the photographs, although her captions—part identification, part direct quotation—are used beneath each photograph. Taylor's longer text, used to connect the sections—"Old South," "Plantation Under the Machine," "Midcontinent," "Plains," "Dust Bowl," "Last West" —is part quotation from published and unpublished sources, part historical analysis. In these two kinds of writing, race, class, and gender are triangulated and interconnected subjects that elaborate on one another. Class and racial contrasts are deliberately and explicitly represented. Gender, in its *repression,* is implicitly represented—for example, in the reproduction of the "Help Wanted—Male" column from the October 31, 1937, *Daily Oklahoman* and in statements such as Rupert B. Vance's "Oklahoma was settled on the run by a white pioneer yeomanry," J. Russell Smith's "The Great Plains is a land of romance . . . of tragedy. For two and a half centuries the white man had marched westward, conquering the land," and Paul Taylor's "For three centuries an ever-receding western frontier has drawn white men like a magnet" (54, 45, 103, 107).

If Lange looked into geographer J. Russell Smith's *North America* (1925) when she was employed by the FSA, it is easy to see why she preferred to work by instinct. *North America* was required reading first for Roy Stryker, when he was collecting the illustrations for Rexford Tugwell and Thomas Munro's *American Economic Life and the Means of Its Improvement* (1925), and later for FSA photographers under Stryker's direction. An environmental determinist, Smith's concern was to explain why "North America is fit to be the home of a great and powerful people." The book is characterized by cultural stereotypes—hardy Yankees, slothful southerners, independent yeomen, dim-witted immigrants, and especially California migrants—in such statements as the "Indian, the Mexican and the bum who beats his way on the freight train" to work in the fields are "not particularly good for the social life of the rural community."[81] Taylor juxtaposes the Smith passage with an antigovernment letter from a reader to the *Dallas Farm News,* a bit of Oklahoma humor on the subject of dust storms, and with his own broader analysis of the dust bowl, which situates it historically and identifies the real subject of *An American Exodus* as the wounded body of the nation, making explicit how closely connected his concerns and Lange's were:

Like fresh sores which open by over-irritation of the skin and close under the growth of protective cover, dust bowls form and heal. Dust is not new on the Great Plains, but never since man came to inhabit them has it been so pervasive and so destructive as in our decade. Dried by years of drought and pulverized by machine-drawn gang disk plows, the soil was literally thrown to the winds which whipped it in clouds across the country. The winds churned the soil, leaving vast stretches of farms blown and hummocked like deserts or the margins of beaches. They loosened the hold of settlers on the land, and like particles of dust drove them rolling down ribbons of highway. (102)

The highway is more than a metaphor for *An American Exodus:* the book is about movement—across the country from the deep South, the cotton kingdom, to the Midcontinent and Great Plains, from the dust bowl states of Texas and Oklahoma west to California. Americans, black and white, young and old, cotton workers swept from Mississippi to Memphis, evicted sharecroppers along the highways in Missouri, hitchhikers from Kansas, Missouri, and Arkansas on an Oklahoma road, homeless families walking from county to county in search of relief, families stalled and stranded in broken-down cars, on the road "first one place and then another." Where were they going? "Destination unknown." "Tens of thousands, across the country, hundreds of miles, up and down, from valley to valley, crop to crop, ranch to ranch" (84, 141). Lange's images of the highway frame the book: on the front cover of the original jacket, the back of a truck, westbound, captioned "Covered Wagon—1939 Style," and on the back cover a sunbonneted, seated woman just arrived in Imperial Valley, California, poring over a map. Within, on the book's flyleaves, the words of the pictured traveling subjects.

An American Exodus, joint production though it is, offers one of the few sources for studying Lange's sequences—pictures and text grouped, as she selected and arranged them, to tell a story in the way she believed photographs are meant to be understood.[82] Many of these images would have been familiar to audiences of the 1930s. By now, they have been so often differently presented and are so overwritten with layers of meaning that it is difficult to disentangle familiar images from a "screen of previous interpretations, of intervening contexts or discourses, and of our own motives, hidden and known," and from the far from neutral context of the FSA file itself, which Trachtenberg has shown to be a "master story with a power beyond that of a mere filing device."[83] Moreover, it is necessary to distin-

guish between the two versions of *An American Exodus*. The first, the work of Lange and Taylor, was published by Reynal and Hitchcock in 1939; the second, published for the Oakland Museum by Yale University Press in 1969, a reissue of the earlier version by Taylor with the help of Therese Thau Heyman, curator of photography at the Oakland Museum, is a different book. The original *An American Exodus: A Record of Human Erosion*, published in the ominous climate of the beginning of World War II, was meant to embody a broad and prophetic notion of History, from the original biblical Exodus to the false security that war brings to human problems associated with agriculture and industry. In the 1969 version, now subtitled *A Record of Human Erosion in the Thirties* and with an added section, "End of the Road: The City," history is scaled down to a record of things past, preserved in documents of a particular decade. The revised edition is larger—with additional photographs in the new section and more passages of text (some rearranged from the original version) by Taylor—but it is also diminished, in the sense of subdued. Quotations from pictured subjects no longer frame the book, but appear on a page toward the end as a sort of appendix, along with some pages of Taylor's notes from the field. Many photographs are rearranged to effect a more aesthetic but less powerful presentation, whereas others that drew power from repetition are now reduced to a single image. Working on the book in 1939, Lange had cropped her negatives so that the pictured subjects seem continuous with other, unpictured people out of range of the camera—slices of life—and printed them so that the full- or half-page photographs bleed horizontally to the edge of the page. In the later version, these same pictures are reduced in size and presented as framed *images:* subjects are framed spatially within photographs as photographs are framed in the text by discrete borders of white page[84] (figs. 5.24 and 5.25). My discussion of *An American Exodus* is based on the original version.

An American Exodus works like a three-part invention: Lange's photographs of tractored-out land and windswept, treeless plains, of deserted homestead shacks, of migrants on the road with their overloaded, often broken-down trucks, function in counterpoint with Taylor's text—different, closely intertwined narratives—with each other, and with the voices of all those others who tell their own stories. Meant to rupture the continuous stream of History by their interruption of official versions, this "third voice," however, has an ambiguous effect in that these quotations are, of course, mediated and chosen by Lange and Taylor for their own purposes.

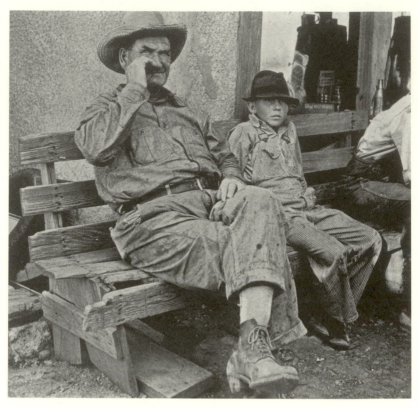

5.24 Dorothea Lange, Oklahoma, 1938 (as identified in *An American Exodus: A Record of Human Erosion* [New York: Reynal and Hitchcock, 1939], p. 80.) Photograph, Edgar Sabogal.

Abbreviated stories meant to stand as "truth" are authors' representations, despite the joint disclaimer: "Quotations which accompany photographs report what the persons photographed said, not what we think might be their unspoken thoughts" (6). Taylor recalled that Lange's "ear was as good as her eye, . . . what they said was reported just as vividly as how they looked." The accuracy of her transcriptions has been noted by documentary filmmaker Pare Lorentz and by Rondal Partridge (Imogen Cunningham's son), Lange's darkroom assistant and sometimes fellow traveler, whose wife Elizabeth recalls, "Her tremendous talent was to remember long captions. She would go back with Ron to the car or motel and write up their words precisely as they said them, with total recall. She could also tell an anecdote or tale like no one else and carry us all along." This last suggests an *enhancement* of quotations through "folk-speak" or "folkwriting," a com-

mon practice in 1930s documents that was used, in the days before tape recorders, to simulate accuracy.[85] Although direct quotation can be an anti-authoritarian strategy, a way "to destroy the credibility of those reigning historical accounts in favor of the point of view of that history's designated losers," as Rossler suggests, it also allows for "a separation between quoter and quotation that calls attention to expression as garment and invites judgment of its cut [as] . . . *a seamless cloak of univocal authoritativeness for citers to hide behind.*"[86]

The tall, heroic woman in frayed sackcloth, standing out against the boundless sky of the Texas Panhandle in 1938 (fig. 5.26), her bent arms angled sharply against and away from her body, her two hands holding her neck and forehead as if in pain: we know her as a Lange *type*. We recognize *this* woman, the subject of one of Lange's most frequently reproduced photographs, as the "Woman of the High Plains" and from her words, which shape our reading of her image: "If you die, you're dead—that's all."[87] Her name, Nettie Featherston, is not given; nor are we privy to her full statement, from which this caption is a cut. In the full accompanying text for this photograph, originally designated "Migratory laborer's wife with 3 children near Childress, Texas," this woman's words refer not to her own despair, but to the attitude of the county agents; she spoke to Lange not of

5.25 Dorothea Lange, Texas, 1937 (as identified in *An American Exodus*, rev. ed. [New Haven: Yale University Press, 1969], p. 68.) Photograph, Edgar Sabogal.

"I let 'em all go. In '34 I had I reckon four renters and I didn't make anything. I bought tractors on the money the government give me and got shet o' my renters. You'll find it everywhere all over the country thataway. I did everything the government said—except keep my renters. The renters have been having it this way ever since the government come in. They've got their choice—California or WPA." *landlord*

death, but of life—of her concern with feeding her family.[88] The image itself is cropped, to just below her waist, cut like her statement, cut to the bone, deleting the details of the flat land upon which she stands, making her loom against the sky. Paired with a broken windmill on a littered ground, this unidentified woman, resigned, worn down by her circumstances, literally embodies the potentially fecund, now drought-stricken land upon which she is grounded. Stepping back from the power of this image, we know that this is a *photograph,* a record of one moment isolated from a string of other moments, like the one just following in which Lange made another exposure, not reproduced in *An American Exodus* but chosen for the MoMA retrospective—not a desperate woman, but one of strong character (fig. 5.27). With the full sun highlighting the fine bones of her face and her downcast, shadowed eyes, this second image is a portrait of a woman yet beautiful, reflective, as Taylor later noted, not tortured.[89]

There are gaps between Lange's picture of the "Woman of the High Plains" and Nettie Featherston's story—between the full and elided versions of her words, between the different visual representations, and also between her symbolic aloneness and her real place as wife, mother, and sister in the human community. In the "Dust Bowl" section of *An American Exodus* there are signs of human habitation and the distant back of a man whose tractor has cut deep furrows in the foreground land, echoing images of "tractored out" land in the preceding "Midcontinent" section,[90] yet Lange presents the "Woman of the High Plains" as the lone human subject. Hers is also the concluding image framing this section, juxtaposed to the opening image of a tall grain elevator behind barbed wire. In between is the barren land, once fertile prairie, plowed under and ground into dust, then swept by the "great blow of 1934," and now "dried up and blowed away," leaving only deserted shacks and lonely sentinels: "If you die, you're dead—that's all" (94, 95, 101). This section is the book in microcosm: a history of fertile land conquered, in violation of God's law and Nature's law, by machine.[91] This is the story the book itself tells, beginning with a photograph of huge burlap-wrapped bales—*The Empire of Cotton Now Stretches from the Atlantic to the Pacific*—and concluding with the image and story of Ma Burnham (fig. 5.28), Confederate daughter, mother and grandmother of a landowning family until the Depression, drought, and worm hit—"the Devil's work or the Lord's work"—who sits alone on her porch in Conroy, Arkansas, her folks all "gone from here" (150). In between, a pictured chronicle of land once worked by hoe culture, now mas-

5.26 Dorothea Lange, *Woman of the High Plains, Texas Panhandle,* 1938.
©The Dorothea Lange Collection, the Oakland Museum of California,
City of Oakland, gift of Paul S. Taylor.

5.27　Dorothea Lange, *Texas Panhandle*, 1938. ©The Dorothea
Lange Collection, the Oakland Museum of California, City of
Oakland, gift of Paul S. Taylor.

tered by machine; of human laborers on the land, their stooped, laboring
bodies, their hunger, the skins of their broken-down habitations; of their
migrations, as they are carried along past rutted and garbage-strewn land
and endless stretches of highway, stopping to shelter behind highway bill-
boards serving as windbreaks, atop dumps, in "camps."

This story bears a certain relationship to the FSA project as a whole, as
Lange herself acknowledged. She wrote to Stryker in December of 1938 to
request time off to work on the book, although, she pointed out, "this is
. . . not primarily a personal venture—it has been done from the first from
the point of view of revealing and communicating a national problem. . . .
It's all the same job and when it comes out it will further your purpose, I
hope."[92] By "your purpose," Lange meant New Deal reform projects, but
Stryker's purpose went beyond his official appointment: with his own view

of history and of himself as historian, he was in the process of amassing the large collection of images that would eventually become the FSA-OWI file at the Library of Congress, whose scope would far exceed the immediate aims of the New Deal. This larger project had to do with Stryker's "personal dream" of a "pictorial encyclopedia of American agriculture"—a dream in the sense of ambition and wish fulfillment. By documenting profound changes, Stryker sought to preserve a kind of innocence that had been lost in American life, such as that pictured in a 1936 photograph of a railroad station in Edwards, Mississippi, which reminded him of his home town in Colorado. "I remember Walker Evans' picture of the train tracks in a small town like Montrose," he recalled. "I would look at pictures like that and long for a time when the world was safer and more peaceful. I'd think back to the days before radio and television when all there was to do was to go down to the tracks and watch the flyer go through. That was the nostalgic way in which those town pictures hit me."[93]

An American Exodus rests upon the "hard" assumptions of social scientist Paul Taylor rather than the "soft" nostalgia of Stryker, but its narration of history is similar to the version created by the overall structure of the file

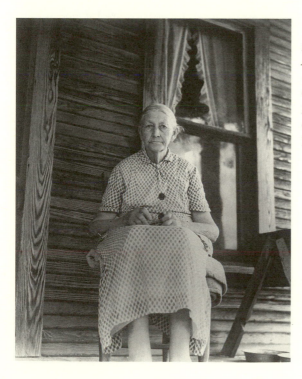

5.28 Dorothea Lange,
Ma Burnham, 1938.
©The Dorothea Lange
Collection, the Oakland
Museum of California,
City of Oakland, gift of
Paul S. Taylor.

itself. Images in the collection assembled by Paul Vanderbilt (hired by Stryker) are ordered according to their "objective" content by geographical region. Within each region photographs of the land and its various crops are followed by pictured buildings, towns, and roadsides, then families—with men, women, and children grouped separately—their transportation, work, social organizations; their war preparations; their health, religion, education, and recreation. Trachtenberg identifies the file's narrative as "a 'pastoral,' . . . in which the lowly 'shepherd' characters—the ignorant, dirty, and hungry, but wise and just country folk—instruct us in dignity, humility, sorrow, transcendence, or whatever we clean urban people . . . might wish to hear from such imagined characters." In this story, we "become *their* narrators, the tellers of *their* story; that we are merely listening to a tale told by a picture is only an illusion fostered by a certain way of thinking about these pictures." The powerful impression of authority for this pastoral story—the reason we accept its "realism"—has to do with its underpinnings of biblical and social science notions of universality, a conjunction powerful enough to make us believe this to be "the natural, self-evident form of the 'history of man.'" In fact, "the file embodies the familiar idea of history as 'progress,' history ordered according to climaxes and resolutions as well as the moral imperatives of a Judeo-Christian ethic. It is 'progressivist,' essentially optimistic about solutions to conflicts and about its own universality."[94] Less optimistic, *An American Exodus*—in its call for a national effort to aid those who till the land in adjusting to conditions of modern agriculture, in its references to the biblical Exodus, and to Tocqueville's view of the move westward on the American continent as "a providential event . . . like a deluge of men . . . daily driven onward by the hand of God"—is also "progressivist" and "universalist" in its notions of (Western) history (5). Yet there are differences between the two stories (of the file, of the book) that have to do with the tensions within *An American Exodus* itself—tensions that reflect disembodied and embodied voices as official and unofficial versions of history, with notions of science and art (or objectivity and subjectivity), and with the intersecting stories of race, class, and gender.

The gaps between the "Woman of the High Plains" and Nettie Featherston's own story—that is, the choices that Lange made in recording the story—are like the silences in women's revolutionary fiction of the thirties that most closely follows proletarian realism. As Rabinowitz points out, these silences pose a risk to the genre, "potentially shifting it from a class

conscious (but ungendered, and therefore masculine) polemic into the degraded position of a feminist (but unclassed, and therefore bourgeois) literature." These terms suggest that the threat (feminine) narrative poses to (masculine) History is the transgression of the boundaries between private and public discourse.[95] For example, Meridel Le Sueur (who, like Lange, gained a new audience in the late 1960s and early 1970s) locates differences between male and female bodies in the belly: "The body of the working-class man of the 1930s—and to an extent its text—is hungry, an empty space once filled by its labor; the body of the working-class woman, as well as her text, is pregnant with desire for 'children,' for 'butterfat' to feed them, and, most significantly, for 'history' to change the world for them." Despite the fact that the maternal metaphor is everywhere, Rabinowitz shows, the mother's *body* has no place in History. The continuously published texts of male writers (Richard Wright's *American Hunger*, for example) have been dominated by "the image of lack—defined by the male body's deprivation of food and labor, the starving and idle bodies of unemployed men." But women, whose works have only recently been republished, remembered this period "less as a decade of (male) lack than as one that mobilized and to some extent fulfilled (female) desires."[96]

Rabinowitz's work helps to situate Lange's narratives of labor and desire within a broader framework of thirties' documents—and to see them not as a single narrative, but as an accumulation of narratives. Repeatedly emphasizing that her work was not "art" and, as we have seen, so often identifying with her pictured subjects, Lange attempted to *approximate* the speaking subject in the verbal and visual re-presentations in *An American Exodus*. In this work with Taylor, she was quite literally fulfilling her own desires and, she urgently believed, effecting change for *them*. Against the master narrative of History, identified in Taylor's text as the broad sweep of industrialization with its economic, environmental, and human consequences, Lange focused on the literal body of the nation during the Depression. In so doing, she ran the risk that women's narratives always run when they emphasize the body and its psychosexual elaboration within history—that their work will be taken as "melodrama" or as "art for art's sake."[97] In the joint production of *An American Exodus*, however, this risk is contained by the master narrative with which it contends. Lange's story reveals what the master narrative represses: narratives of sexual difference.

Taylor's history of this new westward migration constructs difference in terms of race and class. Rural poverty in the South, he finds, where the

number of white and black sharecroppers is almost equal, but white ten-
ants "outnumber the colored by nearly two to one," is no longer only a
problem of race. White landlords promote "modern efficiency"—"Why
maintain a nigger the year around when they need him only a few
months?"—while black sharecroppers lament, "Tractors are against the
black man. Every time you kill a mule you kill a black man." The migrants,
however, are "the most ragged, half-starved, forgotten element in our
population, needy, the butt of jibes of those who look down on 'fruit
tramps,' but with a surprising morale in the midst of misery and a will to
work": "human materials cruelly dislocated by the processes of human ero-
sion" (19, 41–42, 148).

Lange's narrative maps or constructs difference in more specific, and
more specifically gendered ways. Like Taylor, she contrasts images of
power—the plantation system, represented by cotton fields in the Arkansas
delta and by the manor house, the state capitol building, the man on the
tractor, the grain elevator, the modern industrial farm—with images of
black laborers in the field, broken-down buildings, men in unemployment
lines, families with their belongings bundled onto their cars leaving their
home places. Her portraits of racial others tend to be *more* other—that is,
more picturesque: black sharecroppers working with hoes, whose tools
and bodies form striking diagonals (fig. 5.29); an ex-slave couple, enlarged

5.29 Dorothea Lange, *Field
Workers, Alabama,* 1937. © The
Dorothea Lange Collection,
the Oakland Museum of
California, City of Oakland,
gift of Paul S. Taylor.

5.30 Dorothea Lange, *Filipino Lettuce Cutters, Salinas Valley*, 1935. U.S. Farm Security Administration Collection, Prints and Photographs Division, Library of Congress, no. USZ62 19804.

and foregrounded in a portrait cropped to emphasize her beautifully strong, sculpted, sunlit face and body, his somewhat weathered face and worn body, and to erase the ruins of the background civilization that had marked them;[98] the rounded back of an old black man picking cotton, heavy bag slung over his shoulder, and of a younger black man bent over his tractor; the rounded backs of Filipino lettuce cutters whose monumental forms could be those of Millet gleaners (fig. 5.30) and who are linked, in the caption, to all who perform "stoop labor"—"Chinese, Japanese, Hindustanis, Mexicans, Filipinos, Negroes, and now American whites" (103).[99] In Lange's portrayals of the disempowered, however, women and men figure differently. On the road women seem more alien than men do; that is, their bodies are more sharply in disjunction with the rutted or flattened land through which they travel, more at odds with the pictured disorder: they drag, lag behind, perhaps because their feet, bare or in inappropriate shoes, hurt, or their dresses constrict movement, or their babies are heavy to carry. In wagons or cars, men drive, make repairs, change tires; women sit inside or wait in the shadows, holding children. A photograph of a "Hungry Boy" eating is paired with one of an Oklahoma child laborer against a squalid background of tents pitched along the highway, an exhausted little girl dragging her cotton sack through the dirt like a blanket at 7:00 A.M. Women and men also figure differently in their postures and gestures, a distinction reinforced by their words. The tall body of the woman of the Texas panhandle (Nettie Featherston, fig. 5.26), for example, contrasts

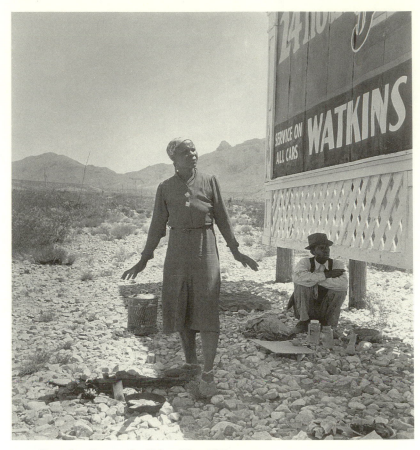

5.31 Dorothea Lange, *On U.S. 80 Near El Paso,* 1938.
©The Dorothea Lange Collection, the Oakland Museum
of California, City of Oakland, gift of Paul S. Taylor.

sharply to pictured men who squat or slouch: laboring, hungry male bod-
ies. In the only other image that suggests the Texas woman's strength, a
black woman stands straight and tall (fig. 5.31), her arms outstretched as if
to emphasize that this place—a rocky roadside camp beneath a billboard
(ironically lettered "SERVICE ON ALL CARS") serving as a windbreak—is not
her place. "The country's in an uproar now—it's in bad shape," she says.
"Do you reckon I'd be out on the highway if I had it good at home?" (35).
Feet in unsuitably soft shoes on the hard ground, the planes of her uplifted
face lit by the sun that also highlights rounded breasts and muscular thighs
modelled softly by the drape of blouse and skirt, she looms against the
mountains behind her, while her husband, his face indistinct in the shad-

ows, sits dejectedly against the billboard, arms wrapped around knees drawn to his chest, protecting his vulnerable and much smaller body.

Against their surroundings and in contrast to their men, the experiences of women in documents like the one of this couple on the road—*On U.S. 80 near El Paso*—are represented as more directly *embodied* in terms of legs and feet, breasts and buttocks, wide laps and bellies. A woman's bare legs follow behind a one-mule single plow, her bare feet in contact with the rough brown earth; a woman's bare feet rest on the hard ground, her legs bare to the knees, her hands cradling her pregnant belly; a young girl stands at a woodstove, bare feet planted on the unevenly planked floor, her thin arm hefting the weight of a skillet (fig. 5.32); a young woman, her back to us, bends over buckets and pans in front of a makeshift tent; Ma Burnham (fig. 5.28) sits straight in her chair on the porch in front of her curtained window, her old body cushioned on an old quilt, wrinkled forearms and arthritic hands resting in her capacious lap as she looks us directly in the eye and tells of the twelve children she has raised.

The white woman sticking it out on the Texas panhandle and the black woman fleeing the tractored-out plantation South tell their different stories as part of a larger narrative of the regions from which they come. Within these narratives they stand out—literally—from the stooped, hungry, laboring bodies of their men. Each woman's story is the story of her

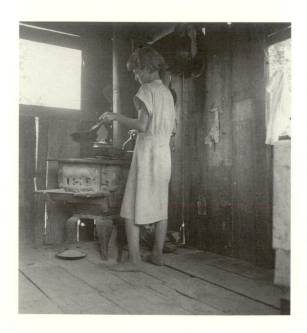

5.32 Dorothea Lange, *Supper Time (On Highway No. 1 of the OK State)*, 1936. ©The Dorothea Lange Collection, the Oakland Museum of California, City of Oakland, gift of Paul S. Taylor.

5.33 Dorothea Lange, *North Texas,* 1937. U.S. Farm Security
Administration Collection, Prints and Photographs Division,
Library of Congress, no. USF34 17983-C.

region, her race and class, but in its focus on home and family, on nur-
turance, each interconnects with other women's stories—with those of the
ex-slave woman, of the woman framed by the geometric shapes of the
home she is making on top of a dump (fig. 5.34), and of Ma Burnham—all
of them survivors. In the images of men who embody this sort of strength
—men who stand erect, larger than life, in full sun—visual representation is
undercut by words and by the juxtaposition of images on facing pages. A
photograph of an Oklahoma farmer in the "Midcontinent" section is
coupled with a line from an old song that makes an obvious reference to his
hunger, "I'm goin' where the climate fits my clothes" (47), and with an
ironic reference to heroism in the classical statue of a frontiersman on
horseback in front of the state capitol. A Texas farmer in the "Plains" sec-
tion, who says that his sons have no future, is pictured next to a group of
squatting, discouraged younger men (fig. 5.33), beneath whom we read
"about the instability and insecurity of farm families." On the preceding
page, these same men, all displaced tenant farmers, stand or lean against a
porch in attitudes of defiant dejection; they say: "Where we gonna go?"
"How we gonna get there?" "What we gonna do?" "Who we gonna fight?"

"If we fight, what we gotta whip?" In the "Last West" section, a farmer who left Nebraska in 1938 says, a year later from Calpatria, California: "I put mine in what I thought was the best investment—the good old earth—but we lost on that too. . . . My boys have no more future than I have" (78, 77, 129). These tall men—one holds a hammer, another hoists his foot on a tractor wheel—are the exception. If they are not working or moving, the hungry, angry, and tired men mostly sit or squat or stoop, like the young men from Texas. A young white sharecropper finds "Hit's a hard get-by"; his neighbor says, "A piece of meat in the house would like to scare these children of mine to death." The husband of the pregnant woman says, "There's lots of ways to break a man down." Stricken farmers on an Oklahoma street, the squatting man on the edge of a pea field near Holtville, California, the dejected unemployed in Calpatria—all have despairing faces like those of the workers whose strike has failed. But women, in the face of hardship, long for home. "I [a woman on the road] say: A rollin' stone gathers no moss"; "He [her husband] says: A settin' hen never gets fat." An Oklahoma mother of eleven children says, "I want to go back to where we can live happy, live decent, and grow what we eat"; her husband says, "I've made my mistake and now we can't go back. I've got nothing to farm with." As "tens of thousands [move], across the country, hundreds of miles, up and down, from valley to valley, crop to crop, ranch to ranch," the starkly beautiful woman atop the dump says, "People has got to stop somewhere. Even a bird has got a nest" (14, 50, 36, 128, 141).

When Lange cropped the photograph of this woman (fig. 5.34) and paired it, for *An American Exodus,* with a photograph of the back of a heavily loaded vehicle, captioned *Destination Unknown—1939,* she made particular decisions in terms of both content and form: cropping the print not only eliminated the woman's husband, creating a different kind of focus, but also constructed a particular kind of picture, a composition of dark and light geometrical forms that frame the woman's sunlit face. The beauty of the woman's face and of the composition in which she figures was intended to evoke an emotional response. For similar reasons, Lange chose to pair the final photograph of Ma Burnham not with a picture of her sterilized fruit jars drying in a line on the pickets of her fence,[100] but with the image of the "Last West"—the place where her family has gone—and, in the great round of the book, with the opening image of the wrapped bales of sanforized cotton in order to make the point that this woman is an old and lone survivor of a bygone era.

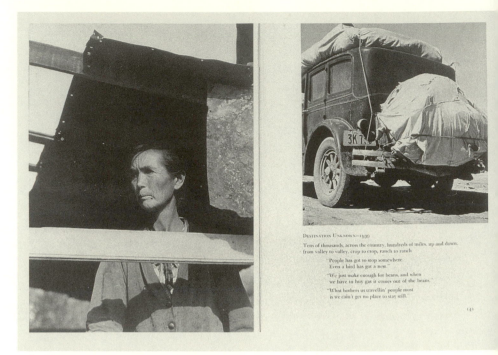

DESTINATION UNKNOWN—1939
Tens of thousands, across the country, hundreds of miles, up and down,
from valley to valley, crop to crop, ranch to ranch

'People has got to stop somewhere.
Even a bird has got a nest.'

'We just make enough for beans, and when
we have to buy gas it comes out of the beans.'

'What bothers us travellin' people most
is we cain't get no place to stay still.'

(4)

5.34 Dorothea Lange, *On the City Dump, Bakersfield, California*, 1935,
and *Destination Unknown—1939*, double-page spread from *An American
Exodus* (1939). Photograph, Edgar Sabogal.

"We laid out photographs in pairs," Taylor recalled, "trying out the fac-
ing pages, section by section," creating a work that was "not primarily his-
tory" and not a story like *The Grapes of Wrath* (published the same year),
but "information of the current condition and the need for doing some-
thing about it now, . . . a documentation saying 'These are the actual condi-
tions.'" Laying out these pictures in pairs, Lange was also grouping *her
materials.* Images were not interchangeable. She wrote to Stryker—some-
times repeatedly and urgently—for the return of particular negatives (the
"negro feet, with plow," the "six Texans, all ex-tenant farmers, standing in a
row before a tenant house"); and she insisted that grouping them in par-
ticular ways could "produce a different effect and a different sort of a
story—more dramatic, more moving, much more human."[101] The result is
an arrangement of images and words that work together to create patterns
that become narratives, for there is more than one. Stories emerge as the

material fragments of labor and desire accrue and resonate against one another: Lange and Taylor's story—for this is, among other things, a record of their work together, their shared intensity of purpose; the pictured subjects' stories—their private histories against the public History in which they now, unwillingly, participate; and the viewer's story—for the effect of those looming images that bleed off the pages is to suggest or project a connection, a responsibility, at the very least an involvement in the labor of constructing meaning. As readers and viewers of *An American Exodus,* our motives—our own histories—are varied and complicated. Yet we make meaning from these materials, pictures and words, by responding viscerally to a weighty body of accumulated visual evidence of the effects of hunger, fatigue, and despair—of the longing for home and the urgent need to feed and comfort one's family—on the sentient bodies of men and women who, with their differences, represent in this narrative the wounded body of the nation, and whose stories, as Dorothea Lange journeyed out to record them, interconnected with her own.

"THE COLOR OF MY SKIN, THE SHAPE OF MY EYES"

Here we bear our honors, here we exercise our power, here we covet wealth, here we mortals create our disturbances, here we continually carry on our wars, aye, civil wars, even, and unpeople the earth by mutual slaughter. And not to dwell on public feuds, entered into by nations against each other, here it is that we drive away our neighbors, and enclose the land thus seized upon within our fence; and yet the man who has most extended his boundary, and has expelled the inhabitants for ever so great a distance, after all, what mighty portion of the earth is he master of?—Pliny, "The Earth," A.D. *77*

Prophetically, *An American Exodus* concludes with this passage from Pliny, marking the end of an era as the nation turned outward from contemplation of its own wounded body politic during the Great Depression toward the defense of ideologies in which *other* wounded bodies would figure as signs of this nation's restored health and power. The Farm Security Administration would be replaced by the Office of War Information, images of desperate and hungry homeless folk for the official files by studies of the good life in American small towns, which we would go to war to defend. We heard the news by radio. Across the country, families huddled around their kitchen table models or living-room consoles; later, preparing for en-

emy attacks, only the glowing green dot of the radio would be visible as we listened in the dark to the President's disembodied voice.

The war in Europe and the Pacific would represent a juxtaposition in the extreme of body and voice. Human casualties—bodies maimed and destroyed—within the war would be the tangible results of verbal issues (freedom, national sovereignty, the right to a disputed ground, the extraterritorial authority of a particular ideology) that stood outside of war. Historic and strategic accounts of military campaigns would omit descriptions of injuries to sentient human bodies, of the actual altering of human tissue; interactions between armies of opposing nations, emptied of human content, would occur as what Elaine Scarry calls "a rarefied choreography of disembodied events." Both sides would dream of an absolute, one-directional capacity to injure those outside one's territorial boundaries, an idea that, "whether dreamed by a nation-state that is in its interior a democracy or a tyranny, may begin to approach the torturer's dream of absolute nonreciprocity, . . . that one will be . . . exempt from the condition of being embodied while one's opponent will be kept in a state of radical embodiment by its awareness that it is at any moment deeply woundable."[102]

Over the airwaves came news of the violation of our own territorial boundaries at Pearl Harbor, followed by the demand for the evacuation of persons of Japanese descent from the West Coast.[103] On February 19, 1942, President Franklin D. Roosevelt signed into law Executive Order 9066 "prescrib[ing] military areas . . . from which any or all persons may be excluded, and with respect to which, the right of any person to enter, remain in, or leave shall be subject to whatever restrictions the Secretary of War or the appropriate Military Commander may impose in his discretion." Within a month, the War Relocation Authority began removing persons of Japanese ancestry from California, Oregon, and Washington to fifteen assembly centers on the West Coast—mostly hastily converted fairgrounds, racetracks, and livestock exhibition halls, each of which held about 5,000 people[104]—and to unfinished relocation centers at Manzanar, California, and Poston, Arizona. Most of the evacuees—110,000 Japanese Americans—would be transferred to concentration camps housing ten to twenty thousand people each in Tule Lake, California; Gila River, Arizona; Topaz, Utah; Minidoka, Idaho; Granada, Colorado; Jerome and Rohwer, Arkansas; and Heart Mountain, Wyoming, where they would live for more than three years behind barbed wire. The army would build these detention centers on unused federal land, land so desolate and forbidding that no one

had tried to develop it. At the peak of the evacuation, 3,750 people a day were moved. They travelled for up to ten days by decrepit trains—the only ones not being used to transport troops—windows covered with black shades day and night, which stopped occasionally to allow the evacuees to move along a narrow strip protected by armed guards. They arrived at compounds, usually located in deserts and swamps, surrounded by barbed wire and policed from guard towers by armed soldiers. Inside were primitive and squalid conditions—animal stables given a coat of paint and flimsily constructed barracks—which were to be their protection from extreme weather conditions: blistering summers, freezing winters, dust and sandstorms.

Three cultural groups coexisted among the approximately 127,000 people of Japanese ancestry in the United States in 1940, about 113,000 of whom lived in West Coast states. *Issei* were Japanese-born immigrants who arrived just after the turn of the century and who established themselves as farmers, orchardists, and merchants. By the 1940s they were the highly respected heads of extended families and family businesses, but relocation and internment would decimate their businesses, scatter their families, and strip them of their stature within family and community. Labeled "enemy aliens" (they had been prevented from attaining citizenship), inside the camps they were not allowed to hold elected office. Nearly 80,000 were *Nisei*—U.S. citizens by birth and native English speakers, as "American" as any second-generation immigrant group. Coming of age at the time of internment, they now found themselves uncomfortably in positions superior to their parents'. *Kibei* were children of *Issei*—American citizens by birth, who had been sent back to Japan for education and were therefore culturally and linguistically at odds with their own generation when they returned to the United States, and thus under particular suspicion in the camps. *Issei* tended to accept their fate passively. Some *Nisei* demonstrated their grounding in democratic principles either by submitting to WRA policies, hoping for successful reintegration after the war, by working for early release and resettlement, or by encouraging military enlistment to prove their patriotism; some became a "left opposition" group demanding immediate restoration of their civil rights; others became a "right opposition" with primary loyalty to Japan.[105]

Farmers, fishermen, doctors, businessmen, graduate students, and artists, these interned Japanese Americans (who represented .03 percent of the total population and 1 percent of California's) sustained almost incalculable

economic losses as a result of relocation. Forced to settle their affairs in a matter of days or weeks, they sold their property for a fraction of its worth or left possessions in the hands of trustees, where it was often stolen, vandalized, or unloaded for next to nothing. The $400 million in property losses later calculated by the Federal Reserve Bank of San Francisco—of which the U.S. government paid about 10 percent in claims—does not take into account the wages, income, interest, and appreciation that the evacuees lost during their incarceration.[106] Nor has it been possible to measure the even greater psychological damage. Japanese Americans point to the fact that although some twenty-five thousand of them served in the U.S. armed forces, they were as a race condemned to suffer the stress of confinement, the humiliation of being regarded as traitors, and the subsequent fear that ancestry would always determine how they were perceived. The United States of America emerged from World War II as the guardian of freedom and justice, but Japanese American citizens have, until recently, been unable to speak of their imprisonment. "We were like the victim of a rape—we could not bear to speak of the assault, of the unspeakable crime," Edison Tomimaro Uno wrote in 1971 after a pilgrimage to Manzanar, California. "I knew that I was there for no crime other than the color of my skin and the shape of my eyes. I knew, too, that the excuse my captors gave— that I was there for my own protection—was sheer hypocrisy, that there was some deeper and more sinister reason for my incarceration."[107]

Photographs taken by outsiders and in one case by an insider, journals kept and drawings made during the incarceration bear witness and prick holes in the private reticence and the official silence that have shrouded this chapter of U.S. history. But Lange, who documented the evacuation and housing at assembly centers, would recall that her photographs "were impounded during the war. Army permission was necessary for their release. They had wanted a record, but not a public record"; the photographs, she said, "were not mine. I was under bond. I had to sign when I was finished, under oath, before a notary."[108]

The public record, on the other hand—the U.S. Army Western Defense Command and Fourth Army's *Final Report: Japanese Evacuation from the West Coast, 1942*—is an official account of actions taken to contain the threat of a Japanese conspiracy. This report documents not the final, but the continuing anti-Orientalism on the West Coast, which had its roots in turn-of-the-century immigration and after Pearl Harbor amounted to a kind of ra-

cial hysteria whose final solution would be the bombing of Hiroshima and Nagasaki. There is not so great a distance from the popular beliefs that "Japanese saboteurs dwelt in inconspicuous hovels near oil refineries and shipyards, that fishermen had their Imperial Navy uniforms wrapped in oilskins in their bait boxes, that houseboys were intelligence agents and farmers militiamen," and that, with the news of successive Japanese victories, the Japanese were a despicable super race who threatened our very national existence,[109] to the *Final Report,* which argues that

> The combination of spot raids revealing hidden caches of contraband, the attacks on coastwise shipping, the interception of illicit radio transmissions, the nightly observation of visual signal lamps from constantly changing locations [and] . . . numerous incidents of violence involving Japanese and others . . . [made it essential to] remove the potential menace to which the presence of this group . . . subjected the West Coast. . . . Because of the ties of race, the intense feeling of filial piety and the strong bonds of common tradition, culture and customs, this population presented a tightly-knit racial group. It included in excess of 115,000 persons deployed along the Pacific Coast. Whether by design or accident, virtually always their communities were adjacent to very vital shore installations, war plants, etc. While it was believed that some were loyal, it was known that many were not. . . . [N]o ready means existed for determining the loyal and the disloyal with any degree of safety. It was necessary to face the realities.[110]

"We" (Caucasians), on the other hand, are represented in the *Final Report* as rational and efficient in dealing with this problem in our midst. The report's "Pictorial Summary" assembles visual materials that demonstrate our fair treatment of those who cooperated in the evacuation. These images prominently display American flags and signs such as "Public Assistance" and "Farm Security Administration"; their captions explain that Japanese Americans who registered "were given opportunity to arrange their affairs" or that "arrangements were made to assist evacuees in the equitable disposition of their agricultural interests and properties." We see how the Army "assists departing evacuees" in a photograph of a soldier handling a Caucasian-featured doll held by a Japanese child as her smiling family watches. The Japanese also smile in the detention centers as they pursue their normal work as laboratory technicians, attend classes, distrib-

ute fresh fish, bake batches of apple cobbler, and dance the hula during one of the frequent talent shows staged for entertainment. Pictured from the air, detention centers have the clean, sharp, impersonal precision of military targets.

"It depended on whom you were, whether you thought it was a scandal or not," Paul Taylor would later say of Lange's involvement. "They wanted it documented. . . . I suppose the reasons were not perfectly clearly worked out. But to have a photographer in a government agency was becoming a little more acceptable than it had been only a few years earlier. Probably there were some who said 'We want to show that we are handling these people all right.' There were possibly some others who saw it another way; but anyway, WRA started to document it, and Dorothea went right to work."[111] None of Lange's photos was published in the *Final Report.* Her record of the evacuation amounts to a story so different from the "Pictorial Summary" that the two narratives seem to document different events— that is, to call into question the very word *document.* The exercise of comparing the two series triggers a reeling sense of déjà vu about the official chronicles of recent racial engagements in Viet Nam and the Persian Gulf[112] —Nintendo images of "smart bombs" versus the contraband images of bodybags, of maimed and destroyed bodies on the other side, many of them women and children mistakenly included in the smart bombs' range. One is left with a notion of documentation as a tool for the deliberate manipulation of collective memory, from the chilling Orwellian notions of the construction of History to recent applications of computer technology that allow the very substance of an image to be entered and modified. Indeed, "the camera is never merely an instrument," as Tagg argues. "It [has] authority to arrest, picture and transform daily life . . . [because] the local state . . . deploys it and guarantees the authority of its images to stand as evidence or register a truth."[113]

This time Lange was hired by the WRA; her photographs of the "relocation" are therefore stored in the National Archives rather than in the Library of Congress. The Farm Security Administration was involved in recruiting farmers to operate the six thousand vacated farms in the middle of the growing season and in arranging for a few hundred Japanese Americans to work as paid migrant laborers in remote sections of eastern Oregon, eastern Washington, and Idaho, but by this time Lange was no longer an FSA employee. Stryker sent Russell Lee to photograph these agency projects: Japanese farmers in rural California; sugar beet workers based at an

FSA migrant labor camp at Nyssa, Oregon; Little Tokyo (the Japanese en-
clave in urban Los Angeles); and the reception center at the Santa Anita
racetrack.[114] Less emotionally involved and more circumspect than Lange,
Lee recorded what he saw with a degree of detachment—as in his long shot
of the barracks that suggests the monotony of confinement—and deliber-
ate irony: a picnic lunch of hot dogs and apple pie for members of the
Japanese American citizens' league just before evacuation, or a child tagged
for evacuation who sits in front of a pile of luggage with his comic books
and chocolate bar (fig. 5.35).

Lange's images of the internment are singular for the way in which she
breaches the distance such wryness affords: an intimate closeup of an eld-
erly man in a small and squalid barracks room (fig. 5.36) is painful for us to
view not only because it lays bare the real nature of our collective malefi-
cence, but also because we squirm at this invasive view of another's private
shame. But the making of these photographs was strenuous for other rea-
sons. The qualities that had been the measure of Lange's success as a cham-
pion of the poor—her sense of her obligation and her ability to disclose and
communicate the truth, her own particular combinations of reporting and
portraiture, of invisibility and sympathy in approaching people who were
strangers to her—had also been the measure of her commitment to the way

5.35 Russell Lee, *Child tagged
for evacuation,* 1942. U.S. Farm
Security Administration Col-
lection, Prints and Photographs
Division, Library of Congress,
no. USF34TOI 72499.

5.36 Dorothea Lange, *Interior of camp housing* [Mr. Konda], 1942. National Archives, Still Pictures Branch, no. RG210-G-3C-584. Photograph, Bara King.

in which she understood that her own work, through its ties to a project and sponsorship by a government in which she believed, could effect change in the lives of her pictured subjects. Now, these subjects were in some cases her neighbors, whose bodily marks of difference made them targets of hate.[115] The government sponsor of her project—the authority whose disembodied voice was omnipresent on signposts and billboards, in the press and on the airwaves—this time exercising its power not to heal but to control and debase other bodies, hired her to record that exercise, a use of power she could only oppose. The year and a half that she worked on this project was "very, very difficult. I had a lot of trouble . . . with the army. I had a man following me all the time," she recalled. "The whole thing, the feelings and tempers and people's attitudes, were very complex and very heated at that time." Whereas in working for the FSA, she had assumed a clarity of purpose, a situation in which exposure meant bringing to light in order to heal, here was debilitating ambiguity. Her photograph of a Japanese businessman (fig. 5.37), tagged for removal, and handled by inspectors, was used both in University of California law professor Caleb Foote's Quaker pamphlet on the evacuation and by the Tolan Committee, which had recommended the evacuation of all persons of Japanese lineage and

called for the creation of a federal agency to oversee their removal. In the case of its pacifist usage, Lange was called to account by the WRA, which also objected, as Paul Taylor recalled, to her photograph "of gardeners, or nurserymen, working in the latticed sheds commonly used to break the force of the sunlight . . . because the streaks of sunlight and shadow made it look as though the evacuees were behind bars or dressed in stripes."[116]

As these incidents suggest, Lange's images are rich in content demanding an emotional response that seemed to some to be inimical to national security—that is, to insist upon the viewer's sharp recognition of the fact that war is a contest in which human bodies are the tokens of victory. Her subject was what Foucault calls the "capillary form" of the existence of power—"the point where power returns into the very grain of individuals, touches their bodies, and comes to insert itself into their gestures and attitudes, their discourses, apprenticeships and daily lives."[117] Over and over again, her focus bears witness to what was "beyond words": the way in which these other bodies were handled, herded, inoculated, lined up, tagged, housed in former horse stalls that stank of manure, in every way humiliated, put away. Lange's dangerously provocative pictures were also

5.37 Dorothea Lange, *Inspection*, 1942. National Archives, Still Pictures Branch, no. RG210-G-2-A95. Photograph, Bara King.

put away, in some cases impounded—like "the obstreperous ones," Japanese Americans who were sent to Tule Lake where photographers were not allowed. "I wanted to go there," she said. "They were all kinds and they had them in a real regime, but I was . . . never permitted to go."[118]

While *Life* magazine published a full page photo-story on "How to Tell Japs from the Chinese" (fig. 5.38) and billboards proclaimed "It Takes 8 Tons to K.O. One Jap," Lange showed us that these were people like us—living in comfortably solid middle-class homes, working on farms, attending public schools and saluting the American flag (fig. 5.39)—ripped out of their environmental skins and transported in sealed trains, ominously, to our historical eyes, like those of the "final solution." We follow typical families—the Tatsunos, the Mochidas, the Shibuyas (fig. 5.40)—the grandparents farmers, their son an importer of special strains of chrysanthemums, their grandson a medical student at the University of California—taken from their spacious, well-kept, familiar, private surroundings and housed,

5.38 "How to Tell Japs from the Chinese," *Life* (Dec. 1941):129. Photograph, Edgar Sabogal.

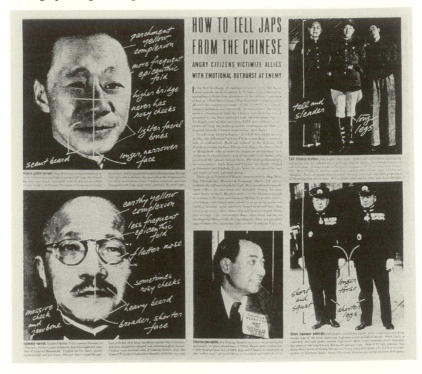

 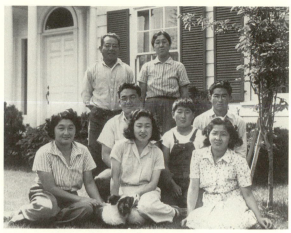

5.39 Dorothea Lange, *Raphael Weill Elementary School,* 1942.National Archives, Still Pictures Branch, no. RG210-G-A76. Photograph, Bara King.
5.40 Dorothea Lange, *Shibuya Family,* 1942. National Archives, Still Pictures Branch, no. RG210-G-1-A60. Photograph, Bara King.

all three generations, in two filthy rooms, one of which had no windows, forced to line up for common meals and for showers and toilets with no doors separating the stalls. These images, that in their particularity cause us most vividly to imagine the effect on bodies so like our own of being transferred to foul-smelling, cramped and squalid barracks, were the ones that were impounded (fig. 5.41). Lange photographed "the procedure, the process of processing": the handling and being handled, the subjection at every sensory level to the ugly, smelly, noisy, rough, distasteful, to the alien touch and vulgar surrounds of the forced and frightening removal. The impact of what she pictured comes not from single images but from the weighty accumulation of the effect of hundreds of them. She constructed difference, in other words, through references to similarity. "I photographed the normal life insofar as I could, in three parts of California," she recalled:

> the Japanese quarter of San Francisco, the businesses as they were operating, and the people as they were going to their YWCAs and YMCAs and churches and in their Nisei headquarters, all the baffled, bewildered people, whose *own* people took it . . . over. They refused army doctors. Their own doctors did it. Everything that was possible that

Impounded

5.41 Dorothea Lange, *Housing in converted horse stalls,* 1942. National Archives, Still Pictures Branch, no. RG210-G-3-C323. Photograph, Bara King.

they could do themselves, they did—asked the minimum, took huge sacrifices, made practically no demands. . . . I photographed, the long lines on the streets waiting, for instance, for the inoculations, down Post Street and around the corner, little, dark people. And . . . when they were all gathered together at the assembly centers—the actual, practical arrangements that had to be made. Oceans of desks and oceans of people with papers were interviewing heads of families, all the questions on their relatives and so on. . . . Arrangements had to be made for each family, either for the disposal of their goods or for storage. Amongst these you would see those who you wouldn't know were Japanese—1/64th blood! They came under the proclamation. All these proclamations, all over town, on the telephone poles . . . telling the people where to go, announcing the fact. And then when the day of removal came they all had to be at a certain place. . . . These people came, with all their luggage and their best clothes and their children dressed as though they were going to an important event. . . . Then I

photographed them on the buses, on the trains, and I photographed their arrival in the assembly centers, and the first days there as these places settled down to routine life and the beginnings of organization, which they did themselves, in the assembly centers. And then they were moved again, into the interior, and I photographed only one of the interior centers, Manzanar, in Owens Valley. I went there three times, I think.[119]

Ansel Adams also photographed what he called "the exodus," but several things distinguish his Manzanar pictures from Lange's work. Adams's wish to become involved seems to have been sparked by the internment of Harry Oye, an elderly man who served as his gardener and cook. Thinking about his Manzanar photographs some thirty years later, he compared the internment to "what's going on in the South. This [George] Wallace business, and the fact that 'if you're a nigger, you're a nigger forever,' you know. And if he [Oye] was a 'Jap,' whether or not he was born in America, he's still a 'Jap.'" Oye was an *Issei* (born in Japan) under the Geneva rules for prisoners of war. Adams goes on to note the irony of Oye's excellent and considerate treatment, as contrasted with the harsh treatment accorded the American citizens of Japanese descent. Taken to the location that was best for his asthma, "he had the best of food to eat. He was completely comfortable."[120]

Working alone, Adams was able to move freely and to photograph without interference. He made several visits to Owens Valley with the intention of bypassing the "sociological" in order to present a work of "human, emotional . . . and strictly personal concept and expression."[121] To bypass the sociological, however, is not necessarily to be apolitical. In fact, in their focus on the accommodationist *Nisei* — that is, those who demonstrated their submission to captivity by working to make the spaces in which they were imprisoned more comfortable and attractive, or who showed their patriotism by enlisting in the armed forces — Adams's Manzanar photographs fit perfectly with the official presentation of the internment as humane, orderly, and even beneficial to the internees.[122]

As Adams described it, Manzanar camp director Ralph Merritt (a Sierra Club friend) came to Yosemite and offered him a "great project." At Manzanar, Merritt told him, "we've been able to get these people in all their destitute, terrible condition to build a new life for themselves. A whole new culture. They're leaving here with a very good feeling about America. They know the exodus was a fundamental wrong, but they said, 'This is the situ-

ation—make the best of it.' If you can photograph that, it's a very important part of the record." And Adams did find at Manzanar that "everyone was *positive*. They'd rejected the tragedy because they couldn't do anything about it. . . . I had them smiling, and cheerful, and happy." Other photographers "raked me over the coals" because "these people . . . were oppressed, prisoners. And so I tried to explain what really happened. Because of this adversity, about which they could do nothing, they became a marvelous group of positive, forward-looking people. They were the lighting candles type, you know, and that's the way you see them."[123]

The collection of beautiful pictures that resulted—portraits framed by the clearly articulated landscapes that are his trademark—was both exhibited at the Museum of Modern Art (where Stieglitz, according to Adams, was "quite visibly moved, wiping his eyes") and published with Adams's text, as *Born Free and Equal*. "Manzanar had a beautiful setting," Adams recalled. "I always tried to bring in the environment of the mountains. I knew a great many of the people would look up at the Sierra Nevada. It was a beautiful place."[124] Against the familiar redeeming mountainous terrain, imprisoned Japanese Americans are posed to suggest the mythic possibility of transcending adversity. One hardly needs the captions, or the concluding lines from Whitman, to realize that in the "sunlight and space" of Owens Valley, the towering Sierra Nevada that "make space definite with glowing light," "Manzanar is only a detour on the road of American citizenship"; "in the presence of the ancient mountains the people of Manzanar await their destiny." The story Adams constructs with his images and their arrangement is that these individuals—"heads," Adams called them (fig. 5.42), "photographed looking directly into the lens and therefore directly at the spectator"—were shaped by their experience in this environment in a positive, "thoroughly . . . American" way.[125] In response to Adams's theory that the permanent and serene presence of these great mountains helped to make the relocation as easy as possible, Lange pointed to "the meanest dust storms there and not a blade of grass. And the springs are so cruel; when those people arrived there they couldn't keep the tarpaper on the shacks." For her there was only one way to view the internment experience. In her judgment, Adams's portrayal of that experience "was shameful."[126]

Unlike Adams, Lange was interested in documenting the extraordinary thing that was happening to ordinary people. Her two-part captions identify evacuation subjects: "Families of two Shinto priests"; "First graders at

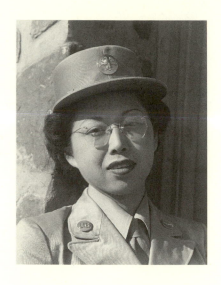

5.42 Ansel Adams, *WAC Private,* 1943.
Ansel Adams Collection, Prints and
Photographs Division, Library of
Congress, no. A35-4-M-68.

Raphael Weill Public School"; "Farm family in their strawberry field. . . .
Their home can be seen in the background at the foot of the Santa Clara
Coast Range hills"; "Scene at Santa Clara home of the Shibuya family.
Madoka Shibuya, 25, . . . a student at Stanford Medical School"; "Oldest
son of the Shibuya family, a graduate in plant pathology of the College of
Agriculture, University of California, in 1939. His father and mother were
born in Japan and came to this country in 1904, with only $60 and a basket
of clothes. He later built a prosperous business of raising select varieties
of chrysanthemums which he shipped to eastern markets under his own
trade name"; "Mrs. Shibuya, . . . four of whose six American-born children
attended leading California universities." They conclude with the repeated
refrain: "shortly before evacuation to an assembly point, where they will
be transferred later to a WRA Center for the duration." Photographs taken
at Turlock and Tanforan assembly centers and at Manzanar are captioned
in the same dispassionate voice, so at odds with their emotion-laden visual
content, and thus the exact reversal of the *Final Report*'s "Pictorial Sum-
mary": "Rear view of horse stalls converted into living quarters for Japa-
nese" (impounded); two photographs of "Japanese families housed in
horse stalls in a converted race track" (impounded); "Mr. Konda in his bar-
rack apartment where he lives with his married daughter and her husband.
They share two small rooms together. He has been a truck farmer in Cen-
terville, Alameda County, where his children were born" (impounded);
pictured in front of his barracks, "Masamichi Suzuki has had . . . three years

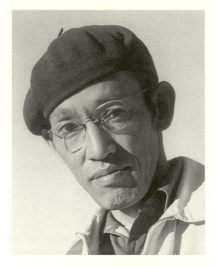

5.43 Ansel Adams, *Toyo Miyatake,*
1943. Ansel Adams Collection,
Prints and Photographs Division,
Library of Congress, no. A351-4-M-
77.

at the University of California Medical School and is a member of Phi Beta
Kappa. He hopes to later specialize in pathology." Crowd scenes are often
shot from above to mark the humiliation of subjection, some with large
American soldiers, inspectors, or drivers exerting a kind of towering pres-
ence.

Among her subjects were "aging women in Manzanar who were casting
their first vote . . . for camp managers and camp officers . . . with the great-
est seriousness. They had classes for voting, classes for those who couldn't
speak English. . . . There was much talent in those camps, too, people who
were competent to teach and to do." Lange did not record life inside the
camp because she was not hired to do so; and she did not explore the way
in which the experience of internment changed the Japanese American
community. Her view is that of an outsider, one who admitted years later,
when she thought about the apparent lack of resentment on the part of the
internees, "I don't understand those people." She marveled at how the
community took over practical medical matters: "Everything that was pos-
sible that they could do themselves, they did. . . . This was very unusual,
almost unbelievable, and this I photographed, the long lines on the streets
waiting, for instance, for the inoculations . . . little dark people," who in the
camps became victims trapped in "an organization for people who had no
activity but the activity that they made for themselves. Static."[127]

Inside the camp, the imprisoned Toyo Miyatake (fig. 5.43), who had
smuggled in a lens and one film holder, built a box camera from pieces of

wood and plumbing fixtures, and (with the cooperation of the camp director) ordered film by mail in order to record his history. Prior to his incarceration, Miyatake was a well-known California photographer. In fact, while Adams and his colleagues who would later style themselves "purists" were still making pictorialist images, the work of Miyatake and other Japanese photographers served as an avant-garde model. And the fact that Miyatake gave the as yet unknown Edward Weston a show in his studio confounds the notion of "us" and "them" at the center of the internment process.[128]

Miyatake's documentation of his experience at Manzanar was different from his work before 1942 or after 1945. Less interested in light and shadow, in patterns made from the abstractions of natural and human forms in unexpected angles of vision, he turned now to record making. There are, of course, no leaps of the body, no sinuous gestures—signs of freedom of movement in space. In fact, in contrast to the great body of portraiture made in his Los Angeles studio, there are no single figures at all and no pictures with a single center of interest. Unlike Lange's portraits of victims, Miyatake's Manzanar photographs from this period are dense with detail—

5.44 Toyo Miyatake, *Beauty Shop,* c. 1944. ©Archie Miyatake.

a visual cataloging of materials that tells a complicated story. Buildings, furnishings, implements, rituals represent the culture of the powerful, the very ground that gives structure to the lives of the disempowered, imprisoned "others."

Repeatedly, insistently, what Miyatake's images show is the fallaciousness of demarcating "otherness." Pictured insiders—that is, those inside the camp—are mostly U.S. citizens. If they play baseball and twirl batons with the marching band, attend high school commencement, go to the hairdresser (fig. 5.44), or tend their gardens, it is not simply in imitation of the white man or in conformity to his expectations: they are reconstructing, insofar as they can in this restrictive environment, their own former outside lives as high school and college students, nurses and teachers, farmers and artists. It is precisely because the line between inside and outside is so unclear—except for skin color and shape of the eyes—that we find the same subject matter often pictured by Adams and Miyatake. The difference seems to be between Adams's attention to compositional detail and Miyatake's broadening of focus so that no one person is singled out from a group (figs. 5.45 and 5.46). Against "landscapes" that include both mountains and scrubby land, prison sign, and barracks, Miyatake bears witness to the ways in which imprisoned Japanese Americans—his family and friends—developed in their gardens and baseball games strategies for survival. Unlike the images made by Lange and Adams, these depictions of everyday life behind barbed wire (fig. 5.47) flatten sentiment, perhaps in response to the act of documenting what so many found unspeakable, or perhaps as a strategy for draining away attributes imposed from outside. Miyatake's subjects are neither objects of pity nor heroes; against the imposed conditions of watch towers, barbed wire, cramped quarters, men, women, and children construct their lives. Groups of people fill and reshape given spaces. Making no argument for other spaces, Miyatake's photographs record what takes place here: groups unloading a truck of vegetables, assembling for memorial services, departing for Army camps.

What distinguishes "outsider" images of the internment—the "Pictorial Summary," Adams's *Born Free and Equal,* Lange's WRA documents—is the way in which the space surrounding human bodies and the shaping of that space for purposes of control figure as subject. The "Pictorial Summary" shows aerial views of the construction of large uniform white buildings in orderly rows, planned communities with supervision by guard tower, "a space of unobstructed lines of sight, open to vision and supervision," where

5.45 Ansel Adams, *Pleasure Park,* 1943. Ansel Adams Collection,
Prints and Photographs Division, Library of Congress, no. A351-3-M-11.
5.46 Toyo Miyatake, *Merritt Park,* 1944. ©Archie Miyatake.

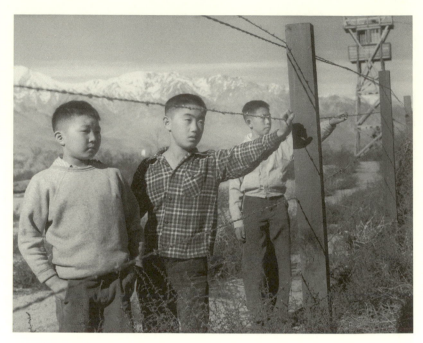

5.47　Toyo Miyatake, *Barbed Wire, Manzanar,* c. 1944.
©Archie Miyatake.

people would be changed into orderly, docile, and disciplined subjects—a strategic space, in Foucault's sense, of power-knowledge.[129] Adams's counterargument emphasizes the beneficial effects of unrestricted environmental space: mountains, and also built structures, define the spaces against which the rituals of daily life are played out. Lange's argument comes directly out of her work for the FSA in that her portrayal of restrictive, unhealthy, offensive spaces, from lines of people crowded into assembly centers to families of people pressed into cramped and filthy camp quarters, makes a claim for other, clear and healthy spaces.

Lange's portrayal, no less than these other records, was propaganda, but, she said, "the line, in the hands of conscientious people, is a fine line. Everything is propaganda for what you believe in. . . . I don't see that it could be otherwise. The harder and more deeply you believe in anything, the more in a sense you're a propagandist."[130] Although she "denied the role of artist" ("It embarrassed me," she said. "And as far as the argument about whether photography is or is not an art, I've thought that it was a useless and a

stupid argument"), what Lange meant by needing "propaganda" was something like what documentary filmmaker Pare Lorentz intended when he said "Good art is good propaganda." She believed, in other words, that in the face of *un*making, we need to create—the made object or artifact. Lange had earlier defined "document" as a factual representation "plus this other quality that the artist responds to": "I always thought . . . 'art' was a byproduct, something that happens, a 'plus-something' that happens when your work is done, if it's done well enough, and intensely enough. . . . But there comes a time when you have a right to ask someone to stop and look at something because this is what you think is important, *you* think is important."[131] That is to say, the document was the original photograph, made at a particular time and place to represent real human beings in actual situations; if it was done well, it also had "this other quality."

This leaves us, however, with important questions about representation—about why Miyatake's images of Manzanar eschew "this other quality" while Adams's have too much of it, and why Lange's images continue to move us not only as artifacts but as *images*.

Photographs are artifacts with a continuing life. As Lange's *materials* they lose their particularity of time and place, taking on new meaning by being joined to other photographs (or words) to express and reinforce ideas, emotional tones, or formal patterns. Her sense of entitlement, authority, and privilege—*power*, that is—was tied to her notion of "conviction, propaganda, faith," and to her sense of her craft.[132]

"She had to do it [photograph the internment] internally," Paul Taylor said. "That was the way she lived, . . . by participating in what was happening at the time. She *wanted* to do it."[133] She had to do it; she wanted to do it; she had the *right* to represent—to document, to picture—difference according to the convictions of the sensitive woman whose own body, lame and ill, was hidden beneath her cloak of invisibility. On another occasion she recounted having to retrace her steps to get clearance for photographs in her "Public Defender" series for *Life* magazine in 1955; she had to confront her subject and explain to him why she needed his picture:

> I had to go into one dive that I'll never forget, in the colored quarter of
> Oakland, looking for a man . . . called "the witness." . . . I found him all
> right. I had two policemen with me. . . . We rode around Oakland in a
> police-wagon while I explained to him just what this was about. . . . me

explaining to this big, black homosexual why I wanted his picture, and his responses. It finally came round that if it was for the general welfare, he was all for the general welfare.[134]

"When you photograph, all you're doing is a job, and you're in control of your job and you have every right—*must* have every right in your mind—to make that photograph, and every reason," Rondal Partridge remembered her saying. "If you have every right and every reason behind you, the people will never notice you."[135] But sometimes they did notice. In Egypt in the early 1960s, women whom she was attempting to photograph "began snarling at her, and then hitting at her camera to knock it out of her hands," and children pelted her with stones because—in a perfect ironic closure—as Taylor learned, "in the eyes of protesting people, we were agents of the Israelis."[136] Shocked at this response, she seems to have seen no contradiction between her own deep sense of the private and her embodiment of others' vulnerability. She was opposed to making the familiar strange, "forced . . . into unnatural shapes . . . in which they need not be interpreted but, like a process, invented." Nevertheless, she invented—in the sense of *invention* spun upon the ground of her convictions—a way in which the strange, though distinct from the realm of the private (i.e., her own environment) presented "in the most ordinary, familiar, usual kind of way"[137] could be made to seem familiar.

An artifact is a made thing. In that sense, and particularly for Dorothea Lange, an artifact is a projection of the human body. In the case of the internment photographs—which represent not simply an occurrence that had incidentally deconstructed the made world of the pictured subjects, but a strategy of war that "deconstruct[s] the structure of making itself"[138]—Lange's response to this *un*making of the world was to make the external world *felt* by making artifacts. In picturing the human subjects of the internment, Lange—no less than Miyatake, who had worked to reverse the process of unmaking by recording the internees' physical presence—attempted to reverse the process of unmaking by depriving the outside world of its privilege of being irresponsible to its sentient inhabitants. Insofar as her imagination is bound up with compassion,[139] Lange forces us to imagine *them,* to reimagine ourselves in relation to them—this was her purpose—and ultimately to reimagine herself. As Scarry suggests of the maker of objects whose purpose is not only to alter the world, but to alter the power of alteration itself, "The human being who creates on

behalf of the pain in her own body may remake herself to be one who creates on behalf of the pain originating in another's body; so, too, the human beings who create out of pain (whether their own or others') may remake themselves to be those who create out of pleasure (whether their own or others')."[140]

VI | The Body's Geography: Female Versions of Landscape

The body repeats the landscape. They are the source of each other and create each other. We were marked by the seasonal body of earth, by the terrible migrations of people, by the swift turn of a century, verging on change never before experienced on this greening planet. I sensed the mound and swell above the mother breast, and from embryonic eye took sustenance and benediction, and went from mother enclosure to prairie spheres curving into each other.—Meridel Le Sueur, "The Ancient People and the Newly Come" [1]

"GREAT-FEATURED NATURAL SCENERY"

What is essential to grasp here is the strangely naive and ultimately perplexing point that appearance is power and that this is a function of the fact that appearance itself can acquire density and substance. . . . Epistemologies of science bound to the notion that truth always lies behind (mere) appearance sadly miss this otherwise obvious point. Daily life, however, proceeds otherwise.—Michael Taussig, Mimesis and Alterity [2]

I can just see the way the land lies as all of these are there. And so can you. And so can you. . . . Geography does not look like it does in relation to the human mind. . . . Because the human mind knows what it knows and knowing what it knows it has nothing to do with seeing what it remembers.—Gertrude Stein, The Geographical History of America [3]

An image of our western landscape introduces us to Jean Baudrillard's *America,* a late twentieth-century scene featuring a man on a white horse, who turns in his saddle to look at the screen of the drive-in movie centered against sloping, empty background mountains (fig. 6.1). What he, and we, see on the screen is his postmodern double: a space explorer, costumed and equipped for the discovery and conquest of an alien, primeval land—a

body of craters and ridges, and possibly hidden riches. The curve of the moon's surface exactly repeats the curve of the rider's hat brim, reminding us that he, too, was once a screen hero and that the Westerns in which he starred helped to create a public taste for the spectacular landscape. The astronaut on the screen is upside down, as he would have appeared in the lens of a photographer's view camera in the latter half of the nineteenth century. And he is the mirror image of that earlier photographer, who, likely a member of the U.S. government's survey team, recorded views of the vast and seemingly unoccupied territories of the newly conquered West. In artist Chris Richardson's witty play with cultural myths, the middle place collectively imaged as garden has become desert, framed both fore and aft by the invading machine: (empty) automobiles and their asphalt highways, signs of the speed and alienation that mark twentieth-century travel through a land*scape* unreeling past glass windows and viewed from another climate; the background sight of mountainous wilderness now a site for the projection of views of the remote and exotic spaces of the New Frontier.

The real point of this image is that everything—the landscape before us and the moonscape represented on the screen, western hero and space explorer, the artwork itself—is a construction, or what Baudrillard calls a

6.1 Chris Richardson, frontispiece of Jean Baudrillard's *America* (London: Verso, 1988). Photograph, Edgar Sabogal.

simulacrum. "I went in search of *astral* America [*l'Amérique sidérale*]," this latter-day Tocqueville announces, in the guise of our own Thoreau-cum-Kerouac: "not social and cultural America, but the America of the empty, absolute freedom of the freeways, not the deep America of mores and mentalities, but the America of desert speed, of motels and mineral surfaces. I looked for it in the speed of the screenplay, in the indifferent reflex of television, in the film of days and nights projected across an empty space, in the marvelously affectless succession of signs, images, faces, and ritual acts on the road." Here, amid "the irony of geology, the transpolitical finds its generic, mental space. The inhumanity of our ulterior, asocial, superficial world immediately finds its aesthetic form here, its ecstatic form." Nowhere else, he concludes, "does there exist such a stunning fusion of a radical lack of culture and natural beauty, of the wonder of nature and the absolute simulacrum."[4]

Baudrillard's postmodern reading of our landscape in the last days of the presidency of Ronald Reagan (a photograph of whom, pointing at his cancerous nose, is included in *America*) points to the underside of our own representations of Nature—what Deborah Bright refers to as the locus of the visually spectacular, the romantic dream, marketed for tourist consumption, of a pure, unsullied wilderness where communion with Nature can transpire without technological mediation, and also as "the repository of the vestiges of the Frontier, with its mythical freedom from the rules and strictures of urban social contracts—a place where social Darwinism and free enterprise can still operate untrammeled."[5] What Baudrillard overlooks in his reading of these signs of the "antagonistic climax" of our "extreme irreferentiality" and of our "primeval and great-featured natural scenery" —and what is apparent in the frontispiece image—is the stereotypical gendering of such signs: the western hero on his horse amid the phallic cacti of the desert plain; against the penetrable female contours of the mountains, the screen projecting the space man with an elongated hoselike structure extending from his crotch and in his hand a tool for probing and penetrating the feminine moon.

"No less than Marlboro Country, American landscape photography remains a reified masculine outpost—a wilderness of the mind," Deborah Bright suggests of the major exhibition, *A Vision of Nature,* mounted at the Art Institute of Chicago in 1985 just before the publication of Baudrillard's *America*. Collectively, the works of the six masters of photography whose

genius the show celebrated—Ansel Adams, Eliot Porter, Alfred Stieglitz, Paul Strand, Edward Weston, and Minor White—embraced dominant attitudes toward landscape: the picturesque sublime of Adams and Porter, in the conservative social climate of a postwar United States "basking in its reborn Manifest Destiny as a world superpower" representing a sanitized conception of the natural world akin to that promoted in Walt Disney's wildlife films; the emphasis on evocative meaning to the exclusion of form in Minor White's reworking of Stieglitz's equivalents; and, on the other hand, the insistence upon form in the work of Strand and Weston. The latter attitude has been especially promoted in the formalist readings (i.e., those that emphasize vantage point, detail, frame) of the influential John Szarkowski, who promoted "wilderness" as *the* American landscape and dismissed issues of patronage, audience, means of reproduction and distribution in favor of an aesthetic theory that could be applied equally to any body of photographs from any historical time and place. In Szarkowski's vision, or construction of landscape, Bright argues, "plucked from their historical world of contracts, commissions, stereographs, and stubborn senators, nineteenth-century photographers like [Timothy] O'Sullivan are thus rehabilitated as the sires of a bloodline of artistic photographers legitimized by a powerful American cultural institution, the Museum of Modern Art, and its provincial satellites: the Art Institute of Chicago, the Corcoran, the Walker, and now the Getty."[6]

As Rosalind Krauss was the first to show, visual documents of the U.S. government survey made in the latter half of the nineteenth century and artistic representations of landscape in photography are projects that occupy distinctly separate ideological and physical spaces. Unlike landscape paintings meant to be displayed on a museum wall, whose horizontal line would be imitated in photography, Krauss argues, the images of Timothy O'Sullivan, William Henry Jackson, Carleton E. Watkins, and others were often differently organized. Using the staff of a bare tree trunk (fig. 6.2) or the sheer edge of a rock formation as center, compositional meaning in these pictures derives from the special sensations of the view. *View* is an active term: in his one published account of his work as a western photographer, O'Sullivan used *view* to describe the documents he made and *viewing* for what he as maker of these documents did. *View* also refers to the dramatic insistence of perspectivally organized depth, and *viewing* to the experience of looking at these pictures, which were not published in the nineteenth century but distributed through stereography. "Organized as a

6.2 Carleton E. Watkins, *Best General View of Yosemite Valley,*
albumen print, 16.5 by 20.5', 1865–66. Collection of the J. Paul Getty
Museum, Malibu, California, no. 85.XM.11.3.

kind of tunnel vision, the experience of deep recession [in stereography] is
insistent and inescapable," heightened by the fact that the viewer's own
ambient space would have been masked out by the optical instrument held
before his or her eyes, one's own surrounds banished from sight, Krauss
points out. This apparatus "mechanically focuses all attention on the mat-
ter at hand and precludes the visual meandering experienced in the mu-
seum gallery as one's eyes wander from picture to picture." In both nine-
teenth-century middle-class homes and public libraries, stereoscopic views
were kept within the physical space of a cabinet, whose drawers cataloged
and stored a whole geographical system. If the museum "represents the
space of an automonous Art and its idealized, specialized History, which is
constituted by aesthetic discourse," the file "holds out the possibility of
storing and cross-referencing bits of information and of collating them
through the particular grid of a system of knowledge" that is also a com-
pound representation of geographic space. In other words, insofar as "the
spatiality of the view, its insistent penetration, functions as the sensory

model for a more abstract system whose subject is also space," view and land survey are interdetermined and interrelated—with one crucial difference. In the case of the stereoscope, like the earlier diorama and the later cinema, "the image transports the viewer optically, while his body remains immobile," Krauss points out; "pleasure derives from the experience of the simulacrum: the appearance of reality from which any testing of the real-effect by actually, physically moving through the scene is denied."[7]

As the creation of abstractions to organize perception and ultimately the substitution of abstraction for perception, the American land survey was the world's most extensive example of the rationalized landscape. "Insofar as the system was based on cartographic lines and points," Paul Shepard argues, "it was a projection upon the earth's surface of a uniform, mechanical treatment of the universe," the effects of which "are more far-reaching than mapping. It seems to provide a rationale and justification for the control of nature that aims to improve it but sanctions the destruction and removal of any elements which do not seem to fit the pattern." That survey photographers like O'Sullivan worked first as Civil War photographers fits with Shepard's view that this kind of abstraction is militaristic—"a kind of war against selected objects, species, processes, forms in the landscape." Linking the low social and political status of women to the general absence in this country of devotion to place and of a mythology of rootedness in nature, Shepard describes our society as having little interest in mysticism, magic, and internal space, as "focused on rational, practical, exploitive, political, commercial, abstract behavior and values, not on intuitive, esthetic, organic, social, and individual ideals." In other, mostly agricultural societies, special attributes of the female—menstruation, reproduction, lactation—have been part of ritual celebration. Slow to change or to alter their environments, such societies are resistant to moving and migration; they are reluctant to accept "progress" when it means the substitution of ideological for organic principles. "If men innately regard the land as organic and animate," Shepard writes, "then the importance of that belief probably goes far beyond the simple response to caves and tunnels as orifices, to ridges as thighs, mountains as breasts, trees as hair, and lakes as eyes. It means that the relationships between men and women partly determine how people use their environment."[8]

Reclaiming Paradise: American Women Photograph the Land, an exhibit which opened at the Tweed Museum of Art in Duluth, Minnesota, two

years after the more auspicious *A Vision of Nature* and aimed to address precisely these issues of gender and the physical environment. Curator Gretchen Garner's purpose in exhibiting together photographs by Berenice Abbott, Anne Brigman, Linda Connor, Barbara Crane, Imogen Cunningham, Judy Dater, Liliane DeCock, Mary Beth Edelson, Marion Faller, Linda Gammell, Lynn Geesaman, Laura Gilpin, Betty Hahn, Dorothea Lange, Cynthia MacAdams, Joan Myers, Marion Patterson, Kathryn Paul, Mary Peck, Meridel Rubenstein, Geraldine Sharpe, Clara Sipprell, Gail Skoff, Evon Streetman, Vida, and Marion Post Wolcott was "to take another view, a view from the bottom up, a view that questions and promises to overturn some of the values of mainstream landscape tradition." Underlying those values, Garner argues, was an assumption of the superiority of culture to nature"[9] that dates back to the "all-male geological and railroad expeditions that followed the Civil War." Survey photographers who struggled with heavy glass plates, awkward chemical "dark-wagons," and unwieldy equipment (fig. 6.3) were engaged in recording "the white man's progress in taming the continent." Their pictures, which often bear telltale traces of railroad tracks and crude engineering projects, remind us that tracks were the central reason for the pictures. Women might not have been instrumental in surveying and mapping the frontier, Garner notes, but they were fully and crucially involved in what came next: settling the land. As "women wrested order from chaos in rude homes and in painfully cleared gardens," alongside their men planting the food and raising the animals that fed the families, performing daily tasks of nurture and care in unfamiliar surroundings, laboring "to create a new paradise in an unknown land," their experience formed "a ground on which later American women were to build in depicting it. . . . [L]ike their settler forbears, women photogra-

6.3 William Henry Jackson, *The Photographer's Assistants*, albumen silverprint, 1886. University of New Mexico Art Museum, Albuquerque, gift of Beaumont Newhall.

phers would struggle toward a human scale, toward harmony and intimacy and toward an identification with the nurturing power of the earth." Drawing on the works of feminist literary scholars, anthropologists, historians of science, religion, and art, as well as poets and photographers, Garner finds that women's images of landscape from the turn of the century to our own time fall into two paradigmatic groups. One is "strongly metaphoric," seeing the land not as sublime idea or "other" but in terms of "close identification," of union not ownership, and with a focus on close, commonplace sites (for example, Linda Connor's "We are nature so why venture very far"). The other paradigm emphasizes nurturance and interdependence rather than possession and production, and represents the land in terms of images of growth and labor (for example, Dorothea Lange's "The people become their land and the land becomes the people").[10] Thus, from Brigman's presentation (circa 1900) of her own naked body replicating, intertwining with, and reflecting the shapes and surfaces of mountains, trees, and pools in California's Sierra Nevada, to Cunningham's pregnant woman in her garden to Dater's nude self-portrait with petroglyph; or from Abbott's cityscapes to Lange's documentary photographs or Myers' recording of the sites of former Japanese American internment camps to Connor's petroglyphs, women photographers have established what amounts to a countertradition in visual representations of the land.

Because there is much that is rich and suggestive in this exhibit, we need to question, rather than to take at face value, the kinds of connections Garner (and others) see in the work of women—for example, the leap from pioneer women to women *landscape* photographers, or the commonality in the "documents" of Cunningham, Abbott, and Lange. Photographer Linda Connor's claim that women respond more intimately to Nature than men do because "women define territory and protect it by their experience; absent is the need to explore, transcend, and possess" should be placed against photographer Deborah Bright's concern that such essentialist constructions—"because a woman is more involved with the 'natural' functions of reproduction and nuture, she is 'closer to nature' than men"—have been used throughout history to devalue women and their cultural production. The corollary to such constructions posits that the male's lack of "natural" creativity causes him to create "artificially" through the mediums of technology and symbols: "men *choose* to interact with nature and bend it to their will, while women simply *are* nature and cannot define themselves in opposition to it."[11]

A "land*scape* depends upon perception," Elizabeth Hampsten points out in her essay accompanying this exhibit: "The land always is there, whether anyone is looking or not. But landscape is defined by a viewer—either the painter nearly fooling us into thinking we see actual land before us, or someone looking at a 'view or prospect,' the eye focused upon what becomes scenery. Landscape is constructed by imagination." This is close to John Stilgoe's definition of *landscape* as "shaped land, land modified for permanent human occupation, for dwelling, agriculture, manufacturing, government, worship, and for pleasure. A landscape happens not by chance but by contrivance, by premeditation, by design." The word *landskip* entered the English language in the last years of the sixteenth century, via Holland, as a way of describing Dutch scenery or *landschap* painting—"the traditional territorial *landschaft,* the houses surrounded by common fields and encircled by wildernesses of ocean or swamps."[12] Stilgoe's theory of landscape as a made environment—directly opposed to Szarkowski's theory that because there is no "landscape" in America, landscape photography begins with views of "wilderness"—derives from what he *sees* (as in the original meaning of the Greek *theoria,* or gaze). A scholar trained in cultural geography and material culture who is also a farmer, Stilgoe knows that there are many varieties of land from which to make "scapes." John Berger, another writer who lives and works on the land about which he writes, points to the way in which the peasant in the paintings of Jean-François Millet emerges quite literally from the shadows. Here he shows that landscape painting was addressed to the visitor from the city; it was *his* view, *his* reward: "Imagine a peasant suddenly appearing at work between the table and the view, and the social/human contradiction becomes obvious."[13]

Hampsten, a literary historian who has studied the diaries and letters of midwestern women settlers, also argues that theories of landscape have to do with class. She finds the perceptions of the photographic artists in *Reclaiming Paradise* to be "extraordinary" in that they seem to think about landscape "as something seen at a distance (however slight)—as a 'scape.'" On the other hand, the private writings of women who lived on the land, working in villages and on farms, tell us almost nothing of "views" of the land before them; nor do they note a distance between themselves and their surroundings. Unlike artist-photographers who "visit" the land and create versions of landscape based upon their own seeing, women who live on the land neither express feelings of special identification with land nor place

themselves in the landscape. Their letters, diaries, and reminiscences rarely describe "a piece of country scenery"; in fact, Hampsten finds that it is often difficult to tell where these writers are. Women who live there apparently feel no particular compulsion to "see" or to report spatial relationships, to stand back and view distances:

> A woman who amazed herself by canning twenty quarts of wild strawberries had nothing at all to say about what the strawberry plants looked like where she found them. This other view of land is highly experiential and set in time rather than space; it is expressed in particular and concrete writing. These authors do not take in distances at a glance. They describe, instead, activities that we know have taken place out of doors, in what painters and photographers would term "Nature," but they take these surroundings for granted, as though they were indifferent to them.[14]

Describing a German homesteader in North Dakota who writes of an excursion to the fields where the children played while she worked, Hampsten understands that

> This woman took the measure of where she found herself in time, not space, the days that became months and years of intricately coordinated simultaneous activities. Time is the one generality she expresses, as though she did not "see" enough space around her to formulate a landscape, to take anything in at a glance as those trained to see landscapes would expect to do. Certainly her daily life is "various, rich, and rare," but at close hand and measured, in her imagining, by time, not space; hours, not shapes.[15]

Women have "inhabited" the land in more ways than as men's helpmates. A collection of photographs that corresponds to Hampsten's work with women's private writings—snapshots and visual documents from local historical societies—makes clear that women were prospecting in Alaska, teaching school in Texas, holding down land claims in Oklahoma, working as prostitutes in the Klondike, operating restaurants in San Francisco, working on assembly lines in Denver, as news reporters in Utah, as telephone operators, midwives, missionaries, and photographers in Oregon (fig. 6.4). The photographs collected by Cathy Luchetti and Carol Olwell in *Women of the West* document the presence of African American, American Indian, and Asian women as well as white women in our western lands.[16]

6.4 M. E. Tyler, attr., Untitled [Cora Baldwin and Mrs. M. E. Tyler, Photographer], Ashland, Oregon, c. 1892. Southern Oregon Historical Society, no. 13386.

If most histories of landscape photography begin, then, with the survey project—as the origins of a tradition that imposes form upon chaos, as a celebration of the picturesque sublime akin to the work of nineteenth-century landscape painters, as an alternative (utopian) vision, as a series of visual documents, or as an imposition of the grid of modernism upon the land[17]—it is because they begin with what is *present*. But what if we look for alternative traditions in what is *not* present, as Hampsten suggests with her work on unpublished women's writings, and as Luchetti and Olwell suggest with their work on women's unpublished photographs? In a recent essay on paintings of the West, "The Absent Other: Women in the Land and Art of Mountain Men," Susan Prendergast Schoelwer argues that in spite of an increasingly large body of historical research documenting female presence on the frontier, in artistic representation the West remains a masculine domain in which women are conspicuously absent or marginal to events depicted. Whether they celebrate western art as heroic visions of the nation's past or launch revisionist critiques that interpret the same im-

ages as narratives of imperialist oppression, recent exhibitions and publications define the central theme of western art as "great male adventures of dominating a challenging environment." (One might add to this that both art historians who see the photographs of the survey project as celebrations of the beginnings of landscape photography and social historians who see the same images as documents of imperialist expansion agree in defining them in terms of male adventure.) In either case, "the mythical realm of western art remains an unnatural land to which the universal laws of human demographics seem irrelevant."

Taking paintings of frontier fur trade as her case study, Schoelwer points out that the central figures in these works symbolize qualities traditionally associated with the frontier in general—"strength, resourcefulness, restlessness, self-reliance, and above all individualism"—all conventional masculine attributes celebrated as preeminent national characteristics. These main men are like the protagonists in much of American literature, from Leatherstocking to Huck Finn: the western hero who, in order to fulfill his solitary destiny in the wilderness, "must be free of both domestic and civil concerns, bound to society by only the loosest of fraternal ties among similarly unfettered fellow adventurers. The mountain man of myth and legend, therefore, necessarily inhabits a world that is exclusively and emphatically male, a landscape defined by the explicit and conspicuous absence of women." Women, of course, indigenous and immigrant, their stories now disinterred by feminist historians, participated in all stages of western development.[18] In the case of visual representations, what the legendary absence of women means is the absence of white women. In lives free from the constraints of "civilization," the trapper depended upon a variety of support services from indigenous American women for his basic needs. In Alfred Jacob Miller's genre scenes native women play supporting roles—cooking, making moccasins (fig. 6.5), bathing, holding children (often of mixed parentage), pounding meat, packing supplies, racing horses, even hunting buffalo—and serve as sexual partners for white men. Such scenes corroborate historian Sylvia Van Kirk's assessment of *active* female participation on the frontier, without which the fur trade would hardly have been possible. Moreover, as Schoelwer argues in examining these works, "To the degree that both women and American Indians represented difference, against which European American males defined their own identities, then Native American women were doubly other."[19]

Visual representations of the survey project, like depictions of the fur

6.5 Alfred Jacob Miller,
Making Moccasins, water-
color on paper, n.d., Yale
Collection of Western
Americana, Beinecke Rare
Book and Manuscript
Library, Yale University,
New Haven, Conn.

trade, are celebrations of an enterprise that begins a particular version of History. To understand whose version, we must begin to think about the fact that the *response* to these pictures coincided with the "Cult of Wild Nature" that arose in the late nineteenth century after the "Indian problem" had been brutally solved. This movement that linked gender and race— men and Indians—had a great deal to do with class as well. In the years leading up to the official closing of the frontier, it was promoted by a collusion of liberal reform and commercial interests, both of which saw the "nature experience" as a desirable antidote to unhealthy urban life. Railroad (and later automobile) interests helped to create a middle-class tourist market for western travel as well as wilderness programs claimed and named as legacies for future generations.[20] Any history of early photographs made in the West and circulated in the East as a masculinist project must therefore take into account the fact that the very forgotten middle-class white women, whose presence early revisionist historians set out to document, also profited from the opening of the West that was the survey's purpose. In reading the photographs of North American Indians and their lands made by Laura Gilpin and Kate Cory, as against those made by Edward Curtis, Adam Clark Vroman, and Roland W. Reed, Lucy Lippard finds "empathy as a factor in the relationship between race and gender lurking in this subject" and warns that for those from the dominant culture, "seeing is

still believing." Tracking down the journals and letters of Mary Sharples Schaeffer Warren, whose sensitive portrait of a family of Stoney Indians in their native British Columbia landscape in 1907 motivated what would become a book about photographs of native North Americans, Lippard writes that "Mary Schaeffer, for all her love of the wilderness (which she constantly called her 'playground') was not free from the sense of power that came with being a prosperous 'modern' person at 'play' in the fields of the conquered." She "expressed a very 'modern' sense of melancholy and loss as she watched the railroad (which she called a 'python') and ensuing 'civilization' inching its way into her beloved landscape," but in her journals she "betray[s] a colonial lens" in her condescendingly "fond" but not very respectful descriptions of the "savages" who are often her friends.[21]

Clearly, any study of gender in compiling the histories that comprise our collective past must include the deeply intertwined issues of race and class. Undeniably, education and the cultural habits of class predispose artist photographers and writers to *see* landscape abstractly, but there are places where these complicated strands do overlap—in the way that both the farm woman (noted by Hampsten) recorded her day, hour by hour, with herself at the center, and in the way many middle-class white women photographers represent the land(scape) as inhabited, whether or not human figures are in the scene, as "places where people belong, or ought to be; places people have created, or left, or to which they may not yet have arrived; locations of careful and intense human activity . . . [which] depend upon the idea of human presence."[22]

AT PLAY IN THE WILDS OF AMERICA

We sometimes admire a woman whose countenance seems more beautiful because of the merest suspicion of a light obliquity of vision, a little mole on the cheek, or some trifling irregularity of feature. It draws the eye and hence induces us to esteem as a mark of beauty what is actually a positive defect. So here, in these landscapes, the sky makes us particularly admire the whole picture.—William M. Murray, "Clouds in Landscape Photography" (1899)[23]

Where I go is wild—hard to reach, and I don't go for Alfred Stieglitz or Frank Crowninshield or Camera Work or Vanity Fair—but because there [are] things in life to be expressed in these places. And in these places I must wait, sometimes seek for the supreme mood in nature.—Anne Brigman, 1915[24]

Vision, in the West, has been a primary route to scientific knowledge. We speak of "knowledge as illumination, knowing as seeing, truth as light," anthropologist Emily Martin notes, associating the illumination that vision gives with the highest faculty of mental reasoning. This emphasis on observing—on mapping, diagramming, charting, recording—has meant that the "ability to visualize a culture or society almost becomes synonymous for understanding it." "Visualism," she writes, connotes "a cultural, ideological bias toward vision as the 'noblest sense' and toward geometry qua graphic-spatial conceptualization as the most 'exact' way of communicating knowledge"—but it is also "a key culprit in the scrutiny, surveillance, domination, control, and exertion of authority over the body, particularly over the bodies of women."[25] Some cultural theorists would privilege *hearing* over seeing: Stephen Tyler describes "post-modern ethnography" as "the study of man talking," and James Clifford offers a "discursive" paradigm in which "cultures are no longer prefigured visually—as objects, theaters, texts . . . [and] the dominant metaphors for ethnography shift away from the observing eye and toward expressive speech (and gesture)."[26] For me, this study of "man talking" is a newer (postmodern) version of Emerson's "Man Thinking" and, by extension, of his definition of Nature as "the NOT ME, that is, both nature and art, all other men and my own body."[27] What the *Writing Culture* people leave out is sentient experience—the feel of sun or rain on the skin, of the smoothness of a rock's surface or the graininess of sand to the fingertips' touch, the fragrance of pine needles or the slickness of ice underfoot, thirst or the anticipation, then taste of sweet wild berries—or what Virginia Woolf described in imagining herself as a tree:

> I like to think of the tree itself: first of the close dry sensation of being wood; then the grinding of the storm; then the slow, delicious ooze of sap; I like to think of it, too, on winter's nights standing in the empty field with all leaves close-furled, nothing tender exposed to the iron bullets of the moon, a naked mast upon an earth that goes tumbling, tumbling all night long. The sound of birds must sound very loud and strange in June; and how cold the feet of insects must feel upon it, as they make laborious progresses up the creases of the bark, or sun themselves upon the thin green awning of the leaves.[28]

Not all anthropologists embrace the new (masculinist) ethnography. Marilyn Strathern argues that feminist anthropology has irreconcilable dif-

ferences with textual anthropology derived from incompatible views of the self and the world. "The constant rediscovery that women are the Other in men's accounts reminds women that they must see men as the Other in relation to themselves," she writes. "Creating a space for women becomes creating a space for the self, and the experience becomes an instrument for knowing the self. Necessary to the construction of the feminist self, then, is a nonfeminist Other . . . most generally conceived as 'patriarchy,' the institutions and persons who represent male domination, often simply concretized as 'men.'" Although Strathern's real target is an anthropology that would dissolve differences between distinct social and cultural practices and beliefs, her argument that between anthropologist (self) and informant (Other) "the dialogue must always be asymmetrical"[29] is useful in thinking about the work of women artists, from a variety of backgrounds, who arrive at the same conclusion.

In presenting the fruits of the earth as male body (fig. 6.6), painter and filmmaker Eunice Golden comments wryly upon a long tradition in western art of portraying the land as female. This is a convention linked to western exploration in the "age of discovery" and to the very naming of "America." In a sixteenth-century engraving of *Vespucci "Discovering" America* (fig. 6.7), for example, the "civilized" explorer—fully clothed, holding compass and flag—stands on the shore of a wild and verdant landscape, there confronting an indolent naked female to whom he will give his own name—America; in Philippe Galle's *America,* a savage female strides across the land with her victim's bloody head in her grasp. Gustav Courbet's *The Painter's Studio* (1855), which depicts a (masculine) self-representation of the maker of a landscape modeled on a nude woman; or Paul Gauguin's

6.6 Eunice Golden, *Blue Bananas and Other Meats,* film still, 1973. © Eunice Golden.

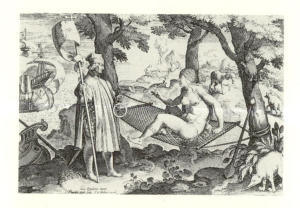

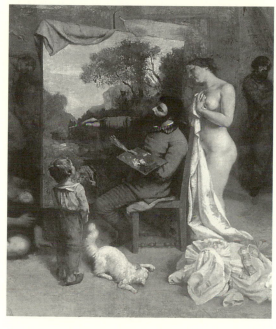

6.7 Theodore Galle, after Stradanus (Jan van der Street), *Vespucci "Discovering" America,* late sixteenth century. Photograph, Edgar Sabogal.

6.8 Gustav Courbet, *L'atelier du peintre* [The Painter's Studio], detail, 1854–55. Louvre Museum, Paris. Photograph, RMN —Hervé Lewandowski.

Tahitian Women (1889), in which women's breasts are like the juicy fruits of the earth, are simply well-known examples in the nineteenth century of an artistic practice so common, its place in history so assumed, that we take it to *be* History, a story we know and recognize. In Courbet's *Studio* (fig. 6.8), which resembles nothing so much as a theater, woman is more than muse;[30] she—her body as the subject of public gaze—and the Nature she is meant to represent become spectacle. Endowed with the grand proportions of classical sculpture, the sexuality of this idealized figure is tempered by her maternal qualities: as is also the case for Gauguin's *Tahitian Women,*

the artist's subject is Mother Earth; as the child to the left of Courbet's artist makes clear, her breasts are for nurturing. Much more subtly, Alfred Stieglitz's photographs of Georgia O'Keeffe with apples (fig. 6.9) take up this theme. Not so subtly, this is the subject of a popular nineteenth-century French magazine advertisement, which is parodied by Linda Nochlin in her 1972 photograph of a naked man selling bananas. Nochlin, like Golden, points to the agency of maleness, the subjectness of females, the femaleness of Nature, and the maleness of art as nothing more nor less than cultural constructs. It is not only a reversal of traditional representations that is at stake in these works by women, however. Golden's and Nochlin's pictures of genitalia explicitly play with the taboo erected by Freud—that male sexual power cannot be fully represented precisely because men are caught between the need to identify sexually with the father and are prohibited from fully identifying with the father who has sexual access to the mother's body. In other words, these images strip away the idealism of male self-presentations. Blurring the boundaries between pornography and erotica, these women artists re-present men's bodies as a subject of mockery and amusement. At play in the wilds of America, their masquerades enact a powerful and disrupting exercise of power.

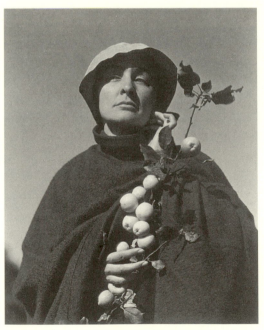

6.9 Alfred Stieglitz, *Georgia O'Keeffe: A Portrait —with Apple Branch,* gelatin silver print, 1921. National Gallery, Washington, D.C., Alfred Stieglitz Collection.

Re-presenting the other's body is one strategy—one that Imogen Cunningham plays with in her early photographs. Creating a space for the self is another, as Anne Brigman does in her photographs of nudes in the California Sierra Nevada at the turn of the nineteenth century. As Cunningham tells it,

> The only western photographer that . . . [Stieglitz] was interested in at that time was Ann [*sic*] Brigman. She was almost exclusively interested in the nude. She was the wife of a sea captain, and she had gone on one trip to sea with him and had fallen into the hold of a ship. She had to have an operation and have one breast removed. That was a great handicap because she was her own model. She always used to get herself up in a pitchy tree, set the camera (it was some little old Kodak, you know, nothing better) and sort of try to conceal that one breast, and photograph herself and call it "The Dryad." Then she would retouch anything that was necessary, put it on. When I look back on what she did and what Stieglitz picked out, I felt that his judgment at that time was just as faulty as anyone else's. . . . [T]hey were not unattractive. They have to be considered in relation to their time. They were just as attractive as anything that was being done at that time except that she did have a very defective technique. Anyway, Stieglitz evidently liked it.[31]

By "western" photography, Cunningham referred neither to the vast and spectacular landscapes of Jackson, O'Sullivan, Watkins, and others of the recent photographic past nor to the picturing of indigenous peoples in their native habitats by her early employer Edward Curtis. Brigman's and Cunningham's embodied landscapes could not be more different from either of these modes of representation in which photographers projected their own distance from nature. If Curtis, as we have seen, was concerned with documenting a vanishing race in a rapidly urbanizing country, the work of surveying was instrumental in setting the stage for that very vanishing and was under the direction of a man who saw the western mountains and rivers as some kind of Gothic landscape—the "abyss of foam," "black precipices," and "strange wild sounds" all having the effect of a "Dantean gulf." As Clarence King wrote these words, he knew that man could name, measure, and classify through the resources of geological knowledge and the scientific tools of perception, thus bringing order out of chaos and turning nature into culture—just as his photographers would

signify the vast distance between viewer and vista with their marks upon the land.[32]

Nor did Cunningham refer to the very different artistic conventions of nineteenth-century European American figured landscapes simulated by many Pictorialist photographers at the turn of the century. She meant instead the kind of work she herself did in her Seattle days, around the edges of her portrait work: "I liked to photograph people in the nude in strange and difficult situations, like standing around in pools of water—regular 'September Morn' stuff, you know"[33] (fig. 6.10). Cunningham makes no distinction here between high art and popular culture; in fact, depictions of an intimate and sensuously detailed nature, including allegorical representations of the female figure as mystic or seer, could be found both at the core of the turn-of-the-century Symbolist movement and in soft porn.[34]

For Pictorialist photographers, who already used special soft-focus lenses and produced a flattening and grain in their gum-bichromate prints,

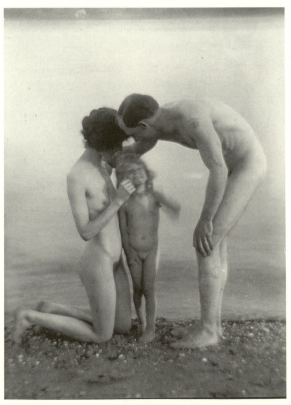

6.10 Imogen Cunningham, *Family on the Beach,* c. 1910. © 1978, 1996 by the Imogen Cunningham Trust.

it was a short step to Symbolism. Moving into the "territory of nuance and suggestive arabesque," they staged productions in "a sacred grove into which there penetrates the light of a specifically visionary kind of knowledge," Rosalind Krauss writes, suggesting that these were female places "articulated by Eve's gesture as she raises her arm to grasp the instruments of knowledge; or sometimes the grove is more classically inflected with the female occupant specified as seer, carrying the emblemata of the mystic."[35] Sometimes, however, the grove is classically inflected with the male occupant specified as mythical representation, as in F. Holland Day's arcadian photographs of a male youth in the Maine woods. Symbolist pronouncements are scattered throughout *Camera Work* and *Camera Notes,* and artists identified with Stieglitz's gallery 291 came to define Symbolist painting as "the attempt to render external an internal state of mind or feeling, to project onto the canvas emotional, temperamental, mental, subjective states." Francis Picabia saw photography as helping "art to realize consciously its own nature, which is not to mirror the external world but to make real, by plastic means, internal mental states." And for Paul Rosenfeld, Georgia O'Keeffe, in her mystical identification of self with landscape "synchronized her 'inner rhythms' with the great rhythms that pulse outside . . . in the earth, in the air." For photographers and painters associated with the Stieglitz group, landscape was not a symbol of an emotional state; it was its visual equivalent.[36] At the heart of the Symbolist project is language as "a form of radical absence—absence, that is, of the world and its objects, supplanted by the presence of the sign," Krauss argues. In photography, Symbolism in its purest form is to be found in Stieglitz's *Equivalents* (fig. 6.11), despite his distaste, by the time he made these photographs, for Pictorialism. Stieglitz cropped these images of clouds—"images without grounds"—so that they seem punched out of the sky, banishing "any indication of the ground, the earth, the horizon, from within the compass of the image." This is no Emersonian project (the usual judgment of the *Equivalents*), for Stieglitz turns natural facts into *unnatural* signs—into the cultured language of the photograph.[37]

That the "old war horse," as Brigman called Stieglitz, should be entranced by the carefully orchestrated pagan abandon of the Hawai'ian-born photographer (the way she presented herself to him) does, as Cunningham notes, seem peculiar.[38] They exchanged letters over a long period of time, he encouraging her and she sending him, along with photographs, long passages of florid prose and poetry such as this "Foreword" to what must

6.11 Alfred Stieglitz,
Equivalents, series 1925.
©The Metropolitan
Museum of Art, New
York, Alfred Stieglitz
Collection, 1928, no.
28.128.6.

have been an autobiography-in-progress in which she describes herself as a
"child of the tropics":

> The memories that are most vivid, as I look back across the years . . .
> are of mountain peaks and blue sea, sun and wind, trees and clouds,
> flowers and fruit and birds . . . as near and as complimentary as ones
> [*sic*] right hand is to the left. Mango trees, tall and ample in their
> glossy foliage, hung in season with huge jewel-like clusters of yellow,
> pendulous fruit, . . . the golden globes of the guava and the heavy
> abundance of the banana and papaya . . . and in their season of blos-
> soming magenta, bouganvillia [*sic*], scarlet ponciana [*sic*] regia and the
> orange trumpets of the bignonia [*sic*], flamed against a tropic sky . . .
> and the exotic crests of the up-sweeping cocoanut trees swayed to
> wind-meles as old as Time. From the misty peaks above Nuuanu Val-
> ley, clothed in their gray-green forests of koa and kukui, to the
> smooth, white crescent beach that was Waikiki, . . . odors and sounds
> were closely related to my young senses . . . the haunting perfume of
> fern jungles and maile and wild ginger.[39]

Stieglitz, in turn, had a great influence upon Brigman,[40] and yet she went her own way. In a kind of inversion of his cloud studies, in the equivalence between natural object and emotional state, the body—her own (wounded) body or those of close women friends—is at the center of the thing framed and is in physical contact with natural things: rocks, trees, water. Going into the mountains from 1906 to 1927, she "ate and slept with the earth" and "found my power with the camera among the junipers and the tamrack [sic] pines of the high, storm-swept altitudes":

> Compact, squat giants are these trees, shaped by the winds of the centuries like wings and flames and torso-like forms . . . unbelievably beautiful in their rhythms. Here stored consciousness began its work . . . not only with the splendor of the strange trees, but a sense of visualization developed in amazing ways in which the human figure suggested itself as part of their motive . . . even before the camera was brought to bear upon the revelation. . . . Into these tree and rock forms the sensitive yet hardy feminine figure took its place with sculptural fitness.[41]

These were not just any trees, Brigman wrote to Stieglitz, but particular trees (fig. 6.12):

> All trees are beautiful or strange but not all are pictorial. I learned how and where to look for trees by the trend of the prevailing wind and the contour of the storm-swept glacial wastes . . . and then I found glorious ones with out any of these apparent indications . . . each find, an ecstatic experience of breathless wonder . . . some times from a distance, some times in a turn in a rocky ledge . . . and my heart missed a beat.[42]

Brigman would have us believe, then, that "natural facts are symbols of spiritual facts"; yet these representations—which dramatize the connectedness between woman's body and the earth—are, for all their pagan abandon, *staged* scenes. And what is most striking to a female viewer is the way these images—their very artifice—suggest the tantalizing problem women face when they turn the camera on themselves: how to re-present the "natural" unmasked, undisguised self, disencumbered of the cultural constructions they, as social beings, have learned. That is, how does a woman divest herself of the ubiquitous representations (by men) of female figures—in Brigman's time ranging from the photographs of her California contempo-

6.12 Anne Brigman, *The Dying Cedar,* c. 1909. ©The Oakland Museum of California, City of Oakland, gift of Mr. and Mrs. Willard M. Nott.

raries to the modernist nudes depicted, for example, by Matisse that appeared as photographs of paintings and sculpture in *Camera Work* in 1912. In the culture at large in this particular period, women would have seen themselves everywhere idealized as larger-than-life female figures, from the classical designs on the money they handled to the statuary announcing the entrances to official buildings and plazas they visited, to the flowering Art Nouveau *femme fatale* who decorated the covers and pages of the books and magazines they read.[43] Some turn-of-the-century women mocked these noble and supernatural representations, as Edith Wharton did in *The House of Mirth* and *The Custom of the Country*. Others like Mary Mac-Monnies and Mary Cassatt re-created versions of Eden in their murals—*Primitive Woman, Modern Woman*—which adorned the walls of the Woman's Building at the World's Columbian Exposition, or like Willa Cather discovered a fusion of human and natural worlds in the vast spaces of the southwestern desert, finding in a landscape emblematic of her own body traces of an earlier, and more empathic tradition.[44]

A 1907 review in *The Craftsman* places Brigman's photographs outside of History, seeing in her dryads the combined qualities of Demeter, Narcissus, Cather's Thea Kronborg, and contemporary dancer Loïe Fuller:

> Out from a crevasse, between a sun-touched boulder and a melting snow bank, steps a splendid figure of womanhood [fig. 6.13]. She comes forth a fine symbol of freedom, the goddess that will touch the sterile earth, and chain up the bleakness of winter. Her drapery blows back from her body and her hair ripples in fresh spring winds. She touches the steep boulder only with her right foot, and as she bends away there is a sumptuous vigor in every harmonious curve. She, too, is gazing into the depths of the brilliant crystal, so brilliant that it seems the quality of life itself. . . . As you look at the picture all sense of separation between the human being and nature is gone, and both seem a part of all that is beautiful in elemental conditions.[45]

This is language—as is Brigman's similar description of her project—to make the modern reader squirm. But if it is "sentimental," it is no more overblown than Clarence King's description of the western landscape he saw. The two pieces of writing are, however, so opposite in intent and effect—the one evoking harmony with a sentient nature, the other the need to master with the mind the terrifying abyss—that, taken together, they seem justification enough for theories about the gendered gaze. Both de-

scriptions draw upon literary and painterly conventions—upon well-learned images, roles, and associations. In the case of Brigman's photograph, gazing into the crystal brings self-knowledge for this "fine symbol of freedom," this naked goddess. Shedding the draperies of cultural constructions—seeing something other than the world reflected—is, however, a more difficult project for mortal women and a conceptually more difficult project than mastering the world with the scientific tools devised by the human intellect. This is the literal reason for the nakedness in these photographs, but Brigman compounds the problem by posing as Woman, thus turning her own body into a (conventional) cultural sign, a mythological representation.

Emerging naked from stony vaginal folds in *The Cleft of the Rock*, embracing a blasted pine, gazing narcissistically into a pool of water, stretching toward the sky in an incantation, her body a representation of rebirth and discovery, of the contours of Eros: these are scenes frozen and enframed in time and space. With the naked self at center stage, this project might be seen as a series of strategies for blocking the male, voyeuristic gaze, especially in *The Bubble* of 1905 (fig. 6.14), in which the reflective surfaces of

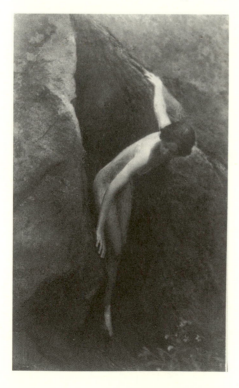

6.13 Anne Brigman, *The Cleft of the Rock*, 1905. ©The Oakland Museum of California, City of Oakland, gift of Mr. and Mrs. Willard M. Nott.

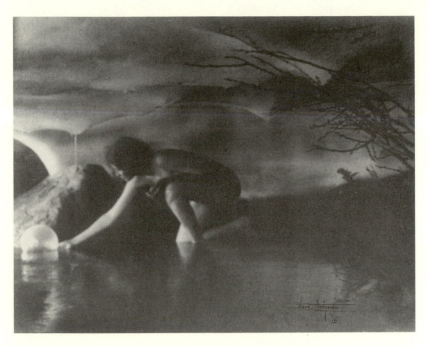

6.14 Anne Brigman, *Nude by Waterpool (The Bubble)*, 1906.
©The Oakland Museum of California, City of Oakland,
gift of Mr. and Mrs. Willard M. Nott.

bubble and pool allow Brigman to watch herself watch herself—not only like Narcissus, but like Celtic goddesses reflected in holy wells[46]—and to discover her self, a subject in process.

Bubble and pool are props and sets, also used by male pictorialists, that would have been familiar to Brigman through her association with *Camera Work*. Images such as her *Incantation* recall F. Holland Day's series in which he posed himself as Christ (figs. 6.15 and 6.16)—different from Brigman's allegorical representations of dryads and other pagan goddesses, to be sure, but similar in that the (overt or covert) subject in each case is the transformation of the wounded body.[47] What is particularly striking about Brigman's images is her self-conscious use of the *machine* in her all-female garden: the mystical merging of self and earth, of mysticism and eroticism, becomes, for Brigman and her friends performing in front of the camera, a playful transformation of the self. "One day," she recounted,

> during the gathering of a thunder storm when the air was hot and still
> and a strange yellow light was over everything, something happened

almost too deep for me to be able to relate. New dimensions revealed themselves in the visualization of the human form as part of tree and rock rhythms and I turned full force to the medium at hand and the beloved Thing [her camera] gave to me a power and abandon that I could not have had otherwise.[48]

In such passages Brigman makes clear that the public and private nature of her project—reversing the unmaking of the world, symbolically healing her own wounded body—is made possible through the use of a scientific tool, if not to master, certainly to see, to "visualize" the human form as part of natural rhythms. In other words, in posing naked among the rocks and cliffs and streams, she shows *what the camera sees,* which suggests the extent to which her project is based upon artifice or masquerade, and even the extent to which her words are meant to mislead us as she authors her own representation. Her statement about her photographs and the photographs themselves together constitute a kind of autobiography, and given that autobiographies *are* fictions of a certain kind, we might well ask what kind of *self* is being constructed or created. This question suggests that we might read Brigman's photographs as parody of the Woman = Nature

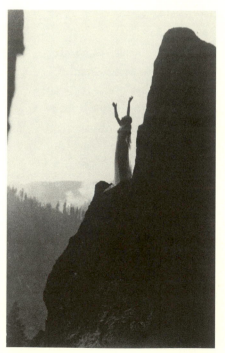
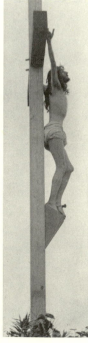

6.15 Anne Brigman, *Incantation,* gelatin silver print, 1905. ©The Metropolitan Museum of Art, New York, Alfred Stieglitz Collection, 1933, no. 33.43.121.

6.16 F. Holland Day, Untitled [Crucifixion], 1898. Prints and Photographs Division, Library of Congress, no. USZ62-52956.

equation at the core of both Romantic and Symbolist projects, as acts of masquerade that confront the sense in which the presentation of the self is always in response to a reflection in another's eye. Turning the lens on herself in order to create distance between self and image, she could use her own body as a disguise, indicating, as Cindy Sherman would do nearly a century later, that the self is a culturally contrived construction.[49] Other women understood what Brigman was up to. Fashion photographer Louise Dahl-Wolfe, for example, wrote of being so "bowled over" by Brigman's "nudes taken in ice caves in the Sierra Nevada Mountains and in cypress trees on Point Lobos" that she and a few art students got together to "do 'Anne Brigmans.'"[50] Dahl-Wolfe and her friends "doing" Brigman were parodying such images as George Fiske's *Clowning on Observation Point* (1905) and the later *Wind Fire* by Edward Steichen (fig. 6.17), a photograph manipulated to suggest the forces of Nature and one that obviously echoes paintings such as Courbet's *Painter's Studio*.

The idea of Brigman's photographs as a kind of performance art—or as "arabesque," with its connotations of dance—brings us back to California, to her contemporaries Loïe Fuller and Isadora Duncan. Fuller turned her body into a sign, a representation of nature, portraying herself as a butter-

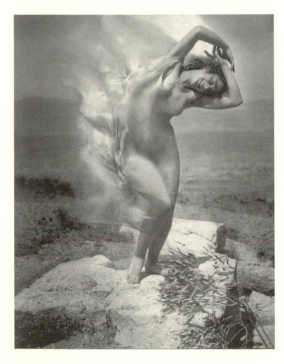

6.17 Edward Steichen, *Wind Fire*, gelatin silver print, 1920. George Eastman House, reprinted with permission of Joanna T. Steichen.

fly or a lily; Duncan became a Symbolist painting in motion: at the core of both performers' work was an ecstatic sense of the body as the center of all knowledge. And Duncan, writing in her autobiography of teaching young dancers, could be the author of Brigman's script:

> Their studies and their observations were not to be limited to the forms in art, but were, above all, to spring from the movements in Nature . . . of the clouds in the wind, the swaying trees, the flight of a bird, and the leaves which turn. . . . They were to learn to observe the quality peculiar to each movement, . . . to feel in their souls a secret attachment, unknowable to others, to initiate them into Nature's secrets; for all the parts of their supple bodies trained as they would be, would respond to the melody of nature and sing with her.[51]

THE NATURE OF FLOWERING

Vision is not only a passive, feminine receptacle where the real gets photographed, but it is also a phalloid organ able to unfold and erect itself out of its cavity and point towards the visible. The gaze is the erection of the eye. —Jean Clair, "La Pointe à l'oeil"[52]

We are the world together,
Here is the place in hope, on time's hillside,
where hope, in one's image, wavers for the last time
and moves out of one's body up the slope.
—*Muriel Rukeyser, "Seventh Elegy"*[53]

"With the idea that you might now begin to collect these pots, I am sending you one with a plant often mountain grown," Imogen Cunningham wrote to Ansel Adams in 1970 in a note accompanying a potted plant in a Hills Brothers coffee can. "As you know, pots and potties have always been my specialty." Adams knew that this was a wicked joke. "Imogen used to give me a hard time about what she considered my 'too-commercial side,'" he recalled. "I know she disapproved of that Hills Brothers coffee can that came out about 1968 — the one with one of my Yosemite snow scenes on it. She made that very clear. She sent me one of the cans with a marijuana plant growing in it!" But he dismissed the seriousness of the criticism behind her joke: "I used to say that Imogen's blood was three percent acetic acid," he said when he told the story, adding that she could also be "very soft, very emotional." Although these were aspects of Cunningham's per-

6.18 Ted Orland,
*Ansel Adams and
Imogen Cunningham
Awarding Jerry Uels-
mann the Title of
Honorary West Coast
Photographer at Weston
Beach, Point Lobos
(Jerry Uelsmann
Receiving the Baptism
of the God Photo-
graphers of the West),*
1969. Courtesy of
Ted Orland.

sonality that she herself promoted, Adams, who had posed with her at
Point Lobos for a photograph known as "Jerry Uelsmann Receiving the
Baptism of the GodPhotographers of the West" (fig. 6.18), comes across
here as condescending. "Imogen wasn't very exacting about the way she
made photographs. She was inclined to be a little sloppy," he said in his
posthumous tribute. "I've always had a feeling that Imogen's final print
never quite achieved what she had intended. Her printing was extremely
uneven. Some had a perfectly gorgeous quality, but some made me feel,
'Jesus, what a great pianist—but the piano's not very good!' "[54]

If Adams was the GodPhotographer of the West,[55] his unpeopled pristine
landscapes promoted everywhere from coffee cans to calendars, Cunning-
ham's success came late in life. "Maybe you are not aware of it, but you
should know that YOUR word is all powerful in the land of photography,"
she wrote to Adams in 1967, noting that neither Helmut Gernsheim nor
Beaumont Newhall had "seen fit to do anything about me" in their histo-
ries of photography. But "after I am gone, history will take care of every-
thing."[56]

Certainly, her project—particularly her lifelong preoccupation with

growing things—was different from his. "The formula for doing a good job in photography," she noted, "Is to think like a poet. There are many choices, but at the moment I recommend Tagore, who wrote: 'My soul is alight with your infinitude of stars. Your world has broken upon me like a flood. The flowers of your garden blossom in my body. The joy of life that is everywhere burns like incense in my heart. And the breath of all things plays on my life as on a pipe of reeds.'"[57] These notes made by the eighty-two-year-old photographer reach back to her experiments with erotic figured landscapes in the early years of the century and forward to later works such as *Taiwan Leaves* (1963) (fig 6.25), *Dream Walking* (1968) (fig. 6.19), and *Morris Graves in His Leek Garden* (1973) (fig. 6.38). "Perhaps," she later wrote, alluding to the fact that she was recognized primarily for her precisionist images made in the late 1920s and her empathic and penetrating portraits, "my taste lies somewhere between reality and dreamland."[58]

6.19 Imogen Cunningham, *Dream Walking,* 1968.
©1970, 1996 by the Imogen Cunningham Trust.

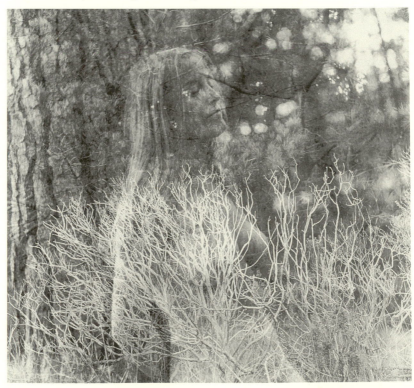

In this she was not, in fact, so different from the other f.64 photographers with whom she was associated. As Michel Oren has shown, they followed a wavering course between "the literal and symbolic, the actual and typical, the particular and the universal."[59] If Modernism was entrenched in California by the early 1930s, its most notable practitioners were all reformed Pictorialists: Cunningham, with her focus on formal design; Edward Weston, now interested in making images that reflected the medium's inherent capacity to see the "veriest" detail; and Adams, who hailed the "Annunciation" of "straight photography."[60] The "Group f.64 Manifesto" proclaimed its intention "to define photography as an art-form by a simple and direct presentation" and described "pure photography" as "possessing no qualities of technic, composition, or idea, derivative of any other artform"—as distinct from Pictorialism, which "indicates a devotion to principles of art which are directly related to painting and the graphic arts."[61] Adams had used standard pictorialist techniques in his early work: soft-focus lenses, matte-surfaced printing papers, and textured, colored mounts. In the 1970s he would attribute the great change in his style to his experience in Taos, New Mexico, about 1929, where "I saw Paul Strand's negatives, and the approach was something so tremendous to me that I literally changed my approach. And I can say that when I came back to California the seed of the Group f/64 movement was sown."[62] Weston, who in his early work had adopted elements of Japanese prints and photographs, publicly announced in 1932 that he found the word "pictorial" irritating because it suggested that photographers follow painters. By 1937, however, he had reinstated himself as a pictorialist, denying the "validity of the Purist/Pictorialist distinction."[63] John Paul Edwards would recognize that adherents of f.64 had "no basic controversy with the photographic pictorialists."[64] The group's home, in fact, was Anne Brigman's old studio at 683 Brockhurst Avenue in Oakland, which Willard Van Dyke, who lived there with Mary Jeanette Edwards, called Gallery 683. There, they photographed each other with their 8-by-10 cameras[65] and with great *esprit* posed in a remarkable *tableau vivant* circa 1920, *Anne Brigman and Friends in Costume*—Brigman posing as the "Mother of Photography" (fig. 6.20). "You know the thing I missed there, that I've always wished I'd done," Cunningham would later recall about this meeting place:

> Anne had a tree growing out of her room. The room had been built around that tree, and she had her shower under it. You see, she had the pipe put in with water spray and that. In the corner was the "john"

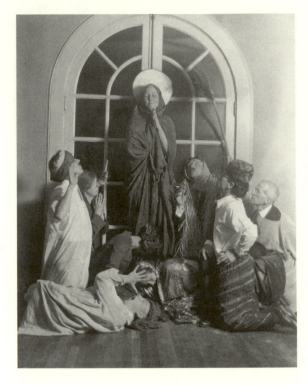

6.20 Attr. Anne
Brigman or Roi
Partridge, *Anne
Brigman in Costume
as Smiling Madonna
with Group of Cos-
tumed Friends Kneel-
ing around Her*,
gelatin silver-toned
print, 9.625 by 7.625"
c. 1920. Collection
of the J. Paul Getty
Museum, Malibu,
California, no.
90.XM.58.4.

that was only concealed by mosquito netting. At that time it used to
be done in big squares. And I always wished I'd photographed some-
body on the "john." . . . I only thought about it and I didn't have the
nerve.[66]

One hardly thinks of Cunningham as lacking "nerve." Her first photo-
graphs were experiments in Pictorialism—"me on the University of Wash-
ington campus in the lower part of the woods, stark naked lying in the
grass," and "a vague and dreamy landscape."[67] Other early work bears a cer-
tain resemblance to Käsebier's Symbolist images, such as *The Bat* (1902),
and suggests certain of Brigman's, White's,[68] and Adolf de Meyer's pictures,
all of which she had seen in 1909 at the International Photographic Exposi-
tion in Dresden. This show—"the most complete photographic exhibition
ever attempted" according to Charles Caffin—made a great impression on
the young photographer, who was just completing a year of study there.[69]
Back in Seattle she made a note to herself to "do one to *The Clouded Mirror/*
mirrored shape of a nude." She posed friends—the painters John Butler
and Clare Shepard, who shared her duplex studio—in diaphanous veils,

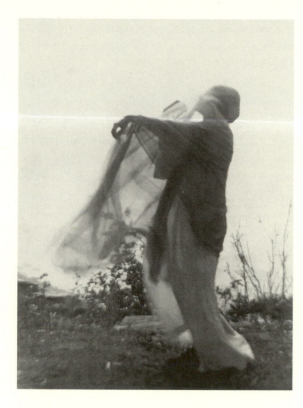

6.21 Imogen Cunningham, *The Wind,* c. 1910. ©1970, 1996 by the Imogen Cunningham Trust.

kimonos, or lengths of fabric patterned after William Morris designs; she also hired models—parents and young daughter—to pose naked for her in the misty woods and by reflecting pools as illustrations for Morris's 1894 prose romance *The Wood Beyond the World,* Swinburne's poetry, or Elizabeth Barrett Browning's *Sonnets from the Portuguese.*[70]

This series of symbolic "woman=nature" images from 1910–1912—*The Wind* (fig. 6.21), *Sun and Wind, The Voice of the Wood, The Vision,* and *The Wood beyond the World*—play with contrasts between stability and movement: a sturdy, rooted earth goddess becomes a zephyr, a symbol of wind moving across the land, as she lifts the upper part of her body draped with filmy, billowing scarves; emerging from the rocks and trees, other veiled and ethereal women sway in dreamy dances. Cunningham's figuring of male and female bodies in *The Supplicant* and *Eve Repentant* (both 1910) are more explicitly erotic. In the latter, the Adam in her garden has been read as rejecting Eve, but Cunningham seems to recast the familiar story to show us a faceless man bowed and made submissive by grief to his woman's support and comfort. Despite the title, the image shows us her strength, his

vulnerable sensuality: one's eye is led along the silhouette of her body to the firmness of her encircling arm, which rests on the seductively lit curve of his back, his vertebrae, his buttocks.

Turning her eye on the juicy body of her husband, artist Roi Partridge, Cunningham experimented with "doing Brigmans"—pool gazing, blasted trees, and all (fig. 6.22). In her Mount Rainier and Dipsea Trail series, however—"made in 1915 when I was first married" and pregnant—pleasure is kindled by another, not self-engendered. In these images, the body of the (male) other seems distinct from, rather than fused with natural objects. What the pictures are about, as both Cunningham and Partridge later recalled, is erotic play and collaborative performance.[71] The series invite a comparison with Stieglitz's photographs of O'Keeffe, but the images themselves are quite different. Where Stieglitz's camera intrudes too closely upon O'Keeffe's isolated body, fetishizing and breaking it into abstract shapes, thus creating a tension between discomfort and attraction, Cunningham's use of an outdoor setting and more comfortable distance allows her to trace the light along the edges of her beloved's body in a way that makes his nakedness seem both natural and intimate. This is not, however,

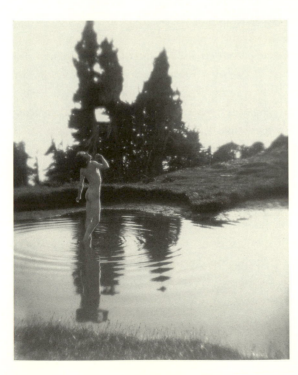

6.22 Imogen Cunningham, *On Mount Rainier 8*, 1915. ©1978, 1996 by the Imogen Cunningham Trust.

the way these images were initially received. Pulling them out of storage after fifty years, Cunningham recalled that when they were first exhibited, they "were so harshly criticized both them and . . . me as an immoral woman, that I gave up and hid them."[72] Her *Eve Repentant* was also considered pornographic in 1912: "The battle did not reach the proportions of the 'September Morn' scandal," according to Margery Mann, "but the photograph shocked Seattle, which Imogen describes at that time as 'Boston moved west.'" The Mount Rainier series committed a different kind of offense against propriety, however. Reversing the given construction of the female form *as* nature and inviting the spectator to gaze upon the erotically charged male body amounted to a transgression of conventions far more shocking than Brigman's presentation of her own body; it was nothing less than an appropriation of the gaze as active subversion of the predominant system of representation.[73]

When she turns her caressing eye on the tender and angular bodies of her children, Cunningham's erotic gaze is more possessively gentle, yet still unconventional. (One imagines a public response, in the early 1920s, similar to that in our own day to Sally Mann's photographs of her naked children.[74]) Just as she captured the light on her husband's silhouetted body—his rounded back, the curve of buttocks and calves, the tautness of thighs and of extended arms—the touch of her lingering gaze on the tender flesh of her male children is loving and playful—and hers. The supple young males in *Rondal and Padriac in the Sierra* (1925) (fig. 6.23) seem to grow out of the sun-dappled rocks upon which they play. In another image from that period, limbs straddling the rock walls of a sunlit crevasse, her twin sons are poised, vulnerably naked, between this open world and the protective cavelike space beneath. And in *Twins with Mirror* (1923) (fig. 6.24), the downy voluptuousness of their young bodies against the richly textured Oriental tapestry is both softened and made fragile by the mirror, whose sharply angled frame nearly cuts into one body at the groin, a sharpness repeated by the angle of this boy's leg stretching toward his brother's penis and by the frame's edge that runs along the length of both bodies, cutting the picture in half, separating image from reflection—the multiple reflections of mirror and photograph—and separating mother/gazer from the private dreamy world, fruit of some secret knowledge in hand, that they share.

"Seeing double," a sixty-year habit Cunningham later attributed to the

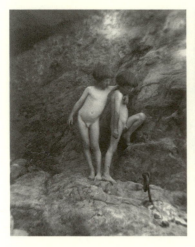
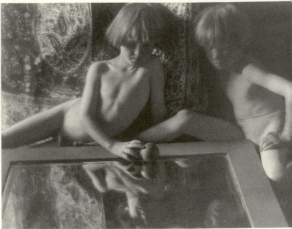

6.23 Imogen Cunningham, *Rondal and Padriac in the Sierra,* 1925.
©1974, 1996 by the Imogen Cunningham Trust.
6.24 Imogen Cunningham, *Twins with Mirror,* 1923. ©1974, 1996
by the Imogen Cunningham Trust.

birth of the twins, would be a recurring theme: double nudes in *Two Sisters* (1928), two erotic open blossoms in *Calla Lilies* (1929), two symmetrical trees in *Cemetery in France* (1961). This habit would also lead her to experiment with double portraits, reflected images, double exposures—most notably *The Poet and His Alter Ego* (James Broughton, 1962)—and superimposed negatives, such as *Taiwan Leaves* (fig. 6.25) and *Dream Walking* (fig. 6.19). But "seeing double" also refers back to the photograph Cunningham said over and over was the one that "started her"—Käsebier's *Blessèd Art Thou Among Women,* with its demarcation of two worlds, one maternal, shared, protected, private; the other beyond the separating door frame and over the threshold into independence.[75]

Cunningham's continued mention of the importance of this photograph throughout her long life suggests that Käsebier's image might have come to seem a representation of herself. In 1901 it inspired the young woman to send away for a correspondence course on photography. As a student at the University of Washington, with no curriculum available in either photography or art, she would major in chemistry. She worked in the studio of the leading pictorialist photographer in Seattle, Edward Curtis,[76] and then traveled to Dresden for a year of postgraduate work. Returning to this

6.25 Imogen Cunningham, *The Taiwan Leaves*, 1963.
©1970, 1996 by the Imogen Cunningham Trust.

country in 1910 as a photographer who had developed a process for substituting lead salts for the more expensive platinum in printing papers, she made a pilgrimage to the elder woman's studio.

Both women did most of their work in portraiture, and both, according to the women and men who wrote down their impressions of photographic sessions, seem to have achieved "collaboration" with their subjects. Minor White is one who recalls being drawn by Cunningham into a kind of aura:

> We went out of doors in a narrow space between house and fence where the light was luminous. I was seated on the ground amid some dried plant branches. Listening to the overtones of her words, which were not particularly connected, a warmth was communicated. Then her face became beautiful. . . . [T]his was the wonder to watch and I gave myself up to the light that seemed to diffuse outward from her face and head. She likes to photograph anything that can be exposed to light, I remembered her saying. Only then did I realize that it was her own light—whether she admitted or even knew it.[77]

What Cunningham does with light (whether or not it is her own)—the way she outlines the human form or face, luring one's eye over flesh and bone caressingly or playfully—is fundamental to her method of composition. In her *Mills College Amphitheater* (c. 1920) (fig. 6.26), for example, an abstract design composed of angular shapes is made intimate by the way in which Cunningham allows the viewer to enter the picture: she has positioned herself and caught the light in such a way that, from the flatness of the lower right-hand corner, one is drawn in a sweep along and into the picture (really a double sweep, one light, one dark), but not through it; movement is stopped, caught, by the diagonal line and dark triangle at the upper right-hand corner. The same play of intimacy and abstraction figures in representations of both human and botanical forms: in her *Nude* (1923), one's eye follows a double path of dark and light from lower right to upper left; in *Hen and Chickens* (1929) (fig. 6.30), moving visually from lower left to upper right, one is caught up in swirling patterns of dark and light.

"I photograph anything that light falls on" most often meant people, both as nudes and portraits, but during the period of her life when she was

6.26 Imogen Cunningham, *Mills College Amphitheater,* c. 1920. © 1970, 1996 by the Imogen Cunningham Trust.

at home with her three small boys (housebound because she did not drive),[78] she made the hill behind her California house into a rock garden and began to keep a photographic record of her earthwork. In interviews with friends and family collected by Judy Dater after Cunningham's death, the photographer's love for her garden is a recurring theme. Dater herself begins her "Portrait" with her recollection of moving to a house with a very overgrown and neglected garden: "she came to visit me and immediately told me everything that should be done—what needed trimming, what plants should come out and what should go in, the name of every plant there."[79] "Her friendship . . . came in a jar of jam . . . [or] a bag of weeds she pulled from your rose bed when she came paying a 'sick call,'" Gina Reading recalled. "And what she inscribed over and over again was the deeper beauty of skunk cabbage and toads."[80] Plantings, propagations, and plant forms are the subject of a good deal of her correspondence: she made a list for her friends Horace and Virginia Bristol, then living in Japan, of plants native to that part of the world; wrote to the director of a botanical research firm offering to propagate a species of *Strophanthus* from which cortisone is obtained; sent the associate chair of the Botany department at UCLA a photograph of *Colletia cruciata* for her office, a jar of jam made from her tree tomato, and the tomato seeds for planting in the university's botanical garden. Landscape architect Mai Arbegast, who met Cunningham in the Berkeley botanical gardens and at meetings of the California Horticultural Society, was fascinated with her way of *looking* at plants—of seeing color and form and texture—and with her photographs, which "really get to the heart of the plant, the gutsiness of the flower." Later, as friends working together in Cunningham's garden, they would "spend hours just pruning the clematis and talking about what plant would be good here or there. . . . Every plant was personal to her, and she cared very much where it was placed in the garden, and how it looked in every season of the year. The funny little plants on the porch, the bougainvillea that was held together with twistings from vegetables, the fig tree, that Mexican mock orange that was rather homely but had such a beautiful fragrance as you came up the steps—they were part of her."[81]

Cunningham's *Pflanzenformen* series (so called because they were first exhibited in Stuttgart in 1929) are clearly an outgrowth of her earlier work in Germany.[82] Parallel to her own development and that of other American Modernists, advocates of the "new Objectivity" in Germany in this period such as Karl Blossfeldt and Albert Renger-Patsch sought to present the for-

mal structures basic to all objects—plants, bridges, factories and their products. Their focus on intrinsic design element and repetitive pattern eliminated change and subjectivity in order to achieve a transcendental level of pure decoration; it also amounted to a mechanical, literally machine-made, aloofness.[83] Cunningham's interest in pattern and abstract design is stylistically related to this work, but her leaf formations, fleshy succulents, and unfolding magnolia blossoms are directly personal: tied to her experience as a woman and mother, they record an intimate, sensual exploration of the growing and blooming of the garden of her own body in these years.[84] These *Pflanzenformen* exude the sort of "voluptuous spareness . . . in contour and surface" that critics have long seen in Georgia O'Keeffe's landscapes (fig. 6.27)—flowers and rhythmic hills exuding an eroticism that, the painter insisted, was "put there" by viewers.[85] Cunningham's "The flowers of your garden blossom in my body. The joy of life that is everywhere burns like incense in my heart" resonates distinctly with O'Keeffe's "Sometimes I think I'm half mad with love for this place [the Southwest]

6.27 Imogen Cunningham, *Black and White Lilies,* late 1920s. ©1978, 1996 by the Imogen Cunningham Trust.

6.28 Imogen Cunningham, *Alfred Stieglitz 3*, 1934. ©1978, 1996 by the Imogen Cunningham Trust.

. . . . My center does not come from my mind—it feels in me like a plot of warm moist well-tilled earth with the sun shining hot on it."[86] And Cunningham points to this affinity in her portrait of Alfred Stieglitz by including O'Keeffe's *Black Iris* (fig. 6.28).

Clearly, the painter's and the photographer's representations of the things that grow around them are life affirming, permeated with eros, confronting us with images of the other half of the world we have split in two.[87] O'Keeffe, like Cunningham, understood the camera's framing eye: she would pick up pelvic bones on the desert and look through them at the vast expanse of sky, making a literal and archaic joining in her paintings of womb and eye.[88] Like Cunningham, she understood the nature of artifice as an aid to seeing: an artificial flower lying on the ground draws her eye to the stones that are there; its painted image serves the same function, pointing to the artifice that art is in order to lead us to see the world that is there.[89] In much the same way, Cunningham's magnolias (fig. 6.29) and water hyacinths are not so much images of flowers as patient visual recordings of the nature of *flowering*—of "its openness and receptivity; its response to the energies of water, soil, and sun; its taking of these energies into itself and transforming them."[90] Generating powerful compositions from everyday objects, Cunningham, like O'Keeffe, understands the transformative energy of light.

Other West Coast photographers were, of course, making their own Modernist versions of plant forms in these years. Henry Swift, Sonya Noskowiak, Alma Lavenson, Edward Weston—whom Ansel Adams saw as "recreat[ing] the mother-forms and forces of nature, . . . [making] these forms eloquent of the fundamental unity of the world"[91]—and Adams himself, in addition to Cunningham, had images of banana plants, cacti, water lilies, and eucalyptus leaves in the 1932 f.64 show in San Francisco.[92] But it is to Weston that Cunningham is most often compared. The two photographers often chose similar subjects—Cunningham's *Hen and Chickens* (1929) (fig. 6.30), Weston's *Succulents* (1928) (fig. 6.31); Cunningham's *Sycamore Trees* (1923), Weston's *Oak, Monterey* (1929). And both played with bodyscapes: Cunningham's *Triangles* and *Shells* (1930) (fig. 6.32), her beautifully flowering *Pregnant Woman* (1959) (fig. 6.33); Weston's *Shell and Rock Arrangement* (1931) (fig. 6.34).[93]

Like Cunningham, Weston was interested in precise depictions of natural objects, the erotic nature of which was a subject of much discussion. He recorded in his *Daybooks* a correspondent suggesting "that I had seen veg-

6.29 Imogen Cunningham, *Magnolia Blossom*, 1925.
©1970, 1996 by the Imogen Cunningham Trust.

6.30 Imogen Cunningham, *Hen and Chickens,* 1929. ©1970, 1996 by the Imogen Cunningham Trust.

6.31 Edward Weston, *Succulents,* gelatin silver print, 1930. ©1981 by the Center for Creative Photography, University of Arizona, Tucson, Arizona Board of Regents.

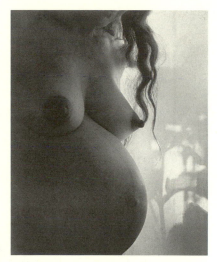

6.32 Imogen Cunningham, *Shells,* 1930. © 1978, 1996 by the Imogen Cunningham Trust.

6.33 Imogen Cunningham, *Pregnant Woman,* 1959. ©1970, 1996 by the Imogen Cunningham Trust.

6.34 Edward Weston, *Shell and Rock Arrangement,* gelatin silver print, 1931. ©1981 by the Center for Creative Photography, University of Arizona, Tucson, Arizona Board of Regents.

etables and other natural forms, *fundamental* forms, with such intensity, such direct honesty that a tremendous force like sex, which enters into, permeates all nature, could not but be revealed. All basic forms are so closely related as to be visually equivalent. Seeing parts of life always in relation to the whole, recording their essence with a simplification which can be called an 'abstraction,' I have had a back (before close inspection) taken for a pear, knees for shell forms, a squash for a flower, and rocks for almost everything imaginable!" "[W]hen I look at a print," he continued,

> I see only that form or force which was my original stimulus. . . . [A] vulva found in my halved artichoke [fig. 6.35]—and very farfetched the likeness—I had often thought would make a fine modern stage set. A rock made on the Mojave—often likened to a great penis—(I might coin a word and say it has penistic insinuations), actually does look like a mighty erection. Nevertheless I can honestly state that when I focussed my camera on it that broiling desert morning, all I felt was the great diagonal cutting the plate, its relation to other forms in the

6.35 Edward Weston, *Artichoke Halved,* gelatin silver print, 1930. ©1981 by the Center for Creative Photography, University of Arizona, Tucson, Arizona Board of Regents.

background, with tiny grasses giving scale at the base: someone likened this grass to pubic hair! . . . The peppers which are more libeled than anything I have done,—in them has been found vulvas, penises or combinations, sexual intercourse, madonna with child, wrestlers, modern sculpture, African carving, ad nauseam, according to the state of mind of the spectator. . . . I have done perhaps fifty negatives of peppers: because of the endless variety in form manifestations, because of their extraordinary surface texture, because of the power, the force suggested in their amazing convolutions. A box of peppers at the corner grocery store holds implications to stir me emotionally more than almost any other edible form, for they run the gamut of all natural forms, in experimental surprises.[94]

The very act of photographing objects over and over again—at least fifty times for peppers, which have exactly the same value for Weston as bedpans and toilet bowls and contorted female bodies—argues a primary interest in abstract form. All forms, he said (sounding like Stieglitz, whose influence is mentioned in the *Daybooks*), are basically so related as to be virtually equivalent. Weston used light to turn peppers—never in their natural environment, not even in the box in the corner grocery—into vulvas, penises, or combinations, madonnas or wrestlers or sexual intercourse. For Weston, shells and knees are equivalents, and vulvas would make good stage sets!—all images of "making it with Paradise."[95] His intense scrutinies of natural and human forms are "de-familiarizing experiences," as Trachtenberg suggests: "The mark of a Weston seem[s] . . . photographic signs of a will-to-power over the visible world. Weston's camera typically seems a constructivist's instrument; visibility flows from it, rather than merely reflecting itself in its lens."[96]

Strikingly different in intent and effect, Cunningham's pictured human and natural forms retain their *thingness*—that is, for her it would be impossible for all things to be "virtually equivalent." When Cunningham used light to reveal the design inherent in a natural object, the subject of her attention is not confused with or "equivalent" to something else. In her plant photographs, a magnolia bud opening to reveal pistil, stamen, and petal is a cumulative image of flowering; her sequences of water hyacinths and agaves record the activities of a gardener at work. Artifice, on the other hand, *is* artifice: conical shells placed upright to resemble pointed breasts mock the symbol-making tradition that Weston represents. Moreover, like

O'Keeffe's artificial flowers, Cunningham's imitation breasts point to the artifice of the photograph itself—and to the presence of the photographer, as in the witty reference to "Suzanna and the Elders," which shows a naked woman bathing, delicately revealed through the bare branches in the Japanese vase in the foreground (fig. 6.36).

In her photographs of male nudes from the 1930s—*John Bovington,* the subject's knees and shins drawn up against his torso, and *Side,* a nude bent at the waist—bodies (as in Weston's representations) almost take on the appearance of rock formations and shells. But as Elizabeth Broun suggested in a letter to Cunningham, although a female nude from 1932 "resembles a print by Edward Weston from 1925 which shows the model from the back, posed so that her body forms a perfect pear shape; your print seems to me to relate to the Weston one without abstracting the model into a strictly symmetrical shape."[97] This is a telling observation—that for Weston, to abstract, to make strictly symmetrical, is to subtract the subjective so that what is left in the perfect artistic print is an abstraction of pure object. The opposite is also true, however: for Weston, the pure object rep-

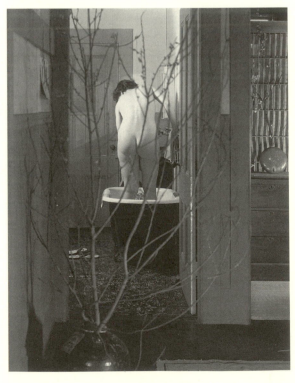

6.36 Imogen Cunningham, *Bath, 1952.* ©1974, 1996 by the Imogen Cunningham Trust.

resented nothing so much as his own subjectivity. "I am seldom so happy as I am with the pear-like nude of A," he noted. "I turn to it again and again. I could hug the print in sheer joy. It is one of my most perfect photographs."[98] Hardly portraits, Weston's "nudes" are "segment[s] of a body of work," recalled Charis Wilson, one of Weston's models (and lover, later his wife). "Paradoxically, I never really did think of these nude photographs as pictures of *me*. They were photographs by *Edward*—his perceptions and his artistry."[99]

If the depiction of natural forms and human forms came down to the same thing for Weston—a study of shapes in relation, of equivalences—for Cunningham the combination of natural and human forms *resonated* with one another without losing their distinct and special qualities. The strongly lit face of the woman in *Phoenix* (1968) (fig. 6.37) sets her apart from the womblike folds and hollows of the enfolding rock behind her. When body and landscape are fused, they are not *con*fused, but deliberately and intricately joined by patterns of light and dark, as in *Dream Walking* (fig. 6.19), a symbolist image from 1968 in which the same woman walks against a shadowy background into eerily lit foreground bushes, aflame like her long blond hair. In Cunningham's first photograph of Morris Graves, the artist is separate from the sheltering rock formation behind him, the lines of its strong projecting shape repeating and almost enfolding those of his frailer body; light on his ethereal and inward-drawn face against his darker chest

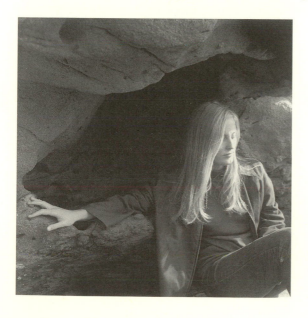

6.37 Imogen Cunningham, *Girl at Point Lobos (Phoenix)*, 1968. ©1970, 1996 by the Imogen Cunningham Trust.

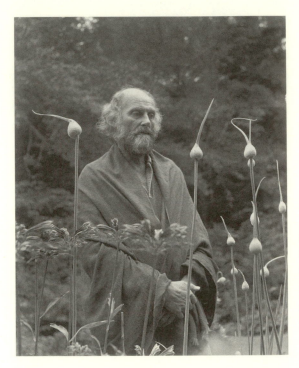

6.38 Imogen Cunningham, *Morris Graves in His Leek Garden,* 1973. ©1974, 1996 by the Imogen Cunningham Trust.

is set off by luminous patches of rock and by the lush surrounds of his garden. The portrait of Graves is an interaction—between this painter of "spirit birds" and "birds of the inner eye"—and this photographer.[100] "There was some kind of very intimate communion between them, something very strong and spiritual," filmmaker Fred Padula recalled about the second portrait of Graves (fig. 6.38), made some twenty years later[101] in the artist's garden, an encircling space in which the reclusive Graves in his monklike robe presides behind a boundary of tall plants that, sentinel-like, protect him. Light falls alike on the globular head of a leek plant and on the spiritual face of the photographer's friend, who has become himself "plant-like, patient in the midst of his ritual field."[102] And light falls alike on the pellucid face of the serenely composed elderly woman and on the veiny stems and eerily glowing leaves of the philodendron behind and above her in *Age and Its Symbols* (1958).

Cunningham's participation in the making of her pictures—as lover of this man, mother of these children, grower of these plants, artful eye in this design, friend of this woman—is the key to her work. In her signature

piece, *My Label* (1973), the witchy triangular shadow of the photographer actively engaged in contemplation figures prominently in the foreground, the lens of her camera signifying active looking, seeing and allowing her mark to be seen. The mark of her working, shaping hands upon a landscape that she called *Self-Portrait* (1972) is an acknowledged human inscription— *not* a possessive mark on the blankness of nature but a sign of an acknowledged and sensitive interaction with a responsive environment.

THE IDEA OF HUMAN PRESENCE

After a near lifetime, I am at last in touch with you! I first knew of you and your beautiful work when I was a student at the Clarence H. White School in 1916–17. . . . I have such a strong feeling that you and I see very much eye to eye. Your beautiful Graves portrait is all I need to see to feel this. —Laura Gilpin to Imogen Cunningham[103]

"From this hour I ordain myself loos'd of limits and imaginary lines, / Going where I list, my own master, total and absolute," Laura Gilpin wrote in her journal at the age of eighty-one as she was about to embark on a new project: a photographic study of the Canyon de Chelly in all its seasons.[104] The entry has to do with the death of her friend Elizabeth Forster, whose care had been Gilpin's responsibility for nearly thirty years, but the lines from Whitman's *Song of the Open Road* also suggest a sense of power and authority, a self-confidence that brook'd no limits as she prepared to camp alone on the canyon floor and, strapped into a small plane whose door had been removed, to fly over the canyon peaks. She was returning, in a sense, to the place where she had begun, to the land itself—but with a deepened knowledge that grew out of her work with the Navajo who lived there. "I really consider myself a landscape photographer more than anything else," she told Margaretta Mitchell a few years later. "I've photographed the Canyon de Chelly more than any other place." She then went on to recount two stories. One had to do with her distant relative, "the great landscape photographer William Henry Jackson," who made his first series of cattle-ranching photographs on her father's ranch in Colorado. In 1932 "we had quite a talk and I remember his saying that when he was in the Southwest he was interested in archeology and landscape but not in the Indians." The other had to do with photographing the canyon: "On one of my trips there I tried to find the exact spot where the great photograph with the seven horsemen by Edward Curtis was taken. I grew up under that print. It hung

on our wall at the ranch for years. I'm sure that is why I have photographed so often in the Canyon."[105]

These two often-repeated legends, along with her description of "surveying" the mountainous terrain of her native Southwest from the air, have framed the way we think about Gilpin's work: connected to but distinct from the heroic/romantic modes of representing the West. Martha Sandweiss sets Gilpin's work against the tradition "developed by men . . . who worked for the government survey teams of the 1860s and 1870s and was closely tied to the idea of exploration and conquest." In order to demonstrate Gilpin's rejection of the conventional, heroic landscape in her return to the intimate and maternal, Karen Hust's perceptive feminist analysis contrasts Jackson's *Cameron's Cone from "Tunnel 4"* with Gilpin's *Corley Road Tunnel* (the former a claustrophobic journey propelling the viewer toward the distant light, the latter a lush and velvety foreground with rolling hills in the middle distance) and Carleton Watkins's phallic *Agassiz Rock near Union Point* with Gilpin's *Cliff Palace, Round Tower, Mesa Verde* (the latter taken from within the tower, from the point of view of a woman looking through the rounded form's windows).[106]

Gilpin's work, as I have suggested, can only be understood in the context of the substantial problems of equipment and travel: she was able to take advantage of new lightweight cameras and gear, established roads and train tracks, and by midcareer the possibility of aerial photography was open to her as well. Although she logged a good many miles by land and air— "Many of the pictures [for *The Enduring Navaho*] have taken two, three, and even more trips and visits to finally win through. On several I have made two and three trips of 500 miles to get one picture!"[107]—she was not an explorer in the usual sense of that term. The clues to her vision, I think, lie closer to hand than (a re-visioning of) the work of the survey teams of the nineteenth century or the vast reaches of Curtis's project—closer to her own times and personal predilections.

Gilpin (like Käsebier and like Cather), as the female child of a transplanted mother who encouraged her daughter's independence, was raised in the West with a great deal of physical freedom. Climbing the mountains for pleasure, riding the back trails, making camp, she knew by name and sight and smell the streams and lookout points, the native wildflowers and rock formations. Unlike Jackson or Curtis or Whitman, she was bound to the homeplace by circumstance and by choice, caring for her father as both son and daughter after her mother's death, providing the financial base and

nurturance, and repeating this pattern in the home she made for herself and her partner, Elizabeth Forster, during their fifty-four years together. Her closest friends were women: the musician, poet, and critic Anne Simon; sculptor Brenda Putnam, who taught Gilpin about form and the modeling properties of light; and Betsy Forster.

Like other women mentored by Käsebier and trained at the White School, Gilpin began as a Pictorialist, but the burden of those dependent on her—she would face financial constraints all her life—necessitated work that constituted another kind of training as well: architectural photography and especially her work for Boeing Aircraft, where she did "everything under the sun from news shots, 'Cheese Cake Girls,' parties, industrial, portraits, etc. etc. all to be accomplished in nothing flat." Needing to photograph visiting dignitaries in the plant and hand them a finished print before they left, she "never made more than one exposure simply to save the labor of having to process more." Roped into a plane whose door had been removed and directing the pilot with a headset, she made the first aerial photograph of a B-29 in flight. She saw the new airplane as the "embodiment of the genius of American industry, engineering, and accomplishment"; it was her responsibility as an artist to interpret and translate "into plastic form the drama of the magnificent effort which is being enacted before us day after day."[108] These very different kinds of training would seem to account for the different kinds of landscape (and other) photographs Gilpin made during her long career, from the evocative plant studies and misty scenes of the 1920s and 1930s to the aerial shots of the Canyon de Chelly in the 1970s.

Vera Norwood suggests that Gilpin represents landscape in two conflicting ways—one aesthetic, often heroicized and romanticized, the other documentary—because of a cultural and gender-based ambivalence toward her photographic subject that has to do with white women's lack of a cultural myth to support their lives in the wilderness, which may account in particular for Gilpin's fascination with Navajo culture.[109] This contention places Gilpin among her contemporaries in a way that bears exploring. But this argument needs to be complicated with a consideration of images that are directly experiential—that is, neither "heroic" nor "documentary," but profoundly personal and erotic.

I begin with the scene of the young woman's meditation at the edge of the Grand Canyon (fig. 6.39) after the death of her friend and mentor Anne Simon, a turning point in Gilpin's life that seems in retrospect almost to

6.39 Laura Gilpin, *Sunrise, Grand Canyon,* platinum print, 1930.
©1979 by the Amon Carter Museum, Fort Worth, Laura Gilpin
Collection, no. 76.158/2.

mime two other famous scenes from photographic history: survey director
Clarence King, similarly positioned, allowing Nature to impress him "in
the dear old way, with all her mystery and glory, with those vague inde-
scribable emotions which tremble between wonder and sympathy"; and
Roland Barthes's Oedipal scenario after the death of his mother (the key to
his *Camera Lucida*).[110] Gilpin's perception of landscape at the beginning of
her photographic career had to do neither with the need (momentarily sus-
pended) to master and control nor with the suspension of discourse.
Rather, she saw the scene before her "as a space of communication with a
motherly female presence," a place of "intimacy and identification [that]
did not contradict artistic expression but inspired it." Poised on the canyon
rim, the young woman dedicated her meditations and her future spiritual
life to her "Guardian Angel," embodied as the land before her:

> Tonight, as I sat gazing out into the mystery of the Canyon in the
> glory of the moonlight I found my first great comfort. Away across

that vast space, I could see you. You were holding out your arms to me, smiling and urging me forward. And all at once I could see the Canyon as my life before me, with its valleys and shadows and its peaks crowned with sunlight. . . . Until now I have not known where to turn, but I know I want to go on. I want to climb some of those sunlight peaks. The valleys and shadows will come in their turn.[111]

As evidence for her argument that the sentiments Gilpin expresses in her diary and represents pictorially are distinctly female, Hust contrasts Jackson's *Grand Canyon of the Colorado, No. 1069,* in which a tiny man at the canyon's rim looks at the awesome, monumental, inhumanly sublime and inaccessible peaks through a telescope that parallels the camera's mechanical act of possession, with Gilpin's *Shiprock, New Mexico* (fig. 6.40). Gilpin's image, she points out, reverses this tradition: foreground, upon which a Navajo mother stands holding her child, predominates over distant peak, implying that Shiprock, smaller than the woman who observes it, lives only in her perceptions.[112]

6.40 Laura Gilpin, *[Landscape with Small Figures], [Red Rock, Arizona],* gelatin silver print, 1932. ©1979 by the Amon Carter Museum, Fort Worth, Laura Gilpin Collection, no. P1979.128.392.

These are extremely important insights, particularly in their congruence with Gilpin's sense of her own compositional goals. "More and more," she would write about her work in 1950, "this photographer has come to the conclusion that the most important thing in the landscape is the foreground."[113] In terms of *history*, however, these comparisons, in leaving out the middle piece, structure Gilpin's landscapes—and shape viewers' responses to her work—in a particular way. Taking her words about finding the exact spot of the seven horsemen at face value, let us assume that her representation of scenes made famous by her male predecessors of a half-century earlier was deliberate, whether as ironic reversal, as Hust suggests, or as a demonstration of a continuing American ambivalence between a vision of wilderness to be tamed to man's use and one to be respected and preserved, as Norwood argues. We are presented in either case with two groups of photographs, each historically situated—one informed by nineteenth-century (masculine Euroamerican) compositional sensibilities, the other presenting the same subject matter but with very different compositional sensibilities marked by gender and by *time*. Like Mark Klett's Rephotographic Survey Project, or like Bill Ganzel's photographs of FSA subjects made famous by Dorothea Lange or Michael Williamson's photographs of Walker Evans's Alabama sharecroppers a half-century later, Gilpin's landscape photographs seen in the context of these earlier images of the West amount to more than "re-photography," more than juxtaposition, more than comparable cultural artifacts. What happens in between is *time*. In the case of the Rephotographic Survey project, it is not only that the new print changes what has preceded it without actually altering it: "Like a punchline or the twist that ends a story," project coordinator JoAnn Verburg writes, "each RSP pair can be rich with cultural meaning and metaphor that go far beyond the surface of what is presented." Moreover, "The 'compositional' purity of the original Jackson photograph" (purity in the cultural sense of what constitutes a well-composed landscape and the "manifest destiny" sense of grandeur: "It's beautiful—and it's ours") "is jarred loose from its 'subject matter' by the effects of time." Photographic meaning is constructed by implicitly photographing the time between the two groups of images. In other words, Paul Berger suggests, "the two taken together, and the triangulation we make between them" demonstrates "something that is fundamental to all photographs but difficult ever to show explicitly: that the meaning of the photograph does not reside in its physical structure, but

rather in the dynamic and negotiating interaction between ourselves, our culture, and the image in question."[114]

Time is also Gilpin's subject, but the span of her photographs does not begin with the historical epoch of the survey project. A twentieth-century woman deeply rooted in her own time and place, Gilpin's sense of history—always peopled—links the archaic with contemporary concerns (she died in 1979). In fact, she often juxtaposes different views of the same scene in order to focus not only on past and present, but also on the time in between—on the triangulation that time makes. Historian Patricia Nelson Limerick means something similar by what she calls "the unbroken past of the American West": rejecting the notions of discovery, conquest, frontier as defining rubrics, she argues that the place that was there long before the surveyors came goes on (littered with their debris) long after they leave.[115] That this is the way Gilpin understood the place whose history she recorded suggests beginning not, as Hust does, with "the tradition she comments on,"[116] but with the view from within—what Gilpin called the "valleys and shadows."

This amounts to a radical revisioning of history—and Gilpin's project was ultimately nothing less—one that reaches back to the time before History in order to re-member sentient experience, her own and that of those visibly present shapers of this very old land; it amounts to a perception of Nature that begins with "the ME, that is, both nature and art, all other [wo]men and my own body." Against this diachronic reading, Gilpin's extraordinarily powerful female landscapes—her *Colorado Sand Dunes* (fig. 6.41), for example—resonate synchronically with such works as Mary Austin's description of the Mojave desert:

> If the desert were a woman, I know well what like she would be: deep-breasted, broad in the hips, tawny, with tawny hair, great masses of it lying smooth along her perfect curves, full lipped like a sphinx, but not heavy-lidded like one, eyes sane and steady as the polished jewel of her skies, such a countenance as should make men serve without desiring her, such a largeness of her mind as should make their sins of no account, passionate, but not necessitous, patient—and you could not move her, not if you had all the earth to give, so much as one tawny hair's-breadth beyond her own desires. If you cut very deeply into the soul that has the mark of the land upon it, you find such qualities as these.[117]

And *Cave of the Winds* (1925) and the *Bryce Canyon* photographs (1930) (fig. 6.42) are sensuously elaborated female landscapes in the tradition of Cather, whose similarly deep interest in history grounds this description of "Panther Canyon" in Arizona:

> one of those abrupt fissures with which the earth in the Southwest is riddled. . . . it was accessible only at its head. The canyon walls, for the first two hundred feet below the surface, were perpendicular cliffs, striped with even-running strata of rock. From there on to the bottom the sides were less abrupt, were shelving, and lightly fringed with *piñons* and dwarf cedars. The effect was that of a gentler canyon within a wilder one. The dead city lay at the point where the perpendicular outer wall ceased and the V-shaped inner gorge began. There a stratum of rock, softer than those above, had been hollowed out by the action of time until it was like a deep groove running along the sides of the canyon. In this hollow (like a great fold in the rock) the Ancient people had built their houses.[118]

6.41 Laura Gilpin, *Colorado Sand Dunes,* platinum print, 1946. ©1979 by the Amon Carter Museum, Fort Worth, Laura Gilpin Collection, no. 79.44/3.

6.42 Laura Gilpin, *Bryce Canyon no. 2*, platinum print, 1930. ©1979 by the
Amon Carter Museum, Fort Worth, Laura Gilpin Collection, no. P1976.158.1.

6.43 Laura Gilpin, *Sotol Plant*, gelatin silver print, 1946. ©1979 by the Amon
Carter Museum, Fort Worth, Laura Gilpin Collection, no. P1979.134.4.

Sisal Plant, Yucatán (1932), and *Sotol Plant* (1940s) (fig. 6.43) recall similar
studies by Cunningham; abstract compositions such as *Taos Ovens, New
Mexico* (1926), and *Church at Picuris Pueblo* (1963) not only bear the stamp
of modernist images by other former White students, but are kin to
O'Keeffe's paintings of her Abiquiu surroundings. And Gilpin's photo-
graph of Texas farmland (fig. 6.44), with its deeply furrowed rows of veg-
etables leading up to the farmhouse on the horizon, brings to the mind's
eye Dorothea Lange's *Tractored Out* (fig. 6.45).

This latter apposition is a surprisingly fruitful pairing: Lange is not usu-
ally seen as a landscape photographer, nor Gilpin as a documentary pho-
tographer. But Gilpin came to photographic maturity at a time of social
transformation during which, as Hust suggests, people projected their
anxieties and desires on American landscape as "a symbolic plane." Works
of the period capture this displacement—for example, Archibald Mac-
Leish's *Land of the Free,* which begins, "We don't know. We aren't sure . . . /
Now that the land's behind us we get wondering . . . / We wonder if the

liberty was the land and the / Land's gone . . . / Under our feet and hands the land leaves us / Blown out . . . tractored off . . . lumbered off"[119]; Lange and Taylor's *An American Exodus,* whose theme is the importance of place and/or dislocation from the land; or the FSA picture files, organized around the notion that land is the most basic category from which to derive knowledge about Americans.

No less than her visual recording of the continuity of Navajo culture, Gilpin's landscapes are documents in the sense that the history of a place—a record of its human habitation—was of primary importance in their making. Moreover, Gilpin, like Lange, saw her most important work as a com-

6.44 Laura Gilpin, *Carrot Field,* safety negative, 1947. ©1979 by the Amon Carter Museum, Fort Worth, Laura Gilpin Collection, no. 2187.1.
6.45 Dorothea Lange, *Tractored Out, Childress Co., Texas,* 1938. U.S. Farm Security Administration Collection, Prints and Photographs Division, Library of Congress, no. USF34 18281C.

bination of picture and text.[120] This sense of her work establishes a conceptual link to the documentary photo-text books of the late 1930s and early 1940s that depicted small town and rural America; but Gilpin's apolitical point of view—she ignored the effects of the Depression and of the war—is totally different from Lange and Taylor's concern with "the social scene of our time," the way in which institutions "function, absorb the life, hold the loyalty, and influence the behavior of human beings" and the way in which change "creates unemployment, changes the face of cities and of the agricultural landscape."[121]

The first of what Gilpin called her "cultural geography" projects—her short works *The Pike's Peak Region* in 1926 and *Mesa Verde* in 1927—were followed by four full-length books. An expansion of her Mesa Verde work, *The Pueblos: A Camera Chronicle* (1941), demonstrated the way in which native culture is linked to and shaped by the physical environment; it was also, as she described, a history of her photographic career to date, "cover[ing] a period of twenty years, commencing with the 'soft focus' period of 1921 when I made my first trip to New Mexico, through successive stages of photographic change and, I hope, progress." As I have suggested, *The Pueblos* is more "progressive" pictorially than socially. It is a work that demonstrates Gilpin's lack, at this point, of experience she would bring to *The Enduring Navaho* (1968): the ancient pueblos are portrayed as a place of retreat, a haven from the modern world, and her human subjects are pictured as inhabitants of an unchanging (and doomed) past—a nostalgic and essentially romantic vision of the Southwest and its native people that would be subject to considerable pressure in successive work.[122]

Between her two Indian books, Gilpin was simultaneously involved in two historical projects: *Temples of Yucatan* (1948) and *The Rio Grande, River of Destiny: An Interpretation of the River, the Land, and the People* (1949). The latter is the volume most exclusively devoted to landscape and is the pivotal work in Gilpin's career. Working at the same time on *The Rio Grande* and *Temples of Yucatan,* Gilpin must continuously have brought to both an awareness of the connection between the earth and its shaping by human hands into sculptural forms. The water hidden beneath the body of the earth that bubbles up from its depths to form "a magic, moving, living part of the very earth itself"—the water that Cather also saw as the source of creativity, the life force held in vessels shaped and lovingly decorated by hand, as the singer holds breath in her body—was to be the subject of

Gilpin's *The Rio Grande,* the history of the river from source to mouth. With its origins in her home territory, this river was a generative source both personal and cultural: unique in its nurturing capacities, its waters were "constantly turned upon the land," she pointed out; *only one other river in the world is used so completely for irrigation—that river is the Ganges of India.*"[123] For Gilpin, then, the history of this river would also encompass the history of diverse human activity along its shores. Thus, the river was the thread through whose windings she could trace her own memories as she moved from Colorado and the line that connected the separate historical moments preserved by distinct cultures.

This tracing would begin with what she knew best—the land through which the river made its course: "I was impressed with the beauty of the landscape," she recalled of a trip to the Rio Grande Valley above Creede, Colorado, in 1941. "It suddenly occurred to me what fun it would be to follow the river, . . . [the] great changes [that] took place in the landscape and also the variety of people and life all along the river." Over the next eight years she would make three trips traversing the river's length, logging some 27,000 miles and working at times against severe drought in order to locate "the most revealing points of view as to the river and the landscape and to find the characteristic native people and the most important of their activities." These sites and subjects were carefully chosen because, as she noted, she began the project during the war years when it was difficult to get film. As had been the case with her Boeing experience, "it was necessary to be perfectly certain that each exposure I made was worth the doing. There could be only one negative to a subject."[124] Her intuitive feel for light in a familiar place led to the making of her finest pictures, she believed. *Storm from La Bajada Hill, New Mexico* (fig. 6.46)—"the best thing in the book"—was made when she saw light breaking through the clouds and stopped her car just west of the highway between Albuquerque and Santa Fe, set up her tripod, and quickly made two exposures. Ansel Adams "would have stopped and then taken two or three meter readings and then it would have been gone," she said. "That is the difference between us. To him photographic technique comes first and to me the picture comes first." "Worth the doing," however, did not necessarily mean most "characteristic"; it had to do with her own sense of *the picture's* importance. She would wait through the drought "until high water," she informed her publishers, "to get a lot of river pictures that will be necessary"; she would wait five

6.46 Laura Gilpin, *Storm from La Bajada Hill, New Mexico,*
gelatin silver print, 1946. ©1979 by the Amon Carter Museum,
Fort Worth, Laura Gilpin Collection, no. P1979.95.96.

days for favorable conditions and plan her flight so that the river would be
backlighted for her image of the Rio Grande emptying into the Gulf of
Mexico.[125]

The book is divided into three sections—"Source," "Midstream," and
"Border"—and includes maps, historical chronology, geographical data,
bibliography, and a glossary of Spanish words with a guide to pronuncia-
tion (but none of the words of native peoples). It traces the routes of ex-
plorers, from Cabeza de Vaca to Colonel John C. Fremont, and the cultural
results of their discoveries in chapters such as "The Indian Pueblos and the
Prehistoric Relics" and "The Heritage from Spain." There are discussions
of industry and agriculture—mining, sheepherding, cattle ranching, fish-
ing, lumbering, the planting and harvesting of crops, the milling of grain,
orchards and citrus groves—and of weather conditions, native plants, reli-
gious rituals, architecture, and geographical landforms. In other words, the
intended audience is the *distant* Anglo reader of popular history—one un-
familiar with the information provided and therefore (so long as one reads
the book, with its controlling text, as intended) detached from the process

of making photographic meaning (in the way, say, that Walker Evans, assuming a familiarity on the part of his audience, could invite in his *American Photographs*). Perhaps because of the accessibility she intended her work to have, she was denied the kind of recognition Edward Weston received in grants and commissions for photographic series of his native California or, more grandly, of America itself in an illustrated edition of Whitman's *Leaves of Grass*. But she did not "want the book to look like *Look* or *Life* magazines. My whole conception . . . has been for one picture with its related text *as a unit*," she wrote to her editor. She saw this as her true form; with the completion of this project, she would apply for a second time to the Guggenheim Foundation, writing: "My quest is increasingly 'IN QUEST OF THE PERFECT BOOK.' Photography is the main structure, with informative text and presented through the art of book making."[126]

Early reviewers of *The Rio Grande* noted the disjunction between what they perceived to be Gilpin's documentary intent and her somewhat romanticized treatment of her theme.[127] Visual anthropologist John Collier Jr. found her "concrete feeling for the place and the people" most compelling in an environment she understood—the Colorado Rockies and New Mexico, where she photographed "men in nature, sheepherders, foresters, cowboys, and prospectors, who appear like wayfarers in the timeless journey of the river"—but weakest where she was "unable to create a shooting script that would bring in the drama of the great agricultural region and the modern enterprise of Texas." A photographer himself, who had worked for the FSA and would go on to publish his own photodocumentary text set partly in the Southwest, Collier was especially critical of the last section of the book in which "the river just flows by, more in harmony with the sleepy world of Old Mexico on the south than the boisterous booming state of Texas to the north." Placing Gilpin in the context of William Henry Jackson rather than Jacob Riis or Lewis Hine, Collier likened her to the western explorer who worked always alone, "the man who measures himself by great seas and mountains," rather than to the documentor of society—"the revolutionary, the man who has become oppressed by a crowded economy." More to the point was cultural geographer John Brinckerhoff Jackson's assessment: Gilpin showed the river to be "a force that has created a whole pattern of living, that has created farms and villages and towns and . . . continues to foster to their growth"; through her eyes we see for the first time "the pueblos, the Spanish-American communities, the whole countryside of farms, as something more than picturesque." But J. B. Jack-

son also noted another, unpictured landscape, one eroded and impoverished by overgrazing, ruthless deforestation, and faulty irrigation practices. "Miss Gilpin's camera, like the sundial, records only the sunny hours," he observed. "What we have in consequence is a collection of some two hundred expert photographs showing the river and its valley at their most brilliant."[128]

Jackson's observations that Gilpin's most striking photographs are those "showing the lonely river meandering through the wild and uninhabited . . . country" and that "the river has not one single identity but several" suggest why this subject might have appealed to her. The river is indeed her real subject in this work which is part cultural geography, part travelogue; but unlike other river works—Twain's Mississippi, Thoreau's Concord and Merrimack—where the physical journey is also a spiritual journey of discovery, the "I" in Gilpin's narrative is missing from the text—or seems to be. What appears to be straightforward text might instead be an encoded document: that is, if we consider, as Gilpin bids us, the picture with its related text as a unit, we might well find the narrator's presence in the beholding eye of the photographer, who presents views of her subject that are by no means consistent. Jackson's suggestion of the multiple identities of her subject, and Norwood's identification of the ambivalent representations of her subject only elaborate upon what Gilpin herself prepares us, in her introduction, to find: "It may be the movement of water, the fact that it travels, which has always been so fascinating. . . . Along the banks of rivers have passed the pageantry of ages and the drama of human progress and endeavor." A river, she continues,

> finds its course with sureness, pushing aside whatever surface matter lies in its way, and as it gathers volume and resulting strength, nothing can withstand its progress. It carves canyons, moves great boulders, erodes the soil, moving insistently onward in its surging need to reach its final goal—the ocean. . . . In years of drought it shrinks to a mere trickle, even disappearing in places, hiding as it were from observing eyes and flowing beneath the surface, then emerging again to continue its travel. (xi)

At the same time as Gilpin was absorbed, both as photographer and historian, in bringing to light, she was also fascinated with what is concealed beneath the surface. She had first proposed to the publishers of this work a

book about Colorado gold. The subject to which she did turn her attention seems in every way more fitting, yet the story of gold—of the search for what is hidden in the body of the earth—runs like a hidden thread throughout *The Rio Grande:* in the tale of the boomtown Creede (the first town on the river), built in 1890 when gold was discovered; in the pictures of the still-standing overhead cables that transported ore to the railroads for shipping and of an old-time prospector panning in the river, who still travels on foot in the mountains with his pack; in the stories of Coronado's futile search in 1540–1541 for the fabulous cities of gold and of the successful discovery of the precious metal by Antonio de Espejo, who followed Coronado's trail both east and west in Arizona.

This is the stuff of myth and legend (recorded by Cather in *My Ántonia*), and also of history. The history Gilpin was after was one in which she could participate, literally by digging it up, by making it. For all its lack of apparent social or political content, *The Rio Grande* is a book with an agenda; moreover, it is a book that records both historical continuity and change. Along the river, immigration patterns have developed, towns have sprung up, some growing into industrial centers, dams have been built, and bridges link old and new cultures. If a kind of sentimental attention to old ways and old-timers—their rituals and material culture—claims precedence, the modern world is by no means ignored: its structures make possible the movement of people and goods across the border by rail and highway, and the very making of those goods, from refineries, smelters, and oil rigs to modern irrigation techniques. If anything, Gilpin's attitude toward the modern world is *too* benign, her belief that Nature can absorb manmade pollution too optimistic: if, with the arrival of the "iron horse" in 1879, "the first puff of black smoke darkened the horizon of the Rio Grande," and if, two hundred miles south of Santa Fe in 1945, "the first atomic bomb shattered the desert silence as its towering mushroom cloud of smoke rose over the valley of the Rio Grande," these irruptions ultimately merge with the landscape. Nature covers the radioactive area with a different shade of green and with more abundant growth. Therefore, "Does not this remarkable stimulation presage future hope that atomic energy directed into constructive channels may be of unimaginable benefit to the world in the years to come?" (xi, 124–25, 140–45).

Both change and historical continuity were important to Gilpin as she worked on this book. In this period, she moved her home from Colorado Springs, a place associated with family failure and burdensome responsi-

bilities, to Santa Fe, where she would find a community tolerant of her living arrangements and supportive of her interest in regional history, archeology, anthropology, and art.[129] She dedicated the book to the memory of her mother, father, and brother and chose as framing images a pair of photographs that picture the world she was leaving behind: an initial image of a horseman positioned in front of a mountainous landscape (the sort of scene that lends itself to the parody with which this chapter begins) and the first trickle of the "life-giving water" amid the gently sloping ridges and hollows that rise from a foreground lush in wildflowers, and a final image of the Rio Grande as it completed its eighteen-hundred-mile journey through ever-changing landscape and its service to the soil, "yield[ing] its surplus to the sea"(4–5, 236) (fig 6.52).

Change—in the sense of curving, bending, exchanging, yielding—could lead us back into history itself, Gilpin believed. "Let us forget historic sequence for the moment," she urges, "and begin with . . . the river's source, following the ever-changing landscape through which it flows, letting history emerge as it is suggested by remnants and heritage from the past, until the river completes its course and joins the sea" (xii). Historical change happens, in other words. Gilpin presents herself as the documentor of change and continuity, but the way in which she juxtaposes nostalgic images of *unchanging* scenes to those portraying the modernization of transportation and recreational facilities, agribusiness, mining industries, and building trades, indicates that she is no neutral observer/recorder. Contrasting photographs of Elephant Butte Dam in New Mexico (figs. 6.47 and 6.48)—an image of the dam itself rising in its concrete ugliness to stand between river and mountains beyond to create an artificial lake, the scene of recreational development by day, and a peaceful night scene with moonlight reflecting on still water—demonstrate this ambivalence in modes of reporting. Paired photographs of a modern horseman, a businessman who exudes power, and of an old-timer seated on the ground with a plate of beans create a similar dissonance, as do the contrasting views across the river of the region from Villa Acuña to Piedras Negras, where large numbers of cattle, sheep, and goats are raised, and of the bridge at Laredo, the main artery of the Pan American Highway. There are also different kinds of textual reporting: the factual description of the El Azúcar Reservoir south of Roma, Mexico, with its "modern mechanical equipment" preparing vast areas for future farmers—"some seven hundred thousand acres will be irrigated as water from Azúcar is used in conjunction

6.47 Laura Gilpin,
Elephant Butte Lake,
safety negative, 1946.
©1979 by the Amon
Carter Museum, Fort
Worth, Laura Gilpin
Collection, no. 2126.1.
6.48 Laura Gilpin,
*Moonlight—Elephant
Butte Lake,* safety
negative, 1946. ©1979
by the Amon Carter
Museum, Fort Worth,
Laura Gilpin
Collection, no. 2127.1.

with the water coming through the headgate at Río Rico"—can be con-
trasted with more poetic observation of "change [that] follows in nature's
modulation—a symphony of growing things fed by the life-giving water"
(232–33). This is the basis of Norwood's argument that Gilpin's representa-
tion of Nature here amounts to a gender-based ambivalence that values
both a "Nature [that] absorbs men's tamperings and turns them back into
beauty" *and* the qualities of human "endurance, oneness with the wilder-
ness, and self-sufficiency." Like Mary Austin, then, she saw the land as fe-
male in its "forgiving" nature and envisioned herself as "a woman able to
put together a whole life based on the principle of self-sufficiency."[130]

Such juxtapositions may indeed provide the key to *The Rio Grande,* but
other images claim attention as well. Some pairs of photographs reinforce
one another: the rounded forms of old Spanish millstones and the comple-
mentary image of a New Mexican woman seated with her children among
a harvest of chili peppers (figs. 6.49 and 6.50), which, strung on long loop-

ing cords and suspended from the *vigas,* festoon the sides of her house; or that of an American Indian woman, the texture of whose apron and skirt seems continuous with the corn sheaves amid which she sits, and another of the glinting seed, "so tightly fitted into its cob," unwrapped from its "encasing sheath of silk," the kernels "released and planted *beneath* the ground in order to sprout" (80–81, 84, 86–87, emphasis original).

In a number of images, abstract form is primary: in the familiar Taos pueblo, with its recessive adobe blocks that "seem to grow out of the earth" and its rounded ovens (*hornos*) that add "soft contrasting lines to the rect-angles of the houses" (72), and the Mission Church of Ranchos de Taos (both painted by O'Keeffe); in man-made constructions such as the bridge at Laredo and the shipping port at Brownsville, Texas; and in natural for-mations—Taos Mountain itself, the beauty of its outlines and "richness of its modeled forms mak[ing] it a monument of nature's sculpture" (76), or the palms lining the highways of the Delta and the sotol plant, a member of the yucca family found in the Big Bend. Nature itself provides contrasts: the sotol has "fierce sawtooth edges," but "areas of eroded desert land,

6.49 Laura Gilpin, *Millstones—Taos,* safety negative, 1945.
©1979 by the Amon Carter Museum, Fort Worth, Laura Gilpin Collection, no. 2072.1.

washed into forms of arresting beauty" are cavelike tunnels explicitly fe-
male and erotic (fig. 6.51) (190–91); flat, open meadows are paired with the
broad, sloping mesa of the cratered *Valle Grande;* a horizontal view of the
river at Santa Elena Canyon sweeps the viewer's eyes away toward the end
of the picture plane where the great cliffs come to an abrupt end, whereas
in the image on the opposite page one looks from the sunlit body of water
up to a great cleft in the rock; a valley made green by the river's nourishing
water is paired with the river bed parched and dry in the drought season of
1945; and the river itself creates both the rich and prosperous farmland of
the San Luis Valley and the mysterious thousand-foot sand dunes that rise
like great breastlike forms from the valley floor. There are views that echo
Cather's sense of the protected place from which the perceived vastness of
exterior space offers freedom—the shelters and hollows of caves, cliff
dwellings, ruins—and there are also a number of long shots, both from the
ground and most exuberantly from the air, of "the prairie sweep[,] . . .
immense, and the sky infinite" (183), of cloud formations, or of the river's
broad expanse, its canyons and shores (fig. 6.52).

As we have seen, Gilpin loved to be up in the air, not only for the view
but for the feat of flying itself. Her pilot and a photographer friend have

6.50 Laura Gilpin,
Ristras, safety negative,
1947. ©1979 by the Amon
Carter Museum, Fort
Worth, Laura Gilpin
Collection, no. 2071.1.

suggested that the wide-open spaces of the sky seem to have given her a sense of freedom. She herself pointed out that after she was up in the sky, she discovered the ground. "Perhaps it is my love for landscape and geography that makes me want to fly," she would write in *The Enduring Navaho*, thus linking herself to her subject, projecting herself into the great sweep of space before her, and back into the present's long prehistory. "From the air one can see so clearly the great structures of the earth's surface, the different kinds of mountains, the sweep of contours, the age-old erosions. In the air one becomes detached and the mind goes deep into the past, thinking of Time in depth."[131]

Flowing through a variety of seasons, landscapes, and cultures, the river's journey was, as J. B. Jackson noted, often lonely as it meandered through wild country. From the air and from the ground, tracing the river's course from the familiar—the eastern slope of the Continental Divide in the San Juan Mountains of southern Colorado—to the more deeply known, Gilpin's passage was an isolated journey for a woman who lacked what Norwood has identified as a cultural mythic structure that offered support for women's lives in the wilderness. What Gilpin called "thinking

6.51 Laura Gilpin, *Desert Erosion,* safety negative, 1946.
©1979 by the Amon Carter Museum, Fort Worth,
Laura Gilpin Collection, no. 2176.1.

6.52 Laura Gilpin, *Mouth of the River from the Air,* safety negative,
1947. ©1979 by the Amon Carter Museum, Fort Worth,
Laura Gilpin Collection, no. 2224.4.

of Time in depth" would, over the course of the next twenty years, ulti-
mately provide her with the missing *groundwork:* coming to understand
and to identify with a culture of women at home in the natural world
would ultimately result in the cultural *encounter* that grounds *The Enduring
Navaho.* It is her journey down the Rio Grande, however—one that has to
do with origins, with growth and change, with creativity, and with histori-
cal experience—that prepared the way for that later achievement.

"ALL THE SPACES OF OUR LIVES"

*As you have reason to know I do not write letters . . . only once in a while a line or two
when I am moved to do so for some special reason. So this afternoon I find myself writing
to you, mainly to say that I find myself so often thinking of you with appreciation and
affection. Also to tell you that you are missed in this part of the world by not only my-
self.—Dorothea Lange to Imogen Cunningham[132]*

"Doubtless you realize that my idea of Imogen in Japan and Dorothea in
Japan would be two quite different tours," Cunningham wrote to Lange in
a note she enclosed with a book in which she had marked things of special

interest. "BUT there must be a lot more to Japan than just the superficial interest of beautiful gardens, distinguished architecture, and art," she continued, suggesting that Lange try to find a classless group living in ghettolike villages that "can be compared to the 'Untouchables' of India"— "something which I think is directly up your alley." The note referred to the way the careers of the two women had diverged during their long friendship.[133] Twenty-five years earlier, Cunningham had advised Lange, then a young mother trying to balance her professional and personal life, to photograph things in her natural environment. "I started to photograph some of the natural forms that I liked very much," Lange recalled:

> I tried to photograph the young pine trees there, and . . . some stumps, and I tried to photograph in the late afternoon the way the sunlight comes through some big-leaved plants with a horrible name, skunk cabbage, with big pale leaves and the afternoon sun showing all the veins. I tried to photograph those things because I liked them, but I just couldn't do it. And I then decided that when I went back to the city I would only photograph the people that my life touched. I discovered that that was my area. Difficult as it was, I could freely move in that area, whereas I was not free when I was trying to photograph those things which were not mine.[134]

In the last years of her life, as I have described, Lange was faced with the choice of concentrating on a new project in which the intimate and familiar place was central—photographing her family, the people whose lives touched hers most deeply, at their seaside retreat Steep Ravine—or of preparing for the retrospective exhibit. Against her own inclinations, she decided upon the latter: a selection and grouping of those works for which we remember her and through which we read back into her words her exclusive interest in people. Thus, "those things which were not mine" suggests an intended contrast with what she would later call those things that touch "the secret places of the heart." "Not mine" referred specifically to "Fallen Leaf," a place where she and her first husband Maynard Dixon and their children were guests of the wealthy Anita Baldwin, a situation in which she felt restricted. Freedom of movement for Lange would come with getting out into the field to photograph those who were unfree to move or who, uprooted, were moving unfreely, caught up in conditions that unsettled their lives.[135] Out there, not only would she photograph the expressive faces, the strong or damaged bodies of people who became

"hers," but would also make images of billowing clouds above a silhouetted mountain range in Arkansas or of deeply furrowed, "tractored-out" land fronting a solitary house on a broad horizon in Texas (figs. 6.53 and 6.45)—though there are striking differences between Gilpin's and Lange's Texas farms. Gilpin's thickly planted rows lead up from a broad fanlike sweep across the foreground toward a group of farm buildings set in the distance amidst a clump of trees on the horizon, against a great wash of sky. Lange shows us the arid furrows of worn-out farmland in which nothing grows; the furrows make a broad, circular, futile sweep beginning in the lower right corner and including an abandoned, solitary house. One is an image of plenty, the other of desolation, but both convey a strong sense of place.

Place was central to Lange's picturing of the people whose lives touched hers. People she met as she worked stand or sit or work in the places where they live—family farmsteads, ex-slave cabins out in the fields, the long view of "that old black ridge" a Mormon woman in Utah can see from her old stone house, the view of the hills and clouds from Ma Burnham's porch in Conroy, Arkansas (fig. 6.53). "These are women of the American soil [who] are the roots of our country. They inhabit our plains, our prairies, our deserts, our mountains, our valleys, and our country towns."[136] Or, as *displaced persons*, her subjects stand out from or sit against alien landscapes: the unemployed on long and dusty roads, anxious mothers and hungry children in makeshift migrant camps, Japanese Americans interned in bleak and barren "relocation centers."

Changes on the land became for Lange not merely setting but backbone of her documentary work, nowhere more insistently than in *An American Exodus*. Lange and Taylor both believed the "documentary" a medium "pre-eminently suited to build a record of change. Advancing technology raises standards of living, creates unemployment, changes the face of cities and of the agricultural landscape. The evidence of these trends—the simultaneous existence of past, present, and portent of the future—is conspicuous in old and new forms, old and new customs, on every hand." Recording these changes was the basis of her Guggenheim application in 1940, for which she proposed "to photograph people in selected rural American communities. The theme of the project is the relation of man to the earth and man to man, and the forces of stability and change in communities of contrasting types." She wanted to work as a free individual in a few places, selecting them carefully and penetrating them deeply in order "to document . . . [social] patterns, photographing people in their relations to insti-

6.53 Dorothea Lange, Untitled [Arkansas], silver print, 1938. ©The Dorothea LangeCollection, the Oakland Museum of California, City of Oakland, gift of Paul S. Taylor. Print, courtesy of the Amon Carter Museum, Fort Worth.

tutions, to their fellowmen, and to the land."[137] But Lange's understanding of herself as a documentary photographer included what she called her "print sense": she could be as particular as Cunningham or Gilpin about the quality of her images. "It hurts me when I see this cover picture, knowing what was in that print, because my print," she complained of the *Aperture* cover that featured her Berryessa Valley, "was three steps down in value from this, much darker. All these grasses are printed through in mine, so that they are not white areas here, but they lead on through." The engraver "had to do . . . the unspeakable thing of drawing a line here because he had not printed it to get this [mountain range]. All this in my print has values." And he had failed to capture the field beyond, which in her image "was all printed through with little things that shimmer, all through here this grass just shimmers."[138]

These things were connected. Just as she had worked long and purposefully to get her FSA prints exactly right, the aesthetic quality of the images in her *Death of a Valley* mattered because the subject was important to her. If she could convey the quality of the shimmering grass as she had seen it, evoking in the reader of the essay not only an aesthetic but an emotional

response, then she could make that place signify, and its erasure count; she could make it resonate with the backs of the couple leaving their home place and with their history, their separate tracks marking an isolation in what should be interconnected.

Originally assigned by *Life* magazine in 1957 to cover the construction of Monticello Dam, an irrigation project that would provide water for California's expanding cities, Lange and Pirkle Jones concentrated on recording the flooding of this small valley nestled in the shadow of the mountains, on Putah Creek at the junction of Napa, Yolo, and Solano counties, which had "held generations in its palm." Their photo essay describing a place "warm, sunny and quiet . . . of settled homes and deep loam soil[,] . . . of cattle and horses, of pears and grapes, alfalfa and grain [which] . . . had never known a crop failure" was rejected by *Life* (undoubtedly because of the attempt to "remind our viewers of the price of progress"). But it was mounted as an exhibit at the San Francisco Museum of Art in 1959 and published as a special issue of *Aperture* in 1960.[139]

Death of a Valley has never had a wide audience, despite the fact that even as it seeks to preserve the legend of a passing way of life, it addresses a problem of increasing contemporary concern. "The development, distribution and control of water has become California's biggest problem," we read in the introduction. "The new people are bringing with them the greatest population increase ever witnessed. . . . Everywhere farms and ranches are being torn up and made over into tract sites, orchards are being

6.54 Dorothea Lange, *Woman of the Far West from Berryessa Valley, California,* 1956. © The Dorothea Lange Collection, the Oakland Museum of California, City of Oakland, gift of Paul S. Taylor.

6.55 Dorothea Lange, *Terrified Horse*, 1956. ©The Dorothea Lange Collection, the Oakland Museum of California, City of Oakland, gift of Paul S. Taylor.

converted into industrial sites." The familiar sentiment that ties this work to the thirties—an elderly woman in a housedress and cardigan, hair neatly netted, face finely wrinkled, standing in a field of flowers and holding out her hand (fig. 6.54); a boy riding his bicycle down a road bordering fertile fields, his dog loping along behind him; a Mexican worker looming against a backlit sky, eyes confronting us directly under his broad-brimmed hat, and holding, Cezanne-like, a box mounded high with grapes—might well have seemed dated to a postwar generation intent upon industrial development. But images that seem to come from a familiar past must also have aroused anxiety in viewers of the apparently "simple, straightforward story" presented by Lange and Jones, whose real message was, as Minor White noted in his introduction, "that bulldozers are only slightly slower than atomic bombs; or that the nature of destruction is not altered by calling it the price of progress."

Some of the images from *Death of a Valley* are timeless. The woman and her home in the opening sequence reappear in *The American Country Woman* (as "Woman of the West welcomes friends gathering on Memorial Day . . ."). The terrified horse (fig. 6.55), alone on the bulldozed land, reappears in the Lange retrospective at the Museum of Modern Art in a section that includes photographs from the Great Depression. Its form, a docudrama, also comes from the thirties. The montage of narrative voices—the on-the-spot reporter describing the local people, "actual" voices (in typescript, not print, to bring them closer), statistics from the government report—and the juxtaposition of contrasting photographs makes it work very much like a Pare Lorentz documentary film. Its motion, however, is deliberately *stopped:* each photograph of the valley as it was, separately and

6.56 Dorothea Lange, from *Death of a Valley*, Aperture 8, no. 3 (1960). Photograph, Edgar Sabogal.

as part of a sequence, is an image of stillness, more emphatically final when paired with images of destruction. Meant to be a pastoral tale, *Death of a Valley* reads like nothing so much as a war story. Nowhere is this more striking than in the image at the center of the book of two old photographs on the floor of an empty room (fig. 6.56). Framed by pictures of the house set against mountain, trees, farmland, "amid the buzz of insects and smell of tarweed in the air, as it had always been," of emptied grave plots and of huge oak trees cut from jagged stumps—"cattle had rested in their shade for generations. On old maps and deeds they had served as landmarks"—the snapshots seem placed deliberately, rather than dropped, markers of lives lived here. The captured memory of someone's grandmother and grandfather stay; their kin, choruslike, say: "We're going to have to scatter out." "On the floor of an upper hall these relics—signs of severed roots—lay exactly like this," the narrator comments. "The home was completely empty, save for these abandoned portraits, a few old school books—and in the attic, some wooden curtain poles with round brass knobs at the ends" (144–49).

This laying bare of rudely scattered, once-intimate fragments of daily life, making a narrative from bits of printed paper and fabrics, from the way curtains were attached, is a view of history that seems to be particularly female. I think here of other war stories—Elsa Morante's description of daily

life behind the scenes of World War II in *La storia,* or Edith Wharton's bearing witness to the destruction of all that gives life meaning in World War I: "The photographs on the walls, the twigs of withered box above the crucifixes, the old wedding-dresses in brass-clamped trunks, the bundles of letters laboriously written and as painfully deciphered, all the thousand and one bits of the past that give meaning and continuity to the present." Particularly painful to Wharton was the destruction of Ypres, where "house-fronts . . . [had been] sliced clean off, with the different stories exposed. . . . In these exposed interiors . . . a hundred signs of intimate and humble taste, of humdrum pursuits, of family associations, cling to the unmasked walls. . . . It was all so still and familiar that it seemed as if the people for whom these things had a meaning might at any moment come back and take up their daily business."[140]

Lange's story opens with an eerie sense of the past reaching out to touch us, giving us the sense—as Lange always wished to do—that we viewers have the power to effect change. In her opening sequence, the woman, literally grounded in the fertile valley that gives her life meaning, stretches her hand out to us. But the power of the story lies in the fact that readers realize something terrible has already happened to this woman they are invited to know. This particular farmhouse—surrounded by flowering shrubs and towering shade trees, with its graveyard out back, its children, meeting places, crops and animals—will in the course of the story be subject to the obliterating roar of gigantic bulldozers and caterpillars, to billowing smoke and searing fire. But even more than the story of the willful destruction of the material history of generations of families in a particular valley, what Lange wanted us most to know is that this is *our* mythic story. With its Biblical overtones, *Death of a Valley* is an archetypal war story, combining Ecclesiastes and Revelation, prefiguring the scenes (as Minor White so presciently observed) of nuclear holocaust. The story takes us from the edenic valley that held generations in its palm to the raw and mutilated earth (figs. 6.57 and 6.58), all that remained when the machines finished, and to the covering flood of water, which banished even the memory of the destruction. "There was still time in the summer of 1957 to bring the cattle down from the hills," we read. "Time to ship them out of the valley. Time for one more harvest. Still Time for the brown hands of the Mexicans to pick 850 tons of grapes for one of California's finest wineries. Time for a few of the homes to be moved to higher ground." But "the water kept rising. It flowed over the land like a river and covered . . . the little valley. . . .

6.57 and 6.58 Dorothea Lange, from *Death of a Valley*, Aperture 8, no. 3 (1960). Photograph, Edgar Sabogal.

All landmarks disappeared. No dust now, no smoke, no hum of insects, no smell of tarweed, only stillness and the water rising and rising" (138–41, 162). Thus, although human voices have the concluding word, they seem, eerily, like voices from beyond the grave, like Eliot's "Till human voices wake us and we drown." Following a photograph of the completed dam and a statement of its vital statistics, they chant: "Everyone said they'd never flood it. Even when they talked about it, we never believed they'd flood it"; "This valley and this land was good to us, but the water over it will be good for the *majority* of the people. We *have* to think that way."

As the storyteller in this work, however, as in *The American Country Woman*, Lange preserves the place, its history by picturing landscape as a place inhabited, tied to memory and timebound—not to the "schedule" of the demolition crews and the developers, but to the time of generations. Her *Death of a Valley* is nothing less than a story of life and death—or, to borrow Elaine Scarry's term, of the making and unmaking of the world. Lange does not allow us to escape the consequences of the *unmaking* that she documents; at the same time, in her own *making*, she includes us in her vision of the regenerative power of art. As Elizabeth Duvert suggests of Georgia O'Keeffe's purpose—working against "a speed that is tearing our lives asunder, a sense of deadness in the spaces we inhabit, an alienation from the products that surround us, our own separation from the natural world of which we are a part"—Lange would ask us to consider "all the spaces of our lives—the houses we live in as well as those in which we worship—holy and living ground, . . . [to see] their walls or floors as alive."[141] If in her time, and perhaps in our own, her strong message was dismissed as *sentiment*, perhaps it is because we are terrified by the gap she shows us between the power of place and the vapidity of our displaced daily lives.

Epilogue

"WHY ARE THESE OLD HAGS LAUGHING?"[1]

Inevitably, a work is always a form of tangible closure. But closures need not close off; they can be doors opening onto other closures and functioning as on-going passages to an elsewhere (-within-here). —Trinh Minh-ha, When the Moon Waxes Red[2]

One of the last photographs Imogen Cunningham made is a portrait of Irene ("Bobbie") Libarry (fig. E.1), an old woman with sparse white hair, fifties' bow-shaped glasses, and sagging breasts straining a gauzy, old-fashioned brocaded dress. Leaning against a fringed satin cushion with her hands clasped in an attitude of resignation, the pictured woman at first glance might be somebody's grandmother, until we notice that she rests her hands, not on a table but on her broad bare belly—and then see that the brocade is a tattoo. The other half of Libarry's decorated body is the subject of another image that draws attention to her painfully misshapen feet (fig. E.2) and to the gnarled hands covering her crotch.

In 1976, Cunningham, ninety-three herself when she made the Libarry photographs, was at work on a series she called *After Ninety*, but she had long been fascinated by grotesques, among whom she included herself. Another nude portrait made the same year—Lyle Tuttle, in full body tattoo (fig. E.3), rests one tense hand in his lap and the other on the upended buttocks of a dismembered doll—includes another set of hands, the photographer's, suspended in mirror image against the black background. The doll is the same mutilated body Cunningham photographed in 1970, its head between its legs—her protest message against the war in Vietnam. The double portrait was a favorite trick: in a self-portrait made in 1961 (fig. E.4), the dark shape of the photographer is superimposed against a plate glass window, on the other side of which is a display of girdles; she (repre-

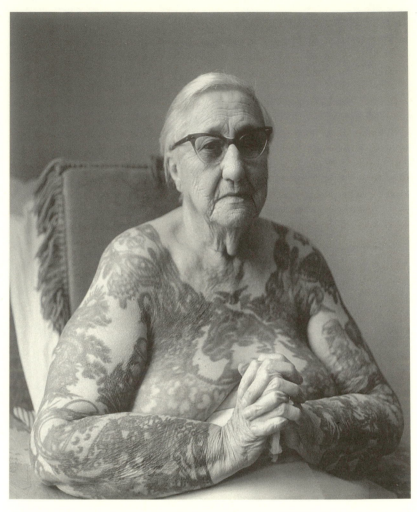

E.1 Imogen Cunningham, *Irene "Bobbie" Libarry*, 1976.
©1978, 1996 by the Imogen Cunningham Trust.

sented only by the familiar dark triangle) stands between the closed public
world—buildings and parked cars—and the private world of the body, here
on display on a city street.

The deliberate violation of the line between public and private is part of
Cunningham's sly, dark humor. Sometimes there is a calculated attempt to
make the viewer uncomfortable—a blind man's face; a pregnant body with
enlarged nipples that, with the handle of the door against which the
woman leans, make three round knobs; a close-up of a freckled ear and

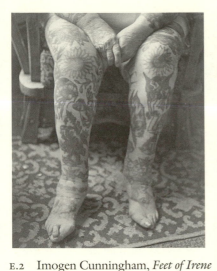

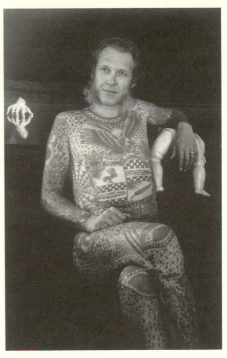

E.2 Imogen Cunningham, *Feet of Irene "Bobbie" Libarry*, 1976. ©1978, 1996 by the Imogen Cunningham Trust.
E.3 Imogen Cunningham, *Lyle Tuttle, Tattoo Artist*, 1976. ©1978, 1996 by the Imogen Cunningham Trust.

neck that seem to be snakeskin (fig. E.5). And sometimes the viewer is discomfited simply by too close an exposure to the private, as in her nude portrait of her shy and vulnerable friend, the painter Morris Graves: a fusion of artist and his garden, each photographed separately, another double image.[3] In the case of the carnival figures, however, Cunningham seems to have been intrigued by the sheer spectacle of their tattooed bodies: she wanted to see it all and got Tuttle, who didn't like doing so, to pose in the nude—"casually told him to take his clothes off," her archivist, Danee McFarr, recalls, "so what could he do?" According to McFarr, Bobbie Libarry was partly paralyzed and in the hospital when she and Cunningham went to see her:

> Imogen got her out of bed and into a chair and started to photograph . . . and then casually said, "Oh, will you take your gown off?" Bobbie hesitated a moment, but then she dropped it a little bit and Imogen said, "A little more," and then she dropped it so that she was nude from the waist up. . . . [Bobbie later] said she never would have taken her clothes off for anyone else—even in her younger days in the carnival

she always wore at least a bathing suit—but she was very comfortable with Imogen. . . . [L]ater we went to Bobbie's house to photograph her, and that was much better. The portrait used in the book is beautiful. Here is this eighty-three year old woman, not a beautiful woman, but looking very beautiful, very calm and contented. Her hands are folded and her breasts come right down to her hands, and it's all tattoos, solid tattoos. . . . Most people . . . are really repelled. Not by the photograph, because it's a beautiful photograph, but by the fact that this woman has done this to herself. So the photograph always gets strong reactions, and Imogen was very proud of it—thought it was one of the best portraits she'd done.[4]

I think we are repelled also by Cunningham's insistent and unflinching *looking*—and by our own simultaneous aesthetic attraction to the picture. This response, as well as the photographer's obvious sympathy with her subjects, distinguishes a picture like *"Bobbie" Libarry* from the voyeuristic work of Diane Arbus, which this series seems at first to resemble.[5] In fact—and this is borne out by her handprint on the Tuttle picture—the obverse of

E.4 Imogen Cunningham, *Self-Portrait, Denmark*, 1961. ©1978, 1996 by the Imogen Cunningham Trust.

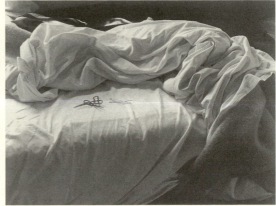

E.5 Imogen Cunningham, *Ear,* 1929. ©1978, 1996
by the Imogen Cunningham Trust.
E.6 Imogen Cunningham, *The Unmade Bed,* 1957.
©1970, 1996 by the Imogen Cunningham Trust.

Cunningham's carnival images is the photographer's display of her own unmade bed: the intimate disorder of her own life as spectacle. In what seems an optical illusion, the folds of the sheet so closely bearing the imprint of the sleeper's body, *The Unmade Bed* (fig. E.6) was seen as a beautiful picture by viewers at the bastion of high modernism, the Museum of Modern Art. "It is gratifying to know that people in New York get something out of the Unmade Bed," Cunningham wrote to MoMA's Grace Mayer in 1961. "I think I must have told you how I happened to do that shot. Dorothea Lange was giving a short course in photography at the California School of Fine Arts and gave one problem to her students and that was to depict their lives without putting any human in the photographs. One morning when I got up, I thought that my bed depicted my life, that it was disorderly enough, so I threw a few handfuls of hair pins in it and photographed it."[6]

Cunningham cultivated this image of disorder—the scattered, bohemian appearance of her person, the acerbic, unconventional remarks for which she was known, the delight in the "crooked borders" of her work.[7] Despite her charter membership in the so-called purist group in the 1930s—of which she was its most original photographer—for most of her life she was overshadowed by Adams and Weston, who valued perfection above all things. Weston especially must have roused her ire in the way he appropri-

ated women's bodies—those of his models/lovers—for their formal properties while disparaging the disorderly (i.e., inferior) aspects of his female colleagues' work.[8] Taking up the challenge, Cunningham, whom the boys in the group saw as "homely as a mud fence," perfected her performance of deliberate chaos: calling attention to the *im*pure, the noisy, unruly, marginalized side of life, while at the same time celebrating it as art.[9] Thus, the unmade bed is a perfectly composed formal image, even as it displays and reverses notions of self-representation; and the delicate tracery inscribing, masking, and displaying the body of the former carnival tattooed lady is a kind of signature in masquerade.

A little-known photograph from the 1940s is a reminder of the long history of doubleness in Cunningham's work and also links her to the other women of this study. In *Tea at Foster's* (fig. E.7) two women in profile, seated at a window table in a cafe fronting a street, engage in earnest conversation. They are marked as bourgeois by the neighborhood of the cafe, its crockery and formica table, and especially by their rounded, somewhat drab bodies and contrastingly flamboyant hats tilting toward one another. If this last detail denotes distance—they are comical—the positioning of the camera also signals connection in that we viewers are almost included at the end of the table: we, too, are inside, separated from the out-of-focus storefront across the street by the plate glass; yet we are not privy to the women's gossip but can only imagine what their story might be. The private speaking that emerges into the public domain to become spectacle by virtue of being photographed is kin to the untold but partially revealed stories of other marginalized, often grotesque subjects *and* of the autobiographical story suggested by the photographer's shape reflected in a store window in Denmark or on Geary Street in San Francisco.

Cunningham's repeated telling of her story of origins—her fascination with Käsebier's *Blessèd Art Thou Among Women*—is not, I think, immaterial. Not only does the earlier image tell a story about inside and outside, private and public, but it marks the point of origins of all of the women of this study as more than coincidental. All of them, I might add, not only operated at the edges of a culture that marginalized women and women's work, but they also bore the stigma of their own physical outsidedness— lameness, illness, homosexuality, a perceived ugliness—that might well account for their strong interest in representations of other aberrant bodies. Cunningham's interest in subjects from the world of carnival may in this sense be only the strongest case of looking in the mirrored lens of the cam-

E.7 Imogen Cunningham, *Tea at Foster's,* 1940s. ©1970,
1996 by the Imogen Cunningham Trust.

era. Her exploration of "an ambivalent redeployment of taboos around the
female body as grotesque (the pregnant body, the aging body, the irregular
body) and as unruly when set loose in the public sphere"[10] might suggest
what it is that drew, and still draws, other women to her in the first place.
This view is cause for rethinking other elements of photographic histories
as well, from Käsebier's interest in *tableaux vivants* to the more dangerous
mimesis of alterity.

Clearly, camera work became a source of empowerment for the women

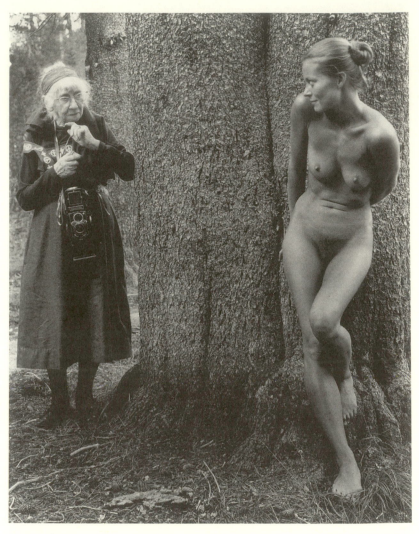

E.8 Judy Dater, *Imogen and Twinka at Yosemite,* 1974.
©Judy Dater.

of this study, not only in the making but in exhibition and publication. In
Cunningham's case, what is displayed—and displaced—is often mitigated
by humor. Her parodies of bourgeois culture are *tableaux* inverted or made
"crooked"; her celebrations of carnival are debased models of high culture.
Carnival is a site of insurgency—and of pleasure—precisely because "the
masks and voices of carnival resist, exaggerate, and destabilize the distinc-
tions and boundaries that mark and maintain high culture and organized

society," Mary Russo suggests. "It is as if the carnivalesque body politic had ingested the entire corpus of high culture and, in its bloated and irrepressible state, released it in fits and starts in all manner of recombination, inversion, mockery, and degradation." Thus, the carnivalesque "in its multivalent oppositional play" is not merely oppositional and reactive but "suggests a redeployment or counterproduction of culture, knowledge, and pleasure."[11]

Judy Dater's memorial to Cunningham, which includes photographs and a collection of interviews with her friends and colleagues, features on the cover an image of the elderly photographer, camera slung around her neck, rounding the trunk of a huge tree in Yosemite to confront Twinka (fig. E.8)—a vision of landscape that focuses on the two women, one a diminutive, wizened witchlike character, the other sleek, classical, nude: an artist's model. Here, the model confronts the artist directly; and the artist—clearly discomfited, herself the subject of representation—confronts the double of her fantasy even as the work in which she is lovingly presented mocks the traditions of artistic photography. This brings us full circle, to the questions I originally posed about "the gaze" (binary and essentialist notions of which are confounded, finally, by Cunningham's Bobbie Libarry picture) and about the lens of photographic history that has traditionally framed the way in which we think about the cultural work that images do. What if, in place of Stieglitz and Weston at the head of a linear, patriarchal history of photographic influence and practices, Käsebier and Cunningham are pivotal figures in a more loosely configured network? Cunningham's response to such (hypothetical) eminence—and to any sort of hierarchy—would be an emphatic "NO!" She was asked in 1973 if the Virginia Slims Book of Days Engagement Calendar could include her as "Woman of the Week" with the description, "Imogen Cunningham, called by many the mother of American photography, has been taking magnificent photographs since 1901." Noting her lifelong uncelebrated status and her need to work, she replied, "I am definitely NOT the mother of photography but the mother of three sons. When I become like Martha Washington—then you can use me. . . . If you really wanted to honor me you would give me the kind of job that I can still do—and that is photographing some of those female smokers."[12]

Notes

PROLOGUE

1 John Berger and Jean Mohr, *Another Way of Telling* (New York: Pantheon, 1982), pp. 285–86.

2 John Berger and Jean Mohr demonstrate this in *Another Way of Telling*. Mohr asks nine people to respond to five of his photographs and records nine separate stories for each image, each different from his own conception of "what was happening" (pp. 41–57). "Memory, based upon the visual, is freer than reason" (p. 133), Berger writes. "Memory is a field where different times coexist" (p. 280).

3 Roy Emerson Stryker and Nancy Wood, *In This Proud Land: America, 1935–1943, As Seen in the FSA Photographs* (Greenwich, Conn.: New York Graphic Society, 1974), p. 19. Lange recalled making five photographs, but she actually made six, all of which are reproduced in Lawrence W. Levine, "The Historian and the Icon: Photography and the History of the American People in the 1930s and 1940s," in Carl Fleischhauer and Beverly W. Brannan, eds., *Documenting America: 1935–1943* (Berkeley and Los Angeles: University of California Press, 1988), pp. 16–17.

4 *San Francisco News*, March 10, 1936, cited in Milton Meltzer, *Dorothea Lange: A Photographer's Life* (New York: Farrar, Straus, Giroux, 1978), pp. 133–34.

5 "Please, mister," she wrote to Stryker's assistant Edwin Locke, in charge of the Washington lab, "this show is the most important photographic show we have. It tours the country. It tours Europe. I couldn't afford to show prints unsigned, which I have not even *seen*. I'll send the negatives right back." Dorothea Lange to Edwin Locke, Sept. 10, 1936. Cited in Meltzer, *Dorothea Lange*, p. 134.

6 George P. Elliott, "Things of This World," *Commentary* (December 1962):542; *Dorothea Lange*, exhibit catalog, with an introduction by George P. Elliott (New York: Museum of Modern Art, 1966), p. 7.

7 Dorothea Lange, "The Assignment I'll Never Forget: Migrant Mother," *Popular Photography* 46, no. 2 (February 1960):42–43, 126.

8 Margery Mann, "Dorothea Lange," *Popular Photography* 66, no. 3 (March 1970):84.

9 Willa Cather, "The Best Short Stories of Sarah Orne Jewett" (1925), in Stephen Tennant, ed., *Willa Cather on Writing* (New York: Knopf, 1949), pp. 47–59. There are many similarities between Käsebier and Cather: both moved to the western territories as children with mothers who followed adventurous husbands but were never quite com-

fortable on the frontier; both traveled to France, took their first lessons from male masters, and in their early work thought of artistic expression in terms of male master-pieces—in Käsebier's case, Renaissance and impressionist portraits, and symbolist "paintings." Like Cather, Käsebier referred to the process of finding her own voice as "simplifying" and of finding her way back to re-membering the early influence of a strong woman, her grandmother. Käsebier would be for Gilpin the kind of mentor Jewett was for Cather.

10 Theodor Adorno, *Negative Dialectics,* trans. E. B. Ashton (New York: Seabury, 1973), pp. 17–18, cited in Carol Shloss, *In Visible Light: Photography and the American Writer, 1840–1940* (New York: Oxford University Press, 1987), p. 6.

11 Elaine Scarry, *The Body in Pain: The Making and Unmaking of the World* (New York: Oxford University Press, 1985), p. 285.

12 See Shloss, *In Visible Light,* pp. 10, 13, 261.

13 Documenting other races and classes with the camera began with the invention of photography. In the mid–nineteenth century, for example, Harvard Professor Louis Agassiz commissioned daguerreotypes of African slaves to study race difference. In chapters 3 and 5, I take up the way in which, in the early twentieth century, such projects were bound up with the new field of anthropology (Edward Curtis's colossal project of photographing the "vanishing race" of North American Indians being the most spectacular example) and with politics, particularly those projects associated with New Deal programs of the 1930s.

14 Susan Sontag, *On Photography* (New York: Farrar, Straus, Giroux, 1973), p. 6; Andrea Fisher, *Let Us Now Praise Famous Women: Women Photographers for the US Government 1935 to 1944* (London: Pandora [Routledge & Kegan Paul], 1987), p. 103; Shloss, *In Visible Light,* p. 12.

15 Walt Whitman, *Specimen Days,* cited in Barbara Novak, *Nature and Culture: American Landscape Painting, 1825–1875* (New York: Oxford University Press, 1980), p. 175. On the connection between the conquest of foreign lands and the colonial gaze that focused upon women's bodies as objects of that conquest, see Malek Alloula, *The Colonial Harem,* trans. Myrna Godzich and Wlad Godzich (Minneapolis: University of Minnesota Press, 1986).

16 Cited in Therese Thau Heyman, *Anne Brigman: Pictorial Photographer/Pagan/Member of the Photo-Secession,* exhibit catalog (Oakland: The Oakland Museum of California, 1974), p. 3.

17 Kathleen Newton Haven, staff assistant to Edward Steichen from 1953 to 1955, interview by Milton Meltzer, May 3, 1976, cited in Meltzer, *Dorothea Lange,* p. 295.

18 See chapter 5 for a discussion of the "real" Florence Thompson. Any reconstruction of her own story, of which we have so little, would necessarily be an imaginative reconstruction.

I HISTORIES: VERSIONS AND SUBVERSIONS

1 Sander Gilman, *Difference and Pathology: Stereotypes of Sexuality, Race, and Madness* (Ithaca: Cornell University Press, 1985), pp. 17–18.

2 James Clifford, introduction to James Clifford and George E. Marcus, eds., *Writing Culture: The Poetics and Politics of Ethnography* (Berkeley and Los Angeles: University of California Press, 1986), p. 10.

3 Susan Sontag, *The Volcano Lover, A Romance* (New York: Farrar, Straus, Giroux, 1992), p. 3.

4 De Keyzer's photograph is the frontispiece in *Cindy Sherman: History Portraits*, exhibit catalog, with a text by Arthur C. Danto (New York: Rizzoli, 1991). The spectator at the Stedelijk Museum, Amsterdam, in 1990 is "a typical Dutch schoolgirl," according to de Keyzer in correspondence with the author.

5 Martha Banta, *Imaging American Women: Idea and Ideals in Cultural History* (New York: Columbia University Press, 1987), p. 213.

6 Peter Stallybrass, "Worn Worlds: Clothes and Identity on the Renaissance Stage," unpublished manuscript cited with permission.

7 Danto, introduction to *History Portraits*, pp. 9, 13.

8 According to Danto, art historians Peter Schjeldahl and Robert Rosenblum were able to identify only five of the thirty-five originals, and a group of Munich art historians, who traced a few "with certainty," noted on a photocopy of one: "Boucher/Nattier/Fragonard/Watteau." Danto viewed the exhibit with Sherman, who stood in front of a picture that refers to *La Fornarina* and said tentatively, "Raphael?" "I am not certain that even she precisely remembers to whom the images originally belonged," he writes. "I asked her if she had found art history interesting when she was a fine arts student at Buffalo. Well, yes, . . . but she had a hard time memorizing all the images together with all the names, and more or less just got through the course." Her images, he concludes, "stand to their originals in something like the way a bad memory of a painting stands to the painting itself." Introduction to *History Portraits*, pp. 9–11.

9 Donna J. Haraway, *Simians, Cyborgs, and Women: The Reinvention of Nature* (New York: Routledge, 1990), pp. 152, 150), emphasis original. Compare Jean Baudrillard's more cynical view that all the world is simulacra in *America*, trans. Chris Turner (Material Word) (London and New York: Verso, 1988), and in other works.

10 Haraway, *Simians, Cyborgs, and Women*, p. 163; Clifford, introduction to *Writing Culture*, p. 15.

11 Stephen Greenblatt, "Resonance and Wonder," in Ivan Karp and Steven D. Lavine, eds., *Exhibiting Cultures* (Washington, D.C.: Smithsonian Institution Press), p. 43.

12 Nina Baym has shown that in the case of the dominant cultural critics who have taught us to read American literature in certain ways, this "neutrality" camouflages a concern with masculinity and alienation in the particular psyches of these writers. "Melodramas of Beset Manhood: How Theories of American Fiction Exclude Women Authors," *American Quarterly* 33 (Summer 1981):123–39.

13 Examples of such sub-versions abound in texts that confound the boundaries between fiction and history. Elsa Morante's *History: A Novel,* trans. William Weaver (New York: Knopf, 1977), places (the history of) World War II as the condition, the background, the setting for the real story: a woman's sense of her own body as alien in an alien world; her physical and emotional struggle, in a world of broken connections, to keep herself and her child alive; the intense, ultimately futile, love that people and animals

bear for one another. Noting that "History," in *The Oldest Living Confederate Widow Tells All* (New York: Knopf, 1989), "is my starting point," Allan Gurganus opens his novel with "a word to the reader about historical accuracy" that recounts the testimony collected from former slaves during the 1930s' Federal Writers' Project of the 1930s, many of whom recalled seeing Lincoln in the South during the Civil War—visitations which could not "in reality" have happened, but which nevertheless remain "truer than fact" (pp. xiii–xiv). Historian Simon Schama's *Dead Certainties (Unwarranted Speculations)* (New York: Knopf, 1991) turns to fiction to reassemble the pieces of historical fact in order to question History; and "metahistorian" Hayden White shows all history to be imaginative literature in *Tropics of Discourse: Essays in Cultural Criticism* (Baltimore: Johns Hopkins University Press, 1978) and in other works.

14　Danto, introduction to *Cindy Sherman: History Portraits,* p. 6.

15　Mike Weaver's *The Art of Photography* (New Haven and London: Yale University Press, 1989), for example, presents woman as subject while ignoring the *work* of women. This monumental tome includes no women photographers between Julia Margaret Cameron and our contemporaries Susan Meisalas and Cindy Sherman. Two exceptions to this general practice are C. Jane Gover's *The Positive Image: Women Photographers in Turn-of-the-Century America* (Albany: State University of New York Press, 1988) and Naomi Rosenblum's *A History of Women Photographers* (New York: Abbeville, 1994).

16　Alan Trachtenberg, *Reading American Photographs: Images as History, Mathew Brady to Walker Evans* (New York: Hill & Wang, 1989), p. 45.

17　Walt Whitman, introduction to the 1855 edition of *Leaves of Grass,* ed. Malcolm Cowley (New York: Viking/Penguin, 1976), pp. 5, 23; Trachtenberg, citing Karl Manheim, "The Problem of Ecstasy," *Essays on the Sociology of Culture* (London: Routledge and Kegan Paul, 1956), pp. 239–46, in *Reading American Photographs,* p. 68. Trachtenberg's choice of Whitman as *the* representative man is not surprising: Whitman has been the hero of American cultural studies at least as far back as Van Wyck Brooks's seminal "America's Coming-of-Age" (1915).

18　Trachtenberg, *Reading American Photographs,* pp. 205–206, emphasis original.

19　Ibid., pp. 284–85.

20　Ibid., pp. 288–90.

21　Joan Wallach Scott, *Gender and the Politics of History* (New York: Columbia University Press, 1988), pp. 20, 39, 197. For a comparison, see Elizabeth Fox-Genovese's critique of American individualism as a basis for constructing theories about U.S. culture. Her suggestion that marginal groups undertake a continuous negotiation with the possibilities afforded by the dominant culture in an attempt "to translate the traditions and values of their own communities into a language that would make them visible to others, . . . [enabling them] to participate in national culture," still foregrounds the dominant culture in a way that does not, finally, move beyond the dialectic Trachtenberg and others set up. See *Feminism without Illusions: A Critique of Individualism* (Chapel Hill: University of North Carolina Press, 1991), pp. 216–17.

22　Joan Wallach Scott, "Deconstructing Equality-Versus-Difference: Or, the Uses of Poststructuralist Theory for Feminism," in Marianne Hirsch and Evelyn Fox-Keller,

eds., *Conflicts in Feminism* (New York and London: Routledge, 1990), pp. 143–44. Scott points to the argument historian Alice Kessler-Harris made in the recent Sears case: "within the female category, women typically exhibit and participate in all sorts of 'male' behaviors. . . . [S]ocialization is a complex process that does not yield uniform choices. . . . [T]he generalized opposition male/female serves to obscure the differences among women in behavior, character, desire, subjectivity, sexuality, gender identification, and historical experience" (p. 143).

23 Imogen Cunningham to Grace Mayer (Museum of Modern Art, New York), Jan. 10, 1961. Cunningham Papers, Archives of American Art, National Museum of American Art, Washington, D.C.

24 Jacques Attali, *Noise: The Political Economy of Music,* trans. Brian Massumi, foreword by Fredric Jameson, afterword by Susan McClary (Minneapolis: University of Minnesota Press, 1985), pp. 6–7, 13, 26, 142, emphasis original. See Mikhail Bakhtin, *Rabelais and His World,* trans. Helene Iswolsky (Cambridge, Mass.: MIT Press, 1968), who organizes his reading of carnival around the concept of "grotesque realism," with particular emphasis on the grotesque body—"the open, protruding, extended, secreting body, the body of becoming, process, and change" as opposed to the "monumental, static, closed, and sleek body" that corresponds to "aspirations of bourgeois individualism." For comparison, see Mary Russo's argument that because the categories of carnivalesque speech and spectacle are heterogeneous "in that they contain the protocols and styles of high culture in and from a position of debasement, . . . carnival can be seen above all as a site of insurgency, and not merely withdrawal." "Female Grotesques: Carnival and Theory," in Teresa de Lauretis, ed., *Feminist Studies, Critical Studies* (Bloomington: Indiana University Press, 1986), pp. 218–19. See also Peter Stallybrass and Allon White, *The Politics and Poetics of Transgression* (Ithaca, N.Y.: Cornell University Press, 1986).

25 Mary Douglas, *Purity and Danger: An Analysis of the Concepts of Pollution and Taboo* (London: Routledge and Kegan Paul, 1966), pp. 2–4, 160–62.

26 Douglas, *Purity and Danger,* p. 5. See also Lawrence W. Levine, *Highbrow/Lowbrow: The Emergence of Cultural Hierarchy in America* (Cambridge, Mass.: Harvard University Press, 1988).

27 According to Sadakichi Hartmann, Whitman never gave himself over to the camera passively; he always struck his own pose. Cited in Trachtenberg, *Reading American Photographs,* p. 67.

28 Trachtenberg, *Reading American Photographs,* pp. 62–63.

29 Fox-Genovese, *Feminism without Illusions,* pp. 122–23.

30 The quotation from Ralph Waldo Emerson's *Representative Men* is the epigraph to Trachtenberg's chapter "Illustrious Americans" in *Reading American Photographs.* The doctrine of self-reliant individualism coincided with the emergence of intentional communities in the United States, at their peak in the mid–nineteenth century, many of which attempted to redefine sexual relationships. See, for example, Judith Fryer, "American Eves in American Edens: Women in Utopian Communities, 1840–1880," *American Scholar* 44, no. 1 (winter 1974/75):78–99.

31 Julia Kristeva, *Powers of Horror: An Essay on Abjection* (New York: Columbia Univer-

sity Press, 1982), pp. 65–77, 100–102, cited in Michel Oren, "On the 'Impurity' of Group f/64 Photography," *History of Photography* 15, no. 2 (summer 1991):124; Trinh T. Minh-ha, *Woman, Native, Other: Writing, Postcoloniality, and Feminism* (Bloomington: Indiana University Press, 1989), p. 37, emphasis added; Hélène Cixous, "The Laugh of the Medusa," trans. K. Cohen and P. Cohen, *Signs* 1, no. 4 (summer 1976), cited in Trinh, ibid., emphasis added. Cixous's word choice is rather strange: *impregnable* in the sense of strong, but not like women's *pregnable* bodies, which, she says, must provide the source of the new language. Mary Ann Doane, "Woman's Stake: Filming the Female Body," in Constance Penley, ed., *Feminism and Film Theory* (New York: Routledge, 1988), p. 221, emphasis added.

32 Oren, "Group f/64," pp. 123–24, citing the Adams-Weston correspondence and the Willard Van Dyke interview with Judy Dater. Adams cited in Nancy Newhall, *Ansel Adams: The Eloquent Light* (San Francisco: Sierra Club, 1964), p. 82. Interviews by Milton Meltzer with Rondal Partridge, Homer Page, Willard Van Dyke, and Arthur Rothstein, cited in Meltzer, *Dorothea Lange: A Photographer's Life* (New York: Farrar, Straus, Giroux, 1978), pp. 152–53. On Consuelo Kanaga's perfectionism in the darkroom, see chapter 4 in this volume.

33 Imogen Cunningham to unidentified interviewer, *Photographer's Journal and Camera*, March 19, 1975, transcribed by Valerie Bayliss. Cunningham Papers, Archives of American Art.

34 Amalie R. Rothschild, "Conversations with Willard Van Dyke," 1981, cited in Oren, "Group f/64," p. 121.

35 Oren, "Group f/64," pp. 120–21.

36 Ibid., p. 120.

37 Rothschild, "Conversations," cited in Oren, "Group f/64," p. 121, emphasis original. For Van Dyke to go to New York, where Paul Strand was working on documentary film, was not to go so very far away.

38 Ibid., pp. 123, 124.

39 Therese Heyman suggests that it was not only Kanaga's subject matter—black faces, black and white hands clasped together—that "was considered outside the ordinary" in the late 1920s and 1930s, but also her interest in photography as social statement (in contrast to the tendency to picture the alien other as exotic) that disturbed the purists of Group f.64. "Perspective on Seeing Straight," Therese Thau Heyman, ed., *Seeing Straight: The f.64 Revolution in Photography* (Oakland: The Oakland Museum of California, 1993), p. 29. Dorothea Lange saw Kanaga as "a person way ahead of her time She was very—generally if you use the word unconventional you mean someone who breaks the rules—she had no rules." Dorothea Lange, *The Making of a Documentary Photographer,* an oral history conducted by Suzanne Riess (Berkeley: University of California Regional History Office, Bancroft Library, 1968), pp. 87–88. Alma Lavenson called Cunningham, her friend and mentor for forty years, the greatest influence on her photography. The silence surrounding the work of these remarkable women, Heyman writes, was created by exhibition curators, art dealers, and photographic historians in the 1950s. Lavenson and Cunningham had no solo shows until later in their lives. As Cunningham noted, she and other women photographers were invisible;

only when she reached seventy did she become a celebrity. Imogen Cunningham, lecture at the Oakland Museum, cited in Heyman, "Perspective on Seeing Straight," p. 29. Recently new books have appeared on Lavenson—Susan Ehren's *Alma Lavenson: Photographs* (Berkeley: Wildwood Arts, 1991), and on Kanaga—Barbara Head Millstein and Sarah M. Lowe's *Consuelo Kanaga: An American Photographer* (Seattle: University of Washington Press, 1992).

40 Ansel Adams, *Letters and Images, 1916–1984* (Boston: New York Graphic Society, 1988), pp. 73, 75, cited in Oren, "Group f/64," pp. 121, 122.

41 Elizabeth Fox-Genovese suggests that women are "bilingual," that they practice "twoness," participating simultaneously in their own cultural patterns and those of the dominant culture, a theory that I find too rigidly binary. See *Feminism without Illusions*, pp. 216–17.

42 Cited in Abigail Solomon-Godeau, *Photography at the Dock: Essays on Photographic History, Institutions, and Practices* (Minneapolis: University of Minnesota Press, 1991), p. 229.

43 E. Isabelle Halderman, "Successful Seattle Business Women: Miss Imogene [*sic*] Cunningham," *Seattle Post-Intelligencer* (n.d. [1913], n.p.), from the files of the Grapestake Gallery, Cunningham Papers, Archives of American Art.

44 Sadakichi Hartmann, "The Broken Plates," *Camera Work* VI (April 1904):35–59, cited in Carol Shloss, *In Visible Light: Photography and the American Writer, 1840–1940* (New York: Oxford University Press, 1987), pp. 55–59.

45 Cited in *IMOGEN! Imogen Cunningham Photographs: 1910–1973*, with an introduction by Margery Mann (Seattle: University of Washington Press, 1974), pp. 34–35.

46 Doane's example of "getting the joke" is a photograph by Robert Doisneau, *Un Regard Oblique* (1981), in which a woman stares at a painting whose content is hidden from the spectator while the man beside her looks across her and beyond to another painting—of a female nude—concentrating attention on his own voyeuristic desire and negating that of the woman. In a second look at this photograph, Doane writes of being able to understand more than she had when she first considered it in her 1982 essay "Film and the Masquerade": "I was able to 'see more deeply' . . . into Doisneau's joke than Doisneau, but only *in a second moment*–a moment made possible by feminist theory. . . . I was able to read the Doisneau joke, without really getting it, due to the historicity of the feminist enterprise." Mary Ann Doane, "Masquerade Reconsidered: Further Thoughts on the Female Spectator," in *Femmes Fatales: Feminism, Film Theory, Psychoanalysis* (New York and London: Routledge, 1991), pp. 40–41. Although Doane bases her psychoanalytic theory on the work of Freud, she departs from his *Wit and Its Relation to the Unconscious* in her insistence that the cultural *work* a joke does has to do with hierarchical constructions of sexuality.

47 The literature includes, as a starting point: Laura Mulvey, "Visual Pleasure and Narrative Cinema," *Screen* 16, no. 3 (1975):6–18, and "Afterthoughts on 'Visual Pleasure and Narrative Cinema'" *Framework* 15–17 (summer 1981):12–15, both reprinted in Mulvey, *Visual and Other Pleasures* (Bloomington: Indiana University Press, 1989); Linda Williams, "Film Body: An Implantation of Perversions," *Cine-Tracts* 12, no. 3 (winter 1981):19–35; Mary Ann Doane, "Film and the Masquerade: Theorising the Female

Spectator," *Screen* 23, nos. 3–4 (Sept.–Oct. 1982):74–88; E. Ann Kaplan, "Is the Gaze Male?" in *Women and Film: Both Sides of the Camera* (New York: Methuen, 1983), pp. 23–35.

48 Linda Williams, *Hard Core: Power, Pleasure, and the "Frenzy of the Visible,"* (Berkeley and Los Angeles: University of California Press, 1989), p. 3.

49 Michel Foucault, *The History of Sexuality, Volume 1: An Introduction,* trans. Robert Hurley (New York: Pantheon, 1978), Vintage ed. used, p. 77.

50 Denis Diderot, *Les bijoux indiscrets,* cited in Williams, *Hard Core,* p. 1.

51 Williams, *Hard Core,* pp. 35, 32.

52 Foucault, *History of Sexuality,* vol. 1, pp. 123, 44–45. Foucault discusses surveillance mechanisms at length in *The Birth of the Clinic: An Archaeology of Medical Perception,* trans. A. M. Sheridan Smith (New York: Pantheon, 1973), and *Discipline and Punish: The Birth of the Prison,* trans. Alan Sheridan (New York: Pantheon, 1977).

53 Williams, *Hard Core,* pp. 3–4.

54 See Judith Mayne, "The Woman at the Keyhole: Women's Cinema and Feminist Criticism," *New German Critique* 23 (1981):27–43, and Mary Ann Doane, "Film and the Masquerade," *Femmes Fatales,* pp. 17–32.

55 Mulvey, "Afterthoughts on 'Visual Pleasure and Narrative Cinema'," *Visual and Other Pleasures,* p. 33. See also, Marjorie Garber, *Vested Interests: Cross-Dressing and Cultural Anxiety* (New York and London: Routledge, 1992).

56 Doane, "Masquerade," *Femmes Fatales,* pp. 21–26; Joan Riviere, "Womanliness as Masquerade," in Hendrick M. Ruitenbeek, ed., *Psychoanalysis and Female Sexuality* (New Haven, Conn.: College and University Press, 1966), p. 213, cited in Doane, "Masquerade," *Femmes Fatales,* p. 25.

57 Riviere, cited in Doane, "Masquerade," *Femmes Fatales,* p. 25.

58 Mulvey utilizes the former in "Visual Pleasure and Narrative Cinema," Doane the latter in "Film and the Masquerade" and in "The Voice in the Cinema: The Articulation of Body and Space," *Yale French Studies* 60 (1980):33–50.

59 Teresa de Lauretis, *Alice Doesn't: Feminism, Semiotics, Cinema* (Bloomington: Indiana University Press, 1984), p. 186.

60 Trinh T. Minh-ha, *When the Moon Waxes Red: Representation, Gender, and Cultural Politics* (New York and London: Routledge, 1991), p. 30.

61 In *The Rites of Assent: Transformations in the Symbolic Construction of America* (New York and London: Routledge, 1993), Sacvan Bercovitch takes up this question from the rhetorical point of view, noting the way we have privileged subversive individualism—"duplicity in Hawthorne, protest in Thoreau, marginality in Poe, antinomianism in Emerson. . . . All . . . in the name of a distinctly *national* tradition, . . . newly recovered for its quintessential 'American–ness'" (p. 363).

62 Rosalind Krauss, *The Originality of the Avant-Garde and Other Modernist Myths* (Cambridge, Mass.: MIT Press, 1985), p. 2.

63 Stanley Cavell (no source given), cited in Krauss, *Avant-Garde,* pp. 3–4, emphasis original; Krauss, ibid., p. 4.

64 Krauss, ibid., p. 5.

65 See Douglas Crimp, "The Museum's Old/The Library's New Subject," and Christo-

pher Phillips, "The Judgment Seat of Photography," in Richard Bolton, *The Contest of Meaning: Critical Histories of Photography* (Cambridge, Mass.: MIT Press, 1989), pp. 3–14, 15–48. As Abigail Solomon-Godeau writes, "reference to and criticism of the activities of the Museum of Modern Art's Photography Department and its enormously powerful director, John Szarkowski, constitute a refrain—a veritable leitmotif—in the essays. To the degree that the museum and its photography director represent the single most influential source of photographic legitimation in America, and that this legitimation is rooted in profoundly conservative values, a continuing and critical interrogation of their activities must inevitably be a component of oppositional photography criticism" (*Photography at the Dock,* pp. xxv–xxvi).

66 In *The Power of Photography: How Photographs Changed Our Lives* (New York: Abbeville, 1991), Vicki Goldberg argues that certain photographs presented in the media have evoked responses powerful enough to have shaped or altered the course of history. By *history* Goldberg means what we might call traces of specific events in the past; her concern is not to interpret the present in light of the past. But this concept of history is rather slippery: repeated references to photography's beginnings and "key" moments suggest a chain of interconnected events that seem to constitute historical continuity. On the other hand, Goldberg also argues that culture can be "reinvented" and that its artifacts are "reconstructed" in each generation. Similarly, she argues both that certain images—such as religious icons—have the innate power to move and persuade (this constitutes the basis of her selection) and that "a photograph must answer some need, belief, and expectation of its times" (pp. 7, 8, 17).

67 The standard British and American work of reference on photographic evidence is S. G. Ehrlich and Leland V. Jones, *Photographic Evidence: The Preparation and Use of Photography in Civil and Criminal Cases* (London: MacLaren, 1967). Behind Ehrlich's detailed technical discussion of photographs with "legal quality"—that is, having certain characteristics of objectivity and accuracy—lies his notion that "the good photographer must have the imagination and creative ability to reproduce scenes . . . so that they will convey to the viewer the same information and impressions he would have received had he directly observed the scene" (p. 10). Ehrlich repeatedly refers to "sharpness and frontality, exhaustive description and true representation," the avoidance of exaggerated effects and overt manipulation, and the expertise of the photographer as guarantees of the photograph as a direct transcription of the real (pp. 26–27). Cited in John Tagg, *The Burden of Representation: Essays on Photographies and Histories* (Amherst: University of Massachusetts Press, 1988), pp. 97–98.

68 See Roland Barthes, "The Photographic Message," in *Image, Music, Text,* trans. Stephen Heath (New York: Hill & Wang, 1977), pp. 15–31; see also *Camera Lucida: Reflections on Photography,* trans. Richard Howard (New York: Hill & Wang, 1981).

69 David Freedberg, *The Power of Images: Studies in the History and Theory of Response* (Chicago: University of Chicago Press, 1989), p. 438. By *response* Freedberg means neither the "high talk" that constitutes art history nor the "reclamation of context" of social historians, both of which "enable evasion and allow one to talk in terms from which the untidiness of emotion is necessarily excluded." Rather, he sees the need to acknowledge and describe "sensations and emotions as part of the experience which

history takes within its sphere. By this I do not mean the curious or amused recording of random emotion and sensation as they feature in anecdotal history, or the elevation of anecdote to indexical status, as is now the fashion. I mean recognition of the deep cognitive potential that arises from the relations between looking—looking hard—and figured material object" (pp. 430–32).

70 See Linda Williams, "Speaking Sex," in *Hard Core*, pp. 4–30, and Andrew Ross, "The Popularity of Pornography," in *No Respect: Intellectuals and Popular Culture* (New York and London: Routledge, 1989), pp. 171–208, for discussions of the literature on pornography, including Andrea Dworkin, Susan Griffin, Susanne Kappeler, Catherine A. MacKinnon, Robin Morgan, Gloria Steinem, the Meese (Attorney General's) Commission on Pornography, Varda Burstyn, Alice Echols, Susan Gubar, Ruby Rich, Ann Snitow, Carole Vance, Simon Watney, and others.

71 See, for example, Tzvetan Todorov, *The Conquest of America: The Question of the Other*, trans. Richard Howard (New York: Harper & Row, 1984); Michel de Certeau, *Heterologies: Discourse on the Other*, trans. Brian Massumi (Minneapolis: University of Minnesota Press, 1986); Clifford Geertz, "'From the Native's Point of View': On the Nature of Anthropological Understanding," in Keith Basso and Henry A. Selby, eds., *Meaning in Anthropology* (Albuquerque: University of New Mexico Press, 1976), pp. 221–38, and "Thinking as a Moral Act: Ethical Dimensions of Anthropological Fieldwork in the New States," *Antioch Review* 28, no. 2 (1968):139–58; as well as many of the essays in Clifford and Marcus, eds., *Writing Culture*.

72 bell hooks, *Yearning: Race, Gender, and Cultural Politics* (Boston: South End Press, 1990), pp. 126–28; James Clifford, "Introduction: Partial Truths," *Writing Culture*, p. 1, cited in hooks, *Yearning*, p. 127. See also Deborah Gordon, "Writing Culture, Writing Feminism: The Poetics and Politics of Experimental Ethnography," *Inscriptions* 3–4 (1988):7–24, for a critique of the cover photo for *Writing Culture* and of the book itself.

73 Edmund Carpenter, *Oh, what a blow that phantom gave me!* (New York: Holt, Rinehart, & Winston, 1972), pp. 129–31.

74 hooks, *Yearning*, p. 51.

75 Ibid., pp. 21, 22, 24, 44, 51–52.

76 Trinh, *Woman, Native, Other*, p. 30.

77 Ibid., pp. 1–2.

78 Trinh, *Woman, Native, Other*, p. 94, emphasis added. Compare Maxine Hong Kingston: "I don't want to listen to any more of your stories. . . ; they have no logic. They scramble me up. You lie with stories. You won't tell me a story and then say, 'This is a true story,' or 'This is just a story.' I can't tell what's real and what you make up." *The Woman Warrior: Memoirs of a Girlhood among Ghosts* (New York: Knopf, 1977), p. 202.

79 Cited by Charles Johnson in his review of Kwame Anthony Appiah's *In My Father's House: Africa in the Philosophy of Culture* (New York: Oxford, 1992), *New York Times Book Review* (June 21, 1992):8. Compare historian Lawrence W. Levine's judgment that those who chronicle events of power and decision making often forget that "all people, not just the movers and the shakers, bring something complex and enduring

to their experiences and that they retain the capacity of affecting events as well as being affected by them, of changing the present as well as being changed by it, of acting as well as being acted upon. "The Historian and the Icon," in Fleischhauer and Brannan, eds. *Documenting America*, p. 15.

80 Donna Haraway, "A Manifesto for Cyborgs," *Socialist Review* 80 (1985), reprinted in Haraway, *Simians, Cyborgs, and Women*, p. 150.

11 THE GEOMETRY OF BODIES: GENDER AND GENRE IN PICTORIALIST PHOTOGRAPHY

1 Michel Foucault, *The Birth of the Clinic: An Archaeology of Medical Perception*, trans. A. M. Sheridan Smith (New York: Pantheon, 1973), pp. xiii–xiv.

2 Bernard Noël, "The Eye's Touch," trans. Sheila Chevallier and Marianne Tinnell Faure, introduction to *The Nude* (New York: Pantheon, 1986), unpaged.

3 Lois Banner points out that by 1900 the voluptuous woman had retreated to the lower-class subculture from which she had emerged. See "The Voluptuous Woman in Eclipse: Lillian Russell, Lillie Langtry, and the Advance of Naturalness," in *American Beauty* (New York: Knopf, 1983; repr. Chicago: University of Chicago Press, 1984, pp. 128–53). See also Nancy F. Cott, *The Grounding of Modern Feminism* (New Haven, Conn.: Yale University Press, 1987). Cott dates the "birth of feminism" to 1914, the year of the First Feminist Mass Meeting at Cooper Union, New York (pp. 12–13).

4 The very word *landscape* implies that the scene framed in the window behind the model has also been shaped into an artifact by human work, just as she herself is being turned into something to look at. The pitcher is an old and often-used symbol of woman's body, probably originating with Rebecca at the well in Genesis.

5 "So many aspects of Renaissance culture, its painting, its literature, its historiography are born of this perception of an active confidence in human powers," Svetlana Alpers writes. "And so much are we heir to this view of man, or perhaps more particularly so much are art historians heir to this view of artistic representation, that it is hard to see it as a particular modality and not just the way representational art is." Alpers goes on to link the problems posed by photography to this mode of visualization and representation. *The Art of Describing: Dutch Art in the Seventeenth Century* (Chicago: University of Chicago Press, 1983), p. 43.

6 The term "Renaissance" was one self-consciously used by American architects, painters, sculptors, decorators, landscape architects, and writers of the turn of the century, particularly by the "guild" who designed palatial homes for American robber barons in direct imitation of those of Italian and French merchant princes and who collaborated on the World's Columbian Exposition—"the greatest meeting of artists since the fifteenth century," and who founded the American Academy in Rome. "We ourselves, because of our faith in science and the power of work, are instinctively in sympathy with the Renaissance," art connoisseur Bernard Berenson wrote; "the spirit which animates us was anticipated by the spirit of the Renaissance. . . . That spirit seems like the small rough model after which ours is being fashioned." *The Venetian Painters*, cited in

American Renaissance, 1876–1917, Brooklyn Museum exhibit catalog (New York: Pantheon, 1979), p. 12.

7 Martha Banta, *Imaging American Women: Idea and Ideals in Cultural History* (New York: Columbia University Press, 1987), pp. 14–15, 213. Banta uses Charles Saunders Peirce's argument that signs, images, and types speak to truths that lie fully within the scope of human experience. By 1868, Peirce had developed his theory about the relation between *object* (the thing, or signifier that arouses interest), *representation* (the sign that stands for the object's signified meaning), and *interpretant* (the person who appraises the arousing sign). This relation leads not only to the assignment of meaning to the object, but also influences the way we behave toward that object (ibid., pp. 13–14). Banta defines four types of American women in the written and visual images of this period: "Columbia as stabilizing power and aggressive action; the American Girl with charm that is innocent and knowing; the Heiress of All the Ages whose wealth restricts her choice of destiny and whose will empowers her to assume new roles; the New Woman who sits to think or dream and who stands to serve" (ibid., p. 1). To her list we should add the femme fatale; see Bram Dijkstra, *Idols of Perversity: Fantasies of Feminine Evil in Fin-de-Siècle Culture* (New York: Oxford University Press, 1986). It should also be noted that none of Banta's types refer to race or class.

8 Letter from Laura Wexler to the author, August 16, 1989. Joel Snyder and Neil Walsh Allen, "Photography, Vision, and Representation," reprinted from *Critical Inquiry* (Autumn 1975) in Thomas Barrow, Shelley Armitage, and William E. Tydeman, eds., *Reading into Photography: Selected Essays, 1959–1980* (Albuquerque: University of New Mexico Press, 1982), p. 70. Snyder and Allen take issue here with Arnheim's "On the Nature of Photography," *Critical Inquiry* 1, no. 1 (Sept. 1974):149–62.

9 In addition to Snyder/Allen and Arnheim, cited in note 8, see John Tagg, *The Burden of Representation: Essays on Photographies and Histories* (Amherst: University of Massachusetts Press, 1988); André Bazin, "The Ontology of the Photographic Image," in *What Is Cinema?* trans. Hugh Gray (Berkeley and Los Angeles: University of California Press, 1967); Stanley Cavell, *The World Viewed: Reflections on the Ontology of Film* (New York: Viking, 1971); Siegfried Kracauer, *Theory of Film: The Redemption of Physical Reality* (New York: Oxford University Press, 1960).

10 Snyder and Allen, "Photography, Vision, and Representation," 75.

11 Linda Williams, "Film Body: An Implantation of Perversions," *Cine-Tracts* 12, no. 3 (winter 1981):22–28. See also Williams, *Hard Core: Power, Pleasure, and the Frenzy of the Visible* (Berkeley and Los Angeles: University of California Press, 1989), pp. 38–48.

12 Roland Barthes, *The Pleasure of the Text,* trans. Richard Miller (New York: Hill and Wang, 1975), p. 10.

13 John Berger, *Ways of Seeing* (London: Penguin, 1972), p. 54. See Susan Danly and Cheryl Leibold, eds., with essays by Elizabeth Johns, Anne McCauley, and Mary Panzer, *Eakins and the Photograph: Works by Thomas Eakins and His Circle in the Collection of the Pennsylvania Academy of the Fine Arts* (Washington and London: Smithsonian Institution Press, 1994).

14 See Banner, *American Beauty,* pp. 59–60. Ellen Sturgis Hooper (mother of Marian

Hooper Adams, photographer and wife of Henry Adams) wrote to Carrie Sturgis: "My consolation now is the Greek Slave! Take the earliest time to see her when in Boston for you will never have seen enough." Cited in Eugenia Kaledin, *The Education of Mrs. Henry Adams* (Philadelphia: Temple University Press, 1981), p. 230. Women of this period also identified with Harriet Hosmer's manacled *Queen Zenobia*. See Claire Richter Sherman, with Adele M. Holcomb, *Women as Interpreters of the Visual Arts, 1820–1979* (Westport, Conn.: Greenwood Press, 1981).

15 Rozsika Parker and Griselda Pollock, *Old Mistresses: Women, Art, and Ideology* (London and New York: Routledge and Kegan Paul, also Pantheon, 1981), p. 115.

16 Walter Benjamin, "The Work of Art in the Age of Mechanical Reproduction," *Zeitschrift für Sozialforschung* 5, no. 1 (1936), reprinted in Hannah Arendt, ed., *Illuminations*, trans. Harry Zohn (New York: Schocken, 1969). On Pictorialism see, for example, Janet E. Buerger, *The Last Decade: The Emergence of Art Photography in the 1890s*, exhibit catalog (Rochester, New York: George Eastman House, 1984); Peter Bunnell, ed., *A Photographic Vision: Pictorial Photography, 1889–1923* (Salt Lake City, Utah: Peregrine Smith, 1980); Charles H. Caffin, *Photography as a Fine Art: The Achievements and Possibilities of Photographic Art in America* (New York: Doubleday, Page, 1901); Wanda M. Corn, *The Color of Mood: American Tonalism, 1880–1910*, exhibit catalog (San Francisco: M. H. de Young Memorial Museum, 1972); Peter Henry Emerson, *Naturalistic Photography for Students of the Art* (London: Sampson, Low, Marston, Searle, and Rivington, 1889); William Innes Homer, *Alfred Stieglitz and the Photo-Secession* (Boston: Little Brown, 1983); Henry Peach Robinson, *Pictorial Effect in Photography: Being Hints on Composition and Chiaroscuro for Photographers* (London: Piper and Carter, 1869); Naomi Rosenblum, "Art Photography: Another Aspect, 1890–1920," in *A World History of Photography* (New York: Abbeville, 1984); Alfred Stieglitz, "Pictorialist Photography," *Scribner's Magazine* 26, no. 5 (Nov. 1899):528–37, reprinted in *Classic Essays on Photography*, ed. Alan Trachtenberg (New Haven, Conn.: Leete's Island Books, 1980).

17 Stieglitz claimed that this was White's idea, but as Barbara L. Michaels points out, a gesture as bold as that in *The Bat* was not to be seen in White's work. Käsebier always signed and exhibited the picture as her own. See Michaels, *Gertrude Käsebier: The Photographer and Her Photographs* (New York: Abrams, 1992), pp. 92, 173 n. 18.

18 As I suggested in chapter 1, this is also true in most writing about photography, in which the photographer's gaze is assumed to be male.

19 The group that called itself Photo-Secession defined itself by its separation from "the fetters of conventionalism, tradition, and provincialism" that dominated most American photography at the turn of the century. The name "Photo-Secession" originated with Stieglitz's naming a 1902 National Arts Club show "American Pictorial Photography Arranged by the 'Photo-Secession.'" Käsebier, arriving at the opening, asked Stieglitz, "What's this Photo-Secession? Am I a photo-secessionist?" Stieglitz asked, "Do you feel you are?" "I do," she replied. "Well," he said, "that's all there is to it." Like the Munich and Vienna Secessions in the fine arts, the American exhibitors stood for the new, the experimental, and the living, "seceding . . . from the accepted idea of what

constitutes a photograph." Alfred Stieglitz, "The Photo-Secession," in *American Annual of Photography and Photographic Times Almanac* (New York: Anthony & Scovill, 1904), and "Four Happenings," in *Twice-a-Year* 8–9 (1942). Cited in William Innes Homer, *Alfred Stieglitz and the American Avant-Garde* (Boston: New York Graphic Society, 1977), pp. 28–29.

20 Trachtenberg, *Reading American Photographs*, pp. 173–75. On the eclipse of the more open Philadelphia school by Stieglitz's New York group, see Mary Panzer, *Philadelphia Naturalistic Photography, 1865–1906*, exhibit catalog (New Haven, Conn.: Yale University Art Gallery, 1982), and William Innes Homer, ed., *Pictorial Photography in Philadelphia: The Pennsylvania Academy's Salons, 1898–1901*, exhibit catalog (Philadelphia: Pennsylvania Academy of Fine Arts, 1984).

21 Allan Sekula, "The Traffic in Photographs," *Art Journal* 41 (spring 1981) 1:15–25. See also Tagg, *The Burden of Representation*, and Laura Wexler's review of this book, "Photographies and Histories/Coming into Being," *exposure* 27 (1989) 2:38–44; Wexler's "Material and Ideological Subtexts of Photography at Turn of the Century: A Comparative Approach," paper presented at the 1989 ASA/CAAS conference, Toronto; and Patricia Holland, Jo Spence, and Simon Watney, eds., *Photography/Politics: One* and *Photography/Politics: Two* (London: Comedia, 1986).

22 *Dorothea Lange: The Making of a Documentary Photographer*, an oral history conducted by Suzanne Riess (Berkeley: Regional Oral History Office, Bancroft Library, University of California, 1968), pp. 38–39, subsequently cited as Lange-Riess interview.

23 "A New School of Photography," *Platinum Print* 1 (August 1914):12.

24 Banta cites an 1877 advertisement by Eakins, which mentioned that models might be masked and could be accompanied by their mothers or other chaperones; the mask, however, might signal more than the model's wish for privacy and respectability, as suggested by an 1885 commentator's noting the paradox of concealed face, exposed body. *Imaging American Women*, pp. 725–26 n. 1.

25 C. Jane Gover's *The Positive Image: Women Photographers in Turn of the Century America* (Albany: State University of New York Press, 1988) provides a good historical overview of women photographers in this period. For earlier collections of women's work in photography at the turn of the century see Weston Naef, ed., *The Collection of Alfred Stieglitz: Fifty Pioneers of Modern Photography* (New York: Metropolitan Museum of Art, Viking, 1978). See also the more recent and wide-ranging works by Constance Sulli-van, ed., with an essay by Eugenia Parry Janis, *Women Photographers* (New York: Abrams, 1990), and Naomi Rosenblum, *A History of Women Photographers* (New York: Abbeville, 1994).

26 In a period when homosexuality, especially among women, was a hidden subject, lesbian and bisexual experiences might well inform the picturing of otherness. It seems likely to me, having studied thousands of photographs and read through her papers— from which her own responses to correspondents are pointedly absent—that this is the case with Johnston. Subsequent chapters discuss differences of sexual preference— and also of physical disability or unattractiveness—with reference to the way in which one kind of otherness is a substitution for another in the work of Gilpin, Kanaga, Lange, and Cunningham.

27 Edith Wharton, *The House of Mirth* (New York: Scribner's, 1905), p. 250.

28 This is the title of one of Banta's chapters in *Imaging American Women*.

29 Giles Edgerton [Mary Fanton Roberts], "Photography as an Emotional Art: A Study of the Work of Gertrude Käsebier," *The Craftsman* 12 (April 1907):88.

30 Charles Caffin, *Photography as a Fine Art* (1901; reprint, New York: Hastings on Hudson, 1971), pp. 61–62. For a more recent discussion of the "real" in American culture, see Miles Orvell, *The Real Thing: Imitation and Authenticity in American Culture, 1880–1940* (Chapel Hill: University of North Carolina Press, 1989).

31 Banta, *Imaging American Women*, pp. 147–48, emphasis original. Compare Henry Peach Robinson's "The poet says, in default of the real thing, 'Tis from a hand maid we must paint our Helen.'" *The Elements of a Pictorial Photograph* (1896), cited in Orvell, *The Real Thing*, p. 86. "By a type," Orvell writes, "we must understand not the scientist's general summation of a class; rather, the typology of nineteenth-century photography is . . . metonymic, whereby the pictured subject, with all its concrete particularity, *stands for* a more general class of like subjects. The individuality of the subject is thus presented on its own terms while it simultaneously serves the larger purpose of representing a general category" (p. 88, emphasis original).

32 *Imaging American Women*, p. xxxiv. Banta refers here to Joanne Reitano's study of the rapport between working women and middle-class reformers in "Working Girls Unite," *American Quarterly* 36, no. 1 (spring 1984):112–34; Stuart and Elizabeth Ewen's *Channels of Desire: Mass Images and the Shaping of American Consciousness* (New York: McGraw Hill, 1982), which notes the rapidity with which newly arrived immigrants became consumers of "the American look"; Neil Harris's call, in various studies of the gilded age, for understanding audience responses; and Lois Banner's remarks, in *American Beauty*, on the difficulty of gauging middle-class values because there were so many middle-classes and values.

33 See, for example, Sadakichi Hartmann's assessment that Käsebier's "gift belongs rather to *expression* than to *technique*" and that she is imitative of great masters—Holbein, Rembrandt, Cassatt. "Gertrude Käsebier," *Photographic Times* 32 (May 1900):195–99, emphasis original.

34 That none of these novels, all in the tradition of Realism, have happy endings only reinforces my point about the appeal of the *illusion* of role-playing. For a discussion of the *tableaux vivants* scene in *The House of Mirth*, see Judith Fryer, "Reading Mrs. Lloyd," in Alfred Bendixen and Annette Zilversmit, eds., *Edith Wharton: New Critical Essays* (New York: Garland, 1992), pp. 27–56.

35 Jack W. McCullough reports that on one occasion, plainclothes policemen in the audience rose from their seats just as Titian's *Venus* was "rising from the sea," leaped upon the stage and arrested the artists—though not the proprietor or the masculine assistants. Material on the history of *tableaux vivants* is drawn from McCullough's *Living Pictures on the New York Stage* (Ann Arbor: UMI Research Press, 1981), pp. 142–45, 42–45. William Glackens's painting, *Hammerstein's Roof Garden*, is a visual recording of such popular entertainment at the turn of the century.

36 *Character and Unique Fashions: Suggestions for Fancy-Dress Costumes* (New York: Butterick, 1897), cited in Banta, *Imaging American Women*, pp. 238–39.

37 This was not always the case, however. Banta has uncovered a number of gender switches at the turn of the century, including the artist John Sloan posing as "Twillbee" in 1894 and the reformer Frederick W. Taylor as "Lilian Gray" in the late 1860s; novelist F. Scott Fitzgerald dressed as a chorus girl for a Princeton production in 1915, and well-known female impersonator Julian Eltinge featured on the covers of sheet music and in advertisements promoting cold cream. Women entertainers such as Vesta Tilley, Maude Adams, Julia Marlowe, and Florenze Tempest also impersonated men. See *Imaging American Women*, pp. 268–80.

38 Lillian Baynes, "An Artist's Model," *The Illustrated American* (Oct. 19, 1895):497, 501.

39 Ibid., 497, 499.

40 Michaels, *Gertrude Käsebier*, p. 139.

41 Michaels points to a composite *tableaux* modeled on Manet's *Le déjeuner sur l'herbe* and/or on *Concert champêtre* (originally believed a Giorgione but now attributed to Titian), with Steichen on the left representing the standing figure in the Titian. Käsebier and Steichen knew both paintings; the latter had already made oblique reference to a sixteenth-century Italian painting when he photographed himself in what he hoped would be "photography's answer to [Titian's] 'Man with a Glove.'" Edward Steichen, *A Life in Photography* (Garden City, N.Y.: Doubleday, 1963), chapter 2, cited in Michaels, *Gertrude Käsebier*, pp. 84–85; ibid., pp. 118, 175 n. 22, 169 n. 6.

42 Willa Cather, whose affinity with Käsebier I discuss later in this volume, also admired the Barbizon painters. See Judith Fryer, *Felicitous Space: The Imaginative Structures of Edith Wharton and Willa Cather* (Chapel Hill: University of North Carolina Press, 1986), pp. 232–44.

43 Michaels points to deliberate artifice in these images: in *The Manger* there is no infant in the swaddling Frances Delehanty holds in a Newport barn, and her white robe may have been the angel's costume her friend F. Holland Day used to play ghost; Beatrice Baxter Ruyl posed as *The War Widow* in 1913, although her husband appears in other photographs from the same sitting. Citing the newsworthiness of the plight of widows in the press from 1910 on, Michaels shows that Käsebier's image was meant to *represent* widowhood: drawing on public concern about fragmented families, and at the same time upon a tradition in nineteenth-century painting of women waiting anxiously alone in dim interiors, the photographer imparted to her composition "a psychological intensity that lifts it from . . . sentimentality into the age of anxiety." *Gertrude Käsebier*, pp. 55–56; ibid., p. 150. John Szarkowski comes to the same conclusion from formalist grounds: he finds something "upsetting, even menacing" about the composition of *The War Widow*. He points to the two closely related light forms on a dark ground, one created by the white dresses of the woman and child, the other by the overlapping shapes of table and window: "The window and table read as a single form—an opening, or negative space. As a result the dark shapes surrounding the table leg become positive, or projecting forms. The signals from our eyes contradict our knowledge, and it is only by an act of will that we can maintain a rational orientation to the picture's very ambiguous space." *Looking at Photographs* (New York: Museum of Modern Art, 1973), p. 56.

44 Michaels, *Gertrude Käsebier*, p. 18; Gertrude Käsebier, "An Art Village," *Monthly Illus-*

trator 4 (April 1895):15; "Peasant Life in Normandy," *Monthly Illustrator* 3 (March 1895):273, cited in Michaels, p. 24; Michaels, ibid., pp. 27, 51, 58, 78.

45 Michaels points out that Froebel's methods were taught in Pratt's teacher-training school and kindergarten and were discussed in public lectures and in Pratt's magazines, and that Käsebier's instructor Ida C. Haskell painted scenes of mothers and children, one of which was shown at the World's Columbian Exposition. In Käsebier's circle, Arthur Wesley Dow, a convert to Froebelian concepts, taught a course for kindergarten teachers at Pratt and addressed the International Kindergarten Union on "Color in the Kindergarten." Käsebier herself used old-fashioned finger play to engage the interest of her young sitters. *Gertrude Käsebier,* pp. 18, 148–50.

46 Charles Horton Cooley, *Human Nature and the Social Order* (New York: Scribner's, 1902), emphasis original, cited in Banta, *Imaging American Women,* p. 266; Banta, ibid., pp. 266–68.

47 See Naomi Rosenblum, "Art Photography: Another Aspect, 1890–1920," in *A World History of Photography* (New York: Abbeville, 1984), p. 299; Charles Caffin, *American Masters of Painting* (New York: 1902), p. 13, cited in Wanda M. Corn, *The Color of Mood: American Tonalism, 1880–1910,* exhibit catalog (San Francisco: M. H. De Young Memorial Museum, 1972), p. 3. See Lary May, *Screening Out the Past: The Birth of Mass Culture and the Motion Picture Industry* (New York: Oxford University Press, 1980), on the way in which middle-class Protestants believed their Victorian family values to be threatened by the counterculture of immigrants, especially as these lower classes and their owns sons and daughters intermingled at the movies.

48 See E. Ann Kaplan, "Is the Gaze Male?" in *Women and Film: Both Sides of the Camera* (New York: Methuen, 1983), p. 26. See also Kaplan's *Motherhood and Representation: The Mother in Popular Culture and Melodrama* (New York: Routledge, 1992). Reading Käsebier's photographs of mothers and children through the lens of the history of science rather than the psychoanalytic lens of feminist film criticism, however, these images can be understood as an instance of the woman photographer's taking control of mechanical reproduction. In this context, see Donna Haraway's "The machine is us, our processes, an aspect of our embodiment. We can be responsible for machines; *they* do not dominate or threaten us." "A Cyborg Manifesto: Science, Technology, and Socialist Feminism in the Late Twentieth Century," in *Simians, Cyborgs, and Women: The Reinvention of Nature* (New York: Routledge, 1991), p. 180, emphasis original.

49 The terms *amateur* and *professional* photographer in this period were used to distinguish one who worked at home or in a camera club from one who had a studio. Alfred Stieglitz, however, called himself an amateur photographer in distinction from a *commercial* photographer, meaning that he worked only for artistic ends, not for profit.

50 Amateurs such as Jacob Riis photographed neither familiar subjects nor hired models, but the poor, who did not consent to and were not paid for posing.

51 Michaels, *Gertrude Käsebier,* p. 148. The Käsebier portraits of the Clarence White family are reproduced in Michaels's book, pp. 146, 147; the Eugene and Steichen portraits of the Stieglitz family are reproduced in Weston Naef, *The Collection of Alfred Stieglitz,* fig. 288 and plate 59.

52 Frances Benjamin Johnston Papers, Manuscripts Division, Library of Congress. Gover

points out that many successful women photographers—Johnston, Alice Austen, Beatrice Tonneson—chose not to marry but maintained close ties with their immediate families and/or with other women (*Positive Image,* chapter 3). On the difficulties and ultimate failure of the woman as artist, see Elizabeth Stuart Phelps, *The Story of Avis* (1877). This women's work has its parallel in the middle-class feminist utopias created, for example, in Charlotte Perkins Gilman's *Herland* (1915). On the other hand, this physical touching, found in middle-class white women's images of friends and family, is not unique to women; a similar antithesis to American individualism is represented visually in Riis's and Hine's images of immigrant cultures.

53 Joseph Keiley, "Gertrude Käsebier," *Camera Work* 20, no. 2 (1907):31. Stieglitz agreed. He wrote to Keiley, "Käsebier is a queer creature; she's touchy, like all women" (Nov. 14, 1901). Stieglitz Archives, Beinecke Library, Yale University, cited in Michaels, *Gertrude Käsebier,* p. 120.

54 Edgerton, "Photography as an Emotional Art," 88.

55 Cited in Michaels, *Gertrude Käsebier,* p. 124.

56 At least according to E. L. Doctorow in *Ragtime,* but see Baynes, "An Artist's Model," pp. 497–501, in which a model named Minnie Clark is credited as the original Gibson Girl and Lillie Daly as Saint-Gaudens's *Diana.* Banta argues that the Gibson Girl was a composite (*Imaging American Women,* p. 450).

57 Four of Eickemeyer's photographs of Nesbit are reproduced in Banta, *Imaging American Women.* A great many more are on file in the photographic archives of the National Museum of American History. American girls also played at being Evelyn Nesbit. See the photograph reproduced in Banta of her mother in 1908 posed as a jilted woman—on a fur rug, in silk kimono, with old love letters (actually laundry bills supplied by the photographer). Whether this image was meant to imitate Eickemeyer's Evelyn Nesbit hardly matters, given Banta's thesis about the prevalence of types in this period. *Imaging American Women,* pp. 262, 265. See also Mary Panzer, *In My Studio: Rudolf Eickemeyer, Jr., and the Art of the Camera, 1885–1930,* exhibit catalog (Yonkers, New York: Hudson River Museum, 1986).

58 Alessandra Comini, *Gustav Klimt* (London: Thames and Hudson, 1975), pp. 22–23. According to Bram Dijkstra, Klimt's "Salome/Judith is a heady mixture of vampire lore, high fashion, and the period's obsession with the notion that the headhuntress had desired to obtain hands-on-knowledge of John the Baptist's head." *Idols of Perversity: Fantasies of Feminine Evil in Fin-de-Siècle Culture* (New York: Oxford University Press, 1986), p. 388. Comini links Klimt's work directly to that of Charles Dana Gibson, writing that the American illustrator would "bottle and cap the erotic vapors of such continental extravagances in an eau-de-cologne spray of femmes fatales as 'wallpaper suitable for a bachelor apartment.'" *Gustav Klimt,* p. 24.

59 Wharton, *The House of Mirth,* p. 3.

60 Gertrude Käsebier, "Studies in Photography," *The Photographic Times* 30, no. 6 (June 1898):269–72, reprinted in Bunnell, *A Photographic Vision,* p. 86.

61 There is very likely a good reason why Henry Adams skipped the photography exhibit: the depression and suicide in 1885 of his photographer-wife, Marian ("Clover")

Hooper Adams, caused by her swallowing the potassium cyanide she used in developing photographs. Henry Adams had discouraged her work, preventing the publication of her impressive photograph of George Bancroft, for example. Using the editorial "we," he wrote to Richard Watson Gilder, editor of *The Century:* "You know our modesty . . . [and we decline to] flaunt . . . our photographs in *The Century.*" Cited in Kaledin, *Education of Mrs. Henry Adams,* p. 191. The photographer's husband had little respect for photography as an art: he had ridiculed Emerson for either "extreme sublimation or tenuity of intelligence" for asserting that "photographs [gave] more pleasure than paintings," and after his wife's death, he declared, "I hate photographs abstractly, because they have given me more ideas perversely and immovably wrong, than I should ever get by imagination." Cited in J. C. Levenson, *The Mind and Art of Henry Adams* (Stanford, Calif.: Stanford University Press, 1957), p. 210.

62 Toby Quitslund, *Her Feminine Colleagues: Photographs and Letters Collected by Frances Benjamin Johnston in 1900,* published with *Women Artists in Washington Collections,* exhibit catalog (College Park, Maryland: University of Maryland Art Gallery and Women's Caucus for Art, 1979), pp. 99–100, 103. See also Gover, *Positive Image,* pp. 115–23, and Rosenblum, *History of Women Photographers.* Letters from exhibitors to Johnston can be found in the Manuscripts Division, Library of Congress. Alice Austin of Boston is not to be confused with Alice Austen of Staten Island, New York, who produced a wealth of images of women engaged in various types of communal, even intimate activities—athletic, social, travel, and play—but whose work was not part of the exhibition Johnston organized in 1900. Austen is worth a study of her own. See Ann Novotny, *Alice's World: The Life and Photography of an American Original, Alice Austen, 1866–1952* (Old Greenwich, Conn.: Chatham Press, 1976).

63 Gover, *Positive Image,* p. 72. In *Private Woman, Public Stage: Literary Domesticity in Nineteenth-Century America* (New York: Oxford University Press, 1984), Mary Kelley makes a similar argument about nineteenth-century American woman writers: "When as dependent women they gained economic power; and when, suffering from a sense of their intellectual inferiority, they became creators of culture, they were forced to confront and grapple with conflict, ambivalence, and guilt" (p. xii).

64 Elizabeth Flint Wade, "Amateur Photography Through Women's Eyes," *The Photo-American* 15 (March 1894):235, cited in Gover, *Positive Image,* p. 67.

65 Quitslund, *Frances Benjamin Johnston,* pp. 100–102. Compare Richard Hines Jr.'s statement: "Cleanliness and patience are two of the cardinal virtues necessary to the successful pursuit of photography. The first seems to be a God-given attribute to most women, while if they have not the latter in sufficient amount, it is a virtue that can be cultivated. The light, delicate touch of a woman, the eye for light and shade, together with their artistic perception, render them peculiarly fitted to succeed in this work." "Women and Photography," *Wilson's Photographic Magazine* 36 (March 1899):137.

66 On the system of patronage and tradition still operative in museums of fine art, see Tom Wolfe, *The Painted Word* (New York: Farrar, Straus, Giroux, 1975). Reese Jenkins, *Images and Enterprise: Technology and the American Photographic Industry, 1839–1925* (Baltimore: Johns Hopkins University Press, 1975).

67 Zaida Ben-Yusuf to Frances Benjamin Johnston, June 1900; Eva L. Watson (Schütze) to Johnston, June 10, 1900, Johnston Papers, Library of Congress.

68 Cited in Constance W. Glenn and Leland Rice, *Frances Benjamin Johnston: Women of Class and Station* (Long Beach, Calif.: California State University Art Museum and Galleries, 1979), p. 5.

69 Johnston's portrait of Mrs. John Philip Sousa, for example, seems to refer to a Sargent painting; her images of Isadora Duncan's dancers resemble Arnold Genthe's dance photographs, collected in his *As I Remember* and *The Book of the Dance* (New York: Mitchell Kennerley, 1916); and they are also in the spirit of Angelika Kauffmann's drawings for furniture decorations (which Johnston photographed).

70 Frances Benjamin Johnston, "Gertrude Käsebier, Professional Photographer," *Camera Work* 1 (Jan. 1903):20; Alfred Stieglitz, "Our Illustrations," *Camera Notes* 3 (July 1899):24, cited in Barbara L. Michaels, "Rediscovering Gertrude Käsebier," *Image* 19, no. 2 (June 1976):21.

71 See Edgerton, "Photography as an Emotional Art"; see also Corn's distinction between sentiment and sentimental in *The Color of Mood*. Nina Baym, "Melodramas of Beset Manhood: How Theories of American Fiction Exclude Women Authors," *American Quarterly* 33 (summer 1981):123–39.

72 See Cathy Luchetti and Carol Olwell, *Women of the West* (Berkeley: Antelope Island Press, 1982; reprint, New York: Orion, 1992); Richard Chalfen, *Turning Leaves: The Photograph Collections of Two Japanese American Families* (Albuquerque: University of New Mexico Press, 1991); Philip Stokes, "The Family Photograph Album: So Great a Cloud of Witnesses," in *The Portrait in Photography*, ed. Graham Clarke (London: Reaktion Books, 1992). Women were not alone in photographing their families, of course. Even Alfred Stieglitz made an album recording the growth of his daughter, Kitty, *The Journal of a Baby*. See also Jeanne Moutoussamy-Ashe, *Viewfinders: Black Women Photographers* (New York: Dodd, Mead, 1986).

73 Jenkins, *Images and Enterprise*, pp. 112, 116–17. George Eastman named his "little roll holder breast camera" *Kodak,* creating a word that could not be mispronounced and one unlike any other for trademark registration. "The elimination of the word 'camera' is a good thing and comes back to my original idea, to make a new word to express the whole thing," he wrote in 1888. Cited in ibid., pp. 114–15.

74 "The Deadly Kodak Girl," *The Photographic Times* 21 (Oct. 16, 1891):581; E. S. Turner, *The Shocking History of Advertising* (New York: Dutton, 1953), p. 185, cited in Gover, *Positive Image,* pp. 14–15. The Kodak girl's independence was presented as a means of harmless flirtation in a poem by William E. S. Fales published in the *Photo-Beacon* in 1902: "delicate and sweet," with her Kodak in her hand, as she prepares to take a snapshot, the male viewer "snap[s] her face" with his eyes, preserving her "witchery and grace" in his brain just as she, with "loving laugh," puts his photograph "on the mantle in a stand." Poem reprinted in Peter Palmquist, ed., *Camera Fiends and Kodak Girls: 50 Selections By and About Women in Photography, 1840–1930* (New York: Midmarch Arts, 1989), p. 127.

75 Jenkins, *Images and Enterprise*, pp. 113, 121.

76 Reprinted in Palmquist, *Camera Fiends and Kodak Girls,* pp. 33–35.

77 Keiley, "Gertrude Käsebier," p. 31.

78 E. F. Hannavan, "Appointments and Order Getting," *Camera Craft* 14, no. 11 (Nov. 1907):481–84; Clara Weisman, "Artistic Retouching," *Camera Craft* 10, no. 1 (Jan. 1905):40–44, reprinted in Palmquist, *Camera Fiends and Kodak Girls,* pp. 185–88, 157–61.

79 Elizabeth Flint Wade, "Photography: Its Marvels," *St. Nicholas* 25, no. 11 (Sept. 1898):952–59.

80 "Photography as a Profession for Women," News Bulletin of the Bureau of Vocational Information 2, no. 7 (April 1, 1924):49–50, 54–55, Clarence White Archives, Princeton University.

81 Banta, *Imaging American Women,* p. 700.

82 Radway suggests that middle-class women turn to romance reading as a task that is solely and peculiarly theirs. "Educated to believe that females are especially and naturally attuned to the emotional requirements of others and who are very proud of their abilities to communicate with and to serve the members of their families," she writes, they "value reading precisely because it is an intensely private act." Radway links the act of reading, for middle-class, housebound women, to the availability of cheap, mass-market paperbacks. A similar availability of inexpensive photography equipment and mass-market periodicals as sources of publication must have had a comparable appeal for middle-class women at the turn of the century. As Radway suggests of romance reading, photography enabled these women "to suspend temporarily those familial relationships and to throw up a screen between themselves and the arena where they are required to do most of their relating to others." As one of Radway's chief informants, a housewife and romance reader turned bookseller put it, "This is for me. I'm doin' for you all the time. . . . Let me have my time, my space." *Reading the Romance: Women, Patriarchy, and Popular Literature* (Chapel Hill: University of North Carolina Press, 1984), p. 92.

83 Women photographers made choices that set them apart from their families and from prescribed behavior for women in this period, Gover claims: "They were often single women in a period when marriage and motherhood were glorified; they were business women at a time when the market place was deemed ill-suited for ladies; and they were creative women when the kind of independence that implied was suspect" (*Positive Image,* p. 35). Michaels points out that in becoming a professional, Käsebier went from "conventionally corseted matron" to photographer "utterly careless of dress or appearance" (*Gertrude Käsebier,* p. 154). On the discouraging attitude Clover Adams's husband displayed toward her work, see note 61.

84 Richard Hines Jr., "Women and Photography," *The American Amateur Photographer* 10 (1898):118–24, 144–52, reprinted in Palmquist, *Camera Fiends and Kodak Girls,* p. 87, 88.

85 Margaret Bisland, "Women and Their Cameras," *Outing* 17 (Oct. 1890):38–39.

86 Frances Benjamin Johnston Papers, Manuscripts Division, Library of Congress.

87 "How a Woman Makes Landscape Photographs," *The Philadelphia Photographer* 13 (1876):357–60, reprinted in Palmquist, *Camera Fiends and Kodak Girls,* pp. 40, 43.

88 "Photography from a Woman's Standpoint," *Anthony's Photographic Bulletin* 21, no. 2 (Jan. 25, 1890):39–42, reprinted in Palmquist, *Camera Fiends and Kodak Girls,* pp. 62–64, 66–67.

89 "Women in Photography," *Wilson's Photographic Magazine* 47 (1910):364–65, reprinted in Palmquist, *Camera Fiends and Kodak Girls,* pp. 193–94.

90 See Nancy Chodorow, *The Reproduction of Mothering: Psychoanalysis and the Sociology of Gender* (Berkeley: University of California Press, 1978), p. 36. Radway points out that because increasing secularization of the culture at large made such communities difficult to sustain, women in later periods turned to the pleasures of discussing books with other women—not in actual groups functioning at local levels but as "a huge, ill-defined network composed of readers on the one hand and authors on the other." *Reading the Romance,* pp. 96–97.

91 "New Home of the Los Angeles Club," *Camera Craft* 1, no. 5 (Sept. 1900):238–39, reprinted in Palmquist, *Camera Fiends and Kodak Girls,* p. 110.

92 Bisland, "Women and Their Cameras," pp. 40–42.

93 Gover, *Positive Image,* p. 55; "Gossip," *The Photographic Art Journal* 61 (January 1851), cited in ibid., p. 73; Clarisse B. Moore, "Women Experts in Photography," *Cosmopolitan* 14, no. 5 (March 1893):580–90.

94 Cited in Dorothy Norman, *Alfred Stieglitz, An American Seer* (Millerton, N.Y.: Aperture, Random House, 1960), p. 43.

95 See Gover, *Positive Image,* pp. 77–79; Quitslund, *Frances Benjamin Johnston;* Naef, *Collection of Alfred Stieglitz.* Citing women for their "taste," "careful work," and "endless patience," Clarence Bloomfield found that "fewer women than men produce good work in photography" because of their "lack of concentration and sustained effort." "Women Experts in Photography," *Cosmopolitan* 14, no. 5 (March 1893):581.

96 Mary Kennedy McCabe, *Clara Sipprell, Pictorial Photographer,* exhibit catalog (Fort Worth, Texas: Amon Carter Museum, 1990), p. 31; Ira Martin, "Women in Photography," *Pictorial Photographers of America* 5 (1929):n.p., Clarence White Archives, Princeton University. Gover notes that most clubs automatically appropriated separate spaces for the meetings, exhibits, and classes of their women members, and that contests for women amateurs encouraged the trend toward a separate sphere for women. In the 1880s and 1890s, the *Herald Tribune* and the *Ladies' Home Journal* offered special contests for women photographers. *Positive Image,* p. 81.

97 Paul Hill and Thomas Cooper, *Dialogue with Photography* (New York: Farrar, Straus & Giroux, 1979), p. 285. Gilpin had invited Stieglitz to her first exhibit in New York (which he did not attend). "I dislike *Exhibitions* intensely," he responded to a note she sent him. "'Exhibitions' have been so cheapened. There is a lack of standards everywhere. Few *know* what standards are." Stieglitz to Gilpin, January 22, 1924, cited in Martha A. Sandweiss, *Laura Gilpin: An Enduring Grace,* exhibit catalog (Fort Worth, Texas: Amon Carter Museum, 1986), p. 40.

98 Michaels, *Gertrude Käsebier,* p. 120; Stieglitz to Johnston, August 6, 1900, Johnston Papers, Library of Congress; Sadakichi Hartmann, "A Purist," *The Photographic Times,* 31 (Oct. 1899):449–55, reprinted in Palmquist, *Camera Fiends and Kodak Girls,* pp.

99–100; Stieglitz to Heinrich Kühn, Oct. 14, 1912, Stieglitz Archives, Beinecke Library, Yale University.

99 Bonnie Yochelson, "Clarence H. White Reconsidered: An Alternative to the Modernist Aesthetic of Straight Photography," *Studies in Visual Communication* 9, no. 4 (fall 1983):29.

100 Yochelson, "White Reconsidered," pp. 26–29; Sandweiss, *Laura Gilpin*, p. 27. The brochure of the White School reprinted these lines from Dow: "The painter need not always paint with brushes—he can paint with light itself. Modern photography has brought light under control and made it as truly art material as pigment or clay. The photographer has demonstrated that his work need not be mechanical imitation. He can control the quality of his lines, the massing of his tones and the harmony of his gradations. He can eliminate detail, keeping only the significant. More than this, he can reveal the secrets of personality. What is this but Art?" Clarence H. White School of Photography brochure, n.d., n.p., cited in ibid.

101 Max Weber, cited in Sandweiss, *Laura Gilpin*, p. 27, and Michaels, *Gertrude Käsebier*, p. 18. Weber's *Essays on Art* is a compendium of lectures he delivered at the White School in 1914. Perhaps the single most important tenet students learned was to consider the photograph as a "space-filled" or "constructed" image rather than an idealized depiction. "Photography is a flat space art, as is drawing, painting or printing. The page or the canvas is empty, but pregnant with birth as is space, waiting for the touch of the inspired mind," he wrote in a 1916 issue of *Platinum Print*. "To my mind," he said later, his teaching at the White School "was the first geometric and authentic approach to the basic *construction* of photography as art." Max Weber, "The Filling of Space," *Platinum Print* 1 (Dec. 1913):6, cited in McCabe, *Clara Sipprell*, pp. 28–29; John Pultz and Catherine B. Scallen, *Cubism and American Photography, 1910–1930,* exhibit catalog (Williamstown, Mass.: Sterling and Francine Clark Art Institute, 1981), p. 42. See also Lucinda Barnes, ed., with Constance W. Glenn and Jane K. Bledsoe, *A Collective Vision: Clarence H. White and His Students,* exhibit catalog (Long Beach, Calif.: University Art Museum, California State University, Long Beach, 1985).

102 "Photography in the home, or home portraiture," White wrote, addressing himself to women, "has had a great deal to do in relegating the Reynolds and Rembrandt backgrounds and the imitation garden balustrades in the studio to the ash can. Women are particularly qualified for this branch of work, in that they can the more easily become a part of the family." But photography is not limited to portraiture, connected as it is with the medical profession, astronomy, the legal field, and "the political, social, and moral welfare of the world through the motion picture." Photography "is a power in advertising and selling; some business institutions depend upon it," as do house and garden magazines. Women, he insisted, who were the pioneers in architectural photography, do good and useful work in all of these fields, suggesting that women photographers can find employment in museums and libraries, with newspapers and magazines, as teachers of photography, and as retouchers, spotters, mounters, developers, and printers. "Photography as a Profession for Women,"

News-Bulletin of the Bureau of Vocational Information 2, no. 7 (April 1, 1924):49–55, Clarence White Archives, Princeton University.

103 McCabe, *Clara Sipprell*, p. 31. Peter Bunnell, *Clarence H. White: The Reverence for Beauty*, exhibit catalog (Athens, Ohio: Ohio University Gallery of Fine Art, 1986), pp. 6, 7, 17. Bunnell argues that the narrative of village life that White created in Ohio became his "private epic" when he moved to New York (p. 17).

104 Yochelson, "White Reconsidered," 40. The association of the White School both with eclecticism in photography and with women's work continued well into the thirties. "Photography today is not only a fine art, but a practical art as well, and an indispensable aid to science and industry," Mrs. Clarence H. White II wrote in 1937. "The layman, wholly unacquainted with the physical exertion, the great skill, and the infinite patience required, is prone to view photography as a clean, light, easy vocation for women. Is the modern woman seeking light, easy work? Then she had best not go in for photography. Those who have made names for themselves know the stress of long, uncertain hours, hurried effort, and mental and physical weariness. One needs plenty of plain 'doggedness.' Women have this quality, as census statistics amply prove." "Camera's Eye," *Independent Woman* 16, no. 2 (Feb. 1937):46.

105 "Some Indian Portraits," *Everybody's Magazine* 4 (Jan. 1901):4, cited in Michaels, *Gertrude Käsebier*, p. 30.

106 Lange-Riess interview, p. 44.

107 Alfred Stieglitz, "Four Happenings," *Twice-a-Year* 8–9 (1942):129. "Always, I decided to photograph what was within me," Stieglitz would say later. "Shapes in relationships" became the core of his late work—his "Equivalents." His photographs of trees and clouds, of faces and interiors, were not representations of special subject matter, but rather of *seeing* in and of itself, or the pictorial equivalent of the emotion produced in the one who sees and photographs. Even his photographs of Georgia O'Keeffe—lover, artistic collaborator—are "equivalents." The camera's eye lingers upon her body at such close range that *we* are prevented from seeing her whole: we are presented with a body truncated, divided into abstract shapes; part of a head; a fascination with hands, the artistic leitmotif; angular planes and rounded surfaces; the play of light, soft or sharp, against darkness. The intimate and reciprocal details of sensuous and sensual experience are translated into an artistic expression of the photographer's private perception and desire.

108 "Alfred Stieglitz and His Latest Work," *Photographic Times* 28 (April 1896):161, cited in Trachtenberg, *Reading American Photographs*, p. 184; extract cited in Dorothy Norman, *Alfred Stieglitz: An American Seer* (New York: Random House, 1960), p. 39, emphasis added.

109 Baym, "Melodramas of Beset Manhood." The term "romantic racialism" comes from George M. Frederickson, *The Black Image in the White Mind: The Debate on Afro-American Character and Destiny, 1817–1914* (New York: Harper and Row, 1971). See Eric Lott's exploration of "the widespread and arguably radical attraction of an African American people's culture even as it postulated innate differences between the 'Anglo-Saxon' and 'African' races" in *Love and Theft: Blackface, Minstrelsy and the American Working Class* (New York: Oxford University Press, 1993), p. 32. Lott finds

that blacks, like women, were considered creatures of feeling in an increasingly aggressive Anglo-Saxon culture, "not only exemplars of virtue but natural Christians" (ibid). The use of sentimental conventions to represent otherness in photography is the subject of Laura Wexler's forthcoming book, *Black and White and Color.*

110 Edgerton, "Photography as an Emotional Art," p. 90.

111 "Iron Tail," *Indian Helper* (August 13, 1897), cited in Michaels, *Gertrude Käsebier,* p. 33; "Some Indian Portraits," *Everybody's Magazine* 4 (Jan. 1901):3–4, cited in ibid., pp. 30–32. Michaels points out that this second portrait resembles the image on the Buffalo nickel.

112 Walter Chambers, "Called Greatest Woman Photographer, Gertrude Käsebier Is Now a Cripple," New York *Telegram* (Jan. 25, 1930), cited in Michaels, ibid., p. 30.

113 Zitkala-Ša's double identity is underlined by Michaels' suggestion, on the one hand, that without knowing anything about Zitkala-Ša, one might mistake her in the latter pictures for one of Clarence White's white-gowned ladies, and, on the other, that Zitkala-Ša's gesture in one of the "Indian" pictures, holding her hand to her brow as if shading her eyes, is an expression of yearning for the West with which Käsebier sympathized (*Gertrude Käsebier,* p. 43). Käsebier, of course, directed the gestures in both *tableaux.*

114 Gertrude Simmons's article in the *Atlantic Monthly* (Feb. 1900):191, cited in Mary E. Young's entry on Gertrude Simmons Bonnin in *Notable American Women, 1607–1950,* vol. 1 (Cambridge, Mass.: Harvard University Press, 1971), pp. 199–200, from which material on Bonnin is drawn.

115 Mina Turner would recall how "Granny loved the Indians. She felt they were the only truly honest people she knew." Another grandchild, Charles O'Malley, would remember his "consternation and fright" when as a six-year-old he first saw Indians in full regalia outside the extended family home in Long Island. It bothered their grandmother "not at all that the neighbors stared from their windows and shook their heads over that crazy Käsebier woman" bringing home a band of colorfully costumed Indians; visitors to the Women's Exchange were no less startled to see Sioux in their moccasins wandering the halls as they waited for the photographer to arrive at her studio. A special favorite was Sammy Lone Bear, who corresponded with Käsebier for some years and who on one occasion, after a Buffalo Bill performance in about 1911, was entrusted with the young Mina, who remembers being "lifted up on the horse and with his great strong arm squashing my middle," as they rode around the deserted ring. "I was too terrified and surprised to cry out, but I caught reassuring glimpses of Granny waving and smiling as I whizzed by." Cited in Michaels, *Gertrude Käsebier,* pp. 29–30, 36.

116 Ibid., p. 34; Johanna Cohan Scherer, "You Can't Believe Your Eyes," *Studies in the Anthropology of Visual Communication* 2 (fall 1975):77.

III "ALWAYS THE NAVAHO TOOK THE PICTURE"

1 Walter Benjamin, "The Storyteller," in *Illuminations,* trans. Harry Zorn (New York: Schocken, 1969), pp. 83-85.

2 Letter from Gertrude Käsebier to Laura Gilpin, June 14, 1919, Laura Gilpin Archives, Amon Carter Museum, Fort Worth, Texas. Cited in Martha A. Sandweiss, *Laura Gilpin: An Enduring Grace* (Fort Worth, Texas: Amon Carter Museum, 1986), p. 42.

3 Laura Gilpin, interview by Mitchell A. Wilder, May 11, 1978, p. 35, Laura Gilpin Archives, Amon Carter Museum. Cited in Sandweiss, *Laura Gilpin*, p. 32.

4 Laura Gilpin, *The Enduring Navaho* (Austin: University of Texas Press, 1968), p. 24; subsequent references are cited parenthetically in the text. Käsebier had enrolled at the Pratt Institute in 1895, just when instructors Arthur W. Dow and Ernest F. Fenollosa were bringing in fresh ideas about oriental art and the principles of composition. Barbara L. Michaels, *Gertrude Käsebier: The Photographer and Her Photographs* (New York: Abrams, 1992), p. 18. In an earlier one-woman exhibit of sixty-one landscapes at Broadmoor Art Academy (Colorado Springs), the Museum of New Mexico, and the Denver Public Library, Denver Art Museum Director George William Eggers had praised Gilpin's photographs as "distinguished for their beauty of design and composition" and pointed out her debt to her mentors: "Her message is decidedly her own, but its clarity of expression is enhanced by that intelligence in light and dark arrangement, and that control of line and form, which comes from an appreciative study of oriental art, particularly from the Japanese as revealed to us first by Fenollosa and Dow and subsequently developed by Gertrude Käsebier, Alice Boughton and Clarence H. White in the field of photography." George William Eggers, "The Art of Laura Gilpin," *Allied Arts* 2 (Dec. 1921):xvii, cited in Sandweiss, *Laura Gilpin*, p. 36. But Gilpin had been introduced to oriental art before she came to New York—at expositions in California and through books. A friend had "two big books of Japanese reproductions of Chinese paintings," she would recall. "I used to go over there and pore over those things. The oriental has affected me all of my life." Laura Gilpin, interview by Margaret Schoonover, tape 3, n.d., 1979, Laura Gilpin Archives, Amon Carter Museum. Cited in Sandweiss, *Laura Gilpin*, p. 23.

5 G. Herbert Taylor, ed., *My Best Photograph and Why* (New York: Dodge, 1937), p. 34, cited in Sandweiss, *Laura Gilpin*, p. 55.

6 Laura Gilpin, interview by Margaretta Mitchell, Santa Fe, n.d., 1977, p. 3, Laura Gilpin Archives, Amon Carter Museum. Cited in Sandweiss, *Laura Gilpin*, p. 34.

7 Laura Gilpin, interview by Arthur Ollman and Rosella Stern, March 1976, Laura Gilpin Archives, Amon Carter Museum. Cited in Sandweiss, *Laura Gilpin*, p. 32.

8 Gilpin's brother Francis, like their father, was eternally optimistic about the possibility of making a quick fortune in oil and gas but perpetually impatient and unlucky. Sandweiss, *Laura Gilpin*, pp. 14, 34–35.

9 Paula Richardson Fleming and Judith Lynn Luskey, *Grand Endeavors of American Indian Photography* (Washington, D.C.: Smithsonian Institution Press, 1993), pp. 80–82, 13. Fleming and Luskey also discuss the earlier World's Fair at the Crystal Palace in London in 1851, where the ethnographic model from America displayed an Indian scalping a white man and two living Iowa Indians to represent peaceful tribes, as well as the collection of Prince Roland Bonaparte, printed as *Peaux Rouges* and presented to the Anthropological Society of Washington, later part of the ethnographical photographic collections at the Smithsonian Institution (pp. 78–79).

10 Sandweiss, *Laura Gilpin,* p. 16. See Fleming and Luskey, *Grand Endeavors,* pp. 85–86, 90–97.

11 Sandweiss, *Laura Gilpin,* p. 20; Fleming and Luskey, *Grand Endeavors,* p. 106. Noting Tom Outland's inability to convey in photographs the "beauty and vastness" of what he had found ("We had only a small Kodak, and these pictures didn't make much show,—looked, indeed, like grubby little 'dobe ruins such as one can find almost anywhere"), Gilpin thought about the possibility of doing an illustrated edition of *The Professor's House.* She approached Cather through Alice Boughton, a photographer who had worked with Käsebier, but Cather never replied, probably because of her similar disinterest in filming any of her work. Sandweiss, *Laura Gilpin,* pp. 44, 324 n. 54; Willa Cather, *The Professor's House* (New York: Knopf, 1925), p. 226. See Judith Fryer, *Felicitous Space: The Imaginative Structures of Edith Wharton and Willa Cather* (Chapel Hill: University of North Carolina Press, 1986), pp. 301–10.

12 The grandest expeditions were those sponsored by Rodman Wanamaker, heir to the Philadelphia department store dynasty, and railroad tycoon Edward Harriman. Wanamaker commissioned Joseph Cossuth Dixon, doctor of law and skilled photographer, to lead The Expeditions of Citizenship to the North American Indian, from 1908 to 1913, the purpose of which was not discovery and scientific study, as had earlier been the case, but to save the Indians from cultural extinction by publicizing their history and to give impetus to a national campaign to make them citizens. The first expedition, in 1908, included shooting a movie version of Longfellow's *Hiawatha* on the Crow Reservation in the Valley of Little Bighorn, Montana. The following year the expedition, endorsed by President William Howard Taft, returned to the valley to record the final meeting of surviving chiefs from the western reservations in the last great Indian Council (Dixon would record and publish their stories, along with his photographs of them, in his book, *The Vanishing Race*) and to re-create the Battle of Little Bighorn in still photographs and film, with Custer's surviving Crow scouts and the opposing Cheyennes playing themselves. The purpose of the 1913 expedition, a 20,000-mile trip by private railroad car, which housed a darkroom, was to take the American flag to the existing 189 tribes, at each stop playing a speech by President Woodrow Wilson on Thomas Edison's new portable recording machine—a message that included the reassurance, "The Great White Father now calls you his Brother." It is these 1913 photographs that Gilpin would have seen at the San Francisco Panama-Pacific Exposition of 1915, where they were introduced by President Theodore Roosevelt and the subject of lectures by Dixon three times a day for over five months to over three million people. Harriman saw his expedition to Alaska (1899) as an opportunity to establish his name in social and business circles while surveying routes for a trans-Alaska railroad. Twenty-three leading authorities in various fields were invited along, including Dr. C. Hart Merriman, chief of the U.S. Biological Survey, Dr. George Bird Grinnell, naturalist and writer-editor on the Plains Indians for *Forest and Stream* magazine, Gifford Pinchot, conservationist and chief of the Division of Forestry, naturalist John Muir, landscape artist Robert Swain Gifford, and photographer Edward Sheriff Curtis. Fleming and Luskey, *Grand Endeavors,* pp. 103–107, 110–11. Curtis's later expeditions are discussed in the second section of this chapter. See also

Susan Applegate Krouse, "Photographing the Vanishing Race," *Visual Anthropology* 3, nos. 2–3 (1990):213–33.

13 In addition to the work of ethnologists Frances Densmore, Alice Cunningham Fletcher, and Matilda Coxe Stevenson, the Smithsonian's National Anthropological Archives include photographs of North American Indians by Susanne Anderson, Marjorie W. Cummins, Jennie Elrod, Mrs. J. R. Falconer, Helen Hamilton Gardner, Elizabeth Compton Hegemann, Grace Chandler Horn, Isabel Truesdell Kelly, Melissa Jones, Janie Ellis Mason, Hannah Maynard, Sally McLendon, Helen Peterson, Dorothy Skinner, Bertha Crum Sparks, and Helen Sparks. See Ute Gacs, Aisha Khan, Jerrie McIntyre, and Ruth Weinberg, eds., *Women Anthropologists: A Biographical Dictionary* (New York and Westport, Conn.: Greenwood Press, 1988); Edward T. James, Janet Wilson James, and Paul S. Boyer, eds., *Notable American Women: A Biographical Dictionary* (Cambridge, Mass: Harvard University Press, 1971), vol. 1, pp. 630–33, and vol. 3, pp. 373–76, for entries on Fletcher and Stevenson; Nancy Oestreich Lurie, "The Lady from Boston and the Omaha Indians" (on Alice Fletcher), *The American West* 3, no. 4 (1966):31–33, 80–84; Delores J. Morrow, "Female Photographers on the Frontier: Montana's Lady Photographic Artists, 1866–1900," *Montana: The Magazine of Western History* 31, no. 3 (summer 1982):76–85; Peter Palmquist, compiler, *Bibliography of Writings by and about Women in Photography* (Arcata, Calif.: Palmquist, 1990; Alan Thomas, "Photography of the Indians: Concept and Practice on the Northwest Coast" (on Hannah Maynard), *BC Studies* 52 (1982):61–85; Claire Weissman Wilks, *The Magic Box: The Eccentric Genius of Hannah Maynard* (Toronto: Exile Editions, 1980). Other than Gilpin, Kate Thompson Cory is the best known woman photographer of American Indians, thanks to a recent book by Marnie Gaede, *The Hopi Photographs: Kate Cory, 1905–1912* (Albuquerque: University of New Mexico Press, 1986). Cory, a New York painter, heard about Hopi mesas from a friend and at age forty-four went to live with the people at Oraibi and Walpi for seven years, painting and photographing, developing her negatives with rainwater. Apparently, she was invited into the kivas, where not even Hopi women were allowed. No one knows why she left the mesas or how she supported herself when she settled in Prescott, Arizona, poor and eccentric, still visited by Hopi friends, where she lived until her death in 1958. Paula Fleming, photo archivist of the National Anthropological Archives Still Photograph Collection, is working on a bibliography of women photographers of North American Indians.

14 Mrs. E. H. Kemp, "Photographing in the Hopi Land," *Camera Craft* 11 (Dec. 1905):247–55; Mildred Ring, "Kodaking the Indians," *Camera Craft* 31, no. 2 (Feb. 1924):71–76, reprinted in Peter Palmquist, ed., *Camera Fiends and Kodak Girls: 50 Selections by and about Women in Photography, 1840–1930* (New York: Midmarch Arts Press, 1989), pp. 154, 229–30.

15 Cited in Sandweiss, *Laura Gilpin*, pp. 44–45.

16 Mildred Adams, "A Worker in Light," *Woman Citizen* 54 (March 1926):11, cited in Sandweiss, *Laura Gilpin*, p. 45.

17 See Fryer, *Felicitous Space*, especially chapter 10.

18 Laura Gilpin, *The Pueblos: A Camera Chronicle* (New York: Hastings House, 1941), p. 60, subsequent references are cited parenthetically in the text.

19 Karen Hust, "'the landscape (chosen by desire)': Laura Gilpin Renegotiates Mother Nature," *Genders* 6 (fall 1989):32, 34.

20 Sandweiss, *Laura Gilpin*, p. 68. Since Forster took up her position at Red Rock in 1931, Gilpin would have been visiting the reservation for a decade by the time *The Pueblos* was published. On the other hand, given the romantic attitudes of much FSA work toward the poor and racial stereotyping in the press and by the U.S. government of Japanese Americans after Pearl Harbor, it is not so surprising to find it here, too.

21 John Collier Sr. was head of the Bureau of Indian Affairs, which had jurisdiction over the Red Rock Reservation where Elizabeth Forster was nurse to the Navajo. On John Collier Jr.'s 1943 photo series in Trampas, New Mexico, see Carl Fleischhauer and Beverly W. Brannan, eds., *Documenting America: 1935–1943* (Berkeley: University of California Press, 1988), pp. 294–311.

22 Brenda Putnam noted in her journal that Kirk Munroe's juvenile fiction about the West "inspired [her] with a romantic love of the West that colors her whole life even now" (cited in Sandweiss, *Laura Gilpin*, pp. 44–45).

23 Clarence King, *Mountaineering in the Sierra Nevada* (Boston, 1872), cited in Alan Trachtenberg, *Reading American Photographs: Images as History, Mathew Brady to Walker Evans* (New York: Hill & Wang, 1989), p. 126.

24 According to his biographer Thurman Wilkins, King arranged a double life in New York City after his marriage in 1888: he kept rooms at the Brunswick at Fifth Avenue and 26th Street and settled Ada Todd across the bridge in Brooklyn, visiting her at night and letting it be known that he was "James Todd," a porter. Thurman Wilkins, with the help of Caroline Lawson Hinkley, *Clarence King: A Biography,* rev. ed. (Albuquerque: University of New Mexico Press, 1988), p. 363.

25 Wilkins, *Clarence King,* pp. 361, 354; Samuel Franklin Emmons to George F. Becker, Feb. 27, 1881, Becker papers, and Henry Adams, in James D. Hague et al., eds., *Clarence King Memoirs* (New York: Putnam, 1904), both cited in Wilkins, p. 359. Wilkins suggests that King's aversion to white women ("To kiss a woman—white, of course—and feel teeth through her thin lips paralyzes me for a week") and his unabashed paganism ("Paradise, for me, is still a garden with a primeval woman") was similar to Adams's own passion for the archaic female, which he would sublimate in his veneration for the Virgin of Chartres, and to that of sculptor William Wetmore Story, who embodied his ideal of womanhood in the Libyan Sibyl, "large-bosomed, luxuriant, frankly African." Both King and Adams found in "types more robust" the primitive force of the Magna Dea; as Adams would note: "It was not the modern woman that interested him; it was the archaic female, with instincts and without intellect . . . rich in the inheritance of every animated energy back to the polyps and crystals." King was frank with his friends about acknowledging the pleasure "pagan" women gave him, quipping, "We press the button and they do the rest." King to Adams, Sept. 17, 1888; King to John Hay, July 28, 1887; Henry Adams, *The Education of Henry Adams* (Boston: Houghton Mifflin, 1918); *Clarence King Memoirs;* Ernest

Samuels, *Henry Adams: The Major Phase* (Cambridge, Mass.: Harvard University Press, 1964), all cited in Wilkins, pp. 360–61.

26 Wilkins, *Clarence King*, p. 359; King, *Mountaineering*, cited in Trachtenberg, p. 126. King also had a relationship with a native woman in California in 1887. He had just returned from Mexico, had been reading Helen Hunt Jackson's *Ramona*, and was planning his own novel, "Santa Rita." At Camulos he met an Indian woman named Luciana, whom he described as "as near Eve as can be" and planned to use as a literary model. "I escaped from her by a miracle of self-control," he wrote to John Hay. "I rode with [her] alone in the mountains among the straying cattle. The world was all flowers, and Luciana's face was the most tender and grave image of Indian womanhood within human conception. I had an almost overpowering attack of—, well, *Locksley Hall*." Stopping at a mountain spring, amid live oaks dewy with fog and blazing orange poppies, he confessed, "I came as near it as I ever shall." King to John Hay, July 18, 1887, cited in Wilkins, ibid., p. 354.

27 Tzvetan Todorov, *The Conquest of America*, trans. Richard Howard (New York: Harper & Row, 1984), p. 3, emphasis original.

28 Wlad Godzich, "The Further Possibility of Knowledge," foreword to Michel de Certeau, *Heterologies: Discourses on the Other*, trans. Brian Massumi (Minneapolis: University of Minnesota Press, 1986), p. xvi, emphasis added. The term *heterologies*—the concurrence of multiple voices—refers to Mikhail Bakhtin's *The Dialogical Imagination*.

29 Clifford Geertz, *Local Knowledge*, cited in Godzich, "Further Possibility," p. xiv. On the problem of representation and the crisis it has precipitated in the field of cultural anthropology in recent years, see James Clifford and George E. Marcus, eds., *Writing Culture: The Poetics and Politics of Ethnography* (Berkeley and Los Angeles: University of California Press, 1986), and Clifford, *The Predicament of Culture: Twentieth-Century Ethnography, Literature, and Art* (Cambridge, Mass.: Harvard University Press, 1988). On seeing oneself as a case among cases, see Ruth Frankenberg, *White Women, Race Matters: The Social Construction of Whiteness* (Minneapolis: University of Minnesota Press, 1993).

30 See Carol Shloss, *In Visible Light: Photography and the American Writer, 1840–1940* (New York: Oxford University Press, 1987), especially the introduction; Trachtenberg, *Reading American Photographs*, for his discussion of the "sociality" of Lewis Hine's work; John Berger and Jean Mohr, *Another Way of Telling* (New York: Pantheon, 1982).

31 Roland Barthes argues that the photograph is a message without a code: that is, there is no signifier, no supplementary message in addition to its content—what we call the style of a painting, for example—no "treatment" of the image that refers to a certain "culture" of the society receiving the message. In other words, a photograph is "indexical": it refers to something in the real world. "The Photographic Message," in *Image, Music, Text*, trans. Stephen Heath (New York: Hill & Wang, 1977), pp. 15–31; see also *Camera Lucida: Reflections on Photography*, trans. Richard Howard (New York: Hill & Wang, 1981).

32 Sigmund Freud, "Frau Emmy von N.," in Josef Breuer and Sigmund Freud, *Studies on*

Hysteria (1893–1895), trans. and ed. by James Strachey in collaboration with Anna Freud (New York: Basic Books, 1937), pp. 53–54.

33 Vine Deloria Jr., *Custer Died for Your Sins* (London and New York: Macmillan, 1969), p. 82.

34 William Welling, *Photography in America: The Formative Years, 1839–1900, A Documentary History* (New York: Crowell, 1978), pp. 7–15, cited in Trachtenberg, *Reading American Photographs*, pp. 53–56. Trachtenberg is helpful only in naming the problem. Faulting science — the Agassiz project — he turns to art for a way of reading these daguerreotypes, drawing upon Sheldon Nodelman's "How to Read a Roman Portrait." The *subjects* of Zealy's daguerreotypes could not be more different from the subjects of Roman portraits, but the *technique* of Roman portraits has something to do with the practice begun by Benjamin West in the eighteenth century of "Romanizing" noble savages, a practice carried on by pictorialist photographers who portrayed African Americans and American Indians as noble chieftains and by Curtis whose technique of "shooting from below" resulted in an ennobling of his subjects. Trachtenberg does not deal with the way in which such practices create distance; his reading of these daguerreotypes through the lens of Art is finally only a neat trick that circumvents the real problem at issue here: the false encounter.

35 M. Gidley, introduction to *The Vanishing Race: Selections from Edward S. Curtis'* The North American Indian (Seattle and Vancouver/Toronto: University of Washington Press, Douglas & McIntyre Ltd., 1976), pp. 10–11. Bill Holm and George Irving Quimby point out that the twentieth volume actually covered only a handful of tribes of western North America. *Edward Curtis in the Land of the War Canoes* (Seattle: University of Washington Press, 1980), p. 33.

36 There are over 350,000 images at the National Anthropological Archives, Smithsonian Institution, according to Paula Richardson Fleming, photographic archivist of the collection. Edmund Carpenter, *Oh, what a blow that phantom gave me!* (New York: Holt, Rinehart, & Winston, 1973), p. 92. Carpenter ascribes the interest in Curtis to the "soft, slack romanticism" of his photographs and to their ready availability that requires little research. Flaherty's photographs would have been made in the year of Curtis's film *In the Land of the Head-Hunters,* although Flaherty did not see this film until 1915. Holm and Quimby demonstrate that *Nanook of the North* (1922) was indebted to the earlier Curtis film (*Edward Curtis,* pp. 29–30).

37 T. C. McLuhan, "Curtis: His Life," in Edward S. Curtis, *Portraits from North American Indian Life,* with introduction by A. D. Coleman and T. C. McLuhan (New York: Promontory Press, 1972), p. viii.

38 McLuhan reports that in 1972 the price for a complete set was $80,000 (ibid., p. xii).

39 It was discontented youth in the 1960s who found in Curtis's Indians symbols of a more profound grasp of human experience: "The stolid Indians staring from Curtis's pictures expressing their disbelief in the universe in general immediately brought home to the malcontents the social and political disruptions of the last century, and symbolized for many the survival of human values in a universe gone mad with materialistic greed. Awakening pride in minority heritage — triggered initially by the movements toward power in ghettos, barrios, and reservations, and further emphasized by

linkage to the Vietnam War and the ecological pressures of an aroused citizenry—did much to bring Curtis to the fore as a pictorial spokesman for the real American experience." Vine Deloria Jr., introduction to Christopher Lyman, *The Vanishing Race and Other Illusions: Photographs of Indians by Edward Curtis* (Washington, D.C.: Smithsonian Institution Press, 1982), p. 12.

40 Rayna Green, "Rosebuds of the Plateau: Frank Matsura and the Fainting Couch Aesthetic," in Lucy Lippard, ed., *Partial Recall: Photographs of Native North Americans* (New York: The New Press, 1992), p. 47.

41 Arnold Genthe, "A Critical Review of the Salon Pictures with a Few Words upon the Tendency of the Photographers," *Camera Craft* 2, no. 4 (Feb. 1901):310, cited in Lyman, *Vanishing Race*, p. 53.

42 Margaret Blackman, "Posing the American Indian: Early Photographers Often Clothed Reality in Their Own Stereotypes," *Natural History* 89, no. 10 (1980):70.

43 Edward S. Curtis, *The North American Indian*, 20 vols. and 20 portfolios (Cambridge, Mass.: The [Harvard] University Press, vols. and portfolios 1–5, and Norwood, Conn.: Plimpton Press, vols. and portfolios 6–20, 1907–1930): portfolio 1, plate 1.

44 Quoted in Thomas F. Gossett, *Race: The History of an Idea in America* (New York: Schocken, 1965), p. 238, cited in Lyman, *Vanishing Race*, p. 59.

45 Lyman, *Vanishing Race*, p. 48. Lyman traces European ideas about the barbarity and savagery of nonwhites to Darwin's *The Descent of Man*, where we read, for example, "The astonishment which I felt on first seeing a party of Fuegians on a wild and broken shore will never be forgotten . . . , for the reflection at once rushed into my mind— such were our ancestors . . . [and that] I would as soon be descended from that heroic little monkey who braved his dreaded enemy in order to save the life of his keeper . . . as from a savage who delights to torture his enemies, offers up bloody sacrifices, practices infanticide without remorse, treats his wives like slaves, knows no decency, and is haunted by the grossest superstitions" (cited in Lyman, ibid., p. 49).

46 Lyman points to the circular logic in *The First Annual Report of the Bureau of American Ethnology*, in which John Wesley Powell, among the most enlightened white observers of American Indians, cites C. C. Royce's "Investigations Relating to the Cessions of Lands by Indian Tribes to the United States": "The great boon to the savage tribes of this country . . . has been the presence of civilization, which, under the laws of acculturation, has irresistibly [*sic*] improved their culture by substituting new and civilized for old and savage acts, new for old customs—in short, transforming savage into civilized life. The great body of the Indians of North America have passed through stages of culture in the last hundred years achieved by our Anglo-Saxon ancestors only by the slow course of events through a thousand years" (p. 49). Compare this to the review of Curtis's work in the *Seattle Times*, 1903: "According to Mr. Curtis' own statement he was led into his present habit of flattening the Indian up against a negative through the desire to reach out after a picturesque subject. . . . He took the present lowness of today and enshrined it in the romance of the past. . . . He has picked up a bundle of broken straws and erected a palace of accuracy and fact" (cited in Lyman, *Vanishing Race*, p. 53).

47 Cited in Lyman, *Vanishing Race*, p. 63. Roosevelt's praise was especially for Curtis's

powers of *observation* of a race so other that any encounter is impossible: "[he] has caught glimpses . . . into that strange spiritual and mental life of theirs, from whose innermost recesses all white men are forever barred." Cited in Holm and Quimby, *Edward Curtis,* p. 13.

48 According to a newspaper article based on an interview with Curtis, the Yebechai dancers were nervous about being photographed, and therefore insisted that the photographer make their costumes himself so that the clothing would not have a religious significance. See Lyman, *Vanishing Race,* pp. 68–76.

49 For example, newspaper accounts in Reading, Pennsylvania, reported in 1912 that nearly one thousand people were held spellbound listening to the prelude by the orchestra, "The Spirit of the Indian Life," "a characteristic outburst of strangely harmonious sound, vibrant with the unbridled primitive impulses. . . . The pictures themselves, both the stereopticon and the cinematographic were superb masterpieces of the photographer's art, . . . true to nature, showing the scenes . . . that defy description." Cited in Holm and Quimby, *Edward Curtis,* p. 27.

50 Best known for the help he gave Franz Boas, supplying the anthropologist with most of his material on Kwakiutl ethnography, folklore, and linguistics, Hunt is central to Kwakiutl studies. In addition to working for Curtis and Boas, he was also interpreter, informant, and collaborator of Adrian Jacobsen and Samuel Barrett. Snapshots taken by Curtis's assistant Edmund Schwinke show Hunt's involvement with *In The Land of the Head-Hunters,* directing the cast while Curtis films with motion picture camera. Holm and Quimby, *Edward Curtis,* pp. 29, 57, 61.

51 The story includes star-crossed lovers who fall prey to the machinations of an evil sorcerer and the first of what would become a classic escape scene in Western films: shooting the rapids by canoe. Yet Holm and Quimby call the film "solid ethnography," pointing to its fidelity to detail, especially in its re-creation of the potlatch ceremony "which stands comparison with the best modern analyses" (*Edward Curtis,* p. 36).

52 From *The North American Indian,* cited in Lyman, *Vanishing Race,* p. 84, and Gidley, *Selections,* p. 12. See reviews of Lyman's *The Vanishing Race and Other Illusions* by Joanna Cohan Scherer, *Studies in Visual Communication* 11, no. 3 (summer 1985):78–85, and by Bill Holm, *American Indian Art Magazine* 8, no. 3 (summer 1983):68–73.

53 Robert M. Berkhofer, *The White Man's Indian: Images of the American Indian from Columbus to the Present* (New York: Knopf, 1978), p. 55.

54 Curtis M. Hinsley, "The World as Marketplace: Commodification of the Exotic at the World's Columbian Exposition, Chicago, 1893," in Ivan Karp and Stuart Lavine, eds., *Exhibiting Cultures: The Poetics and Politics of Museum Display* (Washington, D.C.: Smithsonian Institution Press), p. 350.

55 Frederick Ward Putnam Papers, Pusey Library, Harvard University, cited in Hinsley, "The World as Marketplace," p. 347, emphasis added. Not only American Indians were the subject of ethnographical exhibits at the World's Columbian Exposition. The cover of *Portrait Types of the Midway Plaisance* (introduction, F. W. Putnam [St. Louis: N. D. Thompson, 1894]) suggests the variety of ethnic "types" to be seen there: Eskimos, Arabs, Jews, Chinese, Laplanders, peasants from a variety of cultures, in addition to American Indians of various tribes. The Midway Plaisance was a section of the

exposition devoted to exotica and carnival-type activities and was set apart from the Court of Honor, the pavilion celebrating the achievements in art, science, and technology of Western civilization.

56 Mick Gidley, *With One Sky above Us: Life on an Indian Reservation at the Turn of the Century* (New York: Putnam, 1979), pp. 42–52. Information on Latham's work is drawn from Gidley.

57 Ibid., pp. 63–94, 95–97, 122.

58 Ibid., pp. 131–40.

59 Ibid., p. 150, emphasis original.

60 Donna Haraway, "Situated Knowledges: The Science Question in Feminism and the Privilege of Partial Perspective," in *Simians, Cyborgs, and Women: The Reinvention of Nature* (New York: Routledge, 1991), pp. 194–95.

61 Jewett had written in 1908 to urge Cather to give up her magazine work in order to "keep and guard and mature your force, and above all, have time and quiet to perfect your work." Annie Fields, *Letters of Sarah Orne Jewett* (Boston: Houghton-Mifflin, 1911), pp. 247–48. Letters from Gertrude Käsebier to Laura Gilpin, Oct. 28, 1924; Sept. 1, 1923; Jan. 16, 1923; and July 7, 1926; Laura Gilpin Archives, Amon Carter Museum. Cited in Sandweiss, *Laura Gilpin*, p. 42.

62 Letters from Käsebier to Gilpin, Aug. 26, 1921; Aug. 3, 1925; and Feb. 27, 1925; Laura Gilpin Archives, Amon Carter Museum. Cited in Sandweiss, *Laura Gilpin*, p. 42.

63 As Virginia Woolf in *A Room of One's Own* and Tillie Olsen in *Silences* have shown, the way in which masculine projects are generally supported has a great deal to do with an artist's sense of the importance of his work and his own sense of purpose.

64 Gilpin hired a literary agent in 1955 to find a home for her "problem child," her Navajo book, but the agent withdrew from the attempt in 1956. Sandweiss, *Laura Gilpin*, p. 93.

65 Sandweiss, *Laura Gilpin*, pp. 94–98; letter from Ned Hatathli to Gilpin, Nov. 20, 1968, Laura Gilpin Archives, Amon Carter Museum. Cited in ibid., p. 104.

66 Forster wrote to her employers: "Sometimes I am invited to practice medicine with the medicine man, sometimes am asked to wait the conclusion of the sing so as to be on hand to take the patient to the hospital. I am surprised and gratified to find my medicine men friendly and often cooperative. One of them tells me with a serious twinkle that he is glad to have me attend his sings and see good medicine practiced." Cited in Sandweiss, *Laura Gilpin*, p. 53.

67 Lucy Lippard points out that in 1984, Lillie Benally, who posed for Gilpin's *Navaho Madonna* in 1932, sued the Amon Carter Museum for use of the image in museum publicity, arguing that she had agreed to having the photograph taken, but not to its publication. Introduction to Lippard, ed., *Partial Recall*, p. 31.

68 Interview with John Burris, Nov. 1977, p. 11, Laura Gilpin Archives, Amon Carter Museum. Cited in Sandweiss, *Laura Gilpin*, p. 54. On Indian photographic observation, see the essays in Lippard, ed., *Partial Recall*.

69 Laura Gilpin to Charles Pearce, Oct. 14, 1951; Laura Gilpin to Darlene Bekkedal, April 16, 1954, Laura Gilpin Archives, Amon Carter Museum. Cited in Sandweiss, *Laura Gilpin*, pp. 88–89.

70 Ibid., p. 103; see other journal entries cited on p. 102. Compare Dorothea Leighton and Clyde Kluckhohn's similar description: "the Navaho, though decidedly an individualist in some ways, is essentially group-minded. . . . To accept authority over his fellows or take initiative in any obvious fashion has for the Navaho the psychological meaning of separating him from the social group to which he looks for both support and regulation." *Children of the People: The Navaho Individual and his Development* (Cambridge, Mass: Harvard University Press, 1947), p. 107, cited in Sandweiss, *Laura Gilpin*, p. 332, n. 15.

71 Haraway, "Situated Knowledges," pp. 188–90. Although she is, like Michel Foucault, concerned with questions of power, Haraway parts company with Foucault in insisting on *embodied* vision, on *situated* knowledge—that is, in arguing "for a doctrine and practice of objectivity that privileges contestation, deconstruction, passionate construction, webbed connections." "Vision is *always* a question of the power to see—and perhaps of the violence implicit in our visualizing practices," she writes.

> Self-identity is a bad visual system. Fusion is a bad strategy of positioning. The boys in the human sciences have called this doubt about self-presence the "death of the subject," that single ordering point of will and consciousness. That judgment seems bizarre to me. I prefer to call this generative doubt the opening of non-isomorphic subjects, agents, and territories of stories unimaginable from the vantage point of the cyclopian, self-satiated eye of the master subject. The Western eye has fundamentally been a wandering eye, a travelling lens. These peregrinations have often been violent and insistent on mirrors for a conquering self—but not always. . . . The split and contradictory self is the one who can interrogate positionings and be accountable, the one who can construct and join rational conversations and fantastic imaginings that change history. . . . "Splitting" in this context should be about heterogeneous multiplicities that are simultaneously necessary and incapable of being squashed into isomorphic slots or cumulative lists. . . . The topography of subjectivity is multidimensional; so, therefore, is vision. The knowing self is partial in all its guises, never finished, whole, simply there and original; it is always constructed and stitched together imperfectly, and *therefore* able to join with another, to see together without claiming to be another. Here is the promise of objectivity: a scientific knower seeks the subject position not of identity, but of objectivity; that is partial connection. (Ibid., pp. 191–93)

72 John Collier Jr. recognized the source of the book's emotional power when he observed, "A photographer as a visual anthropologist is a fieldworker who OBSERVES METHODOLOGICALLY. He can have a closed heart and still accomplish RESEARCH. Such a specialist could NEVER have produced *The Enduring Navaho*, for this is a work of LOVE not ANALYSIS." Letter to Martha Sandweiss, June 23, 1982, Laura Gilpin Archives, Amon Carter Museum. Cited in Sandweiss, *Laura Gilpin*, p. 102.

73 Letter from Laura Gilpin to Margaret and Nathaniel Owings, June 25, 1959, Laura Gilpin Archives, Amon Carter Museum. Cited in Sandweiss, *Laura Gilpin*, p. 94.

74 Cited in Lucy Lippard, "American Landscapes," in *Markings: Aerial Views of Sacred Landscapes* (New York: Aperture, 1986), p. 56. Bridges's remarks are similar to com-

ments by other "primitivizing" artists, all of whom have read and often cite Gaston Bachelard, *The Poetics of Space,* and George Kubler, *The Shape of Time.* Linda Connor writes, for example, "That small canyon [near Prescott, Arizona] gave me a new understanding of place. It brought perceptions that I had often thought of as disparate into a new whole. The canyon surrounded me, while I felt it internally. My usual sensation of being separate within an environment dissolved. I felt both the presence of those who had made the marks and the independent vibrancy of the drawings. Their animated power joined me in open silence. Time seemed lost—not just my few hours of absorption, but human time, cultural time, geologic time. This place and its marks were not enclosed in a history; they resonated with eternity as alive as an echo." "Gestures of Faith," in *Marks in Place: Contemporary Responses to Rock Art,* photographs by Linda Connor, Rick Dingus, Steve Fitch, John Pfahl, Charles Roitz; essays by Polly Schaafsma and Keith Davis; foreword by Lucy Lippard (Albuquerque: University of New Mexico Press, 1988), p. 7.

75 Cited in Richard Ellman and Charles Feidelson Jr., eds., *The Modern Tradition: Backgrounds of Modern Literature* (New York: Oxford University Press, 1965), p. 25.

76 Lippard, "American Landscapes, p. 56. See Lippard's *Mixed Blessings: New Art in a Multicultural America* (New York: Pantheon, 1990). In her introduction to *Partial Recall,* Lippard rethinks our attraction to "primitive" scenes. The Indian past, she writes, "represents for some of us a national childhood, when we were always right because we outpowered everyone and the burden of our murderous mistakes had yet to weigh on our collective conscience. . . . Buried in the pride of past conquest, less accessible than guilt and shame, is a distorted memory of primeval contentment . . . [and] spiritual and ethical values that have . . . been neglected in our own culture. But there is another, deeper, desire involved. And that, I suspect is the desire to *be* 'the other,' a kind of cultural cannibalism that is still being played out in our popular culture" (p. 14).

77 See Mircea Eliade, *Shamanism: Archaic Techniques of Ecstasy,* trans. Willard R. Trask (Princeton, N.J.: Princeton University Press, 1964): "The mythology and rites of magical flight peculiar to shamans and sorcerers confirm and proclaim their transcendence in respect to the human condition." Cited in Peter T. Furst, "The Roots and Continuities of Shamanism," *arts-canada,* nos. 184–187 (Dec. 1973–Jan. 1974):45. See also Lippard, *Overlay,* pp. 47, 142–45; Andreas Lommel, *Shamanism: The Beginnings of Art* (New York: McGraw Hill, 1965); Joan Halifax, *Shamanic Voices: A Survey of Visionary Narratives* (New York: Dutton, 1979); Stephen Larsen, *The Shaman's Doorway: Opening the Mythic Imagination to Contemporary Consciousness* (New York: Harper and Row, 1976).

78 Trachtenberg, *Reading American Photographs,* p. 131.

79 Trachtenberg links mapping and naming in the earlier survey photographs as a single act of trespass that was, in the eyes of American Indians, not upon property, but upon religion, upon the sacred. See *Reading American Photographs,* p. 125. Joel Snyder, *American Frontiers: The Photographs of Timothy H. O'Sullivan, 1867–1874* (Millerton, N.Y.: Aperture, 1981), p. 7, cited in Trachtenberg, ibid., p. 130.

80 In addition to her photographs of American Indian sites, Bridges's work includes re-
 cording Nazca lines in Peru, Mayan sites in Yucatán and Chiapas, and marks of pre-
 Celtic peoples in Britain and Brittany. On nonvisual ways of knowing among ancient
 cultures, see Carolyn Merchant, *Ecological Revolutions: Nature, Gender, and Science in
 New England* (Chapel Hill: University of North Carolina Press, 1989).

81 Lippard, "American Landscapes," p. 58; Lippard, *Overlay,* p. 144. See also Michael
 Dames, *The Avebury Cycle* (London: Thames and Hudson, 1977). Lippard cites a re-
 cent story about the Aymara Indians at Lake Titicaca as evidence for the possibility
 that internalized knowledge affects actual physiological experience. A *National Geo-
 graphic* photographer in Peru knew the word *Titicaca* meant *puma* to the Aymaras and
 was connected to early religious cults. When he produced a NASA photo of the lake
 made from 170 miles above the earth, his boatman said immediately, "Look, the
 Puma!" and only then did the photographer see the outline of the lake as a leaping
 puma, with outstretched claws and open mouth, about to seize a fleeing rabbit. Luis
 Marden, "Titicaca, Abode of the Sun," *National Geographic* (Feb. 1971):294, cited in
 Lippard, *Overlay,* p. 145.

82 Trachtenberg notes that the Earth Resources Observation Systems Data Center (EROS)
 maintains an archive of millions of images, growing at the rate of twenty thousand per
 month, of nonmilitary satellite and aerial photographs for the use of geographers, city
 planners, and public interest groups. "The unerring mechanical eye replaces the an-
 cient god of love," Trachtenberg writes, "and photography, in the guise of a disembod-
 ied automatic eye, assumes the name of myth." *Reading American Photographs,* p. 20.

83 Cited in Lippard, "American Landscapes," p. 56.

84 Jaune Quick To See Smith, *Women of Sweetgrass, Cedar and Sage* (New York: Gallery of
 the American Indian Community House, 1985), cited in Lippard, "American Land-
 scapes," p. 58. For the work of other "primitivizing" artists, such as Linda Connor,
 Rick Dingus, Steve Fitch, see Lippard, *Overlay* and *Marks in Place.* In an essay in
 Marks in Place, Keith Davis suggests that "The attraction of these primal marks stems
 from a richly complex set of themes and ideas, including a nostalgia for collective
 systems and shared beliefs; a new interest in myth, ritual and magic; a critique of the
 dominant Judeo-Christian, Cartesian, and scientific world views; an aesthetic interest
 in 'art' by those outside the modernist, academic tradition, a fascination, stemming
 from linguistic theory, with signs and symbols; and our attitudes toward time and
 history" (p. 121).

85 Linda Connor, "Gestures," in *Marks in Place,* p. 9.

86 Bridges, cited in Lippard, "American Landscapes," pp. 56, 59.

87 Haraway, "Situated Knowledges," pp. 198–99.

IV CONTAINMENT AND EXCESS: REPRESENTING
 AFRICAN AMERICANS

1 James Clifford and George E. Marcus, introduction to *Writing Culture: The Poetics
 and Politics of Ethnography* (Berkeley and Los Angeles: University of California Press,

1986), pp. 23–24. "Self-fashioning" here refers to Stephen Greenblatt's *Renaissance Self-Fashioning: From More to Shakespeare* (Chicago: University of Chicago Press, 1980).

2 Susan Sontag, "The Anthropologist as Hero," in *Against Interpretation* (New York: Farrar, Straus, & Giroux, 1966), p. 70.

3 Roland Barthes, *Camera Lucida: Reflections on Photography,* trans. Richard Howard (New York: Hill and Wang, 1981), p. 87.

4 See Albert Boime, "The Question of Black Competency," in *The Art of Exclusion: Representing Blacks in the Nineteenth Century* (Washington, D.C.: Smithsonian Institution Press, 1990), pp. 103–20. For images of African Americans as lazy, as primitively sexual, as buffoons and entertainers, see Boime, passim; Hugh Honour, *The Image of the Black in Western Art,* vol. 4, 2 parts (Cambridge, Mass.: Harvard University Press, 1989); Guy C. McElroy, *Facing History: The Black Image in American Art, 1710–1940,* exhibit catalog (Washington, D.C.: Corcoran Gallery of Art, 1990).

5 Paired photographs were intended by the Carlisle Indian School to represent visually a set of oppositions that invoked a whole series of contemporary meanings, Lonna Malmsheimer points out: "From 'savagery' to 'civilization,' from 'nomadic' to 'settled,' from 'dirty' to 'clean,' from 'crude' to 'gentlemanly,' from 'disorderly' to 'orderly,' from 'peace destroying' to 'peaceable,' from 'indolent' to 'industrious and productive,' . . . from 'ignorant' to 'educated,' from 'barbaric' to 'Christian.'" "Photographic Analysis as Ethnohistory: Interpretive Strategies," *Visual Anthropology* 1, no. 1 (1987):29–30.

6 The comparison tells us more about Kirstein's naive assessment of nineteenth-century American art, which he sees as distinguished by the frontier virtue of candor, than it does about Johnston's photographs. In fact, differences among works by all three artists are far more striking. "In William Sidney Mount's beautiful *Music Hath Charms* [1847]," Kirstein points to "a respectably dressed slave standing beyond the barndoor wherein the young masters play. . . . Bemused, he is separated but unaccusing. In Thomas Eakins's wonderful watercolor of a solemn small Negro boy dancing shyly, there is the same genial gravity and assertion in the cool appreciation of the subservient condition." Foreword to *The Hampton Album,* exhibit catalog (New York: The Museum of Modern Art, 1966), p. 10; subsequent references are cited parenthetically in the text.

As Albert Boime writes of the Mount painting, *Music Hath Charms* refers to the "savage beast" who may be soothed by "The Power of Music" (the work's alternate title). Boime sees the axe and cider jug on the ground next to the black man as "clues to his natural disposition" and the painting as "part of the standard racist ideology attributing to blacks a relaxed and casual sensibility and a love of pleasure that rationalized the actual treatment of them as beasts of burden." Mount's journal describes two other (white) listeners, an older and younger man, as looking into the past and dreaming of the future, whereas "the negro thinks of the present." Thus, Boime writes, "black people have no past and no future but are hopelessly condemned to their 'innate' ever-present disposition" (*Arts of Exclusion,* p. 92; quoted material from Karen M. Adams, "The Black Image in the Paintings of William Sidney Mount," *American Art Journal* 7 [Nov. 1975]:146–47). Mount's *Eel Spearing at Setauket* (1845) may point to Johnston's photographs in its formal composition and perfect stillness, but unlike Johnston,

Mount, for the most part, represented the African American as a grinning entertainer (in *Rustic Dance after a Sleighride* [1830]), or as lazy and sensual (in *Farmers Nooning* [1836]). Eakins portrayed blacks in hierarchical relationships with whites—for example, *Will Schuster and Blackman Going Shooting* (1876) and the later *William Rush Carving His Allegorical Figure of the Schuylkill River* (1908)—or highlighted their exotic and sensual nature, as in *Negress* (c. 1900). In *Negro Boy Dancing* (1878), Eakins offers a rare glimpse of the private side of black life in the nineteenth century. Sidney Kaplan credited Eakins with challenging "the slavophile iconography of banjo, grin, and jig" by showing the intense absorption of the family, who do not perform on the white man's stage, but in their own triangular enclosure, "oblivious to the vaudeville public." See Kaplan's "The Black Soldier of the Civil War in Literature and Art," the Chancellor's Lecture Series, University of Massachusetts, Amherst, 1980, n.p., cited in Boime, ibid., p. 102.

7 Laura Wexler, "Black and White and Color: American Photographs at the Turn of the Century," *Prospects: An Annual of American Culture Studies* 13 (1988):356. Wexler goes on to note that the frozen quality of these pictures, "this calm, the deepest rhetorical supposition of the Hampton views, is not a *necessary* given, but a *chosen* one." Although nearly contemporaneous Washington, D.C., school system images were intended to show "The New Education" in practice and to serve the same promotional function as the Hampton photographs—both were award-winning exhibits in Paris—they are in fact very different from the Hampton photographs. In the Washington pictures, the white children "twist and turn in their places; they do 'stretching and yawning' exercises at their desks; they ride in a bevy on public transportation; they attend an exhibition of fine prints at the Library of Congress." These scenes are also "staged" for the photographer's camera, but Wexler sees in them a "different coding." In the Hampton views, the controlling tropes of station, stillness, and solidity disallow whatever resistance went on at the interstices, beyond the bounds of Johnston's script. Ibid., pp. 356–57, emphasis original.

8 Booker T. Washington's *Up From Slavery* was serialized in *Outlook* magazine in 1900 (reprint, New York: Airmont, 1967), pp. 45–56, cited in Wexler, "Black and White," pp. 362–63. Pointing to such maladroit disjunctions as an encomium to the "Christlike" General Armstrong, who wanted to "assist in lifting up my [Washington's] race," and "the matter of having meals at regular hours, of eating on a tablecloth, using a napkin, the use of the bathtub and of the tooth-brush, as well as the use of sheets upon the bed" that were all "new to me," Wexler argues that such juxtapositions reflect "the difficulty of splicing the heterogeneousness of learning into the profoundly controlled curriculum and ordered sense of persons that Hampton promoted." Johnston, she suggests, had the same problem: that which resists a celebratory appeal "is neither imaged nor imagined by the photographer. . . . In an ominous, familiar, over-determined, and claustrophobic formula, the concept of *race* in the Hampton of Johnston's camera is homologous with a principle of *place*" (pp. 358–59, emphasis original).

9 Mark Roskill and David Carrier suggest that the use of such images from Hampton as "A Hampton Graduate at Home," which shows the "material, spiritual, and domestic life of order, tranquillity, and harmony" of Hampton graduates in juxtaposition with

contrasting images that show the poverty in which other blacks of Virginia lived, amounts to the deliberate creation of a certain kind of falsehood. *Truth and Falsehood in Visual Images* (Amherst: University of Massachusetts Press, 1983), pp. 98–99.

10 James Clifford and George E. Marcus, introduction to *Writing Culture*, pp. 6–7.

11 Barbara Kirshenblatt-Gimblett, "Objects of Ethnography" in *Exhibiting Cultures: The Poetics and Politics of Museum Display*, ed. Ivan Karp and Steven D. Lavine (Washington, D.C.: Smithsonian Institution Press, 1991), pp. 407–408, citing Dean Mc-Cannell, *The Tourist: A New Theory of the Leisure Class* (New York: Schocken, 1976). Kirshenblatt-Gimblett draws here upon Erving Goffman's notion of "front" and "back" spaces—those in which activities for public viewing take place and those for domestic, private rituals—in his book *The Presentation of Self in Everyday Life*. She suggests that one of the attractions of poor neighborhoods in the nineteenth century "was their accessibility to the eye, their 'intimacy at sight' . . . which suggests a kind of social nakedness . . . verg[ing] on what might be termed social pornography—the private made public." If "respectability has the power to conceal, to control access to sight, poverty, madness, children, animals and the 'lower' orders of humankind reveal by exposing themselves fully to view." Thus at Hampton, the photographer, acting for institute officials, was able to penetrate interior recesses, to violate intimacy, which might well account for the stiffness of the black family at dinner: the resulting photograph, as Kirshenblatt-Gimblett writes of museum exhibits of cultural artifacts, "has the quality of a peep show and surveillance—the viewer is in control" (pp. 411–13).

12 Whittier's last volume, "St. Gregory's Guest and Recent Poems," was dedicated to General Armstrong, "whose generous and self-denying labors for the elevation of two races have enlisted my sympathies and commanded my admiration." Cited in Robert Francis Engs, *Freedom's First Generation: Black Hampton, Virginia, 1861–1890* (Philadelphia: University of Pennsylvania Press, 1979), p. 191.

13 Engs, *Freedom's First Generation*, p. 154. "Four millions of Negroes, of whom ninety per cent were illiterate, . . . had to be incorporated in the life of the nation, or remain a permanent menace both to its welfare and its self-respect," Hampton Trustee Francis Greenwood Peabody wrote in 1918, looking back on the success of the institute. "In this task of training a backward race for citizenship, Hampton Institute has had a leading part. . . . Yet it is obvious that the vast majority of the Negro race, as of other races, must continue to be hand-workers, in the fields or in household or mechanic arts, and that their training must be adapted to the rural and industrial conditions in which they are to earn their living." *Education for Life: The Story of Hampton Institute,* Told in Connection with the Fiftieth Anniversary of the Foundation of the School (Garden City, N.Y.: Doubleday, Page, 1918), pp. xiii–xv.

14 Samuel Chapman Armstrong, Catalog of Hampton Normal and Agricultural Institute, 1870–71, p. 19, cited in Engs, *Freedom's First Generation,* pp. 142–43.

15 Engs, *Freedom's First Generation,* pp. 149–50, citing Peabody, *Education,* pp. 8, 119, 135. "During the thirty-four years of black and red education, all of the absurdities, hypocrisies, contradictions, and injustices inherent in American racial attitudes could be discovered at the Institute and in the lives of its Negro and Indian graduates," Engs writes elsewhere. "It is not that Hampton failed in its mission to 'civilize' its students. Rather

it was that American society refused to accept either blacks or Indians on the basis of equality, no matter how 'civilized' they might be" Engs, "Red, Black, and White: A Study in Intellectual Inequality," in *Region, Race, and Reconstruction,* ed. J. Morgan Kousser and James M. McPherson (New York: Oxford University Press, 1982), p. 242, cited in Wexler, "Black and White," pp. 380–81."What is rising up in this photograph are the 'absurdities, hypocrisies, contradictions, and injustices' of that history," Wexler concludes.

16 This could be *A Dash for the Timber* (1889), in which a group of fleeing Anglo men, chased by a warring band of Indians in the distance, hurtle toward the viewer's space, but see my discussion of the Remington print in note 23 below.

17 Samuel Chapman Armstrong, cited in Kirstein, *Hampton Album,* p. 6.

18 Wexler, "Black and White," p. 383.

19 See Paula Richardson Fleming and Judith Luskey, *The North American Indian in Early Photographs* (New York: Harper and Row, 1986); Christopher Lyman, *The Vanishing Race and Other Illusions: Photographs of Indians by Edward Curtis* (New York: Pantheon, 1982); Melissa Banta and Curtis M. Hinsley, *From Site to Sight: Anthropology, Photography, and the Power of Imagery,* exhibit catalog (Cambridge, Mass.: Peabody Museum of Archaeology and Ethnology, Harvard University, 1986); and Lonna Malmsheimer, "Imitation White Man: Images of Transformation at the Carlisle Indian School," *Studies in Visual Communication* 11, no. 4 (1985):54–75.

20 William H. Robinson, "Indian Education at Hampton Institute," in Keith L. Schall, ed., *Stony the Road: Chapters in the History of Hampton Institute* (Charlottesville, Va.: University Press of Virginia, 1977), p. 9, citing Samuel Chapman Armstrong, Hampton Normal and Agricultural Institute (HNAI) Annual Report, 1882, pp. 3–5, 14.

21 Jacqueline Urla points out that "forgetting" is also a part of romanticizing the Indian (conversation with the author).

22 Carolyn Merchant suggests, further, that the mode of instruction was itself a form of cultural imperialism. Indians sent to elite New England colleges rebelled against a "frivolous and useless" mode of knowing associated with vision and transcendence— individual recall without the emotional associations of song, rhyme, rhythm of speech, in which not recalling but problem solving mattered, not repetition but seeing and creating anew. In such a system, "[T]he educational process by which aural learning becomes abstract conceptual knowledge wrenches the student out of a participatory consciousness based on hearing, touching, bodily imitation, and intuition and catapults him or her into an objectified world dominated by vision. The objects of knowledge (gnosis) are concrete images of the abstract forms. The concepts are invisible, but their manifestations can be studied." *Ecological Revolutions: Nature, Gender, and Science in New England* (Chapel Hill: University of North Carolina Press, 1989), pp. 110–11.

23 Kirstein does not specify that the cavalry in this print is very likely black and their leader white, as in *Captain Dodge's Colored Troops to the Rescue* (c. 1890), which portrays a company of black soldiers known for their bravery in skirmishes with the Apache (who referred to them as the "black buffaloes"). Significantly, Hampton Institute founder Samuel Armstrong was himself a commander of a black regiment during the

Civil War. See James Guimond, *American Photography and the American Dream* (Chapel Hill: University of North Carolina Press, 1991), p. 25. Guy McElroy points out that four African American cavalry troops were established west of the Mississippi by Act of Congress in 1866. That white officers were always in charge of these troops became an issue at the turn of the century: in *Scribner's* magazine in 1899 Theodore Roosevelt advocated mandatory command of black soldiers by white officers because of inherent racial weakness that prevented black officers from commanding effectively, but in their anthology, *A New Negro for a New Century* (1900), Booker T. Washington, Fannie Barrier Williams, and N. B. Woods compiled rebuttal examples of black valor in American wars. McElroy, *Facing History*, p. 99; Gates, "The Face and Voice of Blackness," in ibid., p. xxxvi. Hanging a picture of a black regiment on the wall would make sense at the Hampton Institute, whose northern liberal sponsors commissioned, contemporaneously with Johnston's photographs, Augustus Saint-Gaudens's bronze relief known as the *Shaw Memorial* (the country's first black volunteer regiment, *The 54th Massachusetts Volunteer Infantry Led by Robert Gould Shaw in 1863*, completed in 1901), for the Boston Common.

24 "Hampton's experiment in Indian education was highly controversial," according to African American scholar William H. Robinson. "In fact, no sooner did it become known that the first group of Indians had arrived at the school [in 1878] than a great debate [began] . . . that would last for more than thirty years." Among the chief critics of Hampton's program were those who questioned the propriety of having Indians attend school with blacks. At Hampton, the problem of how the Indians should be educated (should their own culture be emphasized or should they be "anglicized?") was the kind of question simultaneously being raised in Congress, by the Bureau of Indian Affairs, and across the nation. The primary issue was whether the Indian could be "civilized." "This question was as philosophically and morally profound as any that could be asked about a people or race," Robinson writes. "If the answer was yes, the subsequent questions about how, where, and when would have to be answered. If the answer was no . . . such an answer would lead to elimination of the Indians." Robinson, "Indian Education at Hampton Institute," pp. 7–8.

There were problems in the other direction as well. In the HNAI Annual Report of 1878, Armstrong noted "prejudice against Hampton as a colored institution" among various Indian agencies. But, he declared, "God has intended good in this way. . . . He has smiled upon this undertaking." "An Indian Raid on Hampton Institute," p. 16; *Southern Workman* 7 (1878):36, in ibid., pp. 19–20.

By 1882 Armstrong could write, "The . . . vexed question of the mingling of the races, seems to have satisfactorily settled itself with little or no interference on the part of our officers. I am convinced that there is nothing better for a wild Indian boy, fresh from the plains, than to room for six months with a good colored student, for such companionship does much, in a quiet way for his habits, manners, and morals." In fact, there were separate facilities: Winona Lodge for Indian girls and Wigwam for boys being constructed in part to fulfill an agreement the school had with the federal government. Moreover, as Armstrong's successor Hollis Burke Frissell noted in 1912, "separate quarters and tables . . . has given opportunity for the study of the race prob-

lems in a broader way than would otherwise have been possible." HNAI Annual Report, 1882, p. 6; "Fifty-fourth Annual Report of the Principal," *Southern Workman* 41 (1912): 297, cited in Robinson, "Indian Education at Hampton Institute," pp. 21, 24.

25 Wexler, "Black and White," pp. 373–76. Johnston's photographic style is also different in other assignments, where rigid classical composition gives way to the softly flowing forms of Art Nouveau or to the lush interior and exterior scenes that provide sensuous backgrounds for women posed as heroines from Sargent paintings or Wharton novels.

26 Wexler, "Black and White," pp. 356–58.

27 Peabody, citing the Hampton Normal and Agricultural Institute catalog, pp. 119, 135.

28 See Constance W. Glenn and Leland Rice, *Frances Benjamin Johnston: Women of Class and Station,* exhibit catalog (Long Beach: California State University Art Museum and Galleries, 1979).

29 Helen W. Ludlow, "Conditions in 1873," in the Armstrong League of Hampton Workers, *Memories of Old Hampton* (Hampton, Va.: Institute Press, 1909), p. 43. A few years later "Uncle Tom" was a more willing subject; Ludlow's chapter begins with his picture.

30 Gates, "The Face and Voice of Blackness," pp. xxxiii–xxxiv.

31 Washington, *Up From Slavery,* p. 37, cited in Wexler, "Black and White," pp. 342–43.

32 Introduction to *A New Negro,* cited in Gates, "The Face and Voice of Blackness," p. xxvii; Mrs. Booker T. Washington, "The Club Movement Among Negro Women," in J. D. Nichols and William H. Crogman, eds., *The New Progress of a Race* (New York, 1902), cited in Gates.

33 Fannie Barrier Williams, "Club Movement Among Colored Women," in *A New Negro;* Williams, ibid., in *Progress of a Race;* John Henry Adams Jr., "Rough Sketches: A Study of the Features of the New Negro Woman," *Voice of the Negro* (August 1904):323–26, cited in Gates, "The Face and Voice of Blackness," pp. xxxviii–xxxix.

34 John Henry Adams Jr., "Rough Sketches: A Study of the Features of the New Negro Woman," *Voice of the New Negro* (August 1904):323–36, reproduced in Gates, "The Face and Voice of Blackness," p. xli. Two months later, Adams published "Rough Sketches: A Study of the Negro Man." Although this "real new Negro man" is described as "[t]all, erect, commanding, with a face as strong and expressive as Angelo's Moses and yet every bit as pleasing and handsome as Rubens's favorite model," in the sketches Gates reproduces, "Gussie" alone is fully embodied; the men are all portrayed head-and-shoulders only, with captions stressing their business aptitude and upward mobility. *Voice of the New Negro* (Oct. 1904):447–52, cited in Gates, p. xxxix; images reproduced pp. xlii–xliii.

35 Michael Taussig, *Mimesis and Alterity: A Particular History of the Senses* (New York: Routledge, 1993), pp. 130, 191, 237.

36 Cited in Kirstein, *Hampton Album,* p. 55.

37 Rebecca West, *1900* (New York: Viking, 1962), pp. 162–63, cited in Wexler, "Black and White," p. 362; Henry Adams, "The Virgin and the Dynamo," in *The Education of Henry Adams* (Boston: Massachusetts Historical Society, 1918).

38 Thomas J. Calloway, Special Agent, Negro Exhibit, "The American Negro Exhibit at

the Paris Exposition," *Hampton Negro Conference* 5 (July 1901):74–80. Calloway, was in charge of the exhibit in Paris.

39 Wexler, "Black and White," pp. 361–62. See C. Vann Woodward's assessment that the principles of the Hampton-Tuskeegee philosophy "came from a bygone day," that the trades taught in its vocational classes were equally old-fashioned, and that Washington's Negro Business League, formulated according to those principles, was based on "maxims of thrift, virtue, enterprise, and free competition. It was the faith by which the white middle-class preceptors of his youth had explained success . . . [but it] never took into account the realities of mass production." *Origins of the New South, 1877–1913: A History of the South,* vol. 9 (Baton Rouge: Louisiana State University Press, 1951), pp. 365–67. James Guimond points out that Johnston's photographs in 1900 would have "had a slightly nostalgic, Norman Rockwell quality" that might have appealed to white philanthropists: "it reminded them of their own boyhoods in an earlier age." How out of place such nostalgia was is made clear from the statistics he offers about lynching: hundreds of blacks murdered, mutilated, and burned alive by white mobs every year between 1890 and 1920. A black man, principal of a Tuskegee satellite school, was shot at by whites when he was driving Johnston, who had come to take photographs, in his buggy; he ultimately was forced to leave town and disband his school, despite Johnston's protests to the governor and to President Theodore Roosevelt. *American Photography and the American Dream,* pp. 43, 48–49.

40 Engs, *Freedom's First Generation,* pp. 154–55; Joseph T. Skerrett Jr., conversation with the author. Waldo Martin suggests that Frederick Douglass's attribution of his feminized "love of letters" to his mother was an attitude widespread among African Americans that may have been responsible for the emphasis of black leaders from Douglass to Booker T. Washington on specifically industrial training. *The Mind of Frederick Douglass* (Chapel Hill: University of North Carolina Press, 1984), pp. 235–36, cited in Eric Lott, *Love and Theft: Blackface Minstrelsy and the American Working Class* (New York: Oxford University Press, 1993), p. 33.

41 Gates, "The Face and Voice of Blackness," p. xli, citing W. A. Domingo, "A New Negro and a New Day," *Messenger* (Nov. 1920):144–45. See also Alain Locke, ed., *Harlem: Mecca of the New Negro,* special issue, *Survey Graphic* (March 1925).

42 See Ivan Karp, "Culture and Representation," in Karp and Lavine, eds., *Exhibiting Culture,* p. 17; Peter Stallybrass and Allon White, *The Politics and Poetics of Transgression* (Ithaca, N.Y.: Cornell University Press, 1986), p. 41.

43 Julia Peterkin and Doris Ulmann, *Roll, Jordan, Roll* (New York: Ballou, 1933), pp. 11–12. Subsequent references are cited parenthetically in the text.

44 "Remembrance by John Jacob Niles," in *The Appalachian Photographs of Doris Ulmann,* exhibit catalog (Highlands, N.C.: The Jargon Society, 1971), n.p.

45 Ian Jeffrey, *Photography: A Concise History* (London: Thames and Hudson, 1981), pp. 159, 162.

46 David Featherstone, *Doris Ulmann, American Portraits* (Albuquerque: University of New Mexico Press, 1985), p. 33.

47 Hamlin Garland, "Doris Ulmann's Photographs," *The Mentor* 15 (July 1927):42, 44,

cited in Featherstone, *Doris Ulmann*, p. 27. Featherstone points out that with the great influx of immigrants from central and eastern Europe in the early part of the century and especially after the first world war, there was a general resurgence of interest in groups who represented "the true heritage of America," sparked both by fear of the country's "multiethnic melting pot" and by a burgeoning social liberalism that took an (anti-industrial) interest in traditional crafts and ways of life, wishing to preserve these "American" traditions before they disappeared. Ibid., p. 28; Niles, "Remembrance," n.p.

48 Niles, "Remembrance," n.p. I retain Niles's use of the word "Negro" here.

49 Doris Ulmann, "Character Portraits," *The Mentor* 15 (July 1927):43, cited in Featherstone, *Doris Ulmann*, pp. 26–67.

50 *Pictorial Photography in America,* vol. 4, cited in Featherstone, *Doris Ulmann*, p. 15. Believing in personal self-sufficiency, Ulmann was "outraged" by a New York City fruit seller's request for money for new shoes for her daughter, although she made it a practice to give her subjects copies of their portraits. Niles, "Remembrance," n.p. Nor did she pay Niles well. She told him: "Johnny, you're a poet, you don't need much. Poets don't need much. If you overpay them, they stop being poets." Niles, "Doris Ulmann: Preface and Recollections," *The Call Number* (spring 1958):9, cited in Featherstone, *Doris Ulmann*, p. 36.

51 Gilpin remembered that Ulmann occasionally visited her classes, sat at the rear of the room, and contributed infrequently to the discussion. Featherstone-Gilpin conversation, Oct. 1972, cited in Featherstone, *Doris Ulmann*, p. 19.

52 Jean Ritchie in conversation with David Featherstone, March 1976, cited in Featherstone, *Doris Ulmann*, p. 58; Niles, in Featherstone, ibid., pp. 58–59.

53 Peterkin (who uses the dialect in her novels) defines "Gullah" as a corruption either of Angola or Galla. *Roll, Jordan, Roll,* p. 23.

54 Nicholas Natanson, *The Black Image in the New Deal: The Politics of FSA Photography* (Knoxville: University of Tennessee Press, 1992), pp. 23–26.

55 Cited in Elinor Reichlin, "Faces of Slavery: A Historical Find," *American Heritage* 28, no. 4 (June 1976):4–11. Agassiz concentrated exclusively on African-born slaves and their first-generation offspring, hoping by this restricted sample "to define that anatomical variation unique to 'the African race' in its original form and to establish a standard against which to measure the permanence of racial characteristics among American-born slaves of more remote African ancestry who had been exposed to a temperate climate for several generations." His host, Dr. Robert W. Gibbes, arranged for Zealy to photograph the slaves Agassiz had examined, posing each one nude to point up anatomical details in which the scientist had shown special interest and labeling each image with the subject's first name, tribe, and owner (ibid., p. 5). Reichlin found fifteen of these images (six of which are reproduced in her article) in an unused storage cabinet in the attic of Harvard University's Peabody Museum of Archaeology and Ethnology.

56 Doris Ulmann to Averell Broughton, Oct. 4, 1929, cited in Featherstone, *Doris Ulmann*, p. 43. Three days later she wrote to Broughton again: "I must stop to gather

myself together for my day's work at Charleston. It has been a great effort to do that which I had planned here and I hope that things will turn out, if not, I shall be a very desperate person." Cited in ibid.

57 Lorenzo D. Turner, *Africanisms in the Gullah Dialect* (Chicago: University of Chicago Press, 1949), pp. 11–14, and "Problems Confronting the Investigator of Gullah," *Publication of the American Dialect Society* 9 (1947):74–84; John Bennett, "Gullah: A Negro Patois," *South Atlantic Quarterly* 7 (1908):336, 338, and *Atlantic Quarterly* 8 (1909):40; Ambrose E. Gonzales, *The Black Border: Gullah Stories of the Carolina Coast* (Columbia, S.C.: The State Company, 1922), p. 10, cited in Lawrence W. Levine, *Black Culture and Black Consciousness: Afro-American Folk Thought, from Slavery to Freedom* (New York: Oxford University Press, 1977), pp. 146–47. Levine recounts stories of the Gullah as Trickster, ibid., p. 380.

58 Featherstone points out that because Ulmann had "a specific concept of how a photograph should look," she used throughout her career the equipment and materials with which she had begun in 1918 — bulky and awkward glass-plate view camera and tripod. Her soft-focus lenses, sharp at the center but with a change of aperture adjustable for gradations of indistinctness, had no shutter. Exposures were made by removing and replacing the lens cap, counting the appropriate elapsed time by educated guess. She used no light meter. Distrusting equipment that utilized mechanical tricks, she shunned flexible-base film, mechanical shutters, light meters, lightweight cameras, and corrected, sharp-focus cameras, all of which became available during her lifetime, although in the early 1930s she bought a small, lightweight Rolleiflex for Niles to use. *Doris Ulmann*, pp. 17–18.

59 Welbourn Kelley, *Saturday Review of Literature* (Dec. 30, 1933):382. Other reviews can be found in Dorothy Van Doren, *The Nation* (Jan. 24, 1934):106–107, and John Chamberlain, *New York Times* (Dec. 15, 1933):21, all cited in Featherstone, *Doris Ulmann*, p. 48.

60 "Some Personal Observations by Kanaga," in *Consuelo Kanaga, Photographs: A Retrospective,* exhibit catalog (New York: Blue Moon Gallery and Lerner-Heller Gallery, May 14–31, 1974), p. 17.

61 Ansel Adams, statement for *Camera Craft,* c. 1933, reprinted in Therese Thau Heyman, ed., *Seeing Straight: The f.64 Revolution in Photography,* exhibit catalog (Oakland: The Oakland Museum of California, 1992), p. 55.

62 Heyman, "Perspective on Seeing Straight," *Seeing Straight,* p. 23.

63 Marius de Zayas, "How, When, and Why Modern Art Came to New York," ed. Francis M. Naumann, *Arts* (April 1980):105; Naomi Rosenblum, "f.64 and Modernism," in *Seeing Straight,* p. 36; John Paul Edwards citing Edward Weston's "Photography," 1934, in "Group f.64," *Camera Craft* (March 1935):107–13, emphasis original, excerpted in Heyman, ed., *Seeing Straight,* p. 61.

64 f.64 "has always been considered not only American, it's western," Cunningham remarked, and then revised herself with typical hyperbole: "it isn't even American; it's western." Cunningham quoted in an unsigned article in *Aperture* 11, no. 4 (1964):157, cited in Rosenblum, "f.64 and Modernism," p. 34.

65 Barbara Head Millstein, "Consuelo Kanaga, An American Photographer," in Barbara

Head Millstein and Sarah M. Lowe, *Consuelo Kanaga: American Photographer*, exhibit catalog (Brooklyn: The Brooklyn Museum, in association with the University of Washington Press, 1992), p. 33. Given her unusual name and because she made so many images of African Americans, Kanaga is often thought to be racially or ethnically "other" (than Anglo) herself. Her parents were Amos Ream Kanaga, a farmer, lawyer, and judge from Bellville, Ohio, who eventually moved the family to San Francisco, and Mathilda Carolina Hartwig, an unconventional woman who compiled the popular *History of Napa Valley* (1901) and later became a real estate broker. According to legend, Tillie Kanaga admired Ferdinand-Marie de Lesseps, the builder of the Suez and Panama canals, and named her daughter Consuelo de Lesseps after his wife. Millstein, "Consuelo Kanaga," pp. 17–18.

66 Edward Weston, from the announcement of an exhibition of his photographs at the Delphic Studio, New York, 1932, reprinted in Heyman, ed., *Seeing Straight,* p. 53; "Group f.64 Manifesto," 1932, displayed at the exhibition at the M. H. de Young Memorial Museum, San Francisco, 1932, reprinted in ibid., p. 53.

67 William Mortensen, "Venus and Vulcan," *Camera Craft* 41 (June 1934):257–65, excerpted in *Seeing Straight,* ed. Heyman, pp. 57–58. In his reply to Mortensen, Willard Van Dyke insisted that "staticism" in portraiture—a reference to Ansel Adams—did not "represent the attitude of all of the workers in the pure manner. Weston definitely disagrees with this point of view, and I am sure that John Paul Edwards and Imogen Cunningham also do not agree." Letter to the editor of *Camera Craft* 41 (July 1934):345–46, excerpted in Heyman, ed., *Seeing Straight,* p. 59.

68 Millstein, "Consuelo Kanaga," p. 94.

69 Kanaga's opinion was that aside from the common sharpness of focus of the works in the show, the photographers of Group f.64 differed greatly: "There were hardly two photographers alike." An unbeliever, she felt that when "the tendency began to get more and more towards sharper photographs . . . a lot of beauty in photography was lost." She didn't concern herself with whether the lens was stopped down or not, she said; she felt that the picture determined the focus, and she never discussed photographic theory with the group: "The truth is I didn't know them all, or if I did, I had just barely met them. Edward, Imogen, Willard, and Ansel were the ones I knew." Taped conversation between Kanaga and Lawrence Saphire about Group f.64, Oct. 23, 1977, archives of Jean S. Tucker, Center for Metropolitan Studies, University of Missouri, St. Louis, cited in Millstein, "Consuelo Kanaga," p. 33.

70 Millstein reports that with her friend Louise Dahl (Wolfe), whom she taught to use a 3G-by-4G camera with a soft-focus lens, Kanaga would roam the city, "mostly around Chinatown or Russian Hill. They . . . admired the work of Arnold Genthe and Francis Bruguière" ("Consuelo Kanaga," p. 23).

71 Kanaga's precise and deliberate printing technique becomes a minor motif in Millstein and Lowe's book. "Kanaga was indisputably a master printer," Millstein writes; "she experimented freely in her pursuit of the perfect print. The exquisite tonality she achieved is reproduced mechanically only with great difficulty." She calls Kanaga "a perfectionist . . . [who] put her entire effort into her work" and suggests that her obsession with perfection in printing became a theme of her artistic life and was the

reason her production was so limited ("Consuelo Kanaga," pp. 17, 22). Kanaga herself told Margaretta Mitchell, "I put a lot into them [portraits] and wanted them to be beautiful. I had to make fifty prints to get one that I liked, so that's why I never did get rich." "Consuelo Kanaga," in Margaretta Mitchell, *Recollections: Ten Women of Photography* (New York: Viking, 1979), p. 159. So much for the frequent churlish remarks by Adams, Weston, and others about the slipshod technique of women photographers, especially Cunningham and Lange, as noted in chapter 1. Weston, in fact, broods in his *Daybooks* about the time Kanaga "took me to task for being prolific—mentioning a well-known N.Y. photographer who made maybe one negative a year—but it was so perfect. Well I can make—given time—one thousand negatives a year not only perfect technically, but fresh and strong in seeing. Then I am just one thousand times as important as Consuela's [*sic*] shining example." Nancy Newhall, ed., *The Daybooks of Edward Weston*, vol. 2 (New York: Aperture, 1961), p. 168.

72 "Ansel did not care for my vegetables," Weston noted in 1935. "This is nothing new! I seem to be continually defending them! I can see the resemblance of some of them, especially the oft-maligned peppers [one of which appeared in the f.64 show], to modern sculpture,— or Negro carving—but I certainly did not make them for this reason." *Daybooks*, vol. 2, p. 239. Weston was referring to Kanaga's visit to Stieglitz on May 20, 1927; the entry continues: "If I had sent my toilet, for instance, how then would he have reacted? And must I do nothing but toilets and smokestacks to please a Stieglitz? . . . Are not shells, bodies, clouds as much of today as machines?" (ibid., p. 24). As late as 1934, Weston was still fussing over this episode, counseling himself to put it behind him (ibid., pp. 237–38).

73 Kanaga, cited in Mitchell, *Recollections*, p. 159.

74 Cited in Millstein, "Consuelo Kanaga," p. 26.

75 Cited in ibid., pp. 27, 28.

76 Mick Gidley, "Hoppé's Impure Portraits: Contextualising the American Types," in Graham Clarke, ed., *The Portrait in Photography* (London: Reaktion Books, 1992), p. 143. Kanaga might also have seen Hoppé's *Book of Fair Women*, published in 1922, which among portraits of mostly "fair" women included "Indian, Hawaiian, and Chinese beauties," or even a catalog for his "New Camera Work" mounted at the Goupil Gallery in London, which included a number of his "American types" among the 221 images exhibited. Gidley points out that Hoppé made approximately four hundred of these "types," often in a series—"Coloured Woman," "Jewish Girl Types," "Negro Type," "New York Type. Female. Holiday mood," and so on—as part of a much larger grouping of "human documents" and that this was the only time they were exhibited as a group. Ibid., pp. 133–35.

77 See Alan Trachtenberg, *Reading American Photographs: Images as History, Mathew Brady to Walker Evans* (New York: Hill and Wang, 1989). In the first treatise on photography, *The Camera and the Pencil* (1864), Marcus Aurelius Root stressed the beneficial, socially educational aspects of photographic reproductions "of the masses." Root saw photography both as the ideal medium for achieving a unique likeness of an individual but at the same time he advocated the adoption of conventions to indicate

social roles or types, recommending, for example, that poets, historians, and others whose work was essentially private be photographed in seated positions, whereas public figures "should be taken in a standing posture." Meanwhile, André Adolphe Eugène Disdéri had patented the cheap and popular *carte-de-visite* portrait process and had developed a set of practical conventions to depict "The Actor," "The Painter," and so on. Cited in Gidley, "Hoppé's Impure Portraits," pp. 138–39.

78 Millstein, "Consuelo Kanaga," p. 76; letter to Bender cited in ibid., pp. 31–32.

79 Conversation between Kanaga and Lawrence Saphire, October 23, 1977, cited in ibid., p. 33.

80 Ibid., pp. 34, 55, drawing on an unpublished story by McDaniel, "The Model," and on Peter N. Carroll and Bruce Kaiper's unpublished manuscript, "Radical Elders Oral History Project." In "The Model," McDaniel describes being "discovered" by Kanaga and art critic Junius Cravens, who took him to the California School of Fine Arts to pose—an experience he likened to being in the crazy house. Thanks to Sarah Lowe for sharing this manuscript with me.

81 "Police Insult Charged by S. F. Women," Nov. 17; "Police Map Own Law in Browbeating," Nov. 18; "Police Apology Given Women Over Insult," Nov. 19; "Negro League Plans Protest," Nov. 20; "Police Destroy Prints of Negro Chauffeur," Nov. 22, 1932, *San Francisco Chronicle*, cited in Millstein, "Consuelo Kanaga," pp. 33–34.

82 Lester Balog and Sam Brody, interview by Anne Tucker, Aug. 23, 1974; Consuela [*sic*] Kanaga, "Writing in Light," *Direction* 1 (Dec. 1937): 22–23, cited in Millstein, pp. 35–36.

83 According to Walter Rosenblum, former secretary of the Photo League, Kanaga may have joined that organization as early as 1931. Millstein, "Consuelo Kanaga," pp. 36–38. Siskind's own work displays a conflict between art and radical politics similar to Kanaga's. See, for example, his "Schoolboy," New York City (1932), which Nicholas Natan-son describes as "dignity by way of primitive exoticism" (*The Black Image in the New Deal*, p. 159).

84 Aaron Siskind, interview by Millstein and Lowe, June 15, 1990; Kanaga to Albert Bender, n.d. (answered March 2, 1936); Wallace Putnam (Kanaga's husband), interview by Sarah M. Lowe, Sept. 16, 1988, cited in Millstein, "Consuelo Kanaga," pp. 37, 39.

85 See "Faces of Harlem," Robert Sklar, ed., *The Plastic Age (1917–1930)*, vol. 7 of *The American Culture* series (New York: Braziller, 1970), pp. 198–206.

86 The traditional function of the portrait in painting "was not to present the sitter as 'an individual' but, rather, as an individual monarch, bishop, landowner, merchant and so on," Berger observes. "The sense of having one's portrait painted was the satisfaction of being personally recognised and *confirmed in one's position*: it had nothing to do with the modern lonely desire to be recognised 'for what one really is.'" "The Changing View of Man in the Portrait," *Selected Essays and Articles: The Look of Things* (Harmondsworth, England: Penguin, 1958), pp. 37–38, emphasis original.

87 Kanaga, "Some Personal Observations," in *Consuelo Kanaga, Photographs*, p. 16. Steichen exhibited this image in a show of fifty photographers at the Museum of Modern Art in 1948, after which it came into Jung's possession through a patron of Kanaga's,

Walter Lewisohn, whose sister reported that Jung called it the "Black Madonna" and wanted to know more of her—"Her background, her problems, what lies behind those eyes." Cited in Millstein, "Consuelo Kanaga," p. 39.

88 She would also have seen FSA photographs—Dorothea Lange's *Migrant Mother* was published in 1935, for example—but not many FSA photographs of blacks were published. See Natanson, *The Black Image in the New Deal;* see also Richard Wright and Edwin Rosskam, *12 Million Black Voices* (New York: Viking, 1941; reprint, New York: Thunder's Mouth Press, 1988).

89 Cited in Judith Kalina, "From the Icehouse: A Visit with Consuelo Kanaga," *Camera 35* 1, no. 10 (Dec. 1972):54.

90 Nicholas Natanson points out that the Photo League exhibited FSA work and sponsored lectures by Roy Stryker and FSA photographers. Arthur Rothstein, Edwin Rosskam, and Ben Shahn were at various times league members, and FSA visitors to the Photo League gallery, especially Dorothea Lange, took considerable interest in the Harlem Document. In fact, Natanson suggests, Lange and others might well have perceived in the Harlem Document an approach similar to that of the FSA in representing African Americans. *The Black Image in the New Deal,* p. 48.

91 Mitchell, *Recollections,* p. 159. In an undated letter from the early 1920s in San Francisco Kanaga wrote to Stieglitz of the impact his work had on her: "For years now I have carried about with me the image of your photographs. No gift has come so near me nor no possession so dear as having seen and known your work. It is not your technique alone but some more ringing message of truth and fearlessness which has helped me in living." Kanaga to Alfred Stieglitz, Stieglitz Papers, Beinecke Library, n.d., cited in Millstein, "Consuelo Kanaga," p. 24.

92 A 1993 exhibit, *Stieglitz in the Darkroom,* National Gallery of Art, Washington, D.C., focused on the photographer as scientist, one who used his darkroom as a laboratory, experimenting with various photographic processes—platinum, silver gelatin, palladium, carbon prints, and photogravures—often returning in later years to his old negatives to reprint and reinterpret them. Striving to make prints that were what he called "A 1," curator Sarah Greenough points out, "he [often] had to make 100 attempts before he achieved even one that met his standards. He worked with sepia- and black-toned papers; varied the temperature of his developing baths; and explored the effects that different waxes and varnishes had on the print. In his quest to make rich, dark images he also discovered . . . that if a palladium print was overexposed to light a reversal of tones occurred and the hue lightened." Greenough, *Stieglitz,* pp. 2, 9, and passim. Because he wrote up his findings (see for example Stieglitz, "Platinum Printing," *Picture Taking and Picture Making* [Rochester, N.Y., 1898], reprinted in *The Modern Way of Picture Making* [Rochester, N.Y.: Eastman Kodak, 1905]), Kanaga would have been able to follow his experiments in her own darkroom.

93 Ben Maddow, *The Photography of Max Yavno* (Berkeley: University of California Press, 1981), n.p., cited in Millstein, "Consuelo Kanaga," p. 38.

94 Connie Bates, "Inner Light: A Conversation with Consuelo Kanaga," *The Yorktowner* (Sept. 29, 1976):n.p., cited in Millstein, "Consuelo Kanaga," p. 45.

95 Barbara Millstein points out that the original negative is in perfect color balance, as are

some prints made from it that Kanaga discarded, so we know that this photograph in which the face is burned (overexposed) was created in the darkroom ("Portraiture," in *Consuelo Kanaga,* p. 93).

96 Although I find no mention of Hurston by Kanaga, given her deep interest in African Americans, she (and perhaps Steichen) must have read this novel in which the protagonist Janie Crawford "saw her life like a great tree in leaf with the things suffered, things enjoyed, things done and undone." Significantly, it is in a photograph that Janie first learns "Aw, aw! Ah'm colored!" Zora Neale Hurston, *Their Eyes Were Watching God* (1937; reprint, Urbana: University of Illinois Press, 1978), pp. 20, 21.

97 Roland Barthes, "The Great Family of Man," in *Mythologies,* trans. Annette Lavers (1957; translation, New York: Hill and Wang, 1972), p. 102. Barthes likens the translated title to "a phrase belonging to zoology, keeping only the similarity in behaviour, [in which] the unity of a species, is here amply moralized and sentimentalized." The exhibit's theme, he writes—the myth of the human condition—rests on a very old mystification that escapes History. "This myth functions in two stages: first the difference between human morphologies is asserted, exoticism is insistently stressed, and customs are made manifest, the image of Babel is complacently projected over that of the world. Then, from this pluralism, a type of unity is magically produced" (ibid., pp. 100–101).

98 Bates, "Inner Light," cited in Millstein, "Consuelo Kanaga," p. 45.

99 This is Allan Sekula's assessment of *The Family of Man* exhibit in "The Traffic in Photographs," *Art Journal* 41 (spring 1981):20. Kanaga and Steichen quoted in Bates, "Inner Light," cited in Millstein, "Consuelo Kanaga," p. 45. Millstein points out that Kanaga was influenced by Steichen's own work. Portraits of sculptors Sargent Johnson and Wharton Esherick, of the folksinger Kenneth Spencer, and her *Portrait of a Man* (plate 36 in the catalog) are all similar in mood and lighting, in printing techniques, in the deceptively simple and confrontational arrangements of head and hands to some of Steichen's portraits. "Her romantic and dramatic *Wallace in His Studio* [Kanaga's husband, Wallace Putnam] is pure Steichen," Millstein writes, and her *"W. Eugene Smith and Aileen* is related to Steichen's *Mr. and Mrs.* (of the Carl Sandburgs), 1925, in composition and lighting" (ibid., pp. 94–95).

100 Edward Steichen, "Artists Behind the Camera," the *New York Times Magazine* (April 29, 1962):62–23, cited in Millstein, "Southern Portraits, Southern Labor," *Consuelo Kanaga,* p. 164.

101 Sekula, citing "Coca-Cola Overseas" (Dec. 1958, p. 15), in "The Traffic in Photographs," pp. 19, 21. Writing in the early 1980s, Sekula's remarks about the exhibit as a sort of blueprint for the "more recent political theater" of the cold war are still relevant today. Eschewing the bellicosity and racism that would accompany the dramas of Vietnam POW "homecoming" and the return of the American hostages from Iran, he argues that the exhibit "represented the limit of an official *liberal* discourse in the cold war era. The peaceful world envisioned by *The Family of Man* is merely a smoothly functioning international market economy, in which economic bonds have been translated into spurious sentimental ties, and in which the overt racism appropriate to earlier forms of colonial enterprise has been supplanted by the 'humaniza-

tion of the other' so central to the discourse of neocolonialism" (ibid., 21), emphasis original.

102 James Clifford, *The Predicament of Culture: Twentieth-Century Ethnography, Literature, and Art* (Cambridge, Mass.: Harvard University Press, 1988), pp. 191–93.

103 Clifford, *Predicament of Culture*, p. 197.

104 Clifford takes up this question in *The Predicament of Culture*, asking "how is unruly experience transformed into an authoritative written account?" with reference to the work of anthropologists. "How, precisely, is a garrulous, overdetermined cross-cultural encounter shot through with power relations and personal cross-purposes circumscribed as an adequate version of a more or less discrete 'other world' composed by an individual author?" (p. 25). We can substitute the work of the photographer for that of the writer; the problem of representing human differences is the same.

105 Leroi Jones (Amiri Baraka), *Blues People: Negro Music in White America* (New York: William Morrow, 1963) p. 99, cited in Michael Rogin, "Blackface, White Noise: The Jewish Jazz Singer Finds His Voice," *Critical Inquiry* 18, no. 3 (spring 1992):448; Rogin, ibid., pp. 419–21. Compare Stuart Hall's contention that the central issues of race always appear in articulation with other categories and divisions, and Stallybrass and White's notion that "disgust bears the imprint of desire"—in other words, "repellent elements repressed from white consciousness and projected onto black people were far from securely alienated; they are always already 'inside,' part of 'us.'" Hall, "New Ethnicities," in Kobena Mercer, ed., *Black Film/British Cinema* (London: ICA, 1988); Stallybrass and White, *Politics and Poetics of Transgression*, cited in Lott, *Love and Theft*, pp. 8, 149.

106 Lott traces an American tradition of class abdication, even a return to adolescence, through gendered, cross-racial immersion in the works of Melville, Whitman, Twain, Stephen Foster; and he finds in the embrace of black culture by Margaret Fuller and Constance Rourke—as a source of our national "folk culture"—a set of racial attitudes and cultural styles that in the United States go by the name of "bohemianism" (*Love and Theft*, pp. 16–17, 52). Stallybrass and White argue that "for white Americans the racial repressed is by definition retained as a (usually eroticized) component of fantasy. . . . The racial partitioning so necessary to white self-presence opens up the white Imaginary. . . . [W]hite subjectivity . . . is a mobile, conflictual fusion of power, fear and desire" absolutely dependent on the Otherness it seeks to exclude" (*Politics and Poetics of Transgression*, p. 5, cited in Lott, ibid., pp. 149–50).

107 If Barbara Millstein is correct in her belief that Kanaga's bisexuality was a closely guarded secret (conversation with the author, March, 1994), then this might well be what the blackness she "tried on" in the darkroom stood for.

108 I am drawing here on Mary Russo's "Female Grotesques: Carnival and Theory," in Teresa de Lauretis, ed., *Feminist Studies/Critical Studies* (Bloomington: Indiana University Press, 1986), p. 213.

109 Russo, "Female Grotesques," pp. 214, 218–19. See Mikhail Bakhtin, *Rabelais and His World*, trans. Helene Iswolsky (Cambridge, Mass.: MIT Press, 1968). See also Mary Douglas, *Purity and Danger: An Analysis of Concepts of Pollution and Taboo* (London: Routledge, Kegan, Paul, 1966); Victor Witter Turner, *From Ritual to Theater: The*

Human Seriousness of Play (New York: Performing Arts Journal Publications, 1982) and *The Ritual Process: Structure and Anti-Structure* (Chicago: University of Chicago Press, 1968); Stallybrass and White, *Politics and Poetics of Transgression*.

V "THE ONLY GENTILE AMONG THE JEWS": DOROTHEA LANGE'S DOCUMENTARY PHOTOGRAPHY

1 Rosalind Krauss, "Tracing Nadar," *October* 5 (1978), reprinted in Thomas F. Barrow, Shelley Armitage, and William E. Tydeman, eds., *Reading into Photography: Selected Essays, 1959–1980* (Albuquerque: University of New Mexico Press, 1982), p. 120.

2 *Dorothea Lange Looks at the American Country Woman,* exhibit catalog, foreword by Beaumont Newhall (Fort Worth, Texas: Amon Carter Museum, 1967), pp. 8–9. Lange's statement is a little misleading. As a study of the microfiche or microfilm at the Library of Congress and of the Dorothea Lange collection at the Oakland Museum make clear, Lange took groups of photographs when she was at work on any project, generally working closer and closer to her subject. The difference she speaks of is that in her later work she makes the single image part of another group of unrelated images, playing with the body of her work to tell some other story.

3 *American Country Woman,* p. 9.

4 See the films *Dorothea Lange: Under the Trees,* edited and directed by Philip Greene and Richard Moore, produced by Robert Katz, and *Dorothea Lange: The Closer for Me,* edited and directed by Greene, Katz, and Moore for KQED, San Francisco, and National Educational Television, released in 1965 and 1966. See also Milton Meltzer, *Dorothea Lange: A Photographer's Life* (New York: Farrar, Straus & Giroux, 1978).

5 Lange used the generic "man" or "he," even to refer to herself, as in the extracted quotation. A large number of the photographs in Edward Steichen's *The Family of Man* exhibit at the Museum of Modern Art in 1955 were by Lange. See Allan Sekula's reading of this exhibit as a glorification of patriarchal authority in "The Traffic in Photographs," *Art Journal* 41 (spring 1981):15–25.

6 Checklist for *Dorothea Lange* exhibit, January 24–March 27, 1966, Museum of Modern Art, New York, available at the Division of Prints and Photographs, Library of Congress, Washington, D.C.

7 I follow common practice in identifying as FSA photography the U.S. government documentary photography project, housed at the Library of Congress as the FSA-OWI Collection and directed by Roy E. Stryker from 1935 to 1943. When this photograph was made in 1936, Lange would have been on assignment for the Resettlement Administration, created under the direction of Stryker's Columbia economics professor Rexford G. Tugwell in order to resettle the nation's poorest farmers, establish rural cooperative enterprises, and carry out rehabilitation programs through grants and loans to tenants and small farmers. In December of 1936 the RA was transferred to the Department of Agriculture, Tugwell resigned, and Secretary of Agriculture Henry A. Wallace appointed Will Alexander of the agency he now renamed the Farm Security Administration. From 1937 to 1942 Stryker's sense of the agency's mission was expanded from collecting pictures that celebrated the agency's success to assembling a

comprehensive pictorial record of America. As the United States prepared to enter the Second World War, the FSA began emphasizing programs that boosted domestic productivity, and in 1942 the photographic section was transferred to the Office of War Information to document war efforts and carry out propaganda assignments. Taking several staff photographers with him when he shifted to the OWI, Stryker sought to maintain the momentum of the RA-FSA picture file. In 1955, archivist Paul Vanderbilt described the overall undertaking as "virtually a continuation, using the same techniques." See Carl Fleischhauer and Beverly W. Brannan, eds., *Documenting America, 1935–1943* (Berkeley and Los Angeles: University of California Press, 1988), introduction, pp. 1–13.

8 Checklist for *Dorothea Lange* exhibit; *Dorothea Lange: The Making of a Documentary Photographer,* an oral history conducted by Suzanne Riess (Berkeley: Regional Oral History Office, Bancroft Library, University of California, 1968), p. 74, subsequently cited as Lange-Riess interview. Robert Coles attributes Lange's focus on mothers and children to her own childhood and to her difficulty in balancing her commitment to her work, which necessitated frequent travel, with the mothering of children and stepchildren; he reproduces another photograph of this damaged child with her family that (like Lange's) includes mother and brother in *Photographs of a Lifetime,* exhibit catalog (Oakland, Calif.: Aperture, 1982), p. 29. Also see text, pp. 25–26.

9 Lange-Riess interview, p. 18. See Meltzer, *Dorothea Lange;* Karin Becker Ohrn, *Dorothea Lange and the Documentary Tradition* (Baton Rouge: Louisiana State University Press, 1980); Robert Coles, "Dorothea Lange and the Politics of Photography," *Raritan* 1, no. 2 (fall 1981):19–53, revised and expanded for the *Aperture* exhibit catalog, *Photographs of a Lifetime,* and published in another version as "The Human Factor: The Life and Work of Dorothea Lange," *Camera Arts* 3, no. 2 (Feb. 1983):34–49, 83–87; William Stott, "Introduction to a Never-Published Book of Dorothea Lange's Best Photographs of Depression America," *exposure* 22, no. 3 (fall 1984):22–30; Christopher Cox, introduction, *Dorothea Lange* (New York: Aperture Masters of Photography series, no. 5, 1987); James Curtis, *Mind's Eye, Mind's Truth: FSA Photography Reconsidered* (Philadelphia: Temple University Press, 1989).

10 On the way in which Franklin D. Roosevelt "stage managed" his disability, projecting an image of resilient recovery, aided by a cooperative press that in general did not depict him as immobilized or confined to a wheelchair, see Sally Stein, "Peculiar Grace: Dorothea Lange and the Testimony of the Body," in Elizabeth Partridge, ed., *Dorothea Lange: A Visual Life* (Washington, D.C.: Smithsonian Institution Press, 1994), pp. 68–73. See also Hugh Gregory Gallagher, *FDR's Splendid Deception* (New York: Dodd, Mead, 1985). Lange always wore pants or long skirts and, as James Curtis suggests, called attention to her upper body with hand gestures, often repeated—at her suggestion—by the subjects of her photographs (*Mind's Eye,* pp. 63–67).

11 Edmund Plowden, a seventeenth-century jurist, cited in Michael Paul Rogin, "The King's Two Bodies: Lincoln, Wilson, Nixon, and Presidential Self Sacrifice," in *Ronald Reagan, the Movie, and Other Episodes in Political Demonology* (Berkeley and Los Angeles: University of California Press, 1987), pp. 81–82.

12 Elaine Scarry, *The Body in Pain: The Making and Unmaking of the World* (New York:

Oxford University Press, 1985), pp. 5, 14, 20–21, 206–207.

13 Lange-Riess interview, p. 11.

14 Ibid., p. 2, emphasis original.

15 Ibid., pp. 17–18.

16 Ibid.

17 Ibid., p. 16.

18 *Paul Schuster Taylor, California Social Scientist,* an oral history conducted by Suzanne Riess, vol. 1 (Berkeley: Regional Oral History Office, Bancroft Library, University of California, 1973), pp. 132–33, subsequently cited as Taylor-Riess interview.

19 Ibid., p. 133.

20 Ibid., p. 226.

21 Lange-Riess interview, pp. 13–14.

22 Ibid., pp. 14–15, emphasis original. Thanks to Jules Chametzky for the Yiddish transliterations.

23 Ralph Ellison's *Invisible Man* is the classic example of the uses of invisibility, but there are also numerous examples in photography and film: Diane Arbus's trying on of alien experience; Cindy Sherman's multiple masquerades; Gertrude Käsebier's American Indian subjects turning their heads to the side to avoid her gaze, a gesture repeated by the young "Josef Stalin" when he is captured by the Germans and forced to stand for his photograph in Agniezska Holland's film *Europa, Europa.*

24 Lange-Riess interview, pp. 60–61., emphasis added.

25 Lange-Riess interview, pp. 118–19; Edith Lewis, *Willa Cather Living: A Personal Record* (Lincoln: University of Nebraska Press, 1953; reprint, 1976), pp. 168–73.

26 See Bonnie Yochelson, "Clarence White Reconsidered: An Alternative to the Modernist Aesthetic of Straight Photography," *Studies in Visual Communication* 9, no. 4 (fall 1983):24–44.

27 Lange-Riess interview, pp. 22–23, 147, emphasis original.

28 Ibid., p. 18.

29 William Stott, "Introduction to a Never-Published Book," 24.

30 Lange-Riess interview, pp. 144–45.

31 Alfred Stieglitz, "Four Happenings," *Twice-a-Year* 8–9 (1942):130.

32 Allan Sekula, "On the Invention of Photographic Meaning," *Artforum* (Jan. 1975):42.

33 Lange-Riess interview, pp. 144–46.

34 Dorothea Lange, interview by Richard K. Doud, May 22, 1964, p. 58; transcript in the Archives of American Art, National Museum of American Art, Washington, D.C., reprinted in Howard M. Levin and Katherine Northrup, eds., *Dorothea Lange: Farm Security Photographs, 1935–1939,* 2 vols. (Glencoe, Ill.: Text-Fiche Press, 1980). "I saw these people," Lange also told Doud, referring to the migration of "Okies." "And I couldn't wait. I photographed it. I had those first ones. That was the beginning of the first day of the landslide that cut this continent, and it's still going on. . . . This shaking off of people from their own roots started with those big storms, and it was like a movement of the earth, you see, and that rainy afternoon I remember, because *I made the discovery.* It was up to that time unobserved. . . . I went home that day a discoverer, a real social observer. . . . I could have been like all the other people on the highway

that day and not seen it. As we don't see what's right before us. . . . But this I discovered myself. This thing they call social erosion. I saw it. It was a day. That was a day *[N]o one helped me, and no one told me*" (vol. 2, pp. 69–70, emphasis added).

35 Lange-Riess interview, p. 155, emphasis added. Elsewhere, Lange and Taylor defined *documentary photography* as recording

> the social scene of our time. It mirrors the present and documents for the future. Its focus is man in his relation to mankind. It records his customs at work, at war, at play, or his round of activities through twenty-four hours of the day, the cycle of the seasons, or the span of a life. It portrays his institutions—family, church, government, political organizations, social clubs, labor unions. It shows not merely their facades, but seeks to reveal the manner in which they function, absorb the life, hold the loyalty, and influence the behavior of human beings. It is concerned with methods of work and the dependence of workmen on each other and on their employers. It is pre-eminently suited to build a record of change. Advancing technology raises standards of living, creates unemployment, changes the face of cities and of the agricultural landscape. The evidence of these trends—the simultaneous existence of past, present, and portent of the future—is conspicuous in old and new forms, old and new customs, on every hand. Documentary photography stands on its own merits and has validity by itself. A single photographic print may be 'news,' a 'portrait,' 'art,' or 'documentary'—any of these, all of them, or none. Among the tools of social science—graphs, statistics, maps, and text—documentation by photograph now is assuming place. Documentary photography invites and needs participation by amateurs as well as by professionals. Only through the interested work of amateurs who choose themes and follow them can documentation by the camera of our age and our complex society be intimate, pervasive, and adequate.

Dorothea Lange, "Documentary Photography," in Thomas J. Maloney, Grace M. Morley, and Ansel Adams, *A Pageant of Photography* (San Francisco: Crocker-Union, 1940), p. 29, cited in Robert J. Doherty, introduction to Levin and Northrup, eds., *Dorothea Lange*, vol. 1, pp. 34–35.

36 Lange-Riess interview, pp. 155–56, 157–58, emphasis added.

37 Beaumont Newhall argued that the documentary photographer "will put into his camera studies something of the emotion which he feels toward the problem, for he realizes that this is the most effective way to teach the public he is addressing. After all, is not this the root meaning of the word 'document' (*docere*, to teach)?" Cited in Meltzer, *Dorothea Lange*, p. 161.

38 Coles, *Photographs of a Lifetime*, pp. 41–42.

39 Coles's continual self-questioning and his numerous digressions in this essay suggest his identification with Lange in confronting problems of moral sensitivity in his own work. His wife functions as a sort of conscience in this piece, telling him, for example, "You are always *characterizing* the people we see! Why don't you let them *be?* Why don't you pay attention to each person in each family we visit, and stop trying to lump them together—first one way, then another!" "She insisted again and again, each child, each family, is different. Why not start out by recognizing *that,* and even documenting the varieties of difference?" *Photographs of a Lifetime*, p. 31, emphasis original.

40 Lawrence W. Levine, "The Historian and the Icon: Photography and the History of the American People in the 1930s and 1940s," in Fleischhauer and Brannan, eds., *Documenting America,* p. 31; Warren I. Susman, "History and Film: Artifact and Experience," in *Film & History* 15 (May 1985):30, cited in Levine, p. 31.

41 Roy E. Stryker and Nancy Wood, *In This Proud Land: America 1935–1943 as Seen in the FSA Photographs* (Greenwich, Conn.: New York Graphic Society, 1973), p. 19. In Beaumont Newhall's *The History of Photography* (New York: Museum of Modern Art, 1964), Stryker defined *documentary* as "an approach, not a technic; an affirmation, not a negation. . . . The documentary attitude is not a denial of the plastic elements which must remain essential criteria in any work. It merely gives these elements limitation and direction. Thus composition becomes emphasis, and line sharpness, focus, filtering, mood—all those components included in the dreamy vagueness 'quality'—are made to serve an end: to speak, as eloquently as possible, of the thing to be said in the language of pictures. . . . The job is to know enough about the subject matter to find its significance in itself and in relation to its surroundings, its time, and its function." Cited in Doherty, introduction to Levin and Northrup, eds., *Dorothea Lange,* p. 34.

42 Stott, "Introduction to a Never-Published Book," p. 28.

43 See Martha Rossler, "In, around, and afterthoughts (on documentary photography)," in Richard Bolton, ed., *The Contest of Meaning: Critical Histories of Photography* (Cambridge, Mass: MIT Press, 1989), pp. 316–17.

44 "The Assignment I'll Never Forget," *Popular Photography* 44, no. 2 (Feb. 1960):42–43, 126, reprinted in Beaumont Newhall, *Photography: Essays and Images* (New York: Museum of Modern Art, 1980), p. 264.

45 John Tagg, *The Burden of Representation: Essays on Photographies and Histories* (Amherst: University of Massachusetts Press, 1988), pp. 99–100.

46 Taylor-Riess interview, pp. 293–95. James Curtis suggests that Lange had a very particular order in mind, that she posed the migrant mother according to techniques that she had learned as a portrait photographer. See *Mind's Eye, Mind's Truth,* pp. 65–67. Curtis's judgment is borne out by an examination of the FSA files, which show Lange, on assignment, repeating over and over a pattern of approaching her subject from a distance and moving in closer and closer until she had *the* image.

47 Tagg, *Burden of Representation,* pp. 178, 156, emphasis original.

48 The republication of James Agee and Walker Evans's *Let Us Now Praise Famous Men* in 1960 signals the beginning of a new interest in documentary photography that increased throughout the sixties, culminating in William Stott's influential *Documentary Expression and Thirties America* (New York: Oxford University Press, 1973).

49 According to Paul Taylor, because Paul Kellogg, director and editor of *Survey* magazine, was interested "in photographs as a means of aiding an understanding of the [social] problems," he began alternating *Survey-Graphic* with *Survey.* "The middle of the month issue was the *Survey,* presenting text only. The first of the month issue was the *Survey-Graphic,* with copious illustrations, something like *The Nation, The New Republic,* or *The Outlook.* "It wasn't *just* like any of these, but more comparable to them than to *Life.* . . . [I]t preceded the development of social work as an organized profession. It became the organ of social workers when they really began to professionalize

themselves in the New Deal days." Taylor-Riess interview, pp. 113–14, emphasis original.

50 Cited in Alan Trachtenberg, *Reading American Photographs: Images as History, Mathew Brady to Walker Evans* (New York: Hill and Wang, 1989), pp. 192–93.

51 Paul S. Taylor, with photographs by Dorothea Lange, "From the Ground Up," *Survey-Graphic* 25 (Sept. 1936):526–27, 529, 537.

52 See Trachtenberg, "Camera Work, Social Work," in *Reading American Photographs.* Trachtenberg draws on George Herbert Mead, a colleague of John Dewey at the University of Chicago, in defining Hine's sense of "sociality" as "extending oneself by internalizing the voices of others, adopting their point of view as the condition for having a point of view of one's own. In order to foster social exchanges between his subjects and his viewers, and between himself and them, Hine attempted "to enter his pictures into the internal experience of his audience, to awaken in them an imaginative response which would issue in a revised identity, one which now acknowledges the imagined voices of his pictured workers as part of one's essential social world" (pp. 203–204).

53 Trachtenberg, ibid. John Tagg suggests that Hine was neither empathic nor alienated, and for this reason Stryker refused to hire him—"because there is no 'positive' element; because he doesn't show people with a potential to recover" (*Burden of Representation,* p. 192).

54 Stott, "Introduction to a Never-Published Book," p. 29, emphasis original.

55 Dorothea Lange and Paul Schuster Taylor, *An American Exodus: A Record of Human Erosion* (New York: Reynal and Hitchcock, 1939), p. 6; subsequent references cited parenthetically in the text. Taylor-Riess interview, p. 212.

56 Paul Schuster Taylor, "The Migrants and California's Future: The Trek to California and the Trek in California," Address to the Commonwealth Club of California, San Francisco, after October 15, 1935, reprinted in Levin and Northrup, eds., *Dorothea Lange,* vol. 2, p. 54. If there are echoes of Jacob Riis here, it is because Taylor *did* acknowledge both Riis and Hine as predecessors. "There is another man early in this tradition . . . and that is the Danish immigrant Jacob Riis, who wrote *How the Other Half Lives,* and illustrated it with photographs," he told Suzanne Riess, and referring to Hine's photographs of social situations as similar to his own work, but unknown on the West Coast (Taylor-Riess interview, pp. 116, 127).

57 Paul Schuster Taylor, "The Migrants and California's Future," p. 49.

58 Taylor-Riess interview, p. 219.

59 Paul Schuster Taylor, "What Shall We Do with Them?" Address to the Commonwealth Club of California, San Francisco, April 15, 1938, reprinted in Levin and Northrup, eds., *Dorothea Lange,* pp. 18–19.

60 Taylor-Riess interview, pp. 215, 217.

61 Taylor-Riess interview, pp. 240–41, emphasis original; Riess and Taylor refer to Beaumont Newhall's "Documentary Approach to Photography," *Parnassus* 10 (March 1938): 2–6.

62 Lange-Riess interview, pp. 173–74, 177, 217–18, emphasis added. It should be noted

that Lange's perspective here is that of looking back over a long career through the lens of memory. Back in 1937 she wrote to Stryker in quite a different vein: "My work on migratory labor has taught me the importance of adequate background when working on a large theme. It is not enough to photograph the obviously picturesque. The same is true of tenancy. . . . I welcome the opportunity to work on a new theme but my first concern is to obtain sufficient background for understanding of the problems. My brief trip and first look last summer will be a great help. Your meeting me and steering me will be another. (*Thanks* for the book. One I had intended to take.) I shall need all the education that can be injected." Dorothea Lange to Roy Stryker, April 27, 1937, Roy E. Stryker Papers, University of Louisville, Louisville, Kentucky, emphasis original.

63 Lange's documentary portraits are studio portraits out of doors, William Stott argues: "The subject is heroicized, made timeless through being separated from its ground and seen against a sky as pale and empty as a matte-silk backdrop. The central figure is backlit to give it thickness and texture; sometimes an edge blazes with brightness (shades of Genthe's flares!)." "Introduction to a Never-Published Book," p. 29. James Curtis argues that in making the six photographs in the "Migrant Mother" series, Lange worked in the manner of a portrait photographer, directing the movements of the participants, rearranging the materials of the setting, until she had what she wanted in the final image (*Mind's Eye,* pp. 47–67).

64 "Arnold Genthe was an unconscionable old goat," Lange recalled. "Yes, he was a real roué, a real roué. But what I found out when I worked for him was that this man was very properly a photographer of women because he really loved them. I found out something there: that you can photograph what you are really involved with. Now his seduction of women was only a part. He wasn't at all a vulgar man; he loved women. He understood them. He could make the plainest woman an illuminated woman. I watched him do it, right and left, and they all fell for it. . . . He was an artist, a real one, in a narrow way, but it was a deep trench." She remembered Clarence White as a man who "lived a kind of an unconscious, instinctive, photographic life. He didn't ever seem to know exactly that he knew where he was going, but he was always in it." In Lange's telling, White becomes a kind of link between her early memory of looking in the windows of Jewish families and her later memory of looking from her studio window down onto the street: "I remember [one of his photographs] . . . light coming in from the window and the whole thing was enveloped in a very delicate restrained light. . . . [H]e could surround figures with light." Lange-Riess interview, pp. 28–29, 42, 41.

65 Jerry Richardson, who kindly allowed me to reproduce this photograph and went to the trouble of having a copy negative made from the original silverprint, the only existing photograph, tells me that he is the pictured babe and that the woman holding him is not his mother, but Gilpin's friend Betsy Forster, a nurse and sister to Richardson's grandmother, who knew of a baby up for adoption in Baltimore and brought him back to Nebraska.

66 See Barbara L. Michaels, *Gertrude Käsebier: The Photographer and Her Photographs*

(New York: Abrams, 1992), pp. 47, 50–53, 76–82, 95–96. The one exception is Käse-bier's *The Manger,* 1899, in which the "child" is swaddling only.

67 Caption for Library of Congress photograph LC-USF 34–18214-E.

68 Rossler, "In, around, and afterthoughts," p. 317.

69 Milan Kundera, *Immortality,* trans. Peter Kussi (New York: Grove Press, 1991; reprint, New York: HarperCollins, 1992), p. 37.

70 Lange-Riess interview, pp. 138–39.

71 Curtis suggests that Lange, the portrait photographer, must have suggested to the subject of this photograph (and others) that she raise her hand to her face; he connects this expressive gesture to Lange's own deliberate use of her hands to distract attention from her withered leg (*Mind's Eye,* p. 66).

72 "Nothing" is an exaggeration. As Therese Heyman points out, Lange was exploring the "primitive yet meditative" quality of American Indian life with her camera at this time; she was also learning about the importance of the horizon on these trips to the Southwest (made from 1923 to 1931). Her series *Clouds, Southwest* demonstrate this growing visual awareness, distinct from her experience as a studio photographer. It is likely that these photographs influenced Dixon in his shaping of visual space. More-over, Lange's 1922 portrait of Dixon—a lone, heroic figure silhouetted against a vast expanse of sky—bears a strong resemblance both to his paintings of the mid-1930s and to many of her later FSA photographs. Therese Thau Heyman, with contributions by Daniel Dixon, Joyce Minick, and Paul Schuster Taylor, *Celebrating a Collection: The Work of Dorothea Lange* (Oakland: The Oakland Museum of California, 1978), pp. 50–53.

73 Lange-Riess interview, p. 139. Lange told a local reporter who was interviewing her as Dixon's "silent partner" that it was "simple" for one artist to be married to another artist—"Simple, that is, when an artist's wife accepts the fact that she has to contend with many things other wives do not. She must first realize that her husband does not work solely to provide for his family. He works for the sake of his work—because of an inner necessity. To do both of these things successfully, he needs a certain amount of freedom—freedom from the petty, personal things of life. An artist's work is great only as it approaches the impersonal. As Maynard's wife, it is my chief job to see that his life does not become too involved—that he has a clear field." Cited in Christopher Cox, introduction, *Dorothea Lange,* p. 7. The difference in tone between the two interviews is not due just to the difference in Lange's age (an elderly woman speaking to Suzanne Riess, a young woman speaking to an anonymous reporter); certainly, the earlier re-porter, whom I take to be male, lacks Riess's great sensitivity in *The Making of a Docu-mentary Photographer.* Given the fact that Lange would soon abandon the "job" of "silent partner," the straight telling of both the reporter and Cox, who repeats the reporter's story, misses the probable irony of her response to a nosy interviewer. She told Riess of her life with Maynard Dixon: "All the years that I lived with him, which were fifteen years, I continued to reserve a small portion of my life . . . out of some sense that I had to—and that was my photographic area" (p. 97).

74 Ibid., pp. 153, 218–20.

75 Ibid., pp. 73–74.

76 Taylor-Riess interview, pp. 150, 297–98.

77 Caroline Bird, *The Invisible Scar* (New York: McKay, 1966), cited in Paula Rabinowitz, *Labor and Desire: Women's Revolutionary Fiction in Depression America* (Chapel Hill: University of North Carolina Press, 1991), p. 17.

78 Lange-Riess interview, p. 147. Lange often referred to the importance of visual memory. Realizing "the great visual importance of what's in people's snapshots that they don't know is there," she told Richard Doud that her first over-the-counter job in San Francisco was "one of the things that guided me finally into documentary work." And she valued Maynard Dixon for his "extraordinary visual memory, beyond anything I've ever encountered." Doud-Lange interview, reprinted in Levin and Northrup, eds., *Dorothea Lange,* vol. 2, p. 56; Lange-Riess interview, p. 97; Rabinowitz, *Labor and Desire,* p. 3.

79 Josephine Herbst, "Yesterday's Road," *New American Review* 3 (1968):84–85, cited in Rabinowitz, *Labor and Desire,* p. 39.

80 John Berger points out that the Greek word for "porter" is *metaphor,* a reminder of how deeply the act of transporting is intrinsic to the imagination. *And our faces, my heart, brief as photos* (London: Writers and Readers, 1984), p. 92.

81 Curtis, *Mind's Eye,* pp. 7–8. Smith's text in *An American Exodus* continues: "On westward, into the . . . Great Plains, marched this army of settlers, but here the battle turned against them and they were thrown back by hundreds of thousands. But his battlefield of their defeat, of the triumph of their enemies is not marked by tablets, monuments, and the usual signs of victory. A lion does not write a book, nor does the weather erect a monument at the place where the pride of a woman was broken for want of a pair of shoes, or where a man worked five years in vain to build a home and gave it up, bankrupt and whipped, or where a baby died for the want of good milk, or where the wife went insane from sheer monotony and blasted hope" (p. 103).

82 I use Lange's term "sequence" here as she did—not as a sequence of images in a photo-assignment, the order of which has been preserved in the microfilmed FSA collection at the Library of Congress, or in a photo project, such as the groups of photographs at the Oakland Museum, but as a group of images from the body of her work that, with their captions, fit together only insofar as Lange chose to group them to tell a particular story. For a good example of the photo-assignment, see Beverly Brannan's selection from the 97 images in the FSA Imperial Valley series on migrant workers in *Documenting America,* pp. 114–27.

83 Alan Trachtenberg, "From Image to Story," in Fleischhauer and Brannan, eds., *Documenting America,* pp. 45, 57.

84 In *Celebrating a Collection: The Work of Dorothea Lange,* Therese Heyman repeats Stott's judgment that the subjects of photographs in the second edition are "figures in history whose hardship the present viewer is incapable of easing—symbols of timeless sorrow. The photographs insist we sympathize far less than the earlier version; they are acquiring the coolness of art" (p. 81). The collection that this volume celebrates contains some forty thousand photographs and Lange projects, manuscripts, journals, correspondence, and interviews donated to the Oakland Museum by Paul Taylor after Lange's death. See William Stott, *Documentary Expression and Thirties America* (New

York: Oxford University Press, 1973; reprint, Chicago: University of Chicago Press, 1986), p. 230.

85 Taylor-Riess interview, p. 212; Partridge interview cited in Heyman, *Celebrating a Collection,* pp. 84–85. Heyman notes that "Telling a good story, cowboy style, was also a favorite pastime of Maynard Dixon, whose poems reflected passages of Southwest 'gab.' Letters from Dixon's made-up character, 'Drygulch Dick'—a cowpoke to stand for all cowpokes—were answered in like manner by Lange, who proved to be just as good at the game." She distinguishes, however, between the "narratives" that accompanied Lange's photographs, which *were* faithful to the original, and the way in which Margaret Bourke-White and Erskine Caldwell simulated words "that might have been said" (p. 85, emphasis original). Lange worked very hard on her captions, writing to Stryker on April 2, 1937, for example, that "I've worked on this job until I'm shaky in the knees. Please hold on to the captions." In an October 6, 1937 letter, she told Stryker: "I am writing captions until my fingers ache to say nothing of my head. This is no small job. Didn't realize myself until I got down to it and looked this over in the quiet of my own workroom just how sizeable [*sic*] it is. Am not sending it on to you in sections, as I had originally planned to do because I am making cross-references. . . . Had a hard pull the first few days getting it going but see it coming along in good chunks every day now. . . . It's not the individual captions that takes the time but it's the arrangement and grouping. If this is not done I believe that half the value of field work is lost" (Stryker Papers).

86 Martha Rossler, a contemporary documentary photographer, is struggling here to define her own work in terms of the history of documentary photography in the United States, and although her sense of her purpose should not be read back onto Lange, she does offer important insights into the problem of representation, especially with regard to the way women have used quotation to document both the voices of the unrepresented as subjects of history *and* their own authenticity as makers of history. Rossler means "quotation" in its visual as well as verbal sense. Late-twentieth-century artists Barbara Kruger, Jenny Holzer, and Sherrie Levine, for example, use quotation to question, undermine, and appropriate official historical constructions; Diane Arbus used it to make the normal strange or the strange normal; and Lange's quotation of the migrant mother gave the woman's words and (Lange's) picture a place in history, although Florence Thompson herself and whatever else there was to her story remained unknown. Rossler, "In, around, and afterthoughts," pp. 326–27, emphasis added.

87 All of these words, title and caption cut, are run together in the Newhalls's *Dorothea Lange Looks at the American Country Woman,* which, in appending the passage from J. Russell Smith's *North America,* cited in *An American Exodus* and reproduced here in note 81, offers the most distorted of readings.

88 Maren Stange reproduces Lange's full caption, sent to Stryker, in *Symbols of Ideal Life: Social Documentary Photography in America, 1890–1950* (Cambridge, England, and New York: Cambridge University Press, 1989): "We made good money a pullin' bolls, when we could pull. But we've had no work since March. When we miss, we set and

eat jest the same. The worst thing we did was when we sold the car, but we had to sell it to eat, and now we cant get away from here. We'd like to starve if it hadn't been for what my sister in Enid sent me. When it snowed last April we had to burn beans to keep warm. You cant get no relief here until you've lived here a year. This county's a hard county. They wont help bury you here. If you die, you're dead, that's all" (p. 121). Therese Heyman suggests that even in its abbreviated form, the woman's desperate statement is "at the same time—like much migrant talk—a conscious denial of despair" (*Celebrating a Collection*, p. 85).

89 Taylor wrote to William Stott in 1971 that neither he nor Lange "gave thought to including the second photograph in *An American Exodus*. The [first] photograph was made at the moment the woman spoke the words quoted, and neither of us doubted that this was the one that belonged in *An American Exodus*. The second photograph was made *after* she had uttered the quoted words, and was reflective rather than tortured." Cited in Stott, *Documentary Expression*, reprint, p. 231, emphasis original.

90 I omit Arthur Rothstein's well-known photograph of a father and two sons fleeing a dust storm in this discussion of Lange's work; the original *An American Exodus* contains two Rothstein images and photographs by J. H. Ward, Hust Studio, Rondal Partridge, Horace Bristol, and Otto Hagel.

91 Taylor quotes Oklahoman Lon Gilmore's letter to the *Dallas Farm News*, May 16, 1939: "Deer, wild turkeys, elk and buffaloes originally roamed the prairies. Then man entered the picture with his gun and killed the buffaloes by the thousands for their hides, and left their bones to dry on the sun-bleached plains. This was the first violation of the law of nature as God intended. . . . Then man entered with his tractors and plows to break up for cultivation the millions of acres of land, plowing under the natural cover crop. . . . Then came old Mother Nature with her dust storms, in answer to Man's ruthless violations" (*American Exodus*, p. 103).

92 Dorothea Lange to Roy Stryker, December 7, 1938. Lange had earlier identified her own work with the larger purposes of the FSA when she wrote to Stryker: "My hope is that this will make a solid contribution to the files—and I think it will be" (October 6, 1937, Stryker Papers).

93 Quoted in Wood and Stryker, *In This Proud Land*, p. 7, this passage is cited by both Alan Trachtenberg in "From Image to Story," p. 59, and John Tagg in *The Burden of Representation*, p. 183. On Stryker's sense of himself as a historian, see, for example, his letter to Caroline Ware of May 10, 1940, in which he writes that "the task of the social historian is to collect the fugitive items of a period and arrange them in what seems to him a logical pattern. . . . [I]n photography, the historian has . . . a new edge to this tool . . . a potent raw material from which to compound new histories. . . . A new material for the loom of the historian is in the making" (Stryker Papers).

94 See the appendix, "The FSA-OWI Collection," to Fleishhauer and Brannan, eds., *Documenting America*, pp. 330–42. The order of the 88,000 images (this figure does not include several thousand more uncatalogued negatives, those gathered from other sources, and those which Stryker "killed" by punching holes in them) in the FSA-OWI file means that it is impossible to follow the work of a particular photographer or a

photographic assignment without also using the microfilmed collection, which preserves the original ordering of images. Trachtenberg, "From Image to Story," pp. 56–57, 64, emphasis original. One might note the eliding of Stryker's, Vanderbilt's, and Trachtenberg's purposes and predispositions here in the creation of this structure; nevertheless, "From Image to Story" is a brilliant reading.

95 Rabinowitz offers a different argument from that made by "metahistorians" such as Louis Althusser, Fredric Jameson, or Hayden White, which claims that by means of "emplotment," "history slides into its other"—narrative—"a story with subjects, causes and effects and endings, . . . a telos that traces their temporal and spatial patterns to an inevitable conclusion." The subjects constructed through such narratives are not in fact so unified, nor are their movements so teleological, Rabinowitz insists. Rather, the work of narrative "is a mapping of differences, and specifically, of sexual difference," as Teresa de Lauretis shows. Rabinowitz, *Labor and Desire*, p. 93. See Rabinowitz's discussion in *Labor and Desire* (pp. 8–9) of Louis Althusser's *For Marx*, trans. Ben Brewster (London: New Left Books, 1977), and *Lenin and Philosophy*, trans. Ben Brewster (London: New Left Books, 1971), Fredric Jameson's *The Political Unconscious: Narrative as a Socially Symbolic Act* (Ithaca, N.Y.: Cornell University Press, 1981); Hayden White's *Metahistory: The Historical Imagination in Nineteenth-Century Europe* (Baltimore: Johns Hopkins University Press, 1973); and Teresa de Lauretis's *Alice Doesn't: Feminism, Semiotics, Cinema* (Bloomington: Indiana University Press, 1984) and *Technologies of Gender: Essays on Theory, Film, Fiction* (Bloomington: Indiana University Press, 1987).

96 Meridel Le Sueur, "Women on the Breadlines," *New Masses* 7 (Jan. 1932):5–7; Richard Wright, *American Hunger* (New York: Harper and Row, 1977), cited in Rabinowitz, *Labor and Desire*, pp. 2–3, 37, 39.

97 See Rabinowitz, *Labor and Desire*, p. 93. See also Nina Baym, "Melodramas of Beset Manhood," op. cit.

98 See Nicholas Natanson, *The Black Image in the New Deal: The Politics of FSA Photography* (Knoxville: University of Tennessee Press, 1992). The Lange photograph captioned in *An American Exodus*—"Hoers going back to work after lunch on a Mississippi Delta plantation, part of day-labor gang hauled by truck out of Clarksdale"—is paired in Edwin Rosskam and Richard Wright's *12 Million Black Voices* with the famous photograph of the Clarksdale plantation owner and his field hands and with this text: "More than one-half of us black folk in the United States are tillers of the soil, and three-fourths of those of us who till the soil are sharecroppers and day laborers. . . . [M]ighty artists . . . have painted one picture: charming, idyllic, romantic; but we live another: full of the fear of the Lords of the Land, bowing and grinning when we meet white faces, toiling from sun to sun, living in unpainted wooden shacks that sit casually and insecurely upon the red clay. In the main we are different from other folk in that, when . . . we are moved to better our lot, we do not ask ourselves: 'Can we do it?' but: 'Will they let us do it?' Before we black folk can move, we must first look into the white man's mind to see what is there, to see what he is thinking, and the white man's mind is a mind that is always changing" (New York: Viking, 1941; reprint, New York: Thunder's Mouth Press, 1988), pp. 30–35.

99 This tends to be true in the file as well, where portraits of racial others are both more picturesque and more embodied: see, for example, Lange's photographs from Georgia, Alabama, North Carolina, and Mississippi; particularly striking are the sensual "Two Negro women with bundles," Macon, Georgia, July 1936 (LC-USF 34–9467-E) and "The daughter of a Negro tenant churning butter," Randolph Co., N.C., July 1939 (LC-USF 34–20211-E), a Walker Evans–like still life.

100 In the FSA file, a slightly different version of this photograph (where "Ma Burnham" is identified as "Old Lady Graham") appears with the photograph of the fruit jars; in *The American Country Woman,* her photograph appears with the one of her Arkansas land, in both cases linking woman to place. The text reproduced in *An American Exodus* is nearly the same as the caption Lange wrote for the file.

101 Taylor-Riess interview, pp. 217–18; Dorothea Lange to Roy Stryker: Jan. 12, 1938; October 20, 1937; April 2, 1937 (Stryker Papers).

102 Scarry, *The Body in Pain,* pp. 63, 64, 70, 80.

103 John Hughes, a radio commentator, was the first to demand evacuation of Japanese Americans from the Pacific Coast early in January 1942. Donald Pike and Roger Olmsted, "The Japanese in California," in Maisie and Richard Conrat, *Executive Order 9066: The Internment of 110,000 Japanese-Americans* (Cambridge, Mass.: MIT Press, 1972), p. 21.

104 Exceptions were the Santa Anita racetrack in California, which held 18,000, and Mayer, Arizona, which held only 247. Deborah Gesenway and Mindy Roseman, *Beyond Words: Images from America's Concentration Camps* (Ithaca, N.Y.: Cornell University Press, 1987), p. 43.

105 See Lauren Kessler, "Fettered Freedoms: The Journalism of World War II Japanese Internment Camps," *Journalism History* 15, nos. 2–3 (summer/autumn 1988):71. See also Pike and Olmsted, "The Japanese in California"; Dorothy Swaine Thomas and Richard S. Nishimoto, *The Spoilage* (Berkeley and Los Angeles: University of California Press, 1946); and Daniel S. Davis, *Behind Barbed Wire: The Imprisonment of Japanese-Americans During World War II* (New York: Dutton, 1982).

106 Pike and Olmsted, "The Japanese in California," p. 23. See also Gesenway and Roseman, *Beyond Words;* Edward H. Spicer, *Impounded People: Japanese Americans in the Relocation Centers* (Washington, D.C.: War Relocation Authority, U.S. Government Printing Office, 1946); Dorothy S. Thomas, *The Salvage: Japanese-American Evacuation and Resettlement* (Berkeley: University of California Press, 1952); Allen R. Bosworth, *America's Concentration Camps* (New York: Norton, 1967); Roger Daniels, *Concentration Camps USA: Japanese-Americans and World War II* (New York: Holt, Rinehart and Winston, 1971); Dillon S. Myer, *Uprooted Americans: The Japanese Americans and the War Relocation Authority During World War II* (Tucson: University of Arizona Press, 1971); Daniel S. Davis, *Behind Barbed Wire,* Richard Drinnon, *Keeper of Concentration Camps: Dillon S. Myer and American Racism* (Berkeley and Los Angeles: University of California Press, 1987); David J. O'Brien and Stephen S. Fugita, "The Concentration Camp Experience," in *The Japanese-American Experience* (Bloomington: Indiana University Press, 1991); and firsthand accounts such as John Modell, ed., *The Kikuchi Diary: Chronicle from an American Concentra-*

tion Camp (Urbana: University of Illinois Press, 1973); John Tateishi, *And Justice for All: An Oral History of the Japanese American Detention Camps* (New York: Random House, 1984); *Kinenhi, Reflections on Tule Lake* (San Francisco: Tule Lake Committee, 1980); Miné Okubo, *Citizen 13660* (Seattle: University of Washington Press, 1983).

107 Edison Tomimaro Uno, introduction to *Executive Order 9066,* pp. 10–11. Within the camps, Japanese Americans did "speak" to one another in the form of camp newspapers, but Kessler argues that all camp newspapers, even those that functioned without direct interference, operated under strict censorship and restraint. "Fettered Freedoms," pp. 70–79.

108 Lange-Riess interview, p. 189. Visitors to the Still Pictures Branch of the National Archives in Washington, D.C., where the WRA documents are stored, can still note "Impounded" written across some of Lange's photographs. Richard and Maisie Conrat, who published *Executive Order 9066* in 1972, discovered some 25,000 photographs of the evacuation when they began to work on this project. Most of the images in their exhibit catalog are Lange's, but also included are works by Ansel Adams, Clem Albers, J. D. Bigelow, Russell Lee, Francis Stewart, and unidentified photographers.

109 Pike and Olmsted, "The Japanese in California," p. 15.

110 U.S. Army, Western Defense Command and Fourth Army, *Final Report: Japanese Evacuation from the West Coast, 1942* (Washington, D.C.: Department of State, U.S. Government Printing Office, 1943), pp. 8–9.

111 Taylor-Riess interview, p. 229.

112 H. Bruce Franklin traces the roots of the Japanese incarceration to *fictions* of a half-century earlier, concurrent with the major influx of Japanese immigration to the United States. Early works such as J. H. Palmer's *The Invasion of New York; Or, How Hawaii Was Annexed* (1897) and Marsden Manson's *The Yellow Peril in Action* (1907) portray Japanese in vicious racial terms as the enemy. In Ernest H. Fitzpatrick's *The Coming Conflict of Nations; Or the Japanese American War* (1909) millions of Japanese troops, aided by a fifth column of Japanese workers in California, conduct apocalyptic battles against the American army in Idaho and Montana. General Homer Lea's *The Valor of Ignorance,* a 1909 invasion fantasy, was reprinted in 1942 just after the invasion of Pearl Harbor, with an introduction by Claire Booth (Luce) that hailed it as a brilliant prophecy. *War Stars: The Superweapon and the American Imagination* (New York: Oxford University Press, 1988), pp. 39–40. More recently, Franklin has shown that films about the war in Vietnam "take images of the war . . . deeply embedded in America's consciousness and transform them into their opposite." Thus, "Americans are pushed from helicopters, a sadistic Asian general puts his pistol to the temple of a prisoner and shoots, exactly reproducing the familiar photograph, but the victim here is an American, and so on, to produce a veritable album of images reversing photographs already known to American audiences in which the Vietnamese were the victims." Review by Diane Johnson of Franklin's *MIA or Mythmaking in America* (Brooklyn, N.Y.: Lawrence Hill Books, 1992) in *The New York Review* (April

8, 1993):25. On the (by comparison) benign manipulation by New Deal photographers see James Curtis, *Mind's Eye,* and Pete Daniel, Merry Forresta, Maren Stange, and Sally Stein, *Official Images: New Deal Photographers* (Washington, D.C.: Smithsonian Institution Press, 1987). On technological manipulation, see Fred Ritchin, "Photojournalism in the Age of Computers," in Carol Squiers, ed., *The Critical Image: Essays on Contemporary Photography* (Seattle: Bay Press, 1990), pp. 28–37.

113 Tagg, *Burden of Representation,* p. 150.

114 See Fleischhauer and Brannan, eds., *Documenting America,* pp. 240–51. A few of Lee's photographs are also included in Maisie and Richard Conrat, *Executive Order 9066.*

115 In response to the question of how Lange was received with her camera by the victims of this racial episode, Taylor recalled that "the Japanese were very grateful to her." When Lange and Taylor traveled later to visit former prisoners, "they received us—well, like guests. One of the evacuees, Dave Tatsuno, had been my student in the 1920s. . . . Of *their* gratitude—in 1967, the 25th Anniversary of the evacuation, the Japanese American Citizens League gave a banquet and honorary plaques to a dozen or so people. Well, they gave me one. That was for Dorothea. . . . When the Tatsunos came back from the camps, they came to our home here, with their children. They played under the oak tree, and Dave filmed it. Dave gave me the film, and I gave it to the Oakland Museum. It is a hand-movie film of Dorothea and me with his children climbing around in that oak" (Taylor-Riess interview, p. 233, emphasis original).

116 Taylor-Riess interview, pp. 229–30; Lange-Riess interview, p. 191. According to Taylor, Lange went to work for the WRA because the "information man for War Relocation" had held that position with the Social Security Board, whose regional director Lange and Taylor knew well. "So when they wanted a photographer, he knew Dorothea and me, knew her work, and got her onto his staff" (Taylor-Riess interview, pp. 228–29). Lange felt that Attorney General Earl Warren was one of those who acted inappropriately at this time: "and it was a black thing on his record when he lost his head and made some very rash statements, which have never really caught up with him" (Lange-Riess interview, p. 191; see Riess's note on the Warren testimony, p. 192).

117 Cited in Tagg, *Burden of Representation,* p. 165.

118 Lange-Riess interview, pp. 193–94.

119 Ibid., pp. 185–88, emphasis original.

120 *Conversations with Ansel Adams,* an oral history conducted by Ruth Teiser and Catherine Harroun for the Sierra Club Oral History Series (Berkeley: Bancroft Regional Oral History Office, University of California, Berkeley, 1978), pp. 23, 25, hereafter cited as Adams-Teiser-Harroun interview.

121 Ansel Adams, *Born Free and Equal: The Story of Loyal Japanese-Americans* (New York: U.S. Camera, 1944), p. 9. Compare Adams's comment to Alfred Stieglitz in 1934 that he was "dreadfully tired of being used as a tool for radical interests—artists in the main are asked to do 'Proletarian' work, photographers are asked to photograph May Day celebrations, old human derelicts in a dingy doorway, evictions, underpaid workers, etc. I grant that times are portentious, but I'll be damned if I see the real

rightness of being expected to mix political economy and emotion *for a purpose*. . . . I do not like being expected to produce propaganda. Half of my friends have gone frantic Red." Cited in Nancy Newhall, *Ansel Adams: The Eloquent Light* (San Francisco: Sierra Club, 1964), p. 98, emphasis original.

122 See Karin Becker Ohrn, "What You See Is What You Get: Dorothea Lange and Ansel Adams at Manzanar," *Journalism History* 4, no. 1 (spring 1977):14–22, 32. A parallel can be drawn between photographs and the camp newspapers. Kessler points out that the accommodationist *Nisei* newspapers, such as the *Heart Mountain Sentinel,* had "the clean, competent look of a good small-town newspaper"; the (Tule Lake) *Tulean Dispatch* represented the most troubled of all the camps but was little more than an information bulletin; and the *Rohwer Outpost,* from a relatively quiet camp with tense moments, was an amateur, mimeographed publication somewhere between these extremes. "Fettered Freedoms," pp. 72–77.

123 Adams-Teiser-Harroun interview, p. 24, emphasis original.

124 Ibid., pp. 57, 25.

125 Adams, *Born Free and Equal,* pp. 10, 13, 24, 106, 112. "I photograph heads as I would photograph sculpture," Adams said. "The head or figure is clearly presented as an *object.* The edge, mass, texture of the skin and general architecture of the face and form is [*sic*] revealed with great intensity. The expression—many possible expressions—are implied." Nancy Newhall, *Ansel Adams,* cited in Ohrn, *Dorothea Lange and the Documentary Tradition,* pp. 139–40. According to Lange's son Daniel Dixon, Adams could photograph "rocks as if they were people," present people "as if they were rocks" (Rondal Partridge, interview by Karin Becker Ohrn, May 29, 1974, cited in ibid., p. 141).

126 Lange-Riess interview, p. 190. "That's Ansel," Lange told Riess. "He doesn't have much sense about these things. He was one of those at the beginning of the war who said—they'd had Japanese in their home always as house help and that was characteristic of his household—he said he saw the point. 'You never get to know them,' and all this. He gave the regular line, you know, but he wasn't vicious about it. He's ignorant on these matters. He isn't acutely aware of social change. . . . [but] it was far for *him* to go, far. He felt pretty proud of himself for being such a liberal [in] that book" (ibid., p. 191, emphasis original). Adams was displeased with the technical quality of the book but took pride in its documentation. "The people had done a wonderful job of adjusting to the inevitable," he said, "and I think that my series of pictures and the text of my book was a rather acceptable interpretation. It did not have the tragic overtones of Lange's work, although there was always a lingering sense of resentment and regret." Ansel Adams, interview by Karen B. Ohrn, April 2, 1975, cited in Ohrn, *Dorothea Lange and the Documentary Tradition,* p. 148.

127 Lange-Riess interview, pp. 194, 193, 187, 189.

128 See David Travis, "Setting Out from Lobos: 1925–1950," in *Watkins to Weston: 101 Years of California Photography, 1849–1950,* exhibit catalog (Santa Barbara: Santa Barbara Museum of Art, Roberts-Rinehart, 1992), p. 126 n. 12; and Dennis Reed, *Japanese Photography in America, 1920–1945* (Los Angeles: Japanese-American Cultural and Community Center, 1985).

129 This is John Tagg's argument about slum photos of Leeds, England, in the 1890s in *The Burden of Representation,* p. 151.

130 Lange-Riess interview, p. 181.

131 Pare Lorentz, "Dorothea Lange: Camera with a Purpose," cited in Doherty, introduction to *Dorothea Lange,* vol. 1, p. 37; Lange-Riess interview, p. 214, emphasis original.

132 See Ohrn, *Dorothea Lange and the Documentary Tradition,* p. 166; see also the Greene, Katz, Moore film, *Dorothea Lange: The Closer for Me,* and Dorothea Lange and Daniel Dixon, "Photographing the Familiar," *Aperture* 1, no. 2 (1952):4–15.

133 Taylor-Riess interview, p. 228, emphasis original.

134 Lange-Riess interview, p. 183.

135 Partridge-Ohrn interview, cited in Ohrn, *Dorothea Lange and the Documentary Tradition,* p. 56, emphasis original.

136 Taylor-Riess interview, p. 279; Taylor also recalled that Egyptian subjects "would pass the hand, with five fingers, or anything numbering five, between themselves and Dorothea. She'd photograph them and they would pass the hand with open palm back and forth before their face in the line of sight of the camera. For a long time she didn't know what that meant. . . . Finally, someone explained to her, 'Well, they think you have the evil eye'" (Taylor-Riess interview, p. 280).

137 Daniel Dixon, "Dorothea Lange," *Modern Photography* 16, no. 2 (Dec. 1952):141; Dorothea Lange and Daniel Dixon, "Photographing the Familiar," 9.

138 Scarry, *The Body in Pain,* p. 279.

139 I have avoided the word *sentiment,* which in its relation to sentience is the right word, but which so often slides into "sentimental" in discussions of Lange. (For example, Stott finds "[T]he pictures . . . [to be] sentimental . . . but not *that* sentimental," in "Introduction to a Never-Published Book," p. 23, emphasis original.) The German word *empfindsamkeit,* with its connotations of sensitivity and susceptibility, comes closest to the quality Stott (and others) cannot quite name. In the film made at the end of her life, *The Closer for Me,* Lange described her interactions with the subjects of her portraits made over a forty-year period in this way: "The human face is the universal language. The same expressions are readable, understandable, all over the world. It is the only language that I know—communicative thing—that is really universal. Its shades of meaning, its explosions of emotion and passion, all concentrate on just this part of the human anatomy, where a slight twinge of just a few muscles runs the gamut of that person's potential." Cited in Ohrn, *Dorothea Lange and the Documentary Tradition,* p. 223. The key to understanding this language, she told Suzanne Riess, is having an "educated heart": "Dürer, . . . way back in fourteen hundred and something, said 'I draw from the secrets of my heart.' And that's what I have in the end. That's what it comes to and that's the best. Provided, of course, you've got an educated heart and a sense of some kind of general responsibility. The secret places of the heart are the real mainsprings of one's action" (Lange-Riess interview, p. 216).

140 Scarry, *The Body in Pain,* pp. 281, 324.

VI THE BODY'S GEOGRAPHY: FEMALE VERSIONS OF LANDSCAPE

1 Meridel Le Sueur, "The Ancient People and the Newly Come," in *Growing Up in Minnesota*, ed. Chester G. Anderson (Minneapolis: University of Minnesota Press, 1976); reprinted in Elaine Hedges, ed., *Ripening: Selected Work, 1927–1980, Meridel Le Sueur* (Old Westbury, N.Y.: Feminist Press, 1982), p. 39.

2 Michael Taussig, *Mimesis and Alterity: A Particular History of the Senses* (New York and London: Routledge, 1993), pp. 176–77.

3 Gertrude Stein, *The Geographical History of America, or The Relation of Human Nature to the Human Mind* (New York: Random House, 1936; reprint, New York: Vintage, 1973), pp. 60–63.

4 Jean Baudrillard, *America,* trans. Chris Turner (Material Word; Paris: Bernard Grasset, 1986; London and New York: Verso, 1988), pp. 5, 126. The Richardson illustration is used only in the Verso, translated edition. Compare the recent special to the *New York Times* from Bozeman, Montana: "A Plan for Yellowstone's Problem Grizzlies: Put Them on Display." Lewis Robinson III of West Yellowstone, president of the Firehold Land Corporation, has won approval from the State Department of Fish, Wildlife, and Parks for his "Grizzly Discovery Center," which would put bears in enclosures and erect "a giant-screen theater near the park's western entrance to show movies of Yellowstone's features" (including bears). "It's been an eight-year dream," Mr. Robinson said of his plans, which include a hotel, museum, and retail stores. *New York Times,* June 27, 1993, sec. I, p. 14.

5 Deborah Bright, "Of Mother Nature and Marlboro Men: An Inquiry into the Cultural Meaning of Landscape Photography," in Richard Bolton, ed., *The Contest of Meaning: Critical Histories of Photography* (Cambridge, Mass.: MIT Press, 1989), pp. 128–29; Baudrillard, *America,* p. 126.

6 Bright, "Of Mother Nature," pp. 129–30, 138. For John Szarkowski, "coherent ways of looking and thinking about the world" began with Alberti and Columbus, "the fifteenth century's two great rationalizers of space"; even nineteenth-century romantics link feeling to form, as in Wordsworth's "To every natural form . . . / I gave a moral life: I saw them feel, / or linked them to some feeling" (*The Prelude*). Like some latter-day Nathaniel Hawthorne or Henry James, Szarkowski argues that nineteenth-century America had little landscape art because it had little landscape: "what was there was for the most part wilderness—from an artistic point of view, chaos." What photographers like Timothy O'Sullivan do is impose form on chaos; thus, Szarkowski's *American Landscapes* begins with photographs from the survey project, celebrating O'Sullivan's views for their "originality and formal beauty" and the photographer for his "mutant, native talent, the kind of natural grace by which a great dancer or singer seems possessed"; it includes only two images by women, one by Dorothea Lange, one by Laura Gilpin (among three by Ansel Adams, two by Stieglitz, two by Strand, five by Weston, and so on). John Szarkowski, *American Landscapes: Photographs from the Collection of the Museum of Modern Art* (New York: Museum of Modern Art; Boston: New York Graphic Society, 1981), pp. 5–7.

7 Rosalind E. Krauss, "Phototography's Discursive Spaces," in *The Originality of the Avant-Garde and Other Modernist Myths* (Cambridge, Mass.: MIT Press, 1985), pp. 136–41.

8 Paul Shepard, *Man in the Landscape* (New York: Knopf, 1967), pp. 108–109, 234–35. See also Carolyn Merchant, *The Death of Nature: Women, Ecology, and the Scientific Revolution* (San Francisco: Harper & Row, 1980).

9 Gretchen Garner, *Reclaiming Paradise: American Women Photograph the Land,* exhibit catalog (Duluth: University of Minnesota Duluth, Tweed Museum of Art, 1987); Merchant, *Death of Nature,* pp. xvi–xvii, cited in ibid., pp. 5–7.

10 Garner, *Reclaiming Paradise,* p. 7. See Barbara Novak, "On Divers Themes from Nature, a Selection of Texts," in Kynaston McShine, *The Natural Paradise: Painting in America, 1800–1950* (New York: Museum of Modern Art, 1976), pp. 60–102; Annette Kolodny, *The Lay of the Land: Metaphor as Experience and History in American Life and Letters* and *The Land Before Her: Fantasy and the Experience of the American Frontiers, 1630–1860* (Chapel Hill: University of North Carolina Press, 1975 and 1984); Susan Griffin, *Made from this Earth: An Anthology of Writings* (New York: Harper and Row, 1982); Linda Connor's presentation to the Silver Mountain Foundation on women and landscape, *Aperture* 93 (winter 1982):48–50; Milton Meltzer, *Dorothea Lange: A Photographer's Life* (New York: Farrar, Straus & Giroux, 1978), p. 321.

11 Garner, *Reclaiming Paradise,* p. 7; Connor, presentation to Silver Mountain Foundation, 49; Bright, "Marlboro Men," 138, emphasis original. See also Sherry B. Ortner, "Is Female to Male as Nature Is to Culture?" in Michelle Zimbalist Rosaldo and Louise Lamphere, eds., *Woman, Culture, and Society* (Stanford, Calif.: Stanford University Press, 1974); Susan Griffin, *Woman and Nature: The Roaring Inside Her* (New York: Harper & Row, 1978); Merchant, *Earthcare: Women and the Environment* (New York: Routledge, 1996).

12 Elizabeth Hampsten, "Land in Space and Time," in Garner, *Reclaiming Paradise,* pp. 10–11; John R. Stilgoe, *Common Landscape of America, 1580–1845* (New Haven, Conn: Yale University Press, 1982), pp. 3, 24.

13 John Berger, "Millet and the Peasant," in *About Looking* (New York: Pantheon, 1980), pp. 75–76.

14 Hampsten, "Land in Space and Time," in Garner, *Reclaiming Paradise,* p. 10.

15 Ibid., p. 11. The text of the letter reads: "We took food along to the fields and while the children played I worked with your father. The children and I, of course, would leave a little earlier in order to build a fire in our wood range and have a nice hot meal waiting for Papa. When he got home, I brought the cows in from the field and milked them and watered and tended our other animals for the night. Then I returned to the house to finish making dinner and put the children to bed. When Father came home, tired and hungry, dinner was ready for him. After dinner I finally had time to do my washing for the children and prepare for the next day's baking. And so day after day passed by, becoming months and years." North Dakota Historical Society of Germans from Russia, *Der Staammbaum* (Feb. 1979):7, cited in Hampsten, p. 11.

16 Cathy Luchetti and Carol Olwell, *Women of the West* (Berkeley, Calif.: Antelope Island Press; reprint, New York: Orion Books, 1992).

17 See, for example, Kevin Starr's view that Carleton Watkins's widely distributed views of Yosemite helped to establish the image of California as a symbol for "beauty, grandeur, expansiveness, a sense of power, and a sense—this in the geological history—of titanic preparation for an assured and magnificent future." *Americans and the California Dream, 1850–1915* (New York: Oxford University Press, 1973), p. 183. See also Szarkowski, *American Landscapes,* pp. 5–15; Estelle Jussim and Elizabeth Lindquist-Cock, *Landscape as Photograph* (New Haven, Conn.: Yale University Press, 1985); Weston J. Naef and James N. Wood, *Era of Exploration: The Rise of Landscape Photography in the American West 1860–1885,* exhibit catalog (New York: Metropolitan Museum of Art, 1975); Alan Trachtenberg, "Naming the View," in *Reading American Photographs: Images as History, Mathew Brady to Walker Evans* (New York: Hill and Wang, 1989); Rosalind Krauss, "Photography's Discursive Spaces." In her introduction to Garner's *Reclaiming Paradise,* Martha A. Sandweiss also sees the origins of American landscape photography in the survey project.

18 Susan Prendergast Schoelwer, "The Absent Other: Women in the Land and Art of Mountain Men," in Jules David Prown et al., *Discovered Lands, Invented Pasts: Transforming Visions of the American West,* exhibit catalog (New Haven, Conn.: Yale University Art Gallery, Yale University Press, 1992), pp. 134–36. For the documentation of women's presence on the frontier, see Susan Armitage and Elizabeth Jameson, eds., *The Women's West* (Norman: University of Oklahoma Press, 1987); Lillian Schlissel, *Women's Diaries of the Westward Journey* (New York: Schocken, 1982) and Schlissel et al., eds., *Western Women: Their Land, Their Lives* (Albuquerque: University of New Mexico Press, 1988); Patricia Nelson Limerick, *The Legacy of Conquest: The Unbroken Past of the American West* (New York: Norton, 1987); Sylvia Van Kirk, *Many Tender Ties: Women in Fur-Trade Society, 1670–1870* (Norman: University of Oklahoma Press, 1980); Vera Norwood and Janice Monk, eds., *The Desert Is No Lady: Southwestern Landscapes in Women's Writing and Art* (New Haven, Conn.: Yale University Press, 1987). For contrasting celebratory and revisionist perspectives on the art of the West, see Alan Axelrod, *Art of the Golden West* (New York: Abbeville, 1990), and William H. Truettner, ed., *The West as America: Reinterpreting Images of the Frontier, 1820–1920,* exhibit catalog (Washington, D.C.: Smithsonian Institution Press, 1991).

19 Schoelwer, "Absent Other," p. 143; Van Kirk, *Many Tender Ties,* passim. Depicting nearly incessant labor in his watercolor *Making Moccasins,* Miller noted that "everybody here wears them [moccasins] in preference to either boot or shoe," but he does not account for the crucial importance of native women (who also produced winter snowshoes) to the fur trade. Miller's comments on childbirth during the expedition further confirm the presence of women traveling with fur traders: "We have seen a female detach herself from the caravan, and in a few short hours return again, as if nothing particular had happened. In the meantime, however, a child had been born into the world." Miller's catalog raisonné lists several versions of erotic pictures of native women, suggesting that these images were popular with his (male) patrons. Peter Rindisbacher also documented the presence of native women; Schoelwer suggests that his work is relatively unknown because his images of "Indians" of mixed

parentage—for example, *In the Tepee* (undated, reproduced in Schoelwer)—display a cross-cultural contact and amalgamation counter to prevailing interests in portraying American Indians as an ethnographically pure race. Marvin C. Ross, ed., *The West of Alfred Jacob Miller (1837): From the Notes and Water Colors in the Walters Art Gallery,* rev. ed. (Norman: University of Oklahoma Press, 1968), pp. 174, 188; Alvin M. Josephy Jr., *The Artist Was a Young Man: The Life Story of Peter Rindisbacher* (Fort Worth: Amon Carter Museum of Western Art, 1970), pp. 5, 36, 65–71; both cited in Schoelwer, pp. 142–43, 146. Rayna Green argues that white men polarized native women in what she calls the "Virgin-Whore paradox," elevating the noble "Indian Princess" (as in Miller's *The Trapper's Bride*) and portraying her darker sister, the "Squaw," as overtly sexual. Schoelwer suggests that these dichotomized female figures may also express the white man's traditional ambivalence to the American landscape—as virgin garden to be husbanded and made productive or as lush wilderness to be conquered and plundered at will. Rayna Green, "The Pocahontas Perplex: The Image of Indian Women in American Culture," *Massachusetts Review* 16 (1975):698–714, cited in Schoelwer, p. 153.

20 See Bright, "Marlboro Men," pp. 126–27; see also John R. Stilgoe, *Metropolitan Corridor: Railroads and the American Scene* and *Borderland: Origins of the American Suburb, 1820–1939* (New Haven, Conn.: Yale University Press, 1983 and 1988); Kenneth Jackson, *Crabgrass Frontier: The Suburbanization of the United States* (New York: Oxford University Press, 1985). Yosemite, Sequoia, and General Grant national parks were established in 1890, the Federal Forest Reserve System was set up in 1891, the Sierra Club was founded in 1892 and published its first *Bulletin* (which included photographs) in 1893, the year of Frederick Jackson Turner's famous address on the closing of the frontier. *The Sierra Club Century, 1892–1992,* a special issue (77, no. 3 [May/June] 1992) of *Sierra,* the magazine of the Sierra Club, reprints some early photographs from the club's archives in the Bancroft Library, University of California, Berkeley. See also *Celebrating the American Earth,* a promotional publication of the Wilderness Society (n.d., received by the author in 1993) that continues this tradition, with essays by Ansel Adams and John Szarkowski.

21 Lucy R. Lippard, ed., introduction to *Partial Recall: Photographs of Native North Americans* (New York: The New Press, 1992), pp. 38, 42–43.

22 Hampsten, "Land in Space and Time," p. 11.

23 William M. Murray, "Clouds in Landscape Photography," *Camera Notes* 2, no. 3 (Jan. 1899):83. The article is illustrated with photographs of women by Frances Benjamin Johnston and F. Holland Day.

24 Letter from Anne Brigman to Frank Crowninshield, editor of *Vanity Fair,* Oct. 6, 1915, Stieglitz Archives, Beinecke Library, Yale University, New Haven, Conn.

25 Emily Martin, "Science and Women's Bodies: Forms of Anthropological Knowledge," in Mary Jacobus, Evelyn Fox Keller, and Sally Shuttleworth, eds., *Body/Politics: Women and the Discourses of Science* (New York: Routledge, 1990), p. 69, drawing upon the work of Evelyn Fox Keller and Christine Grontkowski, "The Mind's Eye," in *Discovering Reality: Feminist Perspectives on Epistemology, Metaphysics, Methodology, and Philosophy of Science* (Dordrecht, Netherlands: D. Reidel, 1983); Richard Rorty, *Philosophy and*

the Mirror of Nature (Princeton, N.J.: Princeton University Press, 1979); and Johannes Fabian, *Time and the Other: How Anthropology Makes Its Object* (New York: Columbia University Press, 1983).

26 James Clifford, "Partial Truths," introduction to James Clifford and George E. Marcus, eds., *Writing Culture: The Poetics and Politics of Ethnography* (Berkeley: University of California Press, 1986), p. 12; Stephen A. Tyler, "Post-Modern Ethnography: From Document of the Occult to Occult Document," in *Writing Culture,* p. 137.

27 Ralph Waldo Emerson, "The American Scholar" (1838) and "Nature" (1836), in Stephen E. Whicher, ed., *Selections from Ralph Waldo Emerson* (Boston: Houghton Mifflin, 1957), pp. 65, 22.

28 Virginia Woolf, "The Mark on the Wall," in *A Haunted House and Other Short Stories* (New York: Harcourt, Brace, Jovanovich, 1949; reprint, Harcourt, Brace & World, 1972), p. 45. Leonard Woolf, who collected these stories after Virginia Woolf's death, does not date this story, which he describes as an unfinished sketch.

29 Marilyn Strathern, "An Awkward Relationship: The Case of Feminism and Anthropology," *Signs* 12, no. 2 (winter 1987):288, 290. See also Ruth Behar and Deborah A. Gordon, *Women Writing Culture* (Berkeley and Los Angeles: University of California Press, 1996).

30 In the Galle engraving, "dis-covers" is a literal translation of the Latin *retexit*—uncovers or disrobes; the rest of the (translated) text reads, "and then he was immediately aroused (excited)." Thanks to Deborah Fryer for this translation. With reference to Courbet, Michael Fried goes so far as to propose that the artist's depictions of women are actually representations of his own body (as other). This suggests the interesting connection Taussig draws between mimesis and alterity—that is, a "putting on" of another's skin—in his book *Mimesis and Alterity;* for further discussion, see chapter 4 in this volume.

31 *Imogen Cunningham: Portraits, Ideas, and Design,* an oral history conducted by Edna Tartaul Daniel (Berkeley: Regional Oral History Office, Bancroft Library, University of California, 1961), pp. 113–14, subsequently cited as Cunningham-Daniel interview. In her correspondence with Stieglitz, Brigman shows how problems with the techniques of developing and printing were a constant source of concern to her. Stieglitz Archives, Beinecke Library.

32 Clarence King, "The Falls of Shoshone," *Overland Monthly* 5 (Oct. 1870):381–85, cited in Trachtenberg, *Reading American Photographs,* pp. 130–31, 142. See chapter 3 in this volume for a discussion of King's expressed attraction/repulsion toward "savage" women, a personal and cultural conflict that he undoubtedly projects onto native lands as well.

33 Cunningham-Daniel interview, pp. 87–88. Cunningham goes on to say that when she made her own studies of nudes in the landscape, she had not yet seen *September Morn,* which would be shown at the San Francisco Fair of 1915, but that such things were "in the air."

34 In her essay, "Encouraging the Artistic Impulse: The Second Generation, 1890–1925," Therese Thau Heyman argues that other California photographers were representing scantily clad or nude women in dreamy landscapes, but that there were striking differ-

ences between such subjects by men like Arthur Kales or Roger Sturtevant and those by Brigman. *Watkins to Weston: 101 Years of California Photography, 1849–1950,* exhibit catalog (Santa Barbara, Calif.: Santa Barbara Museum of Art, 1992), p. 61.

35 Rosalind Krauss, "Alfred Stieglitz's 'Equivalents,'" *Arts* 54 (Feb. 1980):134.

36 *Camera Work* 50 and Paul Rosenfeld, *Musical Chronicle* (New York: Harcourt Brace, 1923):6, cited in Sarah Greenough, "How Stieglitz Came to Photograph Clouds," in Peter Walch and Thomas F. Barrow, eds., *Perspectives on Photography: Essays in Honor of Beaumont Newhall* (Albuquerque: University of New Mexico Press, 1986), pp. 158–59.

37 Krauss, "Equivalents," 136.

38 Brigman also presented herself as adoring, even worshipful. She could range in the same letter from "If some day you wonder why your left ear burns—you will know that I am swearing like a pirate at you and about you," to "if it [her show at gallery 291] must be shunted for another year—why I'm determined to wear crepe and a sad sweet smile." She defended Stieglitz in one letter as "having standards so high that the majority can't come up to it," compared him in another to Satan in *Paradise Lost,* who "would rather reign alone in Hell than be an underling in Heaven," and in another addressed him as her "dear old Warhorse" and "you brave lad": "you're such a dear, so human, Alfred Stieglitz—so clear sighted, so rudely honest—so merciless and yet so merciful—and most of all a friend." Letters from Anne Brigman to Alfred Stieglitz, Feb. 19, 1907; May 24, 1908; and July 18, 1914, Stieglitz Archives, Beinecke Library.

39 Brigman, "Foreword," July 30, 1939, Stieglitz Archives, Beinecke Library, p. 1.

40 In her letters to Stieglitz between 1906 and 1919, Brigman presents herself as the master's disciple—for example, closing her letter of March 27, 1906 with "I praise the powers that call you the 'Dictator'—I salam [*sic*] with all the respect I posess [*sic*]," often asking for advice about developing and printing her negatives and eager for recognition in *Camera Work*. Stieglitz Archives, Beinecke Library.

41 Brigman, "Foreword," pp. 1–2. "The few figures I have used through the years of the mountain series," Brigman wrote of her models, "were slim, hearty, unaffected women of early maturity, living a hardy out-of-door life in high boots and jeans, toughened to wind and sun . . . cooking for weeks over a camp-fire with wood from the forest around us . . . carrying water from the icy lake at our feet . . . bearing and forbearing to the utmost" (ibid., p. 2).

42 Brigman, "Foreword," p 2.

43 See Therese Thau Heyman, ed., *Picturing California: A Century of Photographic Genius,* exhibit catalog (San Francisco: Chronicle Books, 1989), pp. 72–111; Martha Banta, *Imaging American Women: Idea and Ideals in Cultural History* (New York: Columbia University Press, 1987); Bram Dijkstra, *Idols of Perversity: Fantasies of Feminine Evil in Fin-de-Siècle Culture* (New York: Oxford University Press, 1986); Judith Fryer, *Felicitous Space: The Imaginative Structures of Edith Wharton and Willa Cather* (Chapel Hill: University of North Carolina Press, 1986), chapter 1.

44 In Cather's autobiographical novel *The Song of the Lark,* Thea Kronborg, standing naked and sundrenched in a stream, holding in her hands a shard from a pot made by an American Indian woman, literally finds her voice. In *The Professor's House,* Tom Outland returns to the mesa, where he had earlier focused on material relics, and lets

the land possess him: "That was the first night I was ever really on the mesa at all—the first night that all of me was there. This was the first time I ever saw it as a whole," he recounts. "The excitement of my first discovery was a very pale feeling compared to this one. For me the mesa was no longer an adventure, but a religious emotion." Willa Cather, *The Professor's House* (New York: Knopf, 1925), pp. 250–51.

45 Emily J. Hamilton, "Some Symbolic Nature Studies from the Camera of Annie W. Brigman," *The Craftsman* 12, no. 6 (Sept. 1907):664.

46 See Anne Ross, *Pagan Celtic Britain* (London: Routledge & Kegan Paul, 1967), p. 366. See also Erich Neumann, *The Great Mother* (Princeton: Princeton University Press, 1972): "The female powers dwell not only in ponds, springs, streams and swamps, but also in the earth, in mountains, hills, cliffs and—along with the dead and the un-born—in the underworld. And above all, the mixture of the elements water and earth is primordially feminine; it is the swamp, the fertile muck, in whose uroboric nature the water may equally be experienced as male and engendering and as female and lifegiving" (p. 260). Both Ross and Neumann are cited in Lucy Lippard, *Overlay: Contemporary Art and the Art of Prehistory* (New York: Pantheon, 1983), pp. 64–65.

47 See Estelle Jussim, *Slave to Beauty: The Eccentric Life and Controversial Career of F. Holland Day, Photographer, Publisher, Aesthete* (Boston: Godine, 1981). The contrast between Day's project and Brigman's has to do with the explicit erotic pleasure in Brigman's as opposed to the suffering in Day's. American writers have played on this contrast, associating the female with an eroticism that is threatening to males: in Nathaniel Hawthorne's "The Maypole of Merrymount," erotic, feminine abandon is juxtaposed to the stern Puritan order; in Harold Frederic's *The Damnation of Theron Ware,* the temptations of eroticism are associated with both Greeks and females; in Edith Wharton's *The House of Mirth,* Lily Bart, who poses as a wood nymph before the mirror, does not go to church with those who ultimately judge her.

48 Cited in Therese Thau Heyman, *Anne Brigman: Pictorial Photographer/Pagan/Member of the Photo-Secession,* exhibit catalog (Oakland: The Oakland Museum of California, 1974), p. 3.

49 See Mary Ann Doane, "Film and the Masquerade—Theorising the Female Spectator," *Screen* 23, nos. 3–4 (Sept.–Oct. 1982):74–88. See also Erving Goffman, *The Presentation of Self in Everyday Life* (Garden City, N.Y.: Doubleday, 1959).

50 Louise Dahl-Wolfe, *A Photographer's Scrapbook* (New York: St. Martin's, Marek, 1984), pp. 4–5. Thanks to Lynn Fryerstein for the gift of this book.

51 Isadora Duncan, *My Life* (New York: Liveright, 1927), p. 176.

52 Cited in Abigail Solomon-Godeau, *Photography at the Dock: Essays on Photographic History, Institutions, and Practices* (Minneapolis: University of Minnesota Press, 1991), p. 229.

53 Imogen Cunningham, citing Rukeyser in her acceptance speech for the award from California College of Arts and Crafts, May 18, 1968, Cunningham Papers, Archives of American Art, National Museum of American Art, Washington, D.C.

54 Imogen Cunningham to Ansel Adams, June 15, 1970, Cunningham Papers, Archives of American Art. In a film made by Ann Hershey in which she sold grave plots, Cunning-ham also parodied Adams's television commercials for Datsun, which had offered to

plant a tree seedling for every test drive a customer took. Cited in Judy Dater, *Imogen Cunningham: A Portrait* (Boston: New York Graphic Society, 1979), p. 47. Although other photographers agreed that Cunningham was not a careful printer, none was so vitriolic as Adams in denouncing her. Willard Van Dyke, for example, said that "it wasn't important if the images often weren't all that sharp. It was her unique way of seeing things that was important, and we all respected her for that." Her photographer son Rondal Partridge, who often worked with her and who criticized her wasteful and sloppy darkroom technique, said, when he walked into her first big retrospective show, "I . . . saw the whole circle of all my mother's work and I stood there and I said, 'Wow! I've been underestimating her all my life!' At that moment I understood what Imo was all about." Cited in Dater, ibid., pp. 44, 61.

55 Mary Street Alinder writes of Adams's "assured and confident style that spoke of no one's vision but his own, . . . a grand, sweeping vision, triumphantly expressing the sentiments of Cézanne, 'The landscape thinks itself in me. . . . I am its consciousness.'" Diane Ackerman, *A Natural History of the Senses* (New York: Vintage, 1990), p. 227, cited in Alinder, "The Limits of Reality: Ansel Adams and Group f.64," in Therese Thau Heyman, ed., *Seeing Straight: The f.64 Revolution in Photography,* exhibit catalog (Oakland: The Oakland Museum of California, 1992), p. 49.

56 Cunningham to Ansel Adams, February 9, 1967, Cunningham Papers, Archives of American Art. "History" turns out to be somewhat gendered with regard to Cunningham. Women—critics and theorists, curators, collectors, other photographers—are overwhelmingly positive in their responses to her work, often taking her "as a kind of lodestar," whereas many men (though by no means all)—especially other photographers—criticize her technique (Brett Weston, Ansel Adams, Morley Baer) or find that "her photographs don't do for me what those of some other photographers do," as Stephen Goldstine expresses it (p. 57; see similar sentiments expressed by Brett Weston and Pirkle Jones). Interviews collected by photographer Judy Dater after Cunningham's death in *Imogen Cunningham: A Portrait.*

57 Cunningham made these notes for a lecture she was to give in 1965; cited in Dater, *Imogen Cunningham,* p. 14. In 1959 she had participated in a group show at the Pasadena Art Museum called "The Photograph as Poetry," but her acquaintance with the Indian writer Rabindranath Tagore goes back to 1914, when he visited the newly married Cunningham and Roi Partridge. Interview with Roi Partridge in Dater, ibid., p. 25.

58 Cited in Anita Ventura Mozley, "Imogen Cunningham: Beginnings," in *Discovery and Recognition* (Carmel, Calif.: Friends of Photography, 1981), p. 44. She noted for a lecture to be given at San Francisco State University in December 1963 that the successful portrait depended first of all on *empathy*—by which she meant not "aesthetic feeling on seeing a thing or a person" or "sympathy with a person," but something closer to the German *Sich in etwas einfühlen,* the almost impossible "feeling ourselves into and learning to know another, [which is] . . . largely an intuitive process . . . best perfected by time and experience." Cited in Dater, *Imogen Cunningham,* p. 15. Cunningham's first big retrospective show took place at Stanford University in 1957.

59 Ansel Adams, in John Paul Edwards, "Group f.64," *Camera Craft* 42, no. 3 (March

1935):110, cited in Michel Oren, "On the Impurity of Group f/64 Photography," *History of Photography* 15, no. 2 (summer 1991):125. The original members of Group f.64 were Ansel Adams, Imogen Cunningham, John Paul Edwards, Sonya Noskowiak, Henry Swift, Willard Van Dyke, and Edward Weston. The Group f.64 exhibit, which also included the work of Preston Holder, Consuelo Kanaga, Alma Lavenson, and Brett Weston, opened at the de Young Museum in San Francisco on November 15, 1932.

60 Edward Weston, "Photography—Not Pictorial," *Camera Craft* 37 (July 1930):320, cited in Naomi Rosenblum, "f.64 and Modernism," in Heyman, ed., *Seeing Straight,* p. 40; Nancy Newhall, *The Eloquent Light* (Millertown, N.Y.: Aperture, 1980), p. 69, cited in Alinder, "The Limits of Reality," pp. 43–44.

61 Manifesto prepared by members of Group f.64 and displayed in the exhibition held at the M. H. de Young Memorial Museum, San Francisco, November 15 through December 31, 1932; reprinted in Heyman, ed., *Seeing Straight,* p. 53.

62 *Conversations with Ansel Adams,* an oral history conducted by Ruth Teiser and Catherine Harroun (Berkeley: Regional Oral History Office, Bancroft Library, University of California, 1978), p. 181, cited in Alinder, "The Limits of Reality," p. 43. Cunningham would later say that although Adams liked to claim credit for the origins of Group f.64, it was really Willard Van Dyke's idea. See interview with Imogen Cunningham at the home of Imogen Cunningham, San Francisco, June 9, 1975, by Paul J. Karlstrom and Louise Katzman, p. 12, Cunningham Papers, Archives of American Art, and Cunningham-Daniel interview, p. 139.

63 Oren, "Impurity of Group f/64," p. 125, cited in Rosenblum, "f.64 and Modernism," p. 40. In "Setting Out from Lobos: 1925–1950," David Travis points out that, early in his career, Edward Weston was given an exhibit in the studio of Toyo Miyatake. *Watkins to Weston: 101 Years of California Photography,* p. 126 n. 12. See Dennis Reed, *Japanese Photography in America, 1920–1940* (Los Angeles: Japanese-American Cultural and Community Center, 1985).

64 John Paul Edwards, in Jean Tucker, *Group f.64* (St. Louis: University of Missouri Press, 1978), p. 20, cited in Rosenblum, "f.64 and Modernism," p. 40.

65 See the "Self-Portrait" section in Heyman, *Seeing Straight.*

66 Cunningham-Karlstrom-Katzman interview, Cunningham Papers, Archives of American Art, p. 9.

67 Interview for *Photographer's Journal and Camera,* March 19, 1975, interviewer not identified, transcribed by Valerie Bayliss, Cunningham Papers, Archives of American Art, p. 1. The earliest of these photographs, *Marsh—Early Morning* or *Marsh at Dawn,* now in the Alvin Langdon Coburn Collection of the International Museum of Photography at George Eastman House, is a soft print made in 1910 for Coburn after an original sharp print (now lost) from 1901. It is reproduced in *Imogen Cunningham: Photographs,* with an introduction by Margery Mann (Seattle: University of Washington Press, 1970). Cunningham processed her first film by candlelight in a tarpaper-lined darkroom her father made in the woodshed, despite his disdain for her chosen profession: "I can't see what all that study at the university will do if you're just going to be

a dirty photographer." Walli Zimmerman Curtis, "Women's News: Camera 'Dean' Back in Seattle," *Seattle Times* (May 20, 1965), p. 40, cited in Richard Lorenz, *Imogen Cunningham: Ideas without End* (San Francisco: Chronicle Books, 1994), p. 13.

68 "Perhaps to be more accurate, I should not have said that Clarence White was a victim of his times, but rather a product, as almost all of us are," Cunningham wrote to Peter Bunnell, then a graduate student at Ohio University at work on a master's thesis on White. "I know what I was thinking about when I wrote this, and that was a series of things in CAMERA WORK of both soft focus figures in long and flowing chemises (this word you must not use). BUT that was what I mean by the influence of his times. I have some stuff of my own about 1910–1912 in which I did a gal just so dressed and being blown about by the wind. I think the White ones were interested in a huge glass ball. You see what I mean, everybody was doing it." She was impressed at the time, she said, by "things of people in an orchard, charming and poetic. Also one of his sons at a rainy window, Mrs. White sitting in the middle of a dark room a perfect portrait. How can I say how much of an influence either Stieglitz or White were at the time or even later. I know only what interested me at the time." Letter to Peter Bunnell, Feb. 18, 1961, Cunningham Papers, Archives of American Art. White's wife Jane is the model for Käsebier's *The Bat*.

69 Charles Caffin, "Some Impressions from the International Photographic Exposition, Dresden," *Camera Work* 28 (Oct. 1909), cited in Mozley, "Imogen Cunningham," 43. Exhibitors included American, British, French, and Austrian photographers—among them Steichen and Stieglitz himself, represented by views of New York and by photographs made in France, Holland, and the Tyrol—all familiar to readers of *Camera Work* and to visitors of Stieglitz's gallery in New York. Cunningham would also have seen "Annie Brigman's nymphs and naiads, Clarence H. White's interior scenes, Alice Boughton's gentle nudes enacting 'The Dawn' or similar themes, and Baron Adolf de Meyer's portraits and still lifes." Mozley, ibid.

70 Ibid., pp. 44–45. There is a something of Cindy Sherman in this early Cunningham, who as a child collected and memorized Perry Pictures—sets of sepia printed illustrations of European art masterpieces—and in the first artistic work of her own creation posed her "other-worldly" friends—"they spent their spare time play-acting"—"in all manner of fairy tale charades. Typescript of article by Margery Mann for *Town & Country* (April 20, 1969):2, Cunningham Papers, Archives of American Art.

71 Cited in *IMOGEN! Imogen Cunningham Photographs: 1910–1973*, with an introduction by Margery Mann (Seattle: University of Washington Press), p. 34. According to Partridge, "I had been up at Mount Rainier sketching, and Imogen came up to visit me. She was photographing wherever she was, so she suggested I take my clothes off and pose for her. So there I was, sitting on a cake of ice and getting photographed in the buff. Luckily she was using soft focus lenses in those days, so the identification [in a Seattle newspaper] wasn't very exact." The distance between self and other might well have been augmented by Cunningham's pregnancy. The marriage between the two artists was rocky from the start. During the second pregnancy, because "she was apt to be upset when she was pregnant," Partridge recalled, "we decided it would be better if

I went away for a time." Cited in Dater, *Imogen Cunningham,* pp. 29, 26. See also Dater's interviews with Cunningham's sons, Gryffyd, Padriac, and Rondal, in ibid., pp. 21–25, 31–36. As her ex-husband (they were divorced in 1934), Partridge wrote to Cunningham upon receipt of the *Aperture* monograph that featured her, "The photo of the pregnant belly comes close to being repulsive." September 1, 1964, Cunningham Papers, Archives of American Art.

72 Imogen Cunningham to Elizabeth Broun, November 25, 1973. "On Mt. Rainier in 1915 were published in a local paper in Seattle at the time," Cunningham wrote to Broun on December 5, 1973. "They were dragged out and published [in Sept. 1970] in a paper called *RAGS,* since dead." Cunningham Papers, Archives of American Art.

73 Mann, typescript for *Town & Country,* p. 3. In his survey of male nudes in the nineteenth and twentieth centuries, Peter Weiermair points out that from the turn of the century to the First World War, the male nude was a common photographic subject for male photographers. *The Hidden Image: Photographs of the Male Nude in the Nineteenth and Twentieth Centuries,* trans. Claus Nielander (Cambridge, Mass., and London: MIT Press, 1988), p. 18. The fierce criticism directed at F. Holland Day's portrayals of black male nudes was the exception. His *Ebony and Ivory,* published in *Camera Notes* in 1898, must, like Cunningham's male nudes, have amounted to what Peter Stallybrass and Allon White identify as "transgressions": situations that reverse the norm. The frontispiece for their book, *The Politics and Poetics of Transgression* (Ithaca, N.Y.: Cornell University Press, 1986), is a lithograph called "The Topsy-Turvy World" (anonymous, from Nuremburg, 1830), which shows, among other examples, a horse in the driver's seat of a cart pulled by men, a cripple giving money to a gentleman, a lady sweeping while her maid plays the 'cello, and a pig mounting a man.

74 See Solomon-Godeau's comparison of Weston's studies of his son, Neil, as classical statuary in *Photography at the Dock,* pp. 260–61.

75 "If anyone was of great influence to me at that time [1910] it was Käsebier whose work I saw in 1901 and who really started me with the camera." Cunningham to Elizabeth Broun, November 25, 1973, Cunningham Papers, Archives of American Art. "I was self motivated, but I did see something of Gertrude Käsebier—and that's all I'm going to tell you about what started me off," she told the interviewer for *Photographer's Journal and Camera.* "It was the work of Gertrude Käsebier that interested me," she told Edna Daniel. "I can remember to this moment the things in one article in *The Craftsman:* her daughter standing in a doorway, her hand on her child—mother and child—things like that." Cunningham-Daniel interview, pp. 18–19.

76 Cunningham was a printer in Curtis's studio, but as she wrote to Minor White, who was preparing an *Aperture* monograph on her, it was not Curtis—"he seldom if ever turned up in the studio and if he did he never spoke to the help"—but A. F. Muhr "who influenced my life at that time. . . . He was the OPERATOR of the Curtis establishment" (May 20, 1964). "Mr. Muhr," she wrote to Roi Partridge, "did all the developing and the making of new and larger negatives. Also he was THE person who did all the so called commercial portraiture. The only portrait that I remember Curtis making was the wedding of Alice Roosevelt Longworth, and it was good. . . . I would

not say that he [Muhr] had anything to do with the work Curtis did on the Indians[,] certainly no changes by cropping or any other way. Curtis had a good eye and good technique but he could not pack a too large camera into the field so the smaller negatives were copied on large glass for you must remember that the platinum printing process is contact. I learned the platinum printing in that free semester and knew it very well when I got the job. It is not difficult. . . . Curtis never appeared with any helper as far as I know. I encountered him only twice in two years. He was a very busy field men [*sic*] and his onoy [*sic*] uncertainty so far as I could learn was with anthropology. He wanted to know it but did not have the background and hired a young man who was an incomplete student and may sometimes, slightly [have] misinformed him" (May 22, 1974). "Curtis didn't do anything in the studio," she told interviewers. "He just came and unpacked his bags and packed them up again and left. He was very different from his brother [Ashel,] . . . a man who did nature. He was interested in ecology before the work was invented. He really and truly was a marvelously generous man. Edward wasn't. Ed was a determined egoist and didn't see anybody who was inferior to himself. . . . Ashel gave me his studio and his darkroom for nothing." Cunningham-Karlstrom-Katzman interview, p. 12.

77 Minor White, introduction to *Imogen Cunningham,* special issue of *Aperture* 11, no. 4 (1964):160.

78 Cited in Dater, *Imogen Cunningham,* p. 12. "I knew Imogen Cunningham well," Consuelo Kanaga recalled. "I love this story because it's typical of her life. She had two twin redheaded little boys and another boy, all three of them dynamos. I went there one day for tea and couldn't breathe. The kids kept rolling around our feet and knocking tables and chairs over, wanting attention and being pests. Imogen said, 'Connie, you wait, I've set their tea party in the back of the house, and when they go to have it, you and I can have ours and have a few minutes together.' But before we could get one drop of tea in us, those kids had gulped all of theirs and come back to knock our tea over. They were just impossible, she had children, a husband, and a fairly large place to take care of . . . cooking, washing, ironing, shopping for clothes. At night, when her hellish big day was over, she'd go down in the laundry room where she had a little darkroom squeezed off in the corner and work at her photography. I've never known anyone with such will or such energy. I thought she was terrific, but I wouldn't have had that life. I couldn't have taken it, though I was inspired by the beautiful woman she was." Interview by Margaretta K. Mitchell, *Recollections: Ten Women of Photography* (New York: Viking, 1979), p. 159.

79 Dater, *Imogen Cunningham,* pp. 15–16.

80 Gina Harding, *AMSP*NC Newsletter,* no. 5 (July–August 1976), n.p. Cunningham Papers, Archives of American Art. This issue is a tribute to Cunningham after her death.

81 Interview by Dater in *Imogen Cunningham,* pp. 49–51.

82 Cunningham subscribed to a number of photographic periodicals, including German publications. From the latter she would have been aware of avant-garde work in German photography in the 1920s. Her photograph of Gertrude Gerrish from this period "is not only German in design and feeling, but seems to relate directly to the work of

German photographers such as Helmar Lerksi," Joan Murray suggests. "Certainly none of the f64 group did such images." "Looking at Imogen: Two Perspectives," part 2, *Artweek* 14, no. 15 (April 16, 1983):1.

83 Karl Blossfeldt's *Uniformen der Kunst* (Art Forms in Nature) and Albert Renger-Patzsch's *Die Welt Ist Schön* (The World Is Beautiful)—the latter "a model book of objects and things"—were well known outside Germany. Naomi Rosenblum, "Photography and Modernism," in *A World History of Photography* (New York: Abbeville, 1984; rev. ed., 1989), pp. 410–11. Cunningham also photographed machine forms; see, for example, her *Shredded Wheat Water Tower* (1928), reproduced in Rosenblum, ibid., p. 456.

84 This is even more clearly the case when one sees these images the way Cunningham would have viewed them in her ground glass—upside down: they become, for female photographer and female viewer, stunningly erotic expressions of female sexuality. See Thomas Joshua Cooper and Gerry Badger, "Imogen Cunningham: A Celebration," *British Journal of Photography* Annual (1978):127–28.

85 Lippard, *Overlay*, p. 50.

86 Cited in Laurie Lisle, *Portrait of an Artist: A Biography of Georgia O'Keeffe* (New York: Seaview Books, 1980), pp. 343, 211.

87 This is Elizabeth Duvert's view of O'Keeffe in "With Stone, Star, and Earth: The Presence of the Archaic in the Landscape Visions of Georgia O'Keeffe, Nancy Holt, and Michelle Stuart," in Vera Norwood and Janice Monk, eds., *The Desert Is No Lady*, p. 200.

88 See Michael Dames, *The Silbury Treasure: The Great Goddess Rediscovered* (London: Thames and Hudson, 1976) and *The Avebury Cycle* (London: Thames and Hudson, 1977).

89 Duvert, "With Stone, Star, and Earth," p. 210.

90 These are Duvert's words about O'Keeffe, "With Stone, Star, and Earth," p. 200.

91 Cited in Nancy Newhall, ed., *Edward Weston: The Flame of Recognition. His Photographs accompanied by excerpts from the Daybooks and Letters* (New York: Grossman, 1965), p. 100.

92 The show has been reproduced in its entirety in the recent exhibit at the Oakland Museum as *Seeing Straight: The f.64 Revolution in Photography*.

93 "Dad and Imogen were quite close as far as photography was concerned," Brett Weston would later say. "In fact at one point they were doing the same kinds of things Now as to which one influenced the other, I don't know. Imogen was a little older, and it's possible she influenced him somewhat." According to Willard Van Dyke, on the other hand, "Imogen was always doing her own thing. I influenced Weston and Weston influenced me. My sand dunes were the first sand dunes—before Weston ever photographed sand dunes. Ansel and Edward and I all tried to find our own way, our own style, but there was a common impulse behind it. But that wasn't true with Imogen. What other artists did didn't matter. It was her direction, her direct experience of the object through the camera that mattered." Cited in Dater, *Imogen Cunningham*, pp. 41, 44.

94 Edward Weston, *Daybooks,* vol. 2 (Millerton, N.Y.: Aperture, 1978), pp. 224–25.

95 This is the title of the fifth chapter in Annette Kolodny's *The Lay of the Land.*

96 Alan Trachtenberg, "Edward Weston's America: The *Leaves of Grass* Project," in Peter Bunnell and David Featherstone, eds., *EW 100: Centennial Essays in Honor of Edward Weston* (Carmel, Calif.: Friends of Photography, 1986), p. 107.

97 Broun went on to ask if Cunningham was working with Weston's idea at the time. In 1932, Cunningham responded that she and Weston did not see much of each other because he lived in southern California and she in Oakland; moreover, "I never thought of anything of his to copy, for the early models of his were, as I remember them, always against light back grounds [*sic*] and I did not like them. His great stuff was many years later when he photographed Charis in nature. I never saw the Mexican nudes of Tina Modotti but of course that was later. Those I know of Tina were in clothes, in rooms or just heads." Elizabeth Broun to Imogen Cunningham, November 19, 1973; Cunningham to Broun, November 25, 1973. Cunningham Papers, Archives of American Art.

98 *Daybooks,* vol. 1, pp. 147–48, cited in Theodore E. Stebbins Jr., *Weston's Westons: Portraits and Nudes,* exhibit catalog (Boston: Museum of Fine Arts, 1989), p. 19. "In this unguarded expression of pleasure in his work, we are reminded of Walt Whitman's initial line to his great poem *Song of Myself,* 'I celebrate myself, and sing myself,'" Stebbins comments. Each nude subject, he continues, became for Weston a portrait of a type: "in [Anita] Brenner, Weston had seen a pear, and in [Bertha] Wardell, he found 'shapes not unlike great sea shells.'" Ibid., citing *Daybooks,* vol. 2, p. 10, cited in ibid.

99 Charis Wilson, *Edward Weston Nudes* (New York: Aperture, 1977), p. 8, emphasis original. If Weston's nudes seldom have heads or faces, it is, Wilson observed, because he believed that "there were only three perfect shapes in the world—the hull of a boat, a violin, and a woman's body. The problem for a photographer who deals in sharp, unmanipulated images is that he cannot simplify a face, or generalize it into a type, as a painter or sculptor can. If the full face appears, the picture is inevitably the portrait of a particular individual and the expression of the face will dictate the viewer's response to the body. If a photographer wants to make a nude, rather than a nude portrait, he has only three possible options: the face must be averted, minimized by distance, or excluded" (ibid., p. 115).

100 The photographic session took a full eight hours, which Graves later recalled as "the Ordeal of Imogen": totally exhausted, he withdrew inside himself and attained an intensely contemplative state, like the state of concentration he achieved just before starting to paint. Cited in Cooper and Badger, "Imogen Cunningham," pp. 133–34.

101 Padula had driven the ninety-year-old Cunningham to Graves's lakeside retreat in Oregon, and then wandered about by himself, leaving the two friends in privacy. The time there "affected me deeply, and it certainly affected Imogen," he said later. "She retained that peacefulness long after, and it wasn't until the next day that her tongue took on the old knife-edge. It was as if she had had a union, a reunion with something." Cited in Dater, *Imogen Cunningham,* pp. 83–84.

102 Cooper and Badger, "Imogen Cunningham," p. 138.

103 May 31, 1959, Cunningham Papers, Archives of American Art.

104 Journal entry, 1972, n.p., cited in Martha A. Sandweiss, *Laura Gilpin: An Enduring Grace,* exhibit catalog (Fort Worth, Texas: Amon Carter Museum, 1986), p. 106. Gilpin referred here to the death of her lifelong companion Elizabeth Forster, whose long illness had consumed a great deal of Gilpin's time, energies, and financial resources.

105 Margaretta Mitchell, *Recollections: Ten Women of Photography* (New York: Viking, 1979), pp. 121–22.

106 Sandweiss, *Laura Gilpin,* p. 81. Karen Hust argues that although landscape was most often seen as a woman's body, it was at times portrayed as masculine and transcendent, depending upon "whether the observer wanted to objectify an 'other' for conquest or to construct a model of the self from which to draw power. In neither formulation could a woman find an accurate or enabling description of herself." A woman brought up in such a tradition must have had difficulty defining herself as an active observer of nature: "There would be no need for her to 'take' a picture since she is already the picture." "'the landscape (chosen by desire)': Laura Gilpin Renegotiates Mother Nature," *Genders* 6 (Nov. 1989):28–29. In connection with Gilpin's *Round Tower,* the female shape of her structure—a tower given the roundness of a vessel— recalls Cather's description in *The Professor's House* of these same cliff houses, where a skeleton of the last resident is unearthed and named "Mother Eve."

107 Gilpin to Darlene Bekkedal, April 16, 1955, Laura Gilpin Archives, Amon Carter Museum, Fort Worth, Texas, cited in Sandweiss, *Laura Gilpin,* p. 89.

108 Gilpin to Willard Morgan, Sept. 9, 1943; Gilpin interview with Arthur Ollman and Rosella Stern, tape 5, March 1976; Gilpin to Mr. Divinia, n.d. [c. May 1943], Laura Gilpin Archives. All cited in Sandweiss, *Laura Gilpin,* pp. 72–73.

109 Vera Norwood, "The Photographer and the Naturalist: Laura Gilpin and Mary Austin in the Southwest," *Journal of American Culture* 5, no. 2 (summer 1982):1–28. Norwood is dealing here with cultural *myth.* She implies in her argument that conflicting attitudes toward the wilderness among Euroamericans have to do with race and class as well as gender.

110 Hust points out Clarence King's desire to shape the landscape even as he records it, his sense that recording the physical world without also "administering" it is a threat to the civilizing project of his race and nation, indicated in such passages as: "I was delighted to ride thus alone, and expose myself, as one uncovers a sensitized photographic plate, to be influenced; for this is a respite from scientific work, when through months you hold yourself accountable for seeing everything, for analyzing, for instituting perpetual comparison, and as it were sharing in the administering of the physical world. No tongue can tell the relief to simply withdraw scientific observation, and let Nature impress you in the dear old way with all her mystery and glory, with those vague indescribable emotions which tremble between wonder and sympathy." *Mountaineering in the Sierra Nevada* (1871; reprint, Lincoln: University of Nebraska Press, 1970), p. 126. She also cites Roland Barthes's argument that landscape

photography is implicated in a psychosexual quest for and deferral of the feminine referent: "Looking at these landscapes of predeliction, it is as if *I were certain* of having been there or of going there. Now Freud says of the maternal body that 'there is no other place of which one can say with so much certainty that one has already been there.' Such then would be the essence of the landscape (chosen by desire): *heimlich,* awakening in me the Mother (and never the disturbing Mother)." The photo in which Barthes locates the reality of his mother is in a snapshot of her at age five in a "Winter Garden," where he possesses her in an Eden of perfect pre-Oedipal union; likewise, during the silence of her final illness, he and his mother enjoy "the insignificance of language, the suspension of images . . . the very space of love." *Camera Lucida,* trans. Richard Howard (New York: Hill and Wang, 1981), pp. 39–40, 69, 72. King and Barthes cited in Hust, "'the landscape (chosen by desire),'" pp. 26–27, 29–30.

111 Ibid., pp. 30–31; for the complete diary entry for August 10, 1916, see Sandweiss, *Laura Gilpin,* p. 22. Hust draws on literary and psychoanalytic critics such as Luce Iragary and Margaret Homans in suggesting that women's recovery of the maternal origins from which masculine culture separates them would lead to a new form of creativity. See, for example, Homans's argument that in "[R]eturning to proper origins, a woman will acquire so strong a sense of identity that she will not need to search for self in everything she sees; creativity will begin with an acknowledgment that the rest of the world is not to be possessed." Homans, *Women Writers and Poetic Identity* (Princeton: Princeton University Press, 1980), p. 17, cited in Hust, ibid., p. 47 n. 31. See also Audre Lorde's argument that the word "erotic" personifies "love in all its aspects" and is "an assertion of the life-force of women." "The Erotic as Power," paper delivered to the Berkshire Conference on the History of Women, Mount Holyoke College, South Hadley, Mass., August 1978, cited in Blanche Weisen Cook, "'Women Alone Stir My Imagination': Lesbianism and the Cultural Tradition," *Signs* 4, no. 4 (summer 1979):739. Once women experience independent erotic power, Cook writes, "we will connect with the basic source of our strength, and it will be clear that we derive it from ourselves, not from men, not from any outside place" (ibid.).

112 Laura Wexler, "The Puritan and the Photograph," *Texas Studies in Literature and Language* 25, no. 1 (spring 1983):9; Hust, "'the landscape (chosen by desire),'" pp. 24–25, 43. There is a striking similarity between the way Gilpin composed this scene and Gertrude Käsebier's *The Sketch* (1903), in which the landscape is also known only through the woman's perceptions.

113 Draft for "Laura Gilpin's Rio Grande Country," *U.S. Camera* 13 (Feb. 1950):44–47, Laura Gilpin Archives, Amon Carter Museum. Cited in Sandweiss, *Laura Gilpin,* p. 81.

114 JoAnn Verburg, "Between Exposures," in Mark Klett et al., *Second View: The Rephotographic Survey Project* (Albuquerque: University of New Mexico Press, 1984), p. 5; Paul Berger, "Doubling: This Then That," *Second View,* p. 52. See also Bill Ganzel, *Dust Bowl Descent* (Lincoln: University of Nebraska Press, 1984), and Dale Maha-

ridge and Michael Williamson, *And Their Children After Them, The Legacy of* Let Us Now Praise Famous Men: *James Agee, Walker Evans, and the Rise and Fall of Cotton in the South* (New York: Pantheon, 1989).

115 In *Legacy of Conquest,* Limerick has some interesting things to say about gender and sexuality in the West, especially in her chapter on prostitutes.

116 Hust uses the term *tradition* here in the broad sense of Euroamerican perceptions of landscape, from the survey project to Stieglitz's positioning of a tree in *Flatiron Building, New York* (1903), which she compares to Gilpin's tree in *Sunrise, Grand Canyon* (1930), suggesting that "Gilpin's parallel to Stieglitz may . . . involve an ambivalence between the correspondence she is claiming [among organic elements] and a recognition that some distance is both necessary and dangerous. As daughter-photographer Gilpin resists merging completely with her mother-landscape, but she fears the standard objectifying position as well" ("'landscape chosen by desire,'" 34, 36).

117 Mary Austin, *Lost Borders* (New York: Harper, 1909), pp. 10–11, cited in Norwood, "Photographer and Naturalist," p. 5.

118 "Panther Canyon" in Cather's autobiographical *The Song of the Lark* (Boston: Houghton-Mifflin, 1915; reprint, Lincoln: University of Nebraska Press, 1978), p. 297, is based on Walnut Canyon, Arizona. Ellen Moers calls this passage "the most thoroughly elaborated female landscape in literature." *Literary Women* (Garden City, N.Y.: Doubleday, 1976), p. 258. See also Fryer, *Felicitous Space,* chapters 9, 10, 11 for a description of Cather's landscapes and for an analysis of her interest in bringing to light what had been consigned to the shadows—most notably in her *Shadows on the Rock.* Gilpin's affinity for Cather's work is demonstrated by her wish to publish an edition of *The Professor's House* illustrated with her photographs. (A mutual acquaintance, photographer Alice Boughton contacted Cather, but nothing came of the attempt; see Sandweiss, *Laura Gilpin,* p. 44.) Even her language echoes Cather's, for instance: "The Rio Grande Gorge may best be seen looking north toward the low hills which mark the southern boundary of the San Luis Valley. Attaining a depth of over one thousand feet, its walls are precipitous, as though the earth had split open, the great plain through which it winds is covered with low sagebrush, and the bordering hills are studded with piñon and cedar." *The Rio Grande, River of Destiny: An Interpretation of the River, the Land, and the People* (New York: Duell, Sloan and Pearce, 1949), p. 78.

119 Hust, "'landscape (chosen by desire),'" p. 31; Archibald MacLeish, *Land of the Free* (New York: Harcourt, Brace, 1938), pp. 1–2, 23, 29, 42, cited in Hust, ibid., p. 31.

120 Martha Sandweiss points out that Gilpin first became interested in the interconnection of picture and text when she saw Blake's works at the British Museum, which she visited with Brenda Putnam in 1922. "I think this is one of the places that probably jelled things for me," she later said, "because one of the things I admired about Blake was the fact that he wrote everything, printed everything, and bound it and published it. I think that got me thinking in terms of producing things like that." Laura Gilpin, interview by Mitchell Wilder, tape 4, p. 1, May 11, 1978, Laura Gilpin Ar-

chives, Amon Carter Museum. Cited in Sandweiss, *Laura Gilpin,* p. 37.

121 Dorothea Lange and Paul Taylor, "Documentary," 1940, cited in Robert T. Doherty, introduction to Howard M. Levin and Katherine Northrup, eds., *Dorothea Lange: Farm Security Administration Photographs, 1935–1939,* vol. 1 (Glencoe, Ill.: Text-Fiche Press, 1980), pp. 34–35.

122 Laura Gilpin, preface to *The Pueblos: A Camera Chronicle* (New York: Hastings House, 1941), p. 5; Norwood, "Photographer and Naturalist," p. 7. See also Sandweiss, *Laura Gilpin,* pp. 66–69.

123 Laura Gilpin, *Rio Grande,* pp. xi, 26, emphasis original; subsequent references to this are cited parenthetically in the text. All of the ceremonies of the Ancient People, Cather writes in *The Song of the Lark,* go back to water, which was the care of the women: "Their pottery was their most direct appeal to water, the envelope and sheath of the precious element itself. The strongest Indian need was expressed in those graceful jars, fashioned slowly by hand. . . . [In the] care, expended upon vessels that could not hold . . . water any better for the additional labor put upon them, . . . they had not only expressed their desire, but they had expressed it as beautifully as they could . . . even here, in this crack in the world, so far back in the night of the past! Down here at the beginning that painful thing was already stirring: the seed of sorrow, and of so much delight" (pp. 303–305).

124 ["Interview with Laura Gilpin on the Rio Grande"], c. 1949, pp. 1–5, Laura Gilpin Archives, Amon Carter Museum. Cited in Sandweiss, *Laura Gilpin,* pp. 75–76.

125 Laura Gilpin, interviews by Ed Hannigan, Mitchell Wilder, and Martha Sandweiss; "Rio Grande Interview"; Gilpin letter to Walter Goodwin, October 2, 1945, Laura Gilpin Archives, Amon Carter Museum. Cited in Sandweiss, *Laura Gilpin,* pp. 81, 76.

126 Gilpin's applications for a Guggenheim grant were turned down in 1930, 1948, and 1970; she was finally successful in 1974. "I like to flatter myself," she said when Weston received a grant in 1937, "that perhaps I helped pave the way for Weston." Gilpin to Charles Duell, October 9, 1947; to Walter Goodwin, January 29, 1949; fellowship application form, John Simon Guggenheim Memorial Foundation, 1947, Laura Gilpin Archives, Amon Carter Museum. Cited in Sandweiss, *Laura Gilpin,* pp. 60, 79–80, 84.

127 Gilpin seems to have been unaware of the irony of presenting Nature in the way nineteenth-century landscape painters had, as a text to be read—as "God's Holy Book." Asher B. Durand, for example, believed that "you can learn to read the great book of Nature, to comprehend it, and eventually transcribe from its pages, and attach to the transcript your own commentaries"; William Sidney Mount saw "the volume of nature [as] a lecture always ready and bound by the Almighty." Durand, "Letters," letter 3, *Crayon* 1 (Jan. 31, 1855):66; Mount, quoted in John I. H. Baur, "Trends in American Painting," introduction to *M. & M. Karolik Collection of American Paintings, 1815–1865,* Museum of Fine Arts, Boston (Cambridge, Mass.: Harvard University Press, 1949), p. xxvi. Both cited in Barbara Novak, *Nature and Culture: American Landscape Painting, 1825–1875* (New York: Oxford University Press, 1980), pp. 3, 9, 14. Reading Nature as God's text "confirmed the young republic's sense of its

own destiny," Elizabeth Duvert writes, "and nature's 'text' was quickly appropriated for nationalistic goals, ironically justifying the destruction of the text itself." "With Stone, Star, and Earth," p. 216.

128 John Collier Jr., "Laura Gilpin: Western Photographer," *New Mexico Quarterly* 20 (winter 1950–51):491–92, 486–87. Collier went on to praise Gilpin's honesty and tenacity, concluding that "The Rio Grande book has placed her among the few published writer-photographers of the country" (p. 492). Collier's *Visual Anthropology: Photography as a Research Method* (New York: Holt, Rinehart and Winston, 1967) gives some sense of the reasons for his ambivalent response to *The Rio Grande*. The camera "ushered in a new phase of human understanding," he wrote in that work, giving "man for the first time . . . [the opportunity to] see the world as it *really* was, . . . [a] confidence was born from a recognition that photography was an optical process, not an art process. Its images were made by real light, as natural as a shadow cast by a hand, rubbings taken from stones, or animal tracks on the trail" (p. 3). John Brinckerhoff Jackson [review of Gilpin's *The Rio Grande*], *Arizona Quarterly* 4 (winter 1949):369–70.

129 Jackson, ibid., p. 368; Sandweiss, *Laura Gilpin*, pp. 76–77.

130 Norwood, "Photographer and Naturalist," pp. 12, 5. Gilpin cites Austin, Cather, and also Susan Shelby Magoffin's diary of 1846–1847, *Down the Santa Fe Trail and into Mexico,* in her bibliography for *The Rio Grande.*

131 Gilpin's pilot for *The Rio Grande,* Charlie Boyd, remembered her as "that goddamned woman, she was always saying lower, lower. If she fell out she'd take pictures all the way to the ground." Anne Noggle, interview by Martha Sandweiss, Feb. 4, 1981, and Laura Gilpin, interview by Mitchell Wilder, p. 22, Laura Gilpin Archives, Amon Carter Museum. Cited in Sandweiss, *Laura Gilpin*, p. 81. Laura Gilpin, *The Enduring Navaho* (Austin: University of Texas Press, 1968), p. 10.

132 Undated letter, probably 1934, the year Cunningham traveled to New York. Cunningham Papers, Archives of American Art.

133 Imogen Cunningham to Dorothea Lange, April 24, 1958, Cunningham Papers, Archives of American Art. Cunningham did from time to time try her hand at documentary photography. In 1934, she was part of a group gathered by Willard Van Dyke—which included Lange, Mary Jeanette Edwards, and Preston Holder—to photograph the Unemployed Exchange Association (UXA) project at Oroville, California, for Paul Taylor. "You could see the difference between Imogen's and Dorothea's work very clearly," Taylor recalled. "Imogen was soon photographing a man working at a power saw, or something of that sort, where he was in a more or less fixed position and she could take plenty of time to set up and take the photograph with her very fine skill. . . . Dorothea moved around inconspicuously. Imogen set up and made a few studied, well-arranged, well-executed photographs. They just had different ways of working." Paul Schuster Taylor, *Paul Schuster Taylor: California Social Scientist,* vol. 1, an oral history conducted by Suzanne Riess (Berkeley: Regional Oral History Office, Bancroft Library, University of California, 1973), pp. 122, 125, subsequently cited as Taylor-Riess interview. The UXA photographs are at the Bancroft Library, University of California, Berkeley. Cunningham also made a number of

documentary photographs in her rambles along San Francisco streets, some of which are reproduced in Lorenz, *Imogen Cunningham.*

134 Dorothea Lange, *The Making of a Documentary Photographer,* an oral history conducted by Suzanne Riess (Berkeley: Regional Oral History Office, Bancroft Library, University of California, 1968), p. 148, subsequently cited as Lange-Riess interview. In another version of this story, Cunningham offers advice to the younger photographer, who is depressed in her marriage, and again Lange has a kind of antitranscendental experience. "Then one day, while walking alone in the mountains, she was caught in a violent storm," Christopher Cox reports. "'When it broke, there I was, sitting on a big rock—and right in the middle of it, with the thunder bursting and the wind whistling, it came to me that what I had to do was to take pictures and concentrate upon people, only people, all kinds of people, people who paid me and people who didn't.'" Cox, introduction to *Dorothea Lange* (New York: Aperture Masters of Photography series, no. 5, 1987), p. 8.

135 Lange-Riess interview, p. 216. We might contrast Lange's "freedom" in her photographs of the poor and *dis*placed in the 1930s and 1940s with her later photographs taken in Asia, India, and the Middle East, where she felt *un*free to move. She was ill at the time, traveling with her husband Paul Taylor against her own inclinations, and often met with resistance to her picture taking. "Dorothea told me she didn't really want to go to Egypt. She was getting back in shape and wanted to photograph in this country. She wanted to go back over our old trails. But I had committed myself to go to Egypt, and of course, I wanted her to come with me," Taylor recalled. "When she got there she reminded me . . . that Egypt was not her choice, but mine. She did it in the nicest way . . . ; there was such frankness between us. She meant what she said: left to her, photographing in the United States was what she wanted to do. But of course I had agreed that *this* was what *I* was going to do, and I guess I had the main leverage and she had to come in tow." Taylor-Riess interview, p. 277, emphasis original.

136 *Dorothea Lange Looks at the American Country Woman,* exhibit catalog (Fort Worth, Texas: Amon Carter Museum, 1967), pp. 56, 13. Although this photographic essay was published posthumously, the composition and sequence of pictures and text are Lange's. See her statement about grouping photographs for this work at the beginning of chapter 5 in this volume.

137 Cited in Doherty, introduction to *Dorothea Lange,* vol. 1, p. 35; cited in Meltzer, *Dorothea Lange,* pp. 233–34.

138 Lange-Riess interview, pp. 56, 198–99. The negative for this image is in the collection of Pirkle Jones—who claims it as his—and is unavailable for reproduction.

139 Dorothea Lange and Pirkle Jones, *Death of A Valley, Aperture* 8, no. 3 (1960):128, 127. Subsequent references are cited parenthetically in the text. The Vacaville Museum has recently reproduced Jones's photographs in its exhibit catalog, *Berryessa Valley: The Last Year* (Vacaville, Calif: Vacaville Museum, a Center for Solano County History, 1994).

140 Edith Wharton, *Fighting France, From Dunkerque to Belfort* (New York: Scribners, 1915), pp. 58, 152–53. I am struck by a review of Grace Paley's collected stories in which

Ann Hulbert points to Paley's balancing act between sentimental and social realms as a significant difference from her contemporaries—"Bellow and Roth and all those guys"—in that Paley's work is not particularly Freudian. As Paley notes in her introduction, "I'm interested in intergenerations—the young people and the old—because I'm more interested in history than I am in psychology." Being less concerned with the wages of guilt and more curious about the workings of fate means a focus on "everyday life, kitchen life, children life." Ann Hulbert, "New Wives' Tales," a review of *The Collected Stories* by Grace Paley, *The New York Review of Books* 41, no. 14 (August 11, 1994):23–24.

141 Duvert, "With Stone, Star, and Earth," p. 204.

EPILOGUE

1 The title of this section comes from Mikhail Bakhtin's *Rabelais and His World*—"the old hags are laughing"—and refers to the kind of grotesque realism that marks his analysis of the bodies of pregnant old women. For a feminist reader, however, the image of the pregnant hag is "more than ambivalent. It is loaded with all of the connotations of fear and loathing associated with the biological processes of reproduction and aging." See Mary Russo, "Female Grotesques: Carnival and Theory," in Teresa de Lauretis, *Feminist Studies/Critical Studies* (Bloomington: Indiana University Press, 1986), p. 219. See chapter 6, note 71, in this volume.

2 Trinh T. Minh-ha, *When the Moon Waxes Red: Representation, Gender, and Cultural Politics* (New York and London: Routledge, 1991), p. 15.

3 Graves had earlier refused a photographic session on the grounds that "My ego is of the order of ego which also includes an unalterable feeling that the best part of my life is the intensely personal & private area which for me, is violated (& becomes colored with the phony—the pseudo) if someone is there watching with a camera." Morris Graves to Cunningham, April 22, 1969, Cunningham Papers, Archives of American Art, National Museum of American Art, Washington, D.C., cited in Richard Lorenz, *Imogen Cunningham: Ideas without End* (San Francisco: Chronicle Books, 1993), p. 59.

4 Cited in Judy Dater, *Imogen Cunningham: A Portrait* (Boston: New York Graphic Society, 1979), pp. 110–11.

5 "You know, I met her [Diane Arbus] on Haight Street, and she was very rude to me," Cunningham recalled, ingenuously. "All I did was ask her why she always photographed all those freaks and weird people." She recognized that Arbus "had an extraordinary eye [but] not one that I would want, because I feel ill when I look at her prints, too many of them." M[argery] Mann, "For Imogen: with admiration and love—," c. April 1973, Margery Mann Papers, Archives of American Art, n.p. A more direct influence was Arbus's teacher Lisette Model, who arrived in San Francisco in 1946 and whose photographs were shown at the California Legion of Honor in that year. The two women became friends and traveling companions, often exploring the city together in search of photographic material. Lorenz points out that Cunningham's street portraiture lacks the undercurrent of mean-spiritedness found in Model's work (*Imogen Cunningham,* pp. 45–46).

6 Imogen Cunningham to Grace Mayer, January 10, 1961, Cunningham Papers, Archives of American Art.

7 "One of the stories Imogen liked to tell was that Tom Eckstrom (the last young man to work as her assistant) once told her the only difference between her prints and those made by Eddy Dyba [the printer who makes the Trust prints] was that the borders of hers were crooked." Unspecified author, "And Then Imogen Said. . ." [headline for Cunningham memorial issue], *ASMP*NC Newsletter,* no. 5 (July–August 1976):6. Cunningham Papers, Archives of American Art.

8 Weston came back from "a show at the LA County Museum and wrote me a letter," Cunningham said in an interview in 1975. "He said that all the things were dreadful in that show until he came to one of mine. He said: 'If you keep up that standard you will become a great photographer.' Very patronizing, don't you think? I'd worked 20 years longer than he at that time, but he'd never seen it." Interview for *Photographer's Journal and Camera,* March 19, 1975, interviewer unknown, transcribed by Valerie Bayliss, p. 13. Cunningham Papers, Archives of American Art.

9 According to Brett Weston, Cunningham retained her "bohemian" image to the end: "I discarded my beret forty years ago, but she was still wearing hers when she died—her fez, you know, her décor. . . . Of course Imogen as a youngish woman was homely as a mud fence—that red hair! . . . and Dad always had some beautiful girl around. He just appreciated beauty, but Imogen didn't approve." Cited in Dater, *Imogen Cunningham,* p. 41. "I think Imogen sometimes thought up lines and saved them. And if they got a laugh, she'd use them again," Lee Witkin recalled. "She really played to an audience . . . [but] you have to separate the photographs from the person. . . . I think there are ugly-beautiful, beautiful-ugly people, and Imogen was one. It was amazing that given her physical appearance she could really be so beautiful." Cited in Dater, *Imogen Cunningham,* pp. 104–105.

10 Russo, "Female Grotesques," p. 214; Russo does not refer to Cunningham.

11 Ibid., p. 218.

12 John Granville to Cunningham, May 22, 1973; Cunningham to Granville, June 7, 1973. Cunningham Papers, Archives of American Art.

Index

Abbott, Berenice, 198, 301–2

Adams, Ansel, 26–30, 54, 194, 196, 288–91, 298, 324, 338, 356, 381, 433–34 nn. 67, 69, 71, and 72, 452 n. 108, 453–54 nn. 121–22, 456 n. 6, 462–63 nn. 54–56, 464 nn. 59 and 62; and Group f.64, 26–27, 29; and Japanese Americans, 283–84, 287–88, 453–54 n. 121; and Stieglitz, 453–54 n. 121; Works: *Born Free and Equal,* 284, 288, 454 n. 126; *Pleasure Park, 289; Toyo Miyatake,* 286, *287; WAC Private, 285*

Adams, Henry, 73, 116, 181, 399 n. 14, 405 n. 61, 415–16 n. 25

Adams, John Henry Jr., 179, 429 n. 34

Adams, Marion Hooper (Clover), 84, 399 n. 14, 406 n. 61

African Americans, 8–9, 25, 52, 77, 157–209, 298, 417 n. 34, 424 nn. 4 and 6; education of, 172, 175, 181–83, 425 n. 8, 426–27 nn. 12, 13, 15, and 22, 430 n. 40; Gullahs, 10, 184, 187–93; "Negro types," 176, 188, 198, 204, 415–16 n. 25, 424 n. 4, 434 n. 76; "New Negro," 176, 177–78, 179, 183, 203–4, 429 n. 33; and Reconstruction, 157, 182, 183; representations of, 187–92, 194; white attraction to, 410–11 n. 109, 438 n. 106; white identification with, 200–201, 203, 208, 211–13

African art, 200–201, 211

Agassiz, Louis, 21, 119, 188, 388 n. 13, 417 n. 34, 431 n. 55

Agee, James, 204, 252, 443 n. 48

Allen, Frances and Mary, 75, 84; Work: [Two Women in Doorway], *75*

Allen, Neil Walsh, 48, 398 n. 8

Amateur photography, 75–76, 84, 403 n. 49, 442 n. 35

America: American body politic, 252–53, 263, 271; American individualism, 25, 390 n. 21, 391 n. 30, 394 n. 61, 403–4 n. 52; *American Photographs* (Evans), 20, 358; "American types," 20–21, 25, 47, 59–60, 185, 199–200, 398 n. 7, 401 n. 31, 415–16 n. 25, 419–20 n. 55, 434 n. 76; "American way, the," 284, 401 n. 32; cultural constructions of, 21–23, 28, 31, 37, 47, 59, 62, 96, 113, 172, 295, 297, 298, 310, 353–55, 389 n. 12, 390 nn. 17 and 21, 394 n. 61, 398 n. 7, 412 n. 9, 417–18 nn. 39 and 46, 422 n. 76, 424 n. 6, 430–31 nn. 39 and 47, 437–38 n. 101, 447 n. 81, 452 n. 112, 456 n. 6, 473 n. 127; *Gallery of Illustrious Americans* (Brady), 20; *Reading American Photographs* (Trachtenberg), 20–23; *The American Scene* (James), 22; and World War II, 271–74, 373

American Amateur Photographer, 74, 87

American Photography, 235

Anderson, Ruth M.: *Spring Session, Canaan, Connecticut, 91*

Aperture, 369, 370

Appalachia, 10, 184–86, 192

Appiah, Kwame Anthony, 43–44

Arbus, Diane, 7, 213, 219, 222, 228, 380, 448 n. 86, 476 n. 5

Armstrong, Samuel Chapman, 165, 166, 171, 183, 426 n. 12, 427–28 n. 24

Art Nouveau, 72, 319, 429 n. 25

Art photography, 53, 93, 299, 394–95 n. 65,
409 n. 101. *See also* Pictorialism
Atget, Eugène, 198
Attali, Jacques, 24, 391 n. 24
Austen, Alice (from New York), 68, 84,
403–4 n. 52, 405 n. 62; Work: *The
Darned Club, 70*
Austin, Alice (from Boston), 74, 76, 83, 86,
405 n. 62
Austin, Mary, 351, 362, 470 n. 109, 472 n.
117

Bakhtin, Mikhail, 214, 391 n. 24, 416 n. 28,
476 n. 1
Banta, Martha, 47, 59, 83, 398 n. 7, 400 n.
24, 401 nn. 31 and 32, 402 n. 37
Barrier, Fannie Williams, 427–28 n. 23
Barthes, Roland, 38–39, 117, 157, 209, 348,
416 n. 31, 437 n. 97, 470–71 n. 110
Bartlett, Mary, 74
Baudrillard, Jean, 295–97, 389 n. 9, 456 n. 4
Baym, Nina, 79, 389 n. 12, 410–11 n. 109
Beals, Jessie Tarbox, 108
Bellocq, E. J., 39, 47
Bender, Alfred, 199–200
Benjamin, Walter, 52, 103, 119, 399 n. 16
Ben-Yusuf, Zaida, 74, 76–77, 86, 89, 90,
246; Work: *The Odor of Pomegranates, 75*
Berger, John, 3, 50, 116, 204, 303, 387 n. 2,
447 n. 80
Berkhofer, Robert, 130, 419 n. 53
Bird, Caroline, 252, 447 n. 77
Bisland, Margaret, 85, 88
Blackman, Margaret, 125, 418 n. 42
Black Panthers' Newsletter, 5, 6
Blossfeldt, Karl, 335
Boas, Franz, 131, 419 n. 50
Body: and landscape, 113, 310–12, 317–22,
351–52, 472 n. 118; black bodies, 201, 212,
219; conceptions of, 6, 140, 392 n. 31,
397 n. 3; damaged bodies, 219–21, 225,
322, 440 n. 10; grotesque bodies, 26,
377–80, 383, 476 n. 1; representations of,
11–12, 25, 31–34, 45–53, 49–52, 55–57, 140,
142–44, 151–53, 212, 218, 238, 247, 248,
260, 263, 264–67, 268, 271–72, 278–79,
287, 292–93, 295, 310–12, 314, 317–23,

330–32, 342, 367–69, 388 n. 15, 400 n.
24, 425 n. 7, 440 n. 10, 446 n. 71, 460 n.
30, 465–66 nn. 71 and 73
Bohemia, 5
Boughton, Alice, 67, 83, 84; Works:
Children, 67; *Nature, 68*
Bourke-White, Margaret, 7, 54, 92–93, 187,
448 n. 85
Brady, Mathew, 20, 22, 26, 30, 199
Bridges, Marilyn, 147–54, 423 n. 80;
Works: *Fort Mojave Twins,* 149; *Ha-ak,
Blythe Site no. 1, 152; Navajo Hogan,
Monument Valley, Arizona/Utah, 153*
Bright, Deborah, 297, 302, 456 n. 6
Brigman, Anne S., 11, 30, 52, 301–2, 308,
313, 319–23, 327, 331, 461 nn. 38, 40, and
41, 462 n. 47, 465 n. 69; and Stieglitz,
90, 316–17, 460 n. 31, 461 nn. 38, 40;
Works: *Incantation, 321, 322; Nude by
Waterpool (The Bubble), 320, 321; The
Cleft of the Rock, 319, 320; The Dying
Cedar, 319; Anne Brigman in Costume as
Smiling Madonna with Group of
Costumed Friends Kneeling around Her*
(or Roi Partridge, attr.) 327, *328*
Broun, Elizabeth, 342, 469 n. 97
Buffalo Bill's Wild West Show, 9, 97, 99, 108,
134, 411 n. 115

Caffin, Charles, 58, 65, 70, 71, 198, 328
Caldwell, Erskine, 187, 448 n. 85
California, 3, 11, 26, 28–29, 33, 63, 93, 108,
110, 131, 151–52, 194–200, 202, 213, 216,
219, 225–27, 229, 235, 237, 242, 247, 272,
274, 277, 281, 283, 286, 292, 302, 304, 313,
323–24, 327, 335, 338, 358, 369–70, 374,
382, 385, 412 n. 4, 416 n. 26, 444 n. 56,
451 nn. 103, 104, and 106, 452 n. 112, 454
n. 122, 457–58 n. 17, 460–61 n. 34, 469 n.
97, 474 n. 133
Calloway, Thomas, 182, 429–30 n. 38
Camera clubs, 30, 57, 88–92, 205, 408 n. 96
Camera Craft, 30, 88, 433 n. 67
Camera Notes, 53, 64, 89, 315
Camera Work, 8, 32, 53, 57, 65, 79, 90, 93,
101, 198, 213, 308, 315, 319, 321, 461 n. 40.
See also Photographic equipment

Cameron, Julia Margaret, 62, 244, 390 n. 15

Carnival, 19, 24, 213

Carpenter, Edmund, 41, 122, 396 n. 73, 417 n. 36

Cather, Willa, 6, 106, 111, 135, 227, 319, 346, 352, 355, 364, 402 n. 42, 413 n. 11, 461–62 n. 44

Cavell, Stanley, 38–39

Chase, William Merritt, 61, 62, 64, 174

Chodorow, Nancy, 88

Cixous, Hélène, 26, 391–92 n. 31

Clarence H. White School of Photography, 8, 54, 57, 64, 67, 90–94, 106–8, 135, 184, 205, 227, 244, 345, 347, 409–10 nn. 100–102 and 104, 431 n. 51

Clark, Rose, 75–76

Class: issues of, 12, 53, 81–82, 94–95, 158, 170, 173, 176, 185, 213, 216, 244–47, 253, 263, 265, 277, 303, 367, 403 n. 47, 415 n. 20, 417–18 n. 39, 426 n. 11, 430–31 nn. 47 and 50, 434–35 nn. 77 and 86, 438 n. 106, 444 n. 52, 447 n. 84, 450; middle class, 9–10, 79–80, 84, 117, 237, 299, 401 n. 32, 403–4 n. 52, 407 n. 82; migrant poor, 9–10, 119, 209, 219–21, 229, 235–42, 247, 248, 253–54, 258–60, 441–42 n. 34, 445 n. 62, 448–49 n. 88; representations of, 9, 20–21, 25, 51, 52. See also Otherness

Clifford, James, 13, 40, 42, 157, 163, 211, 309, 388–89 n. 2, 423–24 n. 1, 426 n. 10, 438 n. 104

Coburn, Alvin Langdon, 92, 464 n. 67

Coles, Robert, 233, 440 n. 8, 442 n. 39

Collier, John, Jr., 113, 358, 415 n. 21, 421 n. 72, 474 n. 128

Collier, John, Sr., 138, 415 n. 21

Connor, Linda, 153, 301, 302, 421–22 n. 74

Cory, Kate Thompson, 307, 414 n. 13

Courbet, Gustave: L'atelier du peintre [The Painter's Studio], 310, 311, 323

Craftsman, The, 58, 70, 79, 319, 466 n. 75

Cunningham, Imogen, 6–8, 10–11, 19, 24, 26–28, 30–31, 33, 35, 52, 54, 63, 83–84, 93–94, 136, 186, 194, 196, 227, 301–2, 313–14, 316, 324–44, 353, 366, 377–85, 392–93 n. 39, 400 n. 26, 433 n. 67, 433–44 n. 71, 460 nn. 31 and 33, 462–63 nn. 53, 54, and 56–58, 464–65 nn. 59, 62, and 67; and Adams, 324–25, 327, 338, 381, 462–63 n. 54, 464 n. 62, 468–69 n. 93; and Brigman, 327–28, 330; and Curtis, 332, 466–67 n. 76; and Group f.64, 29, 432 n. 64, 464 n. 62; and Kanaga, 467 n. 78; and Käsebier, 328, 332, 382, 385, 466 n. 75; and Lange, 381, 474 n. 133; and O'Keeffe, 336–37, 342; and Stieglitz, 337, 465 n. 68, 69; and Weston, 327, 338–43, 341–44, 381–83, 468–69 n. 93, 469 n. 97, 477 n. 9; and White, Clarence H., 465 nn. 68, 69; as gardener, 11, 324, 326, 335–37, 344; "carnival" images, 377–85; pictured, 384; Works: Alfred Stieglitz 3, 337; Bath, 342; Black and White Lilies, 336; Calla Lilies, 332; Cemetery in France, 332; Dream Walking, 326, 332, 343; Ear, 379, 381; Eve Repentant, 329, 331; Family on the Beach, 314; Feet of Irene "Bobbie" Libarry, 377, 379; Girl at Point Lobos (Phoenix), 343; Hen and Chickens, 334, 339, 340; Her and Her Shadow, 338; Irene "Bobbie" Libarry, 377, 378; John Bovington, 342; Lyle Tuttle, Tattoo Artist, 377, 379; Magnolia Blossom, 337, 338; Mills College Amphitheater, 334; Morris Graves in His Leek Garden, 326, 344; My Label, 345; Nude, 334; On Mt. Rainier 7, 32; On Mt. Rainier 8, 330; Pflanzenformen series, 335; Pregnant Woman, 12, 302, 338, 339, 340; Rondal and Padriac in the Sierra, 331, 332; Self-Portrait, 345; Self-Portrait, Denmark, 377, 380; Shells, 339, 340; Side, 342; Sun and Wind, 329; Sycamore Trees, 338; Tea at Foster's, 382, 383; The Poet and His Alter Ego, 332; The Supplicant, 329; The Taiwan Leaves, 326, 332, 333; Triangles and Shells, 338, 339; Twins with Mirror, 331, 332; Two Sisters, 332; The Unmade Bed, 19, 381; The Vision, 329; The Voice of the Wood, 329; The Wind, 329; The Wood beyond the World, 329

Curtis, Edward Sheriff, 22, 30, 52, 54, 83, 97, 101, 106–7, 111, 119–34, 149, 307, 313, 332, 388 n. 13, 413 n. 12, 417–18 nn. 36 and 37, 418–19 nn. 46 and 47; Works:

Black Belly—Cheyenne, 120; Cañon de Chelly—Navaho, 121; Chief Joseph—Nez Perce, 128; *The Clam Digger,* 123; *A Desert Queen,* 123, *124; The Egyptian,* 123; *Evening on the Sound,* 123, *124; Firing Pottery,* 128; *Haschebaad—Navaho,* 128; *Haschelti—Navaho,* 128; *In a Piegan Lodge,* 128; *In the Land of the Head-Hunters,* 128–131; *Little Dog (Shunkala),* 128; *Mother and Child, 127,* 128; *Night-Scout—Nez Perce,* 128; *The North American Indian,* 118–23, 127–31, 137; *Preparing Wedding Feast,* 128; *Sitting Owl—Hitdatsa,* 128; *Spectators, 127,* 128; *The Three Chiefs,* 125; *Thunderbird dancer "flying" in the bow of the Canoe, 130; Typical Apache,* 127; *Upshaw—Apsaroke,* 128, *129; The Vanishing Race—Navaho,* 125, *126; Yebechai Prayer—Navaho,* 128

Daguerre, Louis, 20
Daguerreotypes, 25, 32, 52, 188, 199, 388 n. 13, 417 n. 34
Dahl-Wolfe, Louise, 323, 462 n. 50
Danto, Arthur, 17, 18, 389 nn. 7 and 8
Dater, Judy, 301–2, 335, 385, 463 n. 56; Work: *Imogen and Twinka at Yosemite, 384*
Day, F. Holland, 52, 63, 90, 99, 315, 321, 402 n. 43, 459 n. 23, 462 n. 47, 466 n. 73; Work: [Crucifixion], 321, *322*
Deloria, Vine, Jr., 118, 123, 417, 417–18 n. 39
Dewey, John, 237, 444 n. 52
"Dia de las Madres," *5*
Dixon, Maynard, 202, 244, 248, 367, 446 nn. 72, 73; 447 n. 78, 448 n. 85
Doane, Mary Ann, 26, 33, 35, 36, 392 n. 31, 393 n. 46, 394 nn. 54, 56
Documentary photography, 8, 9, 11–12, 39, 53, 93–94, 122, 129, 138, 198, 202, 205–6, 222, 230, 232–33, 235–37, 243–44, 247, 252, 258, 275–83, 286–87, 298, 302, 353, 368, 371, 387 n. 3, 388 n. 13, 439–40 n. 7, 440 n. 9, 442 nn. 35, 37; 443 n. 41, 444 n. 56, 445 n. 63, 448 nn. 85, 86; 449–50 n. 94, 452–53 n. 112, 455 n. 139, 474 n. 133
Documenting America, 12, 440 n. 7, 447 n. 82, 453 n. 114

Douglas, Mary, 24, 25, 27, 391 n. 25
Dow, Arthur Wesley, 64, 86, 91, 92, 403 n. 45
Duncan, Isadora, 225–27, 323, 406 n. 69
Dürer, Albrecht, 16, 49, 73; Work: draftsman drawing a nude, woodcut, *47*
Duvert, Elizabeth, 375, 468 n. 87, 473 n. 127

Eakins, Susan MacDowell, 54
Eakins, Thomas, 49, 50, 54, 74, 119, 160, 400 n. 24, 424–25 n. 6; Works: *William Rush Carving His Allegorical Figure of the Schuylkill River, 55; William Rush's Model, 50*
Eastman, George, 80, 81, 406 n. 73
Eddy, Sarah Jane, 75, 89
Edgerton, Giles. *See* Mary Fanton Roberts
Edwards, John Paul, 194, 196, 327
Edwards, Mary Jeanette, 29, 327, 474 n. 133
Eickemeyer, Rudolf, 71, 73
Elliott, George, 4, 387 n. 6
Emerson, Ralph Waldo, 20, 22, 25–26, 43, 96, 309, 316, 391 n. 30, 394 n. 61, 405 n. 61
Engs, Robert, 167, 426–27 nn. 12, 13, and 15
Ethnography, 40–42, 109, 116, 118, 121, 127, 164, 187, 200, 309–10, 396 n. 71, 412 n. 9, 414 n. 13, 416 n. 29, 417 n. 31, 418 n. 46, 419 nn. 50, 51, and 55; 421 nn. 70 and 72, 424 nn. 2 and 5, 426 n. 11, 431 n. 47, 438 nn. 102 and 104; anthropometric photography, 123, 131; Harriman Expedition, 126, 136
Evans, Walker, 12, 20–22, 39, 184, 204, 219, 222, 237, 252, 349, 358, 443 n. 48, 451 n. 99; Works: *American Photographs,* 21, 358; *Annie Mae Gudger,* 204
Expositions and world fairs, 412; Centennial Exposition, 108; Louisiana Purchase Exposition, 108; Panama-California Exposition, 108; Panama-Pacific Exposition, 108; Paris Exposition, 57, 73, 90, 101, 157, 160, 163, 169, 170, 176, 181, 429–30 n. 38; Trans-Mississippi and International Exposition, 108; World's Columbian Exposi-

tion, 62, 74, 77, 108, 131, 133, 319, 397 n. 6, 403 n. 45, 419–20 n. 55

Family of Man, The, 12, 209–11, 437 n. 99, 437–38 n. 101

Family photographs, 65, 67–68, 79, 85, 216, 367, 404 n. 57, 406 n. 72, 409 n. 102. *See also* Mothers and children

Farm Security Administration (FSA), 3, 10–12, 93, 113, 138, 184, 185, 205–6, 220, 223, 232–36, 243, 251–52, 271, 277, 290, 349, 370, 415 n. 20, 436 n. 88, 439–40 n. 7, 443 n. 41, 449–50 n. 94. *See also* Lange, Dorothea; Stryker, Roy Emerson

Farnsworth, Emma Justine, 75, 89

Featherston, Nettie, 210, 257, 258, 262, 266, 448–49 n. 88

Featherstone, David, 190, 432 n. 58

Female nudes, 8, 45–47, 49–52, 55, 214, 310–12, 314, 319, 320–21, 330, 340, 342, 343, 377–79, 384, 385, 460 nn. 33 and 34, 469 nn. 98 and 99. *See also* Body, representations of; Sexuality, constructions of

Feminist film theory, 23, 33, 35–37, 42, 391–92 n. 31, 393 n. 46, 393–94 n. 47, 403 n. 48

Fisher, Andrea, 10, 12

Fiske, George, 323; Work: *Clowning on Observation Point,* 323

Flaherty, Robert, 122

Flint, Elizabeth Wade, 405 n. 64, 407 n. 79

Forster, Elizabeth, 103, 105, 107–8, 111, 136, 138, 141, 143, 345, 347, 415 n. 21, 420 n. 66, 445 n. 65, 470 n. 104

Foucault, Michel, 34, 35, 45, 394 n. 52, 421 n. 71

Fox-Genovese, Elizabeth, 393 n. 41

Freedberg, David, 40, 43, 395–96 n. 69

Freud, Sigmund, 34, 118, 312, 393 n. 46, 470–71 n. 110

Fryer, Judith: Works: "American Eves in American Edens: Women in Utopian Communities, 1840–1880," 391 n. 30; *Felicitous Space: The Imaginative Structures of Edith Wharton and Willa Cather,* 402 n. 42, 413 n. 11, 472 n. 118; "Reading Mrs. Lloyd," 401 n. 34

Fuller, Loïe, 73, 319, 323

Galle, Theodore, *Vespucci "Discovering" America,* 310, *311*

Garner, Gretchen, 301–2, 457 nn. 9, 10, and 11

Gates, Henry Louis, 177, 179, 183, 428 n. 23, 429 nn. 30 and 32

Geertz, Clifford, 116, 416 n. 29

Gender: and difference, 23, 26, 35–36, 43, 67–69, 252, 265–67, 297, 300–304, 319–21, 390–91 nn. 15 and 22, 394 n. 58, 408 n. 95, 409 n. 102; issues of, 7, 9–10, 25–26, 30–31, 33–37, 42, 55–57, 68, 81–82, 89, 118, 167, 175–76, 213–14, 222, 247, 249, 251–53, 262, 264–69, 297, 300–308, 347, 362, 365, 368, 388 n. 15, 390 n. 15, 390–91 n. 22, 396 n. 72, 400 n. 24, 402 n. 37, 405 nn. 61 and 65, 406 n. 72, 407 n. 82, 408 n. 90, 410 n. 104, 414 n. 13, 415 n. 25, 446 n. 73, 448 n. 86, 457 n. 15, 458–59 n. 19, 475–76 n. 140, 476 n. 1

Genthe, Arnold, 30, 83, 125, 205, 226, 244, 406 n. 69, 433 n. 70, 445 nn. 63 and 64; Works: *Isadora Duncan in* La Marseillaise, *226; Old Chinatown,* 227, 232

Gibson, Charles Dana, 16, 47, 62, 71, 173; Work: "The American Girl to All the World," *48*

Gidley, Mick, 121, 133, 199, 420 n. 56, 434 n. 76

Gilpin, Laura, 6–9, 11, 27, 30, 54, 90, 92, 94, 101, 103, 106–8, 110–13, 117, 119, 134, 135–47, 154–55, 186, 244–45, 301, 307, 345–64, 400 n. 26, 413 n. 11, 415 n. 20, 420 nn. 64 and 67, 456 n. 6, 470 nn. 104, 106, and 109, 472 nn. 116 and 120, 473 nn. 126 and 127, 474 nn. 128 and 131; and Cather, 106, 108, 111–13, 135, 352, 356, 360, 364, 413 n. 11, 470 n. 106, 472 n. 118, 473 n. 123; and Cunningham, 345; and Curtis, 106–8, 111, 117, 121, 137–40, 345–46; and Forster, 139; and Jackson, William Henry, 106–7, 345, 349, 358; and Käsebier, 104, 106–7, 134–37, 346–47, 387–88 n. 9, 412 n. 4, 471 n. 112; and Lange, 353; and O'Keeffe, 138, 353, 363;

and Stieglitz, 408 n. 97, 472 n. 116; and
Ulmann, 431 n. 51; friendships with
women, 103, 108, 111, 136, 138, 141, 347;
pictured, *142;* travels of, 108, 110–11;
Works: *The Babe, 245; Bryce Canyon,* 352,
353; Carrot Field, 354; Cave of the Winds,
352; *Changing Woman* [Petroglyph], *137;*
Chartres Cathedral, 106; *Church at*
Picuris Pueblo, 353; *Cliff Palace,* 346; *Cliff*
Palace, Round Tower (Mesa Verde,
Colorado), 112, 346; *Colorado Sand Dunes,*
352; Corley Road Tunnel, 106, 346; *Daisy*
Tauglechee, Hand Study, 143; Desert
Erosion, 364, *365; Doko'oosłííd, Sacred*
Mountain of the West, 148; *Elephant Butte*
Lake, 361, *362; The Enduring Navaho,* 9,
113, 121, 135–47, 346, 355, 365; *Florence at*
Long Salt Hogan, 146; Grace Church,
Colorado Springs, 106; *Hardbelly's*
Hogan, 105; Irene Yazzie, Pine Springs,
142, *143; [Landscape with Small Figures],*
[Red Rock, Arizona], 349, *350; The Little*
Medicine Man, 106; *Long Salt Summer*
Hogan, 145; May Adson, 142; Maya
Women, Yucatán, 245; Mesa Verde, 346,
355; *Millstones—Taos,* 362, *363; Moon-*
light—Elephant Butte Lake, 361, *362;*
Mouth of the River from the Air, 364, *366;*
Mrs. Hardbelly, 144; Mrs. Hardbelly and
Sister, 144; Navaho Madonna, 12, *139,*
245; *Navaho Woman and Child in*
Hogan, 104, 105, 106; *Old Lady Long Salt*
Spinning, 146; Old Woman of Ácoma, 114;
The Pike's Peak Region, 355; *The Pueblos:*
A Camera Chronicle, 111–15, *137,* 355, 415
n. 18; *The Rio Grande, River of Destiny:*
An Interpretation of the River, the Land,
and the People, 355, 472 n. 118; *The Rio*
Grande, River of Destiny, 137, 355, 356, 358,
360, 472 n. 118; *Ristras,* 362, *364;*
Shiprock, New Mexico, 113, 349, *350; Sisal*
Plant, Yucatán, 353; *Sotol Plant, 353;*
Storm from La Bajada Hill, New Mexico,
356, *357; Sunrise, Grand Canyon, 348; Taos*
Ovens, New Mexico, 353; *Temples of*
Yucatan, 137, 355; *Twin War Gods [Rock*
Painting], 136

Golden, Eunice, 310, 312; Work: *Blue*
Bananas and Other Meats, 310
Gover, C. Jane, 88, 390 n. 15, 400 n. 25
Graves, Morris, 343, 379
Great Depression, 12, 29, 210, 222, 235,
248, 252, 258, 263, 271, 355, 371, 440 n. 9
Green, Rayna, 123, 418 n. 40, 459 n. 17
Greenwood, Francis Peabody, 426 n. 13
Group f.64, 26, 28, 29, 30, 93, 194, 198,
202, 213, 227, 327, 338, 432 n. 64, 433 n.
69, 463 n. 55, 464 n. 59, 468 n. 62. *See*
also Adams, Ansel; Cunningham,
Imogen; Edwards, John Paul; Kanaga,
Consuelo; Noskowiak, Sonya; Swift,
Henry; Van Dyke, Willard; Weston,
Edward
"Gussie": from "Rough Sketches: A Study
of the Features of the New Negro
Woman" (John Henry Adams Jr.), *180*

Hampsten, Elizabeth, 303–6, 457 nn. 14
and 15
Hampton Album, The. See Johnston,
Frances Benjamin
Hampton Institute, 77, 157, 160, 166–68,
172, 175–76, 178, 182–83, 425 nn. 7 and 8,
425–26 nn. 9, 13, and 14, 426–27 n. 15,
428–29 n. 24, 430 n. 39
Haraway, Donna, 18, 43, 44, 135, 140–41,
154, 389 n. 9, 397 n. 80, 403 n. 48, 420
n. 60, 421 n. 71
Harlem Democrat, The, 436 n. 90
Hartmann, Sadakichi, 32, 90, 391 n. 27,
401 n. 33
Herbst, Josephine, 252, 447 n. 79
Heyman, Therese Thau, 194, 255, 392–93 n.
39, 446 n. 72, 460 n. 34, 461 n. 43, 462
n. 48, 463 n. 55
Hine, Lewis, 4, 21, 39, 53, 65, 119, 184, 185,
219, 222, 232, 237, 240, 358, 403–4 n. 52,
416 n. 30; Work: *A Tenement Madonna,*
239
History: and art, 13–19, 38–39, 389, 390;
and memory, 16–19, 272, 274, 356, 359–
62, 365, 371–75; and photography, 19–21,
243; cultural constructions of, 6–8, 12,
20–23, 25, 30–31, 37, 44, 162, 168–72, 183,

237, 252, 255–57, 261–63, 274–76, 283–91, 297–99, 305–8, 311, 325, 351, 389–90 n. 13, 395–396 n. 69, 396–97 n. 79, 422 n. 76, 437 n. 97, 448 n. 86, 449 n. 93, 450 n. 95, 452 n. 112; indigenous, 11, 421–22 n. 74. *See also* Sherman, Cindy: *History Portraits*

Holder, Preston, 194, 464, 474 n. 133

hooks, bell, 41, 396 n. 72

Hoppé, Emile Otto, 199, 434 n. 76

"How to Tell Japs from the Chinese" (*Life* magazine), *280*

Hughes, Jabez, 81–82

Hurston, Zora Neale, 209, 437 n. 96

Hust, Karen, 112, 346, 349, 353, 415 n. 19, 470 nn. 106 and 110

Indians. *See* North American Indians

Jackson, John Brinckerhoff, 358–59, 365, 474 n. 128

Jackson, William Henry, 106–7, 117, 298, 313, 345–46, 358; Works: *Cameron's Cone from "Tunnel 4,"* 346; *Grand Canyon of the Colorado, No. 1069,* 349, *350*; *The Photographer's Assistants, 301*

James, Henry, 14, 22, 58, 60, 106, 160, 456 n. 6

Japanese Americans, 228, 415 n. 20, 451 nn. 103, 104, 105, and 106, 452–53 nn. 107–12; at Manzanar, *272*, 283–88; evacuation of, from West coast cities, 273, 277–83, 285–86; Executive Order 9066, 272–73, 452 n. 108; internment in concentration camps, 272–74, 284–90, 302, 368, 451–52 nn. 104, 105, 106, 107, and 112, 454 n. 122. *See also* Adams, Ansel; Lange, Dorothea: work for WRA; Miyatake, Toyo

Jewett, Sarah Orne, 6, 135, 185, 387–88 n. 9, 420 n. 61

Jews: representations of, 212, 227, 419 n. 55, 434 n. 76. *See also* Lange, Dorothea

Johansen, Earnest: *Laura Gilpin, 142*

Johnston, Frances Benjamin, 9, 30, 55–56, 63, 74, 76–77, 79, 84, 88–90, 157–58, 160, 162, 169, 172–76, 181–83, 400 n. 26, 403–

4 n. 52, 406 n. 69, 429 n. 25, 459 n. 23; and Käsebier, 75, 77; Works: *Adele Quinney, Stockbridge Tribe,* 170, *171*; [Alice Roosevelt Longworth], 175; *Arithmetic—Measuring and Pacing, 165, 166; Art Students' League, 56; Class in American History,* 167, *168,* 169–70, 172–73; *Ellen Terry,* 175; "Foremost Women Photographers" series, 86–88; *400 Students in Memorial Chapel, 161; Geography Lesson, 165; The Hampton Album,* 157–59, 162–63, 167, 170, 174, 179, 183, 424 n. 6, 425 nn. 7 and 8; *A Hampton Graduate at Home, 163, 164; A Hampton Graduate's Home, 163; Hampton Institute series,* 9; interior of Johnston's studio, *174; John Wizi, Sioux,* 170, *171;* Mills Thompson, advertising poster, *173; The Old Folks at Home, 163, 164; The Old-Time Cabin, 163; Serving the Dinner, 167; Snow Hill Institute, 176, 177; Stairway of Treasurer's Residence, 157, 158; Trade School—Mechanical Drawing, 165; Woman Worker, Lynn, Massachusetts, 78*

Jones, Pirkle, 370, 463 n. 56, 475 n. 138

Jung, Carl Gustav, 205–6, 435–36 n. 87

Kanaga, Consuelo, 10, 27, 29, 30, 193–211, 194–214, 392 n. 32, 400 n. 26, 432–33 n. 65, 433 nn. 69 and 70, 433–34 n. 71, 435–366 n. 87, 436 n. 91, 437 n. 96, 464 n. 59; and Cunningham, 198; and Group f.64, 195–98, 433 n. 69; and Lange, 198, 205, 210; and Steichen, 206, 437 n. 99; and Stieglitz, 90, 198, 205, 434 n. 72, 436 n. 91; and Weston, 198, 434 n. 72; identification with African Americans, 199–200, 203, 206, 213, 437 n. 96, 438 n. 107; pictured, *197;* radical activities of, 200, 202–4, 213, 435 n. 83; Works: *Annie Mae Merriweather, 195, 204,* 205; "Child with Apple Blossom," 206; *Chinatown,* 198; *Eluard Luchell McDaniel, 195, 202; Frances with a Flower, 195, 196,* 197; "Girl with Double-Heart Ring," 201, 206, 208; *Hands, 195, 196; Kenneth Spencer,*

205; *Mother and Son or The Question, 209;* *Nooning,* 201; *San Francisco Kitchen,* 199; *Self-Portrait with Bottles,* 195; *She Is a Tree of Life to Them, 207,* 208, 210, 211; *Two Women, Harlem, 203; Young Girl in Profile, 208*

Käsebier, Gertrude, 6–9, 27, 30, 37, 52, 57–58, 60, 63–65, 70–71, 73–77, 82–84, 86, 88, 90, 94, 97–98, 100, 108, 134–36, 186, 227, 244–45, 332, 383, 385, 387–88 n. 9, 399 n. 19, 401 nn. 29 and 33, 402 nn. 41 and 43, 403 nn. 45 and 51, 404 nn. 53 and 60, 406 n. 70, 407 nn. 77 and 83, 408 n. 98, 409 n. 101, 410 n. 105, 411 nn. 111, 113, and 115, 412 n. 2, 413 n. 11, 420 nn. 61 and 62, 446 n. 66, 466 n. 75; and Cather, 387–88 n. 9; and Gilpin, 103, 107, 117; and Indians, 94, 96–101, 411 nn. 111, 113, and 115, 441 n. 23; and motherhood, 64–67, 402 n. 43, 403 n. 45; and Stieglitz, 53, 79, 89, 90, 399–400 n. 19; and White, Clarence H., 53–54, 67, 92, 106–7, 403 n. 51; empathy in portraiture, 58, 135, 402 n. 43; Works: *The Bat,* 328; *Black and White, 158, 159; Blessèd Art Thou Among Women,* 66, 245, 247, 332, 382; *Cornelia, 59; Emmeline Stieglitz,* 245; *Gertrude Käsebier O'Malley Playing Billiards,* 246; *Gertrude Käsebier* (attr.), *Self-Portrait, 78; Gertrude O'Malley and Charles O'Malley,* 245; *The Hand That Rocks the Cradle,* 64; *Happy Days,* 67, 69; *Iron Tail, 97, 98; Katherine (Kitty) Stieglitz,* 245; *The Manger,* 12, 63, 64, 65; *Miss N.* [Evelyn Nesbit], *71, 72, 73; Mother and Child, 104, 246; Mother and Child (Adoration),* 245; *Mother and Child (Decorative Panel),* 245; *Mother and Child (Mrs. Ward and Baby),* 245; *The Picture Book,* 67, 245; *The Red Man, 97–98, 99,* 106; *The Rehearsal, 63; Serbonne (A Day in France), 63; The Silhouette, 63; The Sketch,* 471; *The War Widow,* 64, 104; *Zitkala-Ša, 100*

Keiley, Joseph, 52, 69, 90, 99, 404 n. 53

King, Clarence, 115–16, 313, 319, 348, 415 nn. 24 and 25, 416 n. 26, 460 n. 32, 470 n. 110

Kirshenblatt-Gimblett, Barbara, 164, 426 n. 11

Kirstein, Lincoln, 159–62, 169, 172, 424 n. 6

Klett, Mark, 110, 349 n. 114

Klimt, Gustav, *Judith* I, *72,* 73

Kodak camera. *See* Photographic equipment

Kodak girl, 81, 83, 406 n. 74

Krauss, Rosalind, 38, 215, 298, 300, 315, 394 n. 62, 439 n. 1

Kristeva, Julia, 25, 391 n. 31

Ladies' Home Journal, 9, 57, 74, 77, 79, 173, 176, 408 n. 96

Landscape: and body, 384; and history, 11, 141, 356–57, 370, 373–75, 421–22 n. 74, 456 n. 6, 459 n. 20; and women travelers, 11, 86–87, 109, 198; as female, 46–47, 310–12, 317, 319, 322–24, 329, 468 n. 84, 470 n. 106; as subject in Western art, 46, 53, 297, 305–6, 313, 397 n. 4, 456 n. 6, 473 n. 127; definitions of, 303; dominant attitudes toward, 46, 298, 300–1, 306–7, 313, 319, 348, 456 n. 6, 457–58 n. 17, 458–59 nn. 19, 20; 470 n. 106, 470–71 n. 110, 472 n. 116; female visions of, 113, 295, 300–4, 316–23, 347–49, 351–52, 366, 462 n. 46, 471 n. 111, 472 n. 116; redeeming qualities of, 284, 290, 421–22 n. 74, 459 n. 20; redefinitions of, 11, 107, 150, 300–4, 312–13, 316, 366, 385, 457 n. 15, 471 n. 111; representations of, 8, 11, 31, 150, 284, 288, 295–96, 298–300, 421–22 n. 74, 460–61, n. 34, 470 n. 106

Lange, Dorothea, 3, 6–12, 26–27, 29–30, 39, 84, 92–94, 113, 119, 184, 186, 198, 202, 205, 210, 215–53, 301–2, 349, 353–54, 366–75, 381, 400 n. 26, 436 n. 90; and Adams, 284, 454 n. 126; and Cunningham, 366–68, 369, 474–75 n. 134; and Dixon, Maynard, 244, 248, 367, 446 nn. 72, 73; and family, 216–17, 222–23, 228, 233, 248–50, 367; and FSA, 3–4, 220, 232, 234–35, 237–40, 242, 244, 252–53, 260–61, 276–78, 290, 387 n. 5, 445 n. 62, 448 n. 88, 449 n. 92; and Genthe, 83, 226–27, 445 n. 64; and Gilpin, 368–69; and

illness, 216, 221–25, 249, 251, 440 n. 10, 446 n. 71, 475 n. 135; and Jews, 224–27, 445 n. 64; and Taylor, 224, 236, 238–44, 253–55, 264, 271, 354, 368, 475 n. 135; and White, Clarence H., 54, 244, 445 n. 64; as outsider, 224–25, 228; as storyteller, 4, 12, 215–20, 224–25, 228–29, 237, 248, 256, 260–63, 269–71, 373–75, 439 n. 2, 447 n. 82, 448 n. 85, 474–75 n. 134; *The Making of a Documentary Photographer,* 229, 392 n. 39, 440 n. 8, 474–75 n. 134; pictured, *250;* retrospective exhibit, 1966, 4, 12, 215, 216–20, 258, 367, 371, 440 n. 8; work for WRA, 274, 276–83, 285, 452 n. 108, 453 n. 115; Works: *An American Exodus: A Record of Human Erosion* (with Paul Taylor), 241, 252–54, 258, 263, 269, 271, 354, 368, 449 n. 89; *Bad Trouble Over the Weekend,* 219, *228; Clausen Portrait,* 246; *Crowd, San Francisco,* 248; *Damaged Child, Shacktown, Elm Grove, Oklahoma,* 219, *220,* 234; *Death of a Valley,* 219, 370, 371, *372, 373, 374, 375; Destination Unknown—1939,* 268, 269, *270; Ditched, Stalled, Stranded,* 219; *Dorothea Lange Looks at The American Country Woman,* 215–16, 368, 371, 438 n. 87, 439 nn. 2 and 3, 475 n. 136; *Field Workers, Alabama, 264,* 265; *Filipino Lettuce Cutters, Salinas Valley, 265; First Born, Berkeley, 217; Foot of Priest, 218; Hand, Indonesian Dancer, Java, 249; Housing in converted horse stalls,* 281, *282;* "Hungry Boy," 265; *Inspection,* 278, *279; Interior of camp housing* [Mr. Konda], 277, *278; Isadora Duncan in* La Marseillaise, *226;* [Joan Lange Nutzhorn], *226; Katten Portrait, San Francisco,* 228; *Ma Burnham,* 258, *261,* 267; *Mexican Migrant Worker, 239; Migrant Cotton Picker, Elroy, Arizona, 249; Migrant Mother, 3,* 5, 6, 10, 19, 206, *234,* 237, 244, 436; *Mrs. Kahn and Child, San Francisco, 246; North Texas, 268; Oak Tree, Berkeley, 217;* Oklahoma, 1938, *256; Oklahoma Drought Refugees,* 237, *238; On the City Dump, Bakersfield, California,* 268, 269, *270; On U.S. 80 Near El Paso, 266,* 267; "Public Defender" series, 219,

291; *Raphael Weill Elementary School,* 280, *281; Shibuya Family,* 280, *281; A Sign of the Times—Depression, 218; Six Tenant Farmers, 219; Southwest, 244; Strike, San Francisco, 248; Supper Time (On Highway No. 1 of the OK State), 267; Terrified Horse, 371, 372; Texas,* 1937, *257; Texas Panhandle,* 258, *260; To a Cabin,* 216; *Tractored Out, Childress Co., Texas,* 353, *354;* Untitled [Arkansas], 368, *369; White Angel Breadline, San Francisco,* 202, 219, 229, *231,* 248; *Woman of the Far West from Berryessa Valley, California,* 370, *371; Woman of the High Plains, Texas Panhandle,* 210, 219, 257, 258, *259,* 260, 266; *Young Farmer in New Mexico,* 240

Latham, Edward H., 132–34; Work: *Mother and Child, 133, 134*

Lauretis, Teresa de, 36, 42, 391 n. 24, 450 n. 95

Lavenson, Alma, 28–29, 30, 194, 338, 392–93 n. 39, 464 n. 59; Work: *Consuelo Kanaga, 195, 197*

Lee, Russell, 277, 452 n. 108; Work: *Child tagged for evacuation, 277*

Le Sueur, Meridel, 263, 295, 450 n. 96, 456 n. 1

Levine, Lawrence W., 189, 234, 387 n. 3, 391 n. 26, 396–97 n. 79, 443 n. 40

Library of Congress, 4–5, 220, 240, 247, 251, 254, 261, 276, 425 n. 7, 439 n. 7, 447 n. 82, 449–50 n. 94

Life magazine, 77, 236, 280, 291, 358, 370

Limerick, Patricia Nelson, 351, 458 n. 18, 472 n. 115

Linked Ring, The, 57

Lippard, Lucy, 117, 149–50, 307, 420 n. 67, 421–22 n. 74, 422 n. 76, 423 n. 81, 462 n. 46

Lorentz, Pare, 256, 291, 371, 455 n. 131

Lott, Eric, 212, 410–11 n. 109, 430 n. 40

Lowe, Sarah M., 195, 210, 392–93 n. 39, 433 n. 71, 435 n. 84

Luchetti, Cathy, 304–5, 406 n. 72, 457 n. 16

Lyman, Christopher, 123, 127–28, 131, 418 n. 45, 419 n. 48, 427 n. 19

487

MacLeish, Archibald, 236, 252, 353, 472 n. 119

"Male gaze," the, 31–36, 41, 56, 324, 385, 393 n. 46, 393–94 n. 47, 399 n. 18, 403 n. 48. *See also* Feminist film theory

Male nudes, 31–33, 35, 49, 52, 56, 310, 312, 314, 329–31, 342, 377–79, 465 n. 71, 466 n. 73. *See also* Body: representations of; Sexuality: constructions of

Malik, "Poverty Is a Crime," *5*

Mann, Margery, 5, 331, 387 n. 8, 393 n. 45, 464 n. 67, 465 n. 71, 476 n. 5

Mann, Sally, 219, 331

Marcus, George E., 40, 157, 163

Masquerade, 13–19, 26, 35–37, 49–50, 58–60, 68, 180–81, 212, 214, 312, 322, 382, 393 n. 46, 394 n. 58, 402 n. 43, 441 n. 23

Matisse, Henri, 194, 319

McCabe, Mary Kennedy, 89, 408 n. 96

McDaniel, Eluard Luchell, 195, 197, 200–201, 435 n. 80

McFarr, Danee, 379–80

Menuhin, Yehudi, 227

Merritt, Ralph, 284

Merriweather, Annie Mae, 195, 205–6, 435–36 nn. 87 and 88

Miller, Alfred Jacob, 306, 458–59 n. 19; Work: *Making Moccasins,* 306, *307*

Millet, Jean-François, 64, 265, 303, 457 n. 13

Millstein, Barbara Head, 195, 197, 210, 432 n. 65, 436 nn. 70 and 71, 438 n. 107

Mitchell, Margaretta, 198, 345, 412 n. 6, 433–34 n. 71, 470 n. 105

Miyatake, Toyo, 286, 464; documentation of Manzanar, 286–88; pictured, *287;* Works: *Barbed Wire, Manzanar, 290; Beauty Shop,* 287, *288; Merritt Park,* 289

Modernism, 28, 194–95, 205, 211, 212, 305, 327, 335–37, 464 n. 60, 468 n. 83

Mona Lisa: representations of, 14, 16, 58, 60

Morgan, J. Pierpont, 122, 136, 137

Mortensen, William, 196

Mothers and children: representations of, 4, 64–68, 234–38, 244–47, 402 n. 43, 403 n. 48, 440 n. 8. *See also* Gilpin, Laura; Käsebier, Gertrude; Lange, Dorothea; Pictorialism

Mount, William Sidney, 160, 201, 424 n. 6, 473 n. 127

"Mrs. Booker T. Washington," 178, *179*

Mucha, Alphonse, 72

Mulvey, Laura, 35–36, 394 n. 58

Museum of Modern Art (MoMA), 4, 12, 39, 159–60, 163, 170, 183, 205–6, 211, 216, 220, 284, 298, 371, 381, 395 n. 65, 435 n. 87, 439 n. 5

Muybridge, Eadweard, 47–49, 51, 53, 131

Myers, Joan, 301

Natanson, Nicholas, 187, 431 n. 54, 435 n. 83, 436 n. 90, 450 n. 98

Nesbit, Evelyn, *71,* 71–72, 404 n. 57

New Deal, 184, 261, 388 n. 13, 436 nn. 88 and 90, 444 n. 49, 450 n. 98, 453 n. 112

Newhall, Beaumont, 215, 243, 325, 442 n. 37, 443 n. 41, 444 n. 61

Newhall, Nancy, 215, 454 n. 125, 464 n. 60

New Masses, 204, 450 n. 96

New Negro for a New Century, A, 178, 428 n. 23

"New Woman," 47, 60, 173, 176

New York, 9–10, 16, 28–29, 39, 54, 60–61, 64, 68, 74–75, 89, 92–96, 107, 135, 159, 184, 198, 200, 202–3, 216, 224, 226–27, 232, 237, 381

Niepce, Joseph-Nicéphore, 20

Niles, John Jacob, 184–86, 430 n. 44, 431 n. 50

Nixon, Herman, 253

Nochlin, Linda, 312

North American Indians, 8–9, 52, 77, 94, 108, 114, 244, 246, 253, 306–308, 388 n. 13; Anasazi, 111; Apache, 127, 171, 427 n. 23; Apsaroke, 128, 171; as "vanishing race," 9, 40, 97, 109, 126–28, 132, 136, 313, 413–14 n. 12; at Hampton Institute, 167–73, 426–27 n. 15, 427 n. 22, 428–29 n. 24; Carlisle Indian School, 100, 117, 125, 171, 424 n. 5; Cherokee, 235, 239; Cheyenne, 119; education of, 167–73, 426–27 n. 15, 427 n. 22, 428–29 n. 24; Hopi, 218, 414 n. 13; Kwakiutl, 128, 130, 419 n. 48; Navajo (Diné), 101, 103, 105, 107, 111, 114, 117, 119, 121, 136–147, 171, 345, 354,

415 n. 21, 420 nn. 64, 66, and 67, 421 n.
70; Nespelem, 132; photographers of,
125, 170–172; "primitive qualities" of, 96,
116, 125, 127, 152, 154, 168, 171, 172, 412 n.
9, 416 n. 26, 417–18 n. 39, 418 nn. 45 and
46, 419 n. 50, 422 n. 76, 428–29 n. 24,
446 n. 72, 458–59 n. 19; Pueblo, 101, 111,
113–14, 138, 171; representations of, 113,
125, 413–14 n. 12, 414 n. 13, 416 n. 26,
419 nn. 48 and 55; sacred sites, 149–54;
self-representations by, 117; Yebechai,
128, 419 n. 48; Zuñi, 106, 111. *See also*
Curtis, Edward Sheriff; Gilpin, Laura;
Käsebier, Gertrude; Race: representa-
tions of
Norwood, Vera, 347, 359, 362, 365, 468 n.
87, 470 n. 109
Noskowiak, Sonya, 29, 194, 338, 464 n. 59
Nusbaum, Aileen and Jesse, 108, 111, 113

Oakland Museum of California, 194–95,
198, 240, 251, 255, 439 n. 2, 447 n. 82, 453
n. 115, 468 n. 92
Office of War Information (OWI), 232, 234,
261, 271, 439–40 n. 7, 449–50 n. 94
O'Keeffe, Georgia, 33, 312, 315, 337, 363,
375, 410 n. 107, 468 nn. 87 and 90
Olwell, Carol, 304, 305, 406 n. 72
Oren, Michel, 26, 28, 327, 464 n. 59
Orland, Ted, *Ansel Adams and Imogen
Cunningham Awarding Jerry Uelsmann
the Title of Honorary West Coast
Photographer at Weston Beach, Point Lobos
(Jerry Uelsmann Receiving the Baptism of
the God Photographers of the West), 325*
O'Sullivan, Timothy H., 21, 110–11, 150,
298, 300, 313, 422 n. 79, 456 n. 6
Otherness, 23, 200, 397, 400 n. 26, 407 n.
83, 410–11 n. 109, 438 n. 104;
Cunningham's sense of, 84, 382, 477 n.
9; Gilpin's sense of, 84; Lange's sense
of, 6, 84, 224–25, 475 n. 135; representa-
tions of, 6–10, 26, 40–44, 57, 94, 115–16,
125, 140, 142–44, 159, 161, 164–66, 172,
199, 211, 214, 216, 229, 233, 242, 246–47,
264–67, 274–76, 278–87, 291–92, 305–8,
310, 313, 400 n. 26, 415 n. 25, 416 n. 26,

417 n. 34, 424 n. 4, 431 n. 55, 434 n. 76,
438 n. 104, 451 n. 99, 452 n. 112, 460 n.
30, 466 n. 73
Outerbridge, Paul, 54, 93, 227

Padula, Fred, 344, 469 n. 101
Page, Homer, 27, 392 n. 32
Paris, 10, 16–17, 74, 86, 158, 182, 194, 199,
209, 212
Parker, Rozsika, 51, 399 n. 15
Partridge, Elizabeth, 256–57, 440 n. 10
Partridge, Roi, 31–33, 330, 463 n. 57, 465 n.
71, 466 n. 76
Partridge, Rondal, 27, 249, 256, 292, 392 n.
32, 449 n. 90, 454 n. 125, 462–63 n. 54;
Work: *Dorothea Lange, 250*
Performance art, 7, 13–19, 33, 49, 58, 214,
317, 321–22, 465 n. 70. See also *Tableaux
vivants*
Peterkin, Julia, 10, 184, 187, 189–90; Work:
Roll, Jordan, Roll, 10, 187, 190, 200, 430
n. 43
Photo League, 10, 203, 213, 435 n. 83, 436
n. 90
Photo-American, The, 76, 405 n. 64
Photo-Era, 91
Photo-Secession, 53, 57, 90, 399–400 n. 19
Photo-Graphic Art, 92–93
Photographic equipment, 32, 34, 37, 41,
80–82, 84–85, 87, 109, 117, 184, 200, 235,
286, 298–301, 406 nn. 73 and 74, 413 n.
11, 432 n. 58, 433 n. 70
Photographic methods and techniques, 8,
26–27, 32, 53, 77, 91–93, 125, 195, 196–98,
205, 213, 236, 240–41, 243, 314–16, 327,
369, 392 n. 32, 432 n. 58, 433–34 n. 71,
436 n. 92, 443 n. 46, 452–53 n. 112, 454
n. 125, 460 n. 31, 466–67 n. 76; aerial
photography, 147–54, 347, 364, 423 nn.
81 and 82, 474 n. 131
Photographic projects: Harriman
expedition, 413 n. 12; public support for,
9, 122, 125, 137; Rephotographic Survey
Project (RSP), 349–50. *See also* Curtis,
Edward Sheriff;*The Family of Man; The
North American Indian.* Survey projects:
See U.S. Government

Photographic societies, 8. *See also* Camera clubs; Linked Ring; Photo-Secession

Photographic Times, 81, 401 n. 33, 404 n. 60, 406 n. 74, 408 n. 98, 410 n. 108

Photographs: and autobiography, 216–17, 219, 252, 322, 410 n. 107; and memory, 216–17, 223, 230, 247, 252, 387 n. 2, 430 n. 39, 445 nn. 62 and 64, 447 n. 78, 470–71 n. 110; as artifacts, 37–38, 291–92, 395 n. 66, 426 n. 11; as cultural documents, 20, 290–91; as narrative, 3, 12, 18, 21–23, 163, 215–16, 254–55, 258–60, 263, 267–69, 275–76, 279–81, 290–91, 424 n. 5, 439 n. 2, 442 n. 35, 447 n. 82, 449–50 n. 94, 475 n. 136; responses to, 12, 39, 40–42, 129, 234, 236, 240, 247, 251, 271, 380, 395 n. 66, 444 n. 52; uses of, 83, 122, 238, 240, 242, 395 n. 67, 409 n. 102, 410 n. 104, 426 n. 11, 431 n. 55

Photojournalism, 93. *See also* Documentary photography

Picabia, Francis, 315

Picasso, Pablo, 147, 194

Pictorialism, 8–9, 11, 37, 47, 52–54, 57, 64–65, 67, 77, 89–90, 92–94, 106, 123, 125, 127, 135, 140, 158, 185, 186, 205, 244, 286, 314, 316, 327, 328, 332, 347, 399 n. 16, 399–400 n. 19, 465 n. 68

Pictorialist Photographers of America, 227

Pictorial Photography in America, 186, 431

Platinum Print: A Journal of Personal Expression, 92–93, 400 n. 23, 409 n. 101

Polack, Richard, 53; Work: *The Artist and His Model, 46*

Pollack, Griselda, 51, 399 n. 15

Popular Photography, 4, 5, 235, 387 n. 8, 443 n. 44

Popular press, 7–8, 77, 79–81, 84–85, 89, 92, 173, 227, 358

Portable outfit used for outdoor photography in the 1850s, *109*

Portraiture, 58, 71–73, 97–101, 170–72, 175–76, 190–93, 195, 198, 200–208, 247, 258, 278, 333–34, 344, 377–81, 406 n. 69, 409 n. 102, 433 n. 67, 434–35 nn. 77 and 78, 435 n. 86, 437 n. 99, 443 n. 46, 445 n. 63, 446 n. 71, 454 n. 125, 455 n. 139, 463

n. 58, 466–67 n. 76, 469 nn. 98, 99, and 101; 469–70 n. 101, 476 n. 3

Powers, Hiram, 61; Work: *The Greek Slave, 51*

Purity/impurity, 16, 19, 24–27, 29, 42, 194, 196, 198, 213–14, 327, 381–82, 384, 391–92 n. 31, 392 n. 39, 433 n. 67, 462 n. 47, 477 n. 7

Putnam, Brenda, 106–8, 110–11, 136, 347, 415 n. 22, 472 n. 120

Rabinowitz, Paula, 252, 263, 447 nn. 77 and 78, 450 n. 95

Race, 12, 388; issues of, 41, 42, 115, 118, 123, 170, 176, 197–214, 216, 247, 253, 264, 273, 274–77, 279, 283–90, 292, 305–308, 388 n. 13, 392 n. 39, 410–11 n. 109, 415–16 nn. 20 and 24, 416 n. 29, 417–18 nn. 34 and 39, 418–19 n. 47, 424 n. 4, 425 n. 8, 425–26 n. 9, 426–27 nn. 13 and 15, 427–28 nn. 22 and 23, 428–29 n. 24, 431 n. 55, 434 n. 76, 438 n. 105, 452 n. 112, 458–59 n. 19; "race-science," 130–31; racism, 115, 125, 130, 264–67, 273, 274–77, 279–90, 415 n. 25, 424–25 n. 6, 430 n. 39, 452 n. 112, 460 n. 32; representations of, 25, 41–43, 51–52, 97–101, 108, 110, 117, 119, 305–308, 415 n. 25, 419 n. 55, 424–25 n. 6, 425 n. 7, 425–26 n. 9, 427–28 n. 23, 429 n. 34, 430 n. 39, 431 n. 55, 436 n. 90, 450 n. 98, 452 n. 112

Radway, Janice, 84, 407 n. 82

Raper, Arthur, 253

Realism, 36, 43, 58, 236–37, 401 n. 31, 416 n. 31

Reid, Ira, 253

Reiss, Winold, 200; Work: *Two Public School Teachers, 203*

Remington, Frederick, 167, 172

Renaissance ideology, 16, 47, 49, 397 n. 5, 397–98 n. 6

Renger-Patsch, Albert, 335, 468 n. 83

Resettlement Administration (RA), 3, 239, 252, 439–40 n. 7

Richardson, Chris: frontispiece of Jean Baudrillard's *America, 296*

Riess, Suzanne, 224, 251, 392 n. 39, 400 n.

22, 440 nn. 8 and 9, 444 nn. 56 and 61, 446 n. 73, 455 nn. 136 and 139, 474 n. 133, 475 n. 135

Riis, Jacob, 39, 65, 79, 130, 173, 232, 237, 358, 403 n. 50, 403–4 n. 52, 444 n. 56

Rinehart, Frank A., 101; Work (attr.): *A. B. Upshaw—Interpreter, 129*

Riviere, Joan, 36, 394 n. 56

Roberts, Mary Fanton (Giles Edgerton), 58, 70

Rogin, Michael Paul, 212, 222, 440 n. 11

Roosevelt, Franklin Delano, 222–23, 272, 440 n. 10

Roosevelt, Theodore, 125–27, 130, 173, 413 n. 12, 418–19 n. 47, 427–28 n. 23

Rosenblum, Naomi, 194, 390 n. 15, 399 n. 16, 400 n. 25, 403 n. 47, 432 n. 64, 464 n. 60, 468 n. 83

Rosenfeld, Paul, 315, 461 n. 36

Rosskam, Edwin, 253, 436 n. 88, 450 n. 98

Rossler, Martha, 247, 257, 443 n. 43, 448 n. 86

Rothstein, Arthur, 27, 184, 205, 392 n. 32, 436 n. 90, 449 n. 90

Russo, Mary, 214, 385, 391 n. 24, 438 n. 108, 476 n. 1

Saint-Gaudens, Augustus, 62, 71, 404 n. 56, 427–28 n. 23

Sandweiss, Martha A., 108, 111, 113, 141, 346, 408 n. 97, 409 n. 101, 412 nn. 2 and 4–8, 413 nn. 10 and 11, 414 nn. 15 and 16, 415 nn. 20 and 22, 420 nn. 61, 62, 64–66, 68, and 69, 421 nn. 70, 72, and 73, 457–58 n. 17, 470 nn. 106–8, 471 n. 113, 472 n. 120, 473 nn. 122 and 124–26, 474 nn. 129 and 131

Sargent, John Singer, 63, 71, 86, 176

Scarry, Elaine, 6, 222, 272, 293, 375, 388 n. 11, 440 n. 12

Schoelwer, Susan Prendergast, 305–6, 458–59 nn. 18 and 19

Scott, Joan Wallach, 23, 390 n. 21

Sekula, Allan, 54, 211, 230, 400 n. 21, 437 n. 99, 437–38 n. 101, 439 n. 5, 441 n. 32

Sense of place, 11, 135, 141, 303–4, 324, 336–37, 355–57, 364, 367, 368, 370, 373, 421–22

n. 74, 451 n. 100; displacement, 11, 224–25, 374, 375

Sentiment, 65, 69–70, 79, 82–83, 139, 233, 235–36, 243, 278, 292, 307, 319, 375, 402 n. 43, 405 n. 65, 408 n. 95, 410–11 n. 109, 455 n. 139, 463 n. 58

Sexuality: constructions of, 49, 51, 312, 329–31, 340–41, 458–59 n. 19, 462 n. 47, 468 n. 84, 470–71 n. 110, 472 n. 115; cultural constructions of, 34–35, 52, 391 n. 30, 396 n. 70, 415 n. 25, 416 n. 26; identity, 26; lesbian, gay, bisexual identity, 26, 84, 117, 141–43, 213, 292, 400 n. 26. *See also* Body; Gender; Otherness

Shepard, Paul, 300, 457 n. 8

Sherman, Cindy, 7, 14, 16–17, 19, 26, 36, 38, 39, 58, 213, 323, 389 nn. 4 and 8, 390 nn. 14 and 15, 441 n. 23, 465 n. 70; Works: *History Portraits, 13, 14, 15, 16–19, 39*

Shloss, Carol, 33, 388, 393, 416 n. 30

Simon, Anne, 136, 347

Sipprell, Clara, 92, 301, 408 n. 96, 409 n. 101, 410 n. 103

Siskind, Aaron, 203, 435 nn. 83, 84

Smith, J. Russell, 253, 448 n. 87

Smith, Jaune Quick To See, 153, 423 n. 84

Snyder, Joel, 48, 398 nn. 8 and 10, 422 n. 79

Sontag, Susan, 10, 13, 60, 157, 388 n. 14, 389 n. 3, 424 n. 2

Southern U.S., 182–84, 187, 220, 264

Stallybrass, Peter, 16, 213, 389 n. 6, 438 nn. 105 and 106

Steichen, Edward, 12, 63, 67, 90, 205–6, 209, 211, 388 n. 17, 402 n. 41, 435 n. 87, 437 nn. 96, 99, and 100, 439 n. 5, 465 n. 69; Works: *The Family of Man,* 206, 439 n. 5; *Wind Fire, 323*

Steinbeck, John, 237, 270

Steiner, Ralph, 54, 93, 227

Stephens, Alice Barber, 54, 56, 64; Work: *The Women's Life Class, 55*

Stieglitz, Alfred, 8, 21, 28–30, 53–54, 64, 67, 75, 86, 89–91, 93, 95–96, 194, 198, 206, 230, 284, 298, 308, 312–13, 316–17, 341, 385, 399–400 nn. 17 and 19, 400 n. 20,

403 n. 51, 404 n. 53, 406 nn. 70 and 72,
408 nn. 94, 95, and 97, 408–9 n. 98, 410
nn. 107 and 108, 434 n. 72, 436 n. 91,
441 n. 31, 453 n. 121, 456 n. 6, 459 n. 24,
460 n. 31, 461 nn. 35, 36, 38, and 40, 465
nn. 68 and 69, 472 n. 116; and Käsebier,
79; and O'Keeffe, 33, 330, 410 n. 107;
and women photographers, 57, 90, 316–
17, 400 n. 25, 408 n. 97; collaboration
with Clarence H. White, 50, 91;
relationship to Group f.64, 29, 315;
Works: *Camera Work*, 23, 205;
Equivalents, 29, 298, *315,* 410 n. 107, 316;
*Georgia O'Keeffe: A Portrait—with Apple
Branch, 312;* [Miss Thompson] (with
Clarence H. White), *50; The Steerage,* 94,
95. See also Brigman, Anne S.; Kanaga,
Consuelo; Käsebier, Gertrude; White,
Clarence H.

Stilgoe, John R., 303, 457 n. 12, 459 n. 20

Stokowski, Leopold, 227

Stott, William, 229, 234, 240, 440 n. 9,
441 n. 29, 443 n. 48, 445 n. 63, 447 n.
84, 449 n. 89

"Straight" photography, 90, 93, 196–98,
327, 433 n. 69. *See also* Group f.64

Strand, Paul, 28–30, 90, 93, 110–11, 248–
49, 298, 327, 392 n. 37

Strathern, Marilyn, 309, 460 n. 29

Struss, Karl, 92

Stryker, Roy Emerson, 3, 10, 206, 234, 252,
260, 261, 270, 387 n. 5, 436 n. 90, 439 n.
7, 445 n. 62, 449 nn. 92 and 93, 449–50
n. 94, 451 n. 101. *See also* Farm Security
Administration (FSA); Office of War
Information (OWI); War Relocation
Authority (WRA)

Survey-Graphic, 4, 200, 203, 232, 235, 237,
241, 430 n. 41, 444 n. 51

Susman, Warren, 234, 443 n. 40

Swift, Henry, 194, 338, 464 n. 59

Symbolism, 11, 60, 94, 314, 315–16, 323–24,
328–30, 343

Szarkowski, John, 39, 160, 217, 298, 394–95
n. 65, 402 n. 43, 456 n. 6, 459 n. 20

Tableaux vivants, 12, 13–19, 50, 58, 60, 60–

65, 71, 94, 99, 168, 186, 327, 383, 401 n.
34, 402 n. 41

Tagg, John, 236–37, 240, 395 n. 67, 398 n.
9, 443 n. 45, 444 n. 53, 449 n. 93, 455 n.
129

"Take Kodak with You" (Kodak ad), *80*

Taussig, Michael, 180–81, 200, 295, 429 n.
35, 456 n. 2

Taylor, Paul Schuster, 4, 224, 236, 236–43,
279, 291, 441 n. 18, 443 nn. 46 and 49,
444 nn. 51 and 55–61, 446 n. 72, 447 nn.
76 and 84, 448 n. 85, 449 n. 89, 453 n.
116, 455 n. 136, 472 n. 121, 474 n. 133; *An
American Exodus: A Record of Human
Erosion* (with Dorothea Lange), 241,
252, 354, 368, 449 n. 89; marriage to
Dorothea Lange, 221, 251–52

Thompson, Florence ("Migrant Mother"),
12, 235, 237, 388 n. 18, 448 n. 86

Todorov, Tzvetan, 116, 396 n. 71, 416 n. 27

Trachtenberg, Alan, 20–23, 25, 27, 53, 96,
116, 119, 262, 341, 390 nn. 16 and 18, 399
n. 16, 415 n. 23, 422 n. 79, 423 n. 82, 434
n. 77, 444 nn. 50, 52, and 53, 447 n. 83,
449 n. 93, 457–58 n. 17, 469 n. 96

Trinh Minh-ha, 26, 37, 42, 43, 377, 394 n.
60, 396 n. 76

Tugwell, Rexford G., 253, 439 n. 7

Turner, Lorenzo Dow, 189, 432 n. 57

291 (Gallery), 8, 29, 53, 57, 194, 315, 461 n. 38

Tyler, M. E. [Cora Baldwin and Mrs. M.
E. Tyler, Photographer], *305*

U.S. Camera, 4, 235, 471 n. 113

U.S. Government: survey project, 115, 150,
296, 298, 301, 307, 313–14, 348, 422 n.
79; U.S. Army's *Final Report: Japanese
Evacuation from the West Coast, 1942,*
274–76, 285, 290

Uelsmann, Jerry, 325

Ulmann, Doris, 10, 30, 84, 184–92, 200,
205, 244–45, 430 n. 43, 430–31 n. 47, 431
n. 49–51, 431–32 nn. 56, 58, and 59;
Works: [Woman Ironing], *188; Mrs.
Hyden Hensley and Child, Brasstown,
North Carolina, 245; South Carolina, 189,
191, 192, 193*

Uno, Edison Tomimaro, 274, 452 n. 107

Van Buren, Amelia, 74, 76, 86
Van Dyke, Willard, 27–29, 194, 196, 202, 327, 392 nn. 32, 34, and 37, 433 n. 67, 462–63 n. 54, 464 nn. 59 and 62, 468 n. 93, 474 n. 133
Vanderbilt, Paul, 262, 439–40 n. 7
Vanity Fair, 308
Vision: and photography, 48–50, 322, 324, 337, 410 n. 107, 474 n. 128; and scientific knowledge, 309, 322, 417 n. 34, 421 n. 71, 423 nn. 81 and 82, 436 n. 92, 442 n. 35. *See* "male gaze"
Voice of the Negro, 429 n. 36
Vroman, Adam Clark, 307

Wade, Elizabeth Flint, 75–76, 83
Ward, Catherine Weed Barnes, 74, 86–87
War Relocation Authority (WRA), 11, 272–73, 276, 279, 285, 288. *See also* Japanese Americans; Lange, Dorothea: work for WRA
Washington, Booker T., 79, 162, 178, 182–83, 425 n. 8, 427–28 n. 23, 430 nn. 39 and 40
Watkins, Carleton E., 150, 298, 313, 457–58 n. 17; Works: *Agassiz Rock near Union Point,* 346; *Best General View of Yosemite Valley,* 298, *299*
Watson-Schütze, Eva, 74, 76–77, 86, 246
Weber, Max, 92, 409 n. 101
Weil, Mathilde, 74, 76
West, Rebecca, 181, 429 n. 37
Western art, 16, 17, 40, 47, 310, 385, 419–20 n. 55, 424–25 n. 6, 432 n. 64, 435 n. 86
Western United States, 11, 28, 54, 94, 96, 106–8, 110, 114–15, 119, 121, 123, 133, 135, 172, 194, 241, 261, 272–73, 276, 295, 305, 307, 309, 314, 331, 338, 345–46, 349, 351, 358, 414 n. 13, 415 n. 22, 438 n. 106, 444 n. 56, 447 n. 81, 458 n. 18, 472 n. 115; Hayden Survey, 107; Mesa Verde, photograph of, 110; photographic projects, 113. *See also* U.S. Government: survey project

Weston, Brett, 194, 196, 463 n. 56, 464 n. 59, 468 n. 93, 477 n. 9
Weston, Edward, 8, 11, 26, 28–30, 33, 36, 54, 194, 198, 214, 286, 298, 327, 338, 338–42, 358, 381, 385, 392 n. 32, 432 n. 63, 433 nn. 66 and 69, 434 n. 72, 456 n. 6, 464 nn. 59, 60, and 63, 466 n. 74, 468 nn. 91 and 93, 469 nn. 94 and 96–99, 473 n. 126, 477 nn. 8 and 9; and Group f.64, 26–29; Works: *Artichoke Halved, 340; Oak, Monterey,* 338; *Shell and Rock Arrangement,* 338, *339; Succulents,* 338, *339*
Wexler, Laura, 48, 162, 170, 173–74, 182, 398 n. 8, 400 n. 21, 410–11 n. 109, 425 nn. 7 and 8, 471 n. 112
Wharton, Edith, 15–17, 57, 60–61, 73, 106, 319, 373, 401 nn. 27 and 34, 462 n. 47, 475 n. 140
White, Allon, 213, 391 n. 24, 430 n. 42, 438 n. 105, 466 n. 73
White, Clarence H., 8, 10, 30, 37, 53, 83, 90, 92–94, 212, 227, 244, 246, 328, 399 n. 17, 403 n. 51, 409 n. 102, 411 n. 113, 412 n. 4, 445 n. 64; and Käsebier, 54, 67; and Stieglitz, 50, 90, 93; innovative teaching of, 90–93; pictured, *91;* Works: *Nude with Baby, 68;* [*Miss Thompson*] (with Alfred Stieglitz), *50; Ring Toss, 67, 69. See also* Clarence H. White School of Photography
White, Minor, 298, 333, 370, 374, 466 n. 76, 467 n. 77
White, Stanford H., 71–73
Whitman, Walt, 11, 21–22, 284, 345–46, 358, 388 n. 15, 390 n. 17, 391 n. 27, 438 n. 106, 469 n. 98; daguerreotype of, *25*
Whittier, John Greenleaf, 165, 426 n. 12
Williams, Fannie Barrier, 178–79
Williams, Linda, 35, 49, 393 n. 47, 394 n. 48, 396 n. 70, 398 n. 11
Wilson, Charis, 343, 469 n. 99
Wolcott, Marion Post, 301
Women photographers, 8, 10; as exhibitors, 74, 79, 405; education of, 8, 64, 75–76, 79, 87, 92, 94, 409 n. 102, 410 n. 104, 412 n. 4; expressive language of, 8; in the popular press, 8; networks of,

8, 30–31, 57, 74–75, 88, 90, 135, 136, 186,
198, 227, 347, 385, 392–93 n. 39, 403–404
n. 52, 405 n. 62, 463 n. 56
[Women working at Kodak], *81*
Wood, N. B., 178, 428
Woolf, Virginia, 309, 420 n. 63, 460 n. 28
Wright, Mabel Osgood, 86
Wright, Richard, 253, 436 n. 88, 450 n. 98

Yavno, Max, 203, 206, 436 n. 93
Yochelson, Bonnie, 90, 93, 409 n. 100,
441 n. 26

Zealy, J. T., 25, 52, 119, 188, 199, 417 n. 34,
431 n. 55
Zitkala-Ša (Gertrude Simmons Bonnin),
99–101, 411 n. 113

Judith Fryer Davidov is Professor of English
and American Studies at the University of
Massachusetts at Amherst

Davidov, Judith Fryer.
Women's camera work: self, body, other / by
Judith Fryer Davidov.
p. cm. — (New Americanists)
Includes index.
ISBN 0–8223–2054–1 (cloth : alk. paper).
ISBN 0–8223–2067–3 (paper : alk. paper)
1. Photography—United States—History.
2. Women photographers—United States—
History. I. Title. II. Series.
TR23.D38 1998
770'.82—dc21 97–34684 CIP